The Gothic Imagination

Also by John C. Tibbetts

The American Theatrical Film
Schumann: A Chorus of Voices
Composers in the Movies: Studies in Musical Biography
Dvorak in America
All My Loving?: The Films of Tony Palmer
Shakespeare into Film (with James M. Welsh and Richard Vela)
Novels into Film (with James M. Welsh)

The Gothic Imagination

Conversations on Fantasy, Horror, and Science Fiction in the Media

John C. Tibbetts

Preface by
Richard Holmes

THE GOTHIC IMAGINATION
Copyright © John C. Tibbetts, 2011.

All rights reserved.

First published in 2011 by
PALGRAVE MACMILLAN®
in the United States—a division of St. Martin's Press LLC,
175 Fifth Avenue, New York, NY 10010.

Where this book is distributed in the UK, Europe and the rest of the world,
this is by Palgrave Macmillan, a division of Macmillan Publishers Limited,
registered in England, company number 785998, of Houndmills,
Basingstoke, Hampshire RG21 6XS.

Palgrave Macmillan is the global academic imprint of the above companies
and has companies and representatives throughout the world.

Palgrave® and Macmillan® are registered trademarks in the United States,
the United Kingdom, Europe and other countries.

ISBN 978–0–230–11816–4 (hc.)
ISBN 978–0–230–11817–1 (pbk.)

Library of Congress Cataloging-in-Publication Data

Tibbetts, John C.
 The gothic imagination : conversations on fantasy, horror, and science
 fiction in the media / John C. Tibbetts ; preface by Richard Holmes.
 p. cm.
 Includes bibliographical references.
 ISBN 978–0–230–11816–4 Hardback
 ISBN 978–0–230–11817–1 Paperback
 1. Gothic fiction (Literary genre), English—History and criticism.
 2. Gothic fiction (Literary genre), American—History and criticism.
 3. Gothic revival (Literature)—History and criticism. 4. Fantasy films—
 History and criticism. 5. Horror films—History and criticism. 6. Science
 fiction films—History and criticism. 7. Horror television programs—
 History and criticism. 8. Science fiction television programs—History and
 criticism. 9. Fantasy in art. 10. Horror in art. I. Title.

PR830.T3T53 2011
700'.415—dc22 2011012942

A catalogue record of the book is available from the British Library.

Design by Newgen Imaging Systems (P) Ltd., Chennai, India.

First edition: October 2011

10 9 8 7 6 5 4 3 2 1

Printed in the United States of America.

To my father, James C. Tibbetts (1917–1998),
member of First Fandom, who first showed me the way
to the worlds of wonder.

Witness this new-made world, another heaven. . .
Of amplitude almost immense, with stars
Numerous, and every star perhaps a world
Of destined habitation. . .
Milton, *Paradise Lost*, Book VII, 1667 (lines 617–623)

CONTENTS

Preface		ix
Prefatory Note		xiii
Acknowledgments		xv
Introduction:	Voices Heard 'Round the Cosmic Campfire	1
One	The Lovecraft Circle	9
Two	The Heroic Age of Fantasy and Science Fiction	55
Three	The Bradbury Chronicles	141
Four	Destination: Mars!	177
Five	The Extravagant Gaze	201
Six	"Where No Man Has Gone Before..."	245
Seven	The Music of Terror	273
Eight	Postmodern Gothic	283
Nine	"The Heresy of Humanism"	359
Epilogue	"Night Vision"	383
Notes		385
Index		405

PREFACE

By Richard Holmes

Richard Holmes. Image copyright, Stuart Clarke.

It's always a great idea to get a bunch of enthusiasts sounding off about a subject they really know, love, and deeply care for. In the case of the Gothic and science fiction practitioners here, it's genuinely weird and thought-provoking, too. John Tibbetts's wild and exuberant anthology of interviews will certainly test your synapses as well as your literary prejudices. It reminds me that I belong to an old-fashioned generation whose idea of science fiction was defined by two heroic events of the late 1960s: the Apollo 11 Moon landing and Stanley Kubrick's *2001: A Space Odyssey*. More than 40 years later, I am amazed by the Gothic richness, the anarchic wit, and technical resilience of the form as it has obviously continued to develop, especially in America. Just what is it in the Gothic genome that allows it to go on flourishing?

Well, let me give you the reflections of a traditionalist, a British biographer of both writers and scientists, who recently published a mainstream study of Romantic Science entitled *The Age of Wonder*. Not long ago I paid a visit to the National Air and Space Museum in Washington, D. C. There I found a dazzling new exhibition installed, entitled simply "Beyond." It is a display of 148 photographs of all the planets in our solar system (except Pluto). None of the photos was taken from standard, earth-based telescopes. Most were taken by the NASA space probes of the Voyager and Mariner programs over the past 30 years or so.

These "fly-by" pictures (as they are so nonchalantly called) are in fact miracles of technical achievement. Some space probes took many years to reach their target planets, the most ambitious using "slingshot" techniques to swing past the giant gravity field of Jupiter and so sweep on to Saturn and even Neptune. Using multilensed viewing devices, drawing on several different bands of the electromagnetic spectrum, including, of course, infrared, their data has been transmitted back to Earth and gradually built up by computers into these brilliant, colored composite visual images. These are truly astonishing. They give an actual, immediate physical impression of "other worlds"—both beautiful and terrifying—that would be hard to match by anything in my particular favorite science fiction and fantasy authors: Verne, Wells, Arthur C. Clarke, Asimov, Ray Bradbury, or J. G. Ballard. (I said I was a traditionalist.)

So one might think that the inventions of science fiction are always doomed to be overtaken by the fantastic achievements of science itself. (Even *Star Trek* now feels like *The Antiques Roadshow*.) Yet it seems to me that science fiction is now being asked to undertake a rather different task from pure invention. It is to *reimagine what's already been discovered*. Its watchword is quite simply: ok, what then? All its traditional forms—predictions, Cassandra-like warnings, dystopias, satires, technological fantasies, Gothic epics in hyperdrive—are constantly renewed by such a demand.

Central to this idea seems to me a quite old-fashioned notion: the inexhaustible wonder of the universe. As I began working on my *Age of Wonder*, I set out with a very simple definition of this strange stuff called "wonder," based on Plato. Plato says that Wonder is one of the fundamental and defining human impulses not shared by animals. "In Wonder all Philosophy began; in Wonder it ends…But the first Wonder is the Offspring of Ignorance; the last is the Parent of Adoration." (That's how Coleridge, the old science fiction master of the poem "Kubla Khan," translated him anyway.)

As my book expanded from the late eighteenth century into the first third of the nineteenth century, the notion of Wonder became more complicated and ambiguous. It necessarily evolves and expands with knowledge; and it takes you into more and more difficult areas. My book's subtitle, "How the Romantic Generation Discovered the Beauty and Terror of Science," emphasizes that Wonder leads you into both places: into the beautiful and beneficial, but also into the terrifying and menacing.

With NASA still in mind, a pertinent example would be Sir William Herschel's wonderful discoveries as an astronomer. He found the seventh planet Uranus in 1781: the first new planet since Ptolemy, which instantly doubled the size of the known solar system, and, of course, suggested that there might be others out there. But later he hugely increased the size of the universe itself. For the first time he actually observed and drew the shape of our Milky Way, defined it as a separate galaxy in space, and suggested that there were other observable "island universes" out there, like Andromeda. This totally confounded all previous notions of cosmic size and scale. Here were distances that no one could remotely conceive, except mathematically. It was a change as radical as the original loss of the innocent, friendly geocentered universe destroyed by Copernicus.

Herschel was effectively the first person who said that as we look into "deep space," we're actually looking into the past, "deep time." The light of the stars takes "many millions" of years (as he mildly conceived it) to reach us. The stars are unbelievably ancient by the time we greet them. His contemporaries found that idea wonderful, as well as frightening, because they found themselves existing in a universe that was more and more alien, decentered and inconceivable. And probably, as the French astronomer Laplace brazenly remarked, no longer requiring "the hypothesis" of God.

Moreover, there were worlds out there both visible and invisible. It was Herschel who also discovered infrared rays: the invisible but powerful edge of a hitherto unknown spectrum emitted by the sun. Gradually, through the cumulative work of Faraday, Maxwell, and Huggins (among others), the whole world of electromagnetic spectrum was revealed, including, of course, ultraviolet, radio waves, X-rays, and gamma rays. It was an invisible world that no one could have believed in before, and science fiction had not remotely begun to exploit. (Incidentally, the new infrared satellite telescope, just launched in 2009, is christened "Herschel.")

Just four years before Sir William Herschel died, Mary Shelley published her book, *Frankenstein, or A Modern Prometheus* (1818), arguably the first true science fiction novel. It contains absolutely nothing about the solar system or outer space or infrared. But it does open up what my late-lamented friend Jim Ballard famously called "inner space"; and it is driven by the same key SF question: *ok, what then?* Mary had read of attempts to create artificial life, or revive dead bodies with voltaic batteries. What if a scientist actually succeeded in creating the first artificial man? *Ok, what then?*

Mary Shelley pursues the question with brilliant and astonishing originality. She was still only 18 years old when she began the novel. She isn't much interested in the technology, or what happens to the Creature's body. Contrary to the popular idea (largely shaped by the 1890 films and stage adaptations that have since been made) she writes almost nothing about the surgical and electrical techniques used to construct and animate the Creature. What Mary Shelley is really interested in is the Creature's inner

world, its mind and spirit. One can say that the novel *Frankenstein* asks two questions: what happens to the Creature's *soul*? And possibly even more hauntingly: what happens to the soul of the man, the scientist Victor Frankenstein, who dared to create it? I might also add—though no one will believe me—that the actual word "scientist" did not exist until 1834, and Mary Shelley's science fiction novel crucially helped to invent it.

So I conclude, in my stolid way, that the fields of Gothic, fantasy, and science fiction writing are always changing and adapting, simply because their materials are inexhaustible. The demand for human *reimagining* is endless. To rest from the imaginative warp-speed of John Tibbetts's multiversed anthology (I chose my adjective s carefully), I have just begun Stephen Hawking's new book of astrophysics: *The Grand Design: New Answers to the Ultimate Questions of Life*. Here are pages and pages discussing 11 dimensional structures. We can assume that mathematically this makes sense: but how do we *humanly imagine* them? Or, indeed, how do we imagine the mind of the scientist who can understand them? Or (since you mention it) what might it be like to make love in 11 dimensions? Over to you.

31 January 2011

Note: Acclaimed in the *Wall Street Journal* as "our best living biographer," Richard Holmes is well known for his many biographies and books on the Romantic Period, including the landmark *Shelley: The Pursuit* (1974, the winner of the Somerset Maugham Award), the two-volume *Coleridge* (1989–1998, winner of the Whitbread Prize), and two companionable collections of essays, Footsteps and Sidetracks. His latest book is *The Age of Wonder* (Los Angeles Times Book Prize, 2008). He is a Fellow of the British Academy and Professor of Biographical Studies at the University of East Anglia. Among his many enthusiasms is the history (and practice) of ballooning. He currently is working on a study of the "forgotten women" of science.

PREFATORY NOTE

By James Gunn

James Gunn (KUCSSF)

Full disclosure: I've known John Carter Tibbetts since he was in high school, and that was 48 years ago, when I was surprised and delighted to find that he had been named in honor of the hero of Edgar Rice Burroughs' Mars novels. A couple of years later he was a resident in a University of Kansas scholarship hall for which I was the faculty adviser. Still later he took a fiction-writing class from me (and subsequently sold a few stories). Eventually, he became my colleague at the University of Kansas.

I knew his father, James, whose passion for Burroughs and other things science-fictional, led to John's name and to the dedication of this volume. James may have been the first fan I met, probably in a downtown Kansas

City bookstore, probably in 1953, when I was a struggling freelance writer. James was an avid and knowledgeable collector and an enthusiastic fan. That was something in those days. I was an accumulator.

And my name is mentioned a few times in the pages that follow.

John Tibbetts is a man of many talents—author, editor, artist, musician, scholar, teacher. And his range of interests is as varied: literature, music, art, film, all fields in which he has already published one or more of his 18 books. Now he has turned to his and his father's first love, science fiction and fantasy, with a series of interviews from the classic authors who helped shape those fields (many of whom I have known and worked with), the artists who turned them into paintings and illustrations, the biographers who studied them, the filmmakers who broadened their audiences, and the actors who peopled these visions.

I've done some interviewing myself (and been interviewed even more), and I can assure readers that John asks good questions—the kind of questions readers always wanted to ask for themselves—because he knows the creative people he is talking to and the art that has made them great. And he gets good answers, because he knows the fields, he knows these creative people, and they know he will not be satisfied without candor. A reader can tell when an interviewer knows what he's talking about.

And I can assure readers that they will close the back cover of this book a great deal wiser than they opened it. These are indeed voices of wonder.

JAMES GUNN
University of Kansas
Lawrence, KS

Note: In his long and distinguished career, from the late 1940s to the present, science fiction writer/editor/educator James Gunn has published 100 short stories and 3 dozen books, including the acclaimed *The Immortals* (1962) and *The Listeners* (1972). He served as president of the Science Fiction Writers of America (1971–1972) and president of the Science Fiction Research Association (1982–1982). His numerous honors include the Eaton Award for Lifetime Achievement, the 1983 Hugo Science Fiction Achievement Award, and the Damon Knight Memorial Grand Master by the Science Fiction and Fantasy Writers of America in 2007. His *Alternate Worlds: An Illustrated History of Science Fiction* (1975) stands in the front rank of books of its kind. He is Professor Emeritus of English at the University of Kansas, where he founded the Center for the Study of Science Fiction.

ACKNOWLEDGMENTS

My thanks to my editor at Palgrave Macmillan, Samantha Hasey, for her patience, amiable encouragement and support throughout. And thanks to Heather Faulls and Rohini Krishnan. I also wish to thank the following for their assistance in gaining the interviews herin: Professor James Gunn, founder, and Chris McKitterick and Kij Johnson, Associate Directors of the Center for the Study of Science Fiction at the University of Kansas; Donn Albright, curator of the Bradbury Archives; Robin Bailey, former president of the SFWA; Joanie Knappenberger, President of First Fandom; George McWhorter, Curator Emeritus of the Burroughs Memorial Collection at the William F. Ekstrom Library, University of Louisville, Louisville, KY; Wade Williams of Wade Williams Enterprises; Stu Gottesman of the Publicity Departments of Warner Bros. and Paramount Pictures; and Jason V Brock. Thanks to Kimma Sheldon for her assistance in copy editing and to Suzanna Hicks and Matthew Mendoza for help in transcribing some of the interviews. To my colleagues at the University of Kansas, my gratitude—Professors Tamara Falicov, Catherine Preston and Chuck Berg; graduate students Josh Wille, Zach Ingle, Brian Faucette and Tina-Louise Reid; Department of Film and Media Studies staff Marilyn Heath, Lene Brooke, Marilyn Heath, and Karla Conrad; Music Librarians George Gibbs and Jim Smith; and the kind ladies at the KU Digital Media Services Department, Pam LeRow, Paula Courtney, and Gwen Claasen. Thanks are also due to those who have encouraged and assisted my studies of German Romanticism and British and American Gothic, Professors Jacques Barzun, Emeritus Professor of Columbia University; Robert Winter of UCLA; Leon Botstein of Bard College; Alan Walker, Emeritus Professor of McMaster University; Ronald Taylor, Emeritus Professor, University of Sussex; Christopher Gibbs of Bard College; Michael Saffle of Virtinia Tech; and the late Professor John Daverio of Boston College and independent scholar Eric Sams. And thanks to longtime friends and stalwarts Paul Scaramazza, Frank Thompson, Stan Singer, Mary Blomquist, Betsy Green, and James M. Welsh, Professor Emeritus of Salisbury University for a lifetime of boon companionship.

A note about the images:
The University of Kansas' Center for the Study of Science Fiction has been abbreviated to "KUCSSF" for the images they provided.

INTRODUCTION

Voices Heard 'Round the Cosmic Campfire

JOHN C. TIBBETTS

This row of shapeless and ungainly monsters which I now set before the reader does not consist of separate idols cut out capriciously in lonely valleys or various islands. These monsters are meant for the gargoyles of a definite cathedral. I have to carve the gargoyles, because I can carve nothing else; I leave to others the angels and the arches and the spires.

<div align="right">G. K. Chesterton, "On Gargoyles"</div>

In Quest of Wonder...

In 1657, Cyrano de Bergerac (Savinien de Cyrano II) took his readers on a *Voyage to the Moon*. Five years later, this "sailor of aerial seas" ventured on to the sun. He spun quite a tale of speculative science and wild fancy—of rocket vehicles, of a centrist sun, of shape-changing aliens, and so on.[1] Unfortunately, the real de Bergerac, the greatest swordsman this side of John Carter of Mars, is currently unavailable for an interview. His precise whereabouts are unknown. However, his literary, painterly, musical, and cinematic brethren are available—and we hear their voices in these pages. Unlike the storytellers of yore, who crouched around the flame of the rude campfire, they speak out here, illumined in the glare of starshine.

And of what do they speak? They chronicle universes real and alternative, microcosmic and macrocosmic, from yesterday's Gothic romances to today's steampunk anachronisms. Just as Edgar Rice Burroughs' John Carter speeds "with the suddenness of thought through the trackless immensity of space" to Mars, later writers—Jack Williamson, Frederik Pohl, Poul Anderson, L. Sprague de Camp, and Kim Stanley Robinson— follow him to the sun and beyond.[2] Peter Straub, Greg Bear, and Gregory

Cyrano de Bergerac on his way to the moon (KUCSSF)

Benford reverse their rockets and venture into the innermost recesses of the human heart and the human genome, respectively. In worlds between, H. P. Lovecraft unearths cosmic horrors in his native Providence; Ramsey Campbell finds demons under the streets of Liverpool. John Dickson Carr creates miracles in locked rooms. T. E. D. Klein discovers pagan gods in the woods of upstate New York. Ray Bradbury and Ray Harryhausen create dinosaurs in their garage. Suzy McKee Charnas psychoanalyzes a vampire. Wilson Tucker time-travels to an appointment with Abraham Lincoln. Stephen King "walks our dogs at night". And *Psycho's* Robert Bloch rips away the shower curtain and leaves us forever afraid.

The painterly, cinematic, and musical visionaries are here: Art historians Albert Boime and Tim Mitchell recall the Gothic "sublime madness"

of the painters Théodore Géricault, Francisco Goya, and Caspar David Friedrich. Latter-day artists Gahan Wilson, Joseph Mugnaini, Chris Van Allsburg, and Bob Kane unleash their enchanted pencils to inscribe modern-day fairy tales. Filmmakers Dan Ireland, Jason V Brock, and Charles Sturridge deploy their moving images to take us, respectively, to meet "Conan" creator Robert E. Howard on the Texas plains; follow Charles Beaumont into *The Twilight Zone*; and disclose fairy-folk in Yorkshire, England. Like futuristic Peter Pans, Christopher Reeve's "Superman" and the crews of Star Trek's *Enterprise* and Tom Corbett's *Polaris* fly the spaceways to their own Never Lands. Professor Jack Sullivan sounds out the Gothic-inspired music of composers Hector Berlioz, Bernard Herrmann, and others.

And, finally, Professor Harold Schechter and artist Rick Geary take seismic readings of today's subversive cravings for Gothic schlock and true-crime horrors, while Professor Cynthia Miller and T. L. Reid explore that curious Gothic mashup of alternative worlds, punk rebellion, and anachronistic machines known as "steampunk."

By way of a personal note, this book is dedicated to my father, James C. Tibbetts. Like a modern-day Daedalus, he was the artificer of my wings. When I was just four years old, Dad wrote a letter to Edgar Rice Burroughs stating he had given me the middle name of "Carter" in honor of the immortal John Carter of Barsoom—which elicited a return letter from Burroughs that he was "honored to have originated a name for little John Carter." As the twig is bent. Not much later, Dad read to me Burroughs' *A Princess of Mars* (1912). I reveled in the exploits of Captain Carter years before I discovered the chronicles of his brethren, Captain Nemo, Allan Quatermain, and Professor Challenger. Even then I suspected what historian Lin Carter declared, that Burroughs was "the greatest adventure-story writer of all time";[3] and that his stories, as confirmed by Sam Moskowitz, are direct descendents "of the travel tale typified by the Odyssey."[4] Indeed.

Subsequently, Dad wisely stood aside while, on my own, I reached, read, and savored the treasured volumes from his collections of Arkham House, Gnome Press, Donald Grant, and other publishers. So many of the figures interviewed and discussed in these pages were there, on the bookshelves, just inches away from greedy fingers. (Most of those volumes serve as reference sources for this book.) The words of Percy Shelley come to mind:

> While yet a boy I sought for ghosts, and sped
> Through many a listening chamber, cave and ruin
> And starlight wood, with fearful steps pursuing
> Hopes of high talk with the departed dead.[5]

As a member of First Fandom, Dad was welcomed at science fiction and fantasy conventions across America, with me in tow, tape recorder and

notebook in hand. A friend of many, he introduced me to Poul Anderson, Jack Williamson, L. Sprague de Camp, Robert Bloch, Wilson Tucker, Forrest J Ackerman, James Gunn, and many others whom you will find in this book. I like to think that I returned the favor, sharing with him new-found friendships with others in this book, Ray Bradbury, Peter Straub, Chris Van Allsburg, Joseph Mugnaini, Suzy McKee Charnas, and Stephen King, to name just a few. Moreover, as a radio and television reporter, I was subsequently able to contact and interview these and many other filmmakers and actors prominent in science fiction films.

In the end, as Dad lay dying, I once again picked up our volume of *A Princess of Mars*. And, just as he had once read those magical opening pages to me, I now read them back to him. Together, he once again roamed with John Carter across the mossy expanses of the Red Planet. And I know that they both are there, still.

Certain figures and themes haunt these pages. There is scarcely a conversation recorded here that does not cite, directly or indirectly, the presence, example, and influence of the modern American master of Gothic fiction, H. P. Lovecraft (1890–1937). A remark by Stephen King recorded in an interview later in these pages makes the point: "I always say that Lovecraft opened the way for us. He looms over all of us. I can't think of any important horror fiction that doesn't owe a lot to him." In his lifetime frequently regarded—and dismissed—as merely an eccentric scribbler, Lovecraft, as we shall see, is now gaining respect and wider popularity as a significant avatar of the Gothic tradition in all of its thematic variety and cosmic implication.[6] In his pursuit of the terror sublime and the uncanny, this reclusive citizen of Providence, Rhode Island, drew his vast panoply of forbidden sciences, haunted spaces, eldritch horrors, interstellar invasions, parallel worlds, and Faustian pacts from folkloric traditions—what he termed "old lore," or "standard stories invented before the dawn of history or later"[7]—and the extrapolations and visions of eighteenth-century writers Edmund Burke and Horace Walpole; nineteenth-century Romantic visionaries Mary Shelley, the Brontë sisters, E. T. A. Hoffmann, Edgar Allan Poe, Jules Verne, H. G. Wells; and early twentieth-century masters of weird science and cosmic imagination, William Hope Hodgson, Arthur Machen, Lord Dunsany, and Olaf Stapledon.

Terror and wonder, not sentimental love and reason, bound them all together.[8]

Admittedly, I apply the term "Gothic" throughout this book in its most loose-limbed sense, that is, as a mode of speculation that *shares* critical themes and questions with fairy tales, Romanticism, and science fiction. "The methods of the Gothic writers," observes Brian Aldiss, "are those of many science-fiction and horror writers today."[9] Later in these pages, art historian Albert Boime asks, "Don't both [Gothic and Romantic] refer to ways of expanding on a vocabulary? Neither Gothic nor Romantic totally displaces Classicism and the rules; but aren't they are a way of expanding them, to allow for greater effects, for new ideas, for technology, for

changes in the landscape, for things that are happening in the world?" Above all, Lovecraft, along with all of the scientists, poets, writers, painters, cartoonists, composers, and filmmakers, past and present, represented in these pages, obeys the transgressive imperatives of the Gothic imagination—to *resist* the social, political, and gender roles within the conventions of our science and culture. He observes the injunction issued long ago by Walpole to "blend the imagination of Romance with the realism of common life."[10] This is no less true of another important contribution to the Gothic, the fairy-tale tradition. As Bruno Bettelheim writes, "The fairy tale clearly does not refer to the outer world, although it may begin realistically enough and have everyday features woven into it."[11] And there is Carl Sagan's apposite definition of scientific inquiry as "the tension between the natural tendency to project our everyday experience on the universe and the universe's noncompliance with this human tendency."[12]

This blurring of the lines between the terror sublime and the uncanny, the rational and the irrational, science and art—indeed, between the living and dead—is central to the workings and effects of Gothic horror and science fiction, past and present. However, I am fully aware that not everyone—particularly a few "hard" science fiction writers—agrees on these permeable borders. They would separate their work entirely from the Gothic tradition. Rejoinders to this contention are offered throughout, culminating in the concluding conversations and essays about Postmodern Gothic and, in particular, the recent emergence of steampunk.

If my perhaps stubborn insistence that the perceived similarities among the Gothic tale, the fairy tale, the romantic story, the science fiction prophecy, and the alternative universe/steampunk mashup border on identity, let it be on my head.[13] In this, I am merely pursuing Brian Aldiss's thesis in *The Trillion Year Spree* that they all commingled forever after since the 1818 publication of Mary Shelley's seminal *Frankenstein, or the Modern Prometheus*. "For this critic's taste," Aldiss writes, "the Frankenstein theme is more contemporary and more interesting than interstellar travel tales, since it takes us nearer to the enigma of man and thus of life."[14] Drawing upon the precedents of contemporary chemistry and galvanic experiments—Victor Frankenstein was a composite of a generation of scientific men, notably Sir Humphrey Davy and the controversial German physiologist Johann Ritter—Shelley also relied upon the spooky Gothic narrative styles, situations, and settings of German ballads and folk tales. *Romantic Science* was born.[15] Moreover, like Shelley's misshapen creature, the Gothic mode has continued for almost two centuries to display in all the arts the adaptability of a living species: "Backward and nostalgic at first," argues Aldiss, "it developed rapidly...to confront more closely the conditions that nurtured it. The archetypal figures of cruel father and seducing monk were transformed into those of scientist and alien...inventor, [and] space traveler...And evolution provided an essential viewpoint powering the new subspecies of Gothic, science fiction."[16] Indeed, Lovecraft and his Gothic

progeny, according to Jerrold E. Hogle, continue to demonstrate how the Gothic mode "has become a long-lasting and major, albeit widely variable, symbolic realm in modern and even postmodern western culture, however archaic the Gothic label may make it seem."[17]

Thus, as in no other fictional paradigm, the Gothic storytelling tradition, abetted and enhanced by Lovecraft and others, flourishes to this day in the weird tale, the "locked-room" mystery, the visionary painting, the musical *fantasie*, the graphic novel and comic book, and the science fiction movie and television show. As we have always done with the folk and fairy tales of our childhood, we keep rehearsing these stories over and over again, with different elements but certain constant features. In their postmodern incarnations, for example, we encounter contemporary anxieties over gender-crossings, transgressive sexualities, racial hybrids, class fluidities, the child in the adult; and the impact of relativity, quantum physics, and biological inquiry into the nature and purpose—or purposelessness—of the evolution of the universe. "It's the way of the world," writes William Gibson and Bruce Sterling in *The Difference Engine* (1991), "there is no history—there is only contingency."[18]

Central to all of this is the interrogation of that central preoccupation of the Gothic imagination—*What does it mean to be human?* You will not leave this book without confronting how these explorations and searches for wonder affect our sense of common humanity. While Ray Bradbury and Kim Stanley Robinson predict we will ruthlessly stamp our own image onto other planets, H. P. Lovecraft declares that "common human laws and interests and emotions have no validity or significance in the vast cosmos-at-large."[19]

Indeed, as Lovecraft knew, critiques of our androcentric presumptions have long been voiced by a great variety of artists and scientists, including Pascal's *Pensees* in the seventeenth century (man is "nothing in comparison with the infinite"); astronomer Sir William Herschel's "open-ended cosmos" and playwright Heinrich von Kleist's "mismatch between the way we are and the way the universe is constituted" in the early nineteenth century; and Henry Adams' "multiverse" and novelist Olaf Stapledon's "planlessness of the universe" in the early twentieth century. In their conversation that concludes this book, Bear and Gregory Benford remind us that man is interesting, but it's the *universe* that's terrific. "It is a heresy," they warn, "to think that humans are central to the larger grand scale of creation, and it will cost you to believe that." Through it all, writer-scientists like these might, according to Kim Stanley Robinson's new book *Galileo's Dream* (2009), continue to maintain a humble and fearless allegiance to the *truth* of their speculations, as Galileo had done with his telescope: "The good that [Galileo] fought for is not so easy to express," writes Robinson; "but put it this way: he believed in reality. He believed in paying attention to it, and in learning what he could of it, and then saying what he had learned, even insisting on it. Then in trying to apply that knowledge to make things better, if he could. Put it this way: he believed in science" (524).

Ultimately, we come squarely up against Joseph Campbell's classic tripartite analysis of myth structures—*separation—initiation—return*.[20] Maybe the voices we hear around the cosmic campfire remind us that we will have to lose our humanity in order to find it again. And that may be the greatest gift these explorers of the infinite can give us.

In sum, we find that the writers, artists, composers, painters, and filmmakers in these pages enjoy a happier fate than the character in the H. G. Wells story, "The Door in the Wall." Therein, you will recall, a boy found a magical door in Kensington that led him to the "immortal realities" of an enchanted garden. As the years pass, however, the boy, now grown, finds he is too worldly to ever again to enter that door. But for the speakers in this book, that door remains forever ajar. They come and go as they please.

And it pleases *us* very much.

CHAPTER ONE

The Lovecraft Circle

H. P. Lovecraft (KUCSSF)

Out of the deep night I saw demons stretch their fiery claws towards the carefree mortals dancing on the thin edge of the bottomless pit. I saw clearly in my imagination the conflict between human nature and those unknown, monstrous powers which surround man, plotting to destroy him.

E. T. A. Hoffmann, Notes on *Don Giovanni*

It was—well, it was mostly a kind of force that doesn't belong in our part of space; a kind of force that acts and grows and shapes itself by other laws that those of our sort of Nature. We have no business

calling in such things from outside, and only very wicked people and very wicked cults ever try to.

H. P. Lovecraft, "The Dunwich Horror"

The specter of H. P. Lovecraft (1890–1937) haunts these pages. Joyce Carol Oates acknowledges his "monomaniacal passion out of a gothic tradition" and dubs him "the American writer of the twentieth century most frequently compared with Poe, in the quality of his art (bizarre, brilliant, inspired, and original)...and its thematic preoccupations (the obsessive depiction of psychic disintegration in the face of cosmic horror)." How rare, she continues, "to encounter, in life or literature, a person for whom the mental life, the *thinking* life, is so suffused with drama as Lovecraft."[1] In his own appreciation, Stephen King has written, "The best of [Lovecraft's] stories packed an incredible wallop. They make us feel the size of the universe we hang suspended in, and suggest shadowy forces that could destroy us all if they so much as grunted in their sleep."[2] In scarcely two decades of active writing, this native of Providence, Rhode Island, wrought a distinctive combination of science fiction, spectral, and Gothic horror that has profoundly influenced subsequent generations of writers, artists, and filmmakers. His novels *The Shadow Out of Time* (1934), *The Case of Charles Dexter Ward* (1927–1928), and *At the Mountains of Madness* (1931) and many short stories, including "The Colour Out of Space," "The Call of Cthulhu," and "The Shunned House"—many of which derived their atmosphere and place names from his native Providence—created a mythology of monstrous extraterrestrials whose continuing conflicts held Earth in helpless thrall. True to his Gothic roots, he was convinced that man suffers a dreadful fate when, like Faust and Victor Frankenstein, he transgresses the limits of his knowledge, thereby opening himself to cosmic retribution.[3] Indeed, humanity is as incapable of understanding itself as it is the cosmos. "The most merciful thing in the world," Lovecraft wrote in the opening paragraph of "The Call of Cthulhu," "is the inability of the human mind to correlate all its contents. We live on a placid island of ignorance in the midst of black seas of infinity, and it was not meant that we should voyage far.... but some day the piecing together of dissociated knowledge will open up such terrifying vistas of reality, and of our frightful position therein, that we shall either go mad from the revelation or flee from the deadly light."[4]

An indefatigable correspondent, Lovecraft drew around him a circle of young, aspiring writers with whom he corresponded voluminously and to whom he extended valuable advice, criticism, and encouragement. They included August Derleth, Frank Belknap Long, Clark Ashton Smith, Donald Wandrei, R. H. Barlow, and Robert Bloch, to name just a few. They not only carried on the Lovecraft tradition but also went on to distinguished careers of their own. Indeed, long after his death, writers like Ramsey Campbell, Basil Copper, Brian Lumley, and T. E. D. Klein have enthusiastically continued and developed the Lovecraftian style and subject matter. "H. P. Lovecraft's greatest difference from his fellowmen lay not in

the degree of his eccentricity," eulogized Robert Bloch, "but in the *honesty* with which he admitted it, the unusual *courage* with which he presented his personality-profile, the unusual *genius* with which he created both a self-characterization and a complete literary mythos from his inner resources."[5]

Lovecraft's death in 1937, within a year of the demise of his friend and correspondent, Robert E. Howard, dealt *Weird Tales* (1923–1954), the legendary pulp magazine that was the forum for them and many other legendary writers in the field, a blow from which it never recovered.

Due to the untiring efforts of his friend and former protegé, August Derleth, Lovecraft's stories were rescued from obscurity in many volumes from Arkham House publishers (named after the mythical town in which Lovecraft set many of his tales), beginning in 1939 with *The Outsider and Others*. Five other volumes from Arkham House of Lovecraft's *Selected Letters* have documented the amazing number, extent, and variety of his correspondence with the above-named writers.[6] In the past two decades Lovecraft has drawn the attention of many literary scholars, notably the estimable S. T. Joshi. In 2005 Lovecraft's works were collected in a Library of America volume, edited by Peter Straub.

"Now we will go," wrote E. T. A. Hoffmann, "and do what is proper to do and thrives in the night, which is favorable to our work."

"The Provocative Abysses of Unplumbed Space": S. T. Joshi Explores the Universe of H. P. Lovecraft[7]

S. T. Joshi (1958–) knows more about H. P. Lovecraft than anyone on the planet—and perhaps in The Great Beyond, as well. Winner of numerous awards, including the Bram Stoker Award for his *H. P. Lovecraft: A Life* (1996), the Distinguished Critic Award from the International Association for the Fantastic in the Arts in 2003, and the World Fantasy Award for Professional scholarship from the Science Fiction and Fantasy Writers of America, Joshi has edited five volumes of Lovecraft's *Collected Essays* (2004–2006), several Lovecraftian journals, and many volumes of Lovecraft's *Letters*.[8] A prolific scholar, he has also researched and published on writers as various as John Dickson Carr, Ambrose Bierce, and H. L. Mencken.

This interview took place on 26–27 September 2010 from his home in Seattle, Washington.

Interview

JOHN C. TIBBETTS: It seems that Lovecraft is reaching more readers—and viewers—than ever. For years you have been lead-ing the charge. What attracted you to him in the first place?

S. T. JOSHI: Ever since I first read Lovecraft as a teenager, I dimly sensed that he was not only a lively and entertaining writer, but one with a lot to say. As I've continued to study

him over the decades, and especially as I now ponder his place in the long history of supernatural fiction (I am in the midst of writing a comprehensive history of the genre), my sense is that he is an even more important writer than even many of his supporters believe. In the entire range of what he called "weird fiction," Poe and Lovecraft stand out so radically over every other practitioner that comparison is futile. Lovecraft's fiction is a distinctive fusion of intellectual substance with enormous technical skill. This latter quality is often overlooked: Lovecraft, adopting Poe's strictures on the "unity of effect," made every word count—and did so even when he was at his most picturesquely florid. His stories are constructed meticulously to proceed inexorably from beginning to end. And his ability to use the supernatural (or supernormal) as a metaphor for truths about humanity and its place in the cosmos is exceptional. In every new reading of Lovecraft, you will find new features to appreciate.

JCT: For example, would you mind talking about two of his most famous favorite stories, "The Outsider" and "The Colour Out of Space."

STJ: Of course. I fear I agree with Lovecraft that "The Outsider" is basically a story based on a trick, a surprise ending that any astute reader should be able to figure out well before it is announced. Lovecraft said of it—and I quote—that it is "too glibly *mechanical* in its climactic effect, & almost comic in the bombastic pomposity of its language" [*Selected Letters* 3.379]. This may be a bit harsh, but it is generally on target. And yet, the story is richly interpretable from many perspectives, and I think it says a lot about what Lovecraft was thinking and feeling at this juncture in his life.[9] No praise, however, can be too high for "The Colour Out of Space," which, next to the novel *At the Mountains of Madness* (still my favorite among Lovecraft's tales), can probably be called his most nearly perfect story. Possibly the climax is dragged out a bit too long, but otherwise it is masterful. Its best feature is the utter inscrutablity of the entity (or entities) populating that baleful meteor that crashes into the hills. They cannot possibly be called "evil" or "malevolent," even though they wreak terrible havoc on the unfortunate family that encounters them; it is not clear that they are even animate in any sense we can understand. They are a true piece of the "outside"—an utterly alien species whose thought-processes and motivations we are incapable of understanding. And the pathos of the death of Nahum Gardner puts the lie to those who claim that Lovecraft cannot draw character poignantly.[10]

JCT: Your own biography of Lovecraft [*Lovecraft: A Life*, 1996] joins the select company of Frank Belknap Long's *Lovecraft: Dreamer on*

the Night Side and L. Sprague de Camp's *Lovecraft: A Biography*.
They both came out in 1975, which seems a curious coincidence
to me.[11]

STJ: Frank Long's book was not really a biography but a memoir.
I know—he told me so himself—that it was written somewhat
hastily to counteract what Long rightly believed was the overly
negative view of Lovecraft found in de Camp's biography, much
of which he read in manuscript [see the interview with de Camp
elsewhere in these pages]. As a result, Long's book is a bit thin and
insubstantial. De Camp's is a more superficially formidable item,
but I'm sorry to report that it is really quite deficient in a number
of ways, such as factual errors, failure to understand the sources
for Lovecraft's views and actions, and a perplexing failure to place
Lovecraft within the context of his times—politically, socially,
culturally, and (especially) intellectually. De Camp wrote at a time
just prior to the incredible outpouring of Lovecraft criticism in
the late 1970s and 1980s—an outpouring that revolutionized our
understanding of the Providence writer by showing the cogency
of his philosophical thought and the inexhaustible depths of his
fiction. (The best thing de Camp could say about a Lovecraft
story is that it was a "rousing good yarn.") Indirectly, de Camp
helped to foster that outburst of criticism, but his work has now
become merely a historical artifact. As for my own work, I like
to think that it tries to look at Lovecraft from the inside—it tries
to see Lovecraft from his own perspective, without minimizing
or diminishing the various flaws in his character. And I do try to
see Lovecraft not merely as a horror writer but as a cultural figure
within his historical era.

JCT: You just mentioned "flaws," which brings up some controversies.

STJ: Well, yes. I suppose the greatest controversy concerning Lovecraft
the man is his racism, and perhaps no one has dealt with the mat-
ter in a wholly satisfactory way. It's easy to condemn Lovecraft
unthinkingly from our own historical perspective (a perspective
that includes the Holocaust, the civil rights movement, and so
on), and at the same time it is easy to excuse Lovecraft as merely a
"product of his times." Both of these approaches are, I think, cop-
outs. My own take has been that Lovecraft's racism was an intel-
lectual error: It was the one area of his thought where he failed to
exhibit the flexibility of mind and openness to new evidence that
characterized the rest of his thought. How satisfying this approach
is, I shall have to leave to others to decide.

JCT: In your research, did you try to follow his footsteps?

STJ: Lovecraft was a great traveler (putting the lie to the canard that
he was an "eccentric recluse"), and he indulged in extensive trips
up and down the eastern seaboard. While I myself am thoroughly
familiar with his hometown of Providence, with the Brooklyn

and New York where he lived briefly [1924–1926], and with many of the other places he visited, I regret that I never went to several of his favorite locales, such as Quebec and various points in Florida. However, I did spend two wonderful days in Charleston, S. C., quite literally following his footsteps: I took in hand his most extensive travelogue of Charleston (written in 1930, and at that time unpublished), and traversed the entire city in exactly the manner he advised. He said it would take seven hours of walking.... Well, it took me a bit longer than that! But I guess I'm not quite as athletic as HPL was! But I managed it, with several breaks at the wonderful coffee shops of Charleston along the way.... Some of my friends once engaged in a long, hot, tedious attempt to locate an obscure area in Brooklyn where Lovecraft had set one of his *Fungi from Yuggoth* sonnets...only to find, after more than an hour of tramping, that the whole area had been razed!

JCT: Can you remember just when you first encountered his work?

STJ: I guess I was about 13 years old. I was living in Muncie, Indiana, and haunted the public library in quest of books of various sorts. I had already become fascinated with horror literature (I started by reading anthologies for young adults compiled by Rod Serling and Alfred Hitchcock), and one day stumbled upon the Arkham House editions of Lovecraft published in the 1960s. I had never heard of Lovecraft, but the titles were intriguing. (It would have dumbfounded me to realize that, in scarcely more than a decade, I would reedit these volumes after consulting HPL's manuscripts!) I started with the novel *At the Mountains of Madness*...and didn't like it! Or, more particularly, I felt that it was too "deep" for me. I distinctly recall giving up on page 53 of the Arkham House edition, baffled by all the technical scientific lingo. Some months later I started with the much more accessible volume, *The Dunwich Horror and Others* (1963). Even here, I thought "In the Vault" (the first story in the book) a pretty poor specimen, and I didn't run much of a temperature over the next one, "Pickman's Model." But then I read "The Rats in the Walls"...and was hooked! I began devouring everything I could both by and about Lovecraft—not that there was a great deal of the latter at the time. But my public library did have one or two of the Arkham House volumes of Lovecraft "miscellany"—specifically, *The Dark Brotherhood and Other Pieces* (1966). Then I read de Camp's biography in the spring of 1975, and my fascination was renewed. I believe it was from this book that I learned that Lovecraft's books and papers were all at the John Hay Library of Brown University. And so I promptly applied to Brown, and luckily was accepted. The rest is history!

JCT: Before we explore Lovecraft and his work further, I understand you're just now getting ready to attend a Lovecraft Film Festival. What's that all about?

STJ: It's in Portland, Oregon. The H. P. Lovecraft Film Festival has been going on for nearly 15 years—although, regrettably, this may be the last one, at least on this scale. But I believe it has done a great service in generating interest in Lovecraft among younger people. We have to face the fact that the youth of today are "wired" in the sense that us oldsters never will be. While I am quite happy remaining with the printed page, most people today need their aesthetic stimuli in various media formats. The Film Festival has inspired numerous amateur or independent filmmakers to do wonderful things with Lovecraft's work, and I think this has had a marked effect in keeping Lovecraft alive as a pop culture phenomenon. So, too, the role-playing game "Call of Cthulhu," published by Chaosium around 1982. Initially, I was fearful that this game would cheapen Lovecraft by using his work as fodder for what seemed like a corny and contrived game scenario, but I am heartened by the fact that many players of the game have been led by it to seek out the Lovecraft texts, and so have become devotees of the stories and of the man.

JCT: I've interviewed several writers, including Robert Bloch and Ramsey Campbell, who either knew Lovecraft or who have been profoundly influenced by him. They've all written pastiches in his style and manner. What is your opinion of work like this?

STJ: I wrote a whole book called *The Rise and Fall of the Cthulhu Mythos* (2008) to deal with the phenomenon of Lovecraft imitations. The title was deliberately provocative—and now I believe it should more accurately have been called *The Rise, Fall, and Rise of the Cthulhu Mythos.* For what has happened is that, in recent decades, the egregious misconstrual of the Cthulhu Mythos at the hands of August Derleth (and such of his misguided disciples as Brian Lumley) has been put aside, thanks largely to the revolution in scholarship I mentioned earlier. Now, Lovecraft's bleak cosmic vision has become widely known, as have other aspects of his work and thought, and so there are a number of writers who are approaching Lovecraft with a seriousness and independence that we couldn't have imagined two or three decades ago. Ramsey Campbell has himself evolved from his crude teenage pastiches of Lovecraft to write stories and even whole novels (see *The Darkest Part of the Woods*) that use Lovecraft as a springboard for the expression of his (Campbell's) own ideas and visions [see the interview with Campbell elsewhere in these pages]. There has also been a merciful surcease in writers' attempts to imitate Lovecraft's style. August Derleth actually thought this was an "easy" thing to do, but it is "easy" only if one does it badly.... My recent anthology *Black Wings* (2010) is an attempt to showcase this more subtle, sophisticated approach to Lovecraft. None of the writers in the book (most notably Caitlin R. Kiernan, Laird Barron, Michael

Shea, Nicholas Royle, and Jonathan Thomas) has written stories that could in any sense be called pastiches, but their tales are nonetheless Lovecraftian in a deeper sense....

JCT: I take it you are not entirely enthusiastic about August Derleth's many efforts on behalf of Lovecraft.

STJ: Well, his contributions cannot be ignored, especially his establishment of Arkham House to publish Lovecraft's work in hardcover. But his legacy is a highly mixed one: His own obsession with the Cthulhu Mythos (or, rather, his perverted understanding of the Cthulhu Mythos) not merely resulted in his writing a whole series of truly dreadful pastiches that unwittingly parodied the author he claimed to be honoring, but caused Derleth to attribute his erroneous views to Lovecraft himself. And his very establishment of Arkham House caused Lovecraft to be a kind of coterie author who appealed only to a limited audience. It is a sad fact that we had to wait for Derleth's death for Lovecraft, and Lovecraft scholarship, to take flight.

JCT: Could you elaborate a little more on this?

STJ: This might take a while! Derleth's derelictions (pardon the pun) in regard to Lovecraft are many and frequent. The chief of them is his assertion that Lovecraft's pseudomythology (which *he*, not Lovecraft, called the "Cthulhu Mythos") is fundamentally similar to Christianity in its depiction of a cosmic battle of good versus evil. He justified this view by claiming that Lovecraft's "gods" (who are really just extraterrestrials) can be divided into the "evil" Old Ones (Cthulhu, Yog-Sothoth, Azathoth, Nyarlathotep, Shub-Niggurath, etc.) and a countervailing group of "good" entities, the Elder Gods (who, in fact, have no existence in Lovecraft's stories). Derleth, a Catholic, could not endure Lovecraft's bleakly atheistic cosmic vision, so he deliberately perverted his pseudo-mythology to make it more amenable to a religious worldview.

JCT: You say Lovecraft was an atheist?

STJ: Derleth knew that Lovecraft was an atheist, as HPL said so many times in his letters to Derleth. He justified this wildly erroneous interpretation by putting forth a quotation purportedly from a Lovecraft letter, and I quote: "All my stories, unconnected as they may be, are based on the fundamental lore or legend that this world was inhabited at one time by another race who, in practicing black magic, lost their foothold and were expelled, yet live on outside, ever ready to take possession of this earth again." This quotation, however, was fabricated by one Harold S. Farnese, a late correspondent of Lovecraft, who claimed to be quoting the passage from a Lovecraft letter but in fact was misconstruing a passage found in an actual letter to him.

JCT: This is news to me!

STJ: Derleth immediately seized upon this quotation as the ultimate justification for his views. It sounds superficially similar to, but is

in fact widely divergent from, an actual quotation where Lovecraft sets forth his "cosmic" approach. Let me quote again: "Now all my tales are based on the fundamental premise that common human laws and interests and emotions have no validity or significance in the vast cosmos-at-large.... To achieve the essence of real external-ity, whether time or space or dimension, one must forget that such things as organic life, good and evil, love and hate, and all such local attributes of a negligible and temporary race called mankind, have any existence at all." You can find this in *Selected Letters* [2.150].

August Derleth, co-founder with Donald Wandrei of Arkham House (KUCSSF)

Derleth also maintained that the Old Ones were what he called "elementals," but this medieval conception obviously has no rel-evance to Lovecraft's cosmic entities. Absurdly, Derleth main-tained that Cthulhu was a "water elemental"—but surely the fact that he comes from outer space and is *trapped* in the underwa-ter city of R'lyeh suggests that water is not his native element!

Other parallels are even more ridiculous: I'll give you some other examples: Nyarlathotep is somehow an "earth elemental" and Hastur (who is not even declared to be an entity in the one citation in Lovecraft's own stories) is said to be an "air elemental." But Lovecraft, according to Derleth, somehow neglected to come up with a fire elemental, forcing Derleth to come to Lovecraft's posthumous rescue by inventing the god Cthugha! And Derleth's schema overlooks the two most important of Lovecraft's "gods," Azathoth and Yog-Sothoth. Derleth also came up with a rigidly procrustean division of Lovecraft's stories into "New England tales," "dreamland tales," and "Cthulhu Mythos tales"—even though several stories (e.g., *The Dream-Quest of Unknown Kadath*) could be said to belong in each of these groups. The plain fact is that Derleth simply didn't understand Lovecraft's worldview and hence his stories, because Derleth was both philosophically naive and (paradoxical as it may sound for one who devoted his life to the propagation of weird fiction) fundamentally conventional and unimaginative in his taste for the weird.

JCT: It seems like you're describing elements of Gothic horror and science fiction combined.

STJ: It is exactly Lovecraft's Janus-like ability to look both backward and forward—back to the Gothic tradition and forward to the evolving genre of science fiction—that lends his work the dynamism it has. Even a seemingly pure Gothic work such as *The Case of Charles Dexter Ward* (1927) has hints of the cosmicism that would become Lovecraft's signature contribution to literature; so too "The Dreams in the Witch House" (1932), which reinterprets witchcraft through advanced mathematics. But it is his more purely science fictional works—*At the Mountains of Madness* (1931) and *The Shadow Out of Time* (1934–1935)—that to me are representative of Lovecraft's most pioneering work. These works have inspired both horror and science fiction writers of the next several generations. Arthur C. Clarke has testified how electrified he was at reading those two stories in *Astounding*. It is precisely because Lovecraft's work cannot be neatly pigeonholed into some narrow genre that it continues to exert the influence it does.

JCT: I understand that you have published a new edition of your Lovecraft biography. Are there new findings, new questions...?

STJ: My *H. P. Lovecraft: A Life* contained about 350,000 words—cut down from the 508,000 words I had originally written. It was purely a publishing decision to make the cuts. But as the years passed, I felt that I wanted the full version to be published, and I managed to persuade Hippocampus Press to issue it. It has now come out under the title *I Am Providence: The Life and Times of H. P. Lovecraft* (2010). Of course, I did more than merely restore the omitted text; I updated the work throughout, in particular the final chapter, where I traced Lovecraft's influence in literature,

society, and pop culture down to the present day. I can't say that I have any radical new findings to offer. Recent work (especially by Kenneth W. Faig, Jr.) has substantially revised our understanding of Lovecraft's ancestry, and some other small corrections have been made here and there. But the new version simply offers a wealth of detail that the previous version does not.

JCT: It does seem that Lovecraft left behind a mountain of autobiographical materials and letters.

STJ: Indeed. Lovecraft is remarkable in being one of the most exhaustively self-documented individuals in the modern age, thanks to the survival of thousands of his letters. It also seems as if nearly everyone who met him wrote some kind of memoir of him. So there is almost no limit to the level of detail one can include in a biography. Of course, those details have to have some relevance and significance, but a good many of them do shed light on the kind of person and the kind of writer and thinker Lovecraft was.

The Lovecraft/Phillips family plot, Swan Point Cemetery, Providence, Rhode Island. Photo by the author.

"I Am Providence!"[12] Henry Beckwith Talks about
H. P. Lovecraft's Native City

Henry Beckwith, Jr. (1935–) has authored books on heraldry and researched the life and work of Providence native, H. P. Lovecraft

(1890–1937). Beckwith's *Lovecraft's Providence & Adjacent Parts* (1986) is a lovingly researched chronicle of how the city, its buildings, and environs played an important part in his stories and correspondence. "His ancestors on his mother's side were all New Englanders," Beckwith writes in the Introduction, "mostly Rhode Islanders... and he was related, in some degree, to most of the old Yankee population of Rhode Island. Many local landmarks, as well as a number of public figures and events from the history of the state, are woven [into his] plots and settings."

I interviewed Beckwith at the Biltmore Plaza Hotel in Providence, R. I. on 1 November 1986, on the occasion of the World Fantasy Convention.

Interview

JOHN C. TIBBETTS: Henry, many fantasy authors have placed their stories in mythical towns—Ray Bradbury's Green Town, Charles Grant's Ox Run Station, Ramsey Campbell's Brichester, Stephen King's Castle Rock, to name a few. But Lovecraft's native Providence is far from mythical! Or is it?

HENRY BECKWITH: [laughs] As you know, Lovecraft loved Providence and lived here on the East Side most of his life. Some people think that his mythical city of witch-haunted Arkham was supposed to represent Providence. But, you know, Lovecraft set Arkham in Massachusetts, not Rhode Island. And I think it's more accurate to see Arkham as another version of Salem. But it was Providence that Lovecraft wrote the most about and felt the most strongly about. You know, he wrote a letter in 1926 to the local paper in which he pleaded the case for the restoration of the historic areas here. Unfortunately, it was not until many years later, in the 1950s, that the Providence Preservation Society began to organize restoration efforts.

JCT: In fact you claim a distant relationship, I guess.

HB: Yeah, in three or four different ways. Providence was settled by Europeans in 1636, and many of those early settlers were Lovecraft's ancestors and many of the same were my ancestors. It was an insular community. There weren't that many people around to marry. And life was made even tougher by the fact that the Quakers wouldn't marry the Baptists, and the Baptists wouldn't marry the Quakers. After three generations, they got over that nonsense. So, yes, we share that kind of a background, and my father actually knew Lovecraft. They were the same age, and he thought Lovecraft was a very quick kid. He was very poor and this I think really marked him throughout his life. It was a great difficulty for him. Providence is a big city, and we're talking about the old area with the Victorian, Federal, and Colonial structures in it.

That is still inhabited for the most part by the Yankee population. The newer ethnic groups hitting town didn't tend to move into that area. Lovecraft associated himself with that area; that's where he belonged. That's where his people were. Some of these areas of Providence he wrote about in his stories in great detail. For example, if you read one of his best stories, "The Case of Charles Dexter Ward," there is a section that has Ward coming home to Providence from his extended visit abroad. He arrives and goes home by taxi-cab to College Hill, the old part of the city. It's very, very powerful writing simply because it's absolutely straight and from the heart. And in fact, if you look in the selected letters of Lovecraft, you find him writing about his return from New York in 1926 in almost the same words. At that time his marriage was crumbling, and he was really, terribly depressed. Anyway, if you go up the slope of Waterman Street and then go north along Prospect street, you are following the exact route Ward took. Then when you turn down into Barnes Street, you find Number 10, where Lovecraft lived at that time. That address is assigned to "Dr. Willett" in the story. And then, if you go on ahead to the northeast corner of Prospect and Meeting streets you find the site of Lovecraft's last home, which was moved to this site some years ago. Ward's mansion is actually the Halsey Mansion, which was built in 1801.[13]

JCT: Of course, there's "The Shunned House" and "The Call of Cthulhu."

HB: Oh, yes, references to Providence are everywhere! You could say the whole "Cthulhu" cult is born here with the dark doings of Professor Angell of Brown University after discovering a weird clay bas-relief of the infamous monster. And in "The Shunned House" Lovecraft's narrator notes that when Edgar Allan Poe came here in the late 1840s to visit the poet, Mrs. Whitman, he passes this strange old house on Benefit Street, Number 133. He says it's the site of something "unutterably hideous" that surpasses anything that Poe ever imagined. It's a memorable moment when the narrator digs up something monstrous in the cellar. But, I hate to tell you, the house is not haunted! There was never anything out of the ordinary, and there was never anything buried under the basement! It has been recently restored. But in many details, Lovecraft was very accurate. If Lovecraft says, for instance, that on the night of 15 April in 1923, it was raining like hell and thunder-ing, and you go back and check in the newspaper, you find that it did. He was that anal about it. He was very careful about his details. Mind you, he cribbed a lot of it out of popular Rhode Island histories.

JCT: What were some of his haunts here in Providence?

HB: Well, certainly the College Hill Area, particularly the Market Square, the oldest part of Providence. That's where he lived all o

his life. He did explore other parts of the city, but that was where he liked to be. His family had been prosperous earlier on, and this was a golden age, and the old houses were some sort of security for him, I'm sure. He and his aunts loved to go to the Providence Arts Club—check the reference to it in "The Call of Cthulhu"— where his Aunt Lilly Phillips Clark displayed her own works. He loved the Old Narragansett Church, which is down in Wickford, which was built in 1707. He thought it was a beautiful piece of architecture. I think so, too.

JT: But he also hated Victorian architecture.

HB: Yes, it was still too close to him in time. But, of course, now, Victorian architecture's well thought of. I think he would think well of it, now. By the way, I forgot to mention the First Baptist Meeting House, the oldest Baptist congregation in America. Lovecraft regarded it as his "maternal ancestral church." That's how he put it. He and his friend J. F. Morton used to climb the steeple to look at the bell. It's funny to think that he once tried to play "Yes, We Have No Bananas" on the organ—but he couldn't figure out how to turn the instrument on!

JCT: And there was a cemetery you recall that he liked to frequent.

HB: Yes, St. John's Churchyard. It was formerly King's Church. He used to take his friends there. It was an overgrown, old cemetery that was nice to go to at night and was quite spooky. And in "The Shunned House" he tells us that Edgar Allan Poe, whom he admired greatly, used to go there.

JCT: You were also indicating how incredible it is, in some ways, those gravestones haven't weathered all that much.

HB: Well, you know, you hear talk about needing more tests to prove the damaging effects of acid rain. All anyone really needs to do is go out and look at some of the marble stones in our graveyards and how the marble's being eaten away. But the slate in many cases is fine, because it's a different sort of composition.

JCT: How many marks of Lovecraft's passage still remain in Providence?

HB: He and his close relatives are buried in Swan Point Cemetery. At the time of his death no stone was put up to mark his grave; but this has recently been remedied. There is no family left to speak of, except distant cousins. The cemetery is open during the day, but I'd advise you not to go there at night. There are people who have no sympathy for night-walkers. There is the Lovecraft Collection at Brown University. The John Hay Library there has a great collection of Lovecraftiana. It's on the northwest corner of College and Prospect Streets. He mentions the Hay Library in the story, "The Haunter of the Dark." He wanted to become a student at Brown—his uncles were both Brown men— but it never hap- pened. At the head of College Street you will find a stone bench

where he used to sit. You can see a photograph of him sitting there.

JCT: How did you come to know about Lovecraft in the first place?

HB: I was just 15 when I discovered his story, "Through the Gates of the Silver Key." I went from there to read more and to try to locate the many places he wrote about in his stories. My book is really a series of tours of these areas. It's divided into two different walking tours of Providence; and then you've got a tour of Providence by car; and then there's a tour that takes in various places in the state, down round Newport. These were places Lovecraft visited by car. I learned a lot more about the state than I had known before.

JCT: There's so much history here right at our feet.

HB: I'm not really all that hung up on New England culture, but, yes, there is history here; and I was also very pleased to discover things that I liked and appreciated, things that he liked, too.

JCT: How much of his life was spent outside Providence?

HB: There were just a few years in New York City, when he was married, and he hated it. And there were some short trips to Quebec, Florida, and Boston.

JCT: What about New York City as a contrast to Providence? Did he ever write longingly about returning when he was there?

HB: No, but what he did write were a couple of stories like "The Horror at Red Hook," and there's at least one other story that he wrote, but he had absolutely no use for New York. Furthermore, the man was xenophobic. He described the wraith-like, slant-eyed, hordes of New York City, as he put it. You know, as far as he was concerned, if they weren't good Anglo-Saxon stock, they were degenerate, awful. Some of that was simply reacting to his environment.

JCT: In all, he was kind of a self-styled eighteenth-century gentleman, wasn't he?

HB: Well, I don't know how much of this was a pose. If he couldn't get along in the nineteenth and twentieth century, then I guess the eighteenth century was fine, because how're you going to prove it now? But I think some of it was a pose. And you hear a lot of talk about how erudite the man was. Well, my god, he owned a set of the *Britannica*, and he cribbed a lot from that. It's true he was an amazing correspondent. Entire books have been filled with his letters.

JCT: Although a lot of your lifetime has gone into researching your book, you say you actually wrote it in a short period of time.

HB: True, I've been thinking about the whole business for probably more than 20 years. It wasn't until 1975 that I realized my research could be of value to others. That year the First World Fantasy Convention was held on Halloween weekend in Providence.

One of the scheduled events was a tour of Lovecraft's Providence, which I conducted. So, yes, I wrote the book very quickly, flailing around sheets of scribbled yellow legal paper, with my wife typing them up.

JCT: How about others who come here, just passing through. Do they even know who Mr. Lovecraft is?

HB: Yeah, they knew he had something to do with writing and horror stories. He's Halloween.

JCT: Does *Providence* remember who H. P. Lovecraft was?

HB: Yes, by and large, they do. But given the fact that the man wrote for pulp fiction, he's not considered "respectable." The French, of course, consider him eminently respectable, but then, the French consider the comic strip a work of art, too!

JCT: Although it's been as recent as 1946 that Lovecraft's work has been appearing in hard covers now for a larger reading public, I'm wondering if within our own lifetime he is in danger of disappearing. We talk about him but do we really read him much anymore?

HB: I think he is read. Of course, the paperbacks have been out, Ballantine Publishers keeps publishing a line of paperbacks. Certainly, they're always available in Providence, and I would assume they're available everywhere. I don't know. I read the stories and I like them and I'll probably read them again. And I've read the letters. The Providence stories are important, particularly, "The Case of Charles Dexter Ward," because it is autobiographical in many ways. And that meant that Lovecraft was really writing from the heart. He was not a bad writer. He was a perfectly decent writer. His best writing will survive, because a lot of it is local history and a good story. I think he would have been immensely surprised to think that anybody would gather together here to hold a convention to talk about his works. He wrote mostly to please himself, I think.

JCT: If somebody comes to you and says, gosh, Mr. Beckwith, I want to check out who this writer is, what do you tell them?

HB: Well, if I have the time, I say, well, if you've got an hour or so, come along in my car, we'll just drive around Providence, and we can look at a few places. What you get is a native guide that takes you around and shows you what you want to see. Many buildings from his time are gone, of course, and others have changed. I know, because I've seen photographs of these same areas 50, 70 years ago. There were a lot more trees around then; Dutch elm disease hadn't killed them off. A lot of the East Side was still country when he was a child. So, you only get a whiff of the thing, because time changes. But still, some of the environment is still there and you can get some kind of idea of it.[14]

Robert Bloch, author of *Psycho* (KUCSSF)

"*Psycho Is Not* about a Shower Scene!"
Robert Bloch By John C. Tibbetts

Under the tutelage of H. P. Lovecraft Robert Bloch (1917–1994) began writing weird stories in his early teens. "I just remember what he meant to me personally," eulogized Bloch, writing shortly after Lovecraft's death. "If it weren't for him, I'd never have hit *Weird Tales* or any other magazine."[15] His first short story collection, *The Opener of the Way*, was published by Arkham House in 1945. His first novel, *The Scarf* (1947), immediately established him as a master of psychological horror, the weird, and the macabre. It was quickly followed by two other acclaimed novels about serial killers, *Psycho* (1959), which was adapted to film by Alfred Hitchcock in 1960, and *The Dead Beat* (1960). In the opinion of Stephen King, these three novels constitute an important American trilogy "about the Dionysian psychopath locked up behind the Apollonian façade of normality."[16] A prolific writer, his fiction has been frequently seen on television's *Thriller*, *Alfred Hitchcock Presents*, and *Star Trek*. Hailed

by Peter Straub as "one of the all-time masters," he is the recipient of the Hugo Award and the World Fantasy Grand Master Award. His "unauthorized" autobiography, *Once Around the Bloch,* appeared in 1993.

This interview transpired in Schaumburg, Illinois, in November 1990 at the World Fantasy Convention

Interview

JOHN C. TIBBETTS: What special occasion has brought you to this Convention?

ROBERT BLOCH: We're in Schaumburg, Illinois, observing the centenary of Howard Phillips Lovecraft, who was born in 1890. This World Fantasy Convention is the fifteenth such affair.

JCT: In order to get to know you, we have to talk about two careers, don't we? Because the career of H. P. Lovecraft overlapped yours at a very crucial time in your own development as a writer. Tell us something about your association with him.

RB: Lovecraft was the definitive influence on me, when it comes to my own writing; and it was he, in fact, who, during our correspondence in the early 1930s, suggested that I try my hand at writing when I was a teenager. And this, of course, I did.

JCT: Had he seen something of yours that gave him a reason to encourage you?

RB: No, merely my correspondence. Along about the fourth and fifth letter he said, "I seem to think that you might be interested in trying your hand at this sort of thing. I'd be glad to read it and give you my opinions." So I wrote several short pieces during the next year or so, and when I graduated from high school in 1934, I sat down and started to write professionally. I sold my first story six weeks later. I was 17 then and I didn't have enough sense to quit, so I've been writing ever since.

JCT:Now, was he a face to you, or merely a name that you had seen on the cover of magazines?

RB: I seldom saw his name on the covers of magazines, because it seldom appeared there. Lovecraft was not a mass-media favorite. He was not a pop-art favorite. He was more or less a closely guarded secret for the *cognoscenti.* The bulk of the readership of *Weird Tales* Magazine preferred the writings of Seabury Quinn, Robert E. Howard, and several other gentlemen who specialized in action-adventure rather than the type of intellectual fantasy that Lovecraft wrote. And I did not know him except as a byline. Long-distance telephone calls to the rank and file was a considerable event. I don't believe it ever occurred to me that it would be possible to talk to Lovecraft by telephone, nor vice versa, for that matter. And the Depression was such

that 25, 35, 45, 55 cents was a considerable bite out of one's weekly income, *if any*. During our correspondence, of course, he sent me photographs. And that was the only link we had because we never met face to face, unfortunately. It was very difficult during the Depression. Neither he nor I could afford train travel. And although it was hoped that he might come to the Midwest and see August Derleth and myself and several other correspondents of his, including Donald Wandrei, he never did. We had at least reached the stage of discussing the forthcoming visit in the summer of 1937, but he died in March of that year.

JCT: But you *did* meet him, in a way, didn't you? I mean, you include him in one of your stories...

RB: You must be thinking of "The Shambler from the Stars," published in *Weird Tales* just a few years before his death in 1937. Yes, it was about an ambitious writer who went to Providence to meet a certain writer who was *very much* like HPL, although his name was never given. I added a few "Unspeakable Texts" in the story to his *Necronomicon*—something called *The Book of the Worm*.[17] Other than that, there's no resemblance whatever to me and HPL! [laughs] I guess you could say I "met" him again, in a way, in my novel, *Strange Eons* [1978]. It occurred to me that his stories might not be mere fiction at all, but based on weird doings in the real world! The book is a warning: Will we be able to stop Cthulhu and his minions from conquering Earth??? [pause] I leave it to you!

JCT: Duly warned! You mentioned a circle of writers, of course, whose names we now know so well. Did you know each other, and did you correspond actively and meet physically?

RB: I was introduced to a lot of these people by way of correspondence through Lovecraft, and I did correspond with Clark Ashton Smith, with E. Hoffman Price, Frank Belknap Long, and then to a much lesser degree, merely exchanging letters with a few of the others, like Henry S. Whitehead. During the four years of our association, Lovecraft sent me letters and postcards from all over, Providence, Quebec, Charleston, and Florida. He was a friend, counsel, and critic to me. We would have continued our correspondence, but he died not too long after I entered that magic circle. And there were others that I knew merely as peripheral figures in that group. But the only one that I met personally was August Derleth, who lived 120 miles from me in Sauk City, Wisconsin. I was in Milwaukee. So I did get out to Sauk City to meet Augie, and our correspondence was constant for many, many years, at least once a week.

JCT: And, of course, ultimately blossomed in *The Opener of the Way*. I'm wondering if I'm jumping ahead too quickly, though. I did

want to ask you, in your correspondence with Lovecraft, was there a moment, a letter, a line in a letter, that especially stands out—that you were proud of, puzzled by, or in some way maybe revealed something about the character of Lovecraft?

RB: Not at all. I wasn't even thinking in terms of a psychological probe in those days. I was 15, 16, 17 years old, and all I knew was that the person whose work I most respected and enjoyed in the field of fantasy was corresponding with me, and that fact in itself overshadowed everything else. I wasn't inclined to analyze that relationship, or analyze the nature of the man himself. Nor was I equipped to do so at that age, either.

JCT: It must be somewhat amusing to you to see later generations now looking back upon that time, trying to bring some kind of critical scrutiny to it.

RB: Well, no, it merely epitomizes what I've observed in the critical evaluation through the use of hindsight that has been accorded virtually every writer I've ever come across and with whom I had much interest. I, of course, then try to find material on such writers, and I get a lot of this profundity and this, um . . . posthumous psychoanalysis.

JCT: As you talk to younger people today, here at this convention, or people who will read this interview—maybe the name of H. P. Lovecraft is more popular or less popular than I think. As a result of all the publications over the years, has he been well served in your opinion?

RB: I think he has been very well served, and he certainly would have thought so, too, because he lived and died a nonentity, as far as receiving any acclaim from anyone, excerpt a very small group of readers, a circle within a circle. The total circulation of *Weird Tales* was probably never in excess of perhaps 75,000, and I imagine out of that number, perhaps one-tenth appreciated Lovecraft; and out of that one tenth, 7,500, perhaps a tenth of that number, had some basis in their own backgrounds for such an appreciation, in terms of either their own literary endeavors, or their education, which would equip them to evaluate his writing from a proper perspective.

JCT: Let's go to those years now, when you first start writing and the publication of *Opener of the Way* from Arkham House in 1945. When did Lovecraft's influence become something you had to crawl out from under, something that became a burden to you, or you realized it was time to put it aside. Was there a time when the influence began to diminish for you?

RB: I would say that I began to realize that I had to branch out and develop some sort of voice of my own around 1939, about five years after I started writing. Up to that time, I'd been very conscious of the fact that I was imitating Lovecraft, or at least being strongly influenced in my own style by his work. And

from 1939, gradually, without any dramatic decision involved, I began to try other approaches and other attacks, and explore other fields.

JCT: Was there a particular story that you can recall where you began to sense your own voice coming through?

RB: I imagine that the first one might have been "The Cloak," which was published in 1939 in what was then *Unknown Magazine* and later became *Unknown Worlds*—

JCT: —a vampire story!

RB: Oh, yes. I guess you could say that clothes fit the, er, man—or is it vampire? I wanted you to feel that you couldn't be quite sure about this guy—does the cloak really turn him into a vampire, or is it just a powerful suggestion in his own mind? But then, of course, he meets the *real thing*. But by and large, it's difficult for me to pinpoint the turning point in my writing, because I don't do that much self-analysis.

JCT: What is it that you have heard other people tell you, or suggest to you about your work, that you did think on the whole was accurate enough? Have you learned from talking to other people about your work, a little bit more about yourself?

RB: Not in the least. Never. I don't think most of the people that read my fiction have the slightest intimation as to what sort of person that I am. They think they do, but they don't. Because I'm very careful to maintain my private persona. Once or twice in a story I have revealed that persona, and always with disastrous results, with one exception that is a short story, which I personally plugged and pushed to a point where it's come to the attention of a few people. But in the longer things, the things that I most indulged in self-betrayal, have never been caught by anyone!

JCT: I was intrigued by your reference to disastrous results. What does that mean?

RB: [pauses] Nobody paid any attention. And to a writer when nobody pays any attention that's a disaster. Writing is communication. If you don't communicate, you're wasting your time, as well as the time of the reader.

JCT: Recently on television, *Psycho* was inducted into the so-called Horror Hall of Fame. What do we still *not* know about your book, *Psycho*, if we only know the movie? This is a chance I've had to ask you something I've long wanted to. Hitchcock and all of that aside or notwithstanding, tell me about *Psycho* from your perspective, not Hitchcock's.

RB: Well, I did so in that television interview, which was, of course, carefully circumcised by the film editors because it didn't fit within the limitations they had proscribed for such an interview, and I do recall that in one of the two snippets they used, I said, "*Psycho* is *not* a movie about a shower scene." Then I started to

say—and was cut off immediately—"It's a movie about the secrets of human beings, that they carry around with them." It is primarily a story of a girl with a secret. She's just stolen $40,000 from her employer, at a time when this sort of thing was not common practice. And it's about a young man who leads a tortured secret life, so secret that he himself is not aware of it. And it's about the buried and exhumed secrets of his mother and others in the past. And if there's anything that has kept *Psycho* alive, it's *not* the shower scene. The shower scene is what has received all the attention from the film buffs, and is used as a study segment in film classes as an example of how to edit, just as they will use the "Odessa Steps" sequence in *Potemkin*, Eisenstein's silent film. But the emphasis is misplaced. If it was just about a particularly gory murder in the shower, it has been topped a hundred times since by other gorier murders in even more, ah, contrivedly claustrophobic places; and the films in which these took place are quickly forgotten, because they lack *characters*. The audience was not involved, did not care about who was getting killed, or knew very much about who was doing the killing. And without that, it's just a question of providing the same kind of a shock you get if you wired the seat in the theater and shot some juice through the seat—

JT: The William Castle technique.

RB: Yeah, Bill Castle's technique exactly. From *The Tingler*.[18]

JCT: In what sense, then—and you seem to be suggesting that the film maybe is an impediment to us to going back to that original novel and understanding what you wrote in the first place.

RB: Well, it's been a constant source of amazement, not to me but to a lot of people through the last 32 years, who've seen the film and then decide, Oh, I'm going to read the book, thinking that the book has elements and a dimension that the film doesn't possess. But enough of the book has been carried over in terms of structure to give that film a sense of reality that would be totally lacking if all we got was some heavy breathing on the soundtrack, and the subjective viewpoint of the mysterious killer, and some glib one-sentence or two-sentence explanation—"Old Freddy Kruger was what he was not only because he was killed, but because his mother was a nun who was raped by one hundred maniacs." Would you believe that this is an actual plot device or explanation in one of the films? What was the explanation for *Poltergeist*? Oh, the house is an Indian Burial Ground. Well, that explains everything?! What's the explanation for *Halloween*? Well, it must have been the *bogeyman*! And *this* from the psychotherapist. You know, this kind of stuff is garbage, and is for garbage-heads, and it serves its purpose; but to consider that it has any bearing on the transcription of reality that is necessary to make a horror film effective is, I think, a mistake.

JCT: When you look at the real-life case of the notorious Ed Gein—
some of the horror to me, at least, is that we cannot figure out on
a more objective basis just what would have gone into this man's
mind to explain the horrors that he perpetrated. Maybe that's the
ultimate horror. That it's just an ordinary kind of person who
remains inexplicable nonetheless.[19]

RB: Well, that's what I tried to convey in *Psycho*. I had already been
working with the thematic element of a person who led a dou-
ble life, unknown even to himself, in stories like "The Real Bad
Friend," which came out a couple of years before my book. When
I heard of the Gein case, I didn't know anything bout the details,
but I did hear about an apparently ordinary man living an ordinary
life in a very small town [Plainfield, Wisconsin], where he'd been
observed by his neighbors for many years, and who never suspected
his crimes. And I said, "That's the story!" I'm going to write a story
about a man in a similar situation, and point out to people that
they don't necessarily know their neighbors or the people that they
come in contact with. And that, to me, is truly horrifying.

JCT: And you *do* imagine a shower scene murder!

RB: Yes, that's the ultimate refuge of privacy, isn't it? But the murder
was done in one swift stroke, not the way Hitchcock shows it on
the screen.[20]

JCT: Do people sometimes forget the source of the ideas in the film
is your novel, rather the screenplay by Joseph Stefano?

RB: True, and he has done little to dissuade people of that! People
think he introduced the shower murder, killing the heroine so
early in the story, the taxidermy, things like that. They're all in
my book, right down to the final sentence, "I wouldn't even harm
a fly!" Hitch himself did what he could to give me credit. Bless
him for that!

JCT: Tell me about life for Robert Bloch after *Psycho*, and the subse-
quent novels and stories to come. Have they been, in your opinion,
sometimes overshadowed by that, or have you been free to develop
in all of your own directions without that kind of a problem?

RB: Well, *Psycho* pasted a label on my forehead, which I had to wear
when I was doing television and film, because that's what they
expected from me. They didn't want anything else but. And for a
while no matter what I wrote, the byline on the dust jacket or on
the paperback cover was, "By the author of *Psycho*." Nonetheless,
by and large I was able to write, and did write, the kind of thing
I felt like writing at the moment. And whether it disappointed
readers who expected another *Psycho* or not—that's their problem,
not mine. And to this day I continue to write my things. I've done
two sequels to *Psycho* merely in self-defense, because I thought
that the film treatments of the particular situations were not to
my liking.

JCT: In the days of television, in the early-to-later-1960s, there were certainly many venues for writers like you and Roald Dahl and Henry Slesar. Your work appeared in programs like *Thriller* and *Hitchcock*. I remember seeing "The Grim Reaper," "The Sorcerer's Apprentice," and "Yours Truly, Jack the Ripper," among others. First, did you do those scripts yourself, are you happy with how they came out, and do you still see such opportunities for today's writers on television?

RB: If you saw "The Sorcerer's Apprentice," then you must have seen it in syndication! Because it was the only *Hitchcock* that was banned from initial broadcast. Too gruesome, I guess.[21] I'll tell you, I did dozens of the scripts, from stories of my own and by others. I had been rescued from a low-budget series called *Lock-Up* to step up to work on *Hitchcock*. My problem was that I was at that particular time, that period that you're talking about, I was doing a shuttling act between *Thriller* and *Hitchcock* and films. Sometimes I would be asked to do several things concurrently, which is against the rules of the Writers Guild, in the first place, and in the second place it was against my physical, uh, energies. So, some of these things were adapted by others, and I was able to find the time to adapt some myself. I remember that one of my favorites, "A Home Away from Home," came from a story I originally wrote for *Alfred Hitchcock's Mystery Magazine*! It was set in a lunatic asylum, like some of my other stories—my home away from home, I guess! But it was to me the best time, because I had the least interference from up above. You went to your producer—for me, Norman Lloyd, who was a good man—who had a story editor, and in many cases they themselves had selected one of your stories that they'd like you to adapt, or one of somebody else's; and they would pitch it to you. If not, you might have an idea that this would work, and you'd tell them, and they would say yes, let's see how you work it out, and you'd do a little treatment, and they'd say yes or no and you'd go ahead. And they would be the ones who would pass on the script. If they liked the script, we'd shoot it. They had a number of scripts that were just shot as written, no rewrites at all. Today there's as many as 35 copies of these scripts made because so many have to be sent to New York, where the final decisions are made. Your judge, jury, and executioner are *in absentia*. You never meet them, you never see them. So, it's not a comfortable way to write for me. And there are large staffs, all of whom have to have some input, or else what are they getting paid for? So they're going to meddle with what you do, find some way, not necessarily to disapprove of it, but to change it—to *im*prove it.

JCT: And even in an era where we have so many cable channels, is it a bit paradoxical that I would suggest there are fewer venues or outlets for the horror market in the media?

RB: There seem to be more of late, but not that type of horror. These are things that come as close to the splatterpunk film as they possibly can, emulating it, and what they depend on for their strength is the gore.[22] So, I think for the type of thing that flourished in those days, there is virtually no market at all. I know when the *Hitchcock* show was "revived" some years ago, I was asked to attend the presentation that the network made to all of its affiliates—a cross-section of affiliates from all over the country. And the presentation was made by the two young men who were going to be the producers of the show. They started out by saying that they had screened most of the original *Hitchcock* shows—they didn't like 'em! Besides, they were not particularly interested in the *Hitchcock* shows themselves; they admitted that. But they were going to go their own way. I was seated with two young ladies from some other magazine source. They were listening to this and it sounded to them like double talk. One of them leaned over to me and said, "What do they *mean* they're going to update and modernize and improve these shows?" And I said, "That means they're going to put in a lot of car chases." And that's just about what happened. The few of the original shows that they rewrote—which included, I guess, a couple of mine (not having cable I didn't see them) were not necessarily improvements. The things that they presented were not necessarily improvements, and the show went down the toilet. Where it belonged.

JCT: I think it was Orson Welles who once defined television stories as people getting in and out of automobiles.

RB: Well, I can understand, with his corpulent bulk, why he'd be particularly conscious of such movements!

JCT: Well, we are addressing hundreds of people here at a science fiction/horror/ fantasy convention. What are you seeing out there that both discourages and encourages you, among some of the newer writers, trends? You've mentioned a term called "splatter punk," for example.

RB: To tell you the truth, I don't *see* that much. Since I had cataract surgery, I do as little reading as possible. I do not attend horror films, because I have never attended the sort of thing that has gore or violence as its mainstay. My concept of horror films goes back to the olden days of Boris Karloff and Lon Chaney Sr. My favorite actors included Peter Lorre and Conrad Veidt, people of that group and the sort of films that they made. In addition to which, my wife is completely allergic to that type of film, so we see the films that the Academy shows, and I can assure you, the Academy doesn't show very many of the contemporary horror features.

JCT: I showed *Dead of Night* [a ghost story anthology film from 1945] recently to a class at the University of Kansas. And I'm happy to

report that the students surprised me. They liked it, they were with it, they enjoyed it. They found it strange; it wasn't what they were used to. They liked it, though.

RB: It was an intellectual film. And that lovely last sequence when the story doubles back on itself...absolutely perfect. I recall meeting Alberto Cavalcanti, the director of that final sequence, at a film festival in Rio de Janeiro in 1969; and what a great pleasure it was to be able to tell him how much I'd enjoyed his film. And I'm happy with the fact that I was able to meet other filmmakers and get to know some of them rather well. Fritz Lang was a tremendously dear friend of mine. And Boris Karloff and Christopher Lee.

JCT: Any recollections about Karloff we might close with?

RB: Oh, well, Boris was a guest at our house, and we invited the Forry Ackermans. And Fritz Lang got word of it and he called up, he said [puts on a German accent], "Darling, you know I have never met Boris Karloff. I would love to meet him." So we invited Fritz and Lilly, and they gathered at the house at the appointed time. And Fritz took one look at Boris, who was delighted to see him, they shook hands, and Fritz says, "We are the last of the dinosaurs." And it was a great evening. These people were all possessed of one thing in common—they all had a terrific sense of humor. I think this is a compensation, one way of trying to say to the world, "Look, I am not the monster you think I am on the basis of what I write. I am also a human being!" But this is certainly true of Stephen King, of Richard Matheson, of Ray Bradbury, of Harlan Ellison, and just about every great writer today; and it was true in the past of Henry Kuttner and Charles Beaumont and people of their generation. All of those whom I ever got to know shared that sense of humor. And certainly the actors did. Christopher Lee's screen favorite was W. C. Fields, of whom he does an excellent imitation.

JCT: And people like Beaumont and Kuttner particularly enjoyed something of the clownish, even in their most macabre stories.

RB: Yes, well, there's a definite relationship between humor and horror, which is being capitalized on today in some of the contemporary films. But it's also being viewed by certain acne-ridden critics as the invention of these people. They don't realize that there's this kind of grotesquerie in the writers of the past.

JT: Well, I can't think of a story like your "Enoch" without thinking of a sardonic smile attached to it. That makes it all the more scary, which is a pretty nice effect, ultimately, isn't it?

RB: Well, thank you.

JT: A new work coming out we should be watching for?

RB: Well, the next thing's going to be a two-volume anthology that I'm editing, which is a new experience for me, with many of my contemporaries included in the pages, called *Psychopaths* [published in 1991], and it deals with psychological horror, nothing supernatural. And the thrust of the anthology is an exploration of what goes on behind the mask, within the mind, of a psychopathic personality or a sociopathic personality; and it's a good question because the psychotherapists have not been able to clearly define let alone to chart the particular problem, except to insist that it is not legally clinical insanity.

JCT: Well, this is interesting, because it would seem like the insights of a Charles Brockden Brown in America, early in the nineteenth century, and an E. T. A. Hoffman in Germany—

RB: Yes....

JCT:—are way ahead of anything in a so-called psychotherapeutic community, contemporary to their work. *Way* ahead.

RB: Well, I have noted in two lengthy introductions, one to each of these volumes—the first of which will be out in march, I believe—I've noted that psychotherapy has lagged behind fiction; and even today, you'll probably know more about the psychology of a murder in depth if you read *Crime and Punishment*, than if you read the average history of criminology.

From Providence to Liverpool: Ramsey Campbell

Since he first came to prominence in the mid-1960s, John Ramsey Campbell (1946–) has established a secure position as one of the preeminent masters of dark fiction. Writer and editor T. E. D. Klein declared in 2001 that "Campbell reigns supreme in the field today." Campbell survived growing up in a dysfunctional family in Liverpool, and he freely admits that his first stories in the early 1960s were heavily influenced by H. P. Lovecraft. Beginning in the 1970s with *Demons by Daylight* (1973), he broke away from Lovecraft, and in many novels, including *The Face That Must Die* [1979], *Parasite* (1980), *Incarnate* (1983), *The Hungry Moon* (1986), and, most recently, *The Grin in the Dark* (2007) drew more upon psychopathological horror, threat, and insinuation. Among his many honors are several World Fantasy Awards and a Bram Stoker Award. He is the Lifetime President of the British Fantasy Society

This interview is a conflation of two conversations.[23] The first transpired at the World Fantasy Convention at the O-Hare Marriott Hotel in Chicago on 30 October 1983; the second at the World Fantasy Convention in Providence, Rhode Island, on 31 October 1986

Ramsey Campbell (the author)

Interview

JOHN C. TIBBETTS: Here we are in H. P. Lovecraft's hometown, Providence. On Halloween, no less! Just the place for writers and readers of horror fiction! Are you comfortable with the label, "horror" writer?

RAMSEY CAMPBELL: Yes, I think so, I think horror is what I do basically. Although the field is filled up with a lot of old junk it still seems to me that I'd like to called by that term.

JCT: I suppose we should start with the influence on your early work of H. P. Lovecraft.

RC: Well, my first published book was an imitation of Lovecraft called *The Inhabitant of the Lake* [1964]. It was a series of stories written wholly in the style of Lovecraft, using his ideas and his alien beings—the so-called Cthulhu mythos—which he had constructed. I even "quoted" from Lovecraft's fabled *Necronomicon*! I set it in a mythical location in the Severn Valley. That was my version of Lovecraft's Arkham/Dunwhich, Innsmouth. The whole thing about Lovecraft's mythology was that it was so set up that it suggested more than it ever described, until misguided folk like myself came along later and decided to fill in the gaps and fill in all the ambiguities and explain everything away, which

is exactly what Lovecraft didn't want since he was trying to avoid the kind of too tight, too structured paraphernalia of Victorian occult.

JCT: My copy of the book says you were the youngest writer ever published by Arkham House. How old were you then?

RC: That may be true. I was about 17 or 18.

JCT: And not the last book of yours from Arkham House!

RC: Gosh, let's see... *Demons by Daylight* [1973] was another short story collection a few years later.

JCT: And speaking of Lovecraft, I think you edited some Lovecraftian tales for Arkham, also.

RC: You must be thinking of a collection of "Cthulhu Mythos" things [*New Tales of the Cthulhu Mythos* (1980)]. I was lucky to get some of my favorite writers in that style, Stephen King, Basil Copper, T. E. D. Klein, and Frank Belknap Long. I suppose I got started on all this when I was 10 years old, reading Lovecraft's "The Colour Out of Space." Then I bought one book of his, it was published in the 1940s as *The Lurking Fear* and in Britain it came out as *Cry Horror*; it had the same cover.[24] But I just spent one whole day reading it. It really disturbed me, with its attitude that *all* nature is malevolent. He says everything is "tainted" with what he called a "loathsome contagion"?! Wow. I was just steeped in the man's work from there on. I think it's worth saying that one reason why he is the most influential horror writer is the same reason M. R. James is the most influential ghost story writer and Alfred Hitchcock the most influential maker of suspense films— which is to say that they all display their technique. The technique on the surface is integral to the way they do things. It does look easier to copy than it is. It's not a suspense technique in the conventional sense of a thriller, but more a relentless anticipation of something terrible. One can certainly see, I think, why people are attracted to try and do the same thing, because you can't see a display of exactly how to do it.

JCT: Have you been to Providence before and seen the areas where he lived and worked?

RC: Sure, yes, I've done the tour basically and gone to see the "shunned house" and the graveyard that he frequented—only for research, one assumes!

JCT: Is there anything in the assumption that to understand a writer you must understand his environs?

RC: Lovecraft once said, "Providence is me and I am Providence." He identified deeply with the place. He was actually very unhappy when he went to New York for a couple of years and extraordinarily moved to get back to Providence, where he spent his last years There's no question that he was writing profoundly about his response to the landscape. And not merely Providence, but

New England as a whole. His work in *The Case of Charles Dexter Ward* and *The Dream-Quest of Unknown Kadath* seem to be as much dreams of this area as they are horror stories.

JCT: Maybe Providence brought Lovecraft closer to an old world atmosphere than he might have found anywhere else in America.

RC: I'm sure that's true. Not only that, but Lovecraft always lived a couple of centuries in the past. He wanted to be a gentleman of the old school. The architecture particularly gave him, I think, some of that. He could live within that to that extent.

JCT: Any place in Providence related to Lovecraft that particularly moved you?

RC: Yes, going to the graveyard where Lovecraft is buried and discovering that there really is no legend over the grave. Lovecraft's there, but you could walk on by and never notice. But I think we all know he's there by now.

JCT: Now, how about you and Liverpool? I think Liverpool is to you what Providence was to Lovecraft. Is it possible for you to remain a "gentleman of the old school," living near Liverpool?

RC: I don't think I ever was a gentleman of the old school! I've managed to appear like a gentleman, occasionally, but that's about as far as it goes! Lovecraft's Providence frequently appeared in his stories as the mythical "Innsmouth" or "Dunwich"; and my Liverpool and Merseyside have sometimes appeared as the fictional Gloucestershire city of Brichester, near the River Severn. It is an area that retains influences of the decadent Roman. Like Lovecraft, I tend to write about Liverpool as a city in decline. But I'm actually writing about Britain, generally, and about the frustration, meaningless, helplessness of seeing your environment change overnight around you. Seems like, more often than not, when I write about a place, it seems to disappear.... You know, Liverpool was a coastal town that was heavily bombed in World War II. Growing up, I'd find myself wandering through whole areas that consisted entirely of the ruins, the bottoms of building with no roofs, this kind of thing. And I suppose that's why my stories have a kind of love/hate relationship with that environment. I loved going out in the streets, because it was an adventure. There would be this cinema right in the middle of several streets of completely empty houses. I'd go to see a movie like *Night of the Hunter* [1957] there, which seemed inextricably bound up with the area.

JCT: What an interesting movie to have seen in that environmental context.

RC: Well, the film doesn't need that environment, but all the same.

JCT: Let's go back to *The Inhabitant*? Where did you go from there?

RC: As soon as I'd written it, I kind of stopped for a little while before I wrote anything else, which is curious because I had finished a book, which was quite an event for me at 18, obviously. And once

I began to write again, first of all I decided that maybe some of the ideas I was working with didn't really need the Lovecraft crutch, so I didn't need to put the names that Lovecraft had invented, and the stories could do without them. I wasn't very happy with that, but I suddenly went into a kind of brain storm, I suppose, and went completely away from Lovecraft.

JCT: You know, I always loved the endings of his stories where somebody writing in the first person describes his own imminent death at the hands of some foul fiend....

RC: Yeah, that's right! Yes, I did a few of those, myself! In one of my early stories I have somebody writing a telegram saying, "My god, what is this coming down the hall?—surely it can't be that creature that I saw in the vaults beneath the haunted church!!! My god! *Aaaaaaaaahhh!*" But then the telegram didn't get sent! But later I wrote stories that were the absolute antithesis of Lovecraft. They were very, very compressed. This was my second book, actually, the collection for Arkham House I mentioned. And then here was my second novel, called *The Face That Must Die*. It was badly received by the publishers with whom I was then working. The book is told from a psychopathic viewpoint and makes it clear that it really is going to keep with that for quite some proportion of the book. Do we *really* want to live with this guy? I think on the whole my answer would be well, you know, the best way to living with somebody like that is to read about it. It's the most direct and most immediate way of confronting that kind of consciousness without actually having to meet him on the street or live with him.

JCT: The author has to make a choice—do I convey a character like this through a clear window of prose, or do I become a subjective narrator and enter into his world directly?

RC: Yeah, I've always been in favor of getting inside the character. I think you find your own way out if you can, in an extreme way, in this book. As I say, the publisher was not at all happy with it and felt that it was very off putting. But it's interesting, it has now been published in America by all the small presses in an extremely pleasing edition; I'm delighted with it. With acid-free paper and extraordinary illustrations by Jeff Potter, an artist of considerable talent. And it's now getting very good reviews in America.

JCT: Were you still using the name "J. Ramsey Campbell"?

RC: No, by my early twenties, I dropped the tails, as it were, I was pure Ramsey Campbell.

JCT: And I guess there was no question in your mind at this time that full-time writing was something you wanted to do, or not?

RC: That was exactly at the point where I thought, well this is maybe a good idea. One of those extraordinary crazy ideas that one gets in this business I suppose, because I was having precisely two books published. *Demons By Daylight* got some good reviews,

particularly one from T. E. D. Klein who later became the editor of *Twilight Zone Magazine*, who seemed to get precisely what I was trying to do in the book [see the interview with Klein elsewhere in these pages]. I mean, he actually spelled out everything that I wanted to be there. I was delighted to get this essay written. This was actually instrumental in deciding [for] me that I should go out and try and do it full time, since I wasn't going to be able to wait around for a best seller. The only way was to go out there and try and make it in the big wide marketing world, which was almost precisely when the bottom dropped out of the horror fiction market. But these things do happen.

JCT: Were there moments like that when you said, "Well I must go legit and be a civil servant" or something like that?

RC: I'd already been a civil servant! I started work as a civil servant when I was 16. In fact, I wrote some of those stories on the lunch hour in the office before trying to deal with people who'd gotten themselves overtaxed over the phone. So it clearly does prove that one can write under the most adverse conditions.

JCT: Where you living there at that time?

RC: I've always lived in Liverpool. Now I'm across the river on the peninsula, but it's just a river in between. But yes, I just decided to go out there and do it. But my agent then wrote back this rather sad letter basically saying, there aren't many markets for this kind of thing at the moment, have a go at science fiction. I did in fact write some science fiction, which was truly dreadful. One story that got into print, I'm delighted to say, is now *out of print;* and if I have anything to do with it, you'll never see it again!

JCT: So, if I ask you what it is... you're not going to tell me?

RC: Why not? It's a story called "Murders," and the idea at least is probably pretty good. What happened there is somehow I became kind of overawed with the thought that I was writing science fiction. Don't ask me why this should be, but I actually felt somehow I'm writing this much more challenging kind fiction (I don't think that's true at all, but it seemed that way to me). And the style got extraordinarily ponderous and deliberate, pompous and tricksy, which is the sort of writing one gets when one isn't really in tune with the material. I think that demonstrated to me pretty clearly that I should go back to what I do best. Luckily following that, I was able to do so.

JCT: Can you pinpoint in time any book or that moment when you realized full-time writing was something that you could do and make a living?

RC: Well *Demons By Daylight* was it. Then that was the point at which I believed I could make a living. Then I tried to do it, and luckily my wife was teaching, so had we been living off my money I certainly wouldn't have been here talking to you now, I suspect.

JCT: Although you can lead a life that's totally normal, con-
formist, etc., the world of the imagination has to have its say,
occasionally.

RC: Yes, I'm sure that is true. In my case, I know pretty well why
I turned to horror fiction at an early age. It's a longer story than
I can tell you in 15 minutes. I've written a long introduction to a
novel of mine called *The Face That Must Die*, which goes into it
pretty deeply. But in brief and in sketchy form, the fact is that after
my parents were separated, we all lived in the same, pretty small
house, two rooms downstairs and three bedrooms. So, I actually
didn't see my father for maybe 20 years. I dreaded his footsteps on
the stairs side of the dwhen I was laying awake in bed or the sound
on the other side of the door, where if I tried to get into the house
at the same time he'd just come home, and he would hold the door
on the other side so we couldn't meet face to face. That was one
side, and the other side was that my mother was trying to get away
from this, trying to make a living herself, which was difficult.
She actually did write quite a lot but was never published except
for a few short stories. The fact that she wasn't getting published
brought other things to the surface and she began to hear messages
through the radio saying to her that she was going to be published
next time. When she got another rejection slip she was convinced
this whole thing was a conspiracy aimed at her in which British
Broadcast Corporation and the neighbors so forth were involved,
you see. So this was kind of what I grew up with and in a sense it's
perhaps not entirely surprising that I got into in horror fiction.

JCT: Yet you're one of the lucky ones because you can deal with
some of these things in your work.

RC: Well, that's perfectly true.

JCT: Most people probably cannot.

RC: They're the unlucky ones. Those are the folks who end up
schizophrenic themselves.

JCT: Childhood alienation is certainly a common theme.

RC: It is indeed. Although it's interesting, Steve King doesn't nor-
mally talk about it, but his wife does go into this in an autobio-
graphical sketch that Steve's father just went away when Steve was
two years old, and was never seen again by the family [see the
interview with King elsewhere in these pages]. One can't help
thinking that probably had a fairly powerful effect on Steve in
some way later on. You remember Lovecraft, of course, who was
obsessed with the fact that his father died of syphilis and per-
haps that he was going to go in the same way himself. He was
brought up by three mother figures and was terrified to leave his
hometown.

JCT: I've always been fascinated by the figure of Shirley Jackson, who
can write books about raising children like *Raising Demons*—very

wonderful and charming—and yet at the same time write things like *We Have Always Lived in the Castle*, where suddenly childhood is a whole different kettle of fish altogether.

RC: This is true. It's nice to be able to have that odd verse. Bob Bloch, on the one hand, writes extremely grim psychological horror fiction; on the other hand, Bob is one of the great stand up comics of fantasy fiction—both as a writer and on stage, when you get him going. I used to write comedy strips for the BBC, a local BBC station in England in fact, though they did tend toward the macabre. But I must say if I didn't write horror fiction I think I'd most like to be somebody like Stan Laurel, Oliver Hardy maybe. That would be my great ambition.

JCT: Or to write horrific titles like *The Doll Who Ate His Mother* *[1976]*...

RC: That was a title that seemed to me to be utterly implicit in the story. The reason I wrote that book was actually that I finally wanted to do my first novel, having written short stories solely for the better part of 12, or 13 years. My agent was saying, you ought to do a novel. I finally got an idea that seemed to me to be capable of development. The idea fundamentally centered on a mother who becomes deeply involved in an unpleasant diabolical cult and who has to promise her child to the cult's leader. When she refuses to promise the child he gets the child anyway, even after her death causes it to be born in a fairly unpleasant way. This is the point of the title.

JCT: People might ask, how can you possibly deal seriously with something that is grisly and unpleasant? How can this be the stuff of serious academic study much less entertainment?

RC: How can you take it any way but seriously? I'm not out to duplicate a popular entertainment like the *Grand Guignol* tradition.[25] I don't think there's any other way to take it but seriously if you're going to do it at all.

JCT: Is there anything all of us have more in common other than fear?

RC: Exactly, that's right. And I think basically the only way you can do it as a writer is to try and take on directly the things that are deep within your subconscious. I can't ever say in a sense that I set out to write upon a particular theme. It tends to be rather the story unfolds itself. More and more I try just to get on with telling the story and give myself that amount of bread for the imagination.

JCT: Stephen King has suggested that horror writers are helping us to exercise certain muscles that we allow to lay dormant. We exercise all different kinds of aspects of ourselves. We learn how to look positively on life, but we don't learn how to exercise other more darker things in our psyches. What do you think of that?

RC: I think it's a legitimate view, certainly, yes. I particularly enjoy reading stories of mine to audiences. Rather than just writing

alone in my room, which is what writing is, basically. I can go out there and find out how people respond to it. It's a lot of fun. One of the important things about this field, I think, is it enables people to share their fears. This kind of field allows you to do it. What I tend to take issue with Steve King a little about is the notion that it has to be normative. That the horror story basically saying, this is horrible, therefore, we're showing what is abnormal. Therefore, by implication, we're showing at the same time what is normal. Actually, I probably tend to be dealing more with the abnormal in very normal people; or, on the other hand, the the normal in extremely psychopathic folk.

JCT: By the time the story is done, I indeed do not have a sense of what is normal anymore. In fact, that's what I treasure about your stories.

RC: I suppose so. I was a bit disconcerted by a review recently of *Incarnate*, which is the latest novel of mine to be published, where they said—it was *Publisher's Weekly* in fact—where they said in tones that were clearly intended to be praiseworthy, that the book is not simply a horror story, words to this effect, that it does more than simply frighten you, it assails your very grip on reality. A curious thing to praise a book for, in a way. Presumably if I drop acid and LSD in everybody's drinks I wouldn't get praised for it, but this is different.

JCT: Maybe it forces us to look at life in such a different kind of way that it ends up questioning the way that we've been looking at life the other way.

RC: I think that is what I would like for it to be doing. *Incarnate*, which deals particularly among other things in television and news coverage and so forth as one aspect of a fairly complicated plot. Yes, exactly, to shake up what you're taking for granted as being real. If that's happening to people who read the book, then I'm delighted. Where there's so much coming at us that is being sold as real, it seems to me that this is one of the more frightening aspects of contemporary life. I'd certainly be happy if my book is blowing that away a little bit.

JCT: Have you had occasion also to be a screen writer or a television writer as well?

RC: No. I had a brief flirtation with the field. In fact, I was asked by Milton Subotsky, a producer based in Britain, to do a treatment of Solomon Kane, the Robert E. Howard character, the Puritan adventurer. An interesting figure, but alas United Artists pulled out of a deal.

JCT: Are you finding yourself regarded critically now in journals, in schools?

RC: Yes, I think so to some extent. I find it interesting that a story that I might have written mainly in order to get the damn thing

out of the way and finish it so I could get on to something that might interest me more, clearly pleases people a great deal.

JCT: Too many times we think that "artistry" must necessarily involve great pretentiousness and self-indulgence.

RC: It's perfectly true. I'll tell you a story, I spoke last week about the fact that having gone freelance I found that the bottom had dropped out of the kind of market that I was trying to approach, which was simply the very broad market. The only thing I could find to do that appeared to be going at the time was comics aimed toward a more adult readership. I thought I would do a group of stories based on the old horror comics of the 1950s, like "The Vault of Horror" and "Tales from the Crypt." And what I found when reading those comics was some of them are extremely well done, much more restrained than one often suspects they might have been. But one of the things about them is they usually had a built-in O. Henry style of surprise ending. Once you became aware of this pattern, you can't prevent your mind from running ahead of the story. And 80 percent of the time I knew what was coming. So I tried to write a few stories in that vein using traditional themes like the zombie or the vampire and the werewolf, but come up with an ending where you couldn't quite see it coming. I think I did a couple of stories that worked pretty well.

JCT: Let's catch up with your recent work. I love the atmosphere of the bleak moors of northern England in *Hungry Moon* [1986]. Your community of Moonwell seems to disappear at times, or at least come and go.

RC: That's quite true, yes, the influence of the old Druidic forces wipes it out. *The Hungry Moon* takes place mostly in the present day and involves an American evangelist, Godwin Mann, originally British but going over to America and back again, coming to England with the mission to wipe out the last vestiges of paganism, because it's corrupting society.

JCT: How typically American!—the upstart coming into an old world culture thinking to change it over overnight.

RC: Well, there is that, although it's worth saying that the protagonist in the book is also American, and she faces this threat of repression. This is very much a book about what I see as the very disturbing backlash that we're seeing at the moment, which seems to be a desire for order at any cost. And also I think there's an increasing tendency of people to run for any solution or any philosophy that will give you all the answers so long as you give up the right to ask any questions. I find this extremely disturbing. And this, I think, is one of the thing's *The Hungry Moon* is about. The evangelist is very much a fundamentalist and that's an area of religion that I must say I find peculiarly disconcerting. There's a lot of it round where I live around Liverpool too and this is partly where it came

from. But again, as tends to happen in my stories, the man—in this case the evangelist—who goes in there to confront what he believes to be the evil out there, the monster that's threatening the others or the people on whose behalf he's working, comes face to face with something very much more like a reflection of himself. And indeed he turns into the force that he's trying to cast out. In my stories generally speaking, people who try to argue that evil is something other than us tend to come face to face with it and find that they're more likely looking in a mirror.

JCT: And you give us a wonderful Thing That Lies in Wait...And it all takes place in such an extraordinary atmosphere. Take us to the Peak's District. Derbyshire, I believe?

RC: Yes, that's right. Most of that aspect of the story is perfectly true. There is an area between Lancashire and Yorkshire, it's above the midlands basically, between the midlands and the lake district that is extremely bleak. There's less sunlight there than anyplace else in the country.

JCT: You make that point, all right!

RC: Yeah. Where also seems to be traces of the oldest practices or practices as old as any in the country, particularly this business of well dressing, which involves building a lamp with a floral decoration of the wells in the villages. These are now Christian images, I mean they tend to involve saints. But there's no question that what they were originally were Druidic or pre-Druidic practices that were taken over by the Christian church.

JCT: Most of us might be startled to know how many Christian observations do stem from decidedly pagan events.

RC: Absolutely, this is very much what the book is about. It's incidentally an issue that T. E. D. Klein also takes up in his book *The Ceremonies*, which is well worth everybody's attention. But yes, I think it does seem to me a bit salutary to take a look at that aspect of religion now when there is so much what seems to me to be fairly historical religious campaigning, with religion being the only answer, the only purity. It really isn't quite that simple. I tend to be very dubious of people who think in terms of absolute good and absolute evil. I'm not at all convinced there's any such thing around.

JCT: One important feature of this landscape is the stone bowl on the plateau there sloping downward to the well. Have you seen aspects of the landscape like that yourself?

RC: There are things like that. Potholes are cut in that kind of limestone district. Of course, there are people who actually for a hobby will go and climb down them as far as they will go.

JCT: Families would live down in there and function as bandits.

RC: That was my invention, but I'm not entirely convinced. It may not be true, maybe it is true. One of the things I found very

interesting about this book is that once I set up this notion of the Moon God, basically the Druid's moon force being somewhere situated in the Peak District—or even just the notion of the force of the moon being in some way embodied on the earth—how many legends one could find, or bits of Christian tradition, bits of other traditions, which seemed to fit in squarely as bits of evidence that this legend had carried on over the centuries. What's interesting was I had made up the legend and then found bits of evidence to fit it! How about that?!

JCT: Maybe there's a collective unconscious working there, or is it consciousness? I don't know. You come up with a Jim Dandy song there also about Harry Moony.

RC: I'm not going to try and sing it! That's an old Derbyshire street song, according to the text.

JCT: The song is critical to the book and it really describes many of the events to come. Would you at least share a few lines from that?

RC: Well yes, it's a common tradition. You get three brave lads going down and combating some evil. The number of three being an important Druidic symbol, they tended to work in threes. That's why I suspect so many fairy tales work in threes, the "three wishes" kind of thing. Three of them have gone to combat Harry Moony, which is at this stage of the book the inexplicit Thing down in the well. So what happens is—

> Two brave lads leave their heads down below,
> two bodies walking, and one more to go.
> Old Moon's a'laughing and showing his teeth;
> Harry Moony's coming from his grave to beneath.
> The priest's in the well and the knight's in the sun,
> and nobody leaves 'til Harry Moony is done.
> Go down Harry Moony, harry us no more,
> We've flowers to please you, to leave at your door.

JCT: And you're referring, of course, to the dressing of the well.

RC: That's right. The actual floral tribute, yeah.

JCT: Now, is this a word-by-word transcription of a song, or have you also embellished this a little bit?

RC: I made it up completely! It's just fun to do. I had to work on it a bit, but I get these random things. I thought we ought to have a street song in this book to get a background, so I worked it out.

JCT: How musical are you, or do you have a musical friend that might set this to music?

RC: I did consult an authority on folk songs who found a likely tune for it. Who knows, maybe it's more authentic than I thought! The book seems to have gotten the best reviews I've yet seen for a while, which

is all pretty encouraging. And then next June we have the paperback from Tor Books who have just about everything else of mine in paperback right now. I've been doing extremely well by them.

JCT: How about Ramsey Campbell at home? When you're writing a novel are you a very easy person to live with?

RC: No. Not when I tend to scream and say shut up, and no, don't come in right now...I think it does tend to be an unreasonable existence, really, because I write seven days a week anyway, which is a pretty unreasonable way to behave around one's family, but this is the way I feel I have to do whenever I'm writing a novel. Or any story really; I have to continue it and not go away from it. There are tricks that you learn. Bob Shaw, the English science fiction writer, taught me a couple of very useful tricks, which is a way to relax. Because I think the only way to do it ultimately if you're not going to go mad with it, is in some way to relax. I worked out a few ways. You can tell yourself, this is not the final draft, this is just the first draft, you can always rewrite it. I must admit, I always say to myself in the mornings, ok if I write one paragraph, that's it, I've done it. I've done some work today. I'll go away, I'll feel ok. I don't need to do anymore. I never actually do one paragraph unless I've got a particularly virulent hangover, but at the same time I can tell myself that and move along that way.

JCT: Have you also learned not to like your work too much? Have you ever had it happen where you've been very impressed with something, and then as you got distance from it you thought, uh huh...

RC: Yes, I think that's certainly true. But on the other hand I know it's also true that the process that I most enjoy is rewriting. It's a lot of fun to be able to say, "Oh, these three pages are dreadful, right, throw them away! The hell with that."

JCT: It's a great feeling of power too.

RC: That's right.

JCT: Plus it's also marvelous inner discipline to discard hours of work.

RC: Absolutely, yes. You've done a complete day's work on that scene, on that opening passage of a chapter, then six months later you come along and say, well this isn't any good anyway.

JCT: Who are the writers that you turn to in your idle hours?

RC: There's going to be a long, long list! But you can begin and end with M. R. James. He shows unlike anybody else how you can suggest something quite appalling with a passing phrase.

JCT: I remember the moving rumple of bed clothes...

RC: Ah! "Oh, Whistle, and I'll Come to You, My Lad." Was there ever a better title? That's very good. But the one that always gave me uneasy nights was "The Treasure of Abbot Thomas," where the protagonist falls down a well where he knows that bags of treasure

have been hidden. And having found a niche full of leather bags, he begins to pull one of them out. But then he feels this *pull* from something below, dragging him down...

JCT: How about modern authors, your contemporaries? I like Dennis Etchison a lot.

RC: Oh, so do I, yes, very much indeed. I did an introduction to his first collection, where I said he seemed to me to be as fine a writer in the field as anybody writing short stories today. Going back a little further, we find there's Fritz Leiber, Manley Wellman, and Frank Belknap Long. I still regard Long's "Hounds of Tindalos" as one of the most extraordinary horror stories ever written. It's simultaneously very frightening and very moving. That is magnificent. I couldn't have done anything like this.

JCT: You're very generous and enthusiastic about your colleagues and competitors. That's refreshing.

RC: Absolutely. One of the things I do find depressing is the sight of some writers in this field, Roald Dahl for one, and Nigel Kneale, who complain that there's nothing worthwhile being written in this field anymore. I really get the feeling from these guys that they're afraid of the competition, and they have to put it down. Surely they can do something more honorable than that.

JCT: You write with such a strong visual sense.

RC: It's interesting that my novel, *Incarnate* [1983], about dreams penetrating into reality, was written just before Wes Craven's film, *Nightmare on Elm Street*, came out! Funnily enough, I had the experience of going to see another film, Cronenberg's *Videodrome*, just after I delivered *Incarnate*. I was kind of taken aback by how many things, both in terms of theme and in terms of technique my story and these films had in common. It was like looking at a dream that I was having myself the first time I saw *Videodrome*.

JCT: Or it is to say that there's filmmaker in you. or at least a cinematic sensibility.

RC: I think that's right. Whether I'll ever get behind a camera or not, I don't know. But yeah, the cinema's always influenced me pretty deeply in a variety of ways. I love movies. I'm even thinking about writing a novel about a long-lost Boris Karloff film. The film is called *Tower of Fear*. Ever heard of it?

JCT: Why, no.

RC: There you are! [*Ancient Images* was published in 1989.]

JCT: I get your point!

JCT: Now *Incarnate* is not out in paper yet.

RC: It is. Oh, yes, Tor has it, and they've also got the one that came after that, which is *Obsession* [1985], which is a relatively intimate sort of a novel about four young people in the fifties who seem to have insurmountable personal problems. When you're a young teenager everything looks pretty insurmountable. And they get

the chance to have whatever they most want to have done for them. Only they find that their wishes come true much more drastically than they would have wished. And then when they grow up 25 years later, their debt begins to be called in. Oddly enough I suppose this has something in common with Stephen King's *It*, which is also about young people in the fifties and what happens to them in the eighties and the supernatural element that follows them across their lives.

JCT: And Peter Straub tends to follow lines of narratives that span generations or at least decades.

RC: That's true. I suppose I've always been concerned with the thing in your childhood that you thought was safely grown out of, which is in fact only waiting there to come back and get you in some worse form.

JCT: Which is to relate so-called horror fiction to a very responsible and legitimate literary tradition in the eighteenth and nineteenth centuries, the Gothic novel.

RC: Unfortunately, there are so many lookalike paperbacks on the stores calling themselves Gothic novels, that we don't know what the name *means* any more. But the actual Gothic novel was about much more profound things. Think about the theme of the woman in danger, which in the early nineteenth century wasn't a cliché, but a metaphor for the experience of the average woman who was reading the book. I mean, those plots of women in those stories going off to strange houses and meeting sinister men reflected the experience of women facing in marriage the very sexuality that had been repressed in their upbringing.

JCT: And although we may think of *Jane Eyre* and *The Woman in White*, we could certainly go back further than that.

RC: Certainly, back to the relentlessly pursued maidens in Ann Radcliffe's *The Mysteries of Udolpho* [1794] and in a much more perverse and radical way, the corruption of the virgin nuns in Matthew G. Lewis' *The Monk* [1796].[26] I think one of the things that the Gothic novel was doing was suggesting things that ought to be changed, or suggesting that things *should* be changed. But that's not what I want to write about, obviously. My own feeling, I must admit, is that the horror novel is capable of encompassing anything I want to write about.

JCT: In fact, I cannot think of a single major novelist from William Godwin [*Caleb Williams*, 1794] on up to the present, who has not at some time or another been influenced by horror literature.

RC: Sure, indeed. I think what may have happened recently is that there's been a spurious division between the ghost story and the horror story. The ghost story's become the kind of respectable supernatural tale, while the horror story's become more difficult to cope with, mainly due to the graphic horror. I think it's a pity,

because for a long, long time the ghost story and the horror story were interchangeable terms. I was very pleased recently that a couple of stories of mine, which I personally would have called horror stories, were in an Ohio University anthology of English ghost stories, edited by Jack Sullivan, the guy who did the *The Penguin Enclopedia of Horror and the Supernatural*.

JCT: Now is that Jack's *Lost Souls*?

RC: That's the one, yes. I was delighted to see that. I'm much more in favor of that kind of broad view of the field. A couple of things seemed to have happened recently: one is that writers who are writing horror novels are beginning to say they write *novels* rather than *horror stories*. I must say I write *horror stories* and I'm delighted to do it. The second thing that's happening is that there is a breed of horror fiction where the writer will say that horror fiction means *disgusting* fiction. Well I don't think so. If I can work against that, so much the better, that's what I try to do.

JCT: But one way or another, you do shake things up a little bit. You don't let us get complacent about anything.

RC: The other thing I like about horror fiction at its best is when it talks about something larger than itself. That's always been that appeal for me when I came into the field. That the story would show just enough to suggest more.

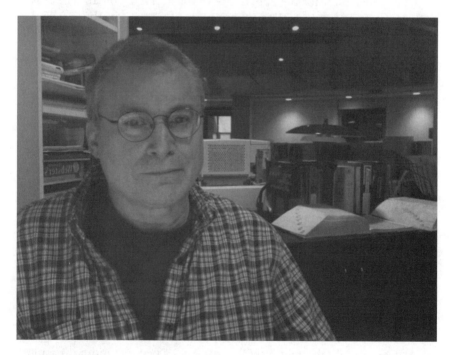

T. E. D. Klein (photo courtesy T. E. D. Klein)

"Certain Things Associated with the Night": T. E. D. Klein

T. E. D. Klein worked for more than four years as the founding editor of *Twilight Zone* magazine.[27] His first two book-length publications, *The Ceremonies* (1984) and *Dark Gods* (1985) have been hailed as modern classics in the realm of contemporary Gothic horror. Stephen King called *The Ceremonies* "the most exciting novel in the field to come along since Straub's *Ghost Story*." Klein currently divides his time between New York City and upstate. His most recent book is a collection of stories, *Reassuring Tales* (2006). I have to thank Jack Sullivan for facilitating our first meeting. This interview transpired in Klein's apartment in the Upper West Side in August 1986. (*Bracketed materials in italics indicate Ted's update on 12 July 2010.*)

Interview

JOHN C. TIBBETTS: Tell us about your name "T. E. D."

T. E. D. KLEIN: That's largely affectation, but I'd rather leave it a little mysterious. On my birth certificate, you'll see "Theodore Donald Klein"—and as for the "E," well, that can stand for anything you like.

JCT: Your books and artifacts and mementos are everywhere around us. It's really a wild collection! I can't help but wonder what all this tells us about you. Give me a brief inventory, will you?

TK: Over there's a table with some standing frogs, and behind me is a tarantula in a glass globe (and on the bottom of the base is a warning about consuming the contents).... I'm looking at a little statuette on my bookshelf of an H. P. Lovecraft figure, Wilbur Whateley; he's holding a carpetbag and a copy of the dreaded *Necronomicon,* which Whateley tried to steal in "The Dunwich Horror." Hanging from the ceiling are models of lighter-than-air aircraft. There's a flintlock and a couple of Civil War swords on the wall above the mantel.

JCT: You're a born collector, I guess. And books! Lots of books!

TK: I'm unable to walk past a bookshop without stopping in to buy something. And I sometimes think my stories are as cluttered as my apartment. One problem I have is that I can't write at all unless I read a bit first—to prime the pump, I suppose. So I depend on other books. Horror seems to me a fairly tradition-conscious genre, and it's hard to imagine somebody writing well who's never read his predecessors. Maybe this has something to do with the limited number of workable plots, or at least the limited

number of things that are actually scary. [Subsequently I wrote a little booklet called *Raising Goosebumps for Fun and Profit*, which contains what I claimed at the time were "the 25 Most Familiar Horror Plots."] Chances are you're not going to come up with an original idea; what's important is the treatment. And it helps to know how earlier writers have dealt with the same human fears.

JCT: Even readers not familiar with your work may know your name from *Twilight Zone* magazine.

TK: I was its first editor. It premiered in the spring of 1981, and I finally left it, a bit burned out, in 1985, after about 40 issues, I guess. It took up all my time, though somehow I was able to complete *The Ceremonies* during that period. I would occasionally sleep in the office, on a big leather couch. If I came home at all, it was at 1 or 2 in the morning, trembling with fatigue. Still, working on *Twilight Zone* was a dream come true; I'd spent my boyhood reading pulp SF and fantasy magazines, but I never imagined I'd actually have the chance to edit one. [*And ten years later, I had the fun of editing another monthly, a true-crime magazine called CrimeBeat.*]

JCT: What was the best thing that came out of those *Twilight Zone* years?

TK: Meeting the very interesting people who populate the field. However, dealing with writers and illustrators taught me one thing that might seem a little shocking—how much nicer and more pleasant illustrators are than writers! Writers tend to be a fairly egotistical and competitive bunch, whereas I invariably found the artists quite charming.

JCT: What kinds of chores occupied a lot of your time?

TK: The correspondence—just answering the mail—was particularly time-consuming. An,d of course, we had our quota of crank readers. We got weird threats, invitations to join various religious cults; we got earnest letters about encounters with saucers.

JCT: As long as they write and do *not* come down to the office!

TK: People would sometime show up unexpectedly. It used to make me a bit nervous.

JCT: You seem to reveal in *The Ceremonies* your own love of literature through the main character. He's struggling to write a doctoral dissertation on the Gothic novel. What about that?—are today's scholars ruining the fun of those old books by analyzing them to death?

TK: I'm just glad *someone's* reading them, even if they're grad students, because I'm afraid otherwise nobody would. I did spend a summer by myself on a farm reading Gothic novels, pretty much like the hero of *The Ceremonies* does. God knows you need time on your hands to get through them, but they have their own old-fashioned pleasures. And, as in the novel, I found myself rather beleaguered

by certain things associated with night in the country. I'm some-
body who goes to a cabin in the woods and stays by the fireside
instead of venturing out. [That's somewhat less true today. For the
past 22 years I've been spending my weekends upstate, in a house
at the end of a dirt road, surrounded by woods—though I do still
spend most of my time indoors.].

JCT: One of the really striking things about the book is that you
demonstrate how just minutes away from downtown New York
City, you can uncover the most primeval kind of wilderness.

TK: [*That, alas, is also less true today—considerably so.*] Just this past
weekend, I was driving in Jersey, and it always amazes me how
beautiful and bucolic and secluded parts of that state can still be.
But as far as my young hero finding a pagan cult out there, well,
that's imaginary—though I suppose it might be nice to think that
such cults *could* exist so close to the city.... And then there are odd
cults *within* the city, even on the Upper West Side of Manhattan.
At any rate, I was playing with the familiar theme of pagan cults
feeding into what became Christianity; I was influenced by some
of the things I was reading at the time.

JCT: Who are these writers, and are they among your heroes?

TK: There's Arthur Machen. Fascinating man, too little known
today. Born in 1863 and died the year I was born, 1947; I feel for-
tunate, at least, for having shared the earth with him for exactly
five months. I would highly recommend a long story of his called
"The White People," a very strange story, mostly told from the
point of view of a teenage girl who has odd experiences of a kind
of ancient pagan magic in the woods near her home. There's an
undercurrent of sexuality to it as well. It's a story that, unlike most,
seems to have been written from *within* the world of the super-
natural rather than from outside it. It has a feeling of authenticity
about it—very powerful. No real plot, just wonderful style, and
very compelling, written in a kind of hypnotic prose. Machen's
best books may very well be his three volumes of autobiography,
but he also wrote a haunting autobiographical novel, *The Hill of
Dreams*. Like its hero, he was born in the Welsh countryside and
journeyed to London as a young man to be a writer. He starved
for a while and was extremely lonely. The novel depicts the con-
trast between cold, unfriendly London and the Welsh hills, where
Roman legions had camped centuries before. It's a very special
book.

JCT: And I have to ask you about other writers you cite frequently in
The Ceremonies, like another Gothic specialist, Charles Maturin.

TK: His *Melmoth the Wanderer* is a massive Gothic novel, rather
intimidating, I think. It's ideal reading if you're going on a long,
leisurely sea voyage! It's the sort of Gothic that has stories within
stories within stories. It takes you all over the world and depicts

incredible atrocities, like those of the Inquisition, all served up on an epic scale.

JCT: And there's Fritz Leiber...

TK: Yes, author of *Our Lady of Darkness* and stories like "Smoke Ghost." He translates Gothic horrors into the modern urban landscape, and does it beautifully. I also admire him because he created the City of Seven-Score Thousand Smokes, Lankhmar. That's where his Fafhrd and Gray Mouser stories take place—a wonderful fantasy city, with aspects of the Baghdad of the Arabian Nights. A perfect setting for tales of swords and sorcery, with its thieves' guild and seedy taverns, wharves, palaces, underground passageways...

JCT: One of the stories in *Dark Gods* really hit the jackpot, didn't it?

TK: Well, "Nadelman's God" won an award at a World Fantasy Convention. It's about someone who makes up a god, but then the god becomes real. I guess I'm intrigued by the by-no-means-new idea that gods don't invent men, it's men that invent gods. As a writer, you have the sense that when you create something, it gets away from you and takes on a life of its own. Look at the Manson gang, how they latched onto *Stranger in a Strange Land* and that Beatles song, somehow twisting inspiration out of them. I remember learning that some weird quasi-religious cult out in the Northwest—possibly, if memory serves, on an island in Puget Sound—was raided by the authorities and that among the books found in the house was *The Ceremonies;* and also that some murderer here in the East, some deranged kid who'd sacrificed a friend in the woods, may also have owned a copy. Yet there's really nothing in the novel that would promote or encourage or inspire such an act; I suspect that what must have appealed to these people was simply the title. Also, of course, "Nadelman" plays on a writer's paranoia about fans. In the story a kind of creepy, slightly maniacal fan fastens onto our hero for his own purposes.

JCT: Catch us up on your writing projects today.

TK: [*In recent years I've written very little, and always as the result of personal arm-twisting or some financial inducement. Writing has never come easy; I'll take advantage of any excuse to avoid it. And I have to admit that, along with slacking off in writing fiction, I read far less of it than I used to, and almost nothing that qualifies as fantasy or horror; like many another middle-aged man, with mortality breathing down my neck, I'd rather read history or science—subjects I somehow managed to skip back in college. Still, I may have a thing or two left to say. God knows I'm still filling notebooks with odd little ideas.*]

The Heroic Age of Fantasy and Science Fiction

Cover of *Unknown* Magazine, Vol. 1, No. 1 (KUCSSF)

[There are] thousands upon thousands of Suns... attended by ten thou-
sand times ten thousand worlds... peopled with myriads of intelligent
beings, formed for endless progression in perfection and felicity.
<div align="right">James Ferguson, Astronomy Explained (1756)</div>

We'll explore the whole solar system! Great cat, what a chance!
<div align="right">E. E. "Doc Smith," The Skylark of Space (1928)</div>

Some of the survivors of the so-called Heroic, or Golden Age of science fiction, detective fiction, and the burgeoning comic book industry are heard in these interviews—Jack Williamson, L. Sprague de Camp, Frederik Pohl, Poul Anderson, Wilson Tucker, Bob "Batman" Kane, Julius Schwartz (see the "Bradbury Chronicles" chapter), John Dickson Carr, and filmmaker Dan Ireland, whose film *The Whole Wide World* evokes the life and work of Robert E. Howard. Their purview embraces the decades spanning the 1920s to the 1950s, which saw a veritable explosion of the classic detective story, "pulp" science fiction and horror magazines, and superhero comics. By the late 1920s science fiction's first magazine, Hugo Gernsback's *Amazing Stories,* and horror fiction's preeminent publication, *Weird Tales,* were specializing in, respectively, the "space operas" of E. E. "Doc" Smith's "Skylark" and "Lensman" series; and H. P. Lovecraft's cosmic horror and Robert E. Howard's swashbuckling "Conan the Barbarian."

Hugo Gernsback(KUCSSF)

While *Weird Tales,* until its demise in 1954, continued to attract the macabre efforts of newcomers like Robert Bloch and Ray Bradbury, *Amazing Stories* and other pulps specialized in a swashbuckling blend of scientific utopias, extraterrestrial contacts, and interplanetary colonization. Weird space aliens swarmed the space ways. As early as 1600 Giordano Bruno had been burned at the stake for his heresies, including the contention that Earth was just one of an infinitude of inhabited worlds. Within a decade of his execution Galileo Galilei, recently

appointed to the chair of mathematics at the University of Padua, claimed in *The Starry Messenger* that the universe might be infinite. Further assertions that these numberless worlds might be populated came a century later when James Ferguson's *Astronomy Explained* (1756) claimed the entire universe was populated with "myriads of intelligent beings" superior to our own. A half century later, peering ever deeper into what he called the "open-ended" universe through his 40-foot telescope, the celebrated astronomer Sir William Herschel openly declared similar convictions, inspiring much of the poetry of John Keats, Percy Shelley, and Samuel Taylor Coleridge.[1]

To be sure, the very term "space opera" continues to be problematic and is disdained by many "serious" SF writers. Coined by Wilson Tucker in 1941 to designate "the hack science-fiction story, a dressed-up western...outworn space-ship yarn," and roundly condemned by 1980s New Wave writers in England, it is characterized, somewhat ironically, by Brian Aldiss, as "heady, escapist stuff, charging on without overmuch regard for logic or literacy, while often throwing off great images, excitements...and a seasoning of screwy ideas."[2] *Star Trek*, *Star Wars*, and the superhero comic book exemplify this basically optimistic attitude, and "space opera" has become a "code term in US marketing circles for best-selling popular SF entertainment."[3]

Safely removed from such rhetorical debate and immune to such harsh criticism (and apparently indifferent to growing evidence that life does not exist in our own solar system), *Astounding Stories* moved to the fore in the mid-1930s with adventure yarns by young writers Jack Williamson and John W. Campbell. Campbell took over *Astounding Stories*, retitled it *Astounding Science Fiction*, and for the next two decades increased the stable of young writers with, among others, L. Sprague de Camp, Isaac Asimov, and Robert A. Heinlein. The First World Science Fiction Convention was held in New York City in 1939, and it brought together the first generation of writers, editors, and illustrators who had grown up with science fiction and fantasy. In 1949–1950 two important rivals to *Astounding* appeared, *The Magazine of Fantasy and Science Fiction* and *Galaxy*.

Science fiction, fantasy, weird fiction, detective fiction—and even space opera—were growing up. The uneasy equipoise between imagination and realism, central to the Gothic narrative (particularly the "locked-room" mystery), was by the 1940s and 1950s beginning to be tipped more toward hard science and folkloric and anthropological research. A particularly interesting example found in these pages is the literary trend of historical fantasy stories introduced by the team of L. Sprague de Camp and Fletcher Pratt and the Norse-related sagas by Poul Anderson, which, while deploying the "virtual history" practices that would be later exploited by the SteamPunk writers—were also solidly grounded in history and folklore. At the same time, foundational themes continued to embrace the traditional Gothic impulses that questioned reality, probed the limitations of knowledge, and investigated the sheer immensity of the cosmos, alternative worlds, and the endlessness of time. Similarly, in the horror and detective fields, led by John Dickson Carr

and Robert Bloch, the hidden and troubled regions of the psyche began to replace haunted attics and graveyards as sites for monstrous evil.

Concurrently during these decades, the comic book industry was gathering steam with the creation of superhero characters in the late 1930s, including Fawcett Comics' Captain Marvel and DC Comics Group's Superman and Batman. Barely into their twenties, artist Bob Kane and agent/editor Julius Schwartz were two of their principal architects. And Christopher Reeve was among many actors who brought Superman and other superheroes to the big screen. Science fiction prophecies of a "superman" by H. G. Wells had held that human evolution would replace muscles with hyperadvanced brainpower Diminutive bodies and enormous skulls, however, seemed a dismal defense against the growing Nazi threat of a Master Race—not to mention any potential interstellar invaders. Thus, the superheroes of the comic books posed more muscular and physically attractive alternatives to their rapidly growing readership of young fans. Superman, Batman, Wonder Woman, and Captain America have been in continuous publication ever since. It is a continuity, declares Henry Jenkins, unmatched in any other aspect of fan culture. In the spirit of optimism typical of space opera, continues Jenkins, and despite "successive waves of revisionism, various stabs at relevance or topicality," the superhero is "always fighting for truth, justice, and the American way," and he or she remains indestructible while the cheap papers of the comic books themselves crumble and we mere mortals must age and die. Thus, he concludes, "Comic books help us to confront those separation anxieties by depicting their protagonists as moving beyond their initial vulnerabilities and gaining some control over their lives after such losses."[4]

Robert E. Howard (drawing by John C. Tibbetts)

Author John Tibbetts with his painting of Schwarzenegger as Conan the Barbarian

Robert E. Howard and the Whole Wide World:
A Commentary by Filmmaker Dan Ireland

> All fled, all done,
> So lift me on the pyre;
> The feast is over
> And the lamps expire
> > Last lines by Robert E. Howard
> > before his suicide, 11 June 1936

The Whole Wide World (1996) was a stunning directorial debut by Dan Ireland, a former film producer and promoter (founder of the Seattle

Film Festival). It did not pretend to be a biopic of the legendary Robert E. Howard (1906–1936), the famed sword-and-sorcery creator of "Conan the Barbarian," Solomon Kane, Kull, Bran Mak Morn, and many other swashbuckling adventurers in the 1920s and 1930s for *Weird Tales* magazine; rather, it simply presented an "impression" of him, based on a 1986 memoir, *One Who Walked Alone*, by Novalyn Price Ellis, a woman who knew him in Cross Plains, Texas, in the mid-1930s. It's a quirky love story, with exactly one passionate clinch, one hesitant peck on the cheek, a lot of conversation, and more than a few personality conflicts. It's a "romance that never was," the kind of story we all know; the kind of memory we never forget.

Despite his eminence for the loyal readers of *Weird Tales* and his privileged position as a frequent correspondent with other *WT* contributors, including H. P. Lovecraft, August Derleth, and E. Hoffmann Price, Howard was to have no book publication until 1937, a year after his suicide; and no major collection of his stories until the Arkham House publication in 1946 of *Skull-Face and Others*. Since then, however, the Howard boom has been ongoing, led by pastiches by Poul Anderson, L. Sprague de Camp, and many publications from Gnome Press and Donald Grant. Two biographies have appeared, and they are discussed in the interview that follows, Glenn Lord's *The Last Celt* (1976) and L. Sprague de Camp's *Dark Valley Destiny* (1983). His was a life full of promise, yet tragically cut short by his death. "His loss at the age of thirty is a tragedy of the first magnitude," eulogized H. P. Lovecraft in 1936, "and a blow from which fantasy fiction will not soon recover" (quoted in *The Last Celt*, 70). According to the interview with L. Sprague de Camp elsewhere in these pages, Howard was "the man who brought heroic fantasy to America...all modern historical fantasy derives from his Conan stories." Novalyn Price met Howard when she had come to Cross Plains to care for a relative. As aspiring writer for romance magazines, she was fascinated by the burly, charismatic, but troubled professional writer of lurid pulp tales, Howard. As it turns out, she read very little of his work—his lurid, sexually charged adventures were not her thing—but she did fall in love with him. Was he in love with her? Probably. But their friendship was so full of verbal sparring—she the conventional observer of life around her, he the maverick chronicler of worlds beyond; she the vulnerable woman in need of love, he the stubborn individualist who feared commitments—that somehow a real romance never blossomed. But their relationship, or series of confrontations, have forever haunted her. She waited until her mid-seventies to write her book.

They parted when she left town to study at LSU.

In a fit of grief over the impending death of his terminally ill mother, Howard shot himself in 1936. He was just 30 years old. Five years before, he had written presciently to Farnsworth Wright, the editor of *Weird Tales*: "Pounding out a living at the writing game is no snap—but the average man's life is no snap, whatever he does....Every now and then one of us finds the going too hard and blows his brains out, but it's all in the game, I reckon" (quoted in *The Last Celt*, 38).

The *Whole Wide World* is disarmingly simple. The cast is pared down to a bare handful of characters. The story consists of several extended conversations as Howard and Price drive about the West Texas hills, visit each other's homes, and watch movies. The style is functional, the cinematography glowing and pristine. Nothing is allowed to interfere with the faces and words of these two unlikely lovers. Vincent D'Onofrio's Howard is a big galoot, a volatile, but shambling figure in white shirt and trousers a bit too short who waves his arms a lot and shouts out the words while hunched over the Underwood typewriter. He walks in a loose-limbed gait, his body rolling like a sailor treading the deck of a ship. When he's telling his tales to Novalyn (Renee Zellweger), his hunched shoulders outlined in the headlamps of his car, he's alive and vital; but when he's locked inside his private obsessions, his love for his mother, his scorn of the townies, his morbid views of humanity, his need for solitude, he implodes into torment and violence. Each is alone in his and her respective worlds, and each finds a fierce ally in the other. Ultimately they survive a series of tests that threaten them, her disapproval of his dress, his jealousy over her dating another man, and so on.

Each sees the world differently, which is brought out in several key scenes. When, ever the realist, she argues she's never seen in Cross Plains any of the voluptuous women and barbaric he-men of his stories, he quietly replies, "But I have." At another time, he asks her: "Suppose you were a beautiful, lonely girl and you came out to enjoy the sunset, and you saw a handsome Indian brave. What you'd do about him is the yarn you'd write." She replies: "I'd just wash off his warpaint, get him a good suit, and ask him to accompany me to Sunday School."

Hans Zimmer's music beautifully limns the rolling hills and silvery streams in gentle melodic contours. And there are some nice moments when Howard's swashbuckling stories come alive on the soundtrack, as when Novalyn opens one of his books and we hear the shouts and sounds of swordplay.

The Whole Wide World glows in the memory, just as Novalyn's moments with Howard remained with her, defiant of age and loss. Even when it veers toward awkward sentimentality at the end—after reading a telegram about Howard's death, a weeping Novalyn returns to Texas in a dusty bus, where she is counseled by an elderly woman ("Aren't you glad you knew him?")—it recovers itself and flattens you with its unabashed emotions. And that's even a greater achievement than anything accomplished by the brawny Conan.

This interview transpired on 15 January 1997 in Kansas City, Missouri, when Dan Ireland was on the road promoting *The Whole Wide World*.

Interview

JOHN C. TIBBETTS: Dan, do viewers of your film need to know in advance anything about Robert E. Howard?

DAN IRELAND: No. In fact, that was the approach that I wanted to take, because, to be truthful, I knew nothing about Robert E. Howard myself until a friend brought me Novelyn Price Ellis's book, *One Who Walked Alone*. And the next five years was a journey of discovery.

JT: And you met her…

DI: I met her several times, yes. She's quite an incredible woman. I mean it was really, I think, the time that I met her that I was completely compelled, and I knew I had to make this film.

JT: And hers is the story of the romance that fuels your movie.

DI: Yes, absolutely.

JT: What is it she says about this man, Robert E. Howard, and her relationship with him?

DI: What she actually said to me was quite different from what I got from her book. I think sometimes you have to read material and meet people. Mrs. Ellis still is in the delusion that she never loved Robert, which is quite extraordinary. Every time I would interview her—and I have her on tape—over the last five years, every time we'd get near the end and I'd ask a personal question, her eyes would well up with tears. Her husband just passed away about a year ago. So I think knowing Howard came at such a tumultuous time in her life; really she was at the crossroads of her life, where she really didn't know whether she was going to be a writer or a teacher. And I think going into this friendship and meeting this guy, she was completely enamored with him. It started off to be her journey into the world of writing, and it completely took a left turn and turned into something quite different. It was a strange kind of romance. I think that probably helped me, as a filmmaker.

JT: Some women viewers have said that they wouldn't have stayed with him. He had such a volatile temper. Did she say anything about why she kept putting up with this?

DI: In that little town of Cross Plains—1,500 people during that period of 1933–1936—he was extraordinary in the sense that I don't think there was anyone else around who had the intelligence, the humor that this man had. She always found him enormously, engagingly funny. She'll tell you that first off. He would perform for her. I think that we always put up with a lot of things in our lives with people. Everything goes on a scale, and I think when the scale finally tips one way or the other, you have to make a decision whether you want to be associated with this person or not. But this man profoundly affected her. I think emotionally that we never really have any control over who would find and completely love. This film I think is really about the head versus the heart all the time, and I think the answer is somewhere in the middle there.

JT: When did Howard start creating the character, Conan the Barbarian?

DI: I think it was around 1929. He was...let's see, he was probably around 24.

JT: I think the sense of small town that plays as a backdrop to all this is intriguing. If it's set in New York or somewhere, it's a totally different story. You've done a really nice job of capturing some of these small–town rhythms without trivializing them and without making them so grandiose that it's hard to accept.

DI: I really tried to depopulate this film. I really tried to keep extras out of the frame. You wouldn't believe the hundreds of extras that showed up everywhere. I was constantly just pulling people out of the frame, because I wanted more of just the landscape. Every other character that was in there was in Mrs. Ellis's book. I was afraid, when I showed her the film, that she would think that I didn't do justice to the other characters in her book, but for me it was never about Mammy, or Aunt Narid or Clyde [Smith], or Truett [Vinson]. It was really about Robert and Novelyn. So, in that time when I was in Cross Plains driving around, it is the landscape. If you go back 60 years in time, there was even less of what there is now, and so I really tried to make that the backdrop. Even in the town, where he has the sombrero and so on, there's only a few people on the streets; really there's not that many more there today. I would have shot the film in Cross Plains there, but it's really not very cinematic, and I did this for very little money, in a very short time period, in a 120–degree heat. I had to keep our locations around Austin Texas. We were in a 60–mile radius of Austin.

JT: I'm curious, though. In Cross Plains, is there any kind of reference, monument, plaque, anything regarding Howard?

DI: Yes. His house has been restored by a group called Project Pride. Every year on the anniversary of his death, everyone comes to Cross Plains...Sprague de Camp...

JT: He's the biographer...

DI: Yes, one of the biographers [see the interview with de Camp about his Howard biography (*Dark Valley Destiny*, 1983), elsewhere in these pages]. The other one is Glen Lord, who wrote a book called *The Last Celt* [1976], which is great. It contains lots of autobiographical and miscellaneous pieces, a biobibliography, and a collection of appreciations by his friends and colleagues. It was actually Sprague de Camp's book that fired Mrs. Ellis up to write her story. She was so enraged by Sprague's views on Robert, which placed great emphasis on his troubled emotional life and the unusual attachment between him and his mother, that it really propelled her to write about Robert the man, not Robert the psychotic.

JT: Could you say something about his mother in the film? Was she so domineering? Or did he have just such an unnatural attachment there? And Anne Wedgeworth did such a nice job as the mother.

DI: Well, if I had really cast the film to what Mrs. Ellis would have liked, I would have had Cruella DeVille at 80 years old playing

Mrs. Howard, and I didn't believe that! Because Mrs. Howard really was the catalyst for everything that got in the way of the relationship. I viewed it simply as a story about a mother and a son. Robert really learned about writing and reading from his mother. From when he was a very young lad, I think five or six years old, she would read him stories at night. Her family had crossed the plains as pioneers, and she would always give him these stories. This is where Robert really got interested in writing, and he made no bones about telling Novelyn that too, that it was his mother who always believed in him. But Mrs. Howard would always lay a guilt trip on Robert whenever he would go out with Novelyn. Robert really was the person who administered the medicine to her, even though Doctor Howard, who lived in the house, was the county doctor. He was usually gone everywhere, because he looked after the entire county, and people would come there to the Howard house at midnight. So Robert took on this responsibility of looking after his mother, and Novelyn despised it. She's a very strong–willed woman, Novelyn Price–Ellis, and at that age, she was even feistier. She thought Robert's relationship with his mother was unnatural, but not in the Oedipal sense at all. And I didn't want to portray it like that. I just wanted to put a mother and a son on the frame and leave it up to the audience.

JT: But at the same time, in a scene in which he is caring for her, and changes her garment, and puts a compress to her forehead, that's a very moving sequence. This is a side of Howard we need to know about, whether we call it Oedipal or not.

DI: That's hardly Oedipal, when someone is sitting there almost on the verge of death, with a fever and chills, and they've lost control of themselves. Instead of hiring a nurse, Robert looked after her, because he was devoted. He had the money to hire a nurse; there was no problem. But he took it upon himself that, as his mother dedicated her life to him, he was going to dedicate this to her. It was part of the thing that really took him down.

JT: I was going to ask how fortunate you think it's turned out to be that Renee Zellweger was your actress, and now is, of course, riding a bit of a crest with *Jerry Maguire*.

DI: Well, it's kind of a gift from God, because she really didn't come to the film until about two weeks before I started shooting it. So the rehearsal time that I had, and the background knowledge at the time that she had, was not much to get into this character. So it was like cramming for exams for Renee. I had another actress whom I'd worked with for a year, and she had a little secret from me: she was pregnant. And I thought it would have been fine had it been two months, even three months, because during the course of shooting, she would have ended up being four or five months. But I found out she was closer to five months, and once I visited Austin, and found the heat intensity to be that of a furnace,

I thought "It's going to kill her, it's going to kill the baby, and there's no way I'm going to have that on my conscience—and it's gonna kill the film." And then when her agent started calling me, telling me she could only work five hours a day, that was it; I kind of had to draw the line.

JT: Tell us about the wonderful music score by Hans Zimmer.

DI: Well, first off, I knew that I had to create a world, to get into this guy's head. There are two ways of doing that. You can flash back to a fantasy, or you can incorporate a fantasy. I had 24 days to shoot this film. Someone said to me, "Did you shoot it during magic hour?" and I said, "No, we shot it during *rush hour!*" And it was just "go, go, go." And if I didn't make the day, I didn't get the shot, and that was it, "next." I produced a film called *Paper House*, and Hans did the score, and it eventually got him *Rain Man*, and it kind of took Hans from the United Kingdom to the United States. So we've just stayed friends, and I think he's simply brilliant. I gave him the script five years ago and said, "Please, please, please," because he's so amazing. He did this film for, like, nothing. He got a million dollars for *The Lion King*, and deservedly so; I mean, he's really quite staggeringly brilliant. But he couldn't put all of his time into it, so he gave me Harry [Gregson-Williams]. And Harry is...well, he's like Bernard Herrmann. I mean, you can hear it in the score, toward the end, near the cabin, and also when Mrs. Howard lost control of herself. Listen to that music, it's so early Bernard Herrmann. Hans would come in, and he'd listen to it, redirect it, add cues, and so it's really a compilation of both guys. But what you're talking about is the voices that we used in *Crimson Tide*. It was a German choir, and they were not recorded exactly for *Crimson Tide*. Hans had all these chorales from these German singers.

JT: We're talking about sequences in which Howard's stories come to life audibly. There's a scene where Zellweger opens the book and is starting to read, and instead we hear the sounds of a battle.

DI: That's Harry, actually. That was Harry's little creation. He played it for me one day.

JT: It's kind of like a mini radio drama.

DI: I was always thinking of clanging swords, but Harry said, "Let me add something to that." I didn't know if it would work; I thought it might be too cute. So he phoned me up and said, "Dan, Dan, come down; I want you to see this." So I went down, and I saw that, and I was blown away by it.

JT: It works.

DI: But it's when she's walking around, and he's bellowing out his story, the first time she goes over there. There's a choir that's there, and it's really not obvious. But I've used it as a metaphor to get into his head.

JT: Your reputation is mostly as a producer, so I was curious to know what drove you behind the camera. Was this something you always

had a passion for, or was this project just particularly something you wanted to handle yourself?

DI: It's kind of a complex answer. Somebody gave me a T–shirt once, when I was at the Seattle Film Festival, which I cofounded and ran for the first 12 years, and it said, "But What I Really Want to Do Is Direct." And I thought about it, and it stayed there. Then, when I did my first film as a producer—it was John Huston's last film, *The Dead* [1987]—I thought, "If I ever make a film, I want to do something that touches me like this." It was so resonant, and alive, and emotional; and it was about something, about people. To try and get that movie made at Vestron—they thought it was a "tea party" movie, and they kept referring to it as "Ireland's Tea Party Movie"—to get *The Dead* made, I had to do things like *Midnight Crossing, Waxwork, The Unholy*, some really horrendous films, and the last horrendous film I did was Ken Russell's *Whore* [1991] with Theresa Russell. It didn't start off to be like that; no film does, hopefully, but it went there. And I thought, "If I ever do another film again, as a producer, as a director, I want to take control of my life, my vision." That really was it; I had done enough bad movies, and enough good movies to know the difference. I wanted my voice to speak. When *One Who Walked Alone* came my way, it came from one of the lead actors of *Whore*, so without *Whore*, I wouldn't be sitting here, which is really amazing.

JT: Well, Ken Russell is Ken Russell, regardless...

DI: Oh, I love Ken...

JT: *Lair of the White Worm* [1988] is a good one too.

DI: I'm very proud of *Lair of the White Worm*. That was something we did to get *The Rainbow* [1989] made, and it turned out to be better than *The Rainbow*.

JT: Dan, are you hearing from the sword-and-sorcery fringe out there? Not necessarily the Sprague de Camp bunch, but the fringe out there who are probably waiting for you in hordes, either to attack you or idolize you because of this movie. I mean the purists out there, the ones who really know all the sword-and-sorcery stuff. Are they on your doorstep?

DI: You know, that was my biggest fear. Anytime you take on the life of someone who has millions of fans, you're setting yourself up to take a bullet, like my friend Bernard Rose did when he made *Immortal Beloved* [1994] about Beethoven. Whether you like or despise it, Bernard was gutsy enough to make it. With *One Who Walked Alone* and *The Whole Wide World*, I wanted to stick purely to Mrs. Ellis's point of view of the man, and also my own interpretation. I read Sprague de Camp's book; I read Glenn Lord's *The Last Celt*, and I read a lot of Howard's work. I became an avid fan. I hope that I infused his character with so much love, because I really love the guy. I went to his grave at midnight about four years ago and asked him his permission to make this film. So I did

this film, not only from my respect and admiration for Mrs. Ellis, but also out of my enormous, profound respect and adoration of Robert E. Howard. James van Hise, the critic for *Cinefantastique*, phoned me up after he saw the film, and took me out, and we went out and talked and talked. He saw that I was pure about it, and he raved about the film in *Cinefantastique*. That's who I wanted to please more than anybody: the Howard fans, to have them think that I did this guy justice. I don't think Sprague did (sorry, Sprague!). I think too much of the psychoanalyzing was all speculative. I got to know somebody who actually *knew* the man!

JT: I guess her letters haven't been quoted or dealt with in existing scholarship, eh?

DI: Yes, the real letters that they wrote back and forth, out of respect for Mrs. Ellis. But I edited a lot of them. They were pulverizing, especially after Howard found out that his friend Truett and Novelyn were seeing each other. Howard was so amazing with words, and he could cut to the bone. He really hurt this woman so powerfully. Those letters were amazing. I still have copies of them, but I made a promise that I would never, ever use them.

JT: But, the quotations we hear from them…

DI: Those are the real words; I just edited them, when he was debasing her character and really taking her to task for betraying him.

JT: It's a profoundly moving moment when we see Howard's last poem, unfinished, still in the Underwood typewriter. Was that really his?

DI: Absolutely. Those were his last words: "All fled, all done, / So lift me to the pyre. / The feast is over, / The lamps expire"—

JT: There's no period at the end of the last sentence, either.

DI: There isn't, which is amazing. And usually, he would put his name— always put his name—at the end of something. I actually saw a copy of that. If you notice the "r" in the font, I kept the font exactly like Howard's font. I found a typewriter, I had my props people work on it so I could get the "r" up. And at the end, if you look at the credits closely, you'll see that the credits all have that "r" up.

JT: What did Vincent D'Onofrio have to work with? Are there any films, audio recordings, anything of Howard that exist?

DI: Nothing. Nothing at all. All we had was a lot of photographs and a lot of letters that Robert wrote to Novelyn. They were profound. When I put the film together, I had cut it to three hours. And the complexity of his character was far darker and deeper in the three–hour version. I found that when I started showing it to people, they started hating him. And a lot of people thought he was a racist because of the purity of race stuff; you know, how Howard always wrote about the purity of race and how a mongrel race was inferior. There was a beautiful sequence in the film—and it rips my heart out to have taken it out—when Robert has gone to the restroom, and Novelyn is sitting there talking to a friend.

Bob looks over and sees them, and now it's about jealousy, and he's such a volatile character. So later he says, "Who was that?" And she says, "A friend." And he basically gets out of her that this guy is the son of a white doctor and a black woman. And he says, "That wasn't a mulatto, was it?" And Novelyn says, "Yes, Bob, it was." And boom, they get into it right there. He goes right into the rhetoric about the purity of race, and she's just hitting him back. It's such a beautiful scene, but every time I showed it, people would get very politically correct.

JT: You mentioned you cut it on film because it was in Scope. I loved the use of the wide screen, but why did you elect to do it like that?

DI: All of the things that were on this film, I had to compromise in so many ways. With my initial budget, I got exactly what I dreamed of getting, but the one thing they tried to cut out was my shooting it in CinemaScope. I said, "No Scope, no movie." Because it was the landscape that really dictated who these people were, and the time period of the mid-1930s. I could never have made this film as intense or as powerful otherwise. And I knew that when I wanted to get close–ups, I wanted to get right into their faces. Without the Scope aspect ratio, it's really hard. I know video is always where this film is going to be seen more, but I don't give a damn. I didn't make this film for video; I made it to be shown in theaters. If the biggest audience is on TV or video, so be it. I got to make it this way, and the people who got to see it this way: that's who I made it for.

JT: Was there a time when you and Ellis actually watched the film together?

DI: Yes there was. That was the most emotional moment of my life, I think.

JT: Where and when?

DI: In LaFayette, Louisiana, where she lives. I flew there in August. I took the print, and I rented the biggest theater that I could find. She's 89 years old [she died in 1999]; she had not seen a film in 45 years. The last one she had seen I think was *Now, Voyager*, and she can still hum the theme to it.

JT: But she truly had not seen a film...?

DI: I promise you.

JT: Hadn't even seen the *Conan* movies [beginning with John Milius' *Conan the Barbarian* [1982]?

DI: Oh, no. She never even read his stuff. She did, she read one of the Conan stories, "The Devil in Iron" [1934] and said, "That's not for me." So we showed her the film, and during the kiss it was so funny. I was sitting about five rows in front of her, and I was looking just to see her reaction, and she turned her head to the left and to the right to see if anyone was looking at her, and then she did it again and then looked up at the screen. You could just feel that awkward look come over her face. Her husband passed away

a year ago, and she's been a little bit more open about confessing the fact that there was possibly a relationship between the two of them, but she could never stop telling me how much she never loved Robert. And the more she told me, the more I didn't believe her; and the more she told me, the more I put it into the film. It was the truth. Read the book; you read between the lines. If you're that profoundly affected, that it takes you 44 years to write, and the subject you write about is this person—she's closeting the fact of how much she cared about this guy. Before I showed her the film, I had to be very sensitive and prepare her for it. Her short–term memory is not very good right now. We could get her on the phone right now, and say, "Hi, Mrs. Ellis, it's Dan." And she'd go, "Oh, Hi Dan, how are you?" And I'd say, "How did you like the film?" "What film, Dan? Was there a film of my book?" I mean, seriously. But her long–term memory about Robert is as sharp as a hawk. So I needed to see at the end of the film the immediate, emotional reaction, and I got it. I got it big time.

JT: How was she at the end of the film? Did she say anything to you?

DI: Mike [Scott Myers] and Ben [Mouton]—my coproducers— and her pupils, and the screenwriter and one of the stars of the film...they all ran out of the theater and hid. They were afraid. They'd been taught at school by her. Her son had seen it twice and said, "Well, I think Mama's gonna like it." I walked down, and I looked at her, and there are these big brown eyes glaring at me. I looked at her and said, "Am I in trouble?" And she looked at me and went, "Yes. Plenty." And I knew that she liked it at that point, because her eyes were all watery, and I just threw my arms around her. I was just holding this little woman who had given me this great story. I think I was a bigger baby than she was at that point; I think she had to calm me down.

JT: Was she introduced to the audience?

DI: There wasn't an audience; it was her friends. I couldn't do that to her; she wouldn't have survived. She's so completely shy. Every time I tell her about the reviews, she'll say, "Why would anybody want to see a film about Robert and me?"

DI: There was so much that just came, that just happened on the day. For example, in the sequence with the kiss, when they're up on the cliff, she says to Robert, "Tell me about that novel." He says, "It's set in Texas; it'll be about the pioneers." She leans in and kisses him, and for a moment their prison doors swing open, and they are themselves. They come together for that moment. Then you see the intensity grow, and he pulls back. When he pulls back, on the screen—you can't see it on video—there's the river right between them in the background. When I looked through the frame, I went, "Oh, my God!" [laughs] "This is gonna look like I planned it!" I found that location 10 hours before we shot it. I had something completely different in mind. So, things like that kept happening.

JT: Now, D'Onofrio is coproducer. What does that mean?

DI: He sure is. That means that I was blessed. I never could have made this movie without him, as an actor and as a producer. When the bond company showed up because I was half a day behind—I mean, give me a break—he phoned up Donald Cushner and said, "Donald, I'm not feeling very well today. I think I might have heat exhaustion. I might be sick for a while, Donald, unless, perhaps your people get the fuck out of here and leave my director alone so he can direct me. You're bothering him, and by bothering him, you're bothering me. Get them off the set now." They're both boys from New York, so they understood that language. Those guys were gone within half an hour. So that was part of it. He paid for the Greyhound bus at the end out of his pocket, because these guys would not go a penny above $1.35 million. He paid for the musicians, so that we could have real musicians on the score. The countless contributions by Vincent were just staggering.

JT: Is this the first time he's coproduced, or produced?

DI: Yeah, but it's not gonna be the last. I'll have him on anything I do. He protects me. [laughs] I love him. Believe me, as an artist, you could not hope for a better actor.

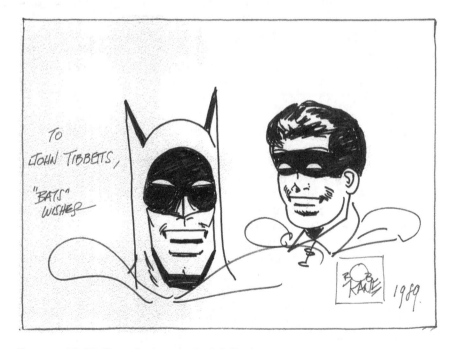

Batman and Robin (drawn for the author by Bob Kane)

"Batman and Me": Bob Kane By John C. Tibbetts

Robert Kahn (1915–1998) was in his early twenties when he created the DC Comics superhero Batman. The Caped Crusader, of course, has gained everlasting fame, and Kahn, who quickly changed his name to Bob Kane, fairly basked in the notoriety ever since. Batman debuted in *Detective Comics* #27 (May 1939). Kane was quickly joined by other young artists, notably Jerry Robinson, who added additional characters, elaborated the costumes, and envisioned new exploits.[5] In later years, Kane enjoyed a postcomics career in television animation and exhibited his paintings in art galleries.

This interview transpired in North Hollywood at the Registry Hotel on 14 June 1989. The occasion was the release of Warner Bros. *Batman*, directed by Tim Burton and starring Michael Keaton.[6] Kane had just written his autobiography, *Batman and Me* (a second volume was published in 1996).

Interview

JOHN C. TIBBETTS: Okay, to begin with, is it "Bob" or "Robert" Kane?

BOB KANE: In the beginning it was Robert. For the first Batman comics I wanted some dignity at the time, so I called myself Robert. Now, the only ones who call me Robert are my ex-wives! When they need a lot of money they say, Robert, or when they're angry at me! Otherwise, it's generally Bob.

JCT: We're here in Hollywood right on the heels of the release from Warner Bros. of *Batman*, starring Michael Keaton and, of course, Jack Nicholson as the Joker. I take it you have not yet seen the film.

BK: Ironically no, because actually the powers that be at Warner Bros. want me to see it in 70 mm, which is the theatrical release for the screen, and so far the press and part of the public have seen it in 35 mm, and it wasn't quite the finished version. So I can understand that. It's like having a blind date and you walk in an hour early and the woman doesn't have her full make up on. And she says, "Boy but you oughta see me an hour later when I have my makeup on, I'm really beautiful!" So I understand the reason.

JCT: Take us back to 1938–1939. You were in your early twenties?

BK: In 1938 I was 18 years old (I just knocked off 7 years conveniently)! That was a year after *Superman* was created, in 1938. I have been with the same comic book outfit now for the last 50 years, DC Comics Group. See I can't really stay at one job, that's my problem. But anyway, I was having a drink with the editor Vincent Sullivan at the time and he said, can you come up with another superduper character, because we're looking for one. So I said, how much do [Jerry] Siegel and [Joe] Shuster make—Siegal

and Shuster were, of course, the creators of Superman [who first appeared in DC's *Action Comics* in June 1938]. And they were making about $800 a piece, which is like $1600 a week. And I was doing fill-in cartoons for DC Comics and I was making only about $25 or $30 a week. I said, "Listen if I can make $1500 a week I could draw anything!" So believe it, it was on a Friday; I said by Monday you'll have a new superhero. That's the truth.

JCT: I suppose the idea of a caped crusader, as we've come to know him, doesn't just come overnight. There must have been some things in your youth, some models or precedents, that you were able to draw upon.

BK: Actually I think we're all influenced by other influences in our lives. And then what you do, you interject a lot of your own individuality into anything you might see. The thing is we all see the same things at the same time, but yet interpret them in our own individual way. I saw when I was 12 or 13 a book of inventions by Leonardo Da Vinci. And, as you know, he was the forerunner to most of the inventions that we have today. He foresaw the first man in flight, a helicopter, a machine gun, steam engines. One did really catch my attention at the time, and that was a man on a sled with large bat wings. It was the first glider in flight, actually, 500 years ago. And Da Vinci had a quote that I recall, the quote was "your bird shall have no other model than that of a bat." So, looking at these large wings and reading the quote, it kind of germinated a Bat Man in my mind. But I wasn't ready to create Batman yet, and I just put it away in an old trunk and I went to the movies. At the movies I saw *The Mark of Zorro* with Douglas Fairbanks, Sr., who was my idol as a child, a kid growing up in New York, in the Bronx actually. Zorro was the most swashbuckling dare devil I've ever seen in my life. He out-acrobated Batman a thousand times, but he gave me the idea of the dual identity, the type of thing you find in all those old Gothic horror stories. During the day, he posed as a foppish bored Don Diego Vega, the son of one of the wealthiest families in Mexico around 1820. But they were under the domination of the Conquistador government at that time, and they robbed the poor and levied the high taxes and really caused all kinds of terrible injustices against the poor people. And Don Diego happened to be very altruistic, and he decided to become a crime fighter. So at night he donned this mask, kind of a handkerchief mask with slits in the eyes; and he'd attach a trusty sword to his side and he'd exit from a cave on a black horse. I think the black horse's name was Tornado. And actually there you can see the reference where many years later to the idea of a bat cave and the bat mobile, instead of the horse. That had a profound influence on me, on the dual identity. There are other dual identities, like the Scarlet Pimpernel, but I got mine mainly from Zorro.

JCT: This is in the spring 1939?

BK: May 1939 was the first issue of *Batman*. There's one more influence, and that was the movie called *The Bat Whispers*, a famous movie from a story by Mary Roberts Rinehart, the mystery writer. And Chester Morris played the part of the villain. He wore a bat head, it looked like a bat and he had kind of bat wings. So all throughout the movie you would see shadows of this bat on the walls. And at one time there was a circle with a bat in it, which was a reflection on the walls of the house. And, of course, I got that idea for a bat signal so many years later. So that was another influence on me. Those were my three influences. Now, many people have seen what I saw, but they didn't create Batman, did they?

JCT: Some of the developments in the character occurred rather gradually; for example, at first, there's no bat mobile, there's no cave.

BK: I was very naive, actually. Let me add another influence, which could have been the comic book character of The Phantom, 1934. He was a crime fighter in Africa. He kind of wore a gray uniform, a Union suit with a mask, and I kind of got a little bit of that. The first cover of Batman in 1939 had just kind of a gray figure with a cowl and he had stiff bat wings that were kind of attached to the back of his arms, on his arms. The reason I came to revise that a bit was, I realized that when he would fight, they were too cumbersome. So I made a cape with scalloped wings and so forth. So it did progress as I went on the first several months, and I started to make a lot of changes on the character in each successive strip. If you've seen other comics characters from the beginning, including Blondie, the first incarnations were very different and crude from the time you develop them into the more mature form. So actually, Batman started to mature very quickly, just a year later. The drawings were better, the bat wings flowed better, so forth.

JCT: Talk about your technique. Did you work first in pen-and-ink, did you work on an easel or drawing board?

BK: At the beginning, I always had a drawing board. When I was a kid and I was too poor to afford a drawing board, I had a bread board. I took my mother's bread board and just took it out from the shelf and leaned it against the table. But when I became affluent at $35 a week in the early days, before Batman, I bought a drawing easel. So I always had a drawing easel, and I remember black Higgins ink was the drawing ink that all the famous cartoonists used. My dad—god bless him—he used to work for *The Daily News* in New York as a printer, and as a printer he came in contact with a lot of *Daily News* cartoonists. And when I was very young he used to bring my drawings down and showed it to many of them, like the creator of Popeye, E. C. Segar, and they all said, gee your son has a lot of talent. And when he brought the drawings down I would emulate Popeye or Moon Mullins, so it would look almost as good as the originals. They said, my

goodness, maybe we can use him someday as a ghost artist. It gave me the confidence that I had a lot of ability even as a kid. I was a great copycat.

JCT: What about the various action poses, did you work from your imagination, did you study anatomy, did you have photographs to work from?

BK: As I just said I was a great copy cat. All I did was copy Flash Gordon figures all over the place. Every neophyte cartoonist at the innovative days of the comic book industry, we all used what we called the morgue swipes. And we would swipe like crazy. And the two most famous artists we'd swipe from were Milt Caniff, who did Terry and the Pirates and later developed Steve Canyon. Alex Raymond was probably the greatest illustrator that ever lived, other than Prince Valiant, which was drawn by Hal Foster. But we did swipe a lot at the beginning and I didn't use photographs. I never wanted to make Batman too illustrative, I wanted him more like Dick Tracy. The Penguin is very cartoony and the Joker's rather cartoony. So I always kept a little bit of the Dick Tracy flavor in my comic strip.

JCT: How soon did it become apparent that the Batman character was going to survive past that one story?

BK: Well, it sold rather well. It was only six pages, in *Detective Comics*. But it had a pretty good reception. Then on the second book, it started selling very well. Actually it sold even better when I introduced Robin. The reason for that was, adding a Boy Wonder into the comics was a great touch of genius, because I visualized that every child in their own imagination and wish fulfillment thinking what it would like to tag alongside of a super hero. So when I interjected Robin into the script, the book sold 100%. That was a year later and they came out at *Detective Comics* and that was the start of Batman and Robin. I drew consistently from 1939 to 1966. I drew him with the help of assistants, but I did all the penciling on Batman for the stories I did. They had ghost writers on other stories. I didn't ink it after a while and I did mostly pencils. Finally, I was bored and I was tired of it. And when the TV show came out I decided, well I'll rest on my residuals, just quit actively drawing a comic book.

JCT: The image of Batman changed a lot over those years, didn't it?

BK: I kept Batman dark and moody and brooding, mysterioso; but when Robin entered it, everything became a bit lighter, because he had such a colorful outfit. And today with the advent of the new *Batman* motion picture in 1989—at least from some of the reviews and some of the critiques I've read about the movie—is that the influences were back to Bob Kane's original lone, dark vigilante style. So it's now gone a complete circle back to whence it came. In the mid-1960s they had a TV show, as you all know.

It was real campy, but that was great for the era, it was the era of pop art.

JCT: Batman came to the movies a lot earlier than that.

BK: Sure, in 1943 Columbia Pictures made a serial in Hollywood. I went out to Hollywood at that time just to visit the set. It was a cheapie and I was on the set standing in front of a gray convertible and I naively asked the director, "Well where's the Batmobile?" He said, "Batmobile! You're standing in front of it!" I said, "What do you mean?" He said, "This gray convertible is the bat mobile!" And I said, "I don't believe it. I know it's a low budget, but this is ridiculous. I'll tell you what though, why don't you just get a black limousine and put a fin on it and you'll have a bat mobile. Forget about the masthead. You don't have to put that on the front!"

JCT: You had some involvement in the television series?

BK: Unfortunately, at that time I did not. You see I wasn't in Hollywood then. And Bill Dozier produced it without me being a creative consultant on the film. And I should have been here to stake my claim, but I didn't. I stayed in New York. In fact when I did come out to Hollywood again, the series was just cancelled. There's nothing as dead as yesterday's cancelled series. So no, I was a little disappointed that I didn't put a stake into my claim at that time. But anyway, this year, in 1989, has made up for it. They were supposed to start *Batman* many times in the last nine years, but we didn't have the right ingredients. We needed the right script, the right director, and the right actor. When we had a script we didn't have the director, when we had a director we didn't have the script. We never had the right actor. Finally, we finally had all the ingredients a year and a half ago and a new script by a new young writer. It was written in the vein as if I had written it, dark, dramatic, and moody and mysterioso. And Robin was not in it. They had him in the first draft at the very end. But I think the reason they left him out is partly because they didn't want to camp it up at all. And plus because we didn't have time to create the origin of Robin again, because we have the origin of Batman in this movie and the Joker and we just didn't have time to establish another origin.

JCT: Did you need any convincing about Michael Keaton as the title role?

BK: Well, candidly I had my reservations when they first mentioned Michael Keaton, because I didn't think he would fit the Batman mold.

JCT: Did you base that on yourself?

BK: If I showed you early photographs, I was very handsome in a mold of young Bruce Wayne. Now, I had a young Robert Wagner in mind. Michael Keaton was the antithesis. He was rather slight— he's gotten a little heavier lately—but he certainly didn't fit the

mold of Batman. He's like Pee-Wee Herman, in a way. I'm not knocking him, because all's well that ends well. Warner Bros. suggested I see a movie Michael just did called *Clean and Sober*, where he played a drug addict. He won awards, critics' acclaim for being a marvelous dramatic actor. So that was the first time I started to think of him seriously. But the mold still wasn't there, but as Tim Burton explained to me, this time around he was not looking to do a comic book character. He was not looking to do the Adam West version of the 1960s. This was not a story "about a chin," as Tim Burton says, but about a three-dimensional, tortured Bruce Wayne, who because of the trauma he experienced as a child when his mother and dad were shot down before his eyes that he became an obsessive-compulsive human being. So when I saw Keaton's performance in *Clean and Sober*, I saw that edge. Then, of course, there was the uniform. They built practically an armored uniform that even Pee-Wee Herman would look great in!

JCT: Tell me what life is like for you these days. Is the phone ringing off the hook?

BK: Well you know Hollywood, when you're hot, you're hot and when you're cold you're very cold out here. This year Batman is big again. Every 20 minutes it rings. *20/20* called, I'm on that. *Entertainment Tonight*. I'll be going on the *Johnny Carson Show* and *David Letterman*. Every newspaper in the world, the Associated Press has taken my story worldwide. It's just been unbelievable the attention I'm getting at the moment. In 1966 Batmania hit the world when the TV show came on the air; even though it was campy comedy, it certainly took the country by storm and the people rediscovered Batman and the kids discovered it for the first time. But this year the hype has been like a rolling stone, a snowball rolling down a hill and it just seemed to get bigger every day. I attribute that to a couple of things. I think basically most people have mundane lives and they would like to escape from their world of boredom by becoming a superhero or a famous baseball player. It's also nostalgic throwback to their youth. And the fact that Batman is kind of like a Jesus almost, where he's fighting all the injustice in the world for the people by putting himself on the line where he can be killed at any moment when he's out there fighting the criminal element. So I think he's fighting for the little man and the little man appreciates that. It's a world of fantasy and everyone would like to escape and have a bat mobile and escape into a bat cave and just live a world of fantasy, do daring deeds, meet beautiful women, and so forth.

You know, I was supposed to have a small part in the new movie, a vignette as Bob the cartoonist in the newsroom. But I got the flu, and by the time they shot the scenes I never got to play Bob the cartoonist.

JCT: At least in the film there's a scene where we see a drawing signed with your name.

BK: Well, yeah and that's also misleading now. People who see that will think the actor who played it is "Bob Kane." Tim Burton called me and said he needed a drawing of Batman. So I drew it and signed it and mailed it to Pinewood Studios, London. So, in a way, I am in the picture! Hopefully I can go on many more years doing my oils and paintings. And there'll be a sequel and I'll be creative consultant on the sequel. I'll write the bible for it, which is the blueprint for the script, which I did on the last movie. Maybe in the sequel I'll play Bruce Wayne's father. Who knows? And now I'll close with saying, thank you Leonardo, where ever you are!

John Dickson Carr (courtesy of Douglas Greene)

"The Man Who Explained Miracles":
John Dickson Carr

By giving the commonplace a heightened meaning, the ordinary a mysterious appearance, the known the dignity of the unknown, the finite an infinite aura, I thus romanticize them.

Novalis

Consider the bizarre circumstances of the crime scene: The victim is found, beheaded, inside a sealed and guarded chamber. Witnesses swear he had been alone in the room. In another, equally baffling case, a man is struck down by a bow and arrow from inside an empty, locked room. And how about the man who is strangled in the middle of a clay-based tennis court that is unmarked by footprints? Or the woman who disappears from a moving carriage that has been under constant observation?

These were all classic mystery novels by John Dickson Carr (1906–1977), one of the greatest practitioners of the so-called locked room school of detective fiction—respectively, *It Walks by Night* (1930), *The Judas Window* (1938), *The Problem of the Wire Cage* (1939), and *Papa La-Bas* (1968). Carr has been dubbed by Robert Adey in his definitive study of the genre, *Locked Room Murders* (1991), "the foremost exponent of the impossible-crime novel."[7]

This tradition is deeply rooted in the Gothic novels of Ann Radcliffe in England (*The Mysteries of Udolpho*, 1794), E. T. A. Hoffmann ("Mademoiselle de Scuderi," 1821) in Germany; Charles Brockden Brown (*Wieland*, 1798) and Edgar Allan Poe ("The Mystery in the Rue Morgue," 1841) in America. In the last 50 years Randall Garrett, Isaac Asimov, and China Mieville have relocated their locked room puzzles and detective mysteries into deep space and fantastic lands, where detectives are also wizards or robots and crimes are locked away in spaceships.[8]

Radcliffe's *The Mysteries of Udolpho* was typical in that it related the desperate attempts of a young woman, Emily St. Aubert, to survive the deaths of her mother and father and the depredations of the evil Montoni, who, with his henchmen, conspire to confront her with bleeding nuns, ghostly visitations, shrieks in the night, haunted paintings, and decaying corpses inside locked rooms. Yet—and here resided the secret of Radcliffe's success—Emily ultimately was provided with natural explanations for the bizarre and inexplicable events with the aid of trap doors, sliding panels, secret passages, wax figures, ventriloquism, and ingenious sleights of hand. Terrors and nightmares were dissected in the cold, rational light of day and, to the relief of anxious readers, they evaporated away.[9] In other words, Radcliffe held that *ghosts of our own making* haunt us—something Gothic novels always recognized, although not all of them had the rational explanations that Radcliffe offered. She has become a favorite study for current feminist studies of the Gothic. Donna Heiland, for example, in her *Gothic & Gender*, writes that Radcliffe's rational explanations offered women strategies and encouragement for resisting the patriarchal social oppressions of women.[10]

However, aside from gender considerations, this is a dangerous game she and her literary progeny were playing with the reader. As E. T. A. Hoffmann noted in his novel, *Kater Murr* (1822), the magician/artist risks disappointing his audience when he explains his illusions: "A terrible fright pleases a man more than the natural explanation of what

seems to be ghostlike. He is not at all satisfied with this world, but insists on seeing things from other worlds which do not manifest themselves physically."[11] Indeed, Radcliffe's successors know that ghosts and witches are not to be so easily banished; consequently, a counter school featuring the exploits of "occult detectives" sprang up late in the nineteenth century, featuring supernatural confrontations by sleuths such as Le Fanu's Dr. Hesselius, Hodgson's John Carnacki, and Algernon Blackwood's John Silence.[12]

Meanwhile, the "miracle crime" challenge was that the rational solution *must match in ingenuity and imagination* the seeming impossibility of the mystery at hand. The Gothic balance of the rational and irrational—a position E. T. A. Hoffmann described as *Besonnenheit* (presence of mind in the face of emotional disorder)—should exist between the howling chaos of the mystery and the ordered logic of the solution. In brief, another modern master of the impossible crime, G. K. Chesterton, insisted that the explanation behind apparent miracles has to be *worthy* of those miracles: "It is useless for a thing to be unexpected if it was not worth expecting.... The climax must not be only the bursting of a bubble but rather the breaking of a dawn."[13]

There must be rules, of course, to the locked-room problem. Even if Ann Radcliffe didn't always follow them, John Dickson Carr insisted on them. In one of the greatest classics of the genre, *The Three Coffins* (1935), Carr lays down the law. Speaking through the voice of his most famous detective Gideon Fell (who in bulk and wizardly paradox was himself modeled after Chesterton), Carr scornfully dismisses the standard cheap-shot solutions like secret panels and secret passageways. The rooms or chambers or arenas of foul play must indeed be sealed or rendered in some way inviolable. The author (and, by implication, the murderer) must utilize sheer ingenuity to dispatch his victim. Strategies include (1) an accident or a suicide made to look like murder; (2) the use of a mechanical device already planted in the room; (3) an action of illusion and legerdemain; (4) the machinations of someone outside the room who contrived to make the act appear to have been committed inside the room; etc. (he especially condemns the use of chimneys!).

The irony, of course, is that by the time we've sailed through a Carr mystery, we're *all too ready to believe in supernatural, even extraterrestrial forces* as the only possible explanation of the horrors. Certainly *real evil* and sadism seems to reside in the villains, no matter if their machinations turn out to be material ones.

In nearly 50 years of writing detective novels, historical melodramas, short stories, and radio dramas, Carr remained faithful to his credo, consistently wreaking ingenious variations on these basic tenets, spinning out from his loom a luridly delicious filigree of dizzying complexity. "Ingenuity lifts the thing up," wrote Carr; "it is triumphant; it blazes, like a diabolical lightning flash."[14] Sometimes, admittedly, Carr's ingenuity tests our comprehension. Indeed, Dr. Fell's unravelling of the

byzantine secrets behind the two murders in *The Three Coffins* is so staggeringly complex that it demands several readings to make it all out. Carr defended such extravagances: "Since apparently [the author/criminal] has violated the laws of nature for our entertainment," Dr. Fell/Carr says, "then heaven knows he is entitled to violate the laws of Probable Behavior!"

Greene, a professor of history at Old Dominion University, is an internationally recognized, award-winning authority on the history of the detective story and, in particular, John Dickson Carr. In addition to his Edgar-nominated *John Dickson Carr: The Man Who Explained Miracles* (New York: Otto Penzler Books, 1995), he has edited many volumes of Carr's stories and radio dramas, including *The Door to Doom* (1980), *Fell and Foul Play* (1991), and *Merrivale, March and Murder* (1991).

The following interview with Carr's biographer, Douglas G. Greene, was conducted on 3–4 August 1994 from his home in Norfolk, VA. At the time, Douglas was putting the finishing touches on his Carr biography. Professor Greene is still teaching and presiding over his Crippen & Landru publishing company, specializing in classic detective stories.

Interview

JOHN C. TIBBETTS: How can we possibly explain our fascination with the whole "locked room" school of Gothic fiction?

DOUGLAS GREENE: Let me answer it obliquely and tell you why I think Carr liked miracle crimes. I think he liked them primarily because he never was quite certain in his own mind if the universe was rational or chaotic. He introduced elements that suggested that no, the pit is open, there is no rationality, the Dionysian element rules. Carr really feared that, I think. So his way of working that through was to have his detectives act almost as exorcists, bidding the demons to go back, affirming, yes the world is rational, yes the world makes sense. I don't know myself if I have that kind of fear of the universe. Maybe. To me, it's the atmosphere, the historicity, the ingenuity, I like about Carr. He was the most ingenious detective story writer of all. We want to be fooled and Carr fooled us almost every time. He never used the same solution more than once. He particularly loved the device of the false solution followed by the true one. He loved to do that, successive solutions. And when you've read the other things, like the radio plays, you wonder—how many different ideas could he come up with?

JCT: As a historian, you must be particularly interested in Carr's connections with the Gothic novel of the late eighteenth and early nineteenth centuries.

DG: The Poe influence is overwhelming in John's early books, like the stories about his first great detective, Bencolin. When I was working on this biography, I tried to find direct connections between Carr and Ann Radcliffe, who wrote about all kinds of horrors with rational explanations. But it wasn't until later in his life in the late 1930s that he really started reading Gothic novels by her. He was interested in witchcraft and had also read Montague Summers. Summers was a great expert on the Gothic novel. But Carr wasn't influenced by that stuff as a kid as much as by Poe and later Conan Doyle and G. K. Chesterton.

JCT: Indeed, I understand Carr was a voracious reader and something of an amateur historian. How does he stack up in that wise?

DG: He was pretty scrupulous about the historical references in his books—at least with the sources available to him. The card game at the end of *Four False Weapons* [1937], for instance, was indeed played in the court of Louis XIV. My own training as a historian was in Restoration England—which is why I loved *The Murder of Sir Edmund Godfrey* [1937] so much! If he got things wrong it was because of the sources. He loved drama and the sweep and movement of history, of great events and people.

JCT: You've written that one of the most important influences on Carr was G. K. Chesterton.[15] Were they at all similar? Did they ever meet?

DG: Carr never met Chesterton. He did write him to tell him he was basing "Gideon Fell" on him. And when he became a member of the Detection Club in 1936, he was excited because he thought he would meet Chesterton, who was president. But Chesterton died before he could be inducted. Like Chesterton, Carr loved paradoxes and shapes and patterns. He loved color the way Chesterton did. And they both loved childlike things. Chesterton's method was to provide a layer of clues that created a shape, or pattern, which you misidentified or saw from the wrong angle. As soon as you saw the correct shape, that explained everything. The other thing Chesterton tended to do was to give clues in a metaphysical way—like the faceless, robot-like aspect of people that tended to make them "invisible," like in the Father Brown story of that name. I agree that Chesterton wasn't in the business of providing much in the way of physical clues, but he does play fair with the reader in that Father Brown never has evidence that the reader doesn't have. Other than things like that, Carr and Chesterton were quite different. Chesterton was very metaphysical, Carr was not at all. He had no real religious beliefs.

Chesterton was basically liberal in his politics; Carr was basically conservative.

JCT: Also like Chesterton, Carr has a very exotic—sometimes fantastic—view of the world, doesn't he?

DG: John saw the world as it should be, as he wanted it to be. He thought it should be romantic, full of adventure. From his earliest high school writing, he yearned for that kind of world. He hated realistic writing. He didn't think the purpose of literature was to describe things the way they are—he said in college he didn't want "the thump of the janitor's mop." He didn't like people like Sinclair Lewis and Dostoevski. And that's what he objected to in the "hard-boiled" detective stuff. He agreed, oddly enough, with Raymond Chandler—although they hated each other—about the so-called mean streets. However, for Carr, although the world might be full of mean streets, he just didn't want to write about them! You ought to write about something more romantic and adventurous. That's one of the reasons why in the early works you see an American visitor to France or Germany looking for adventure. The opening pages of *Hag's Nook* show this. Indeed, that's one of the reasons Carr lived in England. In later days, that's one of the reasons why he went into historical novels. He just didn't like the world after World War II.

He consciously felt himself a storyteller in the grand tradition. You get the impression as his early books begin of someone standing by a fire drinking a glass of port. Storytime. He sets the stage up. He loved the theater. He did a lot of acting as a boy. He did some writing for the stage, especially radio plays. And there's a lot of theatricality in his books. When he was a member of the Mystery Writers of America, he wrote two pastiches of Sherlock Holmes and acted in them (the ones I collected in *The Door to Doom*). He loved to be a ham. Lillian de la Torre, who died this year, gave me all kinds of stories about that. He was a self-dramatizer. He loved telling wild stories about himself, especially when he was in his cups. You could never tell if they were true or false. He claimed to his wife Clarice that he had been born in Paris, where his father was an ambassador. It was only when she met John's father several years later that she learned it wasn't true at all! But it was a better story than the truth!

JCT: When did you first encounter Carr's stories?

DG: I'm turning 50 this year [1994], so it's time for retrospection right now. When I was growing up in Florida, on an island called Pass-a-Grille near St. Petersburg, I read the Oz books by L. Frank Baum (oddly enough, there were some mystery bits in them, which strongly influenced Carr and Ellery Queen and Tony Boucher) and the Hardy Boys and Nancy Drew books. Then

there was Sherlock Holmes in Junior High. I then came across Ellery Queen's anthology, *101 Years Entertainment* [1941], which collected the best stories written up to 1941. That got me into other writers, like Agatha Christie. It wasn't until I was a senior in high school before I was introduced to Carr's books. I read everything I could find while I was at the University of South Florida in 1962–1966.

Death Watch was the first one I read. It's not one of the best, but the atmosphere is good. Then I read all the Gideon Fell and Henry Merrivales. What I liked about Carr was that he did all types of things I love—the atmosphere, the witches and ghosts and supernatural apparatus, the sense of history (I'm an historian)— and all the lore about famous magicians of the past that he would thrown in. And the way he would bring in physical objects from the past, like the Tarot playing cards in *The Eight of Swords* [1934], the snuffbox from *The Emperor's Snuff Box*, and the watches from *Death Watch* [1935]. That goes on and on throughout his books. He had this wonderfully colorful writing style. The Fell books tended to be very atmospheric, and the Merrivale books were comic.

JCT: So, when did you first think you could write about him?

DG: I still remember the joy I first had reading him. I remember the excitement when I wrote to Joan Kahn some time ago, the mystery editor at Harper and Row, asking her if she was going to publish any of his uncollected material. She wrote back and said there wasn't any. I wrote back with a list of uncollected material. We made an agreement that I could edit them. That was exciting to me, to have my name on the same title page. A lot of the impetus for my new biography came through the three anthologies I edited. They gave me the opportunities for many interviews with people who have since passed on. And they introduced me to the Carr family. Mrs. Carr had described herself as a recluse, but she was willing to think of me as a family biographer.

JCT: What kind of guy was Carr?

DG: Unfortunately, I never met him. But I did correspond with him while I was in graduate school at the University of Chicago. It was basically a fan writing to a master. Not quite fawning, but really close! He was living in Greenville and not very well. Like most everybody, he was a mixture of a lot of traits. He was very kind, very generous (to a fault), never cared much about money per se (he would lose royalty checks), and very courtly in manner. He was a private person in some ways and didn't reveal much about himself. When he did his biography of Doyle, he quite consciously declared it was not to be a

psychoanalysis, which he disliked. He married Clarice Cleaves, in 1932. They met on shipboard two years before. He had taken his profits from *It Walks by Night* [1930] and gone to Paris for the summer. He was returning to America via London. It was love at first sight—like with many of his characters. They moved to England in 1933. There were three daughters, Julia, born in 1933, Bonnie, born in 1940, and Mary, born in 1942. It was a good marriage in many, many ways. He looked upon her at first as some kind of "eternal flapper." And he was this worldly, sophisticated young man. It was only later, after John's drinking and trouble with finances, that it turned out Clarice was much less the party girl; she was the strong one. John really needed her to help run things. He really loved her, despite his affairs. He always was writing. Right up to his death from cancer he was writing. After finishing *The Hungry Goblin* (a bad book) [1972], he was so ill, he could only do the book reviews for *Ellery Queen's Mystery Magazine*. He tried to write a book about Conan Doyle as a detective in the 1890s, but he couldn't do it.

JCT: Any problems gaining the family's trust and cooperation?

DG: They all helped tremendously on the book. Clarice, who died last year, was overwhelmingly gracious and helpful and candid. She had indicated to me, while I was working on *Door to Doom*, my first collection of Carr's little-known writings, that she didn't think a biography ought to be done. I told her I wouldn't write one without her permission. It was later as I realized what an irregular life he had, that I realized why. As she got older, she decided it should be done. She trusted me and was willing to talk in more detail with me than she had with others. I don't think an author ever has had more cooperation from the family. When you're an authorized biographer, you have to take the family into account; and I tried to do that. But you also have to be honest.

To date there's been only one critical study.[16] Most of his books, however, remain in print. As far as television and the movies, his work has not been adapted as frequently as say, Agatha Christie, Ellery Queen, and some of the others. In the 1950s Boris Karloff portrayed one of his characters, Colonel March of Scotland Yard, for British television—about half of the 26 episodes were from the stories. Carr's kind of thing is very difficult for that type of adaptation, though. You can see from the "impossible crime" episodes of other TV series like *Banacek* and *Black Magic*, it's clear that too much time has to be expended in recounting the solutions, which are often complex and difficult to visualize.

JCT: Where do you go to find Carr's papers and notes?

DG: Carr never kept papers! He kept destroying stuff as he moved. That made it very hard on me. He had a good agent who kept some copies of contracts. But Carr was no businessman, and he tended to make his own deals without realizing he had to go through his own agent. There is no repository, no archives, no Carr papers anywhere. Recently, when I was at a Bouchercon in London, Tony Medawar, a mystery scholar who did the introduction to my forthcoming Carr book, *Speak of the Devil* [1994], heard Julian Symons talking about the Detection Club. He responded to a question about Carr by referring to the "Carr Archives." Tony and I dashed up and asked him what he knew about any such archives. Symonds just looked at us and said, "Oh, ask Douglas Greene—he knows!"

Only the typescripts for his last two or three novels survive. He threw the others out. Carr knew perfectly well from his work on the Doyle biography how important it was to keep papers. But once a book was written, he moved on to the next one; and he never even had a good collection of his own books.

Writing my book was not a question of writing about somebody like Dorothy Sayers, who kept all her papers. (Fortunately, she kept letters from Carr, which helped quite a bit.) The major sources included the Hamish Hamilton Company, the British publisher who published books under Carr's own name. They had material going back to 1935. Very generously, they copied everything for me. Another good source was the papers from his wartime years with the BBC. They have a wonderful archive. I was able to get a complete collection of his radio scripts.

JCT: What have you learned about his method of writing such complicated puzzles?

DG: John once said he couldn't change anything in a book once it was finished without changing everything else. Every part was dependent on the other. He really constructed a ladder of clues, a whole series of things—which meant that only one explanation was possible. When you're writing a classical detective novel, you're telling a surface story, what the viewpoint characters are seeing; but there's the second story underneath—what the criminal is doing, what led up to the time, what the criminal is doing to protect himself. That has to be there, but the author cannot reveal too much of it. When the final revelation occurs, everything has to make sense—all the little gestures, all the clues must tie together. It's extremely difficult. I don't think anyone has come close to Carr in the ability to handle all that construction business.[17]

The funny thing is, he never took notes. He never outlined a book. He worked it out all in his head, chapter by chapter. Everything was there. He had the most amazing brain. In his early days he could sit down and write a book in about three weeks. It would come out almost letter perfect. Later after his stroke, he tried to dictate a book, but he couldn't. He really needed to see the words appearing.

JCT: I hope you didn't think you would get out of here without talking about your favorite Carr books...?

DG: From the 1930s, I like best *The Burning Court* [1937]. That's the one where Carr *almost* gives you an "out" about the possibility of a supernatural solution to the crime. That's all I'll say about *that*! Of the Dr. Fells I guess I like best *The Crooked Hinge* [1938] and *Hag's Nook* [1933]. Of the Merrivale's, there's *The Judas Window* [1938]—that trick would actually work, you know—Carr tried it! From the 1940s, Carr tended to concentrate his style more. He tended to drop observer characters and make his heroes more concerned with the fate of the mystery. Here the Merrivales are *He Wouldn't Kill Patience* [1944]. Of the Dr. Fells, there is *He Who Whispers* [1946]. Of the historical novels, I think the first two are wonderful, *The Devil in Velvet* [1951] and *The Bride of Newgate* [1950]. *Fear Is the Same* [1956] may be better than all of them.

JCT: I understand you're planning on establishing your own imprint for publishing "locked-room" mysteries...?

DG: Well, Carr one time said that Dr. Fell's books were published by a firm called Crippen & Wainewright. Now Crippen, of course, was a murderer earlier in the century, and Wainewright was a nineteenth-century poisoner. When I decided to start a small press of my own, I decided to make it "Crippen & Landru." Landru was a little better known than Wainewright. He was a French Bluebeard from the World War One period. There are no specialist mystery publishers in the general sense. The Mysterious Press, which Otto Penzler founded, was a specialist publisher; but it became commercial, and it's not a specialty press anymore. Unlike science fiction and fantasy, which have many specialty presses, there are hardly any in the mystery field. My idea is to collect either unpublished works, or reprint uncollected short stories by important mystery writers. The first one is *Speak of the Devil*, an impossible crime mystery that Carr wrote for the BBC. It's absolutely wonderful, about the ghostly manifestations of a woman hanged earlier for murder. The time period is around 1815. Our hero insists he sees her, but everybody else says she's been hanged.

Christopher Reeve with "Superman" poster (photo by the author)

Note: For more information about Greene's publishing imprint, Crippen & Landru, write to CRIPPEN & LANDRU, PUBLISHERS / P. O. Box 9315 / Norfolk VA 23505-9315. www.crippenlandru.com.)

"Superman Is a Friend": Christopher Reeve

In 1979 Christopher Reeve (1952–2004) inherited the cape of Superman from Kirk Alyn and George Reeves. The New York stage-trained actor, who had studied at Juilliard under John Houseman and appeared in *Love*

of Life on television, took on the role in Richard Donner's *Superman: The Movie*. He appeared in three sequels and a number of other, unrelated pictures, including Sidney Lumet's *Death Trap* (1982). Tragically, he became a quadriplegic in 1995 after being thrown from a horse. The Christopher and Dana Reeve Foundation is dedicated to curing spinal cord injury by funding innovative research, and improving the quality of life for people living with paralysis through grants, information, and advocacy.

The following is a brief excerpt from an interview that transpired in Washington, D. C., 23 June 1987 on the occasion of the release of Warner Bros. *Superman IV: The Quest for Peace*. The day before the interview, I spent the afternoon with Reeve, costar Margot Kidder ("Lois Lane"), and Jack Larson ("Jimmy Olsen" from the 1950s television series) at the Smithsonian Institute, where the exhibit "Fifty Years of Superman" was being installed.[18]

Interview

JOHN C. TIBBETTS: Chris, watching you and Margot Kidder yesterday at the Smithsonian was very special.

CHRISTOPHER REEVE: I don't think it ever occurred to either one of us that we were worthy of being in the Smithsonian Institute! We were standing there, watching some of the video clips from the first film, nine years before, and remembering how difficult it was shooting our flying sequence over New York City. I hadn't looked at it in a long time. I remembered being in the harnesses, the lower back pain, the heat, the seven weeks that it took. Margot and I are very close, but at that time, I don't think she thought the whole thing was going to work. There she was, an established actor with film credits from here to there, probably saying to herself, "I'm hanging on with hydraulics with an unknown actor from New York! What am I doing?" I used to have that "What am I doing?" thing from Margot. She told me she had never seen any of the other shows or comics. Of course, I was really gung-ho. I was thinking, "The temperature is six degrees Celsius, and the wind's from the south at ten knots, and we're flying over the Brooklyn Bridge"—my flying training, I guess. Hey, I'm there! And now it's a part of history.

JCT: Any differences in the technology used in your flying sequences now, as opposed to 9 or 10 years ago?

CR: For some reason, the producers of the first three pictures wouldn't sell the sophisticated equipment to the producers of Cannon. They might have been holding out for too much money. So the new equipment we used was primitive by comparison. Instead of the smooth flying moves we had been used to, a couple

of times, Margot and I were strapped into these body molds at the end of a long pole, and instead of a computer, there were these two guys pumping us up and down, up and down—and all the time, we're supposed to be exchanging loving glances...

JCT: At least Lois also had a chance to fly solo!

CR: Well, in a way. I'm supposed to be so strong that I can kind of propel her off into space, and her airspeed allows her to fly on her own. Margot told me she wasn't sure what her "glide ratio" was. I figure it might have been 12-to-1. That's a big step for her! If you look at the history of Lois, you see that in the 1950s, she seemed to embody the suburban dream of the white picket fence and supper in the oven for her husband—but then you cut to her in the 1970s, and you see somebody who is ambitious about her career, who's living on her own; and the idea of a mortgage and all of that is anathema to her.

JCT: I understand that your portrayal is affecting the course of the DC Comics character.

CR: Yes, I guess that's right. They told me a while ago that the way they're now writing him is based on how I'm playing him in the movies. I feel really validated by that.

JCT: Let's assume that sometime in the future, when a new kid takes on the role, you will give him some advice. What will it be?— some warnings, some hindsight...?

CR: The first thing I would say is, don't lose the humanity of it. Remember that the basic ingredient of the character is that he's a friend. He's not a one-man vigilante committee who uses violence as a primary tool. That's the value of most importance to me, not that Superman is a muscle man but that he is a friend, a really good neighbor. This country was founded on the idea of a good neighbor, of walking five miles to lend your neighbor something he needs. We're in this high-tech, nightmarish urban landscape, where people are feeling isolated and alone and not knowing their neighbor; and they're afraid of other people in the street. Life is very overwhelming. And the idea of a friend who is there when you need him is the key to the whole character.

JCT: But it's a friend who has absolute power but is not corrupted absolutely. This is unique to the character. And maybe it's an imperative for the actor not to be corrupted by *playing* such a character.

CR: Well, remember in *Superman III*, there were dark moments with Superman, where he turns evil for a while. The secretaries around the production were saying, "Whoo! Now we're talkin'! Enough of this Boy Scout stuff!" Funny you would ask that, because just recently in *Street Smart*, I did play a morally corrupt character. I made a decision a long time ago that I would never put a value judgment on the people I play. But back to your question...No,

I've never felt such a sense of power coming to *me*, personally. You have to forget that he can fly and has all the muscles and all that—it's the *qualities* that he exhibits that people can identify with. He's really a gentleman. And to put that into big-screen entertainment is, I suppose, an antidote to the "Rambo" style of action pieces we see so much of today. Rambo doesn't think a lot before he opens fire, because he's playing out our revenge fantasies. I wouldn't play somebody like that, because there's not a *character* there. There's not a human being in any of those movies. Rambo is more of a comic book character than Superman is! Superman is a real part, a real human being, ironically enough. We offer an alternative to that, a nonviolent movie about a superhero who admits sometimes that he has doubts, that he doesn't know what to do sometimes.

Christopher Reeve and Margot Kidder at the Smithsonian's "50 Years of Superman" (photo by the author)

JCT: Tell me how you came to write the story yourself.
CR: I don't have screenplay credit, I have story credit. I did the big brushstrokes, and the writers filled them in. I had been disappointed in *Superman III*. I just didn't think it was a very good movie. I showed up and did everything I could and then walked away.

Actors really live in the moment, you know? Anyway, some time ago, I narrated a documentary and did wraparound interviews for a program that some children had made, called *A Message to Our Parents* for WBZ-television. It's a film made by 12 year olds about their fears of growing up in a nuclear age. That's what sparked my idea to have a child in the movie come to Superman with a risk to disarm the nuclear missiles. We wrote this around the time of the Reagan–Gorbachev meeting in Geneva in 1985.

JCT: It's interesting to see Superman taking on this global responsibility, even though his father had warned him *not* to interfere with human destiny.

CR: That's the whole dilemma. Eventually, you've got to throw away the handbook. At what point do you play by the rules, and at what point do you answer the needs of the people around you—a question we all can easily understand. Superman feels he's living on Planet Earth, and that he's not an alien anymore. But really, Superman is not really *crusading* for an antinuclear cause. He sums things up at the end when he simply says, "I wish you could see Earth the way I see it, because when you really look at it, it's just one world." He see it from space as this beautiful, fragile marble that should be cherished and taken care of. If that message goes in a light-hearted way, we would have accomplished something. He's on patrol and gets a letter from a 12-year old who's been talking it over in class about a summit meeting going on between Russia and the United States. The kid writes that he thinks the world would be better without nuclear weapons, but nobody knows how to get rid of them…why don't you take them away? It's very naïve, sure, but from a 12 year old, it makes perfect sense. So Superman decides he does have a moral responsibility, so he goes and speaks at the United Nations and announces that he's going to remove all nuclear weapons from the Earth. But he's thwarted by Lex Luthor, who is making money off arms dealers.

JCT: Jack Larson was with you at the Smithsonian, and his tie from the Superman television series is now behind glass. Will there be something of yours in this exhibit, something from the films you have kept…?

CR: No one has asked me that yet…[pause] The only memento I've kept from my 10-year history with Superman is the "S" I cut out from the back of the first cape I ever wore. I've been through 50 or 60 Superman costumes for every different angle of flying. But I framed that first one and gave it to my seven-year-old son, Matthew, which is hanging over his bed. If I ask him nicely, maybe he'll part with it. It's not that big a deal with him, you know. His favorite thing that I've done so far is a production of *The Royal Family* at Williamstown two years ago when I won a

sword fight on stage. He came several times every week to see me win the fight, and now he's taking fencing lessons!

Jack Williamson and Frederik Pohl (KUCSSF)

"Wonder's Child": Jack Williamson

The publication in *Amazing Stories* in 1928 of Jack Williamson's first short story, "The Metal Man," launched a career unparalleled in the annals of science fiction and fantasy. From early classics like *The Legion of Space* series (and its offshoot, *The Cometeers*) in the 1930s to his last novel, *The Stonehenge Gate* in 2005 the versatile Williamson (1908–2006) excelled in space opera, dark fantasy, and philosophical allegory. He invested the genre of the Gothic shape-changing werewolf story with modernist elements of quantum physics and psychological subtlety in his classic *Darker Than You Think* (1940; revised in 1948). In another classic, *The Humanoids* (1948; a novel-length sequel to his short story, "With Folded Hands"), a race of robots bring peace to the galaxy by rendering mankind powerless—in the most benevolent possible way. In the mid-1970s he was named a Grand Master of Science Fiction by the Science Fiction Writers of America (only the second person to receive this honor; the first was Robert A. Heinlein). In 1983 he published his autobiography, *Wonder's Child*.

Our interview transpired in Chicago at the O'Hare Marriott on 30 October 1983. Jack Williamson was a Guest of Honor at the World Fantasy Convention.

Interview

JOHN C. TIBBETTS: Jack, I described you as a science fiction writer, but just now. you also added "fantasy" to your description.

JACK WILLIAMSON: I think the distinction exists in the mind of the reader and the writer, and not objectively. I've always felt that science fiction is based on the things that we feel could be true or come true, sometime, somehow, and somewhere; and in fantasy we don't care, we're interested in the characters, the story, the drama, the color, and we don't care if it is some type of dreamland.

Hugo Gernsback founded *Amazing Stories* in 1926 (KUCSSF)

JCT: You've had a very long career. You have seen many fads and fancies come and go. You made your start around the time of the pulps, with *Amazing*?

JW: Yes, Hugo Gernsback's *Amazing Stories*, in 1928, which is getting to be a long, long time ago.

JCT: And then, relatively recently, you wrote a sequel to *The Legion of Space*.

JW: Yes. One that was called *The Queen of the Legion* was published this year.

JCT: So 1928 to 1983. That kind of staying power is unusual, isn't it?

JW: Well, it's nice to be still in the game.

JCT: As times have changed, as you have seen writers come and go and stories come and go—to what do you account your enduring popularity? Are you able to tell a whacking good story? Is the imaginative aspect of your work the strongest? What is the secret here?

JW: Well, I'm not sure I'm doing all that well, but I keep trying! I think, more than anything else I take science fiction seriously. I believe in it as a way of thinking about science and progress and change and what the future will be. And people have asked sometimes why I didn't write something else, but I have a frame of mind, a frame of reference, that fits this type of thing, and whatever I want to write seems to fall into it pretty naturally.

JCT: Let's go back to the time of the pulps, because that was at a time, certainly, when science fiction did not have a critical, or, let's say, legitimate reputation, maybe, behind it. Although, curiously enough, many of the great writers of the nineteenth century in one way or another also dealt with what we would now call science fiction.

JW: In the nineteenth century, science fiction wasn't yet in the ghetto, and people such as H. G. Wells could publish science fiction stories that are still great that were part of the science fiction mainstream. Somehow, early in this century in America, science fiction was mostly published in the pulp magazines, which were aimed at a not-very-literate, not very well-heeled, almost adolescent male audience. And that shaped it, pretty much. This was not true so much in Europe, and I believe that overseas science fiction has always been more respectable than it has been here. I was in Yugoslavia a couple of years ago, and I was impressed that the fans I met were mostly serious professional people, and they regarded science fiction as a legitimate area for the discussion of serious social issues.

JCT: Many writers who have survived that age of the late 1920s into the 1930s talked more about survival, I suppose, than social issues. It was a hard way to make a buck at that time, wasn't it?

JW: It was. You were doing pretty well to get a penny a word for what you wrote. Of course, a penny a word was probably equal to a dime a word now, which—it was worth waiting for but it was also hard work.

JCT: And at that time, what were the ideal publications that you had to crack to know you had made it as a writer?

JW: Well, through most of these years, *Astounding Stories* that finally became *Analog*, was the top magazine. And if you were writing fantasy, why, *Weird Tales* was the leader for many years. *Unknown* for a few years flourished and died, with a different type of science fiction, and *Argosy*, through at least the earlier years, was publishing the most popular writers and paying them somewhat better;

people like A. Merritt and Edgar Rice Burroughs were getting a nickel a word or more.

JCT: You mention those two writers. I wanted to ask you if they were two of the folks who may have influenced you the most at this time.

JW: I think certainly they were. I read some of Burroughs, and I still admire him as an excellent story craftsman and stylist, and Merritt was writing a kind of colorful, half-poetic fantasy that infatuated me completely. My first published works were pretty Merritt-esque.

JCT: For example....?

JW: Well, *The Moon Pool* was Merritt's story that influenced me most. My first story called "The Metal Man," was in many ways rather parallel to a story of Merritt's called *The People of the Pit*, an adventure in a volcanic crater with strange creatures and lots of captures and escapes. The basic situation is the same, though we had different locale, different creatures, and so forth.

JCT: Now these are wonderful models, and yet at some time, I suppose, you realize that you cannot continue to be imitative of them. You cannot let that become a kind of a chain around you, either.

JW: No. Well, at the same time or about the time I started writing, I discovered H. G. Wells' short stories and they, I felt, were, well, more sophisticated, probably more intelligent, more realistic. They depended more on ideas and less on a type of poetic style and fantastic imagination. And I gradually got farther and farther away from Merritt. I worked on several stories and collaborations with a doctor named Miles J. Breuer, who was doing good work at the time, in the late 1920s, and he emphasized the values of character and believability and put less emphasis on wild imagination. He steered me toward better plotting and stronger narratives. We worked together on a couple of novels at that time, *The Girl from Mars* and *The Birth of a New Republic*. The last one was about a revolution on colonies on the moon.

JCT: Origins have been so important to many of the famous fantasy and science fiction writers of our century. And I'm thinking about the New England group, the Minneapolis group, the Chicago group, and the New York Futurians. Where was your center of activity as a youth at this point?

JW: I grew up on a farm in eastern New Mexico, and most of the material I came up with may have been printed in New York or Chicago, but it arrived by U.S. Mail.

JCT: Were you always able to write then using the southwest as your center of activity?

JW: Well, I nearly always lived there, and I don't feel it's any great handicap. I spent a little time in various other places with great rewards, but I always felt that New Mexico was my home. Still is.

JCT: We have to, of course, touch on some of your works that justly
now are considered classics. *The Humanoids* is something that you
will often hear devoted readers refer to as one of the Greats, and
certainly it's a book that made a great impression on me. Is this
one of the books that most of your fans and readers want to talk
to you about?

JW: I suppose so. It's certainly been the most often translated and
reprinted work of mine. *The Humanoids* itself is a sequel to a nov-
elette called *With Folded Hands* that appeared in *Astounding*, that I
feel said the same thing more effectively. John Campbell, editor
of the magazine, wanted a sequel, and I wrote a sequel, which for
various reasons has kind of an ambiguous ending, but ambiguity
is not really *bad,* I think.

JCT: That ending really knocked me out!

JW: Thank you. You know, they are units of a cybernetic brain that
are utterly subservient to mankind—so much so that they remove
the threat of interplanetary war; but in the process, they threaten
mankind with complete mental and physical stagnation. If you
resisted them, they used a drug that reduced you to a kind of
childlike robot.

JCT: They "healed" our sicknesses—

JW: Yes. And in doing so, intended to extend their Prime Directive
to other galaxies. "To serve and obey."

JCT: And it *ends* like that! The book preceded a whole decade of sci-
ence fiction films, like *The Day the Earth Stood Still*, in which we
saw creatures of space, usually metallic beings, devoid of feelings,
devoid of emotions and human concerns. It's almost as if maybe
you had been an influence upon the filmmakers to come.

JW: I don't know. I would like to have had the story made into a
film, and it was optioned—it's been optioned a couple of times—
but it's never gotten to the silver screen.

JCT: That concern with an oncoming mechanization of man is that
something that you have lived long enough to see come to fruition?
How do you feel about the state of things now, in hindsight?

JW: It seems to me also that the humanoids are a kind of metaphor
for society, and as our society becomes mechanized and driven
by technology, society then comes to limit the freedom of the
individual more and more. You find that type of thing in all kinds
of Gothic horror stories by E. T. A. Hoffmann about mechanical
automatons. Yes, the story's about what I think is happening.

JCT: Well, I don't mean to sound pretentious, but I'm wondering
if it's fair to say that the science fiction writer sometimes can be
a kind of a watchdog for oncoming technologies and how they
might or might not affect us.

JW: It seems to me that I've said or thought the same type of thing,
that at least science fiction is a way in which we can discuss

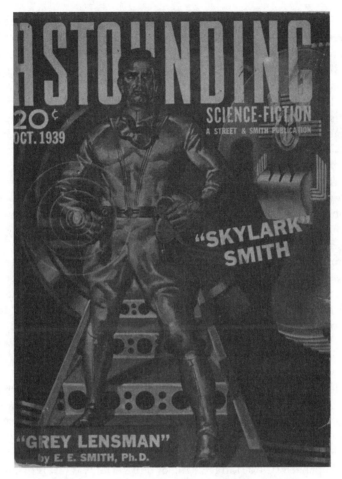

Cover of *Astounding* Magazine celebrating the "space operas" of "Doc" Smith's "Skylark" and "Lensman" (KUCSSF)

and feel the impact of technological change, technological evolution.

JCT: At the same time, your ability to tell a rattling good yarn—we cannot dismiss that. Because to tell a good story has to be one of the most difficult things in the world.

JW: I like a good story, and I've always felt that no matter what you say in a book or a story, why, it's wasted unless people read it. So I have worked hard to make my material readable, to capture the reader and hold the reader.

JCT: I'm thinking of things now like the *Legion of Space* and *Legion of Time* stories, with their unabashed Space Opera with strong stories and colorful characters. And I mean that as a compliment.

JW: Thanks. In my early days I wore the mantle of Space Opera proudly. *The Legion of Space* series has been very popular. I happened by accident to have a good central character for that, "Giles Habibula," a drunken bum that is more or less drawn after Shakespeare's Sir John Falstaff.

JCT: I was going to ask you about Giles Habibula. What is it about this character that has so engaged so many readers over the generations? He wasn't even a major heroic character, but he always stole the show!

JW: Well, in the Roman comedies of Plautus and Terence, there was a stock character of a drunken soldier, and Shakespeare borrowed this stereotype and gave him a wonderful new life as Sir John Falstaff. And I tried to borrow from Shakespeare, and he represents, well, human instincts and weaknesses in a pretty vivid and good way. It was great fun to place him in the middle of the thirtieth century, where he and the Legion battle ferocious aliens. I kept bringing him back, in the *Cometeers* stories. Just this year [1983], he shows up in *The Queen of the Legion*. I don't know how to describe it, but there's something that's still wonderful to me about him. I don't claim any credit for his creation, though.

JCT: When you're working on books like these, do you often *tell* your stories to people; or are they only coming out of your fingers onto paper?

JW: I think it comes out of the fingers on paper. There's a hazard in *telling* the story, because if you tell it, it's expressed and you don't have to write it. So I can think most writers are pretty cautious about at first presenting their material orally. When we were writing for the early pulps, however, it was a little different—the pulp paper was not long-lasting and material was not reprinted. In that way, writing for the pulps was very much like the Homeric bards chanting their narratives. It seemed like just a matter of the moment.

JCT: All writers have had favorite children that maybe went wrong— a book or an idea that just never quite came to fruition, or at least in the way you would have wished. Anything that you'd like to share with us in that regard?

JW: Well, just that this is a painful and disastrous thing, and a good many of my projects over the years have gone off the track, and often for reasons that I wasn't able to diagnose. I've done a good bit of collaboration, most of it with Fred Pohl on our "Undersea" series [1954–1958] and "Starchild" series [1964–1969], and one novel with Jim Gunn, *Star Bridge* [1955]; and many of these things started from projects that I'd undertaken but was unable to finish on my own.

JCT: The very fact that they might develop in unexpected ways, sometimes disastrous ways though, is part of the challenge, the

continuing challenge, of any writer. Life must be tough sometimes when you have to face that day-to-day.

JW: Yes. Especially when you're trying to make a living on a penny a word or less. I always found that what I actually published was written in probably less than half of my working days, and I wasted a lot of time on material that didn't work out well, that either I couldn't finish.

JCT: How about something that you had published in one of the pulps, at least in magazine form, but never got out into hard covers? Anything you would like to have seen come out like that?

JW: Well, I have one paperback novel, *Bright New Universe* [1967], that was just in a nice paperback, and I'd kind of like to see that in hard covers, though it's not a perfect work.

JCT: But why do you think it should be reprinted?

JW: I put a kinda different take on the whole idea of contact with aliens. In the story, there's a white supremacist group that tries to block our efforts to make contact, because it would encourage minority groups to revolt. There's also the fear that contact with advanced aliens might destroy Earth's ancient cultures.

JCT: I see what you mean. Those are the kinds of "heavy" themes that some don't expect from science fiction. A lot of times, you'll hear science fiction writers apologizing, as if they're not doing a legitimate endeavor. Is that a part of it? What is the toughest part?

JW: I'm not sure what the toughest part is. I have always enjoyed writing, and I'm happy to have kept in it, and sometimes it's been tough to make a living at it. There was a period in the—oh, beginning about 1950—when I had a feeling that a lot of new writers were coming in who were smarter and better educated and so forth than I was, and I felt a little bit out of the game, sometimes more than a little bit. I did a comic strip for the *New York Sunday News*, which kind of distracted me from other writing; and when that was done, I got some college degrees and became an English professor for about 20 years.

JCT: It's interesting you bring that up, because I did want to inquire if your own teaching has also kept sharp your writing skills.

JW: Well, I believe that the opportunity to read and talk about a lot of the world's best literature can't have hurt my writing skill. Since I retired from Eastern New Mexico University, I've continued part time to teach Creative Writing and Fantasy and Science Fiction. I've enjoyed studying literature, I enjoyed teaching it, I managed to keep writing when I could during the vacations and holidays, and I was delighted after I retired that I can still write and people will still publish my stories.

JCT: And, of course, your own works are now the subject of many a classroom curriculum around the country and high schools and

universities and I'm curious what you would be hoping, at least, that the instructor would be saying about your work.

JW: Well, I don't know, I wouldn't want to dictate to him.

JCT: Well, this is your chance to go ahead and just do a little wish fulfillment or speculation here. How would you hope that you would be judged eventually? We could put it that way.

JW: [pauses before answering] I'm not really prepared to say that. I'm delighted to be remembered. I have taken my writing seriously, and more and more seriously, I suppose, at least my purposes in writing have probably become more serious and a little more complex. But I've generally written things I've believed in, things that were interesting to me, and I've felt that there is something about science fiction that makes it special—enables us, or gives us a way of talking about technology and what it's going to do to us. Science, I've always said, gives us the hard facts, but fiction gives us a way of feeling about them that the scientific approach doesn't, so it's a way of human feeling about change and progress and technological revolution.

JCT: Jack Williamson, in conclusion, is it possible to also think for a moment and maybe share with us, what's the best science fiction idea, story, or book you ever saw?

JW: It's hard to say. I'm still very fond of H. G. Wells, who I feel is a principal creator of science fiction as we know it, and has done many stories that I still admire tremendously, but if I had to pick *The Time Machine* over *The Island of Dr. Moreau*—

JCT: Yeah.

JW:—it would be pretty difficult.

JCT: And how about projects for the future, anything special on the drawing board?

JW: Well, I've finished an autobiography called *Wonder's Child* that should be published next May by Bluejay Books [1984], and I'm working on a novel called *Life Burst* for Del Rey that will hopefully come out a year from now [1984; revised 2005].

JCT: Would you call yourself a mainstream writer at this point?

JW: Well, I've always been happy to be a science fiction writer. I think that the division between mainstream and science fiction is kind of tending to melt away.

JCT: And, of course, the paperback revolution has aided in that, I believe, too.

JW: I think so.

JCT: Do you think the paperbacks could be compared to the pulps of yesterday?

JW: They've certainly replaced the pulps. That is, the paperbacks, the comic books, and TV between them have done what the pulps used to do.

JCT: And yet if *Amazing* or *Weird Tales* could come back, would you
hurrah! the day?

JW: I suppose so, though they can't come back as they were. I think
that you can't set the clock back.

Poul Anderson (KUCSSF)

Ragnarok and Relativity: Poul Anderson

You could say Poul Anderson (1926–2001) was a creature of Ragnorök
and Relativity. He combined his Danish heritage (he was a student of
medieval Romance and a translator of the Norse sagas) with his knowl-
edge of physics (he graduated from the University of Minnesota with a
degree in physics) to convey, on the one hand, the timelessness of Faerie
in such early works as *Three Hearts and Three Lions* (1953) and *The Broken
Sword* (1954) with a respect for "hard" science in his voyages of inter-
stellar travel in *Tau Zero* (1970) and *The Boat of a Million Years* (1989).
Add a zest for humor (the "Hoka" stories) and swashbuckling action (the
"Flandry of Terra" stories), and you have one of the Golden Age of sci-
ence fiction's most diverse and protean talents. His many honors include
the Grandmaster Award from the Science Fiction Writers of America,
three Nebula Awards and seven Hugo Awards. His commentary on *The
Broken Sword* may stand in for most of his oeuvre: "Whether or not it is
true must be settled by those scientists who argue the reliability of the

annals of faerie and those philosophers who are trying to settle what truth itself may be."

Our interview transpired in Minneapolis, Minnesota, at the World Fantasy Convention on 29 October 1993, where he was Guest of Honor. He had just published *Harvest of Stars*, the sequel to *Boat of a Million Years*. At this particular moment, Mr. Anderson had just concluded readings from his works to an appreciative audience.

Interview

JOHN C. TIBBETTS: We just heard you give a couple of readings, I'm curious, how do you select the things that you read at these things or is there any particular agenda?

POUL ANDERSON: Well, of course, one obvious parameter is simply time. I was looking over some possible stories and some of them were simply too long for the time available, then, of course, appropriateness of theme. In this particular case I felt it should be a fantasy story of some kind and preferably one that would be new to the audience. So since I didn't have any new fantasies I went back to a collection of stuff old enough that probably nobody would have seen it.

JCT: It's no accident you're here in Minneapolis. You were apparently part of a group of young writers who came out of Minnesota back in the day.

PA: Well, Minneapolis was for a long time quite a center for writers, including science fiction writers. Before my time, there was the science fiction fan group, Minneapolis Fantasy Society, which more or less sat at the feet of Clifford Simak. Of course, there were other writers around, Donald Wandrei and others. Then the War came along, and most of the members of the society went off to War. When they came back they were not boys any longer but young men, but they were still interested in science fiction and wanted to reconstitute the society, which they did and that was when I joined. It was more just a group of friends than anything else, but some of us did have such interests.

JCT: How far was that from where we're sitting now, where you were first getting together with these folks and starting to write your stories?

PA: We used to meet either in each other's homes or else in a kind of a low-life downtown bar. There was mainly Gordon Dickson and myself; we were the ones who were really interested in writing. There were one or two others who were interested and would kind of cheer each other on, but those other people eventually went into different lines of work.

JCT: Because of this region, were a fair number of you of Czech, Scandinavian, Norwegian, German heritage?

PA: More or less, but we didn't make a big thing of it usually.

JCT: How about the regional aspect of this interest? Was that an element in your writing as well, or were you just trying to get off the planet?

PA: [*Chuckling*] Well, in those days I was mainly trying to get off the planet! Since then, I find myself increasingly harking back. Gordon Dickson likewise, I think. I consider his book *Wolf and Iron* a very good regional novel by any standard.

JCT: I'm curious now among your own works if you have done something that you also consider a regional work.

PA: Well, to some extent a novel, recently reprinted in paperback, called *There Will Be Time* [1972]. The first several chapters start out in a small Minnesota town, more or less modeled on Northfield, which I think of as my hometown in the 1940s and 1950s. And occasionally in other stories parts of the story might take place in this area as people pass through, or somebody might hail from this area.

JCT: What kind of a young man were you in these days right after the War? What was on your mind?

PA: Well, actually my ambition was to become a scientist. I majored in physics at the University of Minnesota. I thought at most that I might moonlight at writing. But I sold a couple of stories while I was still in college and graduated into a recession where jobs were hard to find, and there was no money left to pursue graduate studies. So being a bachelor who had not had a chance to develop expensive tastes, I thought I would support myself by writing while I looked around for honest employment. And somehow, the search got less and less diligent, and at last, I realized that a writer was after all what nature had cut me out to be.

JCT: But that was a realization that came later. You were not burning to write in the first place.

PA: Not really, except to the extent, of course, that it was something I really liked to do. But I thought of it at that time as more an extremely interesting hobby than as a life work.

JCT: And who were you reading that may have been an influence in those days?

PA: Oh fairly widely. There were the giants of the science fiction's Golden Age at work, of course. But outside of that, I think of various writers who I think became considerable influences on me—not that I pretend to be that good—Homer, the classical Greeks, Icelandic sagas, the King James Bible, Shakespeare; and coming up to more modern times Kipling and Conrad and some of the Scandinavians.

JCT: Having a narrow reading was never part of your agenda. That wide background is always very obvious in your work.

PA: Oh, yeah, it would get awfully boring to read the same thing all the time.

JCT: Let's talk about *Vault of the Ages* [1952]. Was that your very first novel?

PA: It was the first one of mine to see print. It was not the first published novel I ever actually wrote, that was *The Broken Sword*, but it took a long time to find a publisher. Back in that era that was before heroic fantasy had become a genre, nobody quite knew what to do with it.

JCT: And maybe you didn't know what to do with it either.

PA: Well, it circulated and eventually found a publisher. But meanwhile, a couple of other things had appeared.

JCT: I saw a copy of *Vault of the Ages* for $150 downstairs in the Dealers' Hall. I've never read *Vault of the Ages*. What is that all about?

PA: Well, frankly, don't bother. There I was, living hand-to-mouth selling stories to magazines now and then, which weren't paying much, and that particular publisher, Winston, I think it was, was getting up a series of juvenile fiction works, and I got an offer to write one. I was more or less handed the plot. "Would you care to write something about a barbaric post–World War III future where they stumble on a time capsule, and so on? I said, well, all right. But it was frankly a potboiler, and then it got copyedited. I never got a look at the copyedited manuscript, so I frankly don't think much of it myself.

JCT: But that series sure was a lot of fun for kids of my age. My favorites were Richard Marston's *Danger Dinosaurs!* and Donald Wollheim's *The Secret of Saturn's Rings*.

PA: Oh, yes, yes. And by the way, I'm saying nothing against any of the others in the series. There were some books, Chad Oliver, for example, had a very good one [*The Mists of Dawn*]. I'm just saying I don't think highly of my own.

JCT: Let's talk about *The Broken Sword*, a particular favorite of mine. Summarize, if you would, the story of it and then some of the way that you synthesized so many legends into this narrative.

PA: Well, I went back to my readings of the old Icelandic literature. Several motifs come in there, including later medieval fairy tales, like *The Glittering Corpse of Fairy*. I set it in the time of Alfred the Great and its location was the land of Faerie, which is part of the known world but invisible to most humans. Skafloc's sword itself, the accursed broken sword, is both his triumph and ultimately his death. I took that from one of the Icelandic sagas, *Imric the Wise*. As a matter of fact, the great mountain scene in *The Broken Sword* was also adapted from that particular source. It was the kind of fatalism of the pagan Nordic faith.

JCT: Had you read anything quite like that when you wrote this?

PA: No, I think not. I certainly don't recall it. Various children's things, of course. I can't remember the author but there was a very evocative children's book called the *Wee Men of Ballywood* about some Irish fairy folk. And those had some influence. As a matter of fact, if I remember right *The Broken Sword* came out in America the same year as the first volume of Tolkien's *Lord of the Rings* came out in England. Pure coincidence, of course. Neither of us had heard of the other.

JCT: Were you aware when you were first writing this that you were on to something?

PA: It was just a story I wanted to tell.

JCT: Why did you revise it, and when did that happen?

PA: Oh, that happened I forget exactly when, many years afterward. The first version had only a single printing. It really went nowhere, although people who had read it would come up to me and mention it. It had almost a very small cult of its own. So eventually when Ballantine Books was getting up its adult fantasy series, Lin Carter who was running it then approached me. He simply wanted to reprint the novel as it was. But I looked it over and kind of winced at what seemed to me some pretty crudely written sections. I should hope I have learned a good bit about writing since then. I said, Hey look, why don't you let me do it all over again. It's the same story, but I just hope I found somewhat better words.

JCT: There are some writers, if I might suggest, that maybe should be barred from revising their earlier work. Did you have any apprehensions at all?

PA: No, I think that was very much an improvement. It's not something I would propose to do ordinarily, rather than to let my literary sins lie where they fall and go on to something new. This was a rather special case.

JCT: When we were talking about regional books a while ago, I thought you were going to suggest that *Brain Wave* (1954) was one. Because so much of *Brain Wave* takes place in an area like this. And I think it's remarkable that, for a writer so young, there's a very mature insight into your handling of biological and chemical brain functions and the trauma awaiting a human's sudden accelerated intelligence.

PA: Thank you. Nice to hear you say so. Yeah, I think that about that time, I was beginning to hit my stride, acquiring basic techniques and so on. When young people who want to be writers ask me for advice, there's very little I can tell them really. But one thing I say is, if you're going to college fine, major in anything that interests you, especially if it will give you a means to earn a living—except for creative writing. I've seen too many promising talents smothered under that load of theory. However, I won't deny that in my

early stages I would have been the better for some informed crit-
icism and counsel. I had to learn things myself the hard way. So
by the time *Brain Wave* came along I think I was starting to learn
at least some things.

JCT: In fact, our young hero learns quite a lot too!

PA: Yeah. I was, of course, attempting an inherently impossible
job. How do you write about a superhuman intellect like Peter
Corinth's?

JCT: There's that dilemma too in it, about when you achieve a cer-
tain level of knowledge, you detach from your fellows. That's a
very traditional Gothic theme. It's quite a price to pay. I wonder
if science fiction writers ever feel that way? There's something
tragic in that.

PA: Well, I suppose so. There was a psychological study done
many years ago. I think it was back when I was still living here
at Minneapolis. Various writers were asked by mail if they'd be
willing to take it. All right, I was curious. They promised partici-
pants in exchange that you'd get a copy of the report. So I took
part. The finding was that science fiction writers of that time
did have certain specific statistical distinctions at that time. As I
remember, they did tend to be slightly aloof personalities, with
inner directed tendency toward abstract thinking and so on. But I
don't think it was very strong and certainly I've known all kinds
of personality types within the field—and for that matter, intel-
lectual occupations generally—who would not fit in, in the least,
especially nowadays, when the field is so big. There's an awful lot
of people writing it, so, of course, there's bound to be a wide range
of personality types. Actually, most of the people I've met whom I
consider really bright are right out there in the world.

JCT: Do you think that the expansion of our intelligence and sensi-
bilities is as unlimited as you seem to suggest? Is there a correlation
with the expansion of the universe, that is, it's essentially an "open
form," always ongoing?

PA: Anthropologists generally agree the human animal hasn't
changed significantly in 30–40 million years. And for that matter
Neanderthal man apparently wasn't that different from us. So I
think we're basically the same species with the same limitations.

JCT: So a "brain wave" is more your own wishful thinking?

PA: Or just playing with the idea, yes. In other stories I support the
idea of artificially enhancing human intelligence. In a novel called
The Avatar [1978], for example, I looked into the possibility of
direct interfacing between computers and the human brain.

JCT: We have some of that in *The Boat of a Million Years* too.

PA: Yes, this is a very interesting frontier. Of course, things might be
done with genetics, although myself I would be very, very wary
of tinkering with the human genome. And certainly I'd be against

doing anything that would have psychological effects, such as tinkering with brain structure. We're just not wise enough to handle that. It's going to happen anyway. If it's possible, it will be done.

JCT: Maybe we're not wise enough to handle the expansion of our brains.

PA: Just so.

JCT: Every time I tune in to television programs like *Time Jump* and *Quantum Leap*, I think of your "Time Patrol" stories. Time travel permits you to range far afield in ancient and future history. I don't know that I've ever read a series of stories before yours, however, where that theme was taken up so fully as you did in those. Is that fair?

PA: Right off hand I can't think of anything else. I began those 'way back in the mid-1950s, and I still enjoy them. What I set out to do basically was to tell a set of stories that I hope would entertain readers. That's always a fiction writer's first obligation, I think. But entertainment, of course, doesn't have to mean just mindless pastime.

JCT: There's some mind boggling paradoxes in that.

PA: Yeah. Human history is a fragile thing when there is a possibility to alter it with time travel. The Patrol has to guard history against those who would change it. So, policing the time lanes gave rise to a number of different story possibilities. And, of course, what I particularly like about it is showing various historical eras as accurately as I could render them, but through the eyes of essentially a very ordinary mid-twentieth century, Midwestern fellow.

JCT: Manse Everard.

PA. Yes. In other words, take these glamorous looking eras and put them into homely, everyday terms.

JCT: Those were collected recently in a new edition. I think there was a new story as part of it.

PA: Yes, there was. *Star of the Sea* takes Manse back to 70 AD to investigate anomalies in the fabric of history. He's got to save human history from the chaos of paradox. I might still do some more of these Patrol stories!

JCT: When you see programs like I just mentioned on TV do you wince a little bit thinking how that general theme has been taken over by popular media?

PA: I very seldom see science fiction on TV. It seems there are better ways to spend one's time.

JCT: But certainly it has lent itself to the serial episodic format. This week it's Rome, next week it's the Wild West.

PA: Yes, indeed. As a matter of fact, a movie producer has taken out an option on the "Time Patrol" series, but whether anything will actually be made, I don't know. Probably not.

JCT: Is that something you'd be apprehensive and wary of?

PA: Well, when it comes to dealing with Hollywood, the only thing to do is take the money and run.

JCT: Which reminds me, Hollywood would surely love your character of Dominic Flandry. He seems like a spaceways cross between Horatio Hornblower and Simon Templar.

PA: My "Flandry of Terra" stories were a series of more or less swashbuckling adventure stories I did with an interstellar background. I don't believe in galactic empires, you know; the galaxy's simply too big. Most were just stories for entertainment. But there was this background of decadence. To some extent it was a paradigm for the real world and historical incidents. Flandry is in the naval intelligence service of the Terran Empire. He knows it's doomed by its own follies. The best he can hope to do is do whatever little bit he's able to, to keep things going as long as possible.

JCT: A kind of space opera with a bit of a social conscience?

PA: Something like that, yes.

JCT: I miss that kind of stuff in a lot of new books I see. I don't see a lot of humor, a lot of adventure.

PA: Yeah, that's it. I try to supply such elements.

JCT: And speaking of Hollywood, have any of your books been filmed?

PA: No. There is one for which the actual movie rights were recently bought by a German company, of all things, an early book called *The High Crusade*. It's set in the fourteenth century and there's a race of extraterrestrials that land in Britain intending to colonize Earth, but because they've forgotten the arts of hand-to-hand combat, they're defeated. The story goes on from there. I'll be interested to see if they actually make it and if so what they make of it. Then there was going to be a movie of the comic "Hoka" stories by Gordon Dickson and myself.

JCT: Oh, those oversized teddy bears!

PA: But very intelligent... Yes, they look rather like large teddy bears who enthusiastically set out to emulate this or that aspect of human culture, which they only know through books and shows! They're highly adaptable to all aspects of human culture. Anyway, that project got killed in production. That's too bad. They got Robert Bloch to write the script, it must be a terrific script.

JCT: Where is the script?

PA: In some vault somewhere. Our "Hoka" stories came at a very early time for me.

JCT: Those stories are a satirist's dream.

PA: Right. The first collection of these was called *Earthman's Burden* [1957]. Then there's a second collection called *Hoka!* We also did a juvenile novel called *Star Prince Charlie*, with a Hoka character.

JCT: Where does the name come from?

PA: H-O-K-A. We simply made it up. I don't remember if we ever had any specific reason for settling on that.

JCT: To do a series like this with an adult audience in mind strikes me as again being somewhat new to the field, was it not? You would have expected to see this in a juvenile series, but you targeted them for adult readers.

PA: Yeah, we didn't think of it in those terms. We wrote it for anyone of any age who cared to read. There've been humorous stories before in the field, in fact even a series of them. For example, Henry Kuttner did a whole series of—

JCT: The Hogben family!

PA: That, or I was thinking more of his "Gallagher" stories in *Robots Have No Tails* [1952] under the "Lewis Padgett" pseudonym. They were wonderful stories about this scientific genius who was an alcoholic and only functioned when he was drunk. He'd wake up from a toot and found out he'd invented something but he couldn't remember what it was for!

JCT: Do you and Dickson still get together? You don't live in the same places.

PA: Oh, no, I live way out in California these days. He's still here in Minnesota.

JCT: And when you see each other is the last thing on your minds to talk about a book? Is it all just other stuff?

PA: Well, sometimes just swapping gossip and what have you. What are you working on currently? Oh this and that. Then we get onto something else.

JCT: Were these "Hoka" stories when you began to feel that you were really making it as a writer and that this was something that you would do this for the rest of your life? Was there a moment that you began to realize it, or are you still realizing it?

PA: No, it just kind of snuck up on me. Somewhere fairly early on I realized I was basically cut out to be a writer. But sometimes when times got hard I had to get some kind of job just to stay afloat.

JCT: So it didn't always bring in all the bread, the writing. But where were you at that time? Were you still in Minnesota?

PA: As a bachelor I had some odd jobs now and then, some very temporary things. After I got married and the baby came along, the market was in a really bad state at that time. We were broke and in debt, I had to scrap around, so got a job as a very junior grade chemist in a laboratory. That lasted about a year and I'd write evenings and weekends.

JCT: When was that job?

PA: Oh, that must have been about 1956. We were married and had a kid and as my wife puts it, we had to pay off the mortgage on the baby.

JCT: She seems to have quite a remarkable background of varied interests of her own. Was that one of the things that drew you two together?

PA: Oh, yes. I mean besides being beautiful and charming and so forth. Yeah, Karen has brains. We can talk about a lot of things. We're not bored in each other's company. She's published some things of her own and some in direct collaboration with me. She's become what she calls my resident nitpicker. In fact, just before I came here, she went over the first draft of the book I'm currently working on, checking all kinds of facts that I hadn't taken time myself, considering the logic of this and that. Well, hey, this passage, you're not making yourself quite clear here. Hey look, you've got the French grammar all wrong here.

JCT: Most people have to pay a lot of money to have a researcher do that type of thing.

PA: Oh, yeah. As a matter of fact, she's so good at it that our son-in-law, Greg Bear [see the Greg Bear interview elsewhere in these pages], is a writer himself, a very good and very successful one. When he found out what was going on, he asked if he could have the same service. Greg is probably the only man alive who actively invites his mother-in-law's criticism!

JCT: A little bit ago you mentioned Gordon Dickson and the "Hoka" stories. Did the two of you know each other as young folks?

PA: Yes, we met through the Minneapolis Fantasy Society.

JCT: And when did you begin working together, not just as drinking buddies, but collaborators?

PA: Well, we were both writing mostly independent of each other. But from time to time just sitting and talking in the course of conversation we'd get around to batting a story idea and next thing you knew there was a story just needing to be written.

JCT: Is it a question of each of you bringing something different to the task, or do you confirm each others' talents?

PA: Well, I've known a number of collaborations. I've collaborated with other people too and I've known other teams. Collaborations are like marriages, no two are alike. In the case of Gordy and myself, we'd kick the idea around until we knew pretty much what we were going to do. Then he, having the more inventive sense of humor, would quickly do a first draft; and I, being perhaps a little more systematic in my thinking, would do a second draft tying up the loose ends and throwing in any other bits of business that occurred to me. And generally that was it.

JCT: Let's turn to a later work. I've just finished *Boat of a Million Years*, and the sheer scope really stretches your mind! It's nothing less than the whole history of the human race, on Earth and on to the stars. I can scarcely imagine the imaginative power it takes you to conceive such a book. Or did it just grow naturally out of your whole career? It seems to me maybe this book is a kind of synthesis of so many things that you've been working on for such a long time.

PA: Well, to some extent, yes. For anything book length that I do, like that and *The Harvest of Stars*, the writing itself is really only the tail end of the process. I'll be a long time thinking about it, working up background, if necessary calculating whether something ought to go. For example, for the Alpha Centauri system in *Harvest of Stars*, I was consulting people about the orbital stability, orbital mechanics and so on, doing calculations of my own, just how fast would that planetary collision take place and what would it look like. Imagine figuring out, how fast is this thing going to be going and how fast will it seem to grow in your eyes, that type of thing. Trying to get that right, or even such a simple a thing that all too many writers never think about, getting the phase of moon right on a particular day. John W. Campbell used to say nothing happens one at a time. So the future is not going to be determined by any one trend but by an awful lot of them, including many that are unforeseeable that haven't even begun yet, you can only guess at.

JCT: One of the surprises for me in *Boat* was how long it took to get your characters off the planet. You are very careful in laying the groundwork, on all these characters, the Immortals.

PA: Oh, yeah, it was essentially about the Immortals. As a matter of fact the section set in the future was, as I originally wrote it, much shorter. All I wanted to do was really point out the irony of the probable fact that once society had evolved to the point where these people dared reveal themselves, it would be so alien that they'd find it intolerable; and I was going to leave it at that. But the editor asked for more material. So I sent the Immortals off into space. Some readers have said they wished he hadn't; others have said they liked that part best, so.

JCT: But you're squarely against a dilemma that every science fiction writer has to confront, which is how do I talk about interstellar space when nobody lives long enough to make the journey? Heinlein's *Methuselah's Children* has its own way of dealing with it. Your Immortals have another way. Is that almost an insoluble problem?

PA: No, there are various things you can do. Well, the most usual thing, of course, is just to postulate some way of getting around the light speed limit. You talk about hyperspace or warp speed or something, you know, arm waving is what it amounts to.

JCT: It can become jargon if you're not careful.

PA: Yeah. It can be honestly done and there are some stories that simply require a less careful solution.

JCT: "Doc" Smith usually had his own ways around that in his "Skylark" books.

PA: Yeah, I mean if you're going to tell a story at all you have to get your characters onto the scene in a reasonable time and at a

reasonable energy cost. Conceivably, there will be discoveries in physics that will make that possible. And I've assumed it myself often enough. But I find myself increasingly interested in accepting the Einsteinian speed limitation and seeing what you can do within that. And there are different possibilities there. One, of course, would be some form of suspended animation. There'd be limits set on that, but still you could perhaps lie there like a block of ice for several hundred years and then be revived at the other end. Another, of course, if you can find a way to do it, to get the energy is simply to go very fast. I did a whole novel about that in *Tau Zero* [1970], a number of years ago. That's a very "hard science" novel. It assumes relativity. It was based on a perfectly legitimate suggestion by a space scientist that interstellar space is not really a vacuum. There's matter floating around in there, very thin, and gaseous, mostly. So if you could get up to a certain reasonable speed and start scooping up enough of that hydrogen and, using fusion, you could live off the country, so to speak. So I got to thinking, well gosh, in that case theoretically the only limit on speed is light itself. So I had such a spaceship with a crew of people going to another star. But it met with an accident along the way, such that it could not decelerate. It had to keep accelerating because if it simply stopped and floated, the radiation from all this matter it was running into would fry everybody in very short order. So they just had to keep going, pushing closer and closer to the speed of light; and, therefore, by the laws of relativity, their rate of time, so to speak, stretched out until eventually millions of years might pass by outside, while somebody inside the ship drew a breath. So in the end, they outlived the universe and so on. Yes, it got very cosmic. The book has actually been used in some physics classes to help teach relativity.

JCT: Now the psychological dimension *Boat of a Million Years* deals with characters who are living forever and how immortality affects them emotionally and psychologically. As I recall, you only have one of them commit suicide, and one of them is troubled by the weight of what's come. The rest of them remain pretty healthy.

PA: Of course, the idea was that the Immortals would be very rare to start with, and most of them would not survive natural accidents and catastrophes. Remember, the world everywhere used to be a pretty dangerous place and most parts of it still are. Others would live long enough that neighbors would start getting too suspicious of them and think they were witches or something and put them to death. So I was assuming that those who could actually make a go of it for a long time would have to have a combination of determination, cleverness, and sheer luck. That simplifies matters by keeping the cast of characters to a reasonable size!

JCT: *Boat* has gone in and out of different editions now and it seems to be on its way to being regarded as being one of your signature books, one of your best books. What do you feel about that evaluation or is there another title somewhere we haven't even mentioned yet that in your own mind far better aspires to that title?

PA: No, I wouldn't say that because, of course, some are better than others. But Anthony Boucher used to say that the person least qualified to judge a book is the author. I'd say there's, oh, perhaps half a dozen of mine that are better than any of the others, but I wouldn't care to choose between them. For one thing they're very different from each other.

JCT: Have you ever been a mentor for any younger writers?

PA: No, not really. I've never tried to teach anything. If somebody asks for some advice, as I've said before, there's really very little I can say because writing is such a personal matter. At most I can make a suggestion. Maybe this scene will work a little better if you did it such and such a way. But really, that's a function of the editor, I would say. As for new up and coming writers, there are some very good ones but I hesitate to name any for fear of leaving off some who ought to be named. Frankly I don't read an awful lot of fiction anymore, anyway.

JCT: Let me close out by asking you if over the years you have seen what you think are major changes in the science fiction writing field, or on balance has it remained a fairly consistent body of work by you or others? Any big changes, concerns?

PA: Well, yes, in various ways. I would talk about the John Campbell Golden Age of the 1930s and 1940s. I think it was a Golden Age not just because that was when I started reading, although obviously that's part of it, but there was this sense of "green pastures," of all kinds of things that were being explored. And, of course, something is really only new once. So that particular sense will never come again. But, of course, there's all kinds of variations and possibilities to explore, and every once in a while, something really new will come along.

JCT: Or if not new, do you see at least more of a preoccupation with things like ecology and stuff like that?

PA: Yeah. Well, I would say probably the main difference in science fiction now as opposed to, say, back then 30 or more years ago, is just the sheer size of the field. Nobody can keep up. Back in those days, you could read everything that was published under the name of science fiction, and that would probably just be a small part of your total reading. These days, if you spend all of your waking hours reading science fiction, you still couldn't keep up! So, of course, this means that, on the one hand, an awful lot of garbage comes out, but, on the other hand, just on the law of averages, there's going to be a lot of good stuff, too. The problem

is to separate the wheat from the chaff. Today, there's probably more emphasis on trying to deal with current problems, projecting them into the immediate future and so on. But that again is by no means the whole of the field or even the majority of it. You've got all kinds of things going simultaneously. So there's certainly more opportunity for a writer now than there ever was before.

JCT: Beyond the obvious fact that you have immortals in *Boat*, can the book also be seen, though generally, as a metaphor that life will go on, that there is an immortality granted all of us in some way? If it's not a strictly religious statement, is it at least maybe more of a philosophical one?

PA: I suppose so; I would like to believe that. As a matter of fact, biologically speaking, it's overwhelmingly likely that life on earth will go on until the sun gets too hot, perhaps for another billion years. But whether the human race will or not is something else again. Biologically, we are very trivial.

JCT: But as a metaphor for maybe there's a human soul that will go on. Do you ever permit yourself such speculations in your fiction that might approach the more religious in content?

PA: Somewhat, yes. One can speculate about these things, and yeah, I like to think. I hope it's true where—none of us are going to live to see it—but I hope it's true that humanity will go on and actually start acquiring a little wisdom, and the heritage will survive and will continue to grow.

A gallery of science fiction magazines from the early 1950s (KUCSSF)

"The Way the Future Was": Frederik Pohl

Frederik Pohl (1919–) is indisputably one of the busiest and most esteemed of today's science fiction writers. Acclaimed by Kingsley Amis in *New Maps of Hell* as "the most consistently able writer that science fiction has yet produced," Pohl has won numerous awards, including three Nebula Awards and six Hugo Awards (the only person to have won the Hugo both as writer and editor). He began writing in the late 1930s, using pseudonyms for most of his early works. He began publishing material under his own name in the early 1950s, embarking on a notable collaboration with his friend Cyril M. Kornbluth with the now-classic dystopian satire of consumerism, *The Space Merchants* (1953). He also worked tirelessly as an editor on *Galaxy* and *If* magazines. The 1970s saw several of his most celebrated novels, including the Mars book, *Man-Plus*, and *Gateway* (1977) the first of the "Heechee" series (for both of which he won back-to-back Nebulas). A novel begun by Arthur C. Clarke, called *The Last Theorem*, was finished by Pohl and published in 2008. In 1974 he took office as the eighth president of the Science Fiction and Fantasy Writers of America. Our interview transpired on 10 July 1985 at the Center for the Study of Science Fiction at the University of Kansas. My thanks to James Gunn, the Center's Director.

Interview

JOHN C. TIBBETTS: Fred, it's a pleasure to meet you because many of us have read your works over the years, and it's always a bit of apprehension: what will the man be like? Will he be interesting? Will he be as much fun as his books? And listening to you talk all morning, I can see you are indeed a great talker! You like to talk, I suspect, as much as you like to write.

FREDERIK POHL: I like to write better, but I cannot deny that I enjoy the sound of my own voice a whole lot.

JCT: I'd like to do a quick survey, if I may, from your work up to the present day. Could you give us a synopsis of your writing career and how far back it takes you?

POHL: Well, it takes me back to when I was 12 years old. I wrote the first story of my life in the eighth-grade English class in public school number nine in Brooklyn when the teacher wasn't looking, a really remarkably rotten story. It was something about Atlantis.

JCT: Is it polite to ask what year that was?

POHL: It was 1932. I was 12 years old. And I began trying to submit stories to magazines almost immediately. I think I was 13 or 14.

JCT: Were you working from much experience in reading science fiction at that point?

POHL: Not a lot in reading science fiction. I don't remember a time when I couldn't read. I remember being able to read—I read all the boys' books, and most of the girls' books, and all of the other books that I could get my hands on. I discovered science fiction along about 1930 in a magazine called *Wonder Stories*. Someone left it at the house, and I began reading it. And then I read all I could find. I haunted the second-hand magazine stores to buy the back issues of *Amazing*; and *Astounding* had just begun at that time. And I found one or two other people in my school who had also read science fiction, and some of them had magazines I didn't have, so we swapped back and forth.

JCT: And not the kind of writing, at that time, regarded as being respectable, was it?

POHL: It was never regarded as respectable until quite recently. Well, recently in my terms. It was in the last 10 or 20 years maybe.

JCT: And in fact is there a part of you that almost regrets seeing it become respectable, if you know what I mean. A buccaneering instinct, maybe.

POHL: There's a part of me that thinks that its respectability has somehow damaged it. Leslie Fiedler says that science fiction lost its vulgarity around 1960 or so, and in a sense he's right. It lost the feeling that there was no penalty for failure, because people took chances, did all kinds of things that I think many writers would be afraid to do now. I don't mean stylistic chances, but writing about things that—were insane, really. There were a whole series of stories by a man named Joe W. Skidmore about an electron and a proton given animate form. Well, that's ridiculous and nobody would write that now, and they weren't even very good stories. But it's that sort of vulgarity, that sort of recklessness, that I think made science—one of the things that made science fiction interesting 40 years ago. And it does seem to me that a lot of writers have become self-conscious, having become accepted by critics and academics and so on. It's kind of like having somebody else stand behind you while you're writing a story, worrying, Will they like this one as much as they liked the last one? Dare I try this thing, which may fail catastrophically? And often saying, no I do not dare. I'll play it safe this time.

JCT: In fact, writers and artists can rarely take that easy way out through life. A lot of us like to settle back into formulas, be it in life or in work. The writer, especially the science fiction writer, can't afford to do that.

POHL: Ah, but the science fiction writer has one characteristic that is his saving grace. There was an attempt some years ago to make a group psychological profile of science fiction writers and contrast them with ordinary human beings. And they discovered that there was a characteristic of science fiction writers that was

markedly different from the rest of the human race. And that was in a quality, which, translated, means pig-headedness. And science fiction writers are essentially the most stubborn and individual-istic, obstinate people in the world! So this saves them from the worst penalties of this respectability.

JCT: Do these descriptions apply to Frederik Pohl?

POHL: Certainly not, although they have been applied to me from time to time. I did begin trying to write as soon as I was able—as soon as I had a typewriter, as a matter of fact, I began submitting stories. I got the typewriter, I think, for my twelfth birthday. And I was rejected many, many times over a period of several years. And I finally sold a poem, a poem I wrote when I was 15. It was accepted when I was 16, published when I was 17, and paid for when I was 18, so somewhere in that area I became a professional writer.

JCT: "Frederik Pohl, Poet" is not a designation I would have thought of immediately.

POHL: Well, I've always—fooling around with words and poetry is one of the most demanding ways to do it. I still write a little poetry now and then. I have a slim sheaf in my file cabinet entitled "Poems After Fifty," which someday I may publish. There are about a dozen of them.

JCT: Since we're here on the campus of the University of Kansas at James Gunn's Center for the Study of Science Fiction, I wonder if you have been present at any of these gatherings that Jim has had over the years?

POHL: Oh a good many of them. The University of Kansas for some years has had a summer seminar for teachers of science fic-tion, and three writers each took a week of it. That includes Ted Sturgeon, Gordon Dickson, and myself. Until last year I was here every summer. And I have taught courses here for the university, team-taught actually, or sat in on seminars of one kind or another. I've spent more time at this school than at any other school in America.

JCT: We're going to dip back into your career now. When did you first meet Cyril Kornbluth [1923–1958] and begin writing books with him? I'm thinking of the classic *Space Merchants, Gladiator-at-Law, Wolfbane,* and *Search the Sky.* What was that all about, and do you regard that collaboration with a special fondness?

POHL: With a very special fondness! I'm really glad that you asked me this, because I am just now on the point of trying to write a new introduction for a new collection of the short stories Cyril and I wrote [published in 1987 as *Our Best: The Best of Frederik Pohl and C. M. Kornbluth*]. Because most of them have been published repeatedly and I've written introductions before, I've run out of things to say. So if you can stimulate me to think of

something I haven't said before, that would be marvelous. There was an organization in New York called the Futurians. It was a club, a science fiction fan club, different from most of them only in degree, in that more of our members than usual wanted to be science fiction writers. There are few fan groups that don't contain would-be writers. But we had people like Isaac Asimov and Cyril and myself; and James Blish and Judith Merrill and Damon Knight and Don Wollheim and a good many others who did go on to write science fiction. And Cyril turned up as a 14year-old, very arrogant, nasty-mouthed, brilliant, funny, interesting kid. He fit in very well. He was nasty-tempered and sardonic and all the other things that we kind of prided ourselves on being. And we all were trying to write, and to facilitate our writing, we often collaborated, figuring we would fill in each other's deficiencies. Cyril and I began writing, when I think I was 19 and he was 16, short stories for the magazines.

JCT: Now, see, already, I think of the *novels* as collaborative efforts but not the short stories. Many of us may not remember them as well.

POHL: I should tell you, John, that one of the saving graces of my life is that for the first 10 years, I published exclusively under pen names, and, therefore, I can lie about the stories! Some of the ones that Cyril and I wrote together have since been republished under our own names, but they were all under pen names to begin with. But we wrote stories with titles like "Trouble in Time" or "Best Friend" or "Mars 2." Some of them were fairly good, at least they were fairly good by the standards of the time (or we thought so!). But we really were too young, and too wet behind the ears, and too new at trying to learn what writing was all about, to be very good. The way we worked was that I would think of an idea for a story and give Cyril an outline of the story, and he would write a rough draft, I would rewrite it, and then we would try to sell it. Shortly thereafter, I became the editor of a magazine called *Astonishing Stories*, and from then on, we sold them all because I bought them myself if nobody else would! But they were still not very good stories. Then the war came along. Cyril went in one direction, and I went in another. We got together again about five years after the war and began trying to write together again. I had begun a novel for *Galaxy* magazine about the future of advertising. I'd written about a third of it, and the editor wanted it done really quickly. So I asked Cyril if he would collaborate with me on it. We then finished it, and it was *The Space Merchants*, which has been around for a long time. The idea was the "selling" of Venus to prospective colonists, even though the planet was inhospitable.

JCT: And, in fact, advertising is one of the really consistent thematic devices or subjects of many of your own works, too. Has that

always been a predilection for you, the world of mass-marketing and advertising?

POHL: It kind of went the other way, John. While I was in Italy during World War II, I had a lot of time on my hands, and I decided that I would write a novel, having nothing better to do with my time at the airbase in Italy, where my B-24 group was. And I thought I'd write a novel about New York City because that was my home and I was a little homesick for it. And I thought about what would be the most interesting thing to write about in that area. And I thought, write something about advertising. So I wrote an entire novel called *For Some We Love* (a quotation from Omar Khayyam, not really relevant to anything), which I finished; and a couple of years later, when the war was over, I pulled it out and looked at and realized that it was absolutely, hopelessly bad. Among other things, I knew absolutely nothing about advertising. So I applied for a job with an advertising agency.

JCT: I knew there must have been some experience in there someplace. Okay.

POHL: I spent about three years writing advertising copy for one outfit for another, first for an agency and then for a publishing company, realizing my novel was not worth thinking about anymore. It was then I decided to start a science fiction novel about it, which is how *The Space Merchants* began.

JCT: And might I interject at this point that extrapolating the wonders of consumerism, is that necessarily so very different from the wonders of space travel? If you have a talent for one, you might have a talent at the other, maybe.

POHL: Well, see, all fiction is lying, but advertising is pernicious lying.

JCT: Very good. Now when did you know that *Space Merchants* was becoming a classic? How long does it take a science fiction book to become a classic? At the time that it came out, did you have any inklings like that?

POHL: When it came out in magazine form, it was pretty popular, but there's no real way to measure that except by letters from readers or the comments of friends. I then submitted it to every publishing company in America that had a science fiction list, and they all turned it down, some of them very harshly. A good friend of mine—I knew all these people well, all the editors. And one of them being a good friend of mine, took me aside and said, "Fred, I really have to tell you, there are some interesting ideas in here, but it's really not of professional quality. You need to find some skilled, professional writer to pull it together for you." Which was kind of a crushing thing to hear. But I didn't necessarily believe him, so I kept on offering it around until—well, we never found a professional writer to pull it together, but we found an amateur

publisher who didn't need that. Ian Ballantine had just started Ballantine Books. He read it; he didn't know that it was not of professional quality, so he published it.

JCT: I love that.

POHL: And it began getting very good reviews from all types of places. And it was about then that Cyril and I began to think that we really had done something a little better than we had hoped for. I've written about all of that in my memoir, *The Way the Future Was* [1978].

JCT: To my mind, it was one of the first times that science fiction had really taken on a Madison Avenue–type world, and we saw that the two really could go together. It didn't have to be rocket jockeys across the spaceways at all.

POHL: I think that's why it was turned down by all the science fiction editors. It had no space pirates in it, not even one, and they just could not reconcile that with what they thought was science fiction. But then, Cyril and I wrote three other science fiction novels and three novels that were not science fiction at all. And we would probably still be doing it now except that he died, very suddenly and untimely at the age of 34 of a heart attack. The last contact I had with him was about a year before he died. We had just written *Wolfbane*. I think he knew he was dying. He had been told he had essential malignant hypertension. Your heart just cannot push blood fast enough. It's under strain all the time. But he refused to take care of himself and to give up cigarettes and alcohol. I found myself cast on my own resources, and I had to write by myself.

JCT: We think of so many collaborative teams working, and of course, Fletcher Pratt and L. Sprague de Camp is one, and you and Kornbluth are another. What are some of the other great science fiction teams that you have known of over the years?

FP: [Jerry] Pournelle and [Larry] Niven, I think, are in the field, right now. Jack Williamson and I have written a number of books together that I am fairly well pleased with.

JCT: Lots of books, actually.

POHL: Let's see...we had a so-called Undersea Trilogy [*Undersea Quest, Undersea Fleet, Undersea City* (1954–1958)], another series called "The Saga of Cuckoo" [*Farthest Star* and *Wall Around a Star* (1975–1983)], and another trilogy called "Starchild Trilogy" [*The Reefs of Space, Starchild, Rogue Star* (1964–1969)], and there's one we're working on right now [*Land's End*, published in 1988]. One of the good things about working with Jack is that Jack and I write in ways that are quite dissimilar, so there's a conflict or a synergy between us. It's not that we're doing the thing that we do independently. We do something different when we write together. But there have been a lot of well-known collaborative teams,

beginning with people like Earl and Otto Binder, who wrote as "Eando Binder" in the 1930s, I think it was.

JCT: And Henry Kuttner and his wife, C. L. Moore...I have to ask you, did you know Henry Kuttner? I assume you did.

FP: Oh, yes.

JCT: All of us have our own heroes, I suppose, and in this field, Kuttner certainly is one of mine. He must have used as many pseudonyms as you did!

FP: Offhand, I can think of "Lawrence O'Donnell" and "Lewis Padgett" (usually in collaboration with his wife). I admired Henry Kuttner immensely. He was a fine writer. He was a very shy person, so I didn't know him really well. I knew him over a period of 10 or 15 years, but he was reclusive and he lived usually in California, and I hardly ever left New York at that time, so I saw him only occasionally.

JCT: But something happened with him that apparently happened with you—moving from a more traditional kind of science fiction to books like the futuristic social commentary of *Fury* [1947] started showing up....and those memorable short stories, with their quirky humor. Was there a sensibility operating somewhere in the mid- to late 1940s when a lot of science fiction writers were reacting to conventions and were beginning to change the form?

POHL: I know what was happening in Henry Kuttner's mind. And I also just got tired of doing the same thing and wanted to do something different. Then, along about 1960 or maybe a little earlier, there was a thing in science fiction called the New Wave, which was a movement to free science fiction of its shackles as a pulp literature with a plot and a hero and a heroine and an adventure and so on. People like Brian Aldiss [see the Aldiss interview elsewhere in these pages] said things like, "Nobody should write about stupid old Jupiter anymore!" They wanted to write about the inner space, a science fiction of the interior. Because of the example of these people, a lot of writers who had been around a long time, like myself, began to realize, slowly, that there were other ways to write than in the traditional plot, formula—about problems solved by the hero with great resources and winding up with a happy ending. And the New Wave was a great liberating force for me.

JCT: All of which points to the fact that since *Space Merchants* on up to the present, you have continued to grow and develop. What is the wildest thing you have ever tried in a book? Maybe it didn't work, maybe it didn't come off, but in your own mind you were proud of the experiment?

POHL: The wildest thing I have ever tried I haven't published or even quite finished yet. It's what may be the fourth volume of the series that began with *Gateway*, and it's an attempt to write from a point of view that I can't describe. It's a human being who

has the capacities of a large mainframe computer serving several dozen terminals simultaneously; and I'm trying to write it from his point of view. I'm not sure that's working. There are a lot of things I've done that I'm pleased to have done. In *Gateway* [1977], for example, which is the novel of mine that I like best, what I tried to do was to show the world as it could have been seen by the hero himself, or any character in it, without directing the reader's attention to specific things. So I filled the book with what I called "sidebars," or classified advertisements, or pamphlets, or letters—showing everything that was going on, trying to give a total picture of what that world was like. And I think it worked pretty well. I don't know that anybody has ever done anything quite like that before. John Dos Passos did something like it in the *Nineteen Nineteen* [1932] trilogy, and John Brunner did the same as Dos Passos in *Stand on Zanzibar* [1968]. But I don't think anyone's ever done it in the *way* that I did there.

JCT: In the meantime, the form of science fiction short stories seems to be, at least in my mind, a somewhat neglected form; and you and Clifford Simak are two writers who have always had the wonderful ability to really take the reader into a good yarn. What story would you cite as being a favorite son of yours?

POHL: Well, I think the story that I like best, the one that I'm willing to have engraved on my tombstone, is called "Day Million" [1966]. I was trying to write about human beings in terms of what their life was like in conditions so unlike our own that there's almost no point of resemblance. It's a thousand years in the future. I wrote it very rapidly, but if I'd hesitated and thought about it, I might never have written it at all. When it was done, I was really pleased with it and still am.

JCT: On the whole, is this really a crazy way to make a living?

POHL: Writing *is* a crazy way to make a living! In fact it's a really poor way to make a living. It's said of writing that it's a *bad* way to make a living. But for a lucky few one of the better ways to get rich. There's no middle ground. You either starve or you do quite well.

JCT: And meanwhile you've been writing a study of science fiction in film with your son [*Science Fiction in Film*, 1980]. How do you feel about him following the same profession?

POHL: No, I would love it if Fred got into the same profession, but his interest was in film rather than in writing. Actually, his interest is in writing for film, or directing film. What he would really like to be is Stanley Kubrick, but Kubrick currently occupies that job and shows no sign of giving it up! But his degree was in film, and he knew a great deal about the technical aspects that I did not. And, of course, being my son and being exposed to all the science fiction writers that we knew, he knew a great deal about science

fiction from several points of view, as a reader, as a watcher of films, and as somebody who'd grown up with Uncle Lester del Rey around the house.

JCT: "Uncle Lester!" Meantime our time is growing short, just one last question. Update *Space Merchants* for us, because if we've not already found it in hardback we'll shortly be finding it in paperback. What is it called and how have you extended that world?

POHL: The sequel is called *The Merchant's War* [1984]. It is written 30 years after the original and it takes place 30 years after the time of the original. It begins on the planet Venus, and some people come back from Venus to experience what Earth is like 30 years later. And I enjoyed writing it. While I was writing, it I was traveling in China, in the Western reaches, around the Gobi Desert; and there is a sequence in it which takes place on the Gobi Desert.

JCT: There must have been pressures upon you to do a sequel, if that's the word, long since, huh?

Wilson Tucker (right) inducting James C. Tibbetts into First Fandom (photo by the author)

"I Tell *People* Stories": Wilson Tucker

Wilson "Bob" Tucker (1914–2006) was one of the most amiable and beloved figures in all of science fiction writing and fandom. He also was an accomplished writer of many mystery and adventure stories. A

native of Illinois—he lived in Bloomington for many years—he was a superb storyteller who excelled in writing powerful political and social allegories (*The Year of the Quiet Sun*, 1970, and *The Long, Loud Silence*, 1952) and time-travel stories (*The Time Masters*, 1953, and *The Lincoln Hunters*, 1958). Only a few writers, notably the veterans Murray Leinster (*Twists in Time*), Jack Finney *(Time and Again)*, and, more recently, new-comer Connie Willis (*The Doomsday Book*), have rivalled the sheer zest and ingenuity of his time-travel tales. Affectionately known to his many friends as "Hoy Ping Pong," he was in constant demand as a fanzine writer, editor, and speaker at science fiction and fantasy conventions. His awards and honors included the 1970 Hugo for Best Fan Writer, the John W. Campbell Memorial Award in 1976, induction into the Science Fiction Hall of Fame in 1997, and the First Fandom Hall of Fame Award in 1985. [The Hall of Fame is now part of the Experience Music Project, and the Museum is located in Seattle, Washington.] In 1996, he was the second person honored by the Science Fiction and Fantasy Writers of America as Author Emeritus.

This interview transpired on 25 May 1985 at the home of Robin Bailey in Kansas City, Missouri. Tucker was a Guest of Honor at ConQuest 16. (A personal note: At that event, Tucker inducted my father, James C. Tibbetts, into First Fandom. I wish to thank Joanie Knappenberger and Robin Bailey for their assistance in arranging this interview.)

Interview

JOHN C. TIBBETTS: Bob, you have been called the "Toastmaster of Science Fiction." Do you see yourself as the George Jessel of science fiction conventions?

WILSON TUCKER: It is true up to this point. My jokes usually have a fantasy or science fiction tinge; and yes, I'm almost as old as Jessel! My first convention was in 1939, and I helped orga-nize another one a year later; but since then, I must have attended more than 500. I do about 15–20 a year as either Guest of Honor, Toastmaster, or both.

JCT: To the uninitiated, what are these conventions all about?

WT: Let's assume you've seen the advertising and have gone into the hotel. As you come in, you'll likely find people wandering around the lobby in costumes. Those are the people who are the media fans and who dress up as their favorite characters without getting arrested! For the most part, if there are 500 here this weekend, more than half are book collectors, art collectors, and memorabilia collectors. The first thing I do is visit the dealers' room. I want to see what's new, and I'm always on the prowl for the old books that have eluded me over the years. And some are just readers who buy a paperback and then toss it away. But you know everybody here is

a fellow collector or enthusiast. Once in a while, a fan in costume will wander outside to a restaurant or coffeehouse, and immediately, he attracts the stares of crowds. They will say, "Look, there goes one of those nuts now!" At a World Con a few years ago in Washington, D. C., two or three fans went outside the hotel, and a squad car trailed them; cops are not used to Darth Vaders wandering the streets! But the hotel desk clerks don't bat an eye.

JCT: What type of duties do you have as Toastmaster?

WT: If I'm a Toastmaster at a convention, my job is to introduce the guests and make them look good. For example, this time, I'm supposed to introduce Fred Pohl. Now, Fred is an easy person to introduce, because in 1941, when we were very young, he was an editor who bought my first story, "Interstellar Way Station." The first editor to actually *buy* one of my stories! I point to Fred, and I say, "See that man? He is responsible for everything that I am today!" And Fred will roll his eyes and say, "Oh, my god!"

JCT: But because you guys know each other so well, and can predict what's going to happen, it's almost as if you're putting on a piece of theater, with prepared lines and all of that.

WT: That's true. Consider, if I work 15 or 20 conventions a year, and Fred works 15 or 20 a year, we have already met lots of times and pretty know what the other is going to say. I like to set up little traps for him to walk into; and he likes to set up strategies around them. And we look at each other and say, "All right, *next* time I'll get you!"

JCT: We're here on the occasion of your nominating my father for First Fandom. What are your recollections of First Fandom?

WT: I have to go back to when I first discovered science fiction and the readers and the collectors. That was back in 1931, and I was about 15 years old. I got into the habit of corresponding with other fans. In the back of the wonderful old pulps, like *Weird Tales*, there was always a letters column where readers could write to the editor with comments on the stories. And the editor would print the reader's home address. We fell into writing one another through these addresses; and eventually people began to publish mimeographed pamphlets—we call them fanzines—that would go to all the fans with news and gossip and whatnot. That was the real "First Fandom" to me, when I was just discovering writers like H. P. Lovecraft and Robert E. Howard. I published my own fanzine, *The Planetoid,* in the early 1930s and later published another one, *Le Zombie.*

JCT: And fans everywhere know your *Guides to Fandom.*

WT: Actually, John, the official title is *The Neo-Fan's Guide to Science Fiction Fandom!* How about that? It's gone through many editions. Now we have an International First Fandom. The rule is that the club is open to any collector or reader in science fiction who was

actually reading the pulps before 1938. I'm sorry, John, you can't join, you're too young! But I've already been honored to nominate your father as a member.

JCT: Who are some of the writers who emerged from First Fandom?

WT: There was a group in Brooklyn and Manhattan, who called themselves The Futurians. They got started around 1938, I think. Like me, they were all young, some a little younger than me, some a little older. There were Fred Pohl, Isaac Asimov, Donald Wollheim, Dirk Wiley, and Damon Knight. [See Damon Knight's *The Futurians* (1977), a history of the movement.] We all swore that, by George, when we got older, we would be rich and famous writers! Ray Bradbury was not in that group, because he lived in Los Angeles, where he began writing stories. He considers himself a writer; I consider him a poet. Now, I'm in a position to pass the torch, as you say, to younger writers. For example, I usually host a writers' workshop at these conventions, or sit on a panel and help conduct one with other writers. In the past dozen years, I probably sat in on more than a dozen of these workshops. And one of the new writers is a man here in Kansas City named Robin Bailey, who is actively writing now. I helped him get his first novel, *Frost* [1983] published. Mark my words, he will be as big a name as Asimov and Pohl are now. [Note: Bailey served as president of the Science Fiction and Fantasy Writers of America from 2007 to 2008. See his notice of Tucker's passing in the SF/F & Publishing News website.] In all of my years in science fiction, I have never found a writer or an artist who has the least bit of envy or maliciousness toward others. If you would sit in on one of these workshops and watch the veterans nurse the newcomers along, you'd see us oldsters spending hours and hours working with them. For nothing. Never dream of charging anything. Another good man is James Gunn [see his Preface to this book], who teaches at the University of Kansas, and he also conducts workshops and conferences.

JCT: And who were those writers you were reading back in the 1930s who inspired you?

WT: I was reading Jules Verne and H. G. Wells, but I knew I couldn't write like them, because they were of an earlier generation, and writing styles had changed. I do recall being terribly impressed with a writer named Tiffany Thayer, and I still reread his work today, both mainline novels and fantasies. And some of the early mystery writers, like the hard-boiled private detective novels by A. A. Fair [Erle Stanley Gardner]. But it was only when I stopped copying writers like Fred Pohl and began forging my own style that I really became a writer. I feel it was with my novel *Year of the Quiet Sun* [1970] that I really found my voice. I know how to

tell the tale, as they say. And I hope you've discovered something else in reading my books—that I stay very close to *people*, to characters. I tell *people* stories, whereas other science fiction writers tell space stories— I came up with the term "space opera" some time ago to describe them—or monster stories, or concept stories. Arthur C. Clarke, for example, tells concept stories. If he writes about a space elevator going from the earth to the moon, his hero is really an *elevator*. My stories are much smaller than that. In *Wild Talent* [1954]. it was about one boy who grew up to draft age, and when the Army grabbed him, they tested him and found out he could do something no other recruit could do—read minds. It takes place in 1933, the time of the *other* Chicago World's Fair. But the real emphasis is on the story of his growth into manhood and maturity.

JCT: But you put those people into some pretty wild situations! I particularly love your time-travel stories. Will you indulge me in talking about one of my favorites, *The Lincoln Hunters* [1958]?

WT: Good! It's one of my favorites, too. Still is. Keep in mind, when I was writing it, I was living and working in Bloomington, Illinois, which was Lincoln's stamping ground while he was practicing law. One day, a controversy arose in the newspaper that an old brick building called Major's Hall, at the corner of East and Front Streets downtown, was going to be torn down for a parking lot. A hue and cry arose. People said, "No, you can't tear that down; that's where Lincoln spoke." They were referring to the famous "lost speech." Lo and behold, on the third floor of the building was a huge hall where, in 1856, the Republican Party of Illinois had held its convention. Lincoln was one of the speakers. He had just been baptized—we would say he was "born again"—and was full of fire and brimstone. He decided to start a drive to put an end to slavery for once and for all. So he got up on that platform in front of 500 people and he cut loose with a stem-winder of a speech, a real rabble-rouser! And all the local accounts—I've seen them—said the next day that they were so mesmerized by the speech that they forgot to take notes. He was speaking extemporaneously, not from a prepared text. And so the next day, nobody could remember anything, more than just a paraphrase. It really happened that way. Look it up. You'll find it under the heading of "Lincoln's Lost Speech." [Note: The speech was given on 29 May 1856 at the Anti-Nebraska Convention in Bloomington on the occasion of the founding of the state Republican Party.]

JCT: Gosh, wouldn't it be great if we could travel back in time and check it out...!

WT (Laughs): "...he said, meaningfully!" That was a fine lead-in. Thank you! So, when all this furore came up about tearing the building down—and by the way, the building was indeed torn

down—I went to the Withers Public Library in Bloomington, where they have a "Lincoln Room," a special collection, where the librarian allowed me access. I discovered all this history I'm telling you now (I dedicated my book to the Withers staff). I found out that all of Bloomington was going crazy, with extra trains bringing in hundreds and hundreds of conventioneers. And I knew I had to write a novel about that. I had the story begin in the future, 700 years from now, when a museum curator has heard about this famous "Lost Speech" and wants to track it down. So he goes to a government-sponsored project where a Time Machine has been developed, so you can hire it for going back in time to research history. So our heroes go back to 1856, sneak into the hall, and record the speech (just like you and I are recording this conversation now!). Well, a story setup like that is too easy. You just can't have these guys sneak and copy the speech and go back home. No, the whole last half of the book has our heroes trying to get that speech back to their own time. But two of the team don't make it back; they are marooned in 1856. Now things really take a turn. Just imagine that you're back in 1856 with full knowledge of what the future will bring. You know Lincoln's going to be president, you know what will happen to him, you know that you can ride his coattails into the White House, if you want.

JCT: You know, there's only one man I can think of who can rival you in blending time travel with nostalgia and romance…and that's Jack Finney!

WT: Thank you! I've read his stories, and I wonder if one of us is unconsciously borrowing from the other! My first time-travel story was *The Time Masters*, which was published in 1954. And I think that's when Jack was beginning to write things like that, too. [Note: Finney's first time-travel stories were written in the mid-1950s and collected in *The Third Level* (1957)].

JCT: We have to talk about *The Long Loud Silence* [1952]. I think it's your masterpiece. Damon Knight has called it a "perfect" novel. Other writers, from the Gothic stories by Mary Shelley [*The Last Man*, 1826] to a modern writers like Philip Wylie and Stephen King, talk about the destruction of our planet by *natural* means, like plague, flood, and earthquake. But you show it in a very different way.

WT: Let me tell you the back story about that. I'm pleased to say that I was one of the first to take on a postnuclear holocaust story like that. It's Man himself, not Nature, that destroys the planet. Remember, it was written in the late 1940s when World War II had ended and soon things got very tense in Soviet Russia and America about the Cold War. Everybody thought the other side was going to bomb them in their sleep. Everybody was convinced the Bomb was going to fall any minute. In that atmosphere I

wrote a story in 1950 called "The Very Old Badger Game," which Anthony Boucher of the *Magazine of Fantasy and Science Fiction* rejected. He told me it didn't seem like a self-contained story but a fragment of a larger work. So I expanded it into a novel in which the Bomb did fall, and the eastern half of the United States was wiped out by plague and disease. Only the western half is relatively intact. The action of the book takes place 10 years after the Bomb. My protagonist is a corporal on leave from the Korean War. He is a survivor, a kind of "typhoid Mary"—that is, he carries the seed of destruction within him, although he himself is free of the disease.

JCT: And you give us very few details about what really had happened—

WT: —No, it didn't matter exactly what happened or who caused it. The real story here is how this man survives. And it comes down to a very grim ending, which was changed in the first hardback publication. And it's hard to find now.

JCT: You know, *Nickelodeon* magazine published your original ending; and I illustrated it!

WT: Oh, I'm glad to hear that! I must get a copy [*Nickelodeon*, No. 1 (1975)]. My original ending revealed that times had become so bad that my character [Corporal Russell Gary] is so consumed by hate that he considers using his body as a deadly weapon in the Free Zones. And he is forced to resort to cannibalism to survive. We have seen that sort of thing before, you know, like when Japanese soldiers in World War II in the Philippine Islands were cut off and could not get home and fell to cannibalism. So, in my original ending, my protagonist survived by killing and eating other survivors. However, the editor I had at that time at Rinehart and Company, Jean Crawford, had a weak stomach, and she objected to that ending. She wanted a "soft" ending, so I rewrote the last chapter; so instead of my hero killing and eating the woman he was stalking, he greets her like an old friend, and they go out into the wilderness together to hunt rabbits to survive. If it were published now, that original ending would certainly be restored.

JCT: Have there been other instances of editorial censorship like that?

WT: Well...the only other alteration that severe was with my *Ice and Iron* [1974]. It was about the coming Ice Age, and my characters are in Canada helping to evacuate people against the coming of the glaciers. At the end of that book, my hero is a bureaucrat who finishes his job, turns in his paperwork, and walks away. That was the original ending, and it was published by Doubleday just that way. That book is being reprinted in paperback, and you will not find that ending in it. That particular editor objected to the ending, so she had me add two extra chapters to round out the story.

JCT: How do you feel about pressures to make changes like that?

WT: John, it's not just a writer's game, it's an editor's game and a reader's game. All at the same time. I tell young writers not to forget that.

L. Sprague de Camp (KUCSSF)

"The *Complete* Enchanter": L. Sprague De Camp

L(yon) Sprague de Camp (1907–2000) was one of the giants of fantasy and science fiction. Although he wrote about an "Incomplete Enchanter," in his "Harold Shea" stories, he was ultimately a *complete*, or, more properly, *compleat* enchanter. He embodied Vladimir Nabokov's triple-play notion of the "ideal" writer, that is, an author who is not only entertaining and informative, but *enchanting*. The prolific, multi-lingual de Camp also wrote historical fiction, science and technology nonfiction, and light verse. He was present at the creation of modern science fiction in the 1930s and continued to write until the 1990s. He was one of the few writers who kept "heroic fantasy" alive in the 1950s and 1960s and was instrumental in getting the almost-forgotten works of Robert E. Howard back in print (writing numerous "Conan" pastiches of his own and a biography of Howard, *Dark Valley Destiny,* 1983). He also wrote the first independent biography of H. P. Lovecraft in 1975, a writer whose influence he has frankly acknowledged. He is perhaps most famous for his alternative history/parallel worlds books,

notably *The Wheels of If* (1948) and *Lest Darkness Fall* (1939), and his collaborations with Fletcher Pratt in the short story collection, *Tales from Gavagan's* Bar (1953) and the five "Harold Shea" stories, including the masterly *Castle of Iron* (1941; revised 1950), which Lin Carter typifies as "some of the most sprightly, entertaining, witty fantasies ever written, fantasies, in which romanticized adventure took a backseat to rational plotting and interesting characterization." Among his numerous honors were the Nebula Award and the Hugo Award (for his autobiography, *Time and Chance*, 1996). In 1976 he received the World Science Fiction Society's Gandalf Grand Master Award. More recently, in 1995, he received the first Sidewise Award for Alternate History Lifetime Achievement award.

Our interview transpired in Chicago on 30 October 1983 at the World Fantasy Convention. Halfway through the conversation, de Camp's wife, Catherine Crook de Camp, with whom he has collaborated on stories for many years, joined us. Her remarks are included here.

Interview

JOHN C. TIBBETTS: In describing you as a "Grandmaster of Fantasy," it's not just an arbitrary adjective, but a particular honor granted to a very few writers. Let's talk about it.

L. SPRAGUE DE CAMP: Every year the members of the Science Fiction Writers of America have an annual dinner meeting at which the persons whom they wish to honor are given a trophy, a thing made of transparent plastic. And they give one for the best novel, one for the best short story, one for the best artists, and so forth. And they also give one for Lifetime Achievement. And it was about three or four years ago that they gave me one for Life Achievement. It's sitting in my family room today.

JCT: Those of us who've been fans of your books for lo, these many years, hardly need be told you're a Grandmaster at this type of thing, but in case there be a few out there who might still not know the name of L. Sprague de Camp, let's refresh their memories with some of your books. Why don't we go back in your writing before the collaborations with Fletcher Pratt, and some of the titles that have come down to us since then? Could you condense a little brief profile here of your published works?

LSdC: Yes, people sometimes ask me how I became a writer and the answer is very simple, I lost my job. It was in 1938 when I was one of the editors on a trade journal in New York, devoted to the unglamorous subjects of oil heating and air conditioning. The boss decided to economize by firing his two most junior editors, so I got it in the neck.

JCT: At the time I suppose it seemed a disaster to you.

LSdC: Well, not particularly. If you had known this boss, I mean, he was a capitalist straight out of the *Daily Worker*. And I had sold a few stories and articles to John Campbell, who was then the great editor of *Astounding Science Fiction*, now called *Analog*, and I figured that if I spent five hours a week on my own time as I'd been doing, in writing, and made a certain sum, if I spent 10 times that much time, I'd make 10 times that much money.

JCT: Did it prove to be that easy?

LSdC: Well, you run into the law of diminishing returns, but nevertheless I took the plunge into freelancing and found that I could do about as well financially as I had been doing, and furthermore I could be my own boss, work sitting down, and wear out all my old clothes. So except for World War II and a couple of temporary jobs I've been at it ever since.

JCT: And some of the titles that spring to mind, like the "Harold Shea" series. *The Incomplete Enchanter* certainly was a landmark book—

LSdC:—Oh, yes, and *The Carnelian Cube*, and then after the war, *Rogue Queen*, and my "Planet Krishna" series—*The Queen of Zamba*, *The Hand of Zei*, and so on—which now number about seven stories, counting one in press. And I did five historical novels. Remember, only about half of my total output is fiction. The rest is nonfiction, science, history, biography, and so on.

JCT: And you've even written a book about the science fiction field— how to break in, dealing with the publishers, that kind of thing.

LSdC: Yes, *The Science Fiction Handbook* [1953], with my wife, Catherine Crook. And also a lot about marketing and selling and the nuts and bolts of making a living as a writer, which isn't easy, whatever anyone may tell you.

JCT: Legend has it that you had a prediction about World War II. There's a book called *None but Lucifer*, I believe, in which there were certain startling prophecies. Is that correct?

LSdC: Oh, well, that one was a Depression-era novel about a Faustian pact. Actually, *None but Lucifer* was essentially a ghostwriting job on my part. Horace Gold, who later became the editor of *Galaxy Science Fiction*, wrote it, and John Campbell found it not quite acceptable, but he thought that with a rewrite it could be. So he suggested to Horace that I do the rewriting, with a provision for division of the money. Horace didn't like that idea much, but half a loaf being better than none, he agreed and I rewrote it. It appeared in *Unknown Worlds* but did not appear in book form [It was finally published in 2002.]

JCT: It takes place in 1939?

LSdC: Yes. There were several prophecies in it but they all proved dead wrong!

JCT: Well, so much for prophesying!

LSdC: Yes. He prophesied that the fascist regimes in Europe would just collapse and go away without there being any necessity for a war. And—

JCT: Alas.

LSdC: —of course, we know that didn't happen. They didn't go away, they had to be pushed.

JCT: We have to talk about your many collaborations with Fletcher Pratt. How did the two of you first meet?

LSdC: Fletcher Pratt ran a naval war game. He made little balsa and wire and pin models of real warships, on a scale of 550 feet to the inch, which means that a battleship would be about that long, and a destroyer like that.

JCT: So about a foot, up to a foot and a half.

LSdC: Yes. That's right. And he used to whittle these things out at his desk while waiting for the next sentence to form, and he had hundreds of these things on shelves in plastic boxes, and every month his friends would gather and would play this naval war game. They'd crawl around on the floor pushing around these little models, and measuring off distances in knots by means of scales, and estimating ranges, and writing them down, and then the referees would calculate how many hits ship A had made on ship B and how many points damage were done by, let us say, three six-inch hits, and so on. Well, my college roommate and I were living in New York, and he being less shy and inhibited than I, took me around to see Pratt. Well, Pratt was an established writer at that time. He wrote one of the best one-volume histories of the Civil War, called *Ordeal by Fire*. Pratt suggested that we collaborate. He had an idea for a series of stories, whose hero gets himself into various mythical environments by the use of symbolic logic. I had just happened to have been studying symbolic logic at the time, and so I said, sure. We also both knew the stories by E. T. A. Hoffmann, whose Gothic tales frequently plunged their characters into alternate worlds of faerie and terror.

JCT: I see . . . stories like "The Golden Pot."

LSdC: One of my favorites! Yes, Hoffmann was an important precedent for this type of thing. So we went ahead. John W. Campbell had established *Unknown* as a magazine receptive to stories that had offbeat humor and sophistication, so we began our "Harold Shea" stories with "The Roaring Trumpet" in a 1940 issue. Shea was not typical of your standard-issue hero figures. He was rather inept at times and stumbled through his adventures. The procedure that Pratt and I used was that we would thrash out the plot together, and I'd go home with a bunch of notes, and type out a synopsis, and he would approve that, and then I'd type the rough draft and he would do the final draft. In other collaborations with younger writers, I have

found that it worked best to use the opposite system. That is, in other words, have the younger writer do the first draft and the older writer the final one, because the younger writers have to be more facile and more fertile in ideas, and he can work faster; but the older one is more critical and better at catching inconsistencies and infelicities.

JCT: When did your work with him begin?

LSdC: Well, Pratt and I collaborated before the war, on three of the five Harold Shea stories, and also on *The Carnelian Cube.* And then after World War II, when I went back to writing from service in the navy, we collaborated again, on, let's see—excuse me, we'd already written *The Land of Unreason* before the war. But we collaborated again on two more Harold Shea stories and on a series of short fantasies called *Tales from Gavagan's Bar.*

JCT: I wanted to emphasize these collaborations, because they do point up something that we have come to expect from so many of your books. Some kind of a historical premise, background context surrounds the story, and you love to bounce things off of that historical background. You may take a character, a la Mark Twain's *Connecticut Yankee,* back into Roman times, for example, but he won't be able to function the way that we think he should. Or you will bounce characters off of fantastic situations from, say, *The Faerie Queen* or the universe of *Orlando Furioso.*

LSdC: And don't forget the Finnish *Kalevala!*

JCT: This implies not just imagination, but a lot of erudition, and historical scholarship. Where does all of that come from?

LSdC: Oh, we get the books and read 'em. It's as simple as all that.

JCT: Not all writers do their homework like you.

LSdC: When Pratt said that he wanted to do a Harold Shea episode late in the world of *The Faerie Queen,* I had never read the *Faerie Queen,* but I got a copy and read it. I must say I found it pretty tedious for long stretches, and I didn't have quite the enthusiasm for it that Pratt did—

JCT: But yet you make it seem so much fun to the reader.

LSdC: Well, that's something else again. At that time, before World War II, there were two science fiction writers in the country who specialized in humor. And one was myself, and the other was the late Henry Kuttner. Curiously, both Henry and I are rather serious, even solemn fellows, in private life, but that's the way it sometimes is with professional humorists.

JCT: We have fun at the same time as we are educated and entertained. That's a pretty nice package.

LSdC: Well, I suppose it's simply a matter that I like to write the kind of things that I enjoy reading when other people write them. And that is the kind of thing that I enjoy reading most.

JCT: You mentioned *Gavagan's Bar*. Did those stories appear roughly contemporaneously with the *White Hart* series of Arthur C. Clarke. Which comes first there?

LSdC: Actually, both series were written at the same time, but at that time neither one of us knew anything at all about the other's project. I had met Art Clarke once, but that was briefly and had been some years previously. It was a pure coincidence. Actually, I think we had both probably read Lord Dunsany's "Jorkens" stories, but I'm not aware that Pratt's and my stories were consciously derived from them. Pratt just said how about a series of barroom tall tales, so off we went.

JCT: It's just, how you can keep such a firm grip so many times on historical backgrounds and yet still be a master of the tall tale. That is a very diverse kind of talent. [De Camp's wife, Catherine Crook de Camp joins us.] Catherine, you and your husband worked together on many, many books. Did your marriage and writing begin around the same time? I mean, *Lest Darkness Fall* came out in 1939 and has been in print now—how long, Catherine?

CATHERINE CROOK DE CAMP: Forty-four years.

JCT: Forty-four years!

CCdC: We got married on the proceeds of that book and we had to hold up our honeymoon for 10 days while Sprague finished the last 50 pages for John Campbell.

JCT: You must have had fun dropping an American archaeologist back in time to Rome in the sixth century AD! Lots of research, I suppose?

LSdC: I didn't keep track of the hours, but I did go through the main sources, both the primary sources like Jordanes' *History of the Goths*, and also secondary sources like *The Birth of the Middle Ages* and such. I didn't have a bunch of researchers to whom I could say, Go down to the New York Public Library and look up this and that. Oh, I'll tell you one funny thing that happened: No matter how careful you are, you always slip somewhere. Now, because this story is set in Rome under the Gothic kings, to lend verisimilitude, I had a couple of my Gothic characters exchange words in that language, which I looked up in the New York Public Library. And after the novel appeared, I got a letter from a professor at Columbia who asked, did I realize that on such and such a page where my characters were speaking Gothic, I had them wrongly use the nominative case!

JCT: Ah! Disgraceful! Whether it's *Lest Darkness Fall*, or some of the other historical-oriented books I'm thinking about, like *Bronze God of Rhodes*, and other things—Catherine, how much involvement now have you had with the research on these kinds of books?

CCdC: I would say that, on the whole, Sprague does the research. My specialty—I taught English—was style, stylistic characteristics. So I rewrite the books and improve—I may say, hopefully—the style. On some of the sections of the work, I do original work, and Sprague will go over my things. We have lived together and shared the same house for 44 years. We're still on more than speaking terms.

JCT: And I take it you have even survived the recent book that you have published. It's about Robert Howard, and sword and sorcery generally.

CCdC: Oh, yes, *Dark Valley Destiny: The Life of Robert E Howard* [See the interview with Dan Ireland about Robert E. Howard elsewhere in these pages.] Bluejay Books is a new company formed by Jim Franklin, who used to work as an editor for Dell, and he's doing a marvelous job. It's a beautiful book, hand-sown binding and acid-free paper. We found old pictures in Texan homes, garages, and attics that the people would get out for us from their albums.

JCT: Sprague, I hope that in another 100 years, another Sprague and Catherine de Camp will also be researching *your works!*

CCdC: And using acid-free paper! Paper that is acid-free will last for 150 years, they told me, whereas the usual paper used in books today will mean the books will vanish in 20, 25 years…

JCT: I bet you wish that many of the books you've had to go back and search through in dusty libraries have survived as well as maybe this one will.

CCdC: Oh, yes. Of course, the worst period is late nineteenth century, when the sulfite process had just come in. And everybody started using it for everything. So the books printed during that time are apt to be brown, crumbling fragments today. Now, two of the best books I ever had to work with were sixteenth-century books, when I was doing research on Sprague's *Ancient Engineers* in 1963. It was a full account of practical science through the ages. They were great big things, and one of them, for example, had medieval French on one side and medieval Italian on the other, so when I got stuck with one language I could use the other.

JCT: Now let's get back to Conan, because Robert E. Howard and his character of Conan are synonymous in the minds of so many folks out there. I'm dying to know if you can give me a little bit of a preview of *Dark Valley Destiny*. I've not read it yet. What we can expect—any new revelations about Robert E. Howard, the man who committed suicide at age 30 and yet has been such an influence upon succeeding generations.

CCdC: I'll start. Robert Howard, of course, was the man who brought heroic fantasy to America. And all modern historical fantasy derives from his Conan stories, something most people don't

know—just the way Tolkien brought modern heroic fantasy to England with *The Lord of the Rings*. And Robert himself was not the kind of man that he depicts in Conan: the womanizing free man who can bestride the Earth and do exactly what he wants. But, as Sprague will tell you, he was quite a different person.

LSdC: Yes, actually, he was shy, sensitive, moralistic—to the point of prissiness even; rigidly law-abiding, compassionate, sympathetic, and bookish; and though he would have denied it, intellectual. He didn't attribute any of those qualities to Conan, I assure you.

JCT: What is your opinion of Mr. Howard's research into the historical periods for his stories?

LSdC: If he had been living in a large city or a university town where he had access to really good libraries, he might have done a great deal along those lines. As it was, he got a great deal of his background out of the writings of other adventure story writers, especially writers for *Adventure* Magazine.

CCdC: Robert Howard lived in a town of 1,500 people, just in the middle of Texas, across the plains. At the time, a boom was coming in with the oil for the first time, and that meant his town as a boy was raucous with oil-well men and ladies of no-better-than-they-should-be reputations, and so forth. And apparently that change in the world, of his world, from agrarian to modern society, and the influences that came in with the oil boom, had a great influence on Robert Howard himself.

JCT: Sprague, I know that you personally are very much interested and fascinated by the kind of story that Howard wrote. Is this another extension, or indication of your interest in tall tales, generally?

LSdC: Oh, yes, partly. And then, well, I was a fan of Edgar Rice Burroughs' stories of John Carter on Mars back in the 1920s when I was a mere adolescent [see the interview with Robert Zeuschner about Burroughs' "John Carter" stories elsewhere in these pages]. And I've always had a weakness for the sword-and-sorcery type of thing.

JCT: Catherine, while we talk about such swashbuckling yarns, your husband appears and acts as a rather intellectual figure himself—very nattily dressed, with a superb goatee, and wonderfully bristling brows—the epitome of a scholar at an Ivy League school. And yet, here we are, talking about tall tales! I mean, you—Sprague—you've even written stories about Conan. Is there a contradiction here?

CCdC: That's a heck of a question to ask in public! But I'll tell you, yes, at home he is quite quiet and serious. He's just the opposite of Isaac Asimov, who booms around and acts like a clown in public. The public and private Sprague manages to be a humorist in his stories, and yet remains a very scholarly person.

LSdC: No, I'm not myself a Conan type at all. I mean, I'm very domesticated.

JCT: Can we call you a "*Solemn*-man Kane"? [A reference to Howard's swashbuckling character, "Solomon Kane."]

CCdC:Oh! Robert E. Howard is turning in his grave!

LSdC: Yes. In fact, I do most of the cooking at home. Yes, I do. At the time we got married I couldn't boil water without setting something on fire—

JCT: I bet a dollar you can't cook a meal, though, without going to the library first and researching the ethnic derivations of the cuisine.

CCdC: You're right, John! He has to do it from cookbooks. But he does a marvelous dinner. And I do all the business work, and with a hundred books we have a lot of business to take care of! In fact, I even have to hire a secretary to help with some of it. It's only late at night, after I've been on the phone with Los Angeles or some other publishing place, or with someone making dates with fans for new conventions, that I'm able to do my original work, when all is quiet.

LSdC: But, in addition, as I said, I'm not at *all* what you'd call an adventurer type. But I have managed to collect a number of swords. And when a burglar got into the house some years back, I chased him around with my samurai sword! But he got away, unfortunately. His head would have looked so pretty over the fireplace!

JCT: Ancient armaments as well as engineering techniques—I know you're kind of an expert in those as well.

LSdC: Oh, yes, I'm a minor historian of technology among other things, and I once wrote a textbook for the naval ROTC on naval weapons. I've managed to get around quite a bit in the last 50 years. I've also written a textbook on patent law and practice that has been cited in a U.S. Supreme Court decision.

JCT: I was going to ask you, what is the wildest assignment you've ever taken on, but you've given me two examples already.

LSdC: In addition, let's say I've been chased by a hippopotamus in Uganda, I've prospected for uranium by airplane, and I've entertained royalty and then survived a train wreck on the way home from the party. So you can't say I haven't lived.

JCT: Is there going to be an autobiography in the works?

LSdC: I've written one, but Catherine doesn't like it. She says it bogs down in the fourth chapter.

CCdC: Well, it's not true that I don't like it. But I told him that I wouldn't work on it anymore, unless he let himself go and told all when it came to important things—like how he proposed to me, which is really a very funny story. But Sprague only said, "Oohh, it's too personal! I don't think I'll do that!" Nope! You've got to tell *all* or people won't be interested.

JT: Well, don't forget that other people are going to come along and be doing it anyway, so you might as well get your two cents in.

CCdC: I told him I'd do it if he didn't!

LSdC: Well, there is that argument. I'll give it serious consideration. [de Camp's autobiography, *Time and Chance: An Autobiography*, appeared in 1996. It won a Hugo Award for Best Non-Fiction Book.]

JCT: Now, I had been requested to ask you about something called *The Purple Pterodactyls*. Is this correct? What in the world are we talking about?

LSdC: That is a series of short fantasies, which I wrote a few years ago, and which have been published in hard and soft covers. You see, I live on what is called the Philadelphia Main Line, the old four-track line from Philadelphia to Chicago.

CCdC: And the old track of well-to-do people who settled there. We are the beatniks of Philadelphia!

LSdC: You might say…At a New Year's Eve party, I heard one mainliner say about us, "Well, you know, I met a couple of democrats recently. They turned out to be quite nice people!"

JCT: Wait a minute, what does this have to do with *Purple Pterodactyls*?

LSdC: Well, my chief character in it is based partly on myself and partly on a banker friend of ours. And he is a mainline banker and a fairly conservative chap, but nevertheless he has an attraction for the supernatural. It kind of settles in with him. His name is Willy Newbury, short for Woodrow Wilson Newbury, and he's always getting involved, quite without intending it, with the supernatural. For example, his boss, the president, of the bank sends him down to Atlanta to look into the business affairs of a man who wants to borrow half a million dollars to expand his ornamental wrought ironwork business. Well, the story ends up with Willy being chased through tunnels under Stone Mountain by a mob of infuriated gnomes with sledge hammers—

JCT: Well, of course!

LSdC: —and things like that.

JCT: Before we run out of time, incidentally, Catherine, I understand that you have published some children's books on your own. Are they science fiction?

CCdC: Yes. My idea is to catch kids when young and get them broken in, so that they'll want to read Sprague's stories later!

JCT: I love it.

CCdC: I've done two books. One's called *Creatures of the Cosmos*, about a child and an animal from another world. And the other book is *Tales Beyond Time*. And then Sprague and I did another one together, an anthology, called *3000 Years of Fantasy and Science Fiction*.

JCT: I'm reminded of the old Winston stories for young readers of science fiction. What is your target age book with these books?

CCdC: Oh, these were for preteens, 10–12.

JT: Any parting shots from either of you about new works to come or general attitudes about your work?

LSdC: Hmmm. Let's see, what shall we say, darling? Well, we have several books either just out or coming out very soon. There's a novel, *The Bones of Zora*, which is the story of the first paleontological fossil hunt on my imaginary planet Krishna. It's part of the "Viagens Interplanetarias" series and the seventh set on Krishna [published in 1983]. And I went fossil hunting with a Smithsonian scientist to get the background for it.

JCT: I'd love to know where you researched Krishna, incidentally.

CCdC: Down in Texas, of course!

JCT: Of course!

CCdC: And we have another in that series, *The Knights of Zinjaban*, another Krishna story, that completes the problems of the first [published in 1991]. One's in press, and one's with—

LSdC:—One's with the agent. And—oh, yes, let's see, what else have we got coming up?

CCdC: Your three historicals are coming soon.

LSdC: Yes, a reprinting of some of my five historical novels. *The Dragon of the Ishtar Gate* has already come out, and *The Bronze God of Rhodes* is due out.

CCdC: *An Elephant for Aristotle*, too.

JCT: Alas, time to go. Nothing incomplete about this enchanter! Thanks for so many hours of enjoyment, too—on the printed page as well as this conversation!

CHAPTER THREE

The Bradbury Chronicles

Space travel is an immense thing, not a technological feat or military wonder or political toy, but a religious endeavor to relate to the universe.

> Ray Bradbury, Interview with John Tibbetts,
> St. Louis, 5 October 1996

"Ray Bradbury is science fiction's ambassador to the outside world," wrote Isaac Asimov in 1980. "People who didn't read science fiction, and who were taken aback by its unfamiliar conventions and its rather specialized vocabulary, found that they could read and understand Bradbury."[1] Now in his late eighties, Bradbury (1920–) eludes easy categorization. As an icon of today's imaginative fiction, Bradbury is an author, poet, playwright, essayist, lecturer, and visionary.[2] His acclaimed novels and short story collections *Dark Carnival* (1946), *The Martian Chronicles* (1950), *The Illustrated Man* (1951), and *Fahrenheit 451* (1953) have changed the face of fantasy and science fiction; and *Dandelion Wine* (1957) and *Something Wicked This Way Comes* (1962) have blended small town nostalgia with Gothic horror (both are set in "Green Town," his fictional version of his hometown of Waukegan, Illinois). From 1985 to 1992, Bradbury hosted a syndicated anthology television series, *The Ray Bradbury Theater*, for which he adapted 65 of his stories. His numerous honors include the National Medal of Arts, a special Pulitzer Prize Citation, the Grand Master Award from the Science Fiction Writers of America, and the First Fandom Award.

The featured interviews here include Bradbury with some of his closest friends and associates, Ray Harryhausen, Joseph Mugnaini, Forrest J Ackerman, William F. Nolan, F. Paul Wilson, and Donn Albright, who represent his circle of devoted friends, colleagues, fans, and bibliographers.

Ray Bradbury and John C. Tibbetts (photo by the author)

The Bradbury Collaborations "Stan and Ollie":
A Conversation with Ray Bradbury and
Ray Harryhausen

Ray Bradbury and Ray Harryhausen (1920–) have been friends since growing up together in Los Angeles in the 1930s. Harryhausen has become famous for his stop-motion model animation on such films as *Mighty Joe Young* (1949), *The Beast from 20,000 Fathoms* (1953, based on a Bradbury story), *Twenty Million Miles to Earth* (1957), *The 7th Voyage of Sinbad* (1958), and *Clash of the Titans* (1981). In 1992, he was awarded a Technical Contributions Oscar. The indefatigable Harryhausen is currently at work on the movie, *War Eagles,* which is in preproduction and slated for release in 2012.

This brief conversation transpired at the Archon Science Fiction Convention in St. Louis, Missouri, on 6 October 1996. Bradbury and Harryhausen recall here the friendship of their early days in Los Angeles and their subsequent relationship and collaborations. Also present as mediator was science fiction writer Greg Bear. My thanks to them for permission to record their conversation.

The Conversation

RAY BRADBURY: Ray [Harryhausen], don't you think we should first acknowledge that Forry Ackerman is responsible for a lot of our lives? God knows how many people he's helped over a period of 60 years or so. When I joined the Science Fantasy Society my last year in high school, I wrote terrible articles and stories for Forry's magazine, *Imagination*. He financed my own magazine, *Futuria Fantasia*. When I was 17 or 18, he called me one day to come meet a young man named Ray Harryhausen. That's you, Ray! Remember how we met and discovered that we both loved *King Kong* and formed a friendship? At your house, you showed me the dinosaurs and films you were making in your garage. One of the films shows the dinosaurs devouring his father, I believe! Another time, I went over to your house with my Aunt Neva and you made a life mask of me. Our lives interchanged.

RAY HARRYHAUSEN: And we'd go to a little theater outside L. A. and see the reissues of so many old monster movies. Then we'd go by streetcar to special previews of fantasy films out in Pasadena. Over the years, we cemented this desire to be part of the world of dinosaurs and of the future. Later, in 1994, I gave an Oscar to you for a lifetime dedicated to dinosaurs.

GREG BEAR: You both have influenced so many people.

RB: Greg, how many people do you know like us, who've been friends for a lifetime, who got what they wanted?

RH: Right! And thank God for that red street car! It didn't cost much to travel all around Pasadena or Eagle Rock in those days. *King Kong* brought us all together. One rainy night I went out on a streetcar to Hawthorn, outside L. A., and there in the lobby were these beautiful stills that I hadn't seen in years. I asked the manager if I could borrow them. He referred me to Forry. I called him and he loaned them to me. He trusted this kid he didn't even know. Then he introduced me to the Little Brown Room at Clifton's Cafeteria, where the Science Fiction League of Los Angeles met every Thursday. We used to talk about dinosaurs, space platforms, movies like *Metropolis*, etc. Everybody thought we were a little bit unbalanced. So there we all were, and it was all because of this bloody gorilla, King Kong. Life was much simpler, cheaper too. We used to have chocolate malts at Edith Clifton's cafeteria for 50 cents or a dollar. Then, Ray and I met you through Forry's magazine. And we've been talking ever since!

RB: Ray's Stan and I'm Ollie! To meet someone like Ray....I was lonely. We're all lonely people, special people in this world. We care more about space, about the future, than other people do. When I was in high school, I was almost alone among 4,000 students, caring

about these films and the future and space travel. And I found one or two kids who cared like I did. We clustered together; we needed each other's protection. People made fun of us. Many years later, when I was 30, I went to New York to a party; I was greeted by a bunch of ballerinas, doctors, and lawyers, and they called me Buck Rogers and Flash Gordon and made fun of me and what I wrote. Well, I got all their names and phone numbers. I told them that one day in the future, when we landed on the moon, I would call them. And that night, I was in London. I made three calls to three of them, and said: "Stupid son of a bitch"—and hung up!

Buck Rogers (KUCSSF)

JOHN C. TIBBETTS:How far apart did you guys live?

RH: Ray lived quite a distance from me. We used to occupy the phones, constantly, dreaming of working on a dinosaur picture. That all took place for reasonable rates on the Bell Telephone System. Today, as teenagers, we couldn't have communicated like that! We hung out at the Los Angeles Museum. Once, they had a display of models from *The Lost World* and little booths of translucent glass with frames from various films and how the elements were put together. And there were mammals found in the La Brea tar pits. Every Sunday, I would get my father to take me out to Culver City, where you could look through the wire gates and see the big wall that was still standing from *King Kong*. So you see, it was a kind of fanaticism involved; but it's the only way you can survive if you're doing something really different.

GB: You know, that wall was burned in 1938 as the burning of Atlanta for *GWTW*. It stood there for only five years. How did it actually happen that you got involved together in a film?

RB: It was a semiaccident, Greg. Ray was working on his first film, for a producer whose name I've forgotten, thank God. He called me over to the studio at Ray's suggestion and gave me a script to read, perhaps to make some changes. I went into the next room and looked it over, and I came out and said I might work on it. But the story was a little bit like a *Saturday Evening Post* story I'd done the year before, "The Beast from 20,000 Fathoms." I realized that he'd inadvertently offered the project to the very writer from whom he'd stolen it! It was embarrassing to everybody. The next day, I got a telegram offering to buy the rights to my story. The sad thing is, they didn't let Ray do more with the sequence about the lighthouse. It lasted only about 45 seconds or so. But it was a beginning for both of us. We moved on to other projects, and it's a shame we've never been able to work together again.

RH: When I look at the credits of films today, the lists for special effects is longer than for the rest of the film! After *Mighty Joe Young*, animation got a reputation for being terribly expensive. I went to the other extreme in trying to prove it wasn't so expensive. I didn't have an agent because one agent I did get lost me too many jobs.

Ray Harryhausen (photo by the author)

RB: One thing he left out was that we both wanted to "do" Fay Wray! Still, a part of me wants to work with Ray. When I did my television series, we were going to do "The Sound of Thunder" together; and I suggested that the producer get acquainted with Ray's work and get him out of retirement to work with us. They asked if he was expensive. I said I had no idea and offered to pay his salary myself. But he stayed retired, working on his marvelous sculptures. But the project never came off. Maybe we can get him out of retirement yet! You can't blame him. A guy named [Robert] Lippert treated Ray abominably! I saw it. I wrote a short story, "Tyranosaurus Rex," and in it, I had Ray as the hero who changed the dinosaur's face to that of Lippert's. And when they had a preview of the film, there was Lippert's face on the dinosaur! And on the way out, all the kids asked Lippert for his autograph! I used to live over by the Pickwick Theater in L. A. One night, my wife and I went to a sneak preview of a Lippert film, *Lost Continent*. The movie was really bad, which made me happy. Afterward, in the lobby, I spotted Lippert with all of his "yes-men" in the corner. I went over to him, stuck my hand out, introduced myself, and said: "It won't make a dime!

JCT: Looking back, what was the best thing about growing up in Southern California?

RB: I think we were lucky! It was the land of fruits and nuts! In L. A., even now, there's no intellectual or artistic hierarchy. Even the studio hierarchies keep changing. But when we were young, the Southern California atmosphere allowed us to grow up and become what we've become. When we gathered at Clifton's Cafeteria, there was no one to beat up on us. That had a lot to do with it. It was easy to find each other. Heinlein was there, Henry Kuttner, C. L. Moore, later Edmond Hamilton and Leigh Brackett. I used to see her at the volleyball court at Santa Monica Muscle Beach when I was 21 years old. I'd read her my dreadful stories and I'd read her brilliant ones. Gradually, over the years I learned how to write. The culture allowed us to be as crazy as we wanted to be.

RH: That's quite true. California is a great place to grow up, particularly Los Angeles. I always am so grateful to my parents who understood my tinkering with dinosaurs in the garage. My mother would dress the characters in my puppet films, my father would help with the armature and the lathe. Living near Hollywood helped, too. That was the entertainment city of the world, and my ambition was always to crack that part of the entertainment field.

JCT: Because special effects seems to be a theme this morning, we should think about a movie like *Fahrenheit 451*, which has no special

effects to speak of, as opposed to *Something Wicked This Way Comes,* which has many. Could you guys comment on how sometimes a movie with no special effects at all can be the most effective?

RB: I think we've gone so far in the direction of violence and too many special effects. I had a lecture in front of a bunch of virtual reality people a year ago. I told them they made brilliant fireworks; but when they blow away, the sky is empty. It's like a Chinese dinner—an hour later you're hungry. There are no vitamins in your movies. There are no ideas.

Find some way to put a soul into your special effects. Think of Robert Wise's *The Haunting,* and it doesn't show anything. It's widescreen but it's a radio show. And it scares the hell out of you. My wife won't look at it. We should show it to the special effects people and say, "For god's sake, control yourself!"

RH: We've been categorized as "special effects" people, but what we really wanted to do was deal with concepts. We wanted stories. I remember in my youth when Maria Montez and Jon Hall were galloping over the sands in movie after movie, and they talked about monsters and treasures—and you never saw them on the screen. I remember Ray and I went to see Wagner's *Siegfried,* the opera; and we were so upset that the dragon got stuck in the cave: something went wrong and we couldn't see the dragon at all. No, I always liked the visual, and I want to *see* the wonders. Like in the Korda *Thief of Bagdad,* where you actually *saw* these things. However, the young generation today has been brainwashed and their attention span is so limited that they don't want to see a story *develop.* Today, people don't have the patience to wait for the development and the preparation.

RB: It goes without saying I wasn't talking about the kinds of things Ray has made. But take things like *Mission: Impossible,* which are nothing but collections of cinematic orgasms. By the way, Ray, I gotta add to the story about *Siegfried*: we went to see the dragon. That's all we cared about. I never did see the damned thing. My wife saw half of a nostril! We got up and left. We didn't wait for the goddamned music. It was Fafner or nothing!

RH: We've always had our priorities, haven't we?

"Joe and Me": Conversations with Ray Bradbury and Joseph Mugnaini

The long partnership between writer Ray Bradbury and artist Joseph Mugnaini (1912–1992) reveals a remarkable kinship of vision and theme. It is one of the most distinguished collaborations in the history of fantasy

Ray Bradbury with a painting by Joseph Mugnaini (photo by the author)

fiction. Among the many Bradbury/Mugnaini pairings are the jacket covers and interior illustrations for *The Golden Apples of the Sun* (1953), *Fahrenheit 451* (1953), *Dandelion Wine* (1988; Easton Press edition), *A Medicine for Melancholy* (1959), *The Day It Rained Forever* (1959; British edition), *The October Country* (1955), *Something Wicked This Way Comes*; the first British edition; the 1988 Easton Press edition), *The Halloween Tree* (1972), and *S Is for Space* (1966). They also collaborated on a short film, *Icarus Montgolfier Wright* (1962), for which Mugnaini executed hundreds of drawings to accompany the film's narrative.

In these two interviews, each man shares his memories and insights into the other. I met Mugnaini several times, in Los Angeles, and at his home in Alta Dena in December 1990. The Bradbury interview transpired at his home in Los Angeles on 15 December 1995. It is but one among many talks him over the years, since the late 1960s. Here, we talk about Joe Mugnaini. It was just a couple of years after Mugnaini's death.

"He Was My Brother": Bradbury on Joe Mugnaini

JOHN C. TIBBETTS: Let's talk about Joe. When did you first meet him?
RAY BRADBURY: Meeting Joe Mugnaini was a fabulous accident. Back in the spring of 1951, my wife Maggie and I were walking around in Beverly Hills looking at the shops. And we came across a store that had been emptied recently. They had put on a benefit

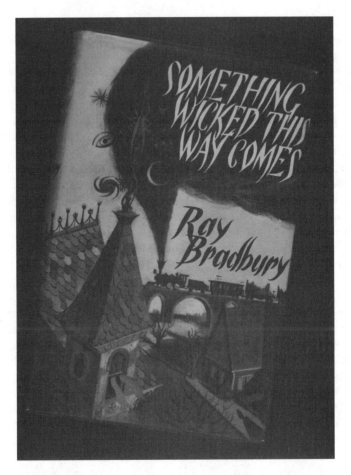

Cover, *Something Wicked This Way Comes* (photo by the author)

show and were selling paintings. In the window was this lithograph, or etching, of a kind of Victorian Gothic house for $75. Well, I couldn't afford that. But I went the next day and talked to the lady in the art gallery and offered to buy it on time. So I bought it and asked about the artist. She took me into the next room, and there was the original painting, in full color. I went ape—my god, I asked, how much is this? She said $300. That was ridiculous. Then she showed me another Mugnaini painting, a huge thing, which I now own, a kind of Renaissance train moving across a trestle with no beginning or end, a metaphorical train with jugglers and clowns and Renaissance people. I thought, this guy Mugnaini is reading my mind! When I finally met Joe, I found out that the house in the painting I first saw was the one that was situated across the street from where I used to live, at Temple and Figueroa, in L. A. I lived there 55 years ago and wrote

a play about it, *The Wonderful Ice Cream Suit* (it's playing in town right now, at Wilton and Fountain, as a musical). It was still standing when I met him. Later, it was moved.

JCT: That image of the train was to prove very important to you...

RB: Yes, later, I wrote a story about the train in Joe's painting—a screenplay for Gene Kelly. I had already been thinking about a scene like this since high school, about this carnival coming to town, with a carousel that ran backward, and so forth. You know, we had fallen in love with Kelly, and he used to invite us out to his house. He invited us to the premiere of his film, *Invitation to the Dance.* Walking home with Maggie, I told her I would tear off my right arm to work with him. She told me to go through my files and write something for him. I did, and I found my short story from *Weird Tales*, "The Black Ferris." I spent two months working out a treatment and a semiscreenplay of 70–80 pages. I gave it to him and he loved it. He took it to London and Paris and came back a month later, saying, "I'm sorry, Ray, nobody wanted to do it!" So instead I sat down and wrote the novel, *Something Wicked This Way Comes.* So, the screenplay became the novel, which later became the screenplay. I must be the strangest writer, I think, in the history of writing: I do all of these things that start as poems, become stories, become novels, become screenplays, and then novel or stories again. It's like one of those weird trees you see in Joe's trees that branch out all over the place.

JCT: Let's get back to Joe Mugnaini. What happened next?

RB: So I fell in love with Joe's work immediately. I said, how much is the second painting? 400 or 500. The prices were impossible. I asked for his address and called him in Alta Dena, asking him if I could come up to visit. A friend of mine drove me up, and I saw this gorgeous stuff and I said, "Look, let me be as honest with you as possible. I can't afford the gallery price. I don't mind bypassing the gallery. If the painting doesn't sell, I'll give you what you would have gotten from the gallery." I told him I hoped it would sell, but I also told him I hoped it wouldn't! Two or three weeks later he called me and told me to come and get the painting. The first one I bought was the Gothic house. I found out later he pulled the painting out of the gallery to give to me. That's really something, isn't it? So our friendship began on a note of his wanting to please me. I found that out years later. I made an agreement to buy both paintings over a year's time.

JCT: From there, when did he begin to do illustrations for your books?

RB: I immediately asked him to do the cover and interior illustrations for some of my books. I had already made designs for them, rough sketches. I just put down the metaphor, crude as it was, and

he took off from that. I said to Joe, "I need a cover for my next collection of stories, *Golden Apples of the Sun* [1953]; can you give me an example? Well, he went on to do 20 jacket designs. I still have half a dozen of them put away. I picked one and sent it to Doubleday.

For *Fahrenheit 451* [1953], I introduced Joe to the Ballantine people. I had seen a sketch of his based on the mythology of Don Quixote, the figure in his armor with his hand over his eyes, the put-upon dreamer. I loved the image so much, I asked Joe to dress this knight in newspapers instead of armor and have him standing in a bonfire of books. The books are burning, and he is burning. That became the metaphor for the book. He later reworked that image for the Easton Press edition. He also did a wonderful painting for me for Easton's edition of *Something Wicked This Way Comes.* Anyway, I loved that illustration. I made him do a duplicate for me. I've got that up in my FAX room. That's the way we worked. I would give him suggestions on some occasions and on others, none at all.

JCT: What kind of advice did he take from you?

RB: It was a perfect marriage. I told him, "Don't show the characters' faces!" In a lot of illustrated works, they show you the faces of the characters, and the reader is disappointed, because it's not the same face in his imagination. I said, "Turn the faces away. The body can be almost anything and still represent the character." He always did that. It's rare that you see the face, except for my story, "The Dwarf," which is very grotesque.

JCT: Was it always such smooth sailing between you two?

RB: We always had fights, but not like you would think. For 40 years, whenever I wanted to buy something, he'd offer to give it to me! I'd say, "Joe, for heaven's sake, you've got to value your things as much as I do!" I sent him a check for $4000 for the "Dust Witch and the Balloon" image in the Easton edition of *Something Wicked* and he sent back $2000. I sent that back to him and he donated it to the Goodwill or some Catholic agency like that. I finally had to accept the fact that that was the way he was. But, dammit to Hell, I don't want to take advantage of artists. Too many people do that; and a lot of gallery owners are not nice people. Now, I have 200 or 300 of his things, like sketches, bits and pieces of concepts, lithographs, and paintings. The thing about this is that I think that Joe never got the recognition that he deserved. When I think about Jackson Pollock and Franz Kline and others, all no-talented people, as far as I'm concerned—well....And the "realist" painters like Andrew Wyeth, they are too popular to be taken seriously, I guess. Once in Chicago, between trains, I went out to the Art Institute to see a Wyeth show. There was a line around the block. I managed to

get in, though. I thought to myself, "Please God, let the curator know who Ray Bradbury is!" [laughs] I don't pull rank like that most of the time! But I had only two hours between trains. It was an incredible show; and, of course, I loved his father, N. C. Wyeth, before him, when I was a child. But the fact that nobody knows who Joe Mugnaini was rankles with me terribly. Anything I can do to change that, for the rest of my life, like talking to you, I'll do.

JCT: You worked with Joe on the 1962 film adapted from your story, "Icarus Montgolfier Wright."

RB: At one time, it was released by Format Films and Pyramid Pictures . I don't know if there is a distributor for it now. I'd like to get hold of it now and cut about three or four minutes. I was much younger then, about 41 or 42 when I made that film with him. I hadn't yet learned much about timing. It didn't need to be 17 minutes, but maybe just 14. Now that we have videocassettes, it might be possible to make a cut. I'm impatient when I look at it now; I say, "Come on! You've made your point! Let's get on with it!"

Joe gave us a thousand drawings. You couldn't stop him. You turned on the faucet and you couldn't find the handle to turn him off! We all worked for about a year on that thing, for free. This was in l961–1962. We got no money. Out at Format Films. George Clayton Johnson, who helped on the screenplay (it was his idea to do it in the first place), introduced me to the Format people. I worked on the script, and George may have done a preliminary script. I had meetings with Joe and the Format people. He brought in dozens of sketches every few days. Some of the sketches were better than the final things on the screen. They were freer. (Of course, if you work too free, you end up like Pollock—you vanish up your own backside!) I have quite a few of those sketches.

The film had a very limited release, in just a few theaters for a few days, late in the year. Then we got nominated by the Short Subjects Committee for the Academy Awards. There were five nominations, and we had a screening at the Academy. I went there with my wife and friends. They showed all five of the nominees, and everybody said it was a winner. I didn't think so. I don't kid myself. I know which of my works make screenplays and which don't. I was convinced that another entry called "The Hole" would win. It was about a black laborer digging a hole in the street, a bomb shelter. I thought people would think it a "safe" vision of the future. Mine was too far away. Space travel hadn't been invented yet. Mercury and Apollo missions were still years ahead. Who cared about space travel? Who knew anything? Sure enough, "The Hole" won the Award. Joe took his daughter Diane and I took my daughter Susan, and we dropped them at the

Awards ceremony. Joe and I didn't go. We went back at 10 o'clock and sure enough, it didn't win. All the way home, Joe was muttering, "God damned son of a bitch! Bastards!" Etc., etc.

JCT: That's how I remember him. He could be pretty blunt.

RB: God, he had a vile tongue! I heard him lecturing in class at times, and he loved to shock people. Once at the Otis Art Institute, after I had only known him a few years, he invited me down to visit his class. He didn't tell me what kind of class it was. There was this naked girl lying there, you know? And I had never seen anything like that! A naked lady in public! I went into shock. Joe loved every minute of it. He said, "Come on in, Ray! Give her a bite! Give her a bite!" It's interesting, most men can't get away with that type of thing; but Joe could. Bette Jaffe, who was one of his students, told me the same thing: He could say anything and get away with it. The women were never upset by it. Occasionally, Joe and I would go down to a museum and look at paintings. Once, we went down to see a Goya, which was a disappointing picture. In the middle of a gallery, a docent was leading a group of 20 people through, with all kinds of high-falutin' talk [burst of laughter]. And in the middle of it all, Joe threw his head back and shouted, "Bull shit!!!" Well, all the pictures tilted on their hangers, dust fell from the ceiling, and the starch went up everybody's spine! Everybody marched out of the room like wooden soldiers. I hugged Joe and kissed him. I said, "Oh, Joe, I've been wanting to say that for years! To all of those people who take Art so seriously!" And when I spoke at his Memorial Service [barely stifled sobs], I ended my speech by saying, "Wherever Joe is—and I hope he's somewhere—he's crying 'Bull shit!' and all the clouds are hanging wrong, and God's having a nervous breakdown!"

JCT: People like me have a tendency to put both your names together. Few writers have been so well served as you have been by him.

RB: He was my brother, he was my twin. I was incredibly fortunate to find him. What if I hadn't gone by that gallery window that night? That's really scary. His life would have been changed, and mine too! Forever. I can't think of any other illustrator for certain kinds of things like him.

"The Third Elephant": The Mugnaini Interview

Joseph Mugnaini was born in Viareggio, Italy, on 12 July 1912. A few months after his birth, Mugnaini arrived in the United States with his family. Settling in Los Angeles, he studied at the Otis Art Institute. After service in the Army during World War II, he returned to Otis as an

Joseph Mugnaini (photo by the author)

instructor and taught there until retirement in 1976. His published books include *The Hidden Elements of Drawing* (1974), *Joseph Mugnaini: Drawings and Graphics* (1981), and *Expressive Drawing: A Schematic Approach* (1988). He is celebrated in the fantasy community for his many collaborations with writer Ray Bradbury. The splintered, facet-like forms and decorative arabesques and scrolls of his gnarled dwarfs, gaunt women, gabled houses, strange moons, and flying clouds became an inseparable part of the Bradbury universe. A volume on Joe's life and work, *The Wilderness of the Mind*, by Ryan Leasher, is slated for publication in 2011.

Joe Mugnaini died in Los Angeles on 23 January 1992.

I will never forget Joe's bristling energy and vitality. I can still see him, scowling amiably at me from beneath his hat brim, bursting into hearty laughter and expostulations as he talked. His hands were always in motion, and after finding some note paper in my hotel room, he happily

scrawled away, the restless lines dashing and skittering across the surface in quick, rapier-like jabs and thrusts. He seemed to be conducting with the pen, as an orchestra leader would gesture and cajole sounds from his players. His dynamic lines seemed to gather themselves of their own accord into forms that coalesced into living images.

At our last meeting, he was anticipating the opening of a retrospective of his works at the Orange Coast College Gallery in nearby Costa Mesa, California. The retrospective encompassed 40 years of work—illustrations for books, films, and prints from the Library of Congress and the Smithsonian. Perhaps it was this event, among other things, that made him so receptive to talking about his career.

Interview

JOHN C. TIBBETTS: Take us back to some of the first images that ingrained themselves into your boyhood consciousness.

JOSEPH MUGNAINI: The first image of my childhood I can recall is of a soap box. I was five years old and my mother had told me to go to the grocery store to get some "Rub–No–More" soap. On the package was a picture of a mother elephant washing her baby with the soap. Within that picture was another soap box, on which was displayed another elephant and her baby. And in that was another picture. . . . Well, I could never get past the third elephant. I'm still trying to get beyond that third elephant!

JCT: Your family is of Italian descent?

JM: I was born in Viareggio, on the coast of Tuscany, Italy on 12 July 1912 and was brought over here, to Riverside California, before I was one year old. I spoke Italian before I spoke English. But I picked up English very easily and it is my language now. We came to Los Angeles when I was about 12 years old. I began to study art rather late. I grew up during the Depression and, between stints working as a truck driver and furniture finisher, went to the Otis Art Institute. I studied Drawing and Painting with a guy by the name of Ralph Holmes, who painted California eucalyptus trees. That was about all he painted, I think! I learned a lot by myself and with the other students. I think they were more important than the faculty members! During the War I was an instructor of photo reconnaissance in the Intelligence Service in Germany. After the War, I went back to the Otis Art Institute on a G. I. Bill. After about three months, I became a teacher. I began to show my work around. I showed some things in a national show at the Library of Congress and I won a First Prize in graphics. The year after that I won it again. Three years in succession I won the Pennell Prize. My first illustration project was a set of lithographs

illustrating Bullfinch's *Age of Fable* for the Limited Editions Book Club. Meantime, I became the head of the Drawing Department at Otis, where I've been for about 30 years until 1976, when I retired. As for other teaching I've been a Visiting Professor at the University of Colorado, and I've also taught at Temple University, the University of California, Sonoma, the University of California, North Ridge, and in workshops everywhere.

JCT: You promised me you would talk about your old friend and collaborator, Ray Bradbury.

JM: Well, it's true I met Ray Bradbury when he saw a piece of mine in an exhibit in Hollywood. He saw it in a window. It was a lithograph of a train going over a bridge. It seemed to remind him of a book he had written, called *Dark Carnival* and of a story of a train that travels only at night. And so he called me up and wanted to know if I wanted to illustrate his new book. I said, sure. I had heard of him because he was a very popular guy. I think a lot of GIs who came out of the Army were reading his books. He called me up, and a friend of mine went to pick him up and bring him over to my house. He got very excited and told me I was doing graphically what he was doing literally. We talked, and I ended up illustrating *The Golden Apples of the Sun* for Doubleday. From that time on, I did a lot of his books.

JCT: What kind of guy was Ray at that time?

JM: At that time, Ray was living on meager wages he got from stories. He's always been a very open, very enthusiastic type of guy. It's impossible to talk to him without becoming enthusiastic yourself. If you ever visit his office, you'll walk into a magical place. He has pictures and toys and all kinds of things, and you have to crawl through there to make your way to his desk. My own studio is rather cluttered, too, with lots of different etchings, lithographs, and paintings. Anyway, when I worked with Ray on *Golden Apples*, I made some sketches and went to see him. Then he made some sketches of his own. His drawings are very interesting, a little more sophisticated than somebody like, say, James Thurber. Then we made some decisions and went from there. It was a real collaboration.

JCT: Those first images for him were mostly pen-and-ink, weren't they?

JM: Yes, I used line drawings with a quill pen for that book because I felt that using simple lines would reproduce better on pulp paper. I kept the lines very controlled and precise to correlate with Ray's images. I also kept the picture size close to the desired size on the finished page so they would not lose too much in reduction. It worked out very well, I think. I remember working on some of those stories: The first one I did was for "The Sound of Thunder," and Ray got very excited about it. For "Fruit at the Bottom of the Bowl," I had to convey the idea of thousands of spiders. So I made a

twirling sort of circular design on a piece of paper, something that was very loose and could be used to that effect. For "The Meadow," the angle of view was very important. I needed an impression of monumentalism, something that needed a sharp upward angle. I like to use extreme low angles. I did that a lot in the images I did later for *The Martian Chronicles*. In "The Pedestrian," I used lots of angularity. No curvilinear movement. The angularity of the bricks was carried through the forms of the city. "The Powerhouse" gave me a chance to work with desert forms. I love the desert and have done a lot of paintings of it. I like the geological structures. They are very dramatic. "En la Noche" is as abstract as a Mondriaan. The details are all categorized by a very simple rectangle shape.

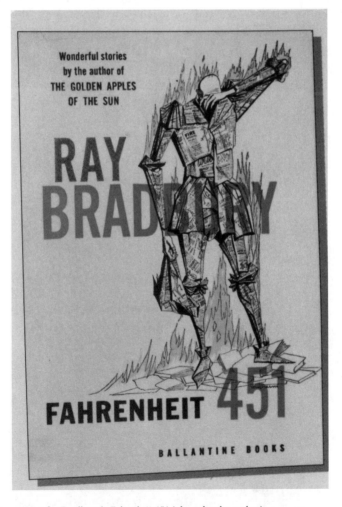

Mugnaini cover art for Bradbury's *Fahrenheit 451* (photo by the author)

JCT: Forgive me for asking, but did the job pay you well?

JM: I did the whole thing for practically nothing. I think I got $250 dollars for all the drawings. Ray has some of the originals and I have kept some. Most of them will be on display at the Orange Coast College Art Gallery. Then we did *Fahrenheit 451* together. That was during the anti-Communist McCarthy period, you know. I remember Sidney Kaufman, who was an editor at Ballantine Books at that time, who came out to California; and we were apprehensive about publishing the book. It was an attack on McCarthyism. But we did it and I did the jacket and the first illustration. It came out in paperback and hardback almost simultaneously.

JCT: I am particularly fond of your images for *The October Country*.

JM: I think a lot of people remember that, which actually was a revised version of Ray's earlier collection of stories, *Dark Carnival*. In "The Wind" I wanted more angular shapes. The shapes for

"The Dwarf" and "The Homecoming" (images courtesy of The Joseph Mugnaini Estate, www. josephmugnaini.com)

the sky and clouds are almost lethal. If I had made little round shapes instead, the effect of Death would have been destroyed. The houses and trees in these drawings all come from a kind of graphic epistemology. For example, you look at this tree in "The Homecoming," you know I've gone back all the way to the beginning of evolution when life began to separate itself into vegetation and so forth. Then you come forward in the evolving process to this tree. As a compositional element, the tree is also part of our visual journey to the house in the background. I love these kinds of houses. They intrigue me. Hell, they're like Gothic cathedrals, in a way—only these particular ones you don't find in France, but in Green Town or Pasadena! And, of course, I have a lot of

fun working these basic architectural shapes into wild decorative fantasies, imaginary structures of my own devising.

[Note: As he talked, Joe doodled away with his pen, producing spasmodic lines that looked almost like seismic readings of our conversation. The images didn't resemble anything in particular; they just were there, constantly growing and changing (I have kept these images to this day)].

JM: The way I work is to take a pencil or pen—I'm working with a line in this case—and do a lot of scribbling until I accidentally strike an image that seems to reflect what I have conceived in my mind. I always say that you can study art and you can gain knowledge and experience, but the muse of art lives in the wilderness of the mind, an area that you don't understand yourself. But if you're lucky, you can go beyond the frontier and go to this unknown area and maybe come back with something. But it has to happen accidentally. Like a composer at the keyboard of a piano, knowing that something has to come out with sound—something that when you hit it, even by accident, you recognize it and put it down. Then, if I work out a very rough sketch, I put a piece of tracing paper over it and begin to develop it, reducing it down to a very simple line or mark.

I don't say I'm putting blackness onto paper. I say I'm working against the whiteness. I have only so much whiteness to spend, so to speak. I'm allowed just so much of the whiteness to come through. I cut away the whiteness, just like a sculptor cutting into a solid piece of material.

If I were to take a piece of charcoal and put it on the paper, then it would begin as just a black-and-white situation. But, if I were to rub it slightly, then it would become something different, something that is light and dark. It's an atmosphere, now. I've changed the damned thing just by doing that. Now, you're conscious not only of a line, but also of the pressure of the tool, the pen, or the brush; and of the speed with which it was applied. It's not a question of subject matter, but of the viscosity of paint and the strokes.

I never do any research. For example, I just got through painting the Grand Canyon. And I didn't go to the Grand Canyon. I'm not a jackass who just stands out there painting the Grand Canyon. I come home and I think about geological structure and I think this way. The Grand Canyon is in there. Know what I mean? I do keep notebooks, though. When you do a notebook, you hold a dialogue with yourself in the future. Later when you read the notebook, you're holding a dialogue with yourself in the past. And that's when you meet a stranger!

JCT: I have to ask you *Icarus Montgolfier Wright*? It's become something of a legend—especially because you can't find a print of it, anywhere.

JM: I know. I have my own print, thank God. Ray had written this story about a little boy who wanted to fly. And the boy dreamed he was Icarus and one of the Montgolfier Brothers and one of the Wright Brothers. Ray went to a film company, Format Films (which was doing "The Chipmunks" at the time) to see about financing a film version with me. James Whitmore and Ross Martin donated their time to the film. I did over a thousand storyboard sketches and hundreds of paintings in acrylic. It was nominated for an Academy Award and it won a Golden Eagle Award. By the use of the camera and editing we were able to get a lot of dynamics and contrasts and overlaps. There was a sense of motion all the way through. The movie came out around 1962, long before we went to the moon.

JCT: Before we wrap this up, please talk to me about some of your own concerns in art and society, generally.

JM: I'm an old fart. I'm on third base, heading for home. I've turned into a curmudgeon, I guess. I'm pissed off at what's happened to this planet. At the idiots who are destroying Nature. I'm making a statement that way. I'm doing a lot of etchings and making statements about how I feel that we're not respecting Nature. We've turned into a hedonistic society and nothing matters but our own selfish interests. As for what passes for art instruction these days, I regret that the colleges are not producing art; that they'd rather promote what I call "cocoanut counting," which is everything but art. Art departments are being emasculated and being done away with. The business men don't give a damn!"

[Note: Shortly before our last meeting in Los Angeles, Joe telephoned my hotel room. "I'll bring the film," he announced abruptly, without any introductory explanation.

"What film?" I asked, temporarily confused.

"*The* film—*Icarus Montgolfier Wright!*" he shouted. "You wanted to see it, didn't you?"

Really. It had eluded me for years. Now, as I blinked at my phone, I must have spluttered a bit: "You mean, you're willing to bring it *here*—?"

"—Yes, and I'll bring my own projector!"

And so he did. What a happy hour that was in the dim hotel room, watching that dazzling square of light on the wall, hearing Joe's growling voice above the whirring noise of the projector....

That was the way it was with Joe. Even for people he scarcely knew, he shared his world unselfishly, unstintingly. He bounced his enthusiasm off you and you felt like a sounding drum.

Like his drawings, Joseph Mugnaini's life was a lively and dynamic line, a line that extended and grew, relentlessly tracking a distant and unknowable vanishing point. Now, since his death on 23 January 1992, I'm sure that restless line has at last traversed the regions beyond the third elephant.]

The Bradbury Circle

These are interviews with more of Bradbury associates, archivists, and friends—Julius Schwartz, William F. Nolan, F. Paul Wilson, Forrest J Ackerman, and Donn Albright. With the exception of the Schwartz and Albright interviews, they were conducted at the World Fantasy Convention in Schaumburg, Illinois, on 30 November 1990. The year marked the fiftieth anniversary of Bradbury's first professionally published story.

"Let's Put on a Show!" Julius Schwartz

Julius "Julie" Schwartz (1915–2004) was an influential comic book and pulp magazine editor during science fiction's Golden Age. He is best known as a longtime editor of the DC Comics Group, where he was primary editor of the *Superman* and *Batman* franchises. In his early days in the 1930s he was a prominent figure in the burgeoning "fan" movement in science fiction. He was Ray Bradbury's first agent and sold his first stories. He was inducted into the comics industry's Jack Kirby Hall of Fame in 1996 and the Will Eisner Comic Book Hall of Fame in 1997.

Our interview transpired at the Rivercon in Louisville, Kentucky in July 1994.

Interview

JOHN C. TIBBETTS: How did your association with Ray Bradbury come about?

JULIUS SCHWARTZ: To tell that story I have to go back many years, to a rainy day in New York City. It was around 1931 and I was just 16. I had nothing to do. Almost by accident I found this big-size magazine, and it had the title *Amazing Stories* on it. It had a garish cover. I flipped through the thing and I came upon a story called "A Runaway Skyscraper." And the title intrigued me, "A Runaway Skyscraper"? I mean, how does a skyscraper run away? So I read the first line of that story, and it changed my life. I'd bet you'd like to know what that first line is? That opening line was as follows: "It all began when the clock on the Metropolitan Tower started to run backward." I thought, "Oh, the clock runs *backward*???" And so I started to read on. The editor was a fellow

named Hugo Gernsback. He took the word "scientific" and "fiction" and coined the word "scientifiction" for the kind of stories he was publishing.

JCT: An awkward word. Today, we would just say "science fiction," or "SF."

JS: Right. But that was the beginning. So that changed my life, because I got very interested in science fiction. The next thing that changed my life was a club called The Science Years, which met regularly in the Bronx, New York, where I live. I decided to attend the meeting, because I wanted to meet other people who were interested in science fiction. None of my friends would read the stuff. When I told them some day we were going to travel to the moon, they would say "Sure, you're a lunatic, that's why." And when we formed a baseball team called The Meteors, they didn't even know what meteors were! So I wanted to meet people who were interested in science fiction. I met this fellow named Mort Weisinger. Mort and I eventually developed a very close friendship. He became my best friend, my closest friend. Together, we changed the course of science fiction comic books. Because in due time, Mort became the editor of *Superman* comics for about 30 years, and when he left, I took over and became editor for another 15 or 16 years or so. We met two or three times a week; we lived about 15 minutes apart, and the only way we could get together was to walk—neither one of us had a nickel for bus or car fare. We realized no one knows anything about these writers who write these science fiction stories. Who are they?

Now, we come to what happened next. We thought, Why don't we write to these various authors, artists, and editors? And let's get some information about them, and maybe we will get to know them, and maybe we'll let other people know about them. The first one who responded was a writer named Edward E. Smith, "Doc" Smith, who wrote the *Skylark* stories. And there was such an exciting account he gave of himself that I said, "Gee . . . we would like to share this with other people; but how are we going to do it?" Remember the old Judy Garland or Mickey Rooney pictures where they said, "Let's put on a show"? Well, I told Mort, "Let's put on out a fan magazine." There were no fan magazines at that time. There were movie fan magazines, but there were no science fiction fan magazines. Now the problem arose. You always need an editor who functions as the fellow who says what goes into the magazine, what it looks like, and so on. So Mort and I were only 16, and we didn't feel we were capable enough of being an editor. So we asked a fellow named Alan Glasser, who was a professional because he had sold a story to *Amazing Stories*. That excited us so much. That was beyond our wildest dreams. Maybe secretly we all hoped that

someday when we grew up, we would write a story that would be sold. We wouldn't think about being paid, we just wanted to get our names in print. So Mort and I agreed that Alan Glasser would be the editor of our magazine. We got the names and addresses of fans from the mail in the back of *Amazing Stories*. A few responses came back. We couldn't afford to print it, so we decided to mimeograph it. Glasser would mimeograph the first two, Mort and I the next two, and I came up with the title called *The Time Traveler*. I figured, we're traveling in time, and we're going to inform everybody what stories by which writers would appear, and when, and what they were all about. So we put out *The Time Traveller* for 10 cents. I claim it was the first science fiction fan magazine, ever. Now, of course, there are dozens or hundreds of fan magazines. They even give out a Hugo Award these days for fan magazines, but Mort and I were the first ones to come up with the concept.

JCT: Were science fiction stories appearing in other places, besides *Amazing*?

JS: You're getting ahead of me! There were so few science fiction stories being printed that we had to look around for other places, like *Argosy*, which once in a while would print science fiction. By this time there were four science fiction magazines, *Wonder Stories*, *Amazing*, and *Astounding*. But you can read those in one day, so what were we going to do for the rest of the month? So we looked for other places where science fiction would appear. We started another fan magazine called *Science Fiction Digest*. And Mort and I interviewed other editors. They were like us; they would say, "I would love to have a time traveling story for the next issue, but we don't have one." So Mort and I would say, "Hey, we know all the writers by this time, why don't we tell writers what the editors are looking for?" So Mort said, "I have a better idea; tell these writers to send the story to us, we'll agent it for you." We collect 10 percent. So I became an agent. So you see how one turning point led to another. In due time Mort had an offer of a job to become an editor of another science fiction magazine, *Thrilling Wonder Stories*. And that was the height of any fan's ambition. So Mort left to become the editor of *Thrilling Wonder*, and I carried on the agency by myself.

JCT: Could you tell us about the very first World Science Fiction Convention?

JS: It took place in New York in 1939. Sam Moscowitz was the chairman. I was one of those who helped out. And we hoped that people from around the country would come to this convention. We called it a "World" Convention because New York City was holding a World's Fair at the time. And we hoped some people outside New York would come. We sent out notices and put the information in the various science fiction magazines, and some people came in from Philadelphia, a few from Chicago, and some,

eventually, from Los Angeles. Now, let's jump to L. A. A guy named Forry Ackerman claimed that he was the "No. 1" science fiction fan, and he was determined to go to that World Science Fiction Convention. He had a friend who was also a fan who also wanted to go. He was 4 years younger than Forry, maybe about 18. But he had no money whatsoever. So he went to Forry and said, "Forry, I would love to go to that convention; could you lend me some money?" So Forry said, "Well, I can lend you 50 dollars." So the kid took the 50 dollars and rode a bus clear across the country, because it was the cheapest way to go. He went to the YMCA, which I think cost five dollars a week.

Now, this young kid was determined to become a writer, and he knew I represented only professional writers. And it was very hard for someone who had never sold a story to sell a story to anyone unless he had an agent who had confidence in him. So in due time, this kid got ahold of me and expressed his desire to become a writer. This was around 1941. I told him to send me some things because he was a friend of Forry. So sure enough, I kept getting stories and stories. They weren't very good, but they were starting to improve. And there was one story called "The Pendulum," which I might have a chance to sell. You know, when you're an agent, you try to sell a story for the highest-paying market, which at that time was *Astounding Stories*. They paid a penny a word on acceptance. They rejected it. I sent it to two or three other magazines. They all rejected it. Finally, I sent it to a magazine called *Super Science Stories*. And the editor I knew quite well, and I kind of said, "This is a story that was written by a fellow who hasn't written anything but who I think has a lot of promise. Would you read it and give a little special attention to it?" Well, he read the story and said, "Yes, I'm going to buy it. I'm going to give you half a cent a word on acceptance."

I had the check in my hand, and I was going to mail it to this writer, when I had a better idea. I was traveling out west with Edmond Hamilton, who was a big name at the time. We were going out to Los Angeles, so I said to Ed, "Wouldn't it be great if I brought the check out with me? We're going to drive day and night, so we can be there in five days, as long as it takes the mail to get there." So we get out to Los Angeles, and we find a room to stay in. We're both hungry, and we decide to get something to eat. So we get down to the corner, and there at the corner selling newspapers was the very young fellow whose story I had just sold! As the cars stopped for a light, I went over to him and I said, "I have good news for you; I have a check for you. I sold your story, 'The Pendulum.'" And that was the first story I sold by this fellow. And I was able to sell 69 more of his stories to the pulps before I became editor of *Comic Magazines*. I often like to say I discovered Ray Bradbury, but that's not true. We discovered each other!

JCT: Were some of Ray's stories difficult to sell?

JS: Oh, sure. All of a sudden, Ray started writing stories with a weird horror atmosphere. I said, "Ray, what happened to the science fiction element you were trying to get into?" He said, "I'm really more interested in fantasy and horror." I said, "Then you have to go to *Weird Tales*. They pay a penny a word on some publications, so you may have to wait a while." Most of his stories that I sold from that point for the next few years went to *Weird Tales* and other magazines, like *Detective Tales* and other pulps owned by Popular Publications.

JCT: I understand that not so long ago Ray paid you a tribute...

JS: So we're in 1981 and I'm at a convention in San Diego. I was persuaded to become a Guest of Honor to receive what is called an "Inkpot Award." I was very reluctant to go and my wife was ill. But the fellow who was involved wrote back and said, "Would you come if Ray Bradbury presented the award to you?" And I told that to Jean, my wife, and she liked Ray, and Ray liked her very much, and she said yes, she would come. So in 1981 I received the Inkpot Award from Ray Bradbury. By the way, when I started to march offstage, Ray says, "Oh, no we have another surprise for you." And out of the audience slips Harlan Ellison. And he announces to one and all, "I have in my hands here, a Batman script which I promised Julie ten years ago to write!"

"Dandelion Chronicles": William F. Nolan

William F. Nolan (1928–) is best known for his many short stories and his cowriting of the classic science fiction novel, *Logan's Run* (1967) and the script for *Burnt Offerings* (1976). He is the twice winner of the Edgar Allan Poe Award from the Mystery Writers of America and in 2010 received the Life Achievement Bram stoker Award from the Horror Writers Association. With Donn Albright, he is the most devoted of the Ray Bradbury bibliographers and archivists. At the time of this interview, Bill was planning to edit, with Martin H. Greenberg, an anthology tribute to Bradbury, which was published as *The Bradbury Chronicles: Stories in Honor of Ray Bradbury* (New York: Penguin, 1991).

Interview

JCT: I guess you and Ray go way back to the 1940s?

WILLIAM F. NOLAN: Yes, but only in a way. We go back to 1944 when I read him in *Weird Tales* and began to collect the issues to see the latest Bradbury stories. I finally met Ray in July of 1950. It was two months after *The Martian Chronicles* had been published.

Ray had only two books out at that time, *Dark Carnival* (1946) and *The Martian Chronicles*. He was a young man of 29 turning 30, and his daughters were just babies. He was dangling little Susan on his lap, and now she's very much an adult. I was 22 years old. I was a firecracker. I exploded all over the place. I was yelling, waving my arms, full of enthusiasm. Ray said it was like being with a wild windmill with all the blades whirling in the wind...

JCT: So, how did you meet?

WFN: Ray had written a letter for a fanzine I was in, the *Fabulous Faust* fanzine, based on the works of Max Brand, the western writer. I was a great Faust fan and still am, for that matter. I've done a lot of work on Faust and written a biography of him for Bowling Green. Ray had contributed a letter to the fanzine, and his address was in Venice, California. That was just after he was married. He was living with his wife at the time. They didn't have enough money to have their own home. I had an address, and I went to Venice, and I looked at this address on the envelope, and I found this address and knocked on the door and said, "Is Ray Bradbury here?" I think it was another family member who answered the door, and she said, "Oh, yeah, he's back there writing one of his crazy stories!" And so, "back there" meant there was a study along the pathway, and he was in the back part of it, writing a story.

JCT: What had drawn you to him in the first place?

WFN: Well, we've been friends for 40 years this year, and I'm editing a book celebrating his career as a writer, which we'll get to in a moment. He was so far above the crowd. I mean, "The Jar" stood out like the proverbial sore thumb, above the general run of *Weird Tales* material. "The April Witch" remains, to this day, one of my favorite stories of his. Nothing like it. Ray simply took the old themes and gave them a very modern twist. He took them into the world of today in a shocking, direct, fresh kind of way. Like a slap across the face. Very stinging and sharp. Made you very aware that here's a new voice in imaginative literature. And, of course, I was a fellow who wanted to write myself; and I'd been writing, in notebooks, since I was 10 years old—stories about the Lone Ranger and Tim McCoy and Tom Mix and the G-Men and all of that stuff. Nonsensical, awful stories they are when I try to go back and read them....So, Ray and I just gravitated toward each other. We both loved the same kind of thing. We both came from the Midwest. He from Waukegan, Illinois; me from Kansas City, Missouri, where I attended the Kansas City Art Institute; and where I was an artist for Hallmark Cards. We had the same winters and springs and summers and October leaves blowing in the wind and all of that in common, which gave us a firm background from the moment we met.

JCT: You have become something of a bibliographer of his work, I see.

WFN: My friends call me "the old organizer," the "old indexer." I love lists. Thousands of lists. I've even got a list of all of my lists! You know, it's unending. I love putting together lists. I wanted to put together a list of Ray's work. Nobody had ever done that. And almost instantly, I began to think about doing a magazine on him. I said, "I want to list all of your work and all the anthologies you've been in and all the essays about you. So, within a year of our meeting, I was deep into the *Ray Bradbury Review*, a fanzine I published in January 1952. I financed it myself, out of San Diego...that's where I was living. And I would drive up to meet Ray and drive back to San Diego where my father was running a lemon grove at the time. But, you know, I got very annoyed when I became known as "Ray Bradbury's No. 1 Fan." I hated that term. I made a big point in the book. I said I'm a friend, a fellow writer, a companion, not anybody's fan. I dislike that word. I don't mind being a "fan" of a lot of writers, but I'm not anybody's No. 1 fan. I'm William F. Nolan's No. 1 fan...Anyway, I celebrated the first 10 years of Ray's career. He had started out professionally in 1941 and my *Review* came out in 1951. So this covered the first 10 years. And I had people like Chad Oliver, the late Anthony Boucher, the late Henry Kuttner—and all of these people contributed to this little fanzine, which became a rather legendary little thing. It was photo-offset, which not many fanzines were in those days. It was photographed from typed pages.

JCT: Bring us up to the present.

WFN: In 1975 I published through Gale *The Ray Bradbury Companion*. Ray wrote the Introduction. It had quite a subtitle: "A Life and Career History, Photolog, and Comprehensive Checklist of Writings." How about that? Now, here I am in 1990 covering 15 more years! And I'm coediting with Martin H. Greenberg a book called *October's Friend*, which will be published by Fantasia Press in October of 1991. Isaac Asimov is writing an Appreciation for it [published in 1991 by Penguin as *The Bradbury Chronicles*].

JCT: What's that all about?

WFN: It's a collection of stories, tributes, and so forth, by Ray's contemporaries, celebrating his first 50 years as a professional writer. We're saying, "Here's a toast to you, Ray...and here's how we love your work through the years." One of the interesting stories in it is a kind of "sequel" to *The Martian Chronicles* by Robert Sheckley; and F. Paul Wilson wrote a "sequel" to one of Ray's most horrific stories, "The October Game," called "The November Game" (which is what happens to the man who is arrested for killing his daughter); and there is Chad Oliver's follow-up to one

of Ray's favorite stories, "The Lake." So, you see, we're spanning several generations in this book. We have a new story by Richard Matheson, who's doing one for me; and by Richard Christian Matheson, his son. I have a reprint of a story by Charles Beaumont, and I have Christopher Beaumont, his son, writing his first prose story for this book. My wife is doing a story for it, has done a story for it. So, I have me and my wife, there's Charles Beaumont and Christopher Beaumont, and Richard Matheson. There are several stories about Bradbury's "Family." You know, the vampire family we first met in *Dark Carnival*. One is about Uncle Einar going on the *Geraldo* show and defending his vampirism against an audience. There's another one about Timothy, the vampire boy from "The Homecoming." About him growing up and seducing a woman in a New York apartment, not knowing if he wants to go to bed with her or suck her blood! Chelsea Quinn Yarbro wrote that. My wife's story is about Douglas Spaulding from *Dandelion Wine*. Ray will do a new story for it and an afterward, looking back on his life. So this will be a rather special book.

JCT: What about you? Did you write one, too?

WFN: My own story is called "The Dandelion Chronicles." It's a mixture of all of Ray's characters and themes in one capsulized form. It's a parody, actually. When I wrote the letters to the authors, I had said, "Don't give me parodies; give me pastiches, moods, memoirs; but don't do any parodies." I reserved that for myself!

JCT: Where does your coeditor, Martin Greenberg, come in?

WFN: Martin called me up and said, "How would you like to do a book celebrating Ray's fiftieth year?" And I said, "What are you talking about?" And he said, "Well, I think I can sell an idea with you as the Bradbury authority, kind of leading the parade, and me as coeditor. I think we can sell this." I said, "Sounds fun to me!" Frankly, I thought I was through doing books about Ray Bradbury. But here I am, doing another one, a lot of fun. I'm back home again. I'm operating on the principle that if you've never read him, you can still enjoy the book; but if you have read him, you can find all kinds of delicious undertones.

JCT: During all this time did Ray have an impact on your own writing?

WFN: We all interrelated together in the old days—Bradbury, Richard Matheson, Charles Beaumont, Chad Oliver, Ray Russell. There was a whole group of West Coast writers who used to sit around and talk all night into the dawn in coffee shops and critique and read each other's stories. Richard Bach, who wrote *Jonathan Livingston Seagull,* was part of that group at the time. Sure, my first short story was in print as a result of Ray Bradbury. It's called "The Joy of Living." It was sold to *If: Worlds of Science Fiction* in August

1954. I got 100 dollars for it. The end of that story was Ray's. I couldn't figure out how to end that story. I had the wrong ending on it. I sent the story to Ray in Ireland. He was working on *Moby Dick* with John Huston at that time. Ray had told me, "Whenever you have a story that you think is really good enough, and that you've reached a point that you really want to break through, send it to me and I'll read it line by line and word by word." And he kept his word. He took time off from *Moby Dick*, God bless him, to do a critique of "The Joy of Living." It's Bradbury's ending. It sold immediately. So when I do these books, *The Ray Bradbury Review*, *The Ray Bradbury Companion*, *October's Friend*—this is my way of paying back a debt.

JCT: Let's turn this around! How have you influenced his own writing?

WFN: He's used me as a sounding board on several things. He turned over to me his first novel since *Something Wicked This Way Comes*. It became *Death Is a Lonely Business* [1985]. He turned over the rough draft to me when he was in Europe on another trip. And I read it and wrote a long letter about what he should and should not do with certain chapter endings; and I said your character does this and he really should do that. Yes, he respects my talent and my opinions as much as I respect his...A good friend does that. A good friend turns to another good friend; but you don't turn unless you know that friend is on an equal and emotional level. You don't give your grandmother the story to critique...

JCT: Any general comments about Ray? What do we *not* know about him?

WFN: He's his dark moments like anyone else. He's not some kind of "happiness machine," from the title of one of his stories. But he's a very ebullient, happy, outgoing man most of the time—I'd say 95 percent of the time. But I've seen him when he was brooding over a rejection of a film script of his for *The Martian Chronicles*. He was anything but ebullient that night. I've been friends with him long enough to see the dark days as well as the light ones. No, Ray is not a walking happiness machine, but a human being who happens to be an optimistic, enthusiastic person most of the time.

"The Repairman Cometh": F. Paul Wilson

F. Paul Wilson (1946–) is a popular writer of science fiction and horror stories. He is best known for Michael Mann's film adaptation, *The Keep* (1983). Among his best-known characters is "Repairman Jack," an urban mercenary introduced in *The Tomb* (1984) and subsequently

subject of a successful series of novels. He won the first Prometheus Award in 1979 for his novel, *Wheels within Wheels*. His novel *Healer* (1990) was honored by the Libertarian Furturist Society's Hall of Fame Award.

Interview

JOHN C. TIBBETTS: I understand that you're involved in a project to honor Ray Bradbury's 50 years of professional writing.

F. PAUL WILSON: I've been talking to William F. Nolan and Marty Greenberg about that. I do stories for him on a regular basis and he always has something interesting to tempt me with. Marty called me up and said, "We're doing a Bradbury Tribute, and we have a lot of writers who were influenced by him or really liked his stuff. Would you be interested?" I always say No to Marty first, because I always have something else to do. But then I just thought about Bradbury...he's one of the most important writers in the field. His story, "The October Game," made me want to write horror. I read it when I was 13 in *Alfred Hitchcock's Stories They Wouldn't Let Me Do on TV.* I remember it was an August night and I sat there and read that book and came to that last line—"And then some idiot turned on the lights!"—and the temperature in the room just dropped 20 degrees. My jaw just dropped—and I said, "My God! We used to play that game!"...And then he just dropped the bottom out of it. And I realize now rereading it, I should have seen it coming. It just knocked the hell out of me. So after talking to Marty, I reread the story and still it holds up wonderfully. It's still an amazingly subtle piece. And it does what I really love fiction to do in the sense that it forms a picture in your brain much more real than anyone could describe. And that's one of the keys to effective horror fiction, to let the reader do some of the work in the really awful parts...You will fill in what you find most horrible...That was one of the most important stories in my genesis as a writer, and I had to just do something in regard to that. And all along in the back of my mind, I am thinking, someone's got to speak for that poor child, poor Marion; to see that her murder is avenged. So I wrote "The November Game" as a sequel. And Marion gets her revenge on her Daddy...It's my story in the sense that it's my style and my voice. It uses his characters and sets the scales even.

JCT: Any personal connections with Bradbury?

FPW: No, I've never met the man. We've exchanged a few notes now and then. He writes postcards, basically. The last time I had any contact with him was during the theatrical release of

Andrew Lloyd Webber's *The Phantom of the Opera*. A bunch of us simultaneously discovered that Gaston Leroux was not given any kind of credit in the playbill—none at all. They credit cigars and Maytag washers for cleaning up things backstage; but they don't credit the author of the original story! So I wrote to Webber and to the Theater Guild; and then I heard Ray Bradbury was involved in the movement. So I wrote to him, saying, Is there anything I can do? And he wrote back saying that everything had been taken care of. But other than that, I have no contact with him, other than being someone who has read him and enjoyed his work.

JCT: Let's go back to his story, "The October Game." I understand that he's not really very happy about it appearing in anthologies.

FPW: Well, it's very horrific. That may be a part of his writing history that he wants to put behind. But it shows his versatility; that he can do just about anything. I think he was a hungry young writer then, cranking stories out for *Weird Tales*. And he just may think it's too strong. And it *is* strong. For all of its subtlety, there is a lot of negative emotion throughout the story. It opens with a guy putting a gun back in the drawer, because that's not the way he wants to hurt his wife. And the only way to really hurt her is to hurt her daughter—their daughter. She looks so much like her. There's emotional violence before there's ever any physical violence.

JCT: What kind of influence, if any, has Bradbury had on your work?

FPW: I don't say so much that I wanted to write like Bradbury. But I have said that I want to do that kind of horrific thing he can do. I want to leave you gasping. At the time I read "The October Game," I wanted to leave readers with their jaws hanging open. He set me on that road at the time I decided I really wanted to be a writer...Even if you're not aware while you're doing it, afterward when you go back to your early work, you see influences like that.

"Mister Monster": Forrest J Ackerman

For more than seven decades "Forry" Ackerman (1916–2008) was science fiction's "Number One Fan," a self-styled "Mr. Monster," and collector of related memorabilia. He was a founder of science fiction fandom, an author's agent, the editor of the fondly remembered magazine, *Famous Monsters of Filmland* (the forerunner of today's horror publications such as *Fangoria* and *Dark Discoveries*), and a former agent and longtime personal friend of Bradbury.[3] In a tribute to Forry, Vincent Price wrote: "Now

Forrest J Ackerman with the "First Fandom" emblem (photo by the author)

there are people whose role in life is to perpetuate the public's memory in certain ways, specific areas of every field of endeavor.... To name the one special, unique, all by himself, we must come up with the name of Forry Ackerman.... Eventually, he and his collection will become monuments to a (but for him) much neglected cinema art form. We all owe him a great debt for keeping alive *his* favorite genre of movies...."[4] In 1953, he was given a special "Fan" Hugo Award by the World Science Fiction Society

Interview

JOHN C. TIBBETTS: I guess you and Ray have known each other since you were kids, right?

FORREST J ACKERMAN: Ray has just turned 70, and I am 74. So I suppose I was around 20 and he was 16 when we first met. I invited him to join the Los Angeles Science Fiction Society. We would meet every Thursday in the Little Brown Room on the third floor of Clifton's Cafeteria. Our group consisted of me, Ray, Henry Kuttner, Leigh Brackett, Arthur Barnes, and frequent visitors like Robert Heinlein.

JCT: What kind of person was he in those days?

FJA: It's a wonder that Ray Bradbury survived his youth! He was an ebullient guy, if there ever was one; and a knave; and a notoriety-seeking clown. He delighted in giving us imitations of W. C. Fields and Hitler and various personalities of the day. He would hang around NBC or CBS—I don't remember which radio station—and when Bob Hope would be going on or Jack Benny, Ray would slip him a couple of jokes. And if they used them on the air, they'd give him five bucks for them. Ray used to stand on a corner selling newspapers for two hours in the morning for two cents a copy. Don't know how much he got to keep. In the evening he repeated it for two hours. And it was enough that he was able for five dollars to rent a little garage a block or two from where he sold the papers, and with his mechanical typewriter he religiously wrote 5,000 words a day. The night before he was married, he stood before an incinerator and became a fireman straight out of *Fahrenheit 451*. He burned 2 million words of his manuscripts he was dissatisfied with. Apparently, his feeling was if he died of ecstasy on his wedding night, he didn't want well-meaning friends to take every little thing he scribbled on the back of an envelope and turn it into a novel! Ray takes a lot of pride in the good opinion of posterity!

JCT: Describe the nature of your relationship with him.

FJA: It seemed like I was always loaning him money! When Ray Bradbury was a teenager and discovered girls, whenever he wanted to take someone out on a date, I was good for a buck. One day he apparently had an extra hot date coming up that evening and he needed two dollars. His excuse for asking for an extra dollar was that he was selling a copy of *King Kong* that had been purportedly signed by Edgar Wallace. Well, I was young and naive, I didn't stop to question how he'd gotten the autograph of an author living 6,000 miles away in London. So I gave him his extra dollar. Well, time marches on, and 25 years later I was living in a 13-room home where I had accumulated so many friends that when I had a birthday, I had to have 5 parties over the days to crowd everybody in. On this particular Sunday of my birthday Ray was there, and he was collecting fans around him like the proverbial iron filings to a magnet. His eye lit on that copy of *King Kong* he had given me. He blushed and took it off the shelf and said, "Oh, Forry, I have a terrible confession to make. I wrote that signature of 'Edgar Wallace.'" I said, "You dirty dog, give me back my dollar!" He fished in his pocket and gave me a dollar. A few days later, I began to think Ray regretted ever having given me the book in the first place—because Fay Wray had signed it, too, and Bruce Cabot and several others associated with the picture! It had become quite an expensive collector's copy. I finally found another copy and ordered it through the mail and sent it over to

him as special delivery. And I inscribed it, "To Ray Bradbury, from the *real* Edgar Wallace!"

Other times I loaned him money was when I loaned him $50 to attend the World Science Convention with me in New York City in July 1939. I also helped him launch his fanzine that year, *Futuria Fantasia.*

"A Bradbury Companion": Donn Albright

Donn Albright (1937–) is Ray Bradbury's authorized editor, archivist, and bibliographer. He develops, designs, and illustrates limited editions of Bradbury's unpublished work. His definitive archive is the prime authoritative resource for all publishers and Bradbury researchers/scholars.

I have corresponded with Donn for many years and have contributed materials to his Bradbury Archive. We first met in New York City in 1991. The following is an extract from our most recent interview, 8 July 2010.

Interview

JOHN C. TIBBETTS: Donn, I guess no one on the planet knows more about Ray Bradbury than you do! What perked your interest in the first place?

DONN ALBRIGHT: It was in 1950, and I was listening to a radio program called *Dimension X.* My parents were away. The story was called "Mars Is Heaven." It scared the daylights out of me. I had never heard the name of the author, but later that fall, I was telling a friend of mine about it, and he said he had read it in an anthology, *The Best Science Fiction Stories of 1949.* He got the book for me at the local library, and the name was Ray Bradbury. I told my mother then and there I was going to read everything this guy had ever written. That's when it started. I was just 13. Soon, I obtained copies of *Dark Carnival* and *The Martian Chronicles.* Now, it seems I have everything! I track down everything—book endorsements, cover changes in various publications, different bindings, first print appearances, reprints, articles, illustrations, you name it. Early on I started writing letters. I would go to phone books in the Public Library and look up used magazine dealers in the Yellow Pages. I'd write all the publishers and ask them to send me copies of Bradbury publications. A good friend of mine once described this as my addiction, my drug. And you lay in bed at night plotting ways to track down the things you don't have. You count ideas of ways to fill the holes. It can be the most unimportant item. The collection is in the Midwest, where I've kept my parent's home.

JCT: When did you first meet him?

DA: At first, I didn't want to meet him! I'm rather introverted and I'm afraid that your idols can fall pretty fast when you meet them. I wrote him the first time and August Derleth forwarded the letter. That was 1951, I think. And Ray sent me a letter with a copy of Bill Nolan's *The Ray Bradbury Review*. I then began writing Ray directly asking him questions about things, and he would send me back postcards full of exclamation points. That started me corresponding with Bill Nolan that year. I was 14 and he was 24–25, just starting to write stories himself. I didn't actually meet Ray until 1967 at a performance of his *Dandelion Wine* in Lincoln Center. Of course, Ray was standing in the lobby with one of his daughters. I introduced myself, and he said, "Oh, my God!" and he signed my program. He signed my first name correctly, so I knew he remembered me. Later, Bill Nolan told me about Ray's fabulous basement. Bill was working on his *Ray Bradbury Companion*. So, in 1977, I went out there for two weeks, and Ray gave me the privilege of going through the basement collection. I still go out there twice a year.

JCT: How does he deal with his celebrity?

DA: He loves it. He loves it. In years past, if you went out with him to dinner, all of a sudden, you'd feel a draft on the back of your neck; and there would be lots of kids behind you wanting his autograph. He always stops to talk to them. He loves to be loved. They all tell him he inspired them, he changed their lives. And he loves it all. And he's sincere. He doesn't put it on.

JCT: Can you pin down what Ray has meant to you, personally?

DA: I've always felt he was writing about *me*. I remember shortly after encountering that radio program *Dimension X*, I read his story, "Season of Sitting." We'd been at my grandparents down on the farm, just sitting on the swings; and I thought, "My God," how does Bradbury, who's only 30 years old, *know* about these things? His background is pretty much the same as mine. He grew up in Illinois and went to California. I grew up in Indiana and went to California every summer because I had asthma. And he wrote all of these touching stories about growing up in the Midwest. So I've always felt a strong affinity for him.

Destination: Mars!

My attention was quickly riveted to a large red star close to the distant horizon. As I gazed upon it I felt a spell of overpowering fascination—it was Mars, the god of war, and for me, the fighting man, it had always held the power of irresistible enchantment.

Edgar Rice Burroughs, *A Princess of Mars*

My memory of Burroughs is that at the age of nine, ten, and eleven, I stood on the lawns of summer, raised my hands, and cried for Mars, like John Carter, to take me home. I flew to the Red planet and never returned.

Ray Bradbury, Introduction to the 2003 edition of
A Princess of Mars

Might it really be possible—in fact and not in fancy—to venture with John Carter to the Kingdom of Helium on the planet Mars?

Carl Sagan, *Cosmos*

It was to be expected that the allure of Mars would entice Burroughs' John Carter to traverse the trackless reaches of space. Mars's distinct red color and odd surface markings had been attracting the attention of astronomers, thinkers, and dreamers long before the realities of space travel. Presuming Mars to be a likely abode of life, explorers of the imagination such as Athanasius Kirchner and Emanuel Swedenborg voyaged there in the seventeenth and eighteenth centuries and mined it for utopian, philosophic, and theological ideas (the sort of thing C. S. Lewis continued later in his own trilogy about Mars, *Out of the Silent Planet* [1938], *Perelandra* [1943], and *That Hideous Strength* [1945]). Late in the nineteenth century, when astronomers Giovanni Schiaparelli and Percival Lowell claimed they had detected artificial canals on its surface, writers Percy Gregg (*Across the Zodiac* [1890]) and Garrett P. Serviss (*Edison's Conquest of Mars* [1898]) hopped on their own rocket ships and journeyed there to confront intelligent but hostile aliens. Meanwhile, the Martian astronomers were

watching us, and in his classic *War of the Worlds* (1898) H. G. Wells imagined fearsome Martians leaving their dying planet to conquer Earth.

In the pulp magazines of the first half of the twentieth century the Red Planet became a kind of "vital geography," a new arena for the Gothic narrative with its haunted places, monstrous life forms, mad scientists, and harassed maidens. The most fondly remembered (and still read) of these swashbuckling sagas was the 12-volume "John Carter" series by Edgar Rice Burroughs, which began in *All-Story Magazine* in 1912.

The reality of space travel in the 1950s stimulated a host of Mars stories that were more concerned with hard science and sociology than with space opera and bug-eyed monsters. Ray Bradbury's famed *The Martian Chronicles,* a collection of short stories published in 1950, were cautionary tales about man's ruthless exploitation of the planet. Arthur C. Clarke's *The Sands of Mars* (1951), Fred Pohl's *Man Plus* (1976), and Greg Bear's *Moving Mars* (1993) applied hard science to fascinating, almost documentary-like speculations about how man might adapt to the hostile terrain.

Now, with the data available from the Viking probes, beginning in 1976 and from more recent scientific findings, science fiction writers have a wealth of information about Mars never before available—including evidence denying the existence of advanced life forms. Pointing the way toward a new, more intelligent and sophisticated vision is Kim Stanley Robinson's *Red Mars* (1993), *Green Mars* (1994), and *Blue Mars* (1996). Common to them all is the broad theme of man's colonization of Mars, described with an unprecedented scope and detail.

Edgar Rice Burroughs with his two most famous characters, "John Carter of Mars" and "Tarzan of the Apes" (drawing by John C. Tibbetts)

"Back to Barsoom": Robert Zeuschner Talks about
Edgar Rice Burroughs' Mars Books

"I am a very old man; how old I do not know." Thus begins the narrative of John Carter in *A Princess of Mars*, by Edgar Rice Burroughs (1875–1950). Those of us reared on the adventures of Captain Carter, the greatest of science romance swashbucklers, can't measure his age, either. While our gait slows and our eyes fail, he never falters. He will always be there, on the surface of the Red Planet, measuring his 20-foot strides and his mighty sword arm against the villainous hordes of Barsoom.

One day in July in 1911, a 35-year-old Chicago pencil sharpener salesman, broke and desperate to feed his growing family, picked up his pen and indulged himself in his favorite pasttime, daydreaming. He hastily dashed off a wild tale about a Confederate Army captain who is mysteriously transported to the planet Mars where he woos a princess and battles bizarre creatures.

Edgar Rice Burroughs had no reason to be optimistic about his newest venture. Not only had he never written a story before, but he had, as he claimed, failed in every enterprise he had attempted. The list of his unsuccessful enterprises was impressive, at least—cavalryman, prospector, clerk, cowboy, railroad policeman, and shop owner.

But then a check for $400 from *All-Story Magazine* changed everything. *Under the Moons of Mars* (later retitled *A Princess of Mars*) was published early in 1912. Aflame with ideas, Burroughs threw himself into an amazing two-year burst of productivity, writing the novels upon which his reputation rests today, including two Martian sequels (*The Gods of Mars* and *The Warlord of Mars*); the first of his "center of the earth" fantasies (*At the Earth's Core*); a historical novel of medieval romance, *The Outlaw of Torn*; and perhaps his greatest work, *Tarzan of the Apes*. Soon he was making $20,000 a year from magazine sales alone. By 1919 he was wealthy enough to leave Chicago and move his family to a 540-acre ranch in the San Fernando Valley, where his prodigious output continued, ultimately numbering 70 books, 59 of them published in his lifetime. In 1923 he incorporated himself, and eight years later formed his own publishing company, Edgar Rice Burroughs, Inc., situated in Tarzana, California (named after his most famous character), and he presided over a veritable empire, guiding the commercialization and marketing of his characters in movies, radio, and comic strips. At the time of his death in 1950 his estate was estimated in excess of 10 million dollars. To date, his world book sales have soared well past 100 million.

Robert "Bob" Zeuschner is the author of *Edgar Rice Burroughs: The Exhaustive Scholar's and Collector's Descriptive Bibliography*, with a foreword by Philip Jose Farmer (Jefferson, NC: McFarland, 1996). For several years he was the assistant to the editor of the *Burroughs Bulletin*, and has contributed numerous articles to the *Burroughs Bulletin* and other fan

publications. He wrote the captions for the recently published art book devoted to the quintessential Burroughs artist, *Grand Master of Adventure: J. Allen St. John* (Somerset, NJ: Vanguard, 2005). Bob is a professor of philosophy at Pasadena City College in Southern California, and has written a college textbook on ethics, *Classical Ethics: East and West* (New York: McGraw-Hill, 2000). He is currently at work on a book tentatively entitled *Asian Thought: Intellectual Traditions of India, China, Japan, and Tibet*. When not researching and writing, Bob plays classical guitar, but in recent years he has focused on acoustic blues guitar music of the 1920s and 1930s, especially the intricate and complex solo guitar style of Scrapper Blackwell.

Our interview transpired in Kansas City, MO, in the spring of 2010.

Princess of Mars, John Carter of Mars (John C. Tibbetts painting after Frank Schoonover)

Interview

JOHN C. TIBBETTS: Since we're talking primarily about Burrough's *A Princess of Mars*, could you talk about its significance in the history of science romance?

Robert Bob Zeuschner: The importance of *A Princess of Mars* cannot be overestimated. It was responsible for an entire genre of pulp fiction and an important inspiration for Flash Gordon, George Lucas's films, and James Cameron's *Avatar*. Any collector or library

hoping to collect the key science fiction books must have a copy of *Princess* for their collection.

A Princess of Mars first appeared as *Under the Moons of Mars* in serial format in the popular pulp magazine called *The All-Story*, from February to July of 1912. At this time Burroughs was an unknown first-time author, and the tale he had written was unlike anything that had been published previously. Six years later, in September of 1917, A. C. McClurg of Chicago published it in novel form, containing several illustrations by the noted artist of the Brandywine School, Frank Schoonever.

It is one of the cornerstones of early American science fiction. Like the great adventure classics by H. G. Wells and Jules Verne, it gave direction and set the parameters for the pulp magazine stories for decades to come. The technical science-based extrapolative novel we call modern science fiction had not yet appeared, and would not appear for several decades more. What Burroughs created was an inspired extension of the "lost-race" fiction of prior decades, only here those "lost races" filled an entire planet!

JCT: So, if it's not precisely science fiction, what is it?

RBZ: *A Princess of Mars* might be better described as a "scientific romance," or "interplanetary romance," where you have all the trappings of those old Gothic novels with their mad scientists and creepy monsters and damsels in distress. Although scientific predictions appear in Burroughs's works (including computers to pilot a space ship), a more typical element in these novels is the hero who performs mighty deeds for the love of a beautiful princess. These mighty deeds take place in realms more exotic than anyone could ever find on Earth. Every tale by Burroughs—and, of course, these include the "Tarzan," "Pellucidar," and "Venus" stories—is filled with imaginative yet unearthly details that create rich mental landscapes in the imagination of the readers.

Burroughs' popularity among readers was so strong that editors wanted to publish more stories like those of ERB, and many of the succeeding authors who attempted to write for the pulp magazines pretty much followed his direction. Pulp authors of the 1920s, 1930s, and 1940s read the romantic fiction of Burroughs, and were inspired to begin their own writing careers—Robert Heinlein, Isaac Asimov, Robert E. Howard, Ray Bradbury, Fritz Leiber, Otis Adelbert Kline, Philip José Farmer, and others.

JCT: You called Burroughs' Mars "exotic." That's an understatement!

RBZ: Burroughs' series of 11 Martian novels is set on a planet called "Barsoom" by its inhabitants. It is encircled by two moons, filled with numerous separate species, warring tribes, ancient decaying

empires protecting themselves from aggressors, abandoned cities that once thronged with mighty warriors and beautiful women, and a continually degrading environment barely able to support life. At the time John Carter arrives there, the ancient Martian canals, originally built to transport water, have all dried up, and the sources of water and oxygen are almost depleted. Mars is a dying world, but not yet dead, and the creatures who inhabit this world battle one another in a Darwinian struggle for survival.

JCT: What would Burroughs have known about Mars at the time he wrote *Princess?* Indeed, what did anybody know?

RBZ: Well, the big news of the day was Sir Percival Lowell's drawings of the "canals" of Mars, which were published in newspapers and books in the 1880s–1890s. Lowell looked through his Arizona telescope, saw what he took to be evidence of intelligent life, and published his own careful drawings of what he thought must have been water canals, which inhabitants of a dying planet used to try to get water from the poles to the inhabited central regions. He thought he saw double canals, and dark spots that he called an oasis. Burroughs read widely in the science of his day, and Lowell published a book in 1895 called *Mars*, and then another one in 1906 called *Mars and Its Canals.* In 1908 he published *Mars As the Abode of Life.* The scientific community was very skeptical, but it seems obvious that these speculations inspired ERB's imagination. The pulp fiction readers would have been aware that an astronomer believed that visible markings showed that Mars sustained intelligent life forms. So, *Princess of Mars* was read by an appreciative audience, not the more knowledgeable and skeptical audience we have today. Nowadays, thanks to photographs sent back from Mars, we realize that ERB's Barsoom is not the Mars that circles our sun!

JCT: John Carter is actually an American Confederate cavalry officer. How did Burroughs contrive to get him to Mars?

RBZ: "Contrive" is really the right word. In 1911 there was no technology available for interplanetary transportation, and trying to explain such technology would have been a book in itself. Technology was not the tale Burroughs wanted to tell, so ERB creates what seems to be an "out-of-body" experience for John Carter. Carter had taken refuge from Indians in an Arizona cave occupied by a shamanness; he inhales some strange odors, feels a "snap" and finds himself standing alongside what appears to be his own body. He stretches his hands out to the god of war, Mars, and feels himself transported to the surface of what seems to be Mars. Although his Earth body still remained in the Arizona cave, he seems to have a solid duplicate body on Mars, a body that is considerably stronger due to the lower gravity on Mars. This get-to-Mars section of "Princess" is quite short, doesn't put too

much stress on this teleportation. The rest of the story pulls us into the tale of the Earthman struggling to make his way in an alien world, pushed and pulled by apparently unrequited love for a very human-looking female inhabitant of Barsoom, and finally able to bring peace to a warring world and even ensure that the supply of oxygen will continue, so Mars can continue to support life.

JCT: He's ageless, I guess...?

RBZ: It is unclear exactly what ERB intended when he describes Carter as an "ageless" human being. Carter remembers no childhood, but Carter never seems to recall any events much earlier than the Civil War, so one can only speculate as to whether he was a Roman soldier, a lord in ancient England, or any such warrior. The ageless John Carter was important for one reason: the Martian human-looking race of Red men have a lifespan of about a thousand years. The love of John Carter's life, Dejah Thoris, Princess of Mars, would also live a thousand years. It would make for a rather unbalanced love affair if one partner lived 950 years longer than the other! So, an ageless John Carter might have a chance of living for a thousand years with the most beautiful woman of two worlds, the incomparable Dejah Thoris.

JCT: I guess the first three Mars books constitute something of a trilogy.

RBZ: As much as I love *Princess of Mars*, I tend to feel that his *The Gods of Mars* was even better, as Burroughs became a better writer. Yes, I think that the three tales of *Princess*, *Gods*, and *Warlord* are truly one of the great trilogies. John Carter and his world are very much a product of the early years of the twentieth century. There are mythic and archetypical elements to ERB's fiction (which will exert a universal appeal), but the way our world has changed and developed in the past hundred years makes many of the themes too absurd for a twenty-first-century mentality conditioned by video games and freely available sexuality everywhere in our society.[1] The "fate worse than death" no longer holds the same reaction in modern times.

The Barsoom tales are justly famous for the vividness of the images ERB weaves in those books (and the other books including Tarzan and Pellucidar, the Earth's core). What an active imagination and dream life he must have enjoyed. In addition to the vividness of his daydreams, ERB could translate the action and images into the written word. He created a compulsive thrust of excitement that brought action to life in a way that pulls each reader into the fantasy realm that Burroughs created, and makes so many of us seek out more ERB to read. This is a characteristic typical of the highest quality of literature. ERB's characters live on in our imaginations, and become an inspiration for the reader's life, but also for artists as well as later novelists.

JCT: After the first three Mars books, John Carter seems to with-
draw from the action in favor of other heroes. What happened?

RBZ: I'm not sure that ERB tired of John Carter, or whether he
simply ran out of variations on his basic plot. Character growth
and character development was not very important for Burroughs.
Pulp fiction was not concerned with character, only action.
Consequently, ERB did not explore the internal life of John
Carter. He certainly has a personality, but in fact he doesn't learn
much from the beginning of a book to the end, or from the early
books to the later books. He makes the same mistakes over and
over. He escapes death and destruction because of sheer dumb luck
as often as his super-normal skill with a sword. I think ERB just
ran out of adventures for the courageous athletic hero he had cre-
ated. He couldn't just continue to have Dejah Thoris kidnapped
again and again, and rescued again and again! So, he began to
write about the son of John Carter, Carthoris, and his lady friend,
and then some alternative Barsoomian adventures. The last three
novels in the Barsoom series have never appealed as much to me
as the first five.

JCT: You say that *The Gods of Mars* caused you at an early age to
think about religious matters. Can you explain?

RBZ: Yes, *The Gods of Mars* depicts a corrupt ancient religion focused
on Goddess Issus, a religion that promulgated mythology for the
purpose of holding onto power and control. The book was filled
with ideas that challenged me to think much more deeply about
religion and philosophy. Burroughs wrestles with the question
of just what is the difference between religion, fairy tales, and
mythology. In college I had a course in mythology and the profes-
sor explained that "mythology is the study of everyone's religion
except your own."

When I first read *The Gods of Mars,* I was just 11 years old, and
for the first time I realized how much power religious institutions
have sought and achieved, and how such controlling institutions
maintain their power. In *The Gods of Mars*, religious faith obscures
the vision of those who worship the Goddess Issus, but when the
priest finally comes face to face with that goddess, for the first
time he sees the reality of an old woman and nothing more. The
mythology of death and dying on Barsoom was also revealed to
be simple myth, and even a tissue of lies. The creation myths on
Barsoom did have analogues with my own world and the numer-
ous church leaders who claim absolute religious authority, and the
corruption and the wars that have been waged in the name of
one group's sacred ultimate versus another group's description of
the divine. I realized that the issues were power and wealth more
often than religion. I began to explore various religious attitudes
found in both the West and in the East, and that also sparked

interest in philosophy, logic, and critical thinking. That led to science and to impartial analysis of a wide variety of religious claims throughout history. In my undergraduate years I studied engineering and mathematics. In graduate school I pursued philosophy and Asian thought. Those interests have continued into the present, and even now I teach courses in ethics and spend a great deal of time discussing "God," or "the sacred ultimate," and classes in religious studies that focus on shamanism and the major traditions of the East, especially Buddhism, Taoism, and Zen.

JCT: Burroughs certainly let his imagination run riot! Are there other examples in the Mars books of particularly bizarre characters and ideas? Did they provide Burroughs an arena for social commentary of the day?

RBZ: I think most of ERB's works are filled with social commentary. Burroughs read carefully in science and accepted Darwin, even though his interpretation was not as sophisticated as we have today. His Darwinian ideas sometimes appear in his Tarzan and Barsoom books, and include the popular view called "Social Darwinism," which would have been rejected by Darwin himself.

Burroughs went out of his way to satirize racist attitudes in America, and consciously made his heroes and his villains from every ethic group. It is not too difficult to draw parallels between civilizations on Barsoom and ethnic groups on earth. He certainly was ahead of his fellow pulp novelists in making nomadic native Americans as heroes at a time when American Indians were portrayed as vile soulless savages in the popular press. In the Tarzan novels black warriors in Africa are heroes while another group are cannibals. Some Europeans are noble, some are evil. Europeans are not portrayed as superior to the Arabs or the blacks. The heroes, of whatever ethnic group, are noble, brave, and staunch friends. An eternal theme of pulp fiction is the strong hero who rescues the damsel in distress. ERB utilized this theme in almost every book, which are basically romances. Nevertheless, Tarzan's wife, Jane, is a strong heroine who can hold her own in the jungle, Dejah Thoris will whip out a sword and fight beside her mate for what is right, and the beautifully savage La of Opar is a self-confident queen who is afraid of nothing.

JCT: Was Burroughs successful with his female characters? What do today's female readers make of his heroines?

RBZ: I suspect that the majority of pulp magazine readers in 1912 or 1930 were young men, not women. In 1911 Burroughs was a 36-year-old daydreamer who put his own male-oriented adventures on the page. His women are a catalyst more often than they are a heroine. Women are strong, but they are not often the primary protagonist in his fiction. From my experience, women who enjoy ERB tend to identify more with the male heroes than the

females. In a November 2005 interview, British primatologist and anthropologist Jane Goodall was asked, "How did a little girl growing up in England before World War II get involved with studying chimpanzees?" Goodall said "I owe just about everything I've done right with my life and nothing I've done wrong in my life to my mother." She said that her mother supported her passion and curiosity for all living things. In 1945 she introduced Goodall to the Tarzan series by Edgar Rice Burroughs when she was 11 years old. "Of course, I was jealous when he married that wimpy other Jane," Goodall said. At 11 years old she decided she would move to Africa and study the native animals of the undiscovered "dark" continent.

JCT: Burroughs seems to have had a rather negative view of our so-called civilization.

RBZ: In his books, often Burroughs wonders why humans are so destructive of their environment, and of one another. Quite often Tarzan ruminates on the beastly nature of so-called civilized humans. It is clear that Burroughs was also intrigued by some profoundly moral questions about life and the role of humans in the universe. Are humans special? Are humans superior to the animals? Were humans given dominion over the animal kingdom? In the Tarzan novels and the Barsoom novels, the answer tends to be "no." In fact, Tarzan usually prefers the jungle over human company that can be so destructive. He also wonders about extrasensory perception (which was popular in the press of that era). He wondered if the mind could actually affect or control physical reality. If a mind could control physical objects, could a mind control another human being? Could a mind bring the appearance of life into existence? How about life itself? ERB explored that in several Mars books. In *The Monster* Men ("A Man without a Soul") and several of the Barsoom novels, he tackled these questions. In his personal life, for most of his life ERB was fiercely patriotic, idealized war, and was staunchly conservative. After he experienced World War II on a personal level as a war correspondent, he no longer saw war as such a noble thing, and became less conservative.

JCT: Take us back to when you first encountered Burroughs. What sort of a child were you back in the day?

RBZ: I was an avid reader as far back as I can remember. I know I went to the library in the fourth and fifth grades, and read the Hardy Boys, lots of books about dogs, Buffalo Bill, etc. I also read Sherlock Holmes. Then in 1952, for my eleventh birthday, my grandmother sent me two books that had belonged to my dad—*The Gods of Mars*, and *The Son of Tarzan*. I had never read anything so wonderfully exciting in all my life. I immediately went to our local bookshop and found a few of the Tarzan titles still in print. I bought several with the money I earned washing cars

and mowing lawns, and I'm sure that my mom and dad bought some titles for me as well. I discovered that in order to read more about Barsoom, I would have to buy used books, and so began a lifelong affection for brick-and-mortar used book shops. I grew up in Pasadena, California, and Pasadena of the 1950s and 1960s was filled with used book shops. I remember my mom dropping me off at one end of the town, and I would walk three or four miles down the main street (Colorado Blvd) stopping at thrift shops and bookshops. Grosset & Dunlap reprints were a dime or maybe 25 cents. Books with dust jackets were quite rare, and sold for $1.00 or more. By 1955 I had made an extensive list of ERB books and ordered some books via mail. I found one bookshop that had three nearly new ERB, Inc. first editions in jacket for $3.50 apiece, and that was the time that I began focusing on first editions and not just titles. During this same period I avidly read science fiction novels, and still have at least a dozen boxes of paperback science fiction from the 1950s, 1960s, and 1970s. In high school and in college I was on the gymnastics team and my specialization was the rings. I wonder whether Tarzan had any influence on that!

I went to college for two years as an engineering major, and then changed my major to mathematics, and earned my BA in mathematics and computer science. I continued to search out all the used bookshops in the UCLA area, but by then I had pretty much obtained and read all the titles and collecting began to fade. In college I read many of the classics of Western literature in addition to my math classes. I got my degree in mathematics in 1962, and then got a job as a mathematician/programmer, but decided to go back to school and earn a PhD. I went to graduate school in philosophy, traveled to Japan, got married, and had no more time to read for fun. I began teaching full time at the University of California at Santa Barbara and to publish technical articles in journals (as was required to hold a teaching position), but I had children, and I read Burroughs to them as they were growing up. All my kids became readers, but none of them inherited their father's Burroughs bug. Their world is quite different from the 1952 world when I discovered ERB thanks to my dad and my grandmother.

JCT: Yet, it seems that your Burroughs interests were just beginning! For example, your book on Burroughs has quite a daunting title. You call it "exhaustive."

RBZ: You have put your finger on a sore topic. The publisher and I disagreed very strongly about many aspects of my book, and the title was one of them. For those who do not know, the publisher renamed my book *Edgar Rice Burroughs: The Exhaustive Scholar's and Collector's Descriptive Bibliography of American Periodical, Hardcover, Paperback, and Reprint Editions.* My title (as many fellow collectors

know) was *The Fantasy Realms of Edgar Rice Burroughs: A Reference Bibliography*. When I saw what the publisher intended to name my book, I considered it silly, pretentious, and absurd, both for length and for the term "exhaustive." I said so to the publisher, and he replied that they knew best and would not change it. The book was aimed for librarians, and because librarians were not very bright, they needed the title to be long and descriptive. The publisher insisted on many changes that I objected to. They insisted upon renumbering each title consecutively, so there is no room to squeeze one additional title into the book. It made it impossible for me to ever do an updated version without destroying the value of the first printing as a standard reference. I've got nearly 300 pages of additions that I've accumulated over the past 15 years, but there's no way I can do a second edition without doing an entirely new book. If I did that, none of the numbers in the new book would correspond with the numbers in the prior edition.

New bibliographical discoveries continue to be made. For example, in 2010 it was discovered that the ultrarare "Auto-Biography," a suede-bound booklet Burroughs wrote in 1916, had a variant cardboardcovered printing. I also discovered that the personal letters of ERB's literary agent exist, and they record the number of copies of each title printed for every quarter (information we do not have), but the owner of the letters wants $25,000 to share that information. I don't have an extra $25,000 but I wish I did! Bibliographers and collectors love stuff like this!

JCT: How did you come to write it in the first place? Did it fill a gap in Burroughs scholarship?

RBZ: When I first started reading ERB in the early 1950s, there were no lists of his works or bibliographies compiled, and so I was reduced to searching the advertising lists at the back of the Grosset & Dunlap reprints that I was buying, and tried to compile my own listing of what I owned, and what I still could look forward to reading. I also searched for references to ERB titles using Encyclopedia Britannica and other such sources. Of course this limited me to just the titles that G&D published, and I did not know that ERB himself began publishing his own books in 1932.

This was decades before computers, so I made 3 x 5" card bibliographies, and I collected the very first attempts at bibliography with deep appreciation. I remember buying Brad Day's 8 ½ x 11" stapled bibliography with great joy in 1956. I discovered the *Burroughs Bulletin* that was published by superfan Vern Coriell, and my first issue was #12. I treasured every issue and through Vern I found other Burroughs fanzines beginning with the first issue of Pete Ogden's *ERBania* and Caz Cazedessus's *ERBdom*. Using these additional sources I kept adding information to my own personal bibliographical lists.

The Henry Hardy Heins bibliography was published in 1964 and was a complete joy to read and study, and it became the cornerstone of all my collecting activities. New ERB titles and reprintings appeared and all the paperbacks flooded the market, and as a result Heins was out of date by 1980. By that time my own collection was fairly complete in terms of first editions, and pulp magazines, but I still kept adding to my bibliography. I had heard that another fan was collecting information to do an amplified version of the HHH bibliography, so I did not think of publishing my lists. Finally, around 1988, I contacted the fan and asked if he was going to do the updated HHH bibliography, and he replied and said that he doubted that he would find the time, and so I should go ahead.

So, I spent four years collecting and collating bibliographical information, and then I sent out early preliminary copies of my bibliography to a half-dozen fellow fans.

I was very lucky when supercollector Bill Ross made numerous corrections, and then supplied a great deal of new information on books in his own library. Finally I had a reasonably complete bibliography compiled. I decided not to use the format of Henry Heins. I simply arranged my own book in alphabetical order, so any title could be found quite quickly and tried to make a very thorough index. I also stressed the first editions (because so many bookshops misidentified G&D or Burt reprints as first editions), and in general stressed hardbacks trying to sort out various print-ings. Personally I did not have a serious interest in paperback edi-tions, so the bibliography did not stress the ongoing paperback reprints, except in the most general way.

As noted above, the publisher imposed many serious changes to my manuscript that left me frustrated and very unhappy. I had paid to have several hundred photos of books and magazines, and commissioned artworks for the book; McFarland simply said they did not use art in their books. I insisted most strongly, and they finally included fewer than half of the art and photographs.

JCT: There seems to be another resurgence of interest these days in Burroughs and, particularly, in John Carter, especially among fantasy artists.

RBZ: In the 1960s paperback publishers discovered the attraction Burroughs had for readers, and almost all of the ERB tales, includ-ing *A Princess of Mars*, were published with very attractive covers. With the inexpensive paperback appearances, the Martian novels were made fresh to a new generation of readers, and also a new generation of artists who did fascinating covers for the Ace and Ballantine editions, including Robert Abbett, Roy G. Krenkel, Frank Frazetta, Boris Vallejo, Gino D'Achille, and Michael Whelan. Among contemporary artists, Frank Frazetta's full-color

dust jacket illustrations for the 1970 Science-Fiction Book Club editions were especially influential. In addition to these editions, excellent artwork continued to appear from even younger artists such as Jeff Jones, Joe Jusko, Thomas Yeates, William Stout, David Burton, and others.

J. Allen St. John, Frank Schoonover, and the other first generation of artists who illustrated the Barsoomian adventures tended to imagine Martian creatures as straightforward variations of earthly beasts. For example, the animal mode of transportation, the eight-legged *thoat*, was illustrated as a horse with eight legs, the four-armed white apes of Barsoom resembled earthly apes, the green warriors of Barsoom were imagined along the lines of human bodies with tusked faces. It is clear that the majority of the artists drew upon earthly models for their species, and often drew inspiration from previous artistic renditions.

JCT: And you've been busy with Burroughs fandom, with the Burroughs Bibliophiles, in particular.

RBZ: The Burroughs Bibliophiles is the organization for those who read and/or collect Burroughs books, and their quarterly publication is called the *Burroughs Bulletin* or *BB* for short. Vern Coriell started the publication in 1947 and kept it going for 30 years until he was no longer able to do so.

In the 1980s, in addition to teaching, I was doing what we used to call "desktop publishing" and in the late 1980s I met George McWhorter (the rare books librarian at the University of Louisville). He and I talked about the *BB* that George wanted to revive. I had the skills to use fonts and formatting, and so I typeset the *Burroughs Bulletin* for its first couple of years (until George got the University to do the layout and publishing). I also did the desktop publishing for George's "Memorial Collection" book, his Arthur Rackam book, the "Fan Directory" of 1996, and a few other separate *BB* publications. I have been playing old-style acoustic blues for many decades, and called my "press" "Bottleneck Blues" as a tip of the hat to those older guitarists who used a wine bottleneck to slide on the strings.

Sometimes I would discover a hitherto unknown article or item, and with George's encouragement I would occasionally contribute an article from time to time to the *Burroughs Bulletin*. I met ERB's brother-in-law, Edward Gilbert, and conducted an interview with him for the *BB*. I also put together an illustrated booklet of Eddie's collection of autographed books, many with ERB's own sketches and doodles. Eddie and I became friends, a friendship that lasted until his death. I admired many of the *BB* writers of the old days of the *Burroughs Bulletin*, writers like John Harwood, Bob Hyde, Darrell Richardson, and John Flint Roy. It was always an honor to see my own name in the same *Burroughs Bulletin*.

Between 1989 and 2010, George published 82 issues of the *Burroughs Bulletin*, a monumental achievement worthy of the greatest respect and admiration of all of the Burroughs readers and fans. I am in awe of his accomplishments and his dedication, and am proud to call George McWhorter a friend.[2]

JCT: It seems inevitable that Burroughs' Mars, or "Barsoom," would make it to the movies. Yet, although John Carter traveled from the Arizona deserts across outer space to the dead sea bottoms of Mars, he has so far failed to make the trek to the silver screen. It is an adventure yet to be told.

RBZ: Of course, while ERB was still alive, the technology of live film could not possibly portray the Barsoomian landscapes, the 12-foot-tall Barsoomian green warriors, or their 8-legged beasts of burden. With the success of early Disney animated films, it was thought that possibly an animated film might work. Warner Bros. animator Bob Clampett proposed an animated John Carter feature in the late 1930s, with costume conceptions borrowed from John Coleman Burroughs, ERB's artist-son. Those early test visualizations are now available on a DVD, which most ERB collectors know about and own.

However, the project never went ahead, and the property languished for many decades. After the success of the original *Star Wars* trilogy, Paramount Studios took an option on the Barsoom novels as a possible trilogy of films. Many script writers made an attempt to capture the Burroughs magic, but the project was never given the green light. I used to talk with Danton Burroughs frequently about the tensions between ERB, Inc. and Paramount. And I was invited to attend meetings between ERB, Inc. and Disney during the early years of their relationship. I own several of the John Carter scripts. I know that in the late 1980s successful Hollywood scriptwriter Charles Pogue (who is also a lifelong member of the Burroughs Bibliophiles) wrote a script, which was supposed to be directed by John McTiernen. Tom Cruise was named as a possible John Carter. Several other scripts have been commissioned and later rejected. All that is changing now. As you know, as of this year, 2010, the Disney-Pixar corporation has a script by Mark Andrews and Michael Chabon (a successful writer) and has begun filming "John Carter of Mars," helmed by Andrew Stanton. Some preliminary storyboard images have been posted on the Internet, and they do look promising. I'm crossing my fingers and hoping that the magic of ERB will be captured.[3]

JCT: Bob, any last words about the enduring popularity of Burroughs Mars and John Carter? After all, we do live in a world where the mysteries of Mars seem to have all been explained.

RBZ: Ah, the mysteries of Mars that have been explained are scientific and the remaining ones can be answered by an unmanned space probe. Those aren't the kinds of mysteries that ERB engendered.

The mysteries that Burroughs explored involve new life forms and ancient alien civilizations, friendship, fantasy and strife, and the fundamentals still apply: life, love, and courage. The successful films like *Star Wars*, *The Lord of the Rings,* and *Avatar* have explored precisely those extraterrestrial mysteries that are not under the purview of science and technology.

JCT: Even today, after all these years, do you yourself occasionally revisit the Mars books?

RBZ: I have three grandchildren, Brandon, Liam, and Maia, and they are hearing about John Carter and Thuvia, Maid of Mars, right now. I have been a lifelong collector of art, especially the artistic creations inspired by Burroughs. I've got walls filled with Barsoom images, and recently received an exquisite John Carter-Dejah Thoris work by Boris Vallejo and Julie Bell. In today's mail there was a fine work by Barsoom artist David Burton. Barsoom lives!

Kim Stanley Robinson, photo by the author

"This Is Where We Start Again": Kim Stanley Robinson's Martian Trilogy

"The beauty of Mars exists in the human mind," says one of the astronauts in Kim Stanley Robinson's *Red Mars*. "It's we who understand it, and we who give it meaning."

Kim Stanley Robinson (1951–)— "Stan" to his friends—first encountered the real Mars when he saw the photos from the Viking expeditions in 1977 and 1978. He was then a graduate student at the University of California, San Diego, where he was teaching freshman composition. After earning a master's degree from Boston University and a doctorate from the University of California-San Diego, he began writing the novels and stories with the high literary sensibilities and lucid prose style that have won him international acclaim, including the Nebula, Asimov, John W. Campbell, and World Fantasy Awards—*The Wild Shore* (1984), *The Memory of Whiteness* (1985), *Pacific Edge* (1990), and the "Mars Trilogy." More recent novels include *Antarctica* (1997), a work about ecology, *Years of Rice and Salt* (2002), an "alternate history" story, and *Galileo's Dream* (2009), a historical novel with alternate world/science fiction overtones. In 2010, Robinson was the guest of honor at the sixty-eighth World Science Fiction Convention, which was held in Melbourne, Australia. He is the very embodiment of the definition of science fiction writing offered by his friend and colleague, James Gunn: "Although science fiction writers may toy with time, putter about in the past, or transport themselves to alternate worlds, their real home is the future."

About the Mars Trilogy

Few projects in the history of science fiction have elicited more enthusiastic critical response than Kim Stanley Robinson's "Mars Trilogy" (1993–1996). Adjectives rivaling the hyperbole of Hollywood publicists have sprung up in its wake. Writing in *Locus*, author/critic Gary K. Wolfe calls it "a provocative epic of science versus history, with nature as the arbiter." In *The Magazine of Fantasy and Science Fiction* John Kessel flatly declared about the first novel in the trilogy, "This is the best novel I've ever read about the colonization of space." *Science Fiction Age* concluded that the series is "the *War and Peace* of science fiction."

The "red," "green," and "blue" of the titles refer to successive stages in the "terraforming" of Mars—the transformation of the lifeless and inhospitable planet to as world where humans can live and prosper. *Red Mars* begins in the year 2026 when a multinational crew (the "First Hundred") departs Earth for a nine-month voyage to Mars. Each crew member is an expert in the fields of medicine, computer skills, robotics, systems design, architecture, geology, biosphere design, genetic engineering, biology, and so on. The project's official mandate, as espoused by the two leaders of the American and Russian teams, Frank Chalmers and Maya Toitovna, is frankly opportunist—to establish a colony on Mars that imitates Earthly models. Within the ranks, however, are dissidents with other goals. Led by the Russian scientist, Arkady, a sort of closet revolutionary, they see in Mars an opportunity for a utopian break from Earth. These growing divisions are temporarily forgotten in the excitement of setting up

basecamp, dubbed "Underhill." There's an unforgettable moment when everyone pauses for a breathless first look at the planet. There are no life-forms there. For them, Mars is like a "blank red slate." As the First Hundred quickly establish camp, fashioned from the materiel that had been previously sent by robot rockets, team members sort out their duties: Arkady is in charge of operations on Phobos, Hiroko Ai, an expert in biosphere design, establishes an experimental colony, and Sax Russell, a systems expert, supervises the terraforming of the surface. Fundamentally opposed to this is Ann Claybourne, the team's geologist, whose long trips across the surface reinforce her respect for the integrity of the planet. She's dismayed at alterations in the planet already evident: This argument over terraforming is one of the central concerns of Robinson's trilogy.

More than three decades pass. It is 2061 and both Mars and Earth are in trouble. Earth is suffering from overpopulation and ecological disaster, while Mars has been transformed from a hostile land into commercially valuable real estate. Robinson leaves no aspect of the colonization untouched, detailing with relentless detail issues involving religion, physics, ecology, technology, city planning, and psychology. But terraforming, exploitation of mineral resources, and waves of immigration representing all ethnic groups, have split Mars into a welter of special interests and ideological subcolonies. The First Hundred, who have discovered a means of prolonging their life spans, have also fallen into ideological squabbles and dangerous confrontations. Earth, meanwhile, is mired down in global warfare, ecological disaster, population explosion, and multicultural chaos. Desperate hopes are pinned on Mars as the future of the human race, and the planet becomes involved in what can best be described as a colossal land grab. Led by factions of the First Hundred, a planet-wide revolution breaks out on Mars. Frank Chalmers alone is Mars's last hope. Only he can forge a balance between the transnational opportunists from Earth and the utopian terrorists on Mars. *Red Mars* ends on a note of desperation: The failure of the revolution of 2061 plunges the planet into a dark chaos. Finally, a few survivors reach the southern polar cap where they find a strange underground city, a religious colony that has been secretly established by the biosphere specialist, Hiroko. "This is home," says Hiroko. "This is where we start again."

Green Mars, the second installment in the trilogy, begins in 2090 in Hiroko's south-polar matriarchal sanctuary, two generations after the end of the first book. Although Survivors of the First Hundred like Sax Russell and Ann Claybourne continue to figure prominently in the action, it is clear that Robinson's real concerns lie now with the new generations, those who have been born on the planet, the real Martians. Since the failed revolution, Mars has again come under the control of Earth's neo-feudal metanational corporations. The ruined cities have been rebuilt, the terraforming resumed, and the plundering of Martian resources begun. Mars, in spite of human efforts, is somehow reasserting itself as Mars. This is a major theme underlying all the actions of the book.

Blue Mars is structured like the first two, that is, presented in a series of novella-length parts, each somewhat independent, each seen from the viewpoint of a different character. Many of the First Hundred return, as well as some of the later generation members. The linked-novella form also allows significant jumps in time, important in a story that takes place over almost a century. It rounds out the overall story of the colonization of Mars, and extends the narrative to the future of the rest of the solar system as well. Thus Blue Mars has sections set on Earth, on Mercury, and in the moons of Uranus, as well as visits to Venus, the asteroids, and the others of the Outer Planets.

Our interview transpired on 17 March 1993. Robinson was finishing his "Mars Trilogy" at the time. As Robinson speaks, imagine his home, a kind of Martian outpost in itself, cluttered with favorite Martian stories by Burroughs, Philip Dick, Fred Pohl, and others. There are stacks of *Science News* pamphlets, a Martian globe, and NASA's *Atlas of Mars*. Revisiting this interview is a "snapshot in time," years before our recent Martian explorations. Yet, his words are indeed prescient.

In a recent update to that interview, Stan has offered the following:

After finishing the Mars trilogy, I went to Antarctica courtesy of the U.S. National Science Foundation, and wrote a science fiction novel called *Antarctica*, which some readers called *White Mars*. It may be that I was still in the Mars phase of my work, because I followed that with a short story collection called *The Martians*, which was a miscellany that either connected to the trilogy or didn't, but in any case were about Mars. Done with Mars at last, I turned to another large project I had been thinking about for some time, an alternative history in which all the Europeans died in the Black Death, and an alternate history then followed through the next 700 years. To span that many centuries I made it also a reincarnation novel, so this was a different kind of project for me, and, therefore, interesting to try. After my trip to Antarctica I returned to National Science Foundation a few times to serve on panels and give talks, and I grew interested enough in the agency to write a science fiction set there, in the very near future, as people began to face the problems presented by climate change. This turned into another trilogy, *Forty Signs of Rain*, *Fifty Degrees Below*, and *Sixty Days and Counting*. Together they make a long novel I call *Science in the Capital*.

During my research for *The Years of Rice and Salt*, I read about the scientific revolution, in the hope of constructing a plausible alternative scientific revolution in my fictional world. The real scientific revolution struck me as fascinating in itself, especially the central character Galileo Galilei; and so in my most recent project I wrote a novel about Galileo that is both a historical novel and a time-travel novel, in a combination called *Galileo's Dream*. In imagining Galileo's first trip to Jupiter, I very definitely had John Carter's trip to Mars in mind!

It's been interesting and gone fast. Stories keep coming to me, and I hope that continues."

Interview

JOHN C. TIBBETTS: What is it about Mars that has always attracted all of us?

KIM STANLEY ROBINSON: I do think that all science fiction writers eventually take on what I call the "other planet" novel, specifically the Mars novel. Until 1976 the most conscientious science fiction writers couldn't really do it right, because they didn't have the data from the Viking missions. So, now, today, we stand on the far side of a giant divide. On this side, we know so much about Mars—about what it looks like and its chemical constitution—that we can talk very specifically about what it would take to terraform it. "Terraforming" is a new idea in history. You read the old philosophers and they don't talk about it because the concept was outside of their experience.

JCT: Most of us have never heard the term before.

KSR: The term was coined by Jack Williamson in the late 1920s in a story for *Astounding* magazine. But since 1976 scientists can actually start crunching numbers on what it would take to transform Mars into a living world. A fascinating thing.

JCT: You seem to debate the issue. The character of "Sax" says we have to spread our "consciousness" around; but Ann objects to turning the planet into a mirror-image of Earth.

KSR: I'm on the seesaw back and forth between the two. One of the things that has energized me in taking on my books is that I can see both these arguments and feel them very strongly, depending on the mood I'm in. There's a part of me thinks this is just a tremendous project, that it ought to be done, and that it is almost like a religious act, like building a cathedral. And there's another part of me that thinks, by analogy, that if somebody wants to change Death Valley like that, I'd be deeply offended. It would be an insult to the intrinsic value of the place as it is now. If you terraform it, you get a garden, a kind of "Disney Mars" that is artificial. You don't have that wilderness, and wilderness is something I very much believe in. But since 1976 more and more scientists have actually started crunching numbers on what it would take to transform Mars into a liveable world.

JCT: All around your room are examples of scientific fact and fiction about Mars.

KSR: I've got a book here called *The Atlas of Mars*, and I've got one of the first commercially available globes of Mars. The atlas was published by NASA as a government document, which you

can buy for about $10, and it's got very detailed topographical features and some of the names that I use. For about 15 years now I've been reading a pamphlet called *Science News*, a weekly periodical; it's like a newspaper of all that's happening in the sciences. A general scientific education is part of the job. This is what I find entertaining for me. There's been too much shying away from this in some science fiction. Isaac Asimov was very instructive in this sense. He doesn't fear to just dive off the edge and talk about something for 50 pages at a stretch—just basically talking science. The novel is a very capacious form and it can handle a lot of information. And I go to annual Conferences called "The Case for Mars" in Boulder, Colorado. The American Astronomical Society publishes their proceedings. Mostly people from NASA and from aerospace industry attend.

JCT: And somehow all that dovetails with all those Martian novels on the shelf, I guess.

KSR: You know, I think fantastic narratives and scientific studies feed in to each other very much. The fantasies of people like Edgar Rice Burroughs were based on the hardest data they had at the time, of Schiaparelli and Lowell, that is, that there might be dying civilizations on Mars. Burroughs use of "atmosphere factories" on Mars may be not too absurd after all. It's rather wonderful that Burroughs understood the concept. I didn't read his books until I was a college undergraduate. I came upon them too late, maybe, to have the same kind of magical link with them that so many others have. It's too bad I didn't run across them when I was younger. Then there was Jules Verne. I thought of him at the time as being one of a kind. I read at least 40 of his books, including a lot of the obscure works. In turn, those fantasies became inspirations for scientists like Von Braun. Science fiction and planetary science have been feeding off each other for several generations. When I began writing about Mars myself, I collected as many Martian books as I could, but then I grew reluctant to read them, because I didn't want to be overinfluenced by them. You can see that my favorite titles on my shelves are two of Burroughs "John Carter" books, Bradbury's *The Martian Chronicles*, Philip K. Dick's *Martian Time-Slip*, and *The Three Stigmata of Palmer Eldritch*, D. G. Compton's *Farewell Earth's Bliss*, Fred Pohl's *Man-Plus*, and Frederick Turner's *The Double Shadow*.

JCT: I would guess the Bradbury book looms large in that list.

KSR: Actually, I only read that a year or so ago. I didn't read it until I had about finished *Red Mars*. And then I realized it had very little relation to my own conception. His main theme was the idea that the Earth explorers will become "Martians" themselves. That's on the last page of his story, "The Martians." That's the critical

passage in all of his books. That indeed is a fundamental realization about what Mars is going to be for us.

JCT: I assume such a massive achievement as your Mars Trilogy must have had a long gestation?

KSR: I started doing the reading for it in the early 1980s. I wrote a short story with the title of "Green Mars" then. I started the first novel, *Red Mars,* in 1989 and finished it at the end of 1991.

JCT: Did the fact that Mars doesn't have all the exotic life-forms in pulp fiction prove to be troublesome for you?

KSR: True, I had to realize that finding no life at all was the obvious course to take. The scientific evidence is against it. My character of Maya even says at one point that Mars reveals "no touch of a god." But, you know, I don't think we have a very good understanding of life anywhere, for that matter! What dates previous Mars novels are those kinds of funky, bizarre life forms that we now know can't live there. At best, what could live there is a fairly uninteresting early bacteria, or lichen. That in itself as a plot device won't work. I thought it better to deal with Mars as a place where we start a new human world.

JCT: True, the very process of colonization and terraforming are clearly uppermost in your mind.

KSR: If we really do go there, we'll drag along behind us our cultural baggage. Some nations will try to produce an ideal version of their old national culture; others will try something new and radical. This will be grounds for a whole lot of conflict. In *Blue Mars,* my second volume, I'm preoccupied with those people who are born on Mars. For me, the second or third generation Martian will be much less interested in Earth culture and more absorbed by the new Martian culture, which in itself will be a kind of melting pot. I'm hoping this will serve as the kind of ground out of which a new utopian culture might be built. My three-volume work, in all, presents a mildly positive utopian vision.

JCT: Yet, the first book ends on a pretty bleak note.

KSR: The second and third volumes even go beyond that! But it certainly was a bleak beginning, yes. I only can say that when you face history and try to write a realistic book, rather than just a utopian one, you have to include that element. And also, right when I was working on *Red Mars,* we got into the war with Iraq. The world was at such a flash point. Wars happen for such irrational reasons and they get out of control of everybody, including the leadership.

JCT: When will the artists arrive on Mars?

KSR: I wouldn't think they would be there at the beginning.

JCT: Well then, how about writers and poets? What would they write about—Earth?

KSR: Can you imagine what their realist literature would be like! My God!

JCT: But you certainly include our own artists and visionaries in the place names you give to Mars.

KSR: Yeah, Bradbury Point, Burroughs, Sheffield base, and the Clarke asteroid, for example. I would love it if these names eventually got adopted. Names have to be chosen by *someone*. You know, most of the names for Martian features were picked out by Schiafarelli in his first map. It was always a hope of mine that I created something that was compelling enough, that it might have its influences. There are similar topographical maps for Mercury, you know. The International Association for Astronomers decided to name all the craters and major features on Mercury after great artists, painters, and musicians. So you've got Van Gogh Crater, Rimsky-Korsakov Crater, etc.

JCT: So... when will we ever get there?

KSR: I think that NASA of late has been a very disorganized and rudderless organization. They have set the stage for their own failure by not properly defining what they want to do with their program. I think the Space Station is a rather amorphous project and not necessary for getting to Mars. If anything, it slows it down. I know there's a lot of scientists and engineers in the aerospace industry that are frustrated by all this. NASA runs sort of a monopoly on this.

A manned expedition is so far down the pipeline that it's not even being talked about. I have a feeling that the Japanese might be a driving force in this. A construction project there has already designed a Martian town, engineered down to the last detail. The Russians have a tremendous amount of expertise in long-term space projects. And the Americans have NASA's expertise.

JCT: Speaking of the future, what lies ahead for you and the Trilogy?

KSR: The books have been getting an encouraging response, and I still feel like I'm working on the thing. Sort of like one of those Victorian three-deckers. Someone wrote a review and said they were a cross between *Lawrence of Arabia*, *2001*, and *My Dinner with Andre*! I feel like filmmakers could go out to Death Valley and, with modern effects, could make a movie out of this. There are places on Earth that are unbelievably "Martian." Meanwhile, I've been hearing from some writers that they're recasting their thoughts about their own work. I hope it would make its mark on future Mars novels. Successful novels do make a mark and for a while afterward, people have to deal with them.

JCT: Do you ever feel like Burroughs' John Carter, stretching out your arms toward the heavens, yearning to go to Mars?

KSR: Well, I would love to go to Mars myself. I've spent so many years looking at these maps and trying to imagine what it would look like, that I'm very curious at this point to get there!

The Extravagant Gaze

Goya's "The Sleep of Reason Breeds Monsters" (1799) (KUCSSF)

"A Sublime Madness": Francisco Goya, Theodore Géricault, and Caspar David Friedrich

The great visionary painters and imaginative illustrators of the past 130 years—luminaries as diverse as John Tenniel, Moritz von Schwind, the Pre-Raphaelites Dante Gabriel Rossetti and Edward Burne-Jones, N. C. Wyeth, Heinrich Kley, Arthur Rackham, Randolph Caldecott, Frank R. Paul, Joseph Clement Coll, Virgil Finlay, H. R. Giger, Francis Bacon,

Fritz Eichenberg, Maurice Sendak, Chris Van Allsburg, Frank Frazetta, Kevin O'Neill, and Joseph Mugnaini—owe much to the pioneering fantastic visions and grotesque nightmares of a generation of artists emerging around the middle of the eighteenth century, including William Hogarth (1697-1764), Henry Fuseli (1741–1825), William Blake (1757–1827), John Martin (1789–1854), and Gustave Doré (1832–1883).

Two distinguished art historians comment on three more of the greatest visionary painters from this period—Francisco Goya (1746–1828), Théodore Géricault (1791–1824), and Caspar David Friedrich (1774–1840)—whose fantastic canvases effectively captured the Gothic Ghastly and grandly *guignol*.

The late Albert Boime (1933–2008) was an emeritus professor of art at UCLA who specialized in the period between Revolutionary France and mid-century America. "I consider myself a social historian of art, as opposed to other kinds of art historical approaches," he says. "I believe that the artwork is more than a document, but also a document of its time, that tells us about the history and society of the period in which it was made." His publications include *Art in an Age of Revolution* (1987), *The Academy and French Painting in the Nineteenth Century* (1986), *Thomas Couture and the Eclectic Vision* (1980), *The Art of Exclusion* (1990).

Interview: Los Angeles, 23 June 1990.

The late Tim Mitchell (?–1993) was a professor of art history at the University of Kansas from 1979 to 1993 and a specialist in the life and work of Caspar David Friedrich. He is the author of *Art and Science in German Landscape Painting* (1993). I remember him as a convivial and generous colleague, the least pretentious of academics.

Interview: Lawrence, Kansas, April 1986.

Albert Boime

JOHN C. TIBBETTS: Do you think the bizarre and fantastic illustrations you find in today's science fiction, horror, and fantasy stories derive, at least in part, from some of the painters we find during the Gothic and Romantic periods in the eighteenth and nineteenth centuries?

ALBERT BOIME: To be sure. Many of those images are inseparable from their texts. Can you think of Coleridge's "Rime of the Ancient Mariner" without seeing in your mind's eye the illustrations of Gustave Dore? Or Milton's *Paradise Lost* without the works of William Blake? Or Goethe's *Faust* without the drawings of Delacroix? Think of other examples—you find Henry Fuseli's "The Nightmare" and landscapes by Caspar David Friedrich on the covers of countless books and record albums. The Fuseli, in particular, was, and remains quite a *cause celebre*, a really horrific

example of the "dream pictures" of the day, and frequently echoed in contemporary poetry.[1] Even today you find images from that time indelibly inscribed into our popular culture—

JCT: —I'm thinking of popular artist-writer associations, like Frank Frazetta and Robert E. Howard, Virgil Finlay and A. Merritt, Joe Mugnaini and Ray Bradbury.

AB: And everything shows up in the movies. The German film-maker F. W. Murnau used the drawings of several of Goethe's *Faust* illustrators as models for his film *Faust* [1926]. Walt Disney draws upon dozens and dozens of European artists and fairy-tale illustrators for his animated fantasies.[2] The storyboard artists for filmmakers like George Lucas have created an art form of their own, in my opinion.

JCT: And Ken Russell uses the Fuseli "Nightmare" in his film *Gothic* (1986).[3] Examples are endless.

AB: As you say.

JCT: In what way can we think of images like these as "Gothic" or "Romantic"?

AB: I don't want to put too fine a point on parsing the terms "Gothic" and "Romantic"—

JCT: —or fantasy and science fiction?

AB. Don't they all refer to ways of expanding on a vocabulary? Neither Gothic nor Romantic totally displaces Classicism and the rules; but they are a way of expanding them, to allow for greater effects, for new ideas, for technology, for changes in the landscape, for things that are happening in the world. Both have roots in the past— think of William Blake's "James Hervey" painting ["Epitome of James Hervey's Meditations among the Tombs, painted in 1820– 1825], with its evocation of the graveyard poets of the mid-eigh-teenth century—although I might add that Romanticism seems to deal more with directly contemporary events. So many painters are hungrily reaching out to record and express all the experiences of their world—Fuseli and Theodore Géricault the borderlines of dream and madness; John Martin, William Blake, and J. M. W. Turner the apocalyptic view; Delacroix the exoticism of North Africa; and Jacques-Louis David and Francisco Goya the political and individual triumphs and horrors of the Napoleonic Age. You can go on and on. They were not just poetically committed but socially responsible.

We see a great eclecticism here. Eclecticism brings an order to chaos in society and the arts in the postrevolutionary period. It was a period of upheaval, when it seemed to a number of peo-ple, especially to the bourgeois and the aristocracy, that anarchy reigned, when anything was possible. And, of course, one wanted order in the political world just as one wanted order in the aes-thetic world. At the same time the French Revolution seemed to

invite every kind of possibility all across Europe and England. Part of the subsequent "anarchy" stemmed from the great deal of experimentation, a great deal of trial and error. People wanted to get some system out of it, and eclecticism comes in to fill the breach, to provide some way of taking into account important styles that had been developed, codified, and creating something new based on prior systems.

As you see in the art world, no single style really dominates and comes forward that can be advanced or advertised in the art periodicals. It seems that everything is possible at the same time. It is a time of self-consciousness. In this sense, it *is* a historically charged moment. No, I don't think more was happening then than at any other time in history. It's just that the people became more *self-conscious* at this time. They suddenly became *aware* of possibilities. Because Classicism was being undermined, there was a self-consciousness about art that previous masters and previous critics didn't have.

JCT: And there's the sense of alienation we find in the Gothic tradition...all those tales about outsiders of one sort or another, revolutionaries, bandits, corrupt monks, mad scientists, the mentally deranged—

AB: —You say "mad"—or do you mean overreachers and visionaries? Either way they are emblems of the revolutionary spirit. True, during this period there's a tremendous preoccupation with the insane, with monomania and other delusions. You see this a lot in the writings of E. T. A. Hoffmann.[4] The upheavals in the Napoleonic period obviously dislocated, disoriented numbers of people who had to be institutionalized. You'll find in this period that psychoanalysis as a separate discipline—although an offspring of the medical profession—finds itself, begins to define itself. Look at the paintings of Théodore Géricault, for example. [5]

JCT: His short life seems to have all the promise and tragedy of a Keats and a Shelley, a Mozart and a Schubert.

AB: Like many Romantic heroes, he is a bit mysterious, a driven artist, with a fascination with the gruesome. And he died young. The irony with him is that this great master of equestrian paintings died from complications from a fall from a horse! I think he had enormous empathy with the power and dynamism of horses. He would have them in his studio, just to study. I think he said something once like he wanted to *draw the horse into himself.* He cared more about social injustice and the victims of suffering than he did about politics. Another irony is that his most famous painting, *The Raft of the Medusa* [1819], which created a political scandal at the time, is really more celebrated today for its melodramatically gruesome, blood-and-thunder violence. And there were many raw evocations of battles and the piles of wounded bodies.

In the last few years of his life, when he is troubled by poverty and illness, he is commissioned by his friend, Dr. Georget, chief of the Salpêtrière, to paint images of the insane, of monomaniacs, kleptomaniacs, and people with various manias, like gambling. Dr. Georget belonged to a first generation of what we now would call modern psychiatry in France. He had been Géricault's doctor when the painter had had a breakdown in 1819. They are some of the most extraordinary portraits in the entire history of art. He executed them with the same curiosity and fascination with pain and terror that he had earlier painted cadavers and body parts.[6]

JCT: Why were they commissioned in the first place?

AB: They may have been commissioned for some practical purpose, maybe as documentation of Georget's clinical studies or as demonstration material for his lectures.

JCT: The insane and the monomaniacs seem to have fascinated Francisco Goya, as well...

AB: Yes, but don't forget here's a passionate artist who spent much of his career watching with horror the ravages in Spain by the French during the Napoleonic Wars. He was torn in his loyalties. He was an admirer of the French Enlightenment, but there's no denying his love of Spain and his horror of the atrocities during the six years of terror during the French invasion. Think about the "Third of May, 1808" [1814], when the French executed without a trial Spaniards presumed to be involved in an uprising. Goya speaks for the victims, respecting their individuality as much as he enforces anonymity on the soldiers. And there's the great series of bizarre etchings, Los Caprichos [1797–1798] and The Disasters of War [1808–1814]. They have the kind of sardonic, yet furious outrage you frequently find in Byron[7]

JCT: "The Sleep of Reason"!

AB: Ah, yes, everyone knows that one! It could stand in for the whole Romantic temper—the sleeping figure succumbing to the irrational nightmare! And yes, he also paints many inmates in madhouses. Think of "The Madhouse" in the mid-1790s, when Goya may have been suffering from encroaching deafness and emotional confusion. There's little to differentiate the mad inmates from their keepers! Although Goya was always interested in the horrific, nothing attains the height of his 14 "Black" paintings that he did in his own home after 1819. He was working in virtual isolation at the time. Nobody commissioned them, and he never intended the paintings to leave his house. Here are terrifying visions of dark forces, terror, hysteria. The "Witches Sabbat" is straight out of the Gothic world of demons and witches; and "Saturn Devouring His Son" is a really overwhelming, relentless vision of cannibalism. That was during the restoration period, following Napoleon. So,

the Restoration brings in its wake a political situation that in some way is far more repressive than under Napoleon. This repressiveness led to this disorientation.[8]

JCT: Again, the borders between dissidents and the insane seem pretty thin, eh?

AB: In fact, many people who were dissidents were accused of being insane and were institutionalized. The insane asylum became a weapon to be used against dissenters. Anything or anyone who deviated from the system, who dared speak about change or revolution was automatically calumnied and labeled a threat to the body politic and, therefore, a social deviant, a heretic who needed to be incarcerated. So in a sense, this became a self-fulfilling prophecy: The greater the repressiveness, the greater the tendency to break out. And in a sense, the insane individual then is no longer considered a social deviant but somebody who embodies a sense of freedom from this repression, a possibility for moving beyond. The painter, I think, inclines toward a sympathetic understanding of the monomaniac, of the person considered a deviant; because in some way he or she is operating within a society that sees them in a similar way—as social deviants...

Géricault's "The Raft of the Medusa" (1818–1819) (KUCSSF)

JCT: But can we say these artists actually border on insanity themselves?

AB: Few artists are actually clinically insane. William Blake is a riddle, a man who claimed to have visions of the dead.[9] In the case of Géricault it's complicated because although he had a nervous breakdown and was treated by Dr. Georget (which was the beginning of their relationship)—I don't think it would be fair to call him "mad." I don't think in the case of these painters you have many instances of actual insanity. But certainly they might loosely compare their exalted states to madness in their letters and writings—that's true. They think of themselves as coming close to it. Perhaps it is because the idea of madness is now being enlarged in their thinking to include the person who is in a sense "breaking the rules," breaking new ground....

This is not to say that *some* artists were not institutionalized, such as Richard Dadd in England and Ernest Josephson, the Swedish painter. One can cite a number of cases. But there's also the idea of madness approximating the creative act. And so psychoanalysts here imposed a term that was very appealing to artists. And artists themselves could use this as a way of protecting themselves, as a way of isolating themselves from a society that was hostile, and at the same time giving to them a stimulus for creativity. Classed by themselves as mad by these conventional terms was also to stimulate, provoke them to creation. Thomas Couture, another French master of the first half of the nineteenth century, did a painting called "Le Fou," the mad person, showing the mad individual in a cell, explaining a point with his fingers. And this clearly is the portrait of an individual of a philosophical nature, trying to explain a system to others that deviates from the norm. For the Romantic, this is a positive image. For people who wanted social and political and religious *change*, they could look to these models, these possibilities as something to work for. But it wasn't long before these individuals were deemed mad by the very forces that wanted to keep society in a fixed position. They were threatened by change.

JCT: When we think about some of the poetry, like Coleridge's "Kubla Khan," we also think of so many projects incomplete and abandoned. Their virtues seem to be that they're *unfinished*.

AB: And you see that in the paintings of Washington Allston, Delacroix, and Thomas Couture and the musical fragments of a Robert Schumann, too.[10] Maybe the *effect* is intended to *seem* unfinished. That's very much in the spirit of the time.[11] Delacroix wrestles in his diaries and journals every day over this issue about the finishing and sketching of his work. He knows that to leave the work unfinished gives it a power, gives it a breath of execution, of broadness, that is very exciting visually, but at the same time he also recognizes the demands the public has, the conventions the academy makes on him that he must complete this

work in order to exhibit the full array of his mental faculties. The sketch itself is associated with the first movement of the hand, akin to the work of the savage, the child, to the insane person. So what it is that distinguishes the mature artist from these other categories—and that is the ability to exhibit your coherence and control. So there's a danger, a risk in allowing the sketch to serve as a completed statement about the world. There's a need to complete it, to work it, to display meditation, erudition, knowledge about the world. It's really the *effect* of spontaneity that they're trying to create.

This very *incompleteness* also creates the *implication* of madness. It's an excellent point that needs to be mentioned all the time— that an artist in a state of madness is *unable* to forge all the details, the components of the work into a unity during a state of madness. There would have to be disruptions that would give it incoherence. Look at the great work, for example, of Vincent Van Gogh and others who were deemed mad, and you see that there is actually a tremendous sense of unity of organization, of understanding. And it's very hard to pin a label of "madness" on the work of the artist of that caliber.

Tim Mitchell

JOHN C. TIBBETTS: How about landscape paintings during the Gothic-Romantic period, especially those of Caspar David Friedrich? They seem different from anything that had come before him.

TIM MITCHELL: This is a different kind of sublime landscape . . . not the sentiment and mythological subject matter of a Poussin, or the apocalypse of a John Martin or a Turner; rather, Friedrich's landscapes are symbolic of a different kind of political and spiritual vision, of a feeling beyond the rational mind and the perceptions. He depicts that in a twilight world, vaguely existing between light and darkness. But it's still the "sublime" that harks back to the English Graveyard Poets and reflects contemporary German poets like Johann von Eichendorff. The idea that art was in some way inextricably bound to climate and culture and political systems led the Germans in the late eighteenth and early nineteenth centuries to pursue the rise of their national interests, to stress those aspects of their culture that were native to northern Europe. And that meant ruggedness, sublime emotions of peaks and valleys, rushing torrents. And they tried to involve these qualities in their own cultural products, by stressing them in literature, art, and in music, in terms of settings for opera, song cycles by Schubert and Schumann, and things of that sort.[12]

Friedrich's "Wanderers and the Moon" (KUCSSF)

JCT: So this is political, you say?

TM: That goes back to ancient times. There was discovered in the sixteenth century a text by Tacitus about the German tribes. And he talks about the Germans living in the forest. They became convinced of that because they grew up not by the sea but in the forest. And there was a growing sense that in some way there were two major cultural forces in Europe—the southern and the northern. The southern in the Mediterranean was characterized by certain lifestyles, certain mental attitudes; but also governed by certain climatic conditions. Soft light, soft skies, generalized landscape forms, the ocean. Whereas in northern Europe with the rugged hills, gnarled oaks, dramatic cloud forms. These conditions in a sense gave rise to two different cultural peoples what were really in some ways in opposition to each other. Much of this comes out in art history, philosophy, and literature in the writings of Winckelmann, the great art historian. He wrote the two basic texts on the history of ancient art, published in the middle of the eighteenth century. He said that images were products of climate. That idea that art was inextricably bound to climate, culture, and system led to Germans stressing those aspects of culture, and that meant ruggedness, sublime emotions of peaks and valleys, rushing torrents; and they tried to involve these qualities in their own cultural products—by stressing them

in literature, poetry, art, and in music, in terms of settings for operas and things of that nature.

JCT: But there's frequently a sense of impending doom, an atmosphere of threat.

TM: Yes, landscapes take on a very particular character, almost a personality of their own, sometimes of encroaching threat, sometimes of decay, sometimes of an almost mystical longing, sometimes even a religious prophecy of an afterlife. You mentioned just now the great German painter, Caspar David Friedrich. An ardent patriot, as early as in the first few years of the nineteenth century he begins to paint landscapes in which he predicts the imminent defeat of Napoleon. There would be a deep forest with a single soldier looking into it. And you know if the soldier ever enters the forest, he will not come out again... This was Friedrich's prediction that the French would never prevail against the Germans. He might paint an eagle swooping over the valley, showing the enduring Germanic spirit. Of course, when I say "Germany" here, I'm talking about a country that didn't really exist yet as a unified nation. There were many principalities and dukedoms, etc. Friedrich was born a Swedish national. All his life he thought of himself as a German-speaking Swede. He was a nationalist and wanted a unified Germany. In fact, he even refused to correspond with his brother as long as he was on French soil. But after the defeat of Napoleon, the old forces came back to power. And there was an outlawing in Germany of wearing the old costumes. This was offensive to the new German powers. Friedrich's paintings often portrayed people wearing these costumes, the wide-brimmed hats. When you see these in the paintings, he's referring to the old nationalist spirit.

JCT: This recalls the spirit of the age, of the Gothic romance, and the Romantic revolution.

TM: Of course. What happens in western Europe is that in the late eighteenth century there's a change in seeing the world as a mechanistic system to a concept of the world as an organic whole, spiritually elevated, internally alive with some kind of vital energy. Now, whether that vital energy is some kind of odd force that's unknowable, or whether it's the divine spirit of God, is debated by various people. But one way or another, once you accept that the universe and the world and man are all parts of the same cosmic, organic whole, then you proceed toward Nature in a different way. You are part of something, you are in some way connected to it emotionally. Friedrich was totally convinced of the reality of this divine spirit. He structured his images in such a way to draw the spectator into this communion, this oneness with God. There are images he uses over and over again.

They conveyed a certain idea or concept he was trying to present. The blasted tree, leafless, just a bare trunk, but with a few new growths coming out of the base—the power of everlasting life. Mountains become a classic symbol of God itself, sublime, unchanging mountain. They saw mountains that had been created and would last forever. The moon became a symbol of Christ, it reflected the light of the sun, God himself, the transmitter of the message. Moonlight was the symbol of faith, the power of God to save you. Color for Friedrich was like the moon, if you see lighter tones, golden tones, it referred to Christ. It could be directly translated into the Trinity—one color represents God, another the Holy Spirit, another the sun.

JCT: The images that most quickly come to mind, though, are those figures on mountain tops, gazing out into some unknown vista.

TM: Well, there's the German term, *Gipfelerlebnis*, which means a view from a peak. It indicates the sense that can only be experienced by being on the top of a mountain range looking out across the valley; the sense of being at the top of creation. Friedrich in fact has a number of paintings showing solitary figures at the tops of mountains, standing with their backs to us, either at the very pinnacle or on the way to the pinnacle, almost at the top. In most of these, it's clear that he's trying to capture this unique sensation of being at the pinnacle of the world. It's intended to convey the divine experience, where the sky is as important as the land. They are the top half of the painting. Just the opposite is the term, *Waldeinsamkeit*. Instead of being at the pinnacle, you're *inside* the forest, looking up at the trees. It accentuates the gnarledness of the trees, the serpentine quality of the limbs, the sense of an organic energy. It's is also normal that the figures are *alone*. He goes to nature by himself. He doesn't want a companion. We think of the spirit of alienation from the city, from conventional life, that's so much of the Gothic spirit. No, it's a private experience, something he can only do by himself. Like a religious experience, it is singular, alone.[13]

JCT: You say, however, these landscapes are not realistic, in a sense, but are *composite* visions.

TM: We are always thinking of the artist's own vision, of his imagination. Throughout his life Friedrich was, as an artist, typified by creating his finished landscape paintings in the studio, based on drawings he had done in the countryside. But the drawings were from different locations, different time periods. He would use a drawing of a tree done in 1806, let us say, as the principal feature in a landscape painting in 1824. The tree is from one part of Germany, the landscape from another. He might use a rock formation done on a sketching trip in 1812 in the Harz Mountains. That rock will appear in a landscape, the background of which

involving Alpine peaks near Salzburg, done from another source, another sketch. So, he mixes and matches. They seem almost photographically real. But almost none of his landscapes is true "vedutti," that is, they are not visions of sites, views of a single site. They are always compilations of parts brought together.

"Scenes from Childhood"

Stand up and keep your childishness:
Read all the pedants' screeds and strictures;
But don't believe in anything
That can't be told in coloured pictures.
 G. K. Chesterton

One of the Gothic contributions to the weird tale was a special consideration of what the poet Novalis called "the extravagant gaze" of childhood—the awareness that for the child there was little or no distinction between the real and the imaginary, and that all things were possible.[14] Early in the nineteenth century Novalis and other poets and composers, including William Blake, Jean Paul Richter, E. T. A. Hoffmann, William Wordsworth, and Robert Schumann held that this wondrous vision was something privileged to the child. The child is *open* to possibilities, to the visionary experience rather than the congealed impact of adulthood and regulated existence. The seminal figure here is the character of "Mignon," in Goethe's novel, *Wilhelm Meister's Apprenticeship* (1795–1796), the child-woman who represents the uncertain intersection of innocence and experience, and who inspired many songs by Romantic composers.[15]

Consequentially, in the folklore-inspired Brothers Grimm, the child is open to an imaginative, sometimes even malevolent side of the universe. Their *Kinder-und-Hausmärchen* (Little Tales for Children and the Family) were first published in Berlin in 1812 and enlarged three years later.[16] There had been a variety of fairy tales in print before this, to be sure— Perrault's *Tales of Mother Goose* (1697), for example—and there would be modern variants, notably James M. Barrie's *Peter Pan*. And there were even the more sophisticated metaphors in the so-called German literary fairy tales, or *Kunstmärchen* of Goethe, Novalis, Ludwig Tieck, and E. T. A. Hoffmann.[17]

The Grimm's Tales not only ranged from the fantastic to the low comic, but they were intended to convey the presence of story-*tellers* rather than story-*writers*. They were illustrated, over the next two centuries, by artists such as Ludwig Grimm (the Grimm's younger brother), George Cruikshank, Moritz von Schwind, Richard Doyle (father of the famed Sir Arthur), Arthur Rackham, Kay Nielsen, David Hockney,

and, of course, Maurice Sendak. The recent fiction and films of writers like Stephen King and Peter Straub and numerous filmmakers such as Walt Disney (*Snow White*, 1938, *Pinocchio*, 1940), George Pal (the "Puppetoons"), Ray Harryhausen (the "Sinbad" films), and Neil Jordan (*Ondine*, 2009, *Company of Wolves*, 1984) also draw upon and exploit those terrors.[18]

As a result of Sendak's illustrations for several German tales and works by the mid- Victorian fantasists, such as George MacDonald, he came to the attention of publisher Farrar, Straus and Giroux. Together with translator Lore Segal, he reread 27 Grimm tales and in 1973 produced the landmark *The Juniper Tree and Other Tales from Grimm*. "I think children read the internal meanings of *everything*," Sendak said at the time. "It's only adults who read the top layer most of the time.... They know that stepmother probably means mother, that the word *step* is there to avoid frightening a lot of older people. Children know there are mothers who abandon their children, emotionally if not literally. Sometime they live with this fact. They don't lie to themselves. They wouldn't survive if they did. And my object is never to lie to them."[19] The results are dark, rather sinister but robust images that seem to burst out of their constricting frames.

In the following interviews with artist/writers Maurice Sendak, Chris Van Allsburg, Gahan Wilson, and filmmaker Charles Sturridge, we find four very different approaches to the fairy-tale tradition for young and old. In general, they echo Carl Sagan's view that "it makes good evolutionary sense for children to have fantasies of scary monsters. In a world stalked by lions and hyenas, such fantasies help prevent defenseless toddlers from wandering too far from their guardians..... Those who are not afraid of monsters tend not to leave descendents."[20] Thus, gentle whimsies, dark visions, and satiric commentaries all find expression on the drawing boards and movie screens of our interviewees.

Grimm Tales: Maurice Sendak

Maurce Sendak (1928–) was born in born in Brooklyn of Polish parents. He first secured his place in the hearts of young and old in 1963 with the text and drawings of *Where the Wild Things Are*. Ten years later he illustrated twenty-seven tales of the Brothers Grimm in his landmark *The Juniper Tree*. His many awards include the Caldecott Prize and the National Medal of Arts. He was the first recipient of the Astrid Lindgren Memorial award for Literature (2003).

Our interview transpired in Kansas City, Missouri on 16 October 1988. Mr. Sendak was supervising a production and putting final touches on the scenic backdrops at the Lyric Opera of a one-act opera based on *Where the Wild Things Are*.

Maurice Sendak and "Max" from "Where the Wild Things Are" (painting by the author)

Interview

JOHN C. TIBBETTS: You have illustrated the tales of the Brothers
 Grimm. When did you begin thinking about the project?
MAURICE SENDAK: It was around 1970 that I really began get-
 ting down to it. I had bought a copy of the Grimm's three-volume
 edition from around 1818. There was an engraving by the younger
 brother, Ludwig, which I liked a lot. I'm attracted by artists who
 aren't at all hung up knowing their audiences may be small people.
 I decided to go to Germany to visit the regions where the Brothers
 gathered their *Tales.* I wanted to avoid an "American" point of
 view; and I also decided just one drawing—designed to look like

an etching, really—for each of the *Tales*, with no decorations or anything else like that.

JCT: Do you see them as primarily intended for children readers?

MS: No, not at all. Collecting the German *Maerchen* and folk tales was very popular in the early Romantic period of the late eighteenth and early nineteenth centuries. Poets like Novalis, Achim von Arnim, and Clemens Brentano all issued collections of them. The tales gathered together by the Brothers Grimm were not necessarily children's stories. They are *stories*. Period. They are great German folk tales, collected by the Brothers— not to amuse children but to save them for posterity.[21] This was the beginning of the Industrial Revolution. The kind of horrors we're going through now were begun then. And the Brothers were philologists and philosophers and collectors, and what they were afraid of was that these peasant tales were going to get lost in the shuffle. Napoleon was rampaging through German towns. The Brothers wondered, what would be left after the Napoleonic Wars?

JCT: Yet, these tales have been always enjoyed by children.

MS: The *Tales* did find a readership among children, that's true. Children have naturally good taste! But when these stories first came out, the Brothers were appalled at first at the response by children. They had no idea that children were going to like them and read them so much. The question is, why did they like them so much? I think it's because they had been given a lot of homilies and pap to read previous to that; and suddenly, here were marvelous stories that were linguistically available to them and were simply told. And, too, they were about life and death and murderous impulses and sex and passion and all the things children are interested in but hadn't been allowed access to. So, of course, they fell in love with the tales! It was a form that everybody loved.

JCT: Should we distinguish them from the *Maerchen* tradition?

MS: The *Maerchen* were something else. Goethe and Tieck transformed simple folk tales into what they called "literary fairy tales," a form of high art. E. T. A. Hoffmann simply adapted the form for his own purposes. His "The Sandman," for example, is one of the most horrific stories ever written. And it was only natural that composers at the time, like Robert Schumann, would fasten upon them for their music and songs. Later in the nineteenth century you still see the fairy and folk tales popping up in writing and song. You go to Gustav Mahler, and you have his *Das Knaben Wunderhorn* (The Youth's Magic Horn) and his *Kindertotenlieder* (Songs on the Death of Children). I mean, *Das Knaben Wunderhorn* is a collection of poetry that is exactly the same thing as the Grimm fairy tales. Mahler wrote some of his best music in them. And his taste was impeccable. He got right back to it.[22]

JCT: Do the *Tales* hold out any particular challenge to the illustrator?

MS: Surprisingly, they're not really picture-book material. Your drawings have to say a lot on their own, but which heighten the stories.

JCT: Writers like Carl Sagan and G. K. Chesterton defend folk and fairy tales in general as positive allegories for children. There may be a dragon, but there's also a knight to *slay* the dragon. Yet there are those who want to censor and ban them. Even your own *Where the Wild Things Are—*

MS: Look—the Brothers knew that going back to childhood was not some sort of "Peter Pan"-ey kind of thing. That has become our own lopsided view of what childhood is and what adulthood is. The early Romantics were more insightful than that. They saw in these *Tales* the natural to-and-fro between the business of being a child and being a grown-up. There was naivete, yes, but there were premonitions of terrors, too. There was nothing eccentric or cute about it. It was just a natural state of things. Now, we have corrupted the folk and fairy tales into what are called "children's books." This was not the Brothers' idea at all. They didn't see them as something specifically for children; they were for *people*. It's hard to put ourselves back into that frame of mind, because we have so corrupted the form into idiocy, which is known as the "kiddie book."

Scene from Charles Sturridge's *Fairy Tale* (1997) (courtesy of Photofest)

"There's a Lot of Reality to These Fantasies!"
Charles Sturridge and *Fairy Tale*

Fairy Tale: A True Story (1997), a film by Charles Sturridge (*Gulliver's Travels*, 1996 and E. M. Forster's *Where Angels Fear to Tread*, 1991) balances the Gothic ambivalence of fantasy and reason found in Ann Radcliff and John Dickson Carr, with the childish gaze and the adult experience of the fairy tale. The film is redolent with gorgeous cinematography (Mick Coulter), a fanciful music score (Zbigniew Preisner), and stunning special effects (Tim Webber).

As a *film*, *Fairy Tale* fulfils the Gothic promise made long ago, that is, that the inanimate will *move*, that the dead will *arise* (and in this case, that fairy folk will *live*). Paintings and sculptures were coming to life in many eighteenth-century Gothic novels, as did Mary Shelley's monster. Contemporary magic lantern shows were deploying multiple projectors and dissolving slide images to create compelling and horrifying movement effects, blending the magic of perceptual illusion with the science of lenses and optics. Pioneering filmmakers and enterprising magicians late in the century, such as W. K. L. Dickson, Thomas Edison, Robert Paul, and Georges Méliès, strived, like so many Victor Frankensteins, to bring inert, still frames to life by means of chemical and mechanical technologies. "The transition from the inanimate to an animate state was a moment of immense cultural and psychic potency," writes Lynda Nead in her estimable *The Haunted Gallery: Painting, Photography, Film, c. 1900* (2010). "It represented the slippage between the dead and the living, between image and reality."[23] The dream of life in the Gothic tale was thus coordinated with the dream of motion in the film medium.

Although distantly removed in time from these early filmic experiments, Sturridge's *Fairy Tale* inherits and extends their legacy. Its arsenal of special effects brings to life the controversy over the so-called Cottlingley Fairies—a true-life incident—that inflamed a nation and involved two of the most famous celebrities of the early twentieth century, Sir Arthur Conan Doyle, creator of Sherlock Holmes, and his friend, Harry Houdini, master illusionist. Their dispute over the authenticity of photographs alleged to have been taken of fairies in a Yorkshire meadow perfectly exemplifies the Gothic ambiguity between fantasy and reality. It all began in 1920 when Doyle, an ardent believer in spiritualism, received a letter from a spiritualist friend, Felicia Scatcherd, claiming that recent photographs from the village of Cottlingley, in Yorkshire, proved the existence of fairies. He learned that the sisters Elsie and Francis Wright had taken the pictures three years before, in July 1917. He had the negatives examined by Kodak technicians who admitted they had not been artificially treated. Unable to visit the girls himself, he nonetheless publicly claimed in *The Strand* magazine that the pictures were real. He gave them to his friend, the magician Harry Houdini, to take to

New York, where Houdini and technicians promptly denounced them as fakes. Nonetheless, in 1922 Doyle repeated his beliefs in his book *The Coming of the Fairies.* "Other well-authenticated cases will come along," he wrote. "The thought of them, even when unseen, will add a charm to every brook and valley."[24] While Doyle continued to suffer ridicule from the press, the Wright sisters continued to insist on the pictures' veracity. As late as the 1970s, the sisters were interviewed on BBC television and claimed the complete authenticity of the photographs.

Sturridge takes liberties with the historical record: He compresses several years into one, sets the story in 1917, and allows Doyle and Houdini to meet. The two sisters, Elsie and Francis (played here by Elizabeth Earl and Florence Hoath), are now cousins, who are visiting each other while Francis' father is away at the front. As for the famous Cottlingley Fairies, we *do* see them...I think...

I spoke with Sturridge in New York City over two days, 5 and 6 October 1997, on the occasion of the release of the Paramount film.

Interview

JOHN C. TIBBETTS: Why did you begin *Fairy Tale* with a stage performance of a modern fairy tale, *Peter Pan?*

CHARLES STURRIDGE: Certainly the Peter Pan story is one of the building blocks of the modern reinvention of fairies.[25] Barrie was one of those who took an interest in the Victorian fairy painters of the late nineteenth century, which included Conan Doyle's father and Richard Dadd.[26] In fact, we went through a lot of those pictures ourselves as part of our research. We shot that in a fantastic theater in the East End of London, one of the last of the Edwardian music halls. The exterior theater is the Aldwych.

JCT: I mention your staging of *Peter Pan* because here, at the very beginning, we see this paradox: There's the illusion that he's flying, but the audience can see that he's suspended from wires.

CS: Well, the film is very much about how magic works. And yes, I did that deliberately so that it was obvious that someone was flying with a piece of wire tied to his back! I wanted to get people to start to think about what and how we believe, in this case a girl playing a fairy sprite with a wire up her back! Contrast that later in the film, when you see fairies flying around *without* the wires, so to speak. That sets the terms, if you will, of how we will be seeing the entire film: I'm serving notice that this is *how it's going to be.* In a later scene I have Doyle [Peter O'Toole] watching Houdini's [Harvey Keitel] illusions—and you realize that Doyle apparently *really thought* Houdini was a medium, that he couldn't do what he did without some access to spiritual health. Not so much in the escapes but in his other illusions that seemed to *defy* explanation. The audiences of his

performers just *couldn't believe* what they were seeing! Even something like his learning to hold his breath for an hour stills seems impossible for us. I thought very carefully about how much I would show in those scenes about how they were explained.

JCT: Like an ambigram that can be seen in two ways.

CS: Right, this is especially so in the last scenes when the fairies appear. Elsie for the first time actually sees the fairies, but Francis doesn't. She's asleep, and when she wakes up she doesn't notice them. I got the inspiration for that from *A Midsummer Night's Dream*, when the fairies come with Puck to bless the house. *We* see what *Elsie* sees. I tried to make a film that *listened* to what the girls said; and the girls never really changed what they said. They never changed their stories that they had seen the fairies.

JCT: It was wise of your composer to avoid Mendelssohn for this sequence, don't you think?

CS: Zbigniew [Preisner] was a critical choice for me. I had never met him before this film. But I knew him for his music for the "Three Colors" trilogy. His music is so direct that it's never sentimental, and yet it's incredibly emotional. He had the ability to go for what is *real* and find emotion in it.

JCT: It seems significant that this is not the *first* time the fairies appear. At the beginning, the camera tracks up a tree trunk, and there they are! Spectacular effects! Very *believable*, if I may say so! As a director, when you come to scenes demanding special effects like this, do you just step aside and relinquish the controls to the effects people?

CS: There's a lot of *reality* to those fantasies! I meticulously wrote out those scenes and story-boarded them. Near the beginning, I specifically wanted the audience to see the fairies *before* the girls did! That's because I didn't want it to be all about whether or not you saw them only because *they* saw them. I wanted you to think, my God, *I see this, and what do I think about that?* We combined digital effects with crane shots and a hover-cam for a seamless effect of following them from the garden, up the house, across the roof, down the chimney, out through the fire and through the room, seemingly uncut. When I storyboarded that out, I thought, My God! This is completely impossible! And we knew we had to suspend our actors on wires, which is jolly uncomfortable! We had to work three weeks on those shots. However, one of the great things about writing is that everybody then takes it very *seriously* and you have to work it out! It was a wonderful problem-solving test for all of us, particularly a guy named Tim Weber, who also worked with me on *Gulliver*. We took risks, because if things don't work, we're in serious trouble. Once you find the solution, it's like learning the secret of one of Houdini's illusions: Oh, *that's* how you do it!

JCT: Is *anybody* in the audience breathing during those scenes? I wasn't!

CS: I dunno! I'm not, at times! I must say, not many of the "fairies" were breathing, either! They were so corseted up and strung together...

JCT: It seems like *Fairy Tale* is asking us to do two things. It's one thing to believe in fairies when we don't see the wires. But you're also asking us to believe in illusions even when they *reveal* their wires, so to speak. The sort of thing that Penn and Teller do. Which is a harder kind of credulity to enlist, isn't it?

CS: I suppose what we're doing is saying, Look, here are a series of pieces of magic, where I'm showing you where the wires are, as if I'm taking you backstage to see the trickery. And also, here are a series of pieces of magic where I'm *not* taking you backstage to see where the wires are. You are the audience in both cases and you have to make up your own mind. Some magic has wires; some magic doesn't. If you like, I'm doing what the girls did. I'm doing what Houdini did. Sometimes I'm showing you things from the *front*; other times I'm showing you from the *back*. Just to remind you that there *is* a back and there *are* wires!

JCT: Charles, have you ever tackled anything like *Fairy Tale* before?

CS: Thematically it's different from everything else I've ever done, especially in the sense that it has a happy ending (sort of). However, working on *Gulliver's Travels* did give me a start to thinking about the kinds of effects that *Fairy Tale* has. It's more playful than my other work. And I did attempt to recreate this very interesting and fanciful look at the past in as realistic a way as I can and not to make it look like a dreamland. This is the kind of story that defines its own "pastness" of 1917.

JCT: How did this project come to you—or did you go to it?

CS: I was only vaguely aware of the actual true story when it came to me as a script. I looked at it and knew straight away this was an extraordinary story but that it should be radically changed in how it would be told. So I went back to the sources of the story. I met the families of the girls who originally took the photographs (the girls themselves had died earlier). This was in February 1996, just after *Gulliver*, and we were shooting by that summer.

JT: Where did you locate the families?

CS: In real life they were sisters, not cousins. I wanted to explain how they were together only during the War. They both in different ways tried later to evade the burden of their story, which seemed to follow them around. Elsie married an Englishman and went off to live in India, where she spent most of her early married life; and Francis went to Ireland. But in fact one of the children came back to England. Elsie's son, a retired town councilor, is living in the north of England in Nottingham; and Francis' daughter now lives in Ireland.

JCT: Any reluctance on their part to talk about the charges of fraud?

CS: Yes, I think Francis' family was much less keen to talk to me until very late, whereas Elsie's son was a major source about his family. He had the photograph albums, many of the drawings, and Elsie's notebook when she was a school girl. Most interesting was that he had a hand-written autobiography she had written in the late 1970s. It was in foolscap paper in piles in his attic. It was partly about the fairies, but also about her life.

JCT: Did any of the cut-out figures survive that supposedly were in the photos?

CS: No. They apparently survived for some years tucked away in Arthur Wright's copy of *Popular Mechanics*, but he never knew it. He never opened it, but that's where they kept them! I have seen Elsie's drawings, though, and they clearly reveal a very talented little girl. There was not a brother. We added him because he became our source for the drawings and cut-outs (in real life, we have to assume the girls did them).

JCT: Did you ever get the sense that these two girls were haunted by these events in later life, the way that Alice Liddell was with the *Alice in Wonderland* connection?[27]

CS: I think they were, up to a point, but not so much. One of the reasons they left England was every six or seven years some journalist would pick up the story and come back to track them down with questions. They didn't want to carry this with them. Now, I've seen Elsie on tape as an elderly lady, and it's clear that she and Francis were both creative and intelligent and very strong women. Elsie was a great story teller, a great game player. But since she was dyslexic, she found writing difficult. She was enormously inventive, which her children often talked about. Francis' children also talk about their mother's enormous vitality and wit. In the end, they were two girls living in a tiny village in a tiny house.

JCT: What about the Arthur Conan Doyle people? Did you track any of them down?

CS: I spoke to friends of his surviving daughter, Dame Jean Bromet, but we didn't actually meet.[28] But I did read a number of books, and my favorite was *Conan Doyle and Houdini,* which was published in the 1930s. It was mainly a collection of letters between them. The great thing about people of that period was that they *wrote*, which in this case gives us a clear picture of both of them. In fact, I got very interested in Doyle and Houdini, and I did have more of them in the film, but in the end it had to go to preserve the girls as the center of the film. Certainly there is much in the Doyle and Houdini story that would make a film in itself. Near the end of Houdini's life the Cottlingley incident did come up again.

JCT: You portray Houdini as being remarkably sympathetic about the pictures.

CS: There is a "cheat" there. Houdini *never* thought the photographs were real, but in the film I allow a chink of light when he teases the girls about the kinship they share, of them all being *performers* of magic. That allows him to doff his cap to them in the end. I was twisting things a bit there, but not so much as to betray Houdini's real opinions.

JCT: Any danger that the village of Cottlingley will end up as a "Field of Dreams" site, where people will make their pilgrimages?

CS: Cottingley has now been sucked into a suburb of Bradford, a sprawling industrial city in the north of England. So it's lost its shape, its singularity. On the other hand, the street is there, the house is there, the door is there. You can go through the back of the house down to the stream at the bottom of the field. That *is* the stream where they took the pictures. It's all there, sort of perched on the edge of the moor. What made it complicated for filming were the modern buildings all around. It turned out to be impossible to shoot exteriors, although we did shoot the scenes in the schoolroom, which was only about a 100 yards from where they lived. It's a village hall. And, ironically, we did shoot one of the streams—not the real one—that the journalist investigates. Actually, I would rather *like* it to be a place of pilgrimage; but whatever fairies were there I'm sure have gone somewhere else!

JCT: Well, you do show them near the end of the film packing their bags! Rather like the Borrowers, leaving the area....[29] Finally, I believe you have a surprise for us. Something you just learned about the Cottlingley Fairies...?

CS: Right. Just this morning I spoke on the phone for the first time with the daughter of Francis, who was the youngest of the two girls. You know, as old ladies neither Francis nor Elsie revealed to anyone, not even to their parents, the secret of the fairy photos. This is astonishing in itself—not until they were elderly ladies did they talk about them. Anyway, Francis' daughter told me that her mother admitted that the four photographs had been faked. Francis had not taken the others, but she did take a *fifth* one. She called it "The Fairy Bower." She claimed she had seen something moving in the grass and so she just pressed the shutter on the camera. What you see is a rather fuzzy image of a figure—fuzzy, perhaps, because it was *moving*...? Well, Francis swore that the fifth picture was authentic. That it was true. You know, in the end, what fascinates me the most is not what the girls did and what they did or did not believe, but what *we* believe. And that I leave up to you.

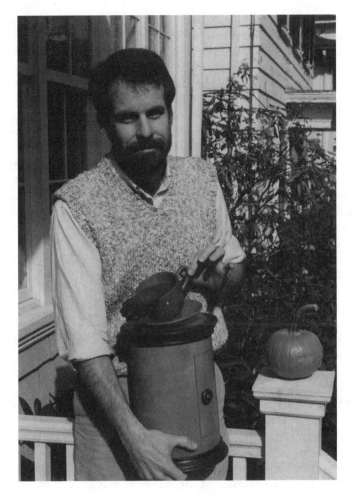

Chris Van Allsburg with one of his wooden sculptures (photo by the author)

The Mysteries of Chris Van Allsburg

In Chris Van Allsburg's *The Wreck of the Zephyr* an old sailor offers some remarkable advice to a small boy: Find the "right sails," as he puts it, "and you can make a boat fly." When I quote the line back to him, Chris smiles in that slow, deliberate, wry way of his. "Yeah, but the wind's got to be just right, too, and the rigging trimmed a certain way—*then*, it seems like it ought to happen!"

Van Allsburg (1949–) has been finding the "right sails" for his millions of readers, young and old, for more than a decade. As E. T. A. Hoffmann had done in the intertwined real and alternate worlds of his fairy tales ("The Golden Pot"), Van Allsburg inscribes in his drawings the interweavings of the fantastic and the real, like the shiftings of figure and

ground in a picture by M. C. Escher. In *Jumanji* (1981) and *Two Bad Ants* (1988) households are transformed into jungles fraught with adventures and hazards; in *Ben's Dream* (1982) a floating house circles the globe. A fabulous train chugs to the North Pole in *The Polar Express* (1985), and a flying bed soars into the future in *Just a Dream* (1990). "Almost everything I write is a trip, a journey of some kind," Chris says. "That's unconscious, although recently I just came to realize it." To date film versions of his books include Joseph Johnston's *Jumanji* (1995), Robert Zameckis' *The Polar Express* (2004), and Jon Favreau's *Zathura* (2005).

Chris is a bearded, soft-spoken man. With his children and wife Lisa he lives in Providence, Rhode Island, in a house full of stairways, sun-drenched alcoves, a gabled attic studio, and windows that look out onto trees and sky. The rooms and hallways have a rambling, storybook quality to them, and you half expect to see elves peeking out at you from behind a closet door or from around the hallway.

As a sculpture and artist, he has exhibited at the Whitney Museum of American Art and the Museum of Modern Art. His books are best sellers. He has won virtually every award in the so-called children's books field—two Caldecott Medals (for *Jumanji* and *The Polar Express*), numerous *New York Times* "Best Illustrated Children's Books" citations and many *Boston Globe* "Horn Book" awards. His works are distinguished by a lean, sculptural precision of word and image. They are lit from below, so to speak, with a peculiar "glow." Like the American master, N. C. Wyeth, whom he greatly admires, Van Allsburg has learned the uncanny knack of putting us into each scene, making us believe in the experience and enabling us to feel the textured light. Wyeth's credo applies: "Don't just paint a sleeve—become the arm!" His latest book is *Probuditi* (2006).

My two interviews with Chris Van Allsburg transpired on different occasions. The first was on 31 October 1986 at his home in Providence, Rhode Island, at the World Fantasy Convention, where he was Artist Guest of Honor. Almost on a whim, really, I telephoned him for an interview. He invited me out and we spent a bright October afternoon talking and sipping tea and apple cider. After several subsequent telephone conversations, I caught up with him a second time in August 2004, on the occasion of the release of Robert Zemeckis' film version of *The Polar Express*.

First Interview

JOHN C. TIBBETTS: Let's begin with some of your first reading experiences.

VAN ALLSBURG: I remember when I checked out my first book from the library. It was a biography of Babe Ruth. I took it home,

started reading it, and read it through dinner, dessert, and to bed. I just simply did not know when to stop or why. Having grown up with television, I was accustomed to watching something until it was finished. I always assumed that as long as the book was there I should read it to the end. When I was eight years old I fell in love with the exotic colored images of stamps. For three weeks I did virtually nothing but devour those stamps with my eyes. Then, when I caught the flu, in my delirium I imagined I was in one of those stamps, one that pictured the Lewis and Clark expedition. I was there, with them, standing in front of a timber fort with our Indian guides, but we never went anywhere. To this day, I read every word on the cereal box at breakfast. I'm an expert on shredded wheat!

JCT: Let's talk about your first book.

VA: Sure. I submitted my first book, *The Garden of Abdul Gesazi*, in 1979 to Houghton-Mifflin publishers in Boston. I was surprised to find it was a success. But after I did it, I went back and started making sculpture again, because it wasn't like I'd made a career decision, or anything like that. I actually expected that I'd end up buying up all the remaindered copies of that first book and have Christmas presents to give to people for the rest of my life! But it didn't turn out that way. Rather, a long association with Houghton-Mifflin was forged and it remains one of the happiest publisher-artist collaborations you can imagine!.

JCT: Indeed. What's the book about?

VA: Well, a boy loses his dog in the garden of a magician. You don't know if the magician truly turned the dog into a duck or not—that's the problem, whether the magician was fooling him with sleight-of-hand, the way stage magicians do, or maybe if he is a real wizard in the phenomenal sense. After that I did *Jumanji*. It's about some kids who are bored one day and they go out and find a board game at the base of a tree in a park across the street from their house. There's a little note attached to the board that says, "Fun for some, but not for all. P. S. Read instructions carefully." It's a jungle adventure game, and as they play it, it transforms their house into a jungle. It rains, there's a monsoon season, and there's a volcano that erupts and lava pours out of the fireplace; and because there's water on the floor from the monsoon season, the house fills with steam and there's a rhinoceros charging. When the game comes to life the kids are actually frightened. They consider simply stopping and waiting for their parents to come home and resolve the dilemma of getting the lion out of the bedroom. But they remember those instructions and they decide they have to complete the game.

There's the possibility of lots of terrible things happening, but they persevere. That is its moral premise—that the kids can solve the problem themselves.

JCT: You love to write about dreams. There are actually *two* of them in *Ben's Dream*.

VA: Yes, they intertwine, in a way. It's about a little boy and a little girl who ride home on their bicycles. It's their intention to play baseball, but it begins to rain. They decide to go to their own homes to study for the big test the next day on great landmarks of the world. So Ben begins to read about the landmarks, and the rain falls heavier and heavier, and it's a deluge—heavier than he's ever seen—and he falls asleep to the sound of the rain. When he wakes up, his house is on a tilt and he's floating off to sea because it's rained so hard. He floats past all the great landmarks, the Statue of Liberty, Big Ben, the Sphinx, and they're all almost underwater. While floating past the Sphinx, he's standing on his front porch and he sees a little house in the distance and there's someone inside it. He thinks he recognizes who is there. Anyway, after he's gone all the way around the world, he comes back home (you can tell he's back because he goes around the world counter-clockwise) and the lips of the statue of George Washington on Mount Rushmore says, "Ben, wake up!" He does and he joins the little girl outside and they play baseball, after all. The girl says to him as they pedal away, "I had a crazy dream. I went around the world. You'll never guess who I saw." And he says, "You saw *me*, because I saw you!" So, they had had the same dream!

JCT: But it's like a riddle without any real answer.

VA: If you say so, John! There are *real* riddles in *The Stranger*!

The whole book is a riddle. There's a clue on every page about who the stranger is. Everyone knows who the stranger is. The stranger has temporarily forgotten who is because he's had an accident, a blow to the head, and he's lost his memory. So you, the reader, get little clues page by page about who the stranger is.

JCT: Speaking of riddles, maybe my own favorite example of that is *The Mysteries of Harris Burdick*. I think it belongs on that slim shelf of modern illustrated books that will long endure—on a par with Everett Shinn's illustrated Dickens, William Pene Dubois' *Peter Graves*, a few works by Wyeth, Joseph Clement Coll, Thomas Hart Benton, and perhaps some of the Roald Dahl/Quentin Blake collaborations.

VA: Pleasant company, thank you very much.

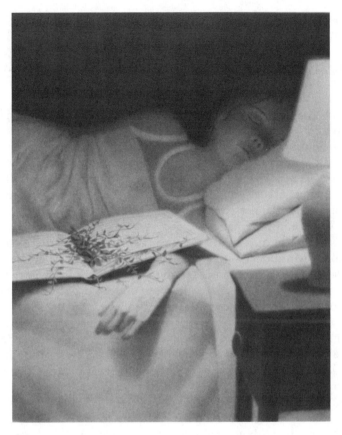

Illustration, "Mr. Linden's Library," from *The Mysteries of Harris Burdick* (photo by Van Allsburg, owned by the author)

JCT: When it came out in 1984 I must have stood a long time at the bookstalls, fascinated, both by its enigmatic "Introduction" and the bizarre series of 14 black-and-white chalk drawings it contained. Your name is on the cover as the "editor," but it's claimed in the Introduction that its true author is one "Harris Burdick." Who's he?

VA [after a pause]. Oh, he's a mystery man who appeared at a publisher's office 30 years ago with these drawings and a few scraps of text. Burdick promised he would return with the rest of the text and more drawings to complete the story. But he never did. His disappearance is complete, total!

JCT: I like to think of the book as your own *Mystery of Edwin Drood*, a mystery that's forever unsolved. But do *you* think it needs finishing?

VA: I have to play it "straight" with *Harris Burdick* because I made a commitment to myself at one point. I can only say that Burdick

disappeared 30 years ago. Meanwhile, a few years back I met a man I call "Peter Wenders," who used to work at a children's book publisher, and he brought up the subject of Burdick's drawings. He pointed out the similarity between some of my drawings and Burdick's work. A close similarity! So he invited me to his house, which wasn't very far away (he was retired by now). There I saw the only surviving Burdick drawings and captions and was amazed by them. It was such a provocative kind of thing that I got hold of my publisher in Boston and with Peter's permission took the drawings and captions to Boston and had them turned into *The Mysteries of Harris Burdick*. Since it came out in 1984 I've received many letters from teachers and students who match their stories with the illustrations.

JCT: What kinds of images?

VA: One image in particular that draws a lot of response is the one called "Mr. Linden's Library." It shows a young girl who has fallen asleep with an open book in front of her. She's lying in the little circle of light from a lamp. Growing out of the gutter of the book you see ivy, little vines trailing out; some of the vines have actually started to grow from between the pages; and a few of the tendrils touch her arm. The caption is, "He had warned her about the book. Now it was too late." So the challenge for the reader is to look at the image and figure out who Mr. Lindon is and what's going to happen to the girl. Sometimes the truth is quite violent, or, I should say, morbid.

JCT: Any news from the missing Mr. Burdick?

VA: At one time I thought perhaps the publication of the book might help unearth some information about Burdick. He might come and claim some royalties. It's hard to believe that he could have led a life so isolated, even 30 years ago, that there wouldn't be people around who knew or remember him or could throw some light on his life. But so far, I haven't heard anything!

JCT: That's all you're going to say about it?

VA: I like to withhold information, which is why some of my—*I mean Burdick's*—drawings are not very specific, or why many of the faces are turned away a little, or figures and objects are partly cropped out of the frame. I also try to keep everything timeless. I don't try to give a specific sense of time or and place and I don't deal with subject matter that has a specific time or place. Although children read my books, I don't consciously write for them. They are not my specific audience. I was one myself, once, and I just write for me. In general, I guess I just like the idea of creating a book that, if it did not have the copyright on the inside, a person would be hard put to say if this was done in 1930 or 1990.

JCT: I'm looking at another of the Burdick drawings, "Another Place, Another Time."

VA: Yes, you see how you can get those ambiguous effects in all kinds of ways. Here, the perspective is provocative. It's got a single-point perspective and these people are on an unusual little rail car. It's a rail car, but it's also a toy. It's got tiny little wheels that fit right over the rails, and it's wind-powered and they're going on a kind of causeway toward a misty bank. You can see what looks like an island beyond the bank. To the extreme right is a castle-like tower, but it's at a great distance. You can't tell exactly what it is. And one of the four characters on the little wind-powered rail car is looking off toward that building.... The caption Burdick wrote is, "If there was an answer, he'd find it there." So, whatever the answer is, he knew he was heading in the right direction. You wait for all my books to resolve themselves at the end, but that won't happen because when you read the last sentence, then the book opens up again because you have to think about it in a different way. I like the idea of a book that doesn't end on the last page.

JCT: I suppose we've gone far enough but that it's time to talk about *The Polar Express.* Your greatest success, I suppose. It's everywhere, in Christmas gift editions...

VA: I didn't intend *The Polar Express* at first as a Christmas story at all. I just had this idea of a train waiting to take a child on a trip. At first, I didn't think of the train as outside his door, the way it happens now, but in a more reasonable place, like in the woods where the boy had never seen tracks before. Then I changed it to right there in the street. The image of that giant behemoth train and the steam all over in thick clouds outside his window was striking to me. I asked myself, where is the boy going? He's going North, I guess. What does he see? Then I realized the North Pole is there. Well, if it's the North Pole, why would he go there? Wow, it's Christmas Eve! I realized. These things just fall into place. I think Santa Claus is the only truly mythic figure in our culture who is believed in by a large percentage of the population (although it's a pity that most of the believers are less than eight years old). The presentation of the Christmas myth to a child by parents, society, and culture is an incredible gift and experience. Here we are, citizens of the late twentieth century, yet we need to believe there's a guy who can fly through the sky, that he can squeeze down a chimney, that he knows if you've been naughty or nice. And that's the way—well, that's the way the Greeks interpreted their own reality, too!

JCT: Is there a particular image of the old gentleman, as interpreted by so many artists, from Nast to Rockwell, that you preferred as a boy?

VA: I think I accepted the fact that none of these artists had ever really seen Santa Claus! Therefore, nobody would draw him the same way!

[Note: While Chris has been talking, I am looking around the room. It's a very curious room. I spot some wonderful things. There, in the corner beside the fireplace, sits a tiny gentleman only about three feet tall. Chris follows my gaze. We interrupt our conversation for a tour of the room.]

"Oh, the Old Gentleman!" he laughs. He goes over to the wizened little figure. "He's made of *papier mache*. It was a gift to me. I think it's me at the age of 80!" Chris pauses cryptically. "But I know for a fact that I won't have that much hair when I get to be that age! He's dressed in the kind of typical old codger New England outfit with the cardigan sweater. He has a cat in his arms, who is *my* cat, who won't be around, I'm afraid, when I turn 80. The man's reading a little book which is called, 'How to Stay Well.' He's a withered old guy, but he has his mouse ears on. Actually, I've got a few hats that'll fit him. He came with an old fedora, but every once in a while, I put the mouse ears on him."

My eyes are only just now getting accustomed to this place, the way you see things more clearly after standing in the dark for a while. Curious sculptures, objets d'art, and other items are everywhere, suddenly beckoning for my attention. Near the little man, standing about two and a half feet high is a sculpture of an armadillo. Chris is bemused at my curiosity. Casually, as if it were the most natural thing in the world, he tells me there is a pig that belongs on top of the armadillo. But it has gotten lost somewhere. On the table before us, where it has been sitting quietly all this time, is a carved wooden cup and saucer. The cup is dangerously tilted, the slather of coffee arrested in its spill over the brim. "That's one of my pieces," he says, handing it to me. "I tried to freeze a moment in time. This one has a big lick of walnut coffee, a brown wood, coming out of a maple cup, which is a lighter colored wood. It's larger than life, maybe 120 percent real scale."

Chris says each of his books takes four to five months to complete. He admits he never got the "sketchbook" habit and he rarely works out of doors, preferring the quiet sanctum of his studio. He works slowly and avoids unduly protracted sessions at the board. The story comes first, and then numerous thumbnail sketches. Eventually he decides on a series of 14 or 15 drawings. "The actual drawing at the board takes so long because the work can't be done for too many hours at a time," he explains. "There's not enough going on up here, around me, and it's just not physical enough. It's tough to keep your motivation after about 10 drawings. Even if your energy and enthusiasm isn't waning, it's good to just get up from the board and go away for awhile."

At first glance Chris' images seem a cross between Charles Addams and Rene Magritte, but gradually they declare themselves on their own terms. The sense of space is immediately arresting. For example, the interiors, furniture, and details of books like *Jumanji* and *Two Bad Ants* all seem hyperreal, everything seen from unusual vantage points. "As I said, I like the less conventional point of view. If you put the point of view

in a place where a person couldn't be—like if you put it very low to the ground (I mean, people don't go into a room and drop their heads on the sofa or the carpet and look at the room from that angle!)...By setting up a drawing like that, you become a different kind of witness to the event. You're forced to look at it in a different way. It's a different kind of space, of course, from the dynamic space created by sculptures. They're two different things, actually. Drawing for me is always an illusion. You're trying to create the illusion of a three-dimensional space on a flat piece of paper. That's not what you do in sculpture. The third dimension is a given. The magic lies in the finding of the forms, like being on an archaeological dig and coming across some odd little specimen you can't quite make out. The mystery is not that of an illusion, but of reality itself."

Chris smiles when I ask him to trade secrets about how he achieves his magical, soft-edged effects in some of his books. He picks up my copy of *Harris Burdick* again. "Now take this drawing," he says, pointing to the first one, entitled, "Archie Smith, Boy Wonder." The image is in black-and-white and depicts several fuzzy, luminous globes of light floating into a bedroom window toward a sleeping boy. "Burdick seems to have executed it in charcoal on fairly smooth paper. I can say that with certainty because I've seen the original drawing! All of them were rather large, about two feet high, I'd say. The scale suggests that Burdick's training was maybe more as a fine artist than as an illustrator. Maybe some of it was done with a finger rather than with a pencil. The drawings appear to have been very intentionally taken out of focus in certain areas. You can see Burdick was very sensitive to issues of depth of field, atmosphere, and perspective."

The technique varies from book to book. The images in *Ben's Dream* (where he employed a scratchboard) are hard-edged, black-and-white line drawings in the style of nineteenth-century engravings. By contrast, *Jumanji* and *Burdick* emphasize the monumentality of a more soft-edged form and mass. The *Wreck of the Zephyr*, *The Polar Express*, and *The Stranger* present furiously vivid colored images that have a textured, almost tactile quality. "I learned how to draw with a drawing instrument first, and only later did I become interested in color as a new challenge. I use pastels, oil pastels, and crayons. You find out that things like color and composition carry their own dramatic charge quite apart from the story itself. The German master, Caspar David Friedrich, who worked on landscapes in the first half of the nineteenth century, was on my mind when I did *The Polar Express*. Probably because of the strange colors he used—very strange and complicated colors, like blues mixed with oranges." And Van Allsburg's use of light is also strangely distinctive. "I work for a kind of clarity that real light doesn't have," he says. "It becomes simpler, starker, a bit surreal. The tough thing about it lies in the way it changes the effect of a color. It's incredible how a color must change in various light and shadow conditions, yet remain unmistakably that color!"

Second Interview

[Note: It's August 2004. We're in Chris Van Allsburg's new Providence home. Chris' studio is on the third floor. The ceiling peaks in a sharp "V" over his small drawing table. There are windows in the gable end through which the trees wave a friendly greeting. The walls are bare and the overall appearance is plain and modest. As Chris says, he's there to work, not enjoy distractions (although occasionally he will tune his radio to the local Public Radio station).]

JCT: Hello again, you've moved, I see. And I see lots of toys!

VA: Sure, I've got some of my toys up here. Because of more children we needed a larger home. When I bought it, I wanted to recreate my old house in the new, larger house. I'm about 10 minutes away from the old house. My studio is on the third floor of my house. A pretty good-sized room. Over there is a five-foot tall model of a ferris wheel that I made myself out of tiny little metal parts—the German version of an erector set. About 10,000 parts. I built it up here, and now it's too big to go out the door! I had always thought of a ferris wheel as a quintessential erector set project. And when I saw this kit for sale, I thought I could build the ultimate ferris wheel. Lincoln Logs are okay, but they're not much of a challenge. My kids come up here and sometimes are curious to see what I'm working on. But it's not the first thing they want to do when they get home. People used to ask me before I had kids how could I be sure as an adult what I was doing would have any interest for kids. I'm not sure. People wonder if I "market-test" my stuff to kids. And there was this assumption that a child's story interest was so specific that an adult could not create things for them without having a close association with them. But I wasn't writing for kids then and I don't now. I just try to write stories that hold my own interest. I may have once said I write for the child in me, but now I think there's something kind of sentimental, kind of corny in that. Maybe I have kind of an arrested development, you know.

JCT: Are the interiors we see in your drawings taken from either of the two houses?

VA: Not necessarily. When I draw interiors, I just make them up. I don't use models, and when I draw chairs or a mantle piece, I just refer to some kind of prototype that I hold in my imagination.

JCT: A lot has happened since we first met years ago in the old house.

VA: To say the least! Although I still teach at the Rhode Island School of Design. I've written a sequel to *Jumanji*. *Zathura* came out two years ago, in 2002, and it is actually another book that is in the late stages of development at the studio that made *Jumanji*. It doesn't have the same characters in it. All that in the movie was

their invention. The sequel I wrote was simply derived from the last page of *Jumanji*, which shows two boys running off with the game board.

JCT: Some of your other books came out closely on the heels of our conversation years ago. Could we start with *The Wretched Stone*? Sort of a seafaring science fiction yarn!

VA: The structure of almost everything I write is a trip, a journey of some kind. The action removes the protagonist from a certain place, or changes the environment of the protagonist. There's motion, activity at the center of the book. Then the return at the end. They're all trips. That's unconscious, although I realized that a little while ago. *The Wretched Stone* is set late in the nineteenth century when a ship called *The Rita Anne* sets out on a long voyage. The story is told through excerpts from the Captain's log. He says how lucky he is that he has such an outstanding crew on board, including some musicians and storytellers. One day they discover an island, which is a surprise, since it's not indicated on their maps. On the island they find a rock, about two feet across, very heavy, mostly rough and gray. But part of it is smooth and shiny and gives off an odd light. They bring it aboard. The light lures the men below decks, and as the days go by, things seem to go downhill. The men become very bad sailors. Finally, something very preposterous and bizarre happens to them, and the Captain is left to sail the boat by himself. I used a big boat model that I have for drawing the ship's exterior. The interiors are kept simple, just a few ribs and planks. One thing about a sailboat is that you have miles and miles of ropes. If you're close enough to it, you have to draw its texture, twisting. A straight line doesn't look like a rope. It was almost a little like the *Z Was Zapped* thing—I was getting tired of drawing rope!

JCT: I don't get the reference.

VA: Oh, in *Z Was Zapped* I had to draw a bunch of curtains 26 times! I guess every artist or writer has to do an alphabet book *some* time. So, I got the idea of doing one based on verbs. Each verb would represent some action, some act perpetrated and demonstrated by some change in each letter. Later, I discovered that there have been very, very few "verb" alphabet books. It brought me back to some of the interests I had when I first got involved with art, namely, sculpture. I sculpted all the letters before I drew them. I enjoy actually being able to observe something from life. The first letter that I thought of was the letter "D"—"D Was Drowned." I don't know why, but the idea of the "D" half underwater was compelling. I like the phenomena of what happens when something is partially submerged and you can look across and see the distortion below the water line. I made the "D" and put it in a fishbowl filled with water. I set the book as a series of little dramatic scenes, all of

them in front of a stage curtain. The most taxing thing about the project was drawing those curtains 26 times! You get very nervous drawing the same thing so many times. It was also difficult with the "X." There are so few "X" verbs! I ended up with "The X was X-Rayed."

JCT: Ingenious! I see on the table there a copy of *Two Bad Ants*. That's a new one on me.

VA: Oh, well, *Two Bad Ants* came from a very mundane motivation. I saw a couple of ants in my kitchen. I'm sure I'm not the first to ponder what kind of journey they had to get there—I mean, it must be a big trip! And I was interested in how the ants might interact with human beings if the human beings and the ants were absolutely unaware of each other. The ants are there in this kitchen because they have committed a high sin in the ant world—even though their sister and brother ants have taken a sugar crystal back to the Queen (which gives them a great deal of pleasure!), these two ants decide to stay in the sugar bowl and live it up! They get mixed up with breakfast preparations and they have some close calls. They are almost crushed in the garbage disposal, roasted in the toaster, and dumped in some hot coffee (they almost get swallowed up). It's a dangerous world!

JCT: You promised me we could get an update on *The Polar Express*. Here we are, almost 20 years since *The Polar Express* was first published. And now a new edition and a movie version are on the way! You have said that you are always disappointed in the reproductions of your drawings, that they never convey the quality of the originals.

VA: That question is more astute than you might realize. When the publisher was contemplating how to respond to the higher level of interest in books that have been turned into films, I suggested we go back to the original art work and use the new digital technology to do new reproductions for a new edition. They said it was a good idea and asked me if I knew where the originals were. I said, "No, I'm sorry, I don't." But then I remembered I had sold some of it to some galleries, and they weren't always sold to dealers who kept good records. In the end, I found all but two of the images and got them back and had them digitally photographed. They then underwent a much more advanced process of reproduction than had been available years ago. And the reproductions are much, much better. If you get a book that was printed before this year, you can tell from the jacket how different it is from the one printed this summer. It's a dramatic difference, quite striking, better contrast, sharper detail, sharper colors. When Christmas rolls around this year, the new edition will be in the stores, and it'll have a sticker identifying it as the source of the new movie.

For the movie of *Polar Express* the digital information that is in the computer is information derived from actors and from the scenery. They didn't photograph the book and then manipulate it and make it come to life; they actually built three-dimensional models of what they saw in the book and which were "built" inside of the computer. The Warner Bros. animators used the special effects facilities of Sony Image Works. I had a contract, or the option agreement when the book was originally optioned, that had a clause that said the film would be live action because the initial overtures were made by Tom Hanks, whose interest in the book drove things at the outset. He was quite sincere and committed to making a film that was faithful to the "look" and story of the book, and which would be live action. I was assured that because it was somebody like Tom Hanks, he would protect the book; his good taste and instincts would prevail at the studio. I made the agreement based on Tom's attachment to the project. However, I was warned that something unforeseen could happen in the future and Warner Bros. might make a different kind of film than the one he had envisioned. What we could guarantee, in that event, was that it would *not* be an animated film by requiring that the film rights be to a *live action* film.

There have been interests by other producers and studios over the years, but this seemed like a more bonafide and credible expression of interest. It also suggested that we could move quite quickly without the ordinary obstacles usually encountered in the development of a film. Now what we have here is not "animation" in the conventional sense, which describes the techniques that an artist can use to create the illusion of movement with a series of still images, by hand or with the computer. There's no illusion of movement in this film, because the actors actually performed in front of motion-capture devices. There are armies of digital artists, but they are not "animators" because the movement is created by the actors in performance.

JCT: Are you concerned that as this technology brings your drawings closer to photographic reality, that we will lose the sense of them as *drawings*?

VA: I think at the very beginning, when they were looking at this technology, they were trying to find an approach that would create images that looked like pastel drawings, but pastel drawings that were animated. The basis for most early animation styles was that they looked like cartoon images that moved. And that was because the cartoon images were so simple that doing multiple drawings required to put them into motion was easier. That became standard. Of course, the standard for live action films was moving photographs, a series of photographs that because of the physiology of the human eye and the mechanism of the project gave the impression of movement. In *Polar Express*, they wanted to create with new software something

that was not a moving comic and something that was not a moving photograph and something that was not a hard-edged sort of plastic reality of other computer-generated animation. They wanted to create the look of a moving pastel drawing. But they couldn't do it. The requirements to run all the descriptive data in a pastel image was just mind-boggling. It's too "dirty," too irregular. But they did find ways of using the software to create something that looks entirely different from the other computer animations that have been done, like something by Pixar. It looks softer and stranger.

JCT: Were you involved at all in the actual filming?

VA: I visited Los Angeles and gave to the artists a little slideshow of my work and talked about the kinds of ideas that were working on me when I first wrote *The Polar Express*. I talked to Tom Hanks. I told him that I thought the narrative in the story was not elaborate enough to drive a film story. It needed some backstory and some details about the characters. And maybe that we needed some backstory about the train and where it came from; and about the conductor and where he came from. They told me that I sounded like some hack producer who was out to ruin the book! They said all they wanted to do was make the book, that they think the book was wonderful all by itself. Anyway, I also saw a lot of the artwork, and it looked fine to me. It was pretty clear they had gotten their marching orders from the director. I was looking at art on the walls, not from the computer. I'm fairly computer-illiterate myself. What they can do is place a character inside a space, and then move it around. And you can create the effect of moving a "camera" around that scene as you see fit. Now, I don't think I have as much RAM in my head as a computer, but I can envision a dimensional space and move around in it pretty easily. I guess there's something analogous there. Basically, my 15-page book was the "style guide." It's not a brightly colored film in any way. All told, they were respectful of the aesthetic of the book.

JCT: I was startled when I saw a full-scale song-and-dance number in the preview trailer!

VA: It's a number that is introduced when the chefs come from the dining car and present the hot cocoa to the kids. It's a fabulously choreographed scene. There are a few musical numbers in it, yes, but it's not a "Grinch"—like thing. It does no damage to the story. It's interesting to watch. I like it!

JCT: Any apprehensions about the final product?

VA: Well, sure, I'm anxious, and I always expect the worst outcome for any undertaking. That's just my nature. I don't have any real reason to be, but that's just the way I'm wired. The book came out 20 years ago, and I was 35 and had already written *Gazazi* and *Jumanji* and had established myself as an illustrator and author. *Polar Express* made the adult best seller list before the *New York*

Times ghetto-ized kids books. They won't put kids books on the main best seller list anymore.

JCT: Do you think the success of *The Polar Express* overshadowed some of your other books?

VA: I don't think so. Generally, success of one will create interest in the other titles.

JCT: How do you feel about having your book read on audio cassette by William Hurt?

VA: That's part of the same set of conflicted feelings I have about the book being made into a film. It's the idea that a lot of picture-book creators like myself have an ideal about how our books will be consumed. Maybe it's a classroom, or a bedroom with a parent and children. *The Polar Express* is something that families bring to bookstores where I'm appearing. Their copies are tattered from many years of family readings at Christmas Eve. At first, I was in favor of the audio cassette, because the book itself has descriptions of lots of sounds, and I thought it could be successful, artistically. But then, having agreed to do it, I had hoped it wouldn't displace the family reading. I disliked the thought of a family gathering around the hearth and then booting up the compact disc instead of opening up the book and reading it aloud. It's not as bad as a video cassette of a Yule log in a fireplace, but it gave me some of those concerns. Now, my concern is that when the film version comes out on DVD, which it will, that some people will decide to view the DVD on Christmas Eve instead of reading the book. And I don't think I want that to happen. I have kids. The stimulation that comes out of a television set is pretty irresistible. You have to make an effort to expose your children to the values and satisfactions of hearing words in a quiet bedroom and seeing how that special stimulation works instead.

JCT: By the way, what happens to the original drawings?

VA: Oh, I sell quite a few of them, keep some. I sell more than I keep. In my daughter Sophie's room right now is the jacket image from *Jumanji* Otherwise, I don't have much of my work up. I have no gallery that regularly handles my things.

JCT: Now, how about we conclude with something about your new work.

VA: Oh, I don't know. All I can say is that these days there are images of gondoliers and Venetian canals I've been thinking about. And I've been making some doodles. Here's one: It shows an oarsman with a funny little hat on. I'm not sure yet what it means. I am not possessed by a book. I have a much "cooler" attitude about making art. Sometimes I think that that creates limitations, that the greatest art comes from people who have the fever. I'm not sure of that. There are some pretty interesting artists who have a kind of remoteness from their work—guys like Marcel Duchamp. Nothing's really caught me by surprise yet. I'd like it to happen!

Gahan Wilson (drawing by the author)

Gahan Wilson's Diner

Fans of Gahan Wilson's short cartoon film, *Gahan Wilson's Diner*, would appreciate the fact that I met him on Halloween 1986 for an interview in a modest little diner in Providence, Rhode Island, home of Wilson's revered H. P. Lovecraft. Granted, this particular diner was considerably less horrific than the demon-infested eaterie of the cartoon. But we, er, *relished* the occasion nonetheless. The playfully grotesque fantasy and distinctive cartoonish style of Gahan Wilson (1930–) has delighted (and horrified) readers of *The New Yorker* and *Playboy*, as well as those inquisitive youths who perfectly understand his perverse wit. His comic strip, *Nuts*, which appeared in *National Lampoon*, was a subversive take on the sort of sentimentalized childhood depicted in Charles Schulz's *Peanuts*. Wilson received the World Fantasy Convention Award in 1981 and the National Cartoonist Society's Milton Caniff Lifetime Achievement Award in 2005. The following remarks reveal him in a more philosophical than diabolical mood.

Interview

JOHN C. TIBBETTS: I can't think of a more appropriate surrounding than this small, thoroughly cozy diner in downtown

Providence. I see you're wearing an army fatigue jacket. You call it your "journalist's habit."

GAHAN WILSON: Yes, it's a correspondent's jacket, as so billed. And it's very good because it's got millions of pockets.

JCT: I think Mel Gibson wore something like this in *The Year of Living Dangerously.*

GW: My god, I bet he probably did! I think, wherein, there's probably a theory of people dressing up in military garb, ah, when wars are imminent, sort of floating around. And I think we're into that sort of phase. I remember before I was in the Air Force, way back when, friends of mine were getting drafted, and one of them came back in his soldier's suit. And a friend of mine and me who were buddies of this guy were all thrilled and trying on his little soldier's hat in the mirror. I looked over at him and he was looking at me with this funny expression, which I did not understand until I too had a soldier's suit of my own. It wasn't kicks anymore.

JCT: I take it then that that expression returned to you in your memory in later years.

GW: Yeah, yeah. But I don't think they're going to draft me now, unless it's really one hell of an emergency. I'm kind of past draft age. I think!

JCT: Of course, the name Gahan Wilson connotes the most fabulously, wickedly funny cartoons that we have seen in the magazine *Fantasy and Science Fiction* and *Playboy* and other places. To me, if any one image sums up your work, your attitude; it's the one where a black-clad figure wearing a tall, peaked hat stands in front of a room full of new-born babies. He's waving a web-fingered hand over them. Like a dark benediction...

GW: Ushering a new generation into the darkness?

JCT: Something like that.

GW: You made your own caption! Life and death. Yeah. If you're alive you can be killed. Very often, when my cartoons are gruesome, I think they're misunderstood. People think that I am sort of anti-something, or down on things. It's quite the reverse. The cartoon of mine I would choose is one I cite every so often, which on first look is extremely *down*. It's a snowy, wintry day and a little boy is all bundled up—one of those absurd costumes you bundle kids up in—and he's holding his father's hand. With the other hand he's pointing at this dead bird in a snow bank with its feet sticking up in the air. It's a very, *very* dead bird. And the kid says, "Look, Daddy. It's the first robin."

JCT: I think that was one of your very first cartoons, right?

GW: Yes, so long ago. The legend says it sold for only $7 dollars.

JCT: Is that true?

GW: Well, if you choose between the facts and the legend...

JCT: Oh. I see.

GW: But what I'm saying there, quite sincerely, is that robins are vulnerable, little creatures who can die, horribly. If we just think of robins as these little, fat critters on a warm lawn in the summer eating worms and having a marvelous time and chirping, that's fine. But they are also these vulnerable, little creatures, who move through terrible weather so they can be on that lawn; and will fly back and many of them will not make it. So the preciousness and the value and the beauty of the robin is very in large part because of its fragility and its irreplaceability.

JCT: It becomes a symbol that can look two ways in either direction, toward a sorrowful, almost morbid cast, or a bright promise...

GW: It should look both ways. The thing is to look both ways.

JCT: I remember a scene in Luis Bunuel's *Viridiana*, when a child's skipping rope in one scene becomes a hangman's noose in another scene. Again, one object, one symbol being used two ways.

GW: Yeah, that's one of the essentials in any creative making of a cartoon. One very important basic rule is to stick to a particular challenge—like you will sit down and say, I'll make a cartoon about a piece of rope. So, you stick with the notion of rope. And you will think of skipping rope, a hangman's noose, a clothesline, something; and you may go all over the lot but you will not leave the rope. You get to this one thing and you work this one notion, this one idea. Yeah, everything pursued far enough represents everything else. There's no exception.

JCT: I once interviewed filmmaker Terry Gilliam after the release of *Brazil* and he admitted that he thinks that he looks at the world through what he calls, "cartoonist's eyes," dramatic foreshortenings, vivid colors, that kind of thing. Is that a fair enough assessment maybe for you as well?

GW: Gilliam is brilliant. God knows *Brazil's* a brilliant movie, a very *cartoony* movie. It's actually one long political cartoon. He takes his images and presents them in a startling, humorous fashion, essentially. He's very careful to make sure that you never really relax because if you do, he'll throw in something at you, just all of a sudden, he'll stretch the lady's face into a grotesque mask—

JCT: And switch to wide-angle lenses or quick dolly shots—

GW: Yeah, or failing everything, he'll just make a large noise. There's very definitely a cartoony aspect to much of my writing. Like Gilliam, I think very much in a cinematic way. My cartoons are like movies, an odd combination of the literary and the visual. The dialogue and the pictures. If you take away the gag line and leave only the drawing, and if you take away the drawing and leave only the gag line, 9 times out of 10 it makes no sense whatsoever.

JCT: Now it seems like these days you are emerging more as a writer. Now, has the writing always been there, or is this something that you've been developing only just recently?

GW: It's been there for a long time. I've done short stories for a long, long stretch. They've appeared in various places, like *Fantasy and Science Fiction* and *Playboy*, and I think in October of last year there was a werewolf story I was particularly proud of. They've been anthologized quite widely. I love writing. But during the last couple of years my agent's been goading me, and I've been moving more and more into writing. I am presently engaged in a book, two books, really—one I'm doing now (which I'm late on), which is half writing, half drawing. The narration is advanced by the writing and also by the illustrations. Really, the illustrations are just another aspect of the narration, in a way. It's fun, but it's enormous work.

JCT: Is this the first time that you have both written and illustrated on a single project?

GW: No, I did a series of kids' books, which were very successful critically. *Publisher's Weekly* gave 'em a star, *Kirkus Reviews* was very enthusiastic, and so on and so on.

JCT: What's the series?

GW: It was called *Harry the Fat Bear Spy*. That was around 1973. And it's a darling series. It was very sweet and was reissued. There's two "Harrys" that have been printed, *Harry the Fat Bear Spy* and *Harry and the Sea Serpent*.

JCT: What age group readers are you considering?

GW: Officially, it was supposed to be from 12–up. Actually, I found that it was, had a wide range. Many adults liked 'em. I have enormous respect for kids so I in no way write down to them. They're very funny. They really are hilarious. I'd love to start Harry off again.

JCT: I'm wondering if children in this age group would appreciate a taste or a tang of your trademark diabolical humor as well.

GW: Well, yeah, see, Harry is this construct that's essentially based on the old pulp story-type heroes. Harry's a spy and there's a legitimate mystery that occurs and Harry does solve it. It takes place in Bearmania, which is inhabited entirely by bears. And for a bear in Bearmania, Harry is very bright. The other bears are astounded at his skills. But the 12-year-old reader is smarter than Harry. Bears are not as smart as people, even though they're smart bears. He's very lovable and very dear, and he's very earnest, and the reader is sympathetic to Harry and rooting for him, even though he gets the clues way ahead of Harry. The spies are absurd and they have a ridiculous series of code words, and it's all terribly involved and complicated. Essentially, it's structured the same way as a *Doc Savage* pulp story, something

like that. There's lots of adventures. Harry has this horrifying episode where he's in this flying machine that crashes, and he's also tied to a sea serpent in the middle of the water, and all kinds of things go on. But, of course, he survives without any trouble because the absolute rule in the Harry books is nobody really gets hurt in any sense. And the villains are not really villains, they're simply just sort of silly. And if they won't do it anymore, everybody will forgive them. I think children are extremely vulnerable, but they loved to be scared. It's very important to their process of maturation that they be scared—and they know it. What they're doing constantly is testing themselves and learning how to survive. That's basically his whole thing, it's his program. He's seeing what he can do; he's strengthening himself, he's mastering various challenges. A grown-up forgets all this, because what happens with a grown-up is he's this assemblage of devices and techniques and so on. For example, just now when we left the hotel and walked to this diner here through historic Providence, we did not consciously duck the traffic, we did not consciously watch for falling objects, we did not consciously keep an eye peeled for potentially dangerous humans. None of this. But we were doing it all the same because we have learned how to handle all of these things. We've learned how to go up steps, down steps; we've learned all these tricks. How to swallow food and how to avoid bad potatoes and all that sort of thing. But a kid though is in the early processes of getting the techniques down. There's a Zen thing where the Zen Buddhists practice techniques in an attempt to get back to the direct experience of being alive. You don't *not* think; you get to the present moment, which is always here but it originates in thinking and not thinking. Both come out of the natural being. And the kid is in there and he's wide open.

JCT: It's as if you're saying that maybe the whole pursuit of Zen is in itself the pursuit of child-like perceptions of the world.

GW: Getting back to the world as it *is*. The world is a very surprising and wonderful place. It's an amazing place. We don't see it; grown-ups don't see it. You see a couple of grown-ups walking a child down the street—they look like zombies. I mean, they're either absorbed in conversation or they're just sort of staring at nothing, just sort of staring into space. Whereas the child looks wide-and-doe-eyed. The child is taking in everything with wonder or astonishment or fright. It's all there. The child sees a dog—ooh, look at the dog! The child sees a truck—yes! They're wonderful creatures! Most grown-ups, very sadly, lose that sense of wonder, which had been very necessary for developing the techniques and defenses of survival. Somehow or other they so bury the immediate moment that they're not really alive, which is a great shame and pity.

JCT: I think of an artist like Paul Klee, an artist who relentlessly strove to paint and write about recapturing that *first* view of things. Yet, even to write about it is a very adult activity.

GW: Well, some, some writers—I'm going back to the Zen thing—say it's anti-intellectual, which it isn't at all. The intellectual thing is a wonderful, fantastic part of our lives. But everything is filtered through or transformed into a logical situation, a problem sort of thing, an abstraction. It's dissociated from its actual root, from experience. It's dead or certainly cut off. It's like too tight a tourniquet of some kind or other. But as I say, a kid is very, very open. It doesn't know what's dangerous and what isn't dangerous. They haven't figured that out yet. I mean, is there something under the bed? Even though there isn't anything really under the bed, the kid hasn't got that straight yet. On the other hand, there's an evil, evil gentleman who could be extremely dangerous to the child, and the child must be aware of that. But it's very difficult for the child to select what is dangerous and what isn't dangerous. They're in a constant state of risk. The point of it is, if you do anything for a kid, you've got to be very careful not to scare the kid too much. And also, you've got to be very careful not to take away the ground underneath the child; because, you can do that. You can absolutely devastate a child. You can really scare them and leave them falling, and they'll never touch ground for the rest of their lives. Unfortunately, many parents will do that. There are lots of adults walking around who are falling helplessly, because the parents jerked the ground out from under them when they were little bitty kids.

JCT: I'm curious that a lot of this is coming from a Gahan Wilson who has retained enough of that child-like perspective on the world that you can just tap into it. Are you surrounded in some way in your own life by children with whom you can test these things out?

GW: Well, I had brought some kids up. You mentioned Paul Klee and Matisse. Matisse has some very good writing on the subject. He said, "You can't be a child. You'd be an unfortunate and tragic creature if you were a grown-up and a child." There are such beings. They're very sweet and dear, but they're helpless. Either they have loving people who go to a lot of trouble to take care of them, or they're put in institutions because they can't function. At the same time, you also mustn't kill the child. There's a sort of alchemical transformation that's got to occur, so the grown-up can function as a grown-up without losing the child. You mustn't detach yourself or cut yourself off from or restrict the experience of the present moment too. I'm talking about the glory of color of your eyes or the feel of the chair under you or the coffee

in your stomach. It's all new and should be sensed and enjoyed enormously.

JT: If you don't already, I bet you would especially love and admire the work of the English man of letters, G. K. Chesterton. If anybody was able to do the things that you're talking about, I think it was he.

GW: Oh, yes, he knew about this sense of vulnerability and, well, *aliveness*. I mean, if you're alive, you're vulnerable by definition.

"Where No Man Has Gone Before..."

TOM CORBETT, SPACE CADET, AND STAR TREK

You knew, deep down, that Tom Corbett was the fastest thing with a Paralo-Ray from here to Arcturus and on the far side as well. Corbett was invincible.

> Frankie Thomas interview with John C. Tibbetts,
> 15 January 1980

It's true, maybe in three hundred years from now, when *Star Trek* is supposed to take place we'll know more. I mean, even if we knew how the universe operates, would we know everything?

> William Shatner, interview with John C. Tibbetts,
> 1 June 1984

American television first blasted off into the spaceways in 1950 with *Tom Corbett, Space Cadet, Captain Video,* and *Space Patrol,* initiating a so-called Golden Age of science fiction television.[1] Yes, even the Gothic imagination has a sense of whimsy! Primarily appealing to young and adolescent viewers, Corbett, Captain Video, and Buzz Corey, respectively, like so many modern-day Peter Pans, flew into the windows, as it were, of the nation's homes and living rooms, carrying away to Never Land the imaginations of children around the world. These adventures were pint-sized versions of the Gothic-inflected space operas of "Doc" Smith's "Lensman," Jack Williamson's "Legion of Space," and Poul Anderson's "Time Patrol" series. We may regard them as variants of fairy tales, particularly those celebrating the Eternal Child. Older viewers, however, sensed a darker, more Gothic paranoia regarding the rampant technology and "forbidden" atomic sciences of the Cold War. "[These] early science fiction adventures," explains media historian Wheeler Winston Dixon, "tapped into America's fear and wonder at the

Frankie Thomas as "Tom Corbett" (center), Jan Merlin as "Roger Manning" (left), and Al Markim
as Astro (courtesy of Wade Williams)

power of the atomic bomb, as well as [other] rapid technological develop-
ments.... Often produced on shoestring budgets, these series neverthe-
less excited the imagination of cold war viewers, who were increasingly
uncertain about their future both at home and abroad."[2] The resulting
visions conjured up by these pioneering space operas arguably shaped
much of what was to come in the more adult science fiction television
in the 1960s and beyond.

For example, 16 years later Gene Roddenberry brought *Star Trek*, a
prime-time television series, to NBC. The adventures in interstellar
space of the crew of the starship *Enterprise*—"Lost Boys" for a new gen-
eration of viewers—ran for three years and brought to its adult viewers

more of the time-honored heroes, villains, and alien life-forms of the space opera tradition. At the same time, however, it really did "go where no man has gone before." M, Keith Booker notes: "Though very much a product of its time, *Star Trek* addresses such big issues, including those of gender, race, and class, that its relevance extends well beyond the 1960s. It projects the ultimate fulfillment of the dreams of the Enlightenment and, in so doing, demonstrates not only the strength but also some of the weaknesses that have informed Western culture throughout the modern era."[3] And, of course, many of the standard Gothic tropes were here, too—including alien life forms, parallel worlds, haunted spaceships, and mad scientists. The inscription on the Distinguished Public Service Medal that NASA posthumously awarded Roddenberry on 30 January 1993 says it all: "For distinguished service to the Nation and the human race in presenting the exploration of space as an exciting frontier and a hope for the future."[4]

Frankie Thomas as *Tom Corbett* (courtesy of Wade Williams Enterprises)

Westward the Stars! Tom Corbett, Space Cadet

Frankie Thomas (1921–2006) will forever be fondly remembered for his eponymous role in *Tom Corbett, Space Cadet*. He was practically born in a trunk, and as early as 1932 was appearing on stage and screen. He originated the part of Bobby Phillips on stage in *Wednesday's Child* and brought it to the screen in 1934. After appearing opposite Bonita Granville in the popular *Nancy Drew* series in the late 1930s, and after a stint in the Navy during the War, he landed the starring role as "Tom Corbett" (1950–1955). In his later years, he turned his love of contract bridge into a second career and wrote several best-sellers on the subject. At his request, he was buried in his Space Cadet uniform.

Thomas' remarks here came as a result of my invitation as editor of *American Classic Screen* to him to talk about his years on "live" television. His remarks are self-contained, and I have preserved them in that format. I have to thank Wade Williams, who introduced me to Frankie, and Randy Neil, founder of *American Classic Screen* for the rights to republish excerpts from this interview, which has not been in print since 1980.[5]

Interview: Frankie Thomas

I'm proud to note that Tom Corbett was television's first man in space, and it all began on 2 October 1950. True, *Captain Video* began earlier on the Dumont network in late 1949, but as first conceived, the Captain was *not* a spaceman. The title was descriptive. Captain Video, from his mountain hideaway contacted agents in the field via video and his operatives were most often Johnny Mack Brown and Tom Tyler. It was a novel way of running old westerns in a serial format. It wasn't until several months of success in space on the part of Tom and the *Polaris* crew that the good Captain joined the space race in his rocket, the *Galaxie*. The third of the successful programs, *Space Patrol*, came into being on 30 December 1950 and did not go national until 1951.

Countdown

The "Space Cadet" idea was originally conceived by Stanley Wolfe, president of Rockhill Radio, a package house having close ties with the Kenyon and Eckhart Advertising Agency by virtue of "Mark Trail," a half-hour radio show twice a week on Mutual Broadcasting System. "Trail" was sponsored by Kellogg's, the cereal giant, and the Space Cadet idea was taken to them with happy results. It was originally titled "Cris Colby, Space Cadet" and was based very loosely on the novel, *Space Cadet* by Robert Heinlein. With a big sponsor standing by, Rockhill went into a frenzy looking for their central character. Albert Aley, script supervisor, had worked out a

"three musketeer" theme with the central character closely involved with his two unit mates, Astro the Venusian, played by Al Markim, and Roger Manning, an intriguing wise-guy, played by Jan Merlin.

I had been fortunate in starting at a very early age in the legitimate theater and at a time when they wrote some great children's parts. *Wednesday's Child* had been my main claim to fame and when RKO bought the play for pictures, I recreated my Broadway role in the film [1934]. It was Broadway and Hollywood then with some 30 major studio productions and leading roles in another half-dozen plays. After the war, NY radio and early television was my playground. The live television of those days required a variety of experience, and a small group of actors did most of the work.[6] There were no tele-prompters, and actors with a variety of experience were in demand. Along with other pioneer shows, I had played one of the three leads on the first five-a-week TV soap, "Woman To Remember." I think this fact, more than anything else, impressed Stanley; Mort Abrahams, producer, and George Gould, director. I met with them briefly on a Friday in the early afternoon and was introduced to Al Markim and Jan Merlin, neither of whom I knew. At four that afternoon they phoned me at the Lambs Club with the news that the part was mine if I would do it. The Rockhill group then decided to make their central character more of a take-charge type. The name "Cris Colby" was changed to "Tom Corbett," and two weeks later we were first televised in what became our regular time slot, 6:30–6:45 p.m., Monday, Wednesday, and Friday.

Blasting Off!

That very first show literally blasted off. Al Aley wrote the first nine programs that comprised a complete story and he did a great job. The introduction of Tom Corbett as a new Cadet at Space Academy 400 years in the future along with his roommates, Roger and Astro, was effected with lightning speed. Suddenly there was a runaway rocket crashing at the spaceport manned by a dying Captain Turner (played by Tom Poston, later to garner fame in the comedy field). The Mercurians from the twilight zone of that planet had a space fleet in the vicinity of the moon. The Solar Alliance of Earth, Mars, and Venus was threatened. The crisis of that first three-week story line (a formula that we continued to follow) came when Tom Corbett and the crew of the rocket cruiser, *Polaris,* came to grips with the invaders.

In his long career Tom instigated many a first but here's certainly one that was never duplicated: though our network show time was relatively late, we were technically a kiddie show. The idea was to sell cornflakes. We were not blessed with a lavish budget and most of that had gone into really impressive sets insisted on by Mort Abrahams, our producer. By the end of the second week, Tom had to come in contact with a tangible menace, the Mercurians. This required another rocket ship interior, the control deck

of the invading fleet's flagship. We didn't have money enough to build it or to hire the additional actors. The program already had a large permanent cast. In addition to the three cadets, there was Captain Strong, their senior officer; Commander Arkwright, Commandant of Space Academy; along with Dr. Joan Dale, Astro-Physicist. Desperation is the spur of invention. During a commercial, the main deck of the Polaris got some frantic face-lifting and became the Mercurian flagship. As mentioned, the invaders came from the twilight zone since Mercury does not rotate and the sun side is too hot and the dark side too cold to sustain any kind of life. I often wondered if their point of origin had any influence later on a choice of titles for one of TV's most imaginative series. To protect their eyes, conditioned to the faint light of their home, the Mercurians had to wear face masks. *Tom Corbett* became the only show where the heroes and the villains were played by the same actors! As Tom, I was trying to frustrate the chief Mercurian played by myself. Behind mask-like helmets and speaking an unintelligible double talk, we pulled it off. There were some amazingly fast costume changes during that Mercurian story. Things got a little less hectic after that. Or did they?

"It's Live!"

I should underline one point. During its entire five years on television, *Tom Corbett* was done *live*. Other shows shot their technical trickery in advance of the broadcast and integrated that footage. With *Space Cadet*, when the red light on camera one went on, it was sink or swim. The West coast and other outlets beyond the reach of direct transmission were serviced by kinescopes, which were no more than recordings on film of the live show. Nowadays you really don't have television save in sporting events and other on-the-spot broadcasts. What we have are midget movies done on tape prior to broadcast. It can be edited, there is not time problem (a constant headache in the live period) and errors can be deleted.

I think it was the third story line that began our sixth week that I wrote along with my writing partner at that time, Ray Morse. Singularly, we had been roommates at Kings Point Academy. Tom was involved in dark doings on the Black Planet of Alkar. Tom Poston (Captain Turner and later a Mercurian fighter pilot) had worked so hard in the earlier episodes doubling in brass that I brought him back as a Cyborg, the first on TV I believe. For the first two weeks all he had to say was one word, "Alkar," which was a relief to him.

Into Orbit

After 10 weeks of breathless adventure, we realized that Tom was a national figure. Comedians and talk show performers were mouthing

"Spaceman's Luck" and "Blast Your Rockets." At that time, Milton Berle and his Texaco Show was the top TV rater with the largest number of outlets. ABC came to Rockhill with a tempting offer. The second largest hookup of stations in national television. After 13 weeks at CBS, we moved to ABC. It was estimated that 25 percent of our viewers were adult and I think the percentage might have been higher. In part, this was due to the fact that Rockhill laid the groundwork for its product well. I've noted that the original idea came from the prolific pen of Robert Heinlein who had cracked the *Saturday Evening Post* in 1947 with his beautiful futuristic folk story, "The Green Hills of Earth." He was an acknowledged dean of Sci-Fi writers and still is. In addition, our technical advisor was Willy Ley, author of scientific works for the layman and international authority on rockets since the 1920s. Willy was dedicated to make our stories deal with scientific possibility. Tom was more earth-bound than any of the other space shows. *Space Patrol* was headquartered on Terra, an artificial planet. *Captain Video* was very involved in aliens whom we never had on *Space Cadet.* The Mercurians were nonterrestrial but they came from our own solar system and the black planet of Alkar was on the trans-Neptune orbit. As I continued to write for the show, I realized that the limitations of scientific probability were not uncomfortable. Willy, an intimate friend of Werner Von Braun, thought we were laid too far in the future and that regular space travel was only 150 years ahead. I must admit that he took a dim view of the Cadets' Paralo-Ray that froze victims into immobility with nonfatal results. Willy considered such a weapon doubtful.

We got a great deal of coverage from our realistic approach, especially from children's organizations grateful for the absence of strange monsters and a concentration on Sci-Fi rather than Horror.

Willy isn't with us any more but he lived to see his prediction come true and sooner than even he expected. One thing is sure, when I saw the astronauts take that giant step and walk out on the moon, their space regalia bore a remarkable resemblance to the outfits we wore on the show when operating in free fall and on strange planetary surfaces. It was old home week.

The year of 1951 continued to be amazing. Bert Lahr burlesqued the show with a sci-fi spoofing sketch in the Broadway review, *Two on the Aisle.* As a wacky looking spaceman, he was the not-too-reluctant object of seductive come-ons by a well-stacked Queen of Venus. All this to the horror of his companion, a celibate Space Brigadesman. When I saw the show, I almost passed out laughing—but it had to be funnier to me than anyone else. Publicity is a fine thing to have and most welcome to a program that, really, had just gotten started. But it is the ratings and sales that foretell the future, then as now. *Sponsor* magazine dealt with that vital factor in its lead story, "Mars Dead Ahead, Sir!" *Tom Corbett* carried the banner of Kellogg's Corn Flakes and Pep. Not long after this the Pep box was changed. It now read: "Pep...the Solar Cereal." With a picture of Tom, of course.

Frankie Thomas with young "Tom Corbett" fans (courtesy of Wade Williams Enterprises)

Escape Velocity

Our move to ABC proved advantageous from the technical side. Instead of incorporating Tom in the new ABC studios off Central Park West, the network secured space on West 57th Street, a two floor area that had formerly housed Stillman's Gym. The running track was still there though the building had been taken over by the School of Radio Technique where my father had once taught radio acting during our run together in the legitimate theater production, *Remember The Day*. Since no other

shows came out of there, all of our permanent sets that figured in every story line could remain standing. The technical crew was ours and got very "gung ho" about their show. We used to say we were all Space Happy and we were! Along with the cast, everybody got involved in the spirit of the thing and there was a Seabee attitude of "[t]he impossible just takes a little time." Technically our boys did the impossible. Remember, this was live television. No film clips inserted save for the standard opening. Yet the *Polaris* crew was shown walking on the exterior of the rocket cruiser and it looked like the flight deck of an aircraft carrier. Actually the *Polaris* in flight was a three-foot wooden rocket and magnified. We were on another set, shot in miniature, and we were superimposed over the model shot. There was a problem here since, with one film running on top of the other, there was a depth distortion. Our director George Gould and our control room group developed the matting amplifier with which an electronic void was created in one film and the other picture was placed inside it. This technical advance, originated on "Tom," allowed us to branch out into elaborate sequences with Tom, Captain Strong, and the boys floating around the control deck when the artificial gravity generator broke down in the story. Later in the run, Dr. Joan Dale invented Hyper-Drive that allowed the *Polaris* to journey into the galaxy and we had quite a time on the planet inhabited by dinosaurs and other giant reptiles. We had great effects and I'm proud of them but I should mention that Tom was not a gimmick show. Oh what we could have done with some of those wonderful *Star Wars* special effects, but the hardware and indications of advanced technology were adjuncts. It was space adventure based on conflict and the relationship between Tom and his unit mates.

The cast was together constantly. After one show was aired, we began rehearsing another. This unity did have a rather shattering effect on actors who joined the show from time to time. There were a lot of them that got their TV bath on *Tom Corbett*. Jack Lord (*Hawaii Five-O*), Jack Klugman (*The Odd Couple* and now *Quincy*), William Windom, Emmy award winner Frank Sutton (*Gomer Pyle*), and Jack Warden. They frequently got a glazed look. It was like working with a unified brain. We'd done it all and knew all the moves, not just our own. Everyone was anticipating. Time problems were nothing. I got so I could sense if we were running long. If I speeded up, the others, so sensitive to any change, any departure, would pick up tempo immediately. On one show we had a replacement in the control room. His principal function was to watch that vital secondhand on the stop watch. An actor new to the show was suddenly taking long pauses. Possibly he was fighting lines, I don't know, but we lost about a minute during his scene. The newcomer became worried in the control room and began looking around *as* though expecting a speed-up signal to be given to the floor manager. Muriel Maron, our associate producer, just smiled her quiet smile. She knew. After the next scene, the technician put his stop watch away. "I'm wasted. Those guys just picked up a minute on the nose. They've got clocks in their heads." We were all tuned to a

master computer. But wait, we didn't have computers in those days. It was just...the show.

The pace was frantic and got more so. Many programs conceived in radio transferred to the TV screen with varied degrees of success. *Tom Corbett* went in reverse. Soon we were doing two half-hour radio shows on Tuesday and Thursday. During this period our sponsor, Kellogg's, had a half-hour spot available on NBC on Saturdays. So Rockhill cut our kinescopes of the nine episode adventures into a series of half-hours. To explain the holes in the plot and sudden change of locale, I did live narration in five spots and also did one of the commercials live with our announcer, Rex Marshall, doing the other. Every Saturday Rex and I trooped over to NBC. Just the two of us and the kinescopes, that was the whole show. No other TV show has run simultaneously on two networks at the same time.

There was a lot about "Tom" that set records. A daily comic strip based on the show was syndicated in newspapers nationally, weekdays and Sundays. The New York outlet was the *Mirror*. When flying saucer sightings were reported all over the country, the *Mirror* sent none other than Tom to interview people reporting strange night lights and other phenomenon. Eight hardback Tom Corbett novels were published by Grossett and Dunlap. There was a series of Tom Corbett comic books by Dell, and 185 separate sale items were manufactured bearing the Corbett name. At one point it seemed like the subsidiary rights were getting bigger than the show, and I was appearing all over the country in department stores on weekends promoting the various items.

Journey's End

It was at the end of our third year that we faced our first reversal, a setback from which the show never completely recovered. Strangely, it had nothing to do with the program, cast, or rating.

I had just made a personal appearance at Battle Creek for the bicycle day celebration, an annual and important civic occasion at the home of Kellogg's. Traveling back to New York, I learned from an executive that Kenyon and Eckhart Advertising, after 25 years, was losing the giant cereal account. I didn't quite realize the drastic effect this would have on Tom. When the Leo Burnett Agency took over Kellogg's advertising, Tom had to go. Corbett had been developed under the K&E banner and served as a constant reminder of the previous agency. After three happy years of association, we parted company with the breakfast food collossus. Burnett directed the firms advertising toward cartoons. But for years thereafter, every month I received a carton of Kellogg's products.

We moved to Dumont sponsored by International Shoes. However, CBS decided to try again with *Rod Brown of the Rocket Rangers* and lured

Tom Corbett Merchandise and Displays (Wade Williams)

away our director, George Gould, along with our top writing team of Jack Weinstock and Willie Gilbert. Cliff Robertson played Rod Brown with Jack Weston as his sidekick. Rockhill filed a suit against CBS claiming that Rod was a direct steal from "Tom." One of the rebuttals of the CBS lawyers had me in stitches: "After all, *Tom Corbett* began on CBS!"

Perhaps that's just a story. I was very occupied at the time with our new style of presentation and the secondary rights appearances. Legal problems notwithstanding, Rod did last a year, which was a lot longer than the others that rose to take a shot at us: *Atom Squad, Commando Cody, Captain Neptune, Flash Gordon, Rocky Jones.* Live and on film, they came and they went.

Finally, in our fifth year, Tom returned to NBC for a season of half-hour weekly adventures sponsored by the Kraft Company. This marked his last flight but four sponsors and four networks must set some kind of a record. Most shows fold after they lose their first sponsor or so it was before multiple deals.

Takes and Outtakes

One is always asked for funny stories in connection with a long running production. We had a lot of fun with the Commander Arkwright scene, which I gave you a sample of at the beginning of this tale. The good commander, most often speaking to Captain Strong, was always concerned about Tom, that raw, green cadet. As the show went on, Tom must have saved the Solar Alliance 57 times at least but the commander was a hard man to convince. Arkwright, by the way, was the only name used from the original Heinlein novel.

We had one wild happening on one of the 15-minute shows. A well-known actor got flustered and, in a long scene that we played together, he began to say my lines. Fortunately, I had written this story so I was able to answer with his lines doing a little revising as I went along. When the scene ended and we went to the commercial, he looked at me wide-eyed:

"What happened?"
"We just switched parts but its okay."

You know it was. Our producer watching the show didn't realize what had happened.

The funniest moment relative to "Tom" in my memory didn't happen on air. Our producer, Mort Abrahams, asked me to make an appearance at a junior high school in Brooklyn early on a Saturday morning. The occasion was the annual stage production of the student body with the title: "Tom Corbett on Mars." The school was untold miles over the Brooklyn Bridge with 5,000 students, every one a die-hard Corbett fan. The villain of this high school extravaganza was the Warlord of Mars intent on

invading earth. At the curtain of the second act, a henchman burst on stage with a dramatic announcement.

"Great news, Sire. Tom Corbett and the *Polaris* crew have been captured."

Facing dead front, the junior heavy reached out a hand and clenched his fingers into a fish as if crushing the whole solar system. With a sinister yet triumphant glower he uttered this gem:

"Corbett is in my hands. Earth is defenseless!"
A far cry from Commander Arkwright's "raw, green, cadet"!

But remember, in the viewers mind, Corbett was invincible.
He almost was, you know.

Epilogue

After Tom departed, I retired from the acting profession on the theory that...after Tom, where do you *go*? Contract bridge, which I have played since the age of eight, took over and, after a period of playing in the tournaments all over the country, I found myself teaching more people to play bridge than any other instructor in the country, possibly the world. A bridge magazine came on the horizon and for the past 10 years I've been editor and publisher of *The Quarterly,* which is not sold on the stands but is a subscription publication. For the same period I've been writing for *Popular Bridge* the second largest magazine for bridge players in America.

Gradually I came to realize that "Tom" has never been forgotten. Two years ago, with the courtesy of the publisher, Joe Sarno of Chicago, I began to receive copies of the *Space Academy Newsletter.* They are still coming and other publications have followed in Joe's wake. Interesting reading they are with some things I never knew about the show. But it was in August of 1979 that I got a real jolt. A letter arrived from Wade Williams of Kansas City who had been a dedicated *Tom Corbett* fan. He introduced me to the editors of *American Classic Screen* magazine, who promptly requested these memories of mine you are reading now. Soon, Wade was on a plane to New York. He went to Stanley Wolfe and bought the kinescopes of all the *Tom Corbett* shows. I've seen three hours of them, a sampling of all of our shows at all of the networks. The quality is great. Those kinescopes were used only once and then carefully packed away so they did not suffer the fate of many of the other shows that were scrapped for the pittance of silver in them. Tom is still with us. Wade Williams intends to release the kinescopes in cassette form [contact Glenwood Films for information about available VHS cassettes].

You know, I feel somewhat Space Happy again. Blast my rockets, Tom *is* invincible.

He always had lots of Spaceman's Luck.

William Shatner ("Kirk") and Leonard Nimoy ("Spock") of *Star Trek* (KUCSSF)

On the Bridge of the Enterprise:
Star Trek Memories

Featured here are four interviews with members of the original *Star Trek* crew, in order, George Takei, William Shatner, Leonard Nimoy, and De Forest Kelly. We begin with the interview with Mr. Sulu (George Takei) regarding *Star Trek II: The Wrath of Khan*, and continue with accounts of the making of *Star Trek IV: The Voyage Home*.

George Takei on *Star Trek Ii:*
The Wrath of Khan

[Note: *Star Trek II: The Wrath of Khan* was nominally a sequel to "Space Seed," one of the episodes from the original television series. When Starship *Reliant* Captain Terrell (Paul Winfield) and Commander Chekhov (Walter Koenig) mistakenly land on the wrong planet on an exploration mission, the evil Khan (Ricardo Montalban), who had been marooned there 15 years before by Captain Kirk, takes over the ship and vows to take revenge on Kirk. Kirk, now an admiral, is persuaded to take command once again of the Starship *Enterprise* and go on a rescue mission. During the course of that mission, Kirk meets his son, David (Merritt Butrick), who has been working on the so-called Genesis Project, which converts barren planets into Eden-like environments. Khan steals Genesis. In the final reel, Spock calculates that he must sacrifice himself to save the Enterprise crew.]

George Takei is a multitalented performer who, long before he donned the uniform and personna of "Sulu," had demonstrated a flair for the theater. His first professional job in film entertainment was as a voice-dubber for the classic Japanese science fiction film, *Rodan* (1957). He appeared before the movie cameras for the first time while a student at UCLA. The film was *Ice Palace* (1960) with Richard Burton, Robert Ryan, and Carolyn Jones. He also debuted on television for an episode of *Playhouse 90* at this same time. Then came many guest shots on other television series, including *Hawaiian Eye, Maverick, 77 Sunset Strip,* and *Adventures in Paradise*. The role of "Sulu," the helmsman for the *U. S. S. Enterprise,* in Gene Roddenberry's television series *Star Trek* occupied George from 1966 to 1969 (a total of 79 episodes).

This interview transpired in George Takei's apartment in Los Angeles in May 1982, one month before the release of *Star Trek II: The Wrath of Khan*. When I caught up with him in his Los Angeles home, he had just returned from a twilight jog. Shooting had begun on Stage 9 at Paramount on 9 November 1981; and principal photography had just concluded on 29 January 1982. It was directed by Nicholas (*Time After Time*) Meyer, scripted by Jack B. Sowards from a story by Harve Bennett and Jack Sowards, and produced by Harve Bennett and Robert Sallin. Very quickly, I realized that George is a man of diverse cultural interests; he can talk about politics, art, and French theater with equal facility. His home is a model of taste and eclectic interests. Yet he is essentially an informal person whose accessibility and ease of manner are wholly disarming. He has taken the whole *Star Trek* phenomenon in stride, so to speak. He readily concedes its importance to his own career, yet he is not intimidated by it in the least. Throughout our conversation, I was struck by his animated, engaging manner, his candor, and (of course) his amazing, richly modulated voice.... More's the pity that his distinctive laugh cannot possibly be rendered in print!

Interview: "Sulu Speaks"

George Takei (photo by the author)

JOHN C. TIBBETTS: The loyalty of the *Star Trek* fan is legendary. Do you attend many *Trek* conventions? What are they like?

GEORGE TAKEI: It's really an incredible phenomenon, this thing called *Star Trek* conventions. They show the television episodes continuously during a weekend. Go anywhere in the hotels at 3:30 in the morning and there are bodies lying all around, watching the shows.

JCT: Have you ever found it embarrassing that some of the fans might know more about *Star Trek* than you do?

GT: No. From the beginning I've prefaced my talks by saying, I just work there! The real experts are the people seated out there. They are the ones who are going to tell me what we did. That gets me off the hook right away.

JCT: Tell me about the positive and negative aspects that you see in this whole fan thing.

GT: Well, for some, the show helps them fill out their lives; for others, there's this wonderful social aspect to the conventions. You meet people who are activists and doers. Then there are others who just try to give you their room keys.

JCT: *Star Trek* groupies? Am I hearing this correctly?

GT: Believe it or not.

JCT: Well, how brazen does this sort of thing get?

GT: Well, that's pretty obvious when they give you a key with a little note attached to it!

JCT: The hazards of stardom?

GT: You want to be a gentleman, so you just say that the convention organizers have packed a full schedule for me and... well, I'd love to... but....

JCT: I understand.

GT: You know, my book, *Mirror Friend, Mirror Foe*, found its genesis in a convention party. This was a convention in Toronto, Ontario. We were sitting around and I started talking about Ninjas, a sub-samurai group in Japanese history. They were hired for sabotage, for espionage, for assassination—the kind of thing that a noble samurai would not take on. From this conversation came the idea for a collaboration on a science fiction novel. That's what I enjoy about these conventions. It's an opportunity to really (call it serendipity) meet some people that you would not have met otherwise. And I think what *Star Trek* is all about is to encourage people to take an active role in shaping not only your own life but also the course of human events, if you will.

JCT: Let's talk about early memories. As a child of Japanese descent, were you involved with the Japanese "relocations" at the outbreak of World War II?

GT: Yes. I was a little baby only about a year old. I did spend my boyhood in those camps. I was born here in Los Angeles and the relocation as they called it, happened almost immediately. We were initially put in a camp created temporarily at the race track at Santa Anita. From there we were taken to a camp in the swamps of rural Arkansas. It was there that my mother did a bold and extraordinary thing: she renounced her citizenship. My uncle, on the other hand, volunteered to fight in the U.S. Army. There we were, rifles pointing at us, behind barbed wire, not knowing if we were going to be there for the next three months or for the rest of our lives.... I do remember the tension and anxiety every time we had to move in those years: the women crying, waking up in the middle of the night, my parents talking under a tiny little light in the corner. I guess that was when she was discussing renouncing her citizenship. My father tried to talk her out of that, but he

always said she was a willful woman! Anyway, she had to be put in what they called a "hard–core" camp, which was in northern California, which meant that the family would have to be separated. My father didn't want that to happen so he volunteered to go with her to the hard–core camp, and, of course, the children went there too. It wasn't until I was much older that I appreciated the anguish they were going through. Now that I have thought of it, I think my mother's reaction was a very American reaction to a very *un-American* act on the part of our government.

JCT: Doubtless you're aware of the recent hearings regarding the relocation camps.

GT: Yes, and I have testified. In a large sense, it was the ideals of this country that were most damaged, and unless we learn that lesson from that experience we might repeat that again and that's why we've got to remember our history with all of its glory as well as its blemishes. I maintain that our system is strong enough and resilient enough and our ideals are noble enough that we can do that. Once we start censoring it or segregating parts that we like and parts of our history that we don't like, we are going to be in real danger.

JCT: Let's jump forward in time to your first acting experiences.

GT: That really started when I did some dubbing for *Rodan*, the famous Japanese horror movie. That was rough work. I was about 16. Not only did we do dialogue but also crowd noises. Take after take and you are going URGHHH and AHHHH and so forth. You come home absolutely raw, throat just torn to shreds. But I enjoyed it; I was acting and I was getting paid for it. I said to my father, who wanted me to be an architect, "I'm going to have to do something about this. I don't want 10 years down the road after I'm done with architecture and ensconced in some architect's office to be thinking I should have gone on with acting." So I ended up at UCLA studying the theater where I was seen by a Warner Brothers casting director named Hoyt Bowers (who is now at Paramount). Through that contact I got a part in Edna Ferber's *Ice Palace*.

JCT: When did *Star Trek* come onto the scene?

GT: That was after I had gotten my Master's Degree at UCLA and had done a whole slew of Warner Bros. television series. The television work was very valuable for me. I learned very early on that if you act as you do for the stage, particularly at Royce Hall at UCLA, when you are projecting out, that you will be the hammiest thing around in front of a camera. So you learn very quickly to restrain yourself. Also, acting for the camera is very technical. You have to know where the key lights are. You can be doing beautiful things, but if you are not in the light, or if you are not on your mark then it's all lost.

JCT: Did your Japanese ancestry have anything to do with your Sulu role?

GT: Gene Roddenberry very consciously wanted a pluralistic look for the "Spaceship Earth" concept. You know this was in the mid- to latter 1960s, when the civil rights issue was tearing the country apart. But somehow on television it wasn't being reflected at all. *Star Trek, I* think, was one of the few shows that dealt with a pluralistic society. But Sulu was never boringly chauvinistic about his ethnicity. Initially, the idea was for a black actor to play the part; and it wasn't until Gene interviewed me that he said, "Why not?" And then after I started the role, we discovered there is a "Sulu Sea" east of the Philippines! Serendipity. I spoke without an accent. You'll notice when I go into the swordsmanship thing (in the television episode, "Naked Time") I don't use a Japanese samurai sword but a French fencing foil. Sulu's really a man of the world and his interests span all cultures, whereas Chekov was Russian and chauvinistically Russian and a little unbelievable within the context of the twenty-third century...You know, there were two pilots made of *Star Trek*. The first one didn't quite sell so a second one had to be made. One of the reasons for the failure of the first was the fact that the second in command was not Mr. Spock. Mr. Spock was a much more subordinate character. There was a female character named Number One played by Majel Barrett (who eventually wound up playing Nurse Chapel). The consensus was that having a woman as second in command was unbelievable and that we couldn't have that. However, we *did* end up with a pointy-eared Vulcan, so it was liberal and progressive in that respect!

JCT: Are there some television episodes you are especially fond of?

GT: Well, "The Naked Time" gave me a chance to do a little bit more than just press buttons. I got to run around with a fencing foil and look a little crazed. In fact, every one of the scenes where I get something to do, I am frenzied or crazed or zapped out. Same thing with "Mirror, Mirror," where we all played the reverse of our characters. Sulu is a wonderful, lovable person as we know him on the series; but in "Mirror, Mirror" we see the reverse of that—the cut–throat, vicious, murderous kind of character.

JCT: Spock is killed in the new film. So what happens next? Is he *really* gone?

GT: In Science fiction anything can happen. Watch the ending very carefully. Watch it. One of the plot elements is the creation of a "genesis factor," or energy burst that creates life. The missile–torpedo bearing Spock's dead body goes off in the direction of the genesis cloud.

JCT: Let's talk about both films together. Same uniforms?

GT: No, different uniforms. In the first film we had a unisex kind of uniform. I didn't like that. I think there is a difference between men and women and there should be an appreciation and acknowledgment of that fact. To dress men and women alike I think is crazy. Anyway, that's corrected in the second film.

JCT: What about things like plot, pacing, and action?

GT: The new film has got plenty of pace, rhythm, genuine conflict and high adventure. Do you recall the episode on television, "Space Seed," with Ricardo Montalban? He was abandoned on this planet with some barbarian types and he comes back and takes over another ship in Star Fleet and that's where the battles come in. Montalban is a wonderful adversary. The problem with the first film was there was no real pitting of forces. *V'ger* was too awesome, too all-powerful. If there had been any conflict, the *Enterprise* would have been wiped out, just like that. As for the sets, things haven't changed appreciably. However, in the first film, many of the buttons were practical—you could punch a button and something really would light up or things would start moving; whereas on the new film that wasn't so. And my gearshift has been eliminated! Do you remember the gearshift I had? Here, I just press a button.

JCT: The word is out, you do your own stunts here.

GT: Well, the *Reliant is* shooting at us and we take one big major hit and there's a lot of stuff flying around. The camera is right on my face and when I take the hit, the explosion is right there. There's a little spring mechanism under me and I bounce off that and fly into a pile of mattresses off to the side. It's no big deal.

JCT: What kind of participation did Gene Roddenberry have on the new film?

GT: Well, Gene had had some difficulties on the first film. We had enormous cost overruns and with each one Gene lost more authority until the cost had gone so far beyond the initial budget that Gene for all rights and purposes was powerless. The real power had reverted to the money source, the front officel. In the new film, *The Wrath of Khan*, Gene is on board as a consultant, but a consultant with no veto power.

JCT: Which means...?

GT: Which means that he can write memos, make recommendations, give advice, and they can thank him and merrily go ahead and do what they were already doing. So it's been a very frustrating situation for Gene in both films, but most particularly with the most recent one. I would think to a creative person like Gene, to a man who has so many ideas, to a man who really is the greatest authority on *Star Trek*, it can be very frustrating to not be able to make a meaningful contribution to it.

JCT: Anything in the new film that the buffs might especially pick up on?

GT: There's an inconsistency in it they might notice. Chekov was a character that was not introduced to the television show until the second season. Yet, the story that was the basis for the film came from an episode from the *first* season when Chekov was not around. But when Chekov sees Khan (Ricardo Montalban) he recognizes him in the film, which is not really possible! See what I mean?

JCT: Yes, but about this source material, "Space Seed"...Is the new film a rehash of that story or what?

GT: No, it's just a continuation of the story. We pick up on the Montalban character 10 years later.

JCT: The film seems to have gone through a number of different titles. What's the latest?

GT: At this time it's called *Star Trek: The Undiscovered Country*. It's a Shakespearean reference from *Hamlet*: "the undiscovered country from whose bourne no traveler returns/puzzles the will and makes us rather bear those ills we have than fly to others we know not of."

JCT: Incidentally, some of my friends who are Trek buffs want to know if Khan is real or an android?

GT: He's real! Yes, that android thing comes from *Time* magazine. They had a shot of Ricardo Montalban and three female barbarians with him. Oh, Montalban is fantastic. He's in his sixties; I think he is about 64 or 65. He is in incredible shape. In *Fantasy Island* he's always wearing that white suit; but here, he's bare—chested through a good portion of the action. The muscles are so tight they could have been drawn on.

JCT: I'm beginning to get the impression that you prefer the second film to the first.

GT: No, actually, I enjoyed the first film very much, although the critics didn't seem to receive it very well. Some of the sexual implications of it were very interesting. Man's relationship with technology seemed to have a lot of this sexual thing. First, there's Kirk's relationship with the *Enterprise*. When he first sees it after all those years, we hear a love song as he circles around this voluptuous mistress of his. He may have had many human female mistresses but his real mistress is the *Enterprise*. The *V'ger* is personified by Ilia who is really herself a product of technology. She in turn has a relationship going with a human, Decker. Also, there is the *Enterprise's* "relationship" with *V'ger* itself: Interesting. I think the sexual metaphor there is very, very prominent...Remember the climax that's reached when the male and female representatives merge and there is a subsequent "birth" of another lifeform?

JCT: How much input do you have generally about what your own character of Sulu does or says?

JCT: Oh, I always have a lot to say about my character. Robert Wise was very receptive on the first film. On the new one, I wrote lots of memos to Harve Bennett. But the result was only one additional scene that gave Sulu something to do. It's a scene in the shuttlecraft (it's the *only* scene in the shuttlecraft). Watch for it. Kirk congratulates me on my new command assignment. But in my memo it was much better! In the new film Sulu is back with the *Enterprise* for one last final service. There is a brief discussion where Kirk congratulates me on getting my own ship. I'm going on to command my own ship. But I'm back on the *Enterprise* for just this one more go round.

JCT: The helmsman becomes the captain of his own ship eventually.

GT: Right. But maybe I'll come back to the *Enterprise* someday. Maybe as the adversary and start some shooting!

Star Trek IV: The Voyage Home: William Shatner, Leonard Nimoy, De Forest Kelly

[Note: In the following brief interviews, given in Hollywood on 1 June 1984, on the occasion of the release of *Star Trek IV*, members of the original crew, Captain James T. Kirk (William Shatner), First Officer Mr. Spock (Leonard Nimoy), and ship's physician Dr. Leonard "Bones" McCoy (De Forest Kelly) revisit the origins of the series and consider the consequences of what it has wrought.]

Canadian born William Shatner (1931–) began his career on the stage and first came to television in the early 1960s in several episodes of *Twilight Zone*. His several television series include *Star Trek* (1966–1969), *T. J. Hooker* (1982–1986), and *Boston Legal* (2004–2008). He will always be best known for his role of James T. Kirk in the *Star Trek* franchise.

Leonard Nimoy (1931–) began his most popular role of Mr. Spock on *Star Trek* in 1966, for which he garnered three Emmy nominations. He was already well known in Hollywood as an acting teacher and for many roles in television and films. Subsequent to the many *Star Trek* sequels, he continued a busy acting career on stage and doing voice-overs for television documentary series. In April 2010 he announced his retirement from acting, relinquishing the role of Spock to the young actor, Zachary Quinto.

De Forest Kelly (1920–1999) began his career as a dance band singer. After a stint in the Army-Air Force in World War II he relocated to Hollywood, where he became a well-known supporting player in television and film westerns. Ironically, in one of his first films, *The Man in the Gray Flannel Suit* (1956), he played a medic. He is best known today for his role of Dr Leonard "Bones" McCoy in the many *Star Trek* television shows and movies.

"I Know What I Don't Know": William Shatner

JOHN C. TIBBETTS: We meet the bridge of the *Enterprise* once again, I see—or am I spilling the beans?

WILLIAM SHATNER: I think you've spoiled the omelet! No one knows yet we're back on the refitted *Enterprise*.

JCT: Well, as Captain Kirk you are riding high again, and you must feel like a jockey on board a winner. Have you seen it with an advance audience yet?

WS: Believe it or not, I haven't seen the film at all.

JCT: Really?

WS: Really. And usually in a film of this magnitude, and the kind of locations we were on, we usually do a lot of postdubbing the voices, synching to stuff that didn't work where there was too much noise or something. There was very little of that in this case, so I haven't seen more than a minute of the film.

JCT: But surely you have a *feeling* about a film...?

WS: Well, certainly from the reaction of people like yourself and from those who preceded you, there is a great deal of enthusiasm.

JCT: It's been almost 20 years since the series began. Can you give us a sense of contrast when in 1966 you first entered the set of the *Enterprise*, and now as a seasoned traveler you're back again. That was then, this is now.

WS: I'm trying to recall how I must have felt at that time. I was a callow youth you know [laughs]. I remember being very excited and very nervous about the success of the series that was going to go on the air some months after we started filming. The set was very strange to us. Here we were in essentially a circular set with a raised platform behind us, and there were pie-like sections that could be separated so we could get different camera angles.

JCT: Sounds like pit-group furniture, or something.

WS: It really was, and we had to learn how it all worked and what to do and where to walk. It was all very strange and new and different.

JCT: Not to mention the costumes.

WS: Oh! the costumes! Yeah, you couldn't go out for lunch, otherwise your gut would show in the bulges in the tight costumes! So it was all very nerve-wracking. Now, in this film, we come on the set knowing how the set works, what to do, and what to do about lunch!

JCT: How about William Shatner now? What has been the difference in you between 20 years ago and now? How do you see yourself as an actor over that intervening period?

WS: I am probably less sure of myself, now.

JCT: Just the reverse of what I might have thought.

WS: I probably don't like what I do anymore. I probably know that I don't know—I know that I don't know...if you *know* what I mean. What happens for me in the aging process is—and in science, for that matter—not only as an actor but as a human being, is that I begin to realize that we don't know anything. We don't know anything. And we make a few discoveries in science like how a molecule works, but even then we're not quite sure. Where that molecule leads us to is another mystery.

JCT: This is precisely what science fiction writers do, remind us of how little we know about anything.

WS: Well, a human being is a microcosm. It's true, maybe in 300 years from now, when *Star Trek* is supposed to take place, we'll know more. I mean, even if we knew how the universe operates, would we know everything?

JCT: Among the ranks of science fiction writers and fans traditionally have been concerns for ecology, protection of animals, and so forth. That's a very wise core to *Star Trek IV*, I think.

WS: I think so.

JCT: Tell us a little about the genesis of that. Did this new film come full blown from the writers, or what?

WS: Leonard Nimoy and Harve Bennett came up with the idea of us going back in time, and needing a device to do that. I don't think I better tell you any more.

JT: Okay. I tell you what— after 20 years, you may know less, but we know more about how much we enjoy *Star Trek*.

WS: That's wonderful.

"The Voyage Home": Leonard Nimoy

JOHN C. TIBBETTS: I've been talking with William Shatner about the contrasts between working on the original television series and now this new film. A lot's gone under the bridge in 20 years for you, too—as it were!

LEONARD NIMOY: Yeah, a lot has changed. All the other people are 20 years older—I'm not, but they are! It's strange what happened to those other people!

JCT: How about the costumes, do they still fit as well?

LN: [laughs] A little adjustment here and there. I've gained some weight. I've put on in the last year about 15 pounds, because I quit smoking. So now I eat. Like I used to skip meals, now I eat.

JCT: Mr. Shatner describes those early sets as being like pit furniture, you arrange them in groups like wedges and pies—

LN: That's true. But everything else has changed. We have changed, and the approach to the show has changed. I would say; on another level, though, we have come back full circle in *Star Trek IV.* I think we are closer, in attitude to the original series.

JCT: Hence that subtitle: "The Voyage Home."

LN: I agree. I think it's a very appropriate title, yes, very much in the spirit that we used to have when we were making the original series.

JCT: Speaking of home, you have a concern here for home—for ecological imbalance, species protection, and so forth. This traditionally has been a priority on the part of science fiction and fantasy writers and readers. I assume you're aware of this, and going into this project, this is going to be very close to home for many of these people. Tell us about your own passions about ecological imbalance. You told me just before our interview that species are disappearing all the time.

LN: Yeah, I became interested in introducing that idea in this film when I read a book called *Biophilia*, by Edward O. Wilson, a biologist at Harvard. He tells us by the 1990s we'll be losing 10,000 species per year at the rate we're going now. That's an average of one species per hour! What's really fascinating is that many of them will not even have been recorded; we won't even know that they were here; we won't even know what they were; and the scientists will not have even gotten to them before they're gone. So, although this picture is essentially an entertainment piece, there is an opportunity to introduce the idea that what we're losing today may turn out to be terribly important to us 100, 200, or 300 years from now.

JCT: I understand that you first decided upon plants.

LN: We thought about some kind of a plant that we might need to create a medicine— something that we had to go back in time to get and bring it back into the twenty-first century to save Earth. What was it gonna be, either a person or a plant or a bird or a fish? Well, we ended up deciding on a couple of very large creatures, namely, whales!

JCT: What aspect of "coming home" can we find in your character of Spock? Of course, we have those classic confrontations with "Bones," which remind you about your half-human identity.

LN: We do have a lot of homecomings in this picture. We come back to Earth now, in 1986 (two years in the future from now, in 1984). We come back to the spirit of the series in the 1960s, and Spock comes back to his full identity at the end of this picture.

JCT: I'd like to ask you one other thing now about this preservation of species business, how about preserving the original

negatives of the *Star Trek* television shows and the films? Martin Scorsese has raised a lot of issues about the studios' mismanagement of negatives and materials disappearing, disintegrating, and all of that. Are you ensuring that we can see *Star Trek* in years to come?

LN: That's a very good question. I don't own the film, I don't own the negatives, which are obviously the property of Paramount. But I would think that they are taking very good care to see to it that the storage facilities they use are right to preserve the film. It's true that there was a time when there were some very slovenly practices, and some very important films were lost, because they weren't stored or preserved properly. I'm sure that, Paramount values this stuff and knows that it's going to be valuable over the years to come.

JCT: Finally I can't wait to see what kind of costume Spock will be wearing in another 25 years [laughs].

LN: You mean that costume I wore while roaming the streets of San Francisco? I had a good time with that. I think people enjoy it.

JT: Members of Star Base in Kansas City and *Star Trek* organizations everywhere are waiting for a message from you, from Mister Spock.

LN: "Live long and prosper!"

De Forest Kelly ("Bones) (photo by the author)

"Physician Heal Thyself!": De Forest Kelly

JOHN C. TIBBETTS: I watched *Star Trek IV* with a preview audience last night. You must have a good feeling about it.

DE FOREST KELLY: Good feeling, yes it is.

JCT: How often in real life do doctors seek you out to speak as "Bones" at conventions about the medical science of the future?

DFK: [laughs] I'm trying to avoid that!

JCT: Really?

DFK: I have not really gone before medical conventions or gatherings of that sort. As a matter of fact, here in Los Angeles I just did an interview at the studio for the *American Medical Journal*, which is the first time I've done anything like that. I don't want to get in too deep, because real doctors might lose a few patients listening to me!

JCT: I ask this because here's a lot in the film about comparing medical technologies in the present and in the future. It's a reminder to us that what we now so smugly think of as advances in medical science still have a long way to go.

DFK: Well, yes, and for that matter, so much has come to pass since we started doing the series! Nowadays, in Intensive Care we have the readouts behind the bed, with heartbeat, pulse, everything the physician wants to know. That was a big thing when we did that on *Star Trek* in the sick bay.

JCT: So are you saying you helped predict some of those things?

DFK: Well, that was far out when we did it. Now you see this in any top hospital you walk into. The needle that I use—the air needle—is now in use. And laser surgery, which is now coming into its own. It's hard to keep up, things are moving so fast today. Ever since they built that little microchip, everything started to change.

JCT: De Forest, it's always struck me and we've talked several times before, you are a contented man. You enjoy your role of Bones. You enjoy being identified with him; and you don't seem to struggle against it.

DFK: No, I had to adjust. I think we all went through a phase of where we fought this thing, you know, because after all we are actors. We spend our lives trying to become something worthwhile in this profession; and after a while, when I saw the power that *Star Trek* had on me and my life, I decided that if I didn't get my head on right with this show, I was going to sit around and be unhappy. Besides, I had already played doctors before in movies and on television—one of them was for a *Bonanza* episode ["The Decision," 1962]—so I decided to let fate have its way and start counting my blessings and be happy with it. And as a result, it's

certainly paid off for me! Mentally and physically...because, you know, you can't do anything about. It's a compliment in one way that people feel so strongly about you and the show.

JCT: Are you saying, it's a case of "Physician heal thyself?"

DFK: Yeah. Absolutely. I had to say, "Look man, you might never have never worked again; but here it's a wonderful thing to be a part of such a wonderful show. To something that will be here long after I'm gone, you know." Very few actors can make that kind of mark in their entire career.

JCT: It's also interesting that it would be part of your role as a surgeon to remind Spock to get in touch with his humanity. Another kind of doctoring, I suppose

DFK: That's right. We really could have done more about things like that, if the series had gone on another two years. We would have gotten deep into that particular area, psychiatry, and that sort of thing. The physician of the future would have been accomplished in all fields of medicine, not just limited to the physiology. McCoy would have been a wonderful psychiatrist.

JCT: Well, it's kind of a holistic science you're talking about there.

DFK: Absolutely, absolutely. Which is becoming very prevalent today, you know.

The Music of Terror

It is precisely from music that...it is possible to say the profoundest things in the world....Wonderful sound-meanings knock at every human heart with the quiet question, "Do you understand me?" but are by no means understood by everyone.

Robert Schumann (1834)

From Mozart's musical evocation of a descent into the Inferno in his opera, *Don Giovanni* (1787), to Rachmaninoff's moody *Isle of the Dead* (1909), after the painting by Arnold Böcklin, to the tangled shrieks of György Ligeti's *Lontano,* heralding the appearance of the Monolith in Stanley Kubrick's *2001: A Space Odyssey* (1968)—music, for our purposes here, has insistently attached itself to the concert hall, recordings, and the motion picture soundtrack to provoke the weird and the grotesque.[1] Don't we all know this evocative power from our own youth? In a remark that could be speaking for all of us, artist Maurice Sendak once wrote, "Music's peculiar power of releasing fantasy has always fascinated me. An inseparable part of my memories of childhood, music was the inevitable, animating accompaniment to the make-believe."[2]

The question remains, how does the Gothic sensibility, text, and image manifest itself in music? Obviously the presumed relationships between music and the broader web of the Gothic universe is a thorny issue with no easily discernible answers. Generally, music has been energetically theorized as an autonomous art. However, theorists and Romantic composers such as Schumann describe music as a concatenation of "sound-meanings" that can meaningfully engage with language, imagery, and the wider world. On the one hand, music seems to remain entirely unaffected by the things with which it mixes, no matter how they may direct or even coerce its expressivity; on the other, it also surrounds, accompanies, suffuses, infuses, and mixes with words, images, movement, narrative, sex, and death. Both sides of the debate—and indeed, through the centuries it has been and continues to be a vexing dispute that culminated literally in fistfights and personal feuds in

the latter nineteenth century—may seem irreconcilable. As musicologist Professor Larry Kramer describes the dilemma, either music sublimely transcends *specific* meanings, or it moves toward intimations of contingency, historical concreteness, constructed and divided selfhood. Or, as Professor Kramer wittily proposes, you may argue that music presents a properly Gothic *dual* character, like one of those ambigrams that can be perceived as one image or another, by turns, or simultaneously. Indeed, Kramer concludes, perhaps the truth of the matter resides *in the interplay of autonomy and contingency*, which "is the general, higher-order context and condition for intelligibility for most modern Western music.... We may know the suspension between autonomy and contingency all around us, but in music we feel it in ourselves."[3]

I propose that if we tilt the tricky balancing act toward music as more a means of *engagement* with the world than of disengagement—that music acknowledges the dense phenomenal life that its apparently noumenal qualities obscure—we may proceed without any undue physical violence.

At any rate, it should come as no surprise that, as music historian Professor Ronald Taylor has told this writer, "It was music which expressed most completely everything that was going on in the world at that particular time of the gothic and romantic age."[4] Thus, as the late John Daverio has noted, the crucial strands of the Gothic-Romantic program were realized in musical works.[5] Just as the key poets, philosophers, and novelists of the day began writing voluminously about music theory and composers of the day (particularly Beethoven), their own texts—notably Goethe's *Faust* and *Wilhelm Meister*, Hoffmann's Tales, Byron's poems (particularly *Manfred*), to name just a few—their texts were becoming in turn the subjects of operas, songs, and instrumental works by virtually every one of the great Romantic composers, especially Franz Schubert, Hector Berlioz, Charles Gounod, Franz Liszt, and Schumann. The study of the influence that E. T. A. Hoffmann and Jean Paul Richter had on many of them, for example, particularly on Schumann, has in itself been worthy of exhaustive analysis.[6]

Professor Jack Sullivan is superbly equipped to tackle the "Music of Terror." The director of American Studies and professor of English at Rider University, he has published many studies about the interactions of film, music, and the Gothic tale, including *The Penguin Encyclopedia of Horror and the Supernatural*, *New World Symphonies: How American Culture Changed European Music,* and, most recently, *Hitchcock's Music,* a pioneering examination of the noted director's relationship with composers and musics in his films. The following condenses several interviews with Professor Sullivan into a unified, uninterrupted narrative. (See the "Steampunk" essays later in this book for views of a different brand of Gothic-inspired music from the punk and rock bands of today.)

"Symphonie Fantastique": Jack Sullivan

The ability of "classical" music to make our hair stand on end, a phenomenon well known to the great composers, is seldom examined by anyone else, including those who might best exploit it. One would think, for example, that more makers of horror films would pick up on what Stanley Kubrick and William Friedkin demonstrated in *The Shining* and *The Exorcist*.

From the opening *Dies Irae* to the more contemporary edginess of Bartók's *Music for Strings, Percussion, and Celesta* and Ligeti's *Lontano*, the music in *The Shining* is surpassingly scary, more so, ironically, than Kubrick's images; and *The Exorcist* is so enhanced by sound—by an unholy mélange of Webern, Penderecki, Henze, Crumb, and the voice of Mercedes McCambridge that we almost forget the tawdriness of its visual effects. Of the classic horror directors, only Edgar Ulmer seemed to know his scary music: *The Black Cat* features an orchestral version of the Liszt B-minor Sonata, the second movement of Schumann's Piano Quintet, Beethoven's Seventh Symphony allegretto, the love theme from Tchaikovsky's *Romeo and Juliet*, and a rendition of the Bach D-minor Toccata played on the organ for Bela Lugosi by a glowering Boris Karloff.[7]

The music of terror is similarly slighted in highbrow culture. Indeed, in contemporary music commentary, it often seems actively suppressed. A recent Lincoln Center program note for Arnold Schoenberg's shuddery *Accompaniment to a Cinemagraphic Scene* dismissed the composer's accurate movement titles ("Threatening Danger," "Panic," "Catastrophe") and pronounced the piece to be one of "almost classic serenity." Again and again Schoenberg, Bartók, and others are defensively described only with adjectives like "classical" and "rigorous," as if they sound like Mozart (whose *Don Giovanni* is at least given credit for its demonic moments).

And yet a vibrant tradition of terror in music does exist, one roughly parallel and contemporaneous to the Gothic tradition in literature. Just as the earliest Gothic romances by Walpole and Radcliffe don't quite terrify us today, the earliest musical spookeries by Mozart, Weber, and Beethoven (whose music, as Jacques Barzun reminds us, was described by his contemporaries as "frightening") now offer only mild chills. Terror as we understand it probably begins with Berlioz, whose *Symphonie fantastique*, begun in 1828, not only struck a new note of satanic terror but also built to it from a deceptive calm—and even parodied it at the end. Nothing in music before quite prepared audiences for the ghoulish tolling bell of the "Witches' Sabbath," the realistic musical depiction of a head being lopped off by a guillotine, the cavernous brass intonement of the *Dies Irae*, or the sinister scratchings, scrapings, and rumblings that forecast "special effects" composers like Penderecki and John Williams. Most significant was Berlioz' revolutionary dissonance, which brought his "diabolic orgy" of "ghosts, magicians, and monsters of all sorts" to vivid life.

Reviewers for *Figaro* and other publications called the new symphony "bizarre" and "monstrous"—and meant it as high praise. Today, however, critics resist the horrific elements of the *Fantastique*, insisting that the grim ending doesn't jell with what comes before. But in the tale of terror as practiced by the British and French, it was perfectly natural, even conventional, to move from the natural to the supernatural, the serene to the horrific. It was also not unusual for the tale to parody its own Gothic conventions even as it played them for straight chills.

Seven years later, Berlioz composed his Requiem, a Gothic extravaganza written for a large space, scored for large orchestra and chorus, 4 offstage brass ensembles, tenor soloist, 16 timpani, 2 bass drums, and multiple percussion. Its uncompromising intensity and innovativeness made it a manifesto for the Romantic movement. If the Brahms and Fauré Requiems are testaments of consolation and comfort—requiems without the final judgment—Berlioz's is the opposite, a wrenching cry of terror followed by a contemplation of the void. Indeed, Berlioz orchestrates such a satanic plunge in the famous "Ride to the Abyss" episode in his *The Damnation of Faust,* when Mephistophes leads the hapless Faust on horseback to Pandemonium

An influential champion of these works was Franz Liszt, whose piano transcription of the *Fantastique* brought that work to the wider public. He also continued the Gothic tradition with his 1865 *Totentanz* for piano and orchestra, a work that, like the *Fantastique*, makes fiendishly clever use of the *Dies Irae*. Indeed, Liszt went a step further than Berlioz by striking the note of terror at once and sustaining it (with one teasingly angelic exception) through the entire work, thus operating in the go-for-broke manner of Poe. Liszt's vision of Death as Grim Reaper is conjured by dissonance as bold for its time as Berlioz', sounded at the beginning by near-Bartókian piano chords. Liszt called *Totentanz* a "monstrosity," and although he devoted a significant portion of his output to the demonic and the macabre, nothing else—including *Les Preludes*, the three *Mephisto Waltzes*, or the *Faust Symphonie*—was ever quite as monstrous. He did, however, make a final leap into the unknown near the end of his life in the 1870s with "Evil Star," "Grey Clouds," "Csardas Macabre," and other proto-impressionist piano works. Their ambiguous harmonies and morbid colors have a ghostliness unlike anything else in nineteenth-century piano music.

The Most Famous Spook Piece

The importance of harmony and color in the evocation of fear becomes clear when we compare Rimsky-Korsakov's popular transcription of Mussorgsky's *Night on Bald Mountain*, perhaps the most famous spook piece in the repertory, to the decidedly more ghoulish original. The most striking contrast occurs at the beginning, in the assembly of the witches:

Rimsky's suave orchestration sounds like a charming Disney scenario (which, in *Fantasia*, it ultimately became); Mussorgsky's more sharply edged, boldly colored original sounds bloodcurdling, like something from a nightmare. (In defense of transcribers, be it noted that the demonic atmosphere in the "Gnomus," "Bydlo," "Catacombs," and "Baba Yaga" sections of Mussorgsky's piano work was faithfully preserved by Ravel in his famous orchestration.)

Another Russian who seemed at home with the Forces of Darkness was Alexander Scriabin, who burdened his late works with all manner of satanic titles and epigraphs in an attempt to "resurrect all monsters and visions of the past." The spellbinding opening of *Prometheus*, with its static harmony and cavernous illusion of space, is pure atmosphere, a startling prophecy of Ligeti and Crumb. But Scriabin's most demented and demonic works are his late piano sonatas, especially as performed by Vladimir Horowitz, who played for a dying Scriabin in 1915 and seems to have this music in his blood. The electrifying trills in Sonata Nos. 9 (the "Black Mass") and 10 are projected by Horowitz with a freedom and ferocity rarely heard in modern pianism. Too bad Horowitz has never recorded Nos. 6 and 7. The latter, subtitled the "White Mass," was meant as an exorcism of the blackness in No. 6, a work even Scriabin considered too hellish to play in public. But the listener who isn't initiated into Scriabin's mystical relativities may be puzzled by the distinction. Less relentlessly grim than No. 6, it is still thoroughly unsettling: The "Whiteness" of its subtitle is closer to Melville's "Whiteness of the Whale" or Poe's white subterranean tunnels—both metaphors for a terrible blankness in the universe—than to traditional associations with goodness and light.

Influential Dance of Death

The period of late Scriabin is also the period of Stravinsky's *Le Sacre du printemps*, perhaps the single most influential work in the music of terror. Like literary landmarks by Walpole, Coleridge, and de Quincy, *Le Sacre* was inspired by a dreamlike experience, in this case a "fleeting vision" of a young girl dancing herself to death in a pagan ritual. Stravinsky's violent dissonance and feverish rhythms influenced the more demonic and "primitive" works of everyone from Prokofiev to film composer Jerry Goldsmith. The importance of dissonance in sustaining anxiety was once again brought into sharp focus, as was the mysterious relationship between terror and pleasure—for the awesome brutality of *Le Sacre* was meant to be exhilarating, not depressing.

Immediately after *Le Sacre* came a flood of unnerving music, again paralleled closely by trends in literature. The nineteenth century is commonly thought of as the great age of the ghost and horror story, but with the exception of Poe, Le Fanu, Stevenson, and a few others, it was actually a rather bland and feeble one. (Romanticism, and its attendant excesses,

was far more felicitous for the poem than the tale.) Clearly the golden age of the tale of terror was the early twentieth century, with the eruption of Algernon Blackwood, Ambrose Bierce, Guy de Maupassant, Rudyard Kipling, M. R. James, Henry James, Edith Wharton, Walter de la Mare, H. P. Lovecraft, and any number of other first-rate spooksters who still chill us today.

The pattern is similar in music, and has similar reasons behind it. The apocalyptic quality of so many books and musical works of the early modern period—the sense of an ominous building of un-containable forces about to explode—was part of a spirit of dissonance and anxiety reflected in such diverse forms as the music of Schoenberg, the essays of Freud, and the fiction of Joseph Conrad. These disturbing, challenging works, so many of which probe the darker recesses of the psyche, were symptomatic of a cultural malaise that many historians view as a premonition of the Great War, and that continued long after it.

Technical reasons play a role as well. Just as the perfection of the modern short story as a form enabled writers to use irony, narrative distance, and singularity of mood to convey horror convincingly, the enlargement of harmonic and rhythmic possibilities enabled composers to explore areas of darkness and disturbance hitherto unheard in music. *Le Sacre* was a detonator setting off wrenching explosions.

Music for the Bad Life

For many listeners this new freedom has been more curse than blessing. Of all the arts, music is the only one that is commonly supposed *not* to be disturbing but pleasant and anesthetizing, something to eat dinner or sign a check to (or, as in New York's concert halls, something to clank jewelry and crinkle paper to). Because sound is so immediate and intimate—and, therefore, so potentially disturbing—most listeners prefer composers to behave themselves and not venture too far beyond the soothing and the predictable. But for those who love being riveted and shaken by music (which, ironically, is what Romantic music is supposed to do), "modern" music's polarization of audiences has a curious advantage: It's good to know that, in our time, music—unlike the thoroughly assimilated art of one-time subversives like Beardsley, Picasso, Munch, Kafka, Conrad, and so many other masters of horror—still retains its radical edge.

One piece that still raises our hackles, a work often compared to *Le Sacre*, is Bartók's *The Miraculous Mandarin*, which does bear a superficial resemblance to Stravinsky's ballet but is really rooted in Bartók's own "Allegro Barbaro," a piano piece preceding *Le Sacre* by two years. As he had demonstrated in *Bluebeard's Castle*, Bartók had a real affinity for the horrific, but in *The Miraculous Mandarin* he went much further. The orchestra is treated as an instrument of aggression; the snarling brass glissandos, pounding ostinato rhythms, and lurid woodwind colors engulf

the listener in a tidal wave that, as with *Le Sacre*, needs no ballet scenario to make its effect.

Although not as overtly horrific as *Mandarin*, several of Bartók's later works are spectral in the extreme. The ominous thumpings and growlings in the opening movements of the First Piano Concerto, the Third and Fourth String Quartets, and the Sonata for Two Pianos and Percussion are matched by the poetic "night music" sequences in their slow movements. The term "night music" was first used by Bartók to describe the slow movement of the *Out of Doors* Suite for piano, which shimmers and vibrates with the sounds of nocturnal animals and insects. Even more bewitching is the slow movement of the *Music for Strings, Percussion, and Celesta*, featuring slithery glissandos for timpani and strings that seem to travel up our spines before they reach our ears.

Bernard Herrmann, a Bartók admirer, surely had the *Music for Strings* in mind when he composed the "black and white" string music for his unforgettable *Psycho* score. The shattering dissonance of "the shower scene," probably the most instantly recognizable film cue, is the cinema's primal scream, profoundly embedded in our movie-going subconscious, though ghost-like quiet sections such as the motel clean-up cue are unforgettable as well. *Vertigo*, Herrmann's other Gothic masterpiece for Hitchcock, is equally gripping and engages a wider emotional range. That Herrmann's stark 1935 Sinfonietta for Strings was *Psycho*'s predecessor brings us full circle: Herrmann was originally an uncelebrated concert and opera composer (the forgotten Gothic operas *Moby Dick* and *Jane Eyre* are his), but his movie scores for Hitchcock were such sensational successes that they are now performed as "classical" works by major orchestras.

Impressionist Ghosts

A more attenuated type of terror is represented by the impressionism of Debussy and Ravel, composers steeped in the aesthetic theories of that master of the American Gothic, Edgar Allan Poe. Debussy's fascination with the mysterious and the fantastic was such a fundamental part of his music that it is difficult to pinpoint specific works for our purposes. Perhaps it is enough to say that the piano pieces tend to be the most ghostly, especially the sounds of tolling bells and chanting monks in "La Cathédrale engloutie" and the creepy bitonalities in "Brouillards." (Debussy attempted an opera version of "The Fall of the House of Usher," but it exists only in spooky fragments.) A more sumptuous combination of enchantment and terror is offered in Ravel's *Gaspard de la nuit*, a piano work inspired by what George Moore once called the "mad and morbid" prose poems of Aloysius Bertrand. To hear the precise nuance of that inspiration, the listener should look for the collaboration offering Gina Bachauer's performance prefaced by Sir John Gielgud's mesmerizing readings of the poems. A special word about recordings also needs to be made

in regard to *Daphnis et Chloe*: As several critics have pointed out, only the Boulez/New York Philharmonic version manages to make the music sound "frightening."

In our own time, the most popular and prolific exponent of impressionist spookery is George Crumb. In remarks made before the 1984 premiere of *A Haunted Landscape*, Crumb acknowledged a debt to Debussy, whose music is "filled with a mysterious sense" and who specialized in "short phrases and short thoughts." Certainly an impressionist, Crumb is also a "minimalist" in the best sense: Every note and gesture is charged with dark electricity.

Since the 1960s, Crumb has turned out a continuous stream of works saturated in the horrific and the supernatural—an emphasis reinforced by suggestive movement titles ("Night of the Electric Insect," "The Phantom Gondolier") and bizarre instructions to performers. In *Ancient Voices of Children*, a mezzo-soprano is asked to chant "a kind of fantastic vocalise" into an amplified piano to produce "a shimmering aura of echoes"; in *Night Music I*, an unearthly effect is produced by a vibrating gong being slowly lowered into water. Crumb is addicted to silences and the most delicate, ethereal sounds, but he can also shock and provoke: *In Black Angels*, the players are asked to shout mystical number sequences and electronically amplify their string instruments to reach "the threshold of pain"; in the "Musics Apocalyptica" section of *Star Child*, a gigantic percussion battery produces a glorious racket that indeed sounds like the end of time. Recently, Crumb has begun to enlarge his sonic and emotional canvas. *A Haunted Landscape* (a title suggestive of Crumb's entire output) sets fierce poundings and screechings from brass and percussion against a modal hymn for strings, one of the most spine-tingling dynamic contrasts in recent contemporary music.

Freudian Horrors

Another horrific tradition, one more overtly ghoulish than impressionism , is the atonal expressionism of the New Viennese School. For sheer demented weirdness, there is nothing quite like the colloquy with a bloody corpse in Schoenberg's *Erwartung*, a work that parallels Henry James's *Turn of the Screw* as a touchstone of Freudian horror. Robert Craft has aptly described the ending as "a bar and a half of musical gooseflesh, an orchestral shiver that seems not to stop but to vanish." Any number of other Schoenberg works are goosebumply as well, including *Pierrot Lunaire*, *Five Pieces for Orchestra*, and the 12-tone *Accompaniment to a Cinematographic Scene*. The latter has often been used as an accompaniment to excerpts from Murnau's *Nosferatu*—a perfect compliment to the film's magnificent creepiness.

Schoenberg's disciples had a similar taste for the morbid. The funeral march in Webern's *Six Pieces for Orchestra* is a crescendo of horror, and

his more muted miniatures such as the *Bagatelles* and the *Four Pieces* for violin and piano feature some of the most ghostly, disembodied utterances in music. Berg's more popular *Wozzeck* and *Lulu* represent the pinnacle of horror in opera, but many of their most heart-stopping moments are orchestral: The shattering "epilogue" of *Wozzeck* and the "orchestral scream" as Lulu is attacked by Jack the Ripper are sounds not easy to forgot.

Singular Nightmares

In addition to composers with a predilection for horror, there are numerous others who—like literary masters Dickens, Faulkner, and others—produced one or two isolated masterpieces in the genre. Some of the more notable single works include Saint-Saens' chestnut *Danse macabre*, with its stereotypical dancing-skeleton solo violin and bone-rattling xylophone; Mahler's Symphony No. 6, with its brutal *hammershlag* death-knells; Prokofiev's *Sacre*-inspired *Scythian Suite* and demonic Third Symphony (based on his opera *The Flaming Angel*, a grisly study of schizophrenia and black magic); Milhaud's *Les Choéphores*, which captures what the composer calls the "savage, cannibal" emotions in Aeschylus; Rachmaninoff's Isle of the Dead, the one work in which Rachmaninoff allowed his gorgeous sense of gloom to emerge undiluted; Shostakovich's last three quartets and Symphony No. 14, the starkest confrontations with death in music; Vaughan Williams' Symphony Nos. 4, 6, and 7, each in its own way an antidote to his usual pastoral pleasantries; Ligeti's static but haunting *Lontano* and *Atmospheres*; Xenakis' *Bohor I*, which the composer likens to "the onset of madness"; William Albright's *Organ Book* series, which finally realizes the horrific potential of the King of Instruments hinted at in so many Gothic tales and movies; and Messiaen's hair-raising *Et Expecto Resurrectionem Mortuorum*, which, when revived in the 1970s, produced one of the most disorderly exits of New York Philharmonic subscribers in Pierre Boulez' tumultuous tenure—a steady stream of blue hair flooding out the doors.

The Lingering Shadow of Poe

The Poe tradition is still a vital one in the postmodern era, though it is often presented on a more epic and garish canvas than the shivery attenuations of Debussy and Ravel. Deborah Drattell, Augusta Reade Thomas, and Damon Ferrante have recently contributed Poe-inspired works. Of special note is Poul Ruders' 1993 "The Bells," a version far creepier than Rachmaninoff's. Rouders told me in an interview that he was attracted to Poe's compact form and "dark exuberance," echoing similar statements by the Debussy school a century ago.

One of the most important recent offerings is *On the Last Frontier*, a choral-orchestral work by Finnish composer Einojuhani Rautavaara,

the last avatar of the Sibelius-Nielsen symphonic tradition. This ambitious piece sets the final passages in Poe's *The Narrative of A. Gordon Pym* against brooding brass chorales, tempestuous strings, and vivid instrumental solos. Like much neo-Romantic music, it is basically tonal, but the harmonies, like Poe's fractured novella, are ambiguous and unstable. The "shrouded human figure" colored by the "perfect whiteness of the snow"—one of Poe's most chilling evocations of existential whiteness—is evoked with a shattering triad from the chorus at the end soaring over a dissonant orchestral fabric, a fusion of closure and irresolution typical of the entire piece.

Today's modernists flourish in Poe's shadow as well. *Maelstrom*, a 1998 orchestral rendering of "Descent into the Maelstrom" by German composer Hans-Peter Kyburz, illustrates Poe's continuing influence on the nontonal avant-garde. Written for four ensembles colliding and interacting, *Maelstrom* thunders, chimes, and rumbles toward the bottom of the whirlpool, the end of all things. Twisting textures, plummeting timpani glissandos, and a violent streak of vibraphone-xylophone color evoke the simultaneous violence and stasis of Poe's maelstrom.

New World Terror

Finally, there is one composer who breathed terror into virtually every note he wrote, and that is Edgard Varese. His is not the terror of trickery or special effects, but the vital disturbance that goes with the discovery of something genuinely new and uncharted. Varese still sounds disturbing and disorienting in a way few other composers do. The combination of piercing "urban" noises and primeval "sound masses" that seem to come from another civilization (or planet!) produces the rare feeling the early masters of horror called the "sublime"—a fusion of terror and ecstasy that dissolves distinctions and opens new worlds. No single work of Varese can be cited as doing this, for they all do, but my favorites are the early *Arcane*, with its final fade-out that reaches toward infinity, and the incomparably weird *Ecuatorial*, with its electronic keyboard instruments that somehow coexist with ancient invocations of the spirit of Earth and Sky.

It remains to be said that another entire tradition of terror exists in opera, one that stretches back to Monteverdi and includes composers as diverse as Mozart and Meyerbeer, Weber and Donizetti, and Britten and Maxwell Davies. But the tradition in concert music is perhaps more enticing because it is more subtle and mysterious. This is music that does what only music can do, carrying us into a world of pure feeling that has nothing to do with language, librettos, or Gothic trappings, leaving far behind what ghost story writer Oliver Onions once called "the groans and clankings of the grosser spook."

CHAPTER EIGHT

Postmodern Gothic

Charles Darwin (KUCSSF)

Passage into new forms, overlapping the bars of time and space, reversal of the laws of inanimate and intelligent existence, had been mine to perform and to witness.

Charles Brockden Brown (1799)

Somewhere there might be a 2020 in which I existed merely as a character in a novel about Frankenstein and Mary Shelley...There was no future, no past. Only the cloud-sky of infinite present states.

Brian Aldiss, *Frankenstein Unbound*

While the writers interviewed and discussed here—Charles Beaumont, Stephen King, Peter Straub, Suzie McKee Charnas, T. E. D. Kline, Greg Bear, Gregory Benford, Brian Aldiss, Philip Jose Farmer, Alan Moore, and William Gibson—continue to rely to an extent on haunted places, guilty secrets, paranoia, mad scientists, ghosts, and vampires, they also translate them into contemporary anxieties over the dissolving boundaries between gender and race, society and nature, biology and technology, transgressive sexualities, class fluidities, factual history and historical alternatives, and human evolution and devolution. We will see, as Chris Barker observes in *Making Sense of Cultural Studies,* how in these writings "the decentered or postmodern self involves the subject in shifting, fragmented, and multiple identities" (12–52).

The interviews and conversations in this section demonstrate how the uneasy tensions at the heart of the Gothic mode that arose in the late eighteenth century—between faith in an ordered cosmos and doubts and anxieties in the face of the irrational—have evolved since the 1960s and received a renewed critical and self-conscious scrutiny. The very notion of an unquestioned *truth* of the Gothic is no longer something that is *found* but something that is tentatively *created,* and then *re-created.* How can we access the Gothic, unless it is only through the discourses from which it arises?

By the end of the nineteenth century and into the twentieth, there had been new inquiries into the technologies of communication, biological and anthropological research, human origins, historical determinism, and gender and sexual identity. The emergence of the New Woman challenged conventional patriarchal social structures. The rapid acceptance of Darwinian theories loosened fundamentalist religion's grip on human affairs and sought refuge in metaphor. Man was now alleged to have descended from an "ancient marsupial animal." As a counterbalance, William James led the charge in the study of spiritualism and the occult, with its concomitant rise of psychical societies all over America and England.[1] Sigmund Freud had located the Gothic modes of the "dual/multiple personality" and the "guilty secret" in the unconscious as a deep repository of infantile and repressed memories or impulses—the archaic underworld of the self.[2]

Through it all, writes commentator Misha Kavka, the Gothic has continued to be grounded in historical conditions, "which themselves give

rise to changes in economic, technological and cultural formations, but it also transcends specific historical moments by articulating the response to such changes in terms of anxieties about the social, sexual, and temporal borders of subjectivity. This explains in part why we easily recognize something called 'the Gothic,' even though it appears in ever different forms."[3]

Thus, the Gothic imagination today, as it had been hitherto known and formulated, has not been threatened so much with extinction, but, as Lisa Hopkins proposes in her *Screening the Gothic*, has been banished "from where we might expect to find it and introduced instead where it had not been before."[4] All of the boundaries of Gothic themes and tropes, particularly the Frankenstein and Dracula prototypes, are being redrawn and reimagined, particularly in the novels of Brian Aldiss (see his interview in this section) and in motion pictures such as Andy Warhol's *Frankenstein* (1974); Kenneth Branagh's *Mary Shelley's Frankenstein* (1994); Roger Corman's *Frankenstein Unbound* (1980); and Francis Ford Coppola's *Bram Stoker's Dracula* (1993).[5] In the Warhol, for example, Victor Frankenstein simultaneously makes love to and disembowels his female creation; in the Branagh, nineteenth-century trappings are conflated with a modern sensibility to the extent that the past seems hardly to exist at all, allowing Victor to imagine heart transplants, experiment with acupuncture, and meditate on the "massive birth defects" of his creature; and the Coppola is not only an exercise in self-reflexivity, but he also reinterprets vampirism as a metaphor for AIDS.[6]

Even space opera in our own time has been subjected to new critical scrutiny and approval. In their series of *New Space Opera* books, editors Gardner Dozois and Jonathan Strahan contend that authors such as Iain Banks, Samuel R. Delaney, and Bruce Sterling are extending and developing the work of past masters Poul Anderson, L. Sprague de Camp, Jack Williamson, Hamilton, and A. E. Van Vogt "with a more rigorous approach to science, greater depth of characterization, and increased sensibility to political realities."[7]

Concluding this section are comments on the Gothic and fairy-tale connections with today's excessive true crime horrors and gore-fests by Professor Harold Schechter and illustrator Rick Geary; and the connections between the visionary technologies of Jules Verne and H. G. Wells and today's steampunk writers, artists, musicians, and filmmakers by Professor Cynthia J. Miller and T. L. Reid.

In sum, we are entering what Barker describes as "a world of complexity, hybridity, and constant change...a collective groping toward a new kind of consciousness, a changed way of being in the world, one that could work creatively on the unstable, ever-shifting terrain of postmodern existence."[8]

H. G. Wells, rising author (KUCSSF)

The Night Ride of Charles Beaumont

Charles Beaumont (1929–1967) was a writer's writer, blessed with great sensitivity, imaginative range, and superb technical gifts. Although perhaps best known today for his work in the 1950s and 1960s for television's *The Twilight Zone* and *Alfred Hitchcock Presents*, he wrote movies for Roger Corman (*The Intruder*, 1961; and the Poe adaptations *The Premature Burial* and *Masque of the Red Death*, 1963–1964) and George Pal (*Seven Faces of Dr. Lao*, 1964) and a host of other films and television shows. First appearing in magazines as various as *Playboy*, *Rogue*, and *Amazing Stories*, his early work brought the modes of the Gothic tradition into the socially conscious moods and tensions of the racially and sexually conflicted decades of the 1950s and 1960s. After publishing his first story collection, *The Hunger*

Charles Beaumont (drawing by the author)

in 1958, he turned to television and movies. "Perchance to Dream" and "The Howling Man" were among the most popular of all *Twilight Zone* telecasts; and his Poe adaptations marked a new trend in the films of Roger Corman.[9] Born Charles Leroy Nutt, Beaumont survived a rough childhood on Chicago's North Side before moving on to a succession of odd jobs in Southern California and settling down in Los Angeles as a full-time writer. Tragically, at the age of 38 and the height of his powers, he was struck down prematurely by an unknown form of presenile dementia.

In revisiting Beaumont's stories, I am struck once again by his sensitivity to the lonely and dispossessed night people of the world, and of the need we all have for magic in the face of disillusionment. No story evokes this bittersweet tension better than "The Magic Man." Above all, he wrote with a musical ear. His fascination—and passion—for the rhythms, agonies, and passions of jazz and blues fueled and inflected masterpieces like "Night Ride" and "Black Country." They evoked "all the lonely cats and all the ugly whores who ever lived, blues that spoke up for the loser lamping sunshine out of iron-gray bars and every hophead hooked and gone, for the bindlestiffs and the city slicers, for the country boys in Georgia shacks and the High Yellow hipsters in Chicago slums and the bootblacks on the corners and the fruits in New Orleans, a blues that spoke for all the lonely, sad and anxious downers who could never speak themselves."[10]

About Beaumont's versatility, his friend, Ray Bradbury, wrote two years before Beaumont's death: "Some writers are one-idea people. Other writers, far rarer, far wilder, are pomegranates. They burst with seed. Chuck has always been a pomegranate writer. You simply never know where his love and high excitement will take him next."[11]

In his last book, *Remember? Remember?*, Beaumont wrote about "life at its keenest edge, at its heavenly, lawless, joyful best."[12] Despite his all-too-brief lifespan, he realized it all.

Filmmaker Jason V Brock has produced the documentary film, *Charles Beaumont: The Short Life of Twilight Zone's Magic Man* (2010). The film contains many interviews with Beaumont's close friends and associates, including writers Ray Bradbury, Harlan Ellison (*Approaching Oblivion*), William F. Nolan (*Logan's Run*), and film veterans Roger Corman and William Shatner. Nolan, who was a lifelong friend and racing buddy of Beaumont's, offers this comment about Brock and the documentary: "It was my great pleasure to be a part of Jason V Brock's Beaumont documentary in which I was able to recount many adventures shared with Chuck. I met him when we were both in our mid-twenties in 1952. I was born in March 1928 and Chuck was born in January 1929, which made me ten months his senior. We were introduced by Ray Bradbury at Universal Studios during the period that Beaumont worked in the Music department on a mimeograph machine. Ray was there to write *It Came from Outer Space*, and Beaumont had a burning desire to be a professional writer. He had made two or three sales at that point, but was just beginning his career after being fired from Universal. He became a full-time writer for some 13 years before his illness began to take a toll. We were very close friends for a full decade, and I still miss him."

The following conversation was held in the home of Jason V Brock in Portland, Oregon on 8 October 2010.

Interview

JOHN C. TIBBETTS: Jason, there's a whole new generation who may not know about this remarkable man named Charles Beaumont. Now we have your *Charles Beaumont: The Short Life of Twilight Zone's Magic Man*. I understand you've just returned from the *H. P. Lovecraft Film Festival*, where you showed your film.

JASON V BROCK: Yes, I've been presenting it in several venues, including the *Lovecraft Film Festival* in Portland, Oregon; at the Egyptian Theatre in Los Angeles; and at the *Buffalo International Film Festival* in New York. We've had subsequent screenings at the Variety Preview Room in San Francisco and *Crypticon* in Seattle. We have several more screenings in the Midwest and East Cost planned for 2011. We've had great reviews in print and online

and lots of support—not only from Beaumont fans but also from the people who are in the film. It's generating new interest in his legacy. People are coming away from the film asking, "Where can I read some of his work?" And that's the point: to get the story out about him, to enlighten...

JCT: And they can still see his work on *The Twilight Zone*! And then go on to his books.

JVB: What I like about Beaumont's work is the quality of the surreal that he brings to it. It's a territory of not quite *here*, but not quite *there*, either. That he existed in a kind of "Twilight Zone" of his own was appealing, because I have as well: we share being musicians, artists, writers, Southern roots, and so on, and we had similarly traumatic childhoods; we both used daydreaming and fantasy as children to escape from the pressures of the realities that we endured.

JCT: We all have our favorite Beaumont stories. What are some of yours?

JVB: Some of my favorite stories are "The Crooked Man," "Black Country," "The Howling Man," "The Beautiful People." They're stories about outsiders. Chuck was an outsider, and proud of his differences, his sense of humor, his intellect, his imagination. I'm the same way. A lot of people are....

JCT: Some of those he adapted for *Twilight Zone*. How did he feel about his work for television and film?

JVB: In my film, Harlan Ellison tells a great story about Beaumont's attitude toward Hollywood. Beaumont used to say, "Success in Hollywood is like climbing an enormous mountain of cow shit to pluck a single rose off the top, but, once you've made that hideous ascent, you discover that you've lost the sense of smell!" It's a very amusing anecdote, and one that I'm sure a lot of creative people can understand. I was close friends with the late Dan O'Bannon (*Alien*), and he expressed a similar attitude regarding his treatment as a writer.

JCT: But was Beaumont's work with Rod Serling an exception to the rule?

JVB: Rod Serling *was* an exception—at least until Jack Laird came along during *Night Gallery* and tried to knock his crown off. Serling had already made his bones, and had the muscle to pull off something as groundbreaking as *The Twilight Zone*. Few could do that: not even Bradbury had that kind of prestige at the time. That was due in large part to the fact that early television was hungry for content, especially the live era, and they needed—essentially—playwrights. Consider the great writers of the age: Serling, Rose, Chayefsky, Foote, Vidal...Trumbo even...Not an easy thing, writing a play: I've done it. That and Rod had a lot of

personal charisma, which translated well to the new medium of television. His presence was commanding.

Now, sadly, Hollywood is in the hands of "Producers," and things are decided by consensus, based on how it will affect the gross over a four-week stretch. It's a shame really, because there is no way to ensure that the "Art" will survive the artifice. Writers are creators, same with designers, directors, and so on. Actors, too. Producers are certainly necessary—they get the funding together, which is critical, but I think that a lot of them are frustrated creative types that are irritated that they are *not* creators. They're the other part of the equation that gets the practical side of it together, but I think that many of them harbor fantasies of being another Charles Beaumont, Bradbury, or Serling.

JCT: What about Roger Corman? Beaumont worked with him on those Edgar Allan Poe films, didn't he?

JVB: Roger Corman was good at the art of the deal, and he was a good director. Not very common, even then. I feel Beaumont was probably commenting, with his "rose" analogy, on the fact that no matter how decent or capable the team for a film was, that it involves compromise, because film is a collaborative art form, unlike painting, say, or composing a symphony...And in some cases, it's *painful* compromise. And who usually gets the shaft? Not the director, not the producer. The *writer*: the writer gets the worst part of the deal. In that respect, the excellent writers from *The Twilight Zone*—arguably the greatest television show in history— got a huge break that Serling was their boss: he was a "writer's writer," and he appreciated the sweat, toil, blood, and tears that go in to crafting an outstanding piece of work. As Bill Nolan has mentioned to me, "Writing is like brain surgery: they're both disciplines that require tremendous skill and precision. Fortunately, most people would *never* try to operate on another person's brain...But *everyone* thinks they're a writer, just because they can write a note to their Grandmother." I agree. Actually, I think a great writer is *rarer*—you can *teach* brain surgery, but writing?— well, that's an *art*, a *talent*. You can't teach talent...You have it, or you don't. *Twilight Zone* had an embarrassment of riches: along with Beaumont, you had Serling, Richard Matheson, Ray Bradbury, George Clayton Johnson, Earl Hamner, Bill Nolan, Tomerlin...And producer Buck Houghton was another great thing: He *got it*. Very unusual confluence of like-minded people, that."

JCT: Your film brings us clips from a film that Beaumont wrote for Roger Corman that many of us may have forgotten.

JVB: Oh, yes. *The Intruder* [1961] was one of the most remarkable films of its time. Beaumont adapted it from his novel, *The Intruder*,

which was a scathing indictment of the horrors of Southern big-
otry at the height of the national debate over segregation in the
late 1950s and through the 1960s. Not only did Chuck adapt his
own book, but he even acted in the film, along with his friends
William F. Nolan, George Clayton Johnson, OCee Ritch, Frank
M. Robinson [*The Power*], and William Shatner. They were all
excellent in the movie, and Corman did a brilliant job on the film
as director.

JCT: We don't associate this kind of social commentary with Roger
Corman!

JVB: *The Intruder* is a powerful film, and it was done under precari-
ous circumstances in a very real and prejudiced town of Sikeston,
Missouri. All the principals involved in the production of the film
were liberal-minded and despised the way that the blacks were
being mistreated at the time, and they went there with Corman to
show what was really going on. At first, the locals weren't sure just
what was going on. They thought the film was in their favor, and
they cooperated fully. But as things wore on they began to get sus-
picious. Eventually the entire cast and crew were literally run out
of town under threat of bodily harm! Very typical of Beaumont,
in a way! He roped everybody into a real dangerous situation. He
was always getting his friends into this kind of trouble ...

JCT: But that didn't stop Beaumont and Corman from working
again, did it?

JVB: No, although Corman says that the relative failure of the film
at the box office persuaded him not to make any more films like
that! Instead, he turned to horror films. Ironically, though, *The
Intruder* has come down to us now not just as a cult item but as one
of the truly significant independent films of the 1960s. I think that
Roger felt he had found a compatriot in Chuck—someone that he
trusted and knew that he could depend on to deliver the goods
he was looking for in a timely manner. They were not only pro-
fessional acquaintances, they were friends as well. It was a natu-
ral partnership, too, in that Corman was working with Richard
Matheson quite a lot, and this was a perfect union considering
Rich and Chuck had been close friends in "The Group" (along
with John Tomerlin [*The Fledgling*], Johnson, Nolan, Chad Oliver
[*The Mists of Dawn*], and Charles E. Fritch [later editor for *Mike
Shayne Mystery Magazine*] among others) as well as staff writers on
The Twilight Zone.

JCT: Let's go back to when you first came to Beaumont ...

JVB: Well, that was when I read Marc Scott Zicree's amazing book,
The Twilight Zone Companion. I read about what type of person
Chuck was: very dynamic, gregarious, interested in art, humor-
ous, how he challenged Rod Serling ... And I thought he would
be interesting to write a script about. I then set about completing

a script called *Between Light and Shadow*. The script, part of a trilogy dealing with Bradbury, E. C. Comics, *The Twilight Zone* and the 1950s era, is currently unproduced, but was the foundation for our documentary, *Charles Beaumont: The Short Life of Twilight Zone's Magic Man*. I must have been 19 or 20 when I wrote the first treatment. That process also sparked my interest in reading some of Beaumont's fiction; I already had books with Beaumont's work in them, because I managed a comic book store in my hometown of Charlotte, North Carolina, beginning at age 13. We sold a variety of pop culture items: paperbacks, collectible Playboys, records, comics (including E. C. Comics), and a few toys. It was a fertile grounding for the imagination. Because I was already an avid reader of science fiction and horror (Ray Bradbury, Karl Edward Wagner, Richard Matheson, and so on), Beaumont was a natural extension of that interest, although I didn't realize the connection at the time.

I had prior experiences in filmmaking: I worked with a local director/cameraman named Harry Joyner; I attempted an aborted documentary on emergency room physicians, and I also worked on microbudget efforts with other local film enthusiasts in the capacities of special makeup effects, writing, and acting. I had also done a few stints on the radio as a DJ for a public radio station, and my father had worked as an artist and in other capacities at the public TV station in Charlotte, NC: WTVI.

The Beaumont documentary came about as a result of my pursuit (along with my wife, Sunni) of a documentary concerning Forrest J Ackerman, of *Famous Monsters of Filmland* fame [see the interview with Ackerman elsewhere in these pages]. Ackerman was Beaumont's first agent, and there was a great deal of overlap with the main players in both of their stories. After speaking with him and a few other people, such as Ray Bradbury and George Clayton Johnson, I decided from that point forward that anytime we had an interview pertaining to people who had Beaumont and Ackerman as a common connection, we'd ask about both of them; it just took off from there. We are now about to get back into the Ackerman doc full-time (it's called *The AckerMonster Chronicles*). Beaumont's film superseded it only because it started to take on a life of its own, not through some grand desire to complete this film first: it just came together more quickly. After the Ackerman film, we are due to finish another film about Fantastic Art, featuring Roger Dean, Ernst Fuchs, H. R. Giger, and many others...

JCT: Did you go into the project with preconceptions about theme and structure, or did you do a bottom-to-top process and just let the film find its own shape?

JVB: We allowed the film to find its own shape. One thing I knew was that I did *not* want it to be a conventional documentary *á la*

Ken Burns, although I like his work. I mean, Beaumont's life was a pretty wild ride—

JCT: —A *Night Ride*, like one of his stories!

JVB: Indeed! Here's a guy who had fantastic energy, not just for writing, but for auto racing (which he wrote about in "A Death in the Country"), for painting, for music, for social justice. He's everywhere, all at once. And he packed all of that productivity into just 13 short years before his untimely death! At first I thought about a narrator, then realized (as we were going through the many hours of footage) that it was better to have the people around Beaumont *reveal* him, rather than have an omniscient presence *describe* him. I think that the process of revelation is better than straight description: it's more intimate, more personal. So we ditched the notion of narration; we also decided to go against the grain and have a nonlinear structure to the film. There was a loose adherence to the way his life unspooled. Only the use of multiple perspectives and candid 8 mm footage and photos could deepen the mental construct of Beaumont as a three-dimensional human being. That said, there are those who wish Chuck were venerated as some type of deity; I don't think that he would be comfortable with that portrayal. As a human, I understand his sense of grandeur, and his philosophy regarding "the greater truth" (meaning that all is not the mere "fact" of reality, but is also an amalgamation of a "metareality" that we all must occupy as well), but he was also intellectually honest, and would want to be depicted as a true, full human being, and not just the empty husk of "Charles Beaumont, author."

JCT: It must have been challenging to gather all the interviews in your film?

JVB: Oh, yes. There were many challenges and difficulties. As usual, money was a consideration—travel expenses, buying equipment, et cetera: we *completely* self-financed the film, from the HD cameras to the editing hard/software. I didn't know anyone related to Beaumont before I started the process. For one thing, I had no one to introduce me to any of the people involved with him; I made all of the connections from scratch. I had no "insider track." And there were a few folks who *could* have assisted, but did not. *C'est la vie.* With regard to William Shatner and Roger Corman, they were very enthusiastic to discuss Chuck Beaumont, as were all the others, such as Nolan, John Tomerlin, Harlan Ellison, Frank M. Robinson, and so on. I feel they had come to love and care about Chuck very much when he was alive, and now they wanted to share their good feelings with the world. The first person I interviewed was Ray Bradbury, at his home, and one of the last was William F. Nolan. After Bradbury's interview was "in the can," so to speak, it was much easier to get other people interested.

Everyone was eager to participate. They had much to say about Beaumont, and once they realized we were serious, they were quite forthcoming with their personal observations and reflections. That includes Chris Beaumont, his son, and a talented writer. However, Chris now claims that he was somehow "tricked" into being interviewed: This is far from the case. The issues he has, I feel, are the result of a long-standing feud between Chris and Bill Nolan, who was Chuck Beaumont's best friend for ten years. It's a long, complicated, distressing story, how that happened, but one best left to the parties involved. At one time, I was hopeful that I could resolve this rift between the two of them, but I see now that it is beyond anything that I can remedy. I wish that were not the case, but it is. As a result, I have had other people who are allies of Chris Beaumont unfairly malign me and smear my intentions... As though I am somehow "not worthy" of being the teller of Beaumont's tale, which is ludicrous.

JCT: But maybe somebody like Beaumont needs a fresh perspective, from somebody like you who speaks to today's generation.

JVB:The bottom line is this: I respect Beaumont's legacy, his family, and I want only to share my enthusiasm for him and his works with other people. I have nothing to hide: other personal issues, although I feel disappointed about them, are not my concern. All I can say in retrospect about that scenario is this: Chuck and I had similar upbringings, as I stated, but also similar worldviews. It saddens me that his life ended so tragically, and was so short; likewise, I am not pleased that his family had this terrible misfortune happen to *them*. It's a miserable situation all around: to add to it is stupid and a waste of time. The world is a hard enough place to navigate without having that kind of trauma to deal with on top of it. Chuck was a down-to-earth person, and he grew up hard. He fought for everything that he accomplished using his enormous talent, his drive, his wits—and so have I. We are self-made people: perhaps that's one of the attractions to tell his story for me as a filmmaker. He was perpetually in financial crises, but he seemed to be happy, and he adored his friends and family, who felt the same about him. Money is not the answer to life's woes, any more than it is the cause, and I feel certain that he felt the same way. Granted, it can "grease the wheels" at times and make things a bit easier, but who cares? We'll never make the money back on this film, but it was a story that needed to be told, and it is told to the best of our ability.

In addition, Chuck and I share another trait: we both suffer with a macabre preoccupation regarding mortality/immortality, disease and death. As a boy, Chuck had a long illness (a form of meningitis) that left him bedridden for over a year; he also lived

with a beloved aunt ("Nana") in an area now considered Everett, Washington, when he was older. She ran a boarding house that frequently was the last residence of some of the people who lived there. These formative experiences informed his outlook as an adult...and perhaps paved the way to his untimely demise.

JCT: This brings up something that's rather sensitive. Would you care to say something about Beaumont's death? It was tragic, wasn't it...and a bit mysterious.

JVB: Well, in retrospect, Nolan, Matheson, Tomerlin, Johnson, and I believe a cascade of events led to his premature death (the causes of which are still unknown due to the lack of an autopsy) at the age of 38. Things may have begun with self-medication for chronic headaches with Bromo-Seltzer, which had aluminum as an active ingredient at the time, a potent neurotoxin (it doesn't now), which likely led to a form of heavy metal poisoning known as Bromism. By the time filming on *The Intruder* was commencing, people had begun to notice subtle changes in his demeanor and behavior. He was about 34.

Within the next few years, the symptoms worsened and accelerated, and he experienced what his friends describe as "premature aging." Once he was diagnosed (incorrectly we can conclude in hindsight with either Pick's disease or Alzheimer's), it was only a few more years before he passed away. By this time, people said he resembled a 90-plus-year-old man at the age of 38. As Ray Bradbury has said, it was a "terrible, tragic, weird event" in all of their lives.

JCT: There are some very moving interviews about that in your film. Were you able to use all of your interview materials? Anything you had to cut?

JVB: Beaumont had a wild reputation for inciting his friends to go out and do crazy things. So we had too many stories (as funny and entertaining as they were) to fit into the documentary...For example, John Tomerlin tells us about "The Drunk Flight Home," which Tomerlin had also written up as an article for an automobile magazine. Fortunately, some of these will make their way into the Director's Cut (on DVD), which has about 35 minutes restored, and in the extras. Some interviewees were a bit thorny, it's true.

JCT: Like Harlan Ellison? He's got quite a feisty reputation!

JVB: We had to *pay* Harlan Ellison (the only one who demanded a fee) before he would agree to speak to us. Fortunately, it was a great interview, and Harlan has been awesome ever since. William Shatner needed special arrangements through his handlers and was disappointed that we didn't bring a makeup crew! He was a great guy, though. George Clayton Johnson talked *nonstop* for six hours! We went through multiple media and battery changes and

finally had to end the interview because the sun went down and we lost our primary source of lighting... As you can imagine, the characters *around* Beaumont are just as eclectic and iconoclastic as he was. It was a blast interviewing them. Most of them have become dear friends in the process, which was an unexpected, touching bonus. My wife Sunni and I have learned a great deal through the process, and cherish the people and opportunities that the experience has opened up for us: we are grateful for the bad, and, especially, the good things that have happened as a result.

JCT: Will your film be available to the general public?

JVB: We are offering the film for purchase on *Amazon.com* and our own website, www.JaSunni.com/shop. I am in the process of other distribution possibilities that I can't detail at the moment...

Stephen King (drawing by the author)

"We Walk Your Dog at Night!" Stephen King

Stephen King is a phenomenon. He is without question the most popular writer of horror fiction of all time. In 1973 he was living with his family in a trailer in Hampden, Maine, struggling to make a living as a high school teacher, when he published his first novel, *Carrie*, a tale of a girl with telekinetic powers. Its sales in hardcover were modest (13,000)

but enough to inspire a paperback reprint and a popular film adaptation by Brian De Palma in 1976. His "breakthrough" book, *Salem's Lot*, an exercise in the pure Gothic vampire tradition, came out that year and quickly sold 3,000,000 copies. Within the next four years, *The Shining*, *The Stand*, *Night Shift*, and *The Dead Zone*—all best-selling horror fiction—established King as the reigning Master of the Macabre. When he cowrote *The Talisman* in 1984 with Peter Straub [See the Straub interview elsewhere in these pages], it was a publishing event unparalleled in modern times. Today, more than 100 million copies of his books are in print.

In his extended essay on horror writing, *Danse Macabre* (1981), in which he confirms his allegiance to the Gothic tradition, King describes his technique as a kind of "dance" in which he searches out the private "phobic pressure points" of his readers.[13]

At the time of our interview in August 1986, King was 43 years old. His 6'4" frame was solid, and the familiar shock of hair curving across his forehead was still thick and dark. He confided that he writes every day, except on his birthday, Christmas, and the Fourth of July. "I have a marketable obsession," he observed. Although he hates being away from the word processor, he does make himself available for interviews, especially if a new book or movie is in release. We are in New York City, and his latest novel, *It*, is nearing publication.

Interview

JOHN C. TIBBETTS: What is it like, touring and doing publicity? It must be a welcome change from the grind of writing.

STEPHEN KING: By the time you meet everybody and talk to everybody, you feel at the end of the day like a figment of your own imagination! My son Owen used to say, "Daddy's going out to be Stephen King again!"

JCT: You're such a target now of the media—how do you handle the constant barrage of questions and people like me sticking a microphone in your face?

SK: You get on this revolving cassette thing—you just pick out one cassette and plug it in. It can get automatic. But if you do that, then you're not listening to what people ask you. But thank heavens, every now and then I'll find myself saying something new, and sometimes somebody will throw me something that I didn't expect at all. The time that you really know that you're going to hear a question you've heard a thousand times before is when the interviewer says, "Now I'm going to ask you something I'll bet you've never been asked before!"

JCT: Touché! So you won't be surprised if I wonder if it's good for a writer to get away from home and the typewriter sometimes...?

SK: No. It's not good for any reason at all. I mean, home is where you're supposed to be. I miss the morning hours from about 8:30 to noon when I usually work. Sure, I can work when I'm away, and I take the stuff along and I do what I have to do. But I'm not comfortable with it and I'm not comfortable with the tour circuit or being a "celebrity" (whatever that means).

JCT: I've seen you absolutely mobbed at fantasy and horror conventions, for example. Must be a new definition of "writer's cramp," signing all of those copies of your books.

SK: Someday, somebody's going to auction off for a billion dollars a rare, *unsigned* Stephen King book!

JCT: Speaking of... What's the latest word on King collectibles? It's quite an industry, isn't it? What's the rarest First Edition these days?

SK: I suppose it's *The Dark Tower*. Funny it should be considered a rare book, since there's about 40,000 copies of it in print—which is more than a lot of novels ever generate in hard cover. Typical sales may range around 12,000 copies. It sold originally for $20, but some collectors may now want upward of $1,000 for a first, or as low as $75 for a second, edition. Which are thieves' rates. But maybe someday, if it gets out of hand, we'll just do a mass marketing of it and put an end to it.

JCT: You've gone on record as deploring that sort of thing, haven't you? Do you think this celebrity business can be a threat to you as a writer?

SK: What you're supposed to be as a writer is an observer, and you can't be an observer when you're the one being observed! In *Different Seasons*, I have this motto that's been adopted by a group of storytellers: "It is the tale, not he who tells it...." That's what's crazy about all of this. It's like one of those things we had when we were kids: "Find what's wrong with this picture." The clock's upside down or the teacher has three eyes (come to think of it, some of them did!). Writers themselves are not supposed to be the object of all of this. What they write is supposed to be the point! It's this game in which we're more interested in people than in what they do. Before I sold my first book, I'd lie awake at night wondering what it would be like to be a celebrity author. Now I know. I think it was when I got a call some time ago from some TV show or other, like the "Ten Thousand Dollar Pyramid," wanting to know if I'd be on. That's when you know you've finally made it!

JCT: You know, I just noticed—it's late summer right now, August— that you've shaved off your beard! What...?

SK: I'll get the beard back this winter. When the Red Sox baseball season's over, I'll put the razor away. That's always sad. I'm not a real shaving fanatic, you know. You hear about women

complaining about THAT time of the month—what about a man's time every day?! If you're like me and you shave early in the morning and then have to do TV or anything like that at 5:00 in the afternoon—you're looking already like Richard Nixon! "I'm not a crook...I'm not a crook!"

JCT: Let's switch gears a minute because I want to talk about your experiences as a movie director. Your directorial debut, *Maximum Overdrive*, is based on your short story titled "Trucks." Regardless of how well the film does at the box office, are you encouraged to want to try directing again?

SK: No, it'll be several years before I try that again. Unless I can have the chance to remake *The Shining!* (Seriously!) You know, as you asked me that, I just flashed back to those mornings at 6:30 on the set in North Carolina when I was surrounded by circling camera people, lighting people, grips, and everybody else—and they're all looking at you wanting to know what in the world is going on? And you'd better have some kind of answer!

JCT: I see. It doesn't sound like a pleasant experience.

SK: I tried to be ready for the job I had to do, and I made the decision going in that I was either going to do it or I was going to get out and nobody was going to do it for me. In other words, nobody was going to "ghost write" my movie any more than anybody ghost writes my books. Like the books, hate the books—they're *my* books and you have a right to your opinion on that basis. The same thing with *Maximum Overdrive*. It was a kind of "earn while you learn" proposition; but I was there and I stood up and I tried to walk that line between making the movie that I had in mind and listening to somebody else's sort of voice of authority masked as, "Hey, this is in your best interest—this is good advice."

JCT: That's the way masters like John Ford and Orson Welles started—

SK: Sure, I think so. People have asked me a couple of times why in the world I wanted to make such a technical movie. And the answer is, I didn't know any better! And I will say this, that I think one of the reasons that the producer asked me if I would do this, is he sensed I must have something visual going on in my mind. And yes, I never had any doubt about what I wanted to see, ever in that movie. That made things a lot easier, I think, for everybody. No ambiguity in my mind about where the cameras should go, what I should be seeing. Now, there were times when somebody would tell me, "We can't do that"; and there were times when there were technical things I would have understood better had I gone to film school.

JCT: Any help from some of your buddies like George Romero?

SK: George was down about three weeks before we started shooting. And I took him out and showed him the set for my truck stop.

That was the center of the action, you'll recall, where these people have been surrounded by runaway trucks like people in a fort surrounded by circling Indians.

JCT: The story is the sort of thing that preoccupies you—a world gone mad, where machines kind of take over—

SK: —But that's not the real horror, is it? I mean, you've got this truck stop with people who work more or less in involuntary servitude to the owner, a guy named Bubba. He runs the truck stop by day and a sort of "Do you need a gun service?" at night. In the basement are weapons ripped off from the National Guard, rocket launchers and stuff. I don't know how many places you'll find with basements like that...

JCT: We can't ever see a truck stop anymore without wondering....Or a big resort hotel, like in *The Shining*...or a shopping mall in *The Mist*...a '57 Plymouth Fury in *Christine*...or even modern appliances....I mean, thanks a lot! You really do enjoy doing this to us, don't you?

SK: I told a friend of mine once that it's like I'm a dentist—only when I uncover the nerve, I don't fix it, but drill on it. I'll stand by that.

JCT: You do have this fascination with our consumer culture. You take the things we use around the house and—well—show how dangerous they really are.

SK: I just want to make commonplace things as unsettling as possible. I just look around and find the things that seem nice at first, on the surface, and then show what they really can do if they were to—well, to go mad. Think about your everyday lawnmower or chainsaw. Or what's more commonplace than a vending machine?—what if it suddenly burped out cans at a great rate like a deadly machine gun.[14]

JCT: I like what your friend Douglas Winter said about you in one of his essays, that you conjure up fears we can't laugh away—fears that won't ever meet Abbott and Costello!

SK: The sorts of thing I have to write about. Especially if nobody else does. Like the neighbor's dog, in *Cujo*. Yeah. You know, people write books because they can't find them in their library. I write stories that I don't find anywhere else and that I know I'll like to read.

JCT: But your knowing your readers, your audience—that's really tricky, isn't it? To get your effects, to scare them, you have to stay one step ahead of them, don't you?

SK: I think that with the film medium, there are a lot of technical aspects that people become familiar with. There was a time when *King Kong* opened—the original—when people were just flabbergasted. It was the *Star Wars* of its time. People had no idea how such things could have been done. Well, Willis O'Brien, the

special effects designer, knew. He used a technique called "stop-motion" photography. And Ray Harryhausen learned from him and made pictures like *Twenty Million Miles to Earth* and *Earth Vs the Flying Saucers* and *Jason and the Argonauts*. But people got "wise" to it. They saw a certain jerkiness of motion. Then *Star Wars* came along, and George Lucas invented a whole bunch of new techniques in place of that. I think *Star Wars* was a hit from the minute that big, huge spaceship came in at the very beginning. But people know those effects now, I think.

JCT: You've said you're a product of those movies, especially the ones of the 1950s—

SK: I remember watching *Earth Vs the Flying Saucers* in 1957, and in the middle of the thing, the house lights came on, and the manager came in and told us the Russians had launched Sputnik. Suddenly, the real world was more frightening than the movie! There's always something there...waiting...something even worse than what you've imagined.

JCT: Something even worse than *you* can imagine?

SK: I like to remember what the famous scientist J. B. S. Haldane said: "The universe is not only queer, but it's queerer than we can imagine!"[15]

JCT: Wow! We're in H .P. Lovecraft country!

SK: Oh, yes, I was just 11 or 12 when I found a collection of his stories, *The Lurking Fear*, in a box of my father's books. I remember the cover of a loathsome thing with fangs and green eyes coming out from behind a tombstone! I always say that Lovecraft opened the way for us. He looms over all of us. I can't think of any important horror fiction that doesn't owe a lot to him.

JCT: But getting back to my original question, do you sometimes think you have to keep ahead of your readers, keep a step ahead of them as they grow more sophisticated at the techniques and effects of today's rather graphic horror?

SK: If you do that sort of thing, you're hurting yourself. If you don't write for an audience of one, if you start writing directly for an audience—it's like a baseball pitcher who starts to aim the ball. It's no good. Does that make sense? So, I don't really think about the audience.

JCT: So much of your work seems to come out of your own family life. Behind all the horrors are really rather simple things—fathers and sons—especially in *The Shining*, children and their nightmares, for example. Is the world of childhood something particularly important to your work?

SK: Yes, and in my book, I think I have the final word about that. It deals with children and monsters, but it's really about me as a father to my children, the sort of thing I also wrote about in *Cujo* with little Tad Trenton and the "Monster Words" game he played

in the dark. I've been a father for almost half of my life now, since I was 23. Back in those days, I was broke and working through ambivalent feelings about my kids—resentment, even anger. But now, well, my kids are growing up. I have a different relationship with them now and perceive them in a different way. I see myself in a different way. I think having kids is part of the process that finishes off our own childhood and allows us to be adults with more serenity. And maybe that will change some of the things I need to write about. So maybe something ended with that book.

JCT: You've talked a lot about the art of writing horror fiction. You certainly have a vivid way of describing the process. You've called it "keeping the gators fed." And you wrote somewhere: "Think of us horror writers as the people who walk your dog at night." What on earth did you mean by that?

SK: I tell you, I think we have emotional musculature the same way we have physical musculature. That is to say, you have emotions you need to exercise the same way you need to exercise your body. And society gives you brownie points for exercising the good emotions—you take old ladies across the street and demonstrate all of those Boy Scout virtues by being friendly, brave, courteous, and all the rest of it. But we have another set of emotional muscles, too—where we're aggressive, we're fearful, sometimes we're even hateful. And those emotions need to be exercised too—except that society has no awards for those. You can't just say, all right, I'll just exercise my arms, but I won't ever do any leg lifts. You have to exercise your whole body. But you can't exercise those bad emotions, can you? You can't bash people over the head; or if some guy cuts you off in traffic, you can't actually haul him out of his car and put a .45 in his mouth and pull the trigger. Somebody has to take your darker emotions for a walk and exercise them. And I guess I'm one of the guys who do that.

JCT: And undeniably, you've brought the horror story to a new level of prestige and popularity.

SK: Popularity I'll agree with. Prestige and the rest of it, I don't know. I just have this childish urge to go "boogah-boogah!" at people, it's kind of fun!

"A Magellan of the Interior": Peter Straub

Peter Straub (1943–) is one of America's most successful and esteemed contemporary writers of dark fantasy. He was born in Milwaukee, Wisconsin. After receiving his BA at the University of Wisconsin and his MA at Columbia University, he taught English at a boys' school in Milwaukee in 1966–1968. During subsequent travels in Dublin and London, he wrote

Peter Straub (photo by the author)

a volume of poetry, *Open Air* (1973), and his first novels, *Marriages* (1973) and *If You Could See Me Now* (1977). In his "breakthrough" novel, *Ghost Story* (1979), he took the elements of fantasy and horror that had been present in his earlier work and developed them into the full-throated Gothic expression that has marked all of his subsequent writing—*Shadowland* (1982), *Floating Dragon* (1982), *The Talisman* (1984) (cowritten with Stephen King, perhaps his only competitor in the American popular horror fiction market), *Koko* (1988), *Mystery* (1989), *Black House* (2001, a reteaming with Stephen King), *lost boy, lost girl,* (2003), and *In the Night Room* (2004). Straub has edited the Library of America volume of H. P. Lovecraft (2005), and has confirmed that he and Stephen King will begin work on another collaboration early in 2011.

In most of his works, the webs and complexes of a past, or repressed, evil inevitably surface to threaten our well-ordered, "normal" world. These long and intricate novels may be read on many levels—as psychological studies, scary horror thrillers, or simply as richly allusive literary entertainments. They synthesize into a unique contemporary expression the styles and subjects of many writers he claims as inspiration—the Gothic stylists Nathaniel Hawthorne and Henry James, contemporary novelists Marguerite Duras and Gabriel Marquez, and poet John Ashbery. He has won the British Fantasy Award, the August Derleth Award, the Bram Stoker Award, and the World Fantasy Award.

I first interviewed Mr. Straub at the World Fantasy Convention in Providence, Rhode Island, in 1987 and four years later in his New York brownstone home on 5 May 1991. The focus of our conversations was his seminal collection of interrelated short stories, *Houses without Doors* (1991). As he speaks from his workroom, you should picture the scene around him—a crowded desk with a computer; a stack of handwritten journals (one of which bears the cryptic, scrawled title "The Strange Fate of the Mind's Eye"); a coffee table stacked high with compact discs and the manuscript of his new novel, *The Throat*; a leather couch; and shutters drawn against the sunlight ("I never look out the window unless I have to," he says. "I want artificial light here, not sunlight.")

Interview

JOHN C. TIBBETTS: You're one of a handful of the most popular so-called horror writers in the world. But you're unique because your books have a distinctive "literary" sense. Can you have it both ways—to be, as one critic has put it, a hit at the checkout counter as well as in the English Department?

STRAUB: Sure, I've heard that complaint before and frankly, I don't see what's wrong with that! When my latest book, *Houses without Doors,* came out, one critic gave it a good review while another complained that I was trying to be a "literary" horror writer. He made a word with a pretty positive top-spin sound terrible. To me, "literary" still sounds pretty noble. I sense there's something wrong in the reviewer's mind when he does that particular kind of "push-up."

JCT: *Houses without Doors* is your first collection of short stories. I guess we think of you as primarily a novelist. Did you enjoy the greater restrictions the short story format places upon you?

PS: It comes close to being my favorite book. I think I've changed a bit since *Shadowland* and *Floating Dragon* and moved on to a shorter kind of book, or at least to writing with more concision. I would love to write more stories like these.

JCT: Lots of childhood pain here, lots of characters misshapen from terrible things that happened to them in their youth. I have to ask if some of this is autobiographical.

PS: There is probably more about my childhood there than—well, there's a lot I wanted to repress and a lot I had to repress about my childhood. My childhood was marked by big ups and downs. In a word, it was traumatic. In my new novel, *The Throat*, which isn't out yet, I have my narrator call childhood "Vietnam before Vietnam." That child I was is still fairly present inside me. I have to keep him under control and be sort of nice to him.

JCT: Are you referring to a story like "The Juniper Tree" [a harrowing account of a young boy whose sexual molestation by a stranger in a movie theater affects his adult development]?

PS: I wrote "The Juniper Tree," which refers to one of the most famous of the Grimm's *Tales* because I was struck by the situation of a boy being molested and having a complicated response to the man who does him tremendous damage.[16] Reading Marguerite Duras' *The Lover* awhile ago, which was about the sexual abuse of a young girl, was another influence on that story. We never lose that child inside us, really. Unfortunately, now a psychologist on PBS, John Bradshaw, has made all of this sound sort of soppy—you know his phrase, "your inner child"? But that's the whole point of *Houses without Doors*—that things that are crucial and important in our childhood may be buried. But one day they come up, they speak again. Most of the central figures in these stories have denied or forgotten some crucial and determining event that boils and smokes inside them. Like Bobby Bunting, in "The Buffalo Hunter," who never really does find out what it was that almost comes up into his mind. It scares him so much he pushes it back down. And, therefore, he's imprisoned within this odd little repressed world, this childish world that he's created about himself.

JCT: But your stories seem to suggest that you've kept your lines of communication open back to your own childhood.

PS: I wrote my first stories when I was a kid. And I've thought about them a lot, about how odd they were. When I was a child in the Second and Third Grades, I wanted very, very much to write. I loved the whole idea of a blank page, of pencils, of a desk. Of a sort of "sacred space" where you could go and make something up. Once in the Fourth Grade I wrote what seemed to me to be an amazing story, about a spy who tried to kill himself by jumping out a window. It was really bleak and full of desperation and a sense of self-betrayal. And my teacher was nonplussed. She had no idea what to make of this tale. And it turned her against me, in a way. The only case in my whole grade school life where my teacher didn't like me. Then my next story was about Judas wandering from place to place and being stoned and driven away—

JCT: What a strange subject for a child to write about!

PS: It always struck me as very odd that a child's imagination would fasten on betrayal so early. That is mysterious to me. I turn those old stories over in my mind now and then. I remember what it was like to write them. And how they felt.

JCT: Anything you could tell me about why you were always writing horror stories?

PS: I always knew I could write them and that I was deeply serious about it. It seemed to me, looking around at other horror writers,

that some of them were not very serious about it. And also that
they were not very good. So I drew a lot from the great American
writers in the field—who were simply good writers, not just good
fantasy or horror writers, by the way. Henry James, especially.
And Hawthorne.

JCT: You even name some of your characters in *Ghost Story* after
these guys.

PS: You mean the members of the Chowder Club? Sure. They had
read those authors! Hawthorne was a very powerful writer. He
had a deep streak of whimsy, even of perversity, of seeing behind
the face, seeing what impulses lurked behind the respectable face,
the hypocrisy behind conventionality, like in "Young Goodman
Brown." Our literature starts with a vision of blackness, and I
think that has a lot to do with the fact that our country at first was
mostly untameable forest. There were truly bad things out there.
Now we don't want to have that. Now in America, we want to
believe in the surface of things. We put a lot of faith in appear-
ance and spend a lot of money trying to look good according
to some rule we have in our minds. But I think daily life is still
filled with uncertainty, anxiety, and fear. Nobody's life is really
safe. Nobody's job is secure. Nobody's children have a guaranteed
future.

JCT: I thought you were going to add that nobody's books are safe
from the movies, either!

PS: You must mean the movie made of my book, *Ghost Story*. Yeah,
there are crucial parts of the book that they decided could be left
out of the movie—but then they left everything else out, too!

JCT: So, you didn't care for the movie version?

PS: I did feel almost personally wounded after I really realized what
had happened to my book. I don't want to point any fingers
because many, many people went into it with good feelings and
with good intentions. The actors certainly did, and the screen-
writer certainly did, and most of the people surrounding that
project had good feelings about the book. But somebody didn't,
and the thing didn't work right. So that has made me a little wary
about film versions of my books, and I have turned down some
projects because of that. I also remember the Stephen King film
projects, which have almost been universally botched. I have no
wish to be made ridiculous, and I don't need the money.

JCT: You and Stephen King are friends, and you have collaborated
on a book, *The Talisman*. It strikes me that the two of you were
instrumental in getting the horror novel onto the bestseller lists
back in the mid-1970s. Yet you're both quite different, in temper-
ament as well as in your books. How did you ever get together?

PS: I think Stephen King drove a wedge into the Bestseller lists and
it didn't happen accidentally and it wasn't just a matter of timing

that led people to buy horror books. It happened because Stephen King was a genuinely talented and immensely powerful writer. And I happened to be standing next to him at the time. We both first published this stuff in the same year, 1973. His *Salem's Lot* came out at the same time as my books, *Julia* and *If You Could See Me Now.* All of them did well in paperback. *Julia* saved my life and made me a decent amount of money so that I could support myself. I bought a house and my wife and I lived in England where everything suddenly became decently comfortable in the way that one thinks it ought to be!

I started thinking about what to write next and Steve and his wife were also in London. They didn't like it so well so they left after a couple of months. But not before we got together late one night and Steve said to me, "Why don't we collaborate on a book?" And I said, "Gee, that'd be nice, but I have this two-book contract and that'll take me about another four years." And he said, "Okay, in four years let's write a book!" In those four years everything turned upside down. We moved back to America. We had our second child. Steve's life entered the truly fast track. But we formed a really good, decent friendship because we understood each other.

JCT: I understand you both wrote *The Talisman* on word processors that were interconnected in some way.

PS: We did that because he lived in Maine and I lived in Connecticut and we didn't want to have to depend on the mail and ship 200/300 page packages back and forth. So I persuaded Steve the summer before we started to buy word processors and learn to use them. He thought that was okay, so it just made it technically easier. After finishing a segment, all I had to do was punch a few buttons and push a special button on my telephone (which was hooked up to his modem) and then all of those pages would just zip through air and arrive in Steve's memory bank in about a second and a half!

JCT: I can't think of a precedent in popular fiction for this kind of collaboration.

PS: It was a nice experience. But the nicest part was the beginning and ending of the book when we just sat together and wrote side-by-side. Sometimes Steve would sit down and zip along, steam through five or six pages, and I'd sit down later and everything would still be smoking. And I'd do my little riff. It went on very happily. Then we would each rewrite a little. It was dancing and making music and making love. It was intensively collaborative.

JCT: And yet…it's amazing, considering how different you both seem to be. You have a deliberate way of writing, while—

PS: That's pretty accurate. Steve has almost instant access to his imagination. I thought he was like a guy in whose living room

there's a diving board and a deep pool and all he has to do is walk off the board and he's immediately in the pool. And I have to walk outside and walk around the pool a little bit.

JCT: Or maybe it's just that you prefer to use the ladder to descend into the pool!

PS (laughing): It takes me a little longer. But Steve sits down and his eyes glow and his fingers warm and he starts to rattle away. It sounds like a guy hauling chains across the deck of a boat. The extraordinary thing was the way I could move through his mind and he could move through my mind. And that's an experience writers never have. And it was very, very moving to have done that.

JCT: I take it you're not likely to find another collaborator so agreeable...?

PS: No, I would never collaborate with anybody else. First of all, Steve is a workhorse. I mean, he's a horse. He's strong. He can lift whole buildings with one hand. That's a valuable thing in a collaboration!

JCT: Wasn't there anything about the collaboration that was difficult?

PS: Well...Steve hates to make changes and he wouldn't ever suggest any and he didn't want to hear about any. We ended up making plenty, but we had to make a rule that if anybody suggested something, it had to go. It had to come out. I quite happily took out everything he thought I should; and he took out everything that he really, really loved. Except one little bit.

JCT: Let's talk about the process of writing. Frequently in your stories you describe authors as working in front of a kind of "blank screen." You do this in *Houses without Doors*. What do you mean? Is this describing a writer before a word processor? Or are you using a metaphor for the creative process? As if to say the writer is like a painter in some way?

PS: It's very interesting that you made that kind of connection, because I never would have. I enjoy paintings and buy them at art galleries here in New York. You see there on the wall two works by R. B. Kitaj. But writing for me is still a longhand kind of thing. I went back to that after *The Talisman*. It seems more comfortable and more like real writing to me. No, when I write about an author looking at a kind of "screen," what I have in mind is sitting in front of a large horizontal plane, like a desk. The writer puts his hand on this big panel and wherever you touch it, something springs to life. You see trees, a road, and fairly soon a whole landscape is visible before you—complete with human beings moving through it. This image suggests itself to me because of what seems the magical nature of creation. I sit down and begin writing something without being too sure of what it is I'm really writing, or

where it's going to go. It seems to take on life by itself, as if images come up on the surface of the screen by themselves.

JCT: What do you mean by "images," then?

PS: Writing—at least the kind of writing I do—is all about representation. Trying to represent the real world through symbols. Through words like "leaf," "path," "cold," "skin." You try to translate the actual world on to your page the same way that Corot set up a canvas in a field and tried to paint the field. If you get it right, something really astonishing happens. There's a thrill that comes through the words or strokes of paint because of the seamlessness of the illusion. It's so good that it isn't an illusion, I think.

JCT: Is this what painters call *trompe l'oeil*, fooling the eye?

PS: Not exactly. I'm thinking of a writer like Flaubert, especially in *Madame Bovary*, where the details are chosen so carefully and described so leanly and perfectly that the words disappear and you're right there on the page with them.

JCT: You say, "real world." But in your stories there are many worlds, separate realities. You can't tell if a dream is more real than reality itself. Or if a movie or book is more real than the world surrounding the reader or the viewer. Even fairy tales, like in *Shadowland*, become as real as anything else.

PS: Right.

JCT: But aren't you making lots of heavy demands on your readers—to keep things straight? My head was spinning at the end of *Ghost Story*!

PS: It seems to me that the types of demands I make have more to do with thought than endurance! Either the reader "gets it" or he doesn't. If he doesn't, he doesn't miss it. If he does get it, I think it's kind of like a light bulb that goes on in his head.

JCT: Need we "get it," as you say, to enjoy your stories?

PS: Let me answer that this way. I discovered a poet named John Ashbery in 1966 when I read his book, *The Tennis Court Oath*. That book made it possible for me to write. What staggered me about it and what really did change my life was that those poems seemed to make no sense at all! Yet, they were perfect. They had a sort of power and authenticity and rightness that was inexplicable to any of the means or techniques that I had been taught. When you read my story, "Mrs. God," in *Houses without Doors*, you'll discover that my character of Isobel Standish is this kind of poet. Well, my books are like these poems—events repeat themselves like words that rhyme with each other. Rhymes are repetitions, too. In *Shadowland* I wanted every event in the first part of the book to be echoed—or rhymed—later in the latter part. And if you look through the book carefully, I think you'll find everything is repeated in that way. In "Mrs. God" that's about the only

kind of organization that there is, how one event "rhymes" with another.

JCT: But I still think these central meanings can be pretty elusive. I think of the line in one of G. K. Chesterton's detective stories where Father Brown says: "Gentlemen, we have come to the end of the world. We have found the truth, and the truth makes no sense!"

PS: Well, that's a sort of nightmare. To think there really is no meaning in life is to live in an empty, dead world, I think. Is the everyday a kind of blank or does it reveal a transfiguration? Is there a hidden radiance or a hidden nothing? There's no question which side of the duality I have chosen as the truth. I like the drawing by Chris Van Allsburg in his book, *The Mysteries of Harris Burdick* [see the interview with Van Allsburg elsewhere in these pages]. It could have been from *The Talisman*. It shows some children pedalling a machine through a desert; and there before them is a huge palace. The caption says: "If it was anywhere, it was there." Although I don't really think there is a theological or supernatural motif that breathes through the world, what I really believe is that the world is its own meaning. If it's just dead matter, then we're left in a sort of pointless hell, it seems to me.

There are certain meanings all through *Koko, Mystery,* and *Houses without Doors*—but I would hesitate to make them explicit. For example, in *Mystery* the real crime at the center of the book is never brought up to the surface of the novel. It's alluded to, it's the mainspring for everything that happens. But it's never directly described. I got a few letters asking about *Mystery*: "What's really happened here?" But there was another letter saying that by not saying that incest is the central crime, the core of the book, I acted like society in denying or repressing the revelation. To me, it was a little off the point. What I was doing was a dramatic strategy. A book that has its whole origin and its emotional energy from the crime of incest can't be said to deny incest. The same thing we talked about with the childhood of Mr. Bunting in "The Buffalo Hunter" in *Houses without Doors*. It's that business of repressed memories, events that have been rejected and buried.

JCT: It's like Schopenhauer's metaphor about the artist as an archer. While most might notch our arrow and aim at a target, the artist aims at a target the rest of us cannot see.

PS: That's good! True, I sometimes think I'm aiming at a target that nobody else can see!—judging by the reviews I get sometimes! Somebody might praise or damn some book the he or she read, but one that's different from the one I wrote! Yes, every sentence should be an arrow to the secret heart of the book. I have my character in "The Juniper Tree," say that no sentences should be wasted, no scene should be just there because it's cute or funny or

"good looking." Every element in a book, even the punctuation, ought to serve some central purpose I have in mind.

JCT: Horror stories by their nature try to scare us, or unsettle us, at least. I have found myself very disturbed at times while reading your stories. The grisly murders in *Ghost Story*, for example. Or the sexual molestation scenes in "The Juniper Tree." Do you ever feel you should pull back at times? That you might be going too far?

PS: Usually when I think that, I know I'm on to something! But I admit "The Juniper Tree" spooked me so much that I didn't even look at it for two years after I wrote it. I didn't even type it up. I revised it very carefully and just put it away and didn't want to look at it. Finally, I took it off the shelf and rewrote it again by hand.

JCT: Most of us would avoid something that disturbs us so much.

PS: What about the readers who buy my stories? They read them, don't they?

JCT: What about new projects? What's on tap?

PS: By the fall of 1991, the paperback edition of *Houses without Doors* will be out. My new novel, *The Throat*, is linked in important ways to my earlier novels, *Koko* and *Mystery*. You don't need to have read them, but they do form a trilogy I call the "Blue Rose" trilogy. That's a reference to the "Blue Rose" murders that are mentioned in *Mystery*. Some characters will reappear from those books. The book should be out in a little more than a year. There are some filmmakers who have spoken to me about doing *Koko*, but that's all I can say about that right now.

JCT: What about Peter Straub as a person, a guy to talk with and get to know? Any mysteries—any surprises for us?

PS: When people meet me, they're always amazed at how friendly I am! I'm always interested in what people have to say. And I guess I seem kind of playful.

JCT: As if we were expecting some kind of monster straight out of *Ghost Story*?

PS: Right. I've been told I'm not at all what people expect. But then again, they are meeting the social person who's out there to be met. They meet the person I'm willing for them to meet. When some writers go out, they just babble. I'm the reverse. I don't say much unless I really feel comfortable. I want to know what others are saying. I eavesdrop. I sit in bars and in cafes with my ears open, just listening to crazy things that people routinely say to one another.

Otherwise, it's hard to spend your whole life alone, and that is a demand that the job makes on you. The ultimate reward is that you're not alone at all. You make up this whole world—or you go exploring for it—and it's full of extremely interesting, entertaining

folks. You listen to them talk and you watch what they do. You're exploring some inner country, being a "Magellan of the Interior," as I say in one of my stories. You get these ideas that are full of excitement because you don't know what they mean yet, or quite know where they're going. But you go along anyway.

Addendum

As an addendum to this interview, I met again with Peter Straub in May 2011 at his home on the Upper West Side of Manhattan. We talked about our first meeting and the course of his career since then. His most recent novel is *A Dark Matter*, published last year. Peter is 68 years old now, and I reminded him of the words of the jazz musician "Hat" in his story "Pork Pie Hat": "You start to grow up when you understand that the stuff that scares you is part of the air you breathe." How true that is, Peter admits. "You know, I have a lot more time behind me than before me, but I am still writing. I don't see any book from now on as my last, but I do know I'm in the late phases of my career. And I think I'm writing really well. But here I am, filled with infirmities, without the stamina I have been used to. My wife says, 'Remember, Peter, you're not 40 anymore!' (laughs). Okay, I don't write as fast as I used to, and it takes me longer. But right now, I'm trying to write a book that I hope I can finish in two years. I'm thinking of calling it *Hello, Jack!* And Stephen King and I want to do another book together. He doesn't shilly-shally around. It's obvious *he* hasn't slowed down. Although I used the good old iMac and even of late have dictated some things, I still sometimes write in longhand. In moments of stress or trouble, I always revert to that."

"The Kiss That's a Bite": Suzy Mckee Charnas

Suzy McKee Charnas's *The Vampire Tapestry* (1980) signaled a dramatic evolution in the traditional Gothic vampire story. From the Byron-inspired *Vampyr*, by Polidori—a product of that eventful June night in Switzerland in 1816 with Lord Byron and the Shelleys that had also given birth to Mary's *Frankenstein*[17]—to James Malcolm Rymer's *Varney the Vampire* (1846), Sheridan Le Fanu's masterpiece, *Carmilla* (1862), Bram Stoker's seminal *Dracula* (1897), H. G. Wells' Martian vampires in *War of the Worlds* that same year, George R. R. Martin's *Fevre Dream* (1982), and today's "Vampire Lestat" novels by Anne Rice and the *Twilight* series by Stephanie Meyer, tales of the Undead have been very much alive in literature and film. Stoker's novel appeared at a time that was witnessing a newly revived series of Gothic themes—most importantly, the struggle

Suzy McKee Charnas (photo by the author)

between materialistic science and religious faith, the taint of "bad blood" in the "hordes" of arriving "degenerate" Eastern European immigrants, and the male fear of the sexually powerful and predatory female.[18] In his book, *Images of Fear*, Martin Tropp argues that this latter theme had long been "an erotic and sadistic element [that had] always been part of the vampire myth and of the Gothic tale in general."[19]

It remained for Charnas to reinvent the genre and subject an all-too-mortal vampire to a modern psychological and psychosexual examination. In this, she fully realized some of the implications extant in Rymer's *Varney the Vampire*.[20] Critics and writers greeted it rapturously. Peter S. Beagle, for example, pronounced it "the best vampire novel I have ever read." Charnas recalls, however, that almost immediately "bad luck" attended the book: "When it first came out in 1980, my editor, David G. Hartwell, was locked in a death struggle with the publishers. As a result, despite more than enough reorders for the book to warrant a second printing at least, there was only the one printing of 6,500 hardcover copies. I recently saw one of these hardbacks, used, with an exorbitant price attached (none of which, of course, goes to the author!)."

It would be 13 more years before the book, by now having won a Nebula Award for one chapter as a freestanding novella and having become something of a cult classic as a whole, appeared in a major new edition from Living Batch Press. Again, the critics cheered. Reviewer Bruce Allen's notice in *USA Today*, 29 October 1993, deserves to be quoted in its entirety:

> It's a fascinating conception, handled with masterly skill. Charnas' characters are boldly drawn, memorably complex; her prose is alive with energy and wit, her narrative inventions ingenious and atmospheric. Nothing better has been done in this vein since Bram Stoker's legendary *Dracula* in 1897. And, as a pure piece of writing, Charnas' deeply intelligent, disturbing novel may actually be the superior book.

Ms. Charnas has continued to consider themes of vampires and vampirism in some of her more recent fiction. Details can be found at her website, www.suzymckeecharnas.com.

The Vampire Tapestry consists of five linked stories concerning the adventures of Dr. Edward L. Weyland, PhD, an anthropologist and an intellectual who happens to be a vampire. But Weyland claims no kinship to the blood-and-thunder Romantic creations of Byron and Stoker. He is no dark lord possessing supernatural powers, no Old World aristocrat battening upon the voluptuous necks of virgins; rather, beyond his predatory skills to gain the blood that allows him to live, Weyland is all too mortal, vulnerable to physical injury. Also absent are the usual trappings of vampire stories, like bats, garlic, earth-filled coffins, crucifixes, wooden stakes, and the sexually suggestive lust for virginal victims.

For the most part, Weyland is seen through the eyes of the people with whom he comes into contact. In the first part, titled "The Ancient Mind at Work," set on a college campus, his masquerade as a scientist is eventually uncovered by Katje de Groot, a widow of a professor. Attacked by Weyland, she shoots and wounds him severely. In part two, "The Land of Lost Content," Weyland is captured by two petty criminals and forced to feed as a sideshow exhibit for the voyeuristic delight of a coterie of followers of a Satanist named Reese. Injured, Weyland manages to escape with the help of one of the captors, a young man named Mark, who restores him to health with the gift of his own blood. Part three is the novel's central episode, "The Unicorn Tapestry," in which Weyland submits to psychoanalysis at the hands of therapist Floria Landauer. Pretending to suffer from a "delusion" that he's a vampire—here at last he speaks in the first person—he achieves a newfound empathy with the woman, an emotional detachment new to him. And, although she learns his "delusion" is all too real, she returns his love. But their tryst is brief. He leaves her to take up a new identity elsewhere. In "A Musical Interlude," Weyland finds himself in New Mexico, once again a college professor. He meets

another "Floria," this one the heroine of Puccini's opera, *Tosca*. During a performance of the work at the Santa Fe Opera, Weyland's blood lust is aroused at the sight of Floria's predicament at the hands of the predatory villain, Scarpia. "How often had Weyland himself approached a victim in just such a manner, speaking soothingly, his impatience to feed disguised in social pleasantry....Here was that experience, from the outside." At a key moment in the opera, Weyland slips away to kill brutally and indiscriminately one of the cast members.

Finally, in part five, "The Last of Dr. Weyland," the vampire is ferreted out by an artist, Dorothea, and out of fear of exposure he determines to end his masquerade as "Dr. Weyland." By now, he realized that the newfound sense of humanity he's achieved over the course of his adventures threatens his survival as a vampire. "He could not hunt successfully among prey for whom he might come to care....His life had been broken into, anyone might enter." No longer could he regard people merely as "human livestock." His similarity to them enabled him to hunt them, but it also made him vulnerable to their emotions and, yes, to their humanity.

He seeks the sleep that has preserved him over the centuries, the sleep that brings forgetting and that will allow him to start anew upon waking, a hunter once more. "I am not the monster who falls in love and is destroyed by his human feelings," he thinks to himself. "I am the monster who stays true." As he drifts off to sleep, he is momentarily visited by scattered memories of recent events. Finally, tranquilly, he sleeps.

This interview transpired on 30 October 1993, in Minneapolis, MN, at the World Fantasy Convention.

Interview

JOHN C. TIBBETTS: Your *The Vampire Tapestry* has brought you a measure of fame that might still be growing with the reissue of that book. In your own opinion, what place does this book occupy in the ongoing vampire-related tradition?

SUZY MCKEE CHARNAS: Okay; well, the personal context I think will help to give you the parameters that I was working in. I've always been a great fan of Dracula and vampire movies, especially the more elegant treatments of the theme. I guess for too long I read too much vampire stuff, and I got bored with it. Years later, I was in New York, hiding out from writing a difficult science fiction novel, and as part of my rest and recuperation, I went to see the Broadway revival of the old Balderston-Deane play, *Dracula*, with stage design by Edward Gorey. Despite the lusciousness of Frank Langella as the lead, I came away extremely disappointed. Then I went down to the Cherry Lane Theater in Greenwich Village to see a play called *The Passion of Dracula*, by a

couple of comic book artists, in this little teeny weeny theater. It was funnier and it was faster, the script was better written, and the actors were brash and lively. It was much more fun.

JCT: Purely coincidental to see both of them?

SMC: Absolutely coincidental that they were both there at the same time. In fact, I went home and wrote a review of the one at the Cherry Lane, raved about it because it was so much fun. But it was still not satisfying, and I was thinking about that, I was sitting in Grand Central Station thinking about it waiting to meet my sister. I thought, well, what's missing? What is it that's so disappointing about both these plays—even the successful one for me. After a while I picked up on it, I was working through it, I was thinking, well this Dracula figure is so romanticized, he's not really a vampire, he's just Lord Byron with long teeth. I'm not very interested in Lord Byron.

JCT: We remember the Romantics' interest in the vampire.

SMC: That's right, exactly. But I feel that this was just a kind of a graft of that Romantic sensibility onto something else, and it was the something else I was really interested in. I finally figured out what the something else was: it was the idea of the vampire as a predator. Not a Romantic hero, not a guy who's lonely out there in eternity all by himself, but a predator, a tiger, a sabre-toothed tiger—and we are the prey. And once I figured that out, I said that's the story I want to write. I want to write about a vampire who's not a dead nobleman from Europe, which is what everybody is in these stories. He's an animal, he's a tiger, and how he lives among us. Because I know how a Romantic nobleman from central Europe lives among us. I've seen enough stories about that to be able to figure out what the cultural story is on that and I'm bored with it. I think everybody else must be a little bit bored with it at least. Of course, it turns out that everybody else is not bored with it, but I was. So I wanted to take this back to the original impulse that I think keeps the idea going, which is this predatory intelligence.

JCT: Was it novel length or was it short story length?

SMC: No, I started with a story. It's set in a college because I wanted to stress that this was an intelligent animal; it has to be intelligent or it's not going to survive among us. I had started out with the idea of artificial blood. There had been something in *Omni Magazine* about developing artificial blood, so I thought a university teaching hospital would be the background to develop that as a plot ingredient. From that came the idea of a vampire as a professor, somebody on the staff of the university. Luckily the idea of artificial blood story went away, because it was silly. But I kept the setting because by that time I had gone to Skidmore College to do a talk and they put me up in the faculty club. I really liked the

building. I said, I want to put a story in here, this is where part of this vampire story's going to happen. It's going to be a school like this, not very big university and it's going to have a faculty club and that's somehow the heart of this first vision of the vampire.

JCT: Were they doing sleep therapy?

SMC: I don't think they did, I don't know where that came from. That was one I guess when I was still thinking that he might be a nighttime animal. Then later I thought, nah, that's much too restrictive, it takes half the fun out of the story. I said, he's studying anthropology and he's interested in the psychological end of it, in the way our minds work, so he's studying dreams. He's studying dreams because he never has any himself. Besides, dream research makes it easy for him to get to young people, who come into his lab and lie down and go to sleep. And he takes a little sip and they wake up, they don't know what happened, or maybe they dream something funny. I never got into that part, but yeah, there are some weird dreams. It just seemed like an easy way for him to get his nourishment without having to leave acres of dead people lying around, which is what the usual vampire novel's cluttered up with, and one of the reasons a lot of them don't make sense.

JCT: You have an interesting way of handling the quasi-immortal lifespan of the vampire.

SMC: Well, I was thinking about the way most writers handle this. They run their vampire's life back to the 1800s or the 1500s or even the ancient world. The vampire is in the present day trailing this immense, snaky trail of experience. a long, discontinuous life broken where he's had to flee because he was about to be discovered. I don't believe it in the sense that I don't believe any kind of mind is built to carry that much experience in an intelligible form. I don't believe the characters in the books that are written this way because they don't seem to me any different from just regular folks. They don't come across as ancient beings who have had all of this accumulated experience and learned from it. I have a credibility problem with this. With Weyland, I'm proposing a very old, very sharp, but basically simple animal mind—I mean, he's intelligent, but he's not a complex soul until the end of the story. It seemed to me that you could not maintain that kind of purity of impulse. "I'm hungry"—that kind of impulse; or, "I'll play with that!" he wouldn't still operate on that primitive level if he had the experience of all of his previous lives to draw on. He has to forget all of that when he sleeps. So the essence of this animal's success is that, at the point where it becomes too complex (through its experience of a given lifetime) to maintain that purity of impulse, it goes to sleep and forgets it all so it can start off fresh and clean again and say, ah here I am, I'm a hunter. There are no complications. I'm a hunter, you're the prey, gimme.

JCT: But it's also important to choose the right place to go to sleep.

SMC: That helps. You have to be . . . He's very bright. But it's, I think, a classic image of the extremely intelligent person who has a very rudimentary soul.

JCT: But wouldn't the accumulated weight of experience drive a person mad?

SMC: Absolutely. Especially if it were a person whose capacity was not very great, which is certainly the case with this vampire. His experience is very narrow, and as it broadens in the course of the book, he gets closer and closer to that point at which he says, I can't reliably perform anymore my essential function—feeding myself on human blood—any more. So I've got to erase this life's experience because it has changed me and the abilities that I need to survive.

JCT: Also, you need to confront so much of the apparatus of the legendary vampire and somehow make it conform to a practical reality.

SMC: Well, I just got rid of it all because it was so absurd.

JCT: For example?

SMC: For example, the coffin. You sleep in a coffin, and you have to have dirt and you have to be awake only at night and the sunshine will rot you and you can't eat garlic and you have to stay away from crosses and you can't cross water and all of that rubbish, most of which is actually inventions of the movies. The original vampire legends are really rather simple and crude. In fact, that was one of the reasons that I had no problem with jettisoning all of this junk, because I said, well, the erotic Byronic vampire is a fraud, it's an artifact of our culture, our century, especially the past 25 years or so. Because the vampires of the middle European legends, which all of this starts with, were peasants. These were dead peasants who would get up out of their graves at night and prey on their families. So already the original impulse has been discarded to make this present cultural artifact of the Romantic vampire. So I said to myself, I can dump all of this stuff—why not? It's only dramatic embellishment. Everybody just takes what they want and leaves the rest.

JCT: You have an interesting twist on the whole blood-sucking thing.

SMC: Yeah, there were some things that I thought needed to be adjusted, so that they made sense. I guess here I was thinking more about vampire film than about vampire books. They always have these big long canines, right. It never made sense because the bite marks are these little punctures right here like from two little straws in the front. Or else they're big wide things and nobody knows what they are, you know these enormous holes in the neck and everybody's gee, what's that, what kind of strange insect. Like

they don't live in the world, they never heard of a vampire, right. I thought, well, if you have these big long teeth hanging out of your mouth, you can never smile, you can never open your mouth. It just seemed to me to be ridiculous. So while I was researching, I read everything I could lay my hands on about real and fictional vampires when I was working on this book. While I was researching, I ran across a Polish version of the vampire legend in which the vampire has a sting under its tongue with which it makes the wound from which the blood is drawn. So I said great, that makes perfect sense. This is something that's not in the way, that doesn't show, that nobody knows is there. Your sting secretes a natural anesthetic, and bingo! Your victims never feel a thing, so nobody knows what's going on. I like the idea of making this not just a predator and a product of evolution but a rational being in its design, as well as its intentions and its mental designs, mental activities.

JCT: You certainly have rejuvenated the genre for jaded audiences!

SMC: I was just having a really good time, and I hoped other people would enjoy it. I didn't really think I was going to change the direction of the whole vampire field, and I don't think I have. An awful lot of stuff is still being written around the heroic Romantic vampire. It's irresistible to a lot of people.

JCT: Is it the first time that a vampire was psychoanalyzed?

SMC: I think so. I saw one other book later, about a year after *Tapestry* was published, in which a vampire goes to a therapist. It's not a very good book, and I can't remember what happens, but somebody else did work it a little bit. I don't think other writers have dealt with it because I pretty much put my own stamp on it with this book.

JCT: Tell us more about the process.

SMC: He needs to get his job back. The plot device was that—well, actually what happened was I started him out in a small college where he was teaching and he picked the wrong victim and she shot him. So he ended up imprisoned in a New York apartment, where he's exhibited for profit by an unscrupulous little creep and escapes with the help of the creep's nephew. At that point I said, I see this is going to be a book, these were two separate stories. Oh, this is going to be a book. I was thinking, I need a story about the vampire who was a creature of art, he doesn't exist in the real world in close conjunction with an art of some kind. I'd like to see what happens when you do that. That became the story set in the opera house. But there was something in between. When I looked at the story set in the opera house—I hadn't written it yet, but I knew it was coming—I thought, well I need to be inside his head there, and I'm not. The first story was written from the point of view of the woman who shoots him, the second from the point of

view of the boy who helps him escape. Well, I thought, I need a third story that will begin to set us up for what's inside his head, because in the opera story, we change to his viewpoint, getting ready to shift there completely for the last chapter. And you know, I looked around and said, I don't know what's in his head. How the hell am I going to find out what's in there, I don't know what's in this guy's head. So then I thought, well, let's get him talking to somebody and let him tell me because that's the only way I'm going to know. I'll eavesdrop, so I sent him into therapy. The plot device was that he had to get his job, he wanted to go back to teach. He was telling the administration that he had a blackout and a nervous breakdown and just disappeared, because he was gone for about two months in this basement where he was being exhibited, you see. So they've told him, sure you can come back to teach—because he's a good teacher—but first we want to make sure this isn't going to happen again. Go talk to this therapist, and when she says that she thinks you're pretty stable, you come back to work. So he goes in very hostile, not very happy with the situation but prepared to manipulate it to his own advantage. What happens in that story is he begins to talk about his life, and he begins to talk about his life as it really happens, not the phony life as the professor. The character himself came up with the right approach: "I have this delusion that I'm a vampire." Now we can get right to the good stuff. So pretending that it is delusional material, he tells her his real story. For her, it's the experience of dealing with someone who she thinks is a psychotic and who she eventually realizes is just exactly what he says he is, and falling in love with from the intimacy that honesty creates between them. For him, it's the experience of actually speaking his truth to someone for the first time in all of his lives. And that, as anybody knows who's ever been able to do it, to be able to tell the truth of their life to somebody else who's a sympathetic listener who does not judge them, that is the most powerful experience in people's lives. It's tremendously transformative and strengthening to people. And it is for him too.

JCT: Here we have the psychologist's realization of the truth.

SMC: For her, the world becomes informed with wonder again. She's very jaded and exhausted and ready to give it all up at the beginning. At the end, even though it's a horror that she's encountered, at the same time, it's the assurance that there are wonderful things here still. It's not just guys punching their wives in the nose and kids shooting each other. There are other things happening, there is an element of wonder in the world still. For him it's, that's what I am. Oh, I see now, I speak it and I get it reflected back from you and I see myself. Because remember, he's single, there's only one of him. He's not one of a tribe of vampires, he doesn't create

other vampires, he's the only one. So there's nothing to look at. So for him, it's an extraordinarily strong experience, and I guess for readers, it was too because that chapter went out and got me a nebula, which is really nice; it got me an award as a novella. Then it went on from there. By then, I knew how to get inside his head; I knew what I would find there.

JCT: The world of grand opera plays an important part here. Why Puccini's *Tosca*?

SMC: Yeah, at that time, we would go up to the Santa Fe opera, which is 60 miles from where I live in Albuquerque. It's a small opera house, and it's run by somebody who, generally speaking, is enamored of German opera and French opera, both of which I loathe. But once in a while, he does the Italians, when he knows he has to fill the house: people love the Italian operas. He did *Tosca* that summer, and we went to see it. I was watching the second act, the scene between Tosca and Scarpia, where Scarpia is essentially tormenting her to make her do what he wants. I thought, oh boy, I wonder what my vampire would think about this. I'll bring him to this opera, fictionally, and we'll see what happens. We'll find out. Essentially, I described that production.

JCT: Were you afraid that the reader might not care or know anything about Puccini's operas?

SMC: That was part of the challenge of that story. Part of the challenge was to make it attractive enough so a reader would be interested. That particular production really lent itself to that. I went to the opera house in the winter and I talked to the production director, the stage manager. He was somebody who took me on the tour of the place, and he brought out the score with all the marks, all the prompts, and everything. I went over the whole backstage setup and that gave me another element that readers could be interested in, which is how the thing worked, how the production worked. Then I had the fun of sitting with two librettos and a couple of recordings and timing that story so that everything fell at the right place in the action as it ran along parallel to the action of the opera. So when my vampire has to dump the dead body over the back railing, I've got the right moment in the opera that's got some noise going on so that he can do that without being caught. Nobody will be watching him because backstage is here, there, or someplace else and I know where they are. So that part was wonderful fun, and I just had a blast. Played around with the audience, because the sound of opera audiences is kind of special. So I had a real good time, and I never worried that people wouldn't enjoy it, because it was so much fun to work on. And it was the pivot point, where among all of the points of view, you get in that little story. I slipped the vampire's points of view in there, his blocks of action that were seen through his eyes. People just

don't even notice that they're being slipped into his head and then for the last section, you're in there and you're comfortable and you're prepared to go along with him.

JCT: What kind of realization does he finally come to in the end?

SMC: Well, the major change is that instead of looking at people as just a neck, a vein, he has actually been in crucial relationships with a number of them; and so they've lodged in his mind as real people, not just as good meals. They really were there and they have had interactions with him that leave lasting impressions. So he can no longer look at people as just a neck, because there's always the potential of something real from them, getting involved with them the way it's happened with these other people. So he is afraid to stay in the world because it's too dangerous and too wrenching and too painful to prey on the people whom you might love or who might love you.

JCT: It's almost an allegory about an expanded awareness or poetic sensibility, where suddenly you learn hurtful things about yourself.

SMC: And you can hurt things, and it matters to you. It's about a kind of way of living in the world where you deliberately wall yourself off from other people so that they can't hurt you, but you can hurt them if you want to; and a lot of people live that way. It's especially attractive to men who are taught that they're not allowed to have feelings anyway, and if they do, they might not be able to control them, and it might destroy them. Really, he's a model of a certain kind of self-contained male who doesn't connect to anything. He's a Clint Eastwood figure in some ways. His plan is to run away and change his identity. After he's killed his major persecutor, he's going to change his identity and become somebody else, behave as somebody else, and essentially disappear in the population again. But as he's thinking about doing this, he realizes that he has a past. There are people who matter to him, and he's lost his predatory detachment. At that point, he sees that his only recourse is to retreat into sleep. So he goes into a cave that he's preselected, thinking, "If I'm going to have to do this, I want a secure place to do it in." He goes to his hideout. As he prepares to go to sleep and lies down and is about to drift off, he thinks back about all the people who have been important to him. There's a moment when his whole life comes back to him in a very highly colored and very perceptible way, and that's his reward. At the same time, it's the moment when he lets it all go. Just the way we do when we die. But he's giving up his memories of this forever. He'll wake up in the future, but he will have forgotten it all. This book is my answer to the extremely sexist and misogynist take of the original vampire, Bram Stoker's *Dracula*, in which the vampire is mainly just a wicked and dangerous seducer of women. Then, a band of stalwart young men

under the leadership of an old guy, a wise old man, goes in and destroys them with a phallic stake. Instead I said, well, no, how about the real world, how do things really work. This vampire is destroyed by a progression of relationships with women and children. There is also a man with whom he has a relationship, and that's Irv, the teacher, who's a very warm person, not a killer diller abstract scientist, but a sociologist who's extremely sensitive and, in fact, kills himself because his own emotional life is out of control. So I was kind of deconstructing that little band of stalwart men and replacing them with the people who might really be the ones with the power to deal with such a creature.

JCT: What are some responses from other writers?

SMC: I think I was part of a wave of new kinds of ways of integrating this story into present culture. There are a lot of people writing detective stories now with vampires—the Tanya Huff "Blood Books" series is one like that. So there's been a kind of crossing of the line of bringing the vampire over onto the good guys' side. I didn't do that. What I did was I brought him over into the side where he is a being who has a soul.

JCT: Somebody like Anne Rice seems to be a throwback.

SMC: I think so. It's the romantic stuff and that's what she's been dealing in, and people are still very responsive to it. I think it's deadly dull myself, but a lot of people still get off on that. They think it's wonderfully exotic and kind of upper-classy kind of Gothic—elegant, lovely, smarmy junk.

JCT: Any pressure to write another Weyland story?

SMC: There are readers who want to see him active again, and there is another story, I think, but it may be just a short piece. There's one I want to do, not about forgetting but about remembering. The thing about Weyland is, the reason he doesn't remember his past lives is because if he remembered them, he would become a human being, he would learn from all of that experience. What he'd learn is not to be a vampire but to be a person—one of the prey. So he has to *not* remember. That's the only way he can retain his integrity as a predator. But I'm thinking in terms of, I'd like to do a story that brings that perspective into a world in which we all begin remembering all of our past lives, and he's the only one who *can't* remember. I'd like to see what would happen, but I'm not sure it's more than just a gimmick, just a story rather than a book. I'm not sure there's a book in it. And I'm not sure if I want to do just a story. When I get involved with this figure, I like to be there for a while because it's extremely rich and there's a lot of reverberation. I don't want to just dip in.

JCT: Do you have any favorites among other vampire stories?

SMC: There's a story by Tanith Lee called *The Blood Stone* [1980] that I quite liked. Actually, the one I like of hers the best is called

The Silver Metal Lover [1981], which is about a woman in love with an android. But it's a little bit like Floria and Weyland, and it has some of the same elements and vibrations. I like her treatment of these ideas very much. I can't think of anybody else's that really sticks in my head offhand.

JCT: How about George R. R. Martin's *Fever Dream* [1982], a favorite of mine?

SMC: It's okay. I'm very impatient with the good vampire/bad vampire stuff. I get really bored with that really fast because it just looks like the mafia reworked with fangs. The good guys and the bad guys, the cops and the robbers, and it's boring. I think George is the one that I remember to really set that up with the strong structure, where there's the guy who's got the cure and then there are the other guys who don't want to get cured. The good guys and the bad guys, and I just find it kind of feeble.

JCT: Has the longstanding success of this book been at all a surprise to you?

SMC: Well, I expected it to be a success right out of the starting gate because I knew it was good. It took a lot longer than I expected because there was a lot of bad luck involved, just tremendous bad luck from the beginning. And now there's been a stroke of good luck, several strokes of good luck. So I'm very lucky that I've had a second chance.

JCT: Several strokes of good luck?

SMC: Well, yeah, the first one was that the reason there's a reissue of this book is not because a mainstream publisher said, oh, this is a wonderful book, let's do it. Tor had it out and I said, do you want to reprint, and they said, no, drop dead. I thought it was gone, that was it. I was talking about it with a friend of mine in Albuquerque, his name is Gus Blaisdell, and he's been everywhere and done everything and he loves books, poetry, and horror movies. And he said, "I know that book, that's a good book, I'll publish it for you." I was stunned. I said, "But you publish books of modern poetry, not fantasy." He said, "Yeah, but why not? I put out a couple of good books a year just because I think good books ought to stay in print."

JCT: That's quite a wonderful review in the 28 October *USA Today* by Bruce Allen. He said nothing better has been done in this vein (as it were) since *Dracula*. Wow! Are people interviewing you about this?

SMC: Once in a while, but there hasn't been very much. This is just like a gift from heavens. But that's because when it first came out in 1980 from Simon & Schuster, my editor was locked in a death struggle with the publisher that he was working for and so my book got trashed.

JCT: The vampire is almost an inexhaustible metaphor, isn't it?

SMC: I think it is and I think it's inexhaustible in the sense that you can repeat as much as you want, and it doesn't matter because it's so strong that people continually want to imbibe more of this pattern. So you just keep turning them out.

JCT: We can become addicted ourselves, in a sense, to these stories.

SMC: We have a society that is very bad at intimacy. We don't touch. We're scared of it and we don't do it much. And when we do it, it is fraught. What more intimate touch is there than the kiss that's a bite?

Brian Aldiss (photo by the author)

"The Trillion Year Spree": Brian Aldiss

Brian Aldiss (1925–) holds a distinguished place in the ranks of science fiction *litterateurs*. Now approaching his eighty-fifth birthday, Aldiss has garnered every conceivable honor and award in the field, including the prestigious Hugo and Nebula Awards, the British Science Fiction Award, and the first James Blish Award. In addition to his prolific output of speculative fiction, he is a noted novelist, critic, anthologist, and essayist. His *Hothouse* (1962) and *Report on Probability* (1967) launched the "New Wave" of British experimental speculative fiction. His *Helliconia Trilogy* (1982–1985) is ranked among the modern classics of apocalyptic fables. His autobiographical works include *A Soldier Erect* (1971), a chronicle of his years in

Burma during World War II. As we have already noted, there have been no more thoughtful and sharply intelligent examinations of the history of science fiction as an outgrowth of the Gothic mode than his two volumes, *The Billion Year Spree* (1973) and its sequel, *The Trillion Year Spree* (1986). Film enthusiasts perhaps know him best for his short story, "Supertoys Last All Summer Long," which inspired the Spielberg-Kubrick film, *A. I.*[21] His most recent novel is *Walcot* (2010).

Of particular interest here is his trilogy of novels derived from and expanding upon Mary Shelley's *Frankenstein*, Bram Stoker's *Dracula*, and H. G. Wells' *The Island of Dr. Moreau*—respectively, *Frankenstein Unbound* (1973), *Dracula Unbound* (1991), and *An Island Called Moreau* (1980). They are classics in the postmodern interrogation of the Gothic tradition and have helped pave the way toward today's Gothic time-twistings and alternative worlds of steampunk.[22] In *Frankenstein Unbound*, nuclear explosions in the stratosphere have brought about "time slips" that threaten to tear apart the fabric of history, space, time, fiction, and reality. In *Dracula Unbound*, vampires are stalking history and threatening the very survival of their prey, mankind. In *An Island Called Moreau* [alternative title: *Moreau's Other Island*], a global war is threatening to annihilate mankind unless Dr. Moreau (renamed Mortimer Dart) can create a race of mutants to repopulate the planet. Aldiss seizes upon the fact that each of these classic novels is about man's attempt to create artificial life, but life without soul or spirit. These transgressions against the natural order—a monster stitched out of cadavers and given life by electricity, an "undead" vampire who subsists only by preying on mankind, and beast-men who are neither man nor beast—threaten to procreate and replace mankind.

Brian Aldiss is an outstanding example of that vanishing breed, the Man of Letters. His credo comes from Bishop Berkeley: "This making and unmaking of ideas doth very properly denominate the mind active...."

He lives in England.

Interview

Mr. Aldiss came to the University of Kansas in July 2004, where he was inducted into the Science Fiction Hall of Fame. Under the guidance of author and educator James Gunn, the university has for many years been the site of the Center for the Study of Science Fiction and its annual summer writers' seminars. "It seems that when you get fossilized, you're inducted into Museums and Halls of Fame," Aldiss wryly said at the time. Later, I sat down with Aldiss for a chat, which included his boyhood memories, his postmodernist views on the Gothic tradition, and his work with filmmaker Stanley Kubrick. His trim, white mustache, shock of white hair, slightly knit brow, thrusting chin, and generally tweedy deportment identify him as a Proper English Gentleman. But don't be fooled. He's as

uncomfortable with that label as with any other kind of categorization, *including* the appellation "science fiction writer."

JOHN C. TIBBETTS: Okay, you've said you're uncomfortable with the designation of "science fiction writer." Why?

BRIAN ALDISS: "I feel that we should rethink the term, "science fiction." If you get that label put onto you, it deters you from having your own voice. Which can destroy you. If you're going to be a writer, you have to find your own voice or you're nothing. I think I began to look for my own voice very early on. I grew up in a dull, middle-class family. We had a shortage of books in the house. My parents were religious, and on a Sunday the only books to read were the Holy Bible and Bunyan's *Pilgrim's Progress*. I suppose I could describe myself as an "auto-didact." I was discovering writers like J. B. Priestley and Thomas Hardy, Dickens, any book that was in the school library, including a dose of Freud; even some science fiction. Early on, at the age of four, I suppose, I was writing and illustrating short stories and binding them in wallpaper and putting them up on my nursery shelf.

JCT: In one of your essays, you refer to your father as a "Prospero-like" character—someone to be respected rather than loved.

BA: I could never interest my father in any of the things I read, in any of the things I wanted to do. He worked in my grandfather's shop and ran the Gents' Outfitters department. I'll never forget one day when he looked around the room and uttered those ghastly words, "Son, one day all this will be yours." Well, all those things would never be mine. Science fiction became my escape clause. At the age of six, I was sent to a preparatory school. Preparatory for what, God knows. But at least there in that rotten little dormitory, I learnt to tell the other kids stories when the lights were out. What did I tell them? It happened my family had moved to a house that proved to be severely haunted. And so I told them stories based on our ghost. And when one of the boys would dive under the covers and shout, "Shut up all this, you bastard!", I felt—"Ah! What a power!" The power was there! All storytelling begins with the wizard around the campfire telling stories to hold the others in thrall. That's what I did. Then, sometime in the mid-1930s I went on to a public school that was much more competitive. It was a horrible, sadistic school, actually. The great thing was if you were a new boy in the dormitory consisting of 30 beds, you had to get up on your bed and tell a story. And if it didn't gain acceptance, the boys threw shoes at you, hard. Well, never a shoe hit me! I became the dormitory storyteller. It was a crucible of experience, in a way. I was in competition with another boy, who told stories about natural history. I told "serial" stories. After 20 minutes, I would get to a cliff-hanger ending, and then I would say, "I'll tell

you more tomorrow." They'd say, "C'mon, tell us now!" I would say, "Sorry, I haven't made it up yet!"

JCT: What kinds of stories?

BA: They were stories about guys going to other planets, giant robots, frogmen from the Sargasso Sea. This would go on, night after night. Lights out is the best time for stories, but the rules very strictly forbade it. The House Master had a little peephole, so if he heard a voice, he would come in with a cane twitching in his hands. Reluctantly, I would come out and he would beat me, through my pajamas. Many a scar I carried. And, of course, because of this, I became a hero to the other boys. Whether I was beaten or not, I would go on, telling my stories. The experience has taught me not to fear the critics! I feel that I've become very secure as a result of that.

I began to write my stories down. Since I had reached puberty, some of them were sexual stories. I knew very well if they were discovered by any of the masters, I would be sacked. But the excitement of writing them was very strong. They would circulate all around the form, and then round the lesser forms in the school. They were humorous, in the manner of the "Yank Mags," the type of thing sold in Woolworth's—the three-penny and six-penny stores, like your dime stores.

JCT: And I suppose you were watching movies, too...?

BA: My sister and I always went to the cinema. Those were the days when there were continuous performances, from 11:00 to midnight—whence came the expression, "This is where we came in" (which now is obsolete). You could go in to the middle of the film and try to figure out what had gone before. We always liked the B movies, so we could see it first, then the main feature, then the B movie again. And the American films like *Stagecoach* and *Dodge City* and *They Died with Their Boots On*. And a few British things like *A Matter of Life and Death*. That's the one where Heaven was in black-and-white, and the scenes on Earth were in Technicolor. There's a marvelous joke in there, when the Heavenly Messenger comes down to Earth and watches his black-and-white rose change into color. "Ah," he says, "the blessings of Technicolor!" I was learning that the cinema is very strong on fantasy. It will always be like that. Like T. S. Eliot said, "The human mind can't stand too much reality."

[Note: Aldiss got a good dose of "reality" while serving in the Royal Corps of Signals in Burma and Sumatra during World War II. He had joined up at the tender age of 17. It was a time, he has written elsewhere, "of suffering and mutation." Shortly before the advance on Japanese-held Mandalay, while awaiting a typhus injection, he stumbled upon a copy of Olaf Stapledon's classic *Last and First Men*. Published in 1930,

it is a masterpiece of unbridled imagination, chronicling nothing less than the evolution of the entire human race from World War I until the death of humanity on the planet Neptune 2 billion years later. For Aldiss, it was the proverbial shock to the system. "What sustained me then," wrote Aldiss years later, "as we advanced across the Burmese plains, was (Stapledon's) bleak vision of humankind locked within the imperatives of creation." Stapleton's influence on Aldiss has been profound. Meanwhile, immediately after his demobilization, there was the business of making a living.]

JCT: Take us back to your release from the service. What was Brian Aldiss like at that time?

BA: When I came back from the Far East after four years, I was no longer an adolescent, but a seasoned man. I didn't fit in to anything. There had just been a general election, in which the old war hero, Churchill, had been thrown out for a Socialist government that brought in the National Health Service. No one wished to know what had happened to you, or what the places were like that you had seen. But even though I had been in Sumatra and had fought for my country, I couldn't vote because I was under 21. I was broke and life was awful. For years I felt very estranged from it all. The only job that opened to me was an opportunity to become an architect. My uncles wanted me to join their company. Fortunately, I had a charming cousin, John Wilson, who told me, "Brian, just don't do it. You're seven years working until you get your final exam. And you're already behind in the rat race." That proved to be very good advice, so I didn't do it. Instead, I still had this ambition to tell stories. I wanted to write a novel about my Army days in Sumatra. However, I found out right away that I could not allow my troops to speak as they really did. So I gave it up. But years later came the trial of *Lady Chatterley's Lover,* around 1962, I think. After that court case, I could write in the way the soldiers really talked, including all the obscenities!

JCT: And what were you writing at that time?

BA: From around 1948 onward, I was starting to write seriously. I edited a magazine and wrote most of the stuff myself. When my first book came out in 1955, a series of humorous essays called *The Brightfount Diaries,* published by Faber and Faber (that wonderful firm), it was a success. People laughed at my jokes. How extraordinary. So I went on to write a science fiction novel, *Non Stop* [1958]. I enjoyed setting stories in the future and on distant planets (I did, after all, seriously believe in the existence of other planetary systems at a time before such thinking became popular). There were no literary agents at that time who knowingly would handle science fiction. The editor of the leading magazine, *New Worlds*, whose name was Ted Carnell, said to me, "Brian, I could

sell this novel for you abroad." He went to Criterion. At that time the title was changed to *Starship*, which gives away the first surprise of the book."

[Note: Aldiss was coming along at about the time of a so-called New Wave movement in science fiction. *New Worlds* magazine had been founded years before by British fans, and under the editorship of E. J. "Ted" Carnell, it had published groundbreaking work by Arthur C. Clarke, J. G. Ballard, and Aldiss. Since 1964, under the guidance of Michael Moorcock, the magazine ventured into more experimental directions, a new wave of science fiction that reflected Moorcock's personal admiration for the work of William Burroughs. *New Worlds* became the mirror of what Moorcock regarded as "our ad-saturated, Bomb-dominated, power-corrupted times." The time was ripe for writers like Aldiss to venture into new territories, to chart new regions of what Kingsley Amis had once described in his history of science fiction as "New Maps of Hell." It was also a time when Aldiss ventured into a "postmodern" examination of the Gothic traditions underlying much of science fiction. For example, during the writing of *The Billion Year Spree*, Aldiss's classic history of science fiction, he renewed his respect for Mary Shelley's *Frankenstein: Or, a Modern Prometheus* (1817). Convinced that the beginnings of real science fiction are found in the Gothic novel, Aldiss plunged into a fresh study of Mary Shelley and her circle, resulting in, among other things, a novel called *Frankenstein Unbound* (1973).[23] It is a fascinating mixture of the real and the imaginary, in which the time-traveling protagonist, Joe Bodenland, goes back to 1816 to become part of the Shelley circle and mix with the fictitious characters in her book.]

BA: Yes, I have written several books, or variations, on classic Gothic themes. After I had written *A Billion Year Spree*, I thought that of all the thousands of novels that I had covered, the one that continually engaged my interest was Mary Shelley's *Frankenstein: Or, a Modern Prometheus* (1917). The movies have always played it up for the horror element. I hoped in a way to "redeem" the book from such gross caricatures. The impulse behind my writing *Frankenstein Unbound* was, in a way, exegetical. I hoped to explain to people what Shelley's story was really about. She wants to deal with the "secret fears of our nature." I've always thought yes, that's one of the things that real science fiction does: treat "the secret fears of our nature." It's by no means about the future. Hence, I wrote my Frankenstein book.

JCT: It was made into a movie. How did that happen?

BA: Eventually it was picked up by Roger Corman. He was a very nice man. He came to my house with his producer, and they had dinner with me. At the end of the meal, I suggested that if he made *Frankenstein Unbound*, he would then have to film its sequel,

Dracula Unbound. In a moment of foolish generosity, he said, "You write it, I'll film it." So, I had to go ahead and write *Dracula Unbound* [1991], a sort of continuation of the earlier book, in which I retained the character of Bodenland. But in fact it was far too long and needed too many special effects. And so when I sent it to Roger, he didn't say anything. I never heard back from him. Later, I got him to be invited Guest of Honor at the Conference of the Fantastic. And he came along with his charming wife. I sidled up to him and said, "What did you think of *Dracula Unbound?*" All he said was, "You know I can't film that, Brian, I'm just a cheapo outfit." This from a guy whose autobiography was titled *How I Made a Hundred Films in Hollywood and Never Lost a Dime*! But he was a charming man.

[Note: Shelley, Stoker, and Wells are Aldiss's great triumvirate of monster-makers. Their creatures all hint at the great mutability of mankind. "The beast in the human, the human in the beast—it's a powerful theme," Aldiss has written in his essay, "Wells and the Leopard Lady"—"and one that seems in Wells' case to owe as much to inner emotion as to evolutionary understanding." Thus, *An Island Called Moreau*, the third novel in Aldiss's Gothic project, recasts Wells' novel with the character of Dr. Mortimer Dart, whose experiments in genetic mutations arouse the suspicions of a castaway, Calvert Roberts. Dart ultimately escapes Robert's attempts to destroy his work, and at the end of the story, he flees, hoping to find a world that can benefit from his knowledge.]

BA: You would think with my writing *An Island Called Moreau* that I would be proceeding with some sort of plan to finish a trilogy started by the Frankenstein and Dracula projects [in Britain it was published under the title *Moreau's Other Island*]. No, there was no plan. There was too much time between the first two, and the third came even later. But certainly I saw that the things that had been done in Wells' original novel by vivisection could be done in a more sophisticated way by genetic mutation. I admire Wells greatly, and in my novella, called *The Saliva Tree* [1973], Wells was a real character.

JCT: Do you see these books as postmodernist forerunners of today's fascination with virtual history and counterfactuals?

BA: I'm not really happy about terms like that. But it's true that this sort of thing demonstrates the way fiction permeates our lives. You couldn't live without fiction. Indeed, it is as real to us as anything else in our waking lives. Books like this are all over the place, now. You find Jane Austen as a character in a series of detective novels. And there's *Wide Sargasso Sea*, by Jean Rhys, which is a "prequel" to *Jane Eyre*. It speaks to something of the way in which the generic divisions have dissolved under the excitements and pressures of modern life. Having written

my own autobiography, I realize that I've assumed a role in my own mythology. It's changed me in a way, made me feel that I'm free now to do what I like, win or lose. Do you suppose authors in the future will reference me as a character in their own fictions? What a terrible fate! Reminds me of a story by Max Beerbohm, "Enoch Soames." The title character makes a pact with the devil to peek into the future to see if he's referenced in the histories of literature. And he finds he's only a fictional character in a work by Max Beerbohm! Hilariously wonderful! The trouble is, critics take this sort of thing and call it "postmodern" and serve it up with all kinds of academic phraseology and references to Derrida and all of that. It's unreadable. What would George Orwell make of it?

[Note: Aldiss first met Stanley Kubrick in the mid-1970s. In *The Billion Year Spree*, he claimed that *Dr. Strangelove*, *Clockwork Orange*, and *2001* qualified Kubrick as "the great of writer of the age." Kubrick loved science fiction, notes Aldiss. He admired Spielberg's *E.T.* and was impressed at the box office profits of *Star Wars*. A fan of Ridley Scott's *Blade Runner*, he was convinced that artificial intelligence would supersede mankind. Duly impressed with Aldiss's accolade, Kubrick telephoned him in 1975 and invited him to dinner.]

BA: My claim was made partly—but only partly—tongue in cheek. I was actually raising a finger to all the guys who were making big, big claims to be the "great" science fiction writer (Alfred Bester was one of those). I found out that Kubrick had bought my book and that he particularly enjoyed my remark. He had just finished his version of the Thackeray novel, *Barry Lyndon*, which had had a very negative reception, and perhaps he was still uncertain about what to do next. We had lunch together, and it went extremely well. He had his own private restaurant in Boreham Wood. We had a lot of fun, a lot of laughter. With the beard, curly hair, jungle greens and boots, he looked like Che Guevara! A little later, my wife Margaret and I were invited to what I call "Castle Kubrick," this enormous place of his in St. Albans. We had lunch with him and Christiane, his charming wife. He asked me to send him some of my work. I sent him my new novel, *The Malacia Tapestry* [1975] and a collection of short stories. The novel is full of theatrical scenes and chiaroscuro moods and effects. I thought it might be of interest to Stanley. I also recommended Philip K. Dick's novel, *Martian Time-Slip* [1964], but Kubrick wasn't interested. Eventually, he picked my short story, "Super Toys Last All Summer Long." I love that title, by the way: It's poetic, it sounds innocent; but when you think of it, you wonder, "What's going to happen in the *Fall*?

[Note: "Supertoys" was first published in 1969. It is set in the near future, when overpopulation has necessitated strict State control over

reproduction. Denied permission to have a child, Monica and Henry Swinton acquire an android substitute, three-year-old David, a product of biochemistry and synthetic flesh. But David is no mere machine. He is capable of love. And when he is unable to win the love of his mother, he is baffled and disappointed. The story ends when David, who is only dimly becoming aware that he is not human, learns that Monica and Henry have at last won permission from a State Lottery to conceive a child. At the story's end, David overhears his parent's plan to return him to the factory. Years later, Aldiss wrote two sequels, "Supertoys When Winter Comes," and "Supertoys in Other Seasons." In the first, David is damaged in an accident while fleeing his father's house. In the second, David, who has suffered damage during his flight, is reconstructed by a mechanic. He reunites with his father, who intends to rebuild him into a more sophisticated android.]

BA: Stanley liked "Supertoys" and offered to buy it. I was a bit strapped at the time so, after a lot of haggling, I sold it and went to work with him on a screenplay. The process took years. It was interrupted by his filming of *The Shining* in 1980. It wasn't until two years later that we resumed work on it. A limo would come for me at my door on Boars Hill about 9 in the morning, drive me over to Castle Kubrick, where I would work all day. I'd start in about 10 and Stanley would be coming downstairs, just dressed. He'd be up all night until about 5 in the morning so he could communicate on the phone with his friends in California. Poor old Stanley, it was rotten luck that e-mailing had not yet been invented. But that was the way it was. Before we would do anything, we'd go for a short walk. He wanted to enjoy the fresh air, he said. That was a joke. Our walks lasted just a few minutes. After a day's work, when we smoked a lot and drank gallons of coffee, the limo would drive me back to Boar's Hill. At night, I would write up the day's notes and fax them to Stanley. It wouldn't have been possible to work with him without the fax machine. You can find all of those notes today in my cupboard at home. They are destined for the Bodleian Archive (but you can have them if you offer me a fabulous sum!). From very early on, I doubted how my story, just a vignette, really, could become a full-length movie. But Stanley reminded me that he had taken Arthur C. Clarke's short story, "The Sentinel," and done just that. "It's easier to enlarge a short story into a film than to shrink a novel," he would say.

JCT: But Kubrick has such a reputation for being difficult, and taking so much time for projects, that you must have thought it would never happen.

BA: Yes, of course. And there were other doubts. I should have taken the hint that Stanley intended all along that my character of David would be a kind of "Pinocchio" figure, that he would meet the Blue Fairy in his desire to become a "real boy." I didn't want to

do that. I always felt the "Pinocchio" idea was vile. I felt this was looking at the past, and that it would be better if we could create a more modern myth. But it was not to be. I couldn't change his mind. It was not in his nature, and everyone who worked with him knew that he wouldn't listen to arguments. But the guy was a genius! Look, you just can't say to Beethoven, "Don't you think you should have a B-minor chord there instead of an A-major?" You just don't do this. Stanley would always handle such arguments in his own humorous way. He'd interrupt things suddenly, and say, "Let's go see Christiane!" And we'd walk through this great labyrinth of rooms to the ballroom, which was a wonderful room, where Christiane would be sitting with her easel and palette painting bright pictures of flowers. She was so sweet. The day was wasted if I didn't have a smile from Christiane.

JCT: What kept you going?

BA: Throughout all of this, my wife Margaret said to me, "Darling, why are you doing this to yourself?" I had enjoyed my own creative independence for many years. But I knew that you expect a rough ride when you work with a genius. But you see, I had a semiconviction that I was *also* a genius in my own way. At least one thing Stanley and I had in common was that we were both *restless*, that we were always trying something different from what we had just done. I had always regarded my ability to write narrative as one of my strong points. But Stanley rejected my reliance on narrative. He said to me, "You don't need *narrative*, here. This is a *movie*. What you need in a movie are six or seven 'nonsubmersible units.' And then you're home." That was his phrase, "nonsubmersible units." And that was what we concentrated on. And when you think back to his films, it makes things a lot clearer. For instance, in *The Shining*, you have these kinds of "units." Whenever a simple blackboard [title card] goes up, announcing, "Tuesday," or "A Month Later," you think, God, what awful thing is going to happen *next*? Sure enough it does. No narrative. Just a blackboard. Think of individual chunks of scene, character, dialogue in *2001*. They may not seem to quite fit together, at first, but that's good. How do you make sense of images of individual scenes of monoliths and computers and apes and a cosmic fetus? Your intellect takes those disparate elements, those contrasts, and *wills* to make the pieces fit together. Think of each of them as irritants—*good* irritants that drive things forward. Without the grit, you don't get the pearl. That's the reason we sustain our interest throughout the film.

JCT: Hardly a new concept, though. You can find ideas like that back with the Soviet filmmakers, Eisenstein, and Dovzhenko.

BA: And I think I had been doing things like that already in my writing, but without being conscious of it. Since then, I have pursued

it further in my own recent writing. My novel, *Super State* [2002], a futuristic fable, which has not been published in America, had many of these units, or scenes and characters, that at first don't seem to cohere, but that gradually accumulate into basic structures important to the larger meaning. I try that in my new book, *Affairs at Hampden Ferrers* [2004], about the lives of various people in a small, Oxfordshire village. *Hampden Ferrers* is not science fiction, exactly, but it concludes with some pretty cosmic questions, all right. Come to think of it, maybe humanity in general is a kind of nonsubmersible unit in the Cosmos!

[Note: A crucial stumbling block to Aldiss and Kubrick was how to visualize the boy, David. A real boy could be cast as the android, certainly, but Kubrick, ever the perfectionist, suggested that a real android might be built. After discussing—and rejecting—the technological possibilities and limitations at the time, the project was eventually scrapped. Computerized special effects were not yet available. Kubrick went on to make *Full Metal Jacket* (1987) as his next project. After his death, it would fall to Steven Spielberg to take all three of Aldiss's "supertoy" stories—including the Kubrickian notions of a "Pinocchio" allegory—as the basis for *A. I.*]

BA: I'll never forget something Stanley once asked me. "Brian," he says, "what do people do who don't make films or write science fiction?" The last time I saw Stanley was at Castle Kubrick. I'll never forget the day when he suddenly said, "It's not working, Brian. We'd better part company." He was very blunt about it. He just lit a cigarette and turned his back on me. He didn't even say goodbye. The limo was waiting. You see, he worked like that. The same thing happened to Malcolm McDowell, who worked with him on *Clockwork Orange*. He had felt he was a close friend of Stanley's. But he was also hurt when after the film he never saw him again. The relationship just stopped. There was always this sense that he was nourishing the myth that he was a creative, but eccentric and isolated genius. But I still go back to Castle Kubrick, from time to time. For New Year's parties and summer carnivals and that sort of thing. Christiane is still there, of course; and she has the support of her family, including her very talented brother, Jan Harlan. Tony Frewin is in charge of the Archive. We all get on fine.

JCT: What's this I'm hearing about you thinking about working on an opera?

BA: A *science fiction* opera, if you will... While at Castle Kubrick not long ago, I met a composer named Henning Lohner. He composes film music. We got to talking about an idea I have for an opera. *Oedipus on Mars*, which would be based on my new novel, *Jocasta* (a reworking of Sophocles). He's coming to see me in August.

It's really on my mind, right now. It's the sort of thing that could only be an opera, because of its fantastic elements. In the backstory, the goddess of fertility, Ishtar, has a sister who rules in the Underworld. After her love for Gilgamesh is rejected, Ishtar goes down to the Underworld to force the Dead to build her a great wooden boat. She kidnaps Oedipus and all of Thebes into the boat. The Dead row this great boat across the heavens to Mars. That's where the bulk of the drama is set. They find a Mars that's green and beautiful. And it's the destructive love between Ishtar and Oedipus that dries up the planet, leaving behind the desiccated shell we know. That's how it ends.

[Note: It's been an eventful life. In his essay, "The Veiled World," Aldiss looks back on his life as a "series of successive selves." There was, he writes, "the adventurous small boy, the unhappy lad at school, the macho soldier in the war, the wage slave, the lover, the traveler, the timid scribbler, the family man, and now the most unlikely avatar of them all—the established writer." He is proud of his four children, of his regular appearances on BBC TV, of his frequent invitations to be Guest of Honor at science fiction gatherings all over the world, his work as a respected literary editor and critic, and, most recently, of his induction into the Science Fiction Hall of Fame. In the introduction to his collection of stories, *Man In His Time* (1988), he wrote that the world and the universe is a problematic place. "It is hubris to think we yet have it all figured out." The field of writing, once proud of its "outsider" status, has plummeted to respectability.]

BA: I'll always be an outsider, a Steppenwolf, I suppose. I've felt that all of my life. I remember one day, long ago, as a boy I was at home, sitting in the living room, while my father read his newspaper by the fire. I was reading a story in *Astounding Science Fiction,* edited by John W. Campbell. I thought that story was so wonderful, so breathtaking, that I felt compelled to share it with him. My father wasn't a man you would easily approach, but I asked him to read the story. He put his paper down and read it through. He never changed his expression. At the end, he put it down, picked up his newspaper, and continued without a word. I was desolated. I cannot tell you. I thought, he has such a contempt for this. I felt so bad. For years, I felt badly that I couldn't share this with him. Long after, as an adult, I realized that the old fool didn't understand it. But at least I eventually found that small community of science fiction people who could communicate with each other....

JCT: What's life like for you these days in England?

BA: I live now in Headington, a comfortable part of Oxford. I realize that as a single man I must fend for myself in the everyday world—do the shopping and the laundry and all of these things that don't come naturally to an unregenerate old chap. But you

know, my life has rarely been better. Lots of interests, and I can do what I like. I turn 80 next summer, you know. The family will be around me, and there'll be lots of dancing, music, drink, and presents. But that younger me, that boy who insisted on telling stories in the dormitory, is still around, I suppose.

JCT: Might I suggest you are your very own "submersible unit"?

BA [laughs]: Touche! You know, there are always those larger things that I think about more and more— the origins of mankind, the planet, the universe: how does it all happen and how does it all work out? So, the writing goes on. I find there are moments when out of nowhere comes a line of dialogue, and I'll say, "Yes, so-and-so must say *that*." And I'll write it down, and later it'll pop up in my writing. . . .

"Savage Pastimes": Gothic Schlock and True Crime Horrors: Harold Schechter and Rick Geary

The incapacity of sound sleep denotes a mind sorely wounded.Charles Brockden Brown, *Edgar Huntly* (1799)

Harold Schechter, a professor of American literature at Queens College, the City University of New York, and artist Rick Geary, a New Mexico–based writer-illustrator, are friends who share a passion for Gothic-inflected violence and true crime horrors. We first hear from Professor Schechter. Among his more than 30 published books are *The Bosom Serpent: Folklore and Popular Art* (1988), *Savage Pastimes: A Cultural History of Violent Entertainment* (2005), and a half-dozen historical true crime narratives, a series of mystery novels featuring Edgar Allan Poe, and an anthology of American true crime writing published by the Library of America.

Schechter Interview

Our conversation transpired from Professor Schechter's home in Brooklyn on 19 January 2011.

JOHN C. TIBBETTS: If you could take Mephisto's magic cloak and go back in time to that first generation of Gothic writers, who would you want to visit and talk to and what would you ask them?

HAROLD SCHECHTER: Since I lead a double life as a professor of American literature and a true crime writer, I'd have to go with Charles Brockden Brown, the father of American Gothic fiction. I love his 1798 novel *Wieland* for several reasons. The Evil

Drawings by Rick Geary (courtesy of Rick Geary)

Ventriloquist Dummy is one of my favorite horror motifs, and *Wieland*, so far as I know, is the first Gothic tale to exploit the creepy potential of "biloquism" (in Brown's terminology).[24]

JCT: Yes, I remember being puzzled by the term. First time I ever heard it.

HS: Yes, the character of the villainous Carwin was a "biloquist" or ventriloquist. And it was also the first American novel to base its plot on an actual, real-life murder case: the family massacre perpetrated by James Yates, a farmer in upstate New York who slaughtered his wife and four children in December 1781. It thus stands at the head of a literary tradition that includes Theodore Dreiser's *An American Tragedy*, James M. Cain's *Double Indemnity*, Robert Bloch's *Psycho*, and every other novel, short story, or script "ripped from the headlines."

JCT: And doesn't Brown set some of his stories outside the usual haunted castle, or house?

HS: Indeed. Think of *Edgar Huntly*. In fact, I devoted a chapter of my doctoral dissertation to it. *Huntly* was a pioneering work in which Brown deliberately set out to transpose the conventions of the European Gothic to an American setting, substituting, as he puts it in his preface, "the incidents of Indian hostility and perils of the Western wilderness" for the "puerile superstition and exploded manners, Gothic castles and chimeras" of his predecessors."[25] Beyond expressing my admiration, I'm not sure what I'd say to him, though I'd want him to know that, in writing *Edgar Huntly*, he hit upon a theme that turned out to be central to our cultural mythology: the civilized, peace-loving man who makes a journey into the savage wilderness where he is reborn as a stone-cold killer (what the scholar Richard Slotkin calls the theme of "regeneration through violence").[26]

JCT: Do your students know about these books? Based upon your experiences in the classroom, what sorts of horror and fantasy and science fiction are they reading and watching? Do they even know much about the Gothic tradition?

HS: I'm always disheartened by how few current films and classic books my undergraduates see or know about and how unaware they are of the Gothic as a literary mode. I suppose the *Twilight* movies and novels are the ones they're most familiar with (though a few of them would be able to identify those fantasies as part of a centuries-old imaginative tradition). On those rare occasions when a serious horror film is a blockbuster event, they'll probably go see it in the theaters, though I can't think of an example more recent than *The Ring*.[27] Thankfully, there are generally a few fanboys (and girls) who can be counted on to have watched at least some of the more obscure movies I mention in class. This semester, for example, I had a couple of students who shared my enthusiasm for *Let the Right One In* (the original Swedish version), *The Human Centipede*, *Splice*, and *Joshua* (an excellent Psychopathic Child film, my second most favorite genre after the Evil Ventriloquist Dummy movie). Perhaps unsurprisingly, I find that the hardcore horror buffs are the most literate of my

students, since they tend to be early readers of writers like Poe, Lovecraft, Bradbury, and King.

JCT: Because of your interests in the macabre and the irrational, do your students (and their parents!) assume you're spending your nocturnal hours away from the academy indulging in "savage pastimes"?

HS: I think my colleagues are more prone to see me as leading a strange, schizoid existence—English professor by day, crime writer by night (though, in fact, I do my writing in the morning). And to tell the truth, even I am sometimes struck by the bizarre nature of my professional life. While my colleagues are off delivering papers on "Iconic Syntax in Modern Poetry" or "Difficulty and Indeterminacy in Late Medieval Narrative," I am far more likely to be invited to address gatherings of homicide detectives on the subject of "Albert Fish, America's Most Notorious Cannibal Pedophile." And I am certainly the only member of the Queens College English faculty to have appeared as a guest on *The Jerry Springer Show* ("Women Who Love Serial Killers" was the topic, and I am happy to report that no one got punched out; this was in 1996 before the show turned into an "I-Slept-with-My-Boyfriend's-Dad" slugfest). As for my students, they are, for the most part, oblivious of my expertise in the field of psychopathic sex-murder, though I sometimes have occasion to bring up the matter in class. In one of my literature electives this semester, for example, we were examining the theme, common to female fantasy, of women who find themselves torn between dutiful but dull husbands and seductively dangerous lovers, and I related it to the phenomenon of serial killer groupies. Every now and then, however, I'll have a student who shares my interest in serial killers and is familiar with my work, usually *The A to Z Encyclopedia of Serial Killers* [1996], which they have actually purchased and will sometimes bring to class for me to autograph. I try not to let such behavior influence my objective evaluation of their class work, though I notice that those students tend to be unusually bright and receive an inordinate number of "A's"!

JCT. In your book, *The Bosom Serpent*, you seem to say there's "nothing new" in our current state of science fiction and horror stories and movies. As if no matter how far we stray out into other galaxies and how deeply we delve into visceral horrors, we're still drawing upon time-honored Gothic traditions and folklore...

HS: I would go further and say that the Gothic itself is a particularly time-bound manifestation of a far more archaic narrative tradition. For whatever reasons—followers of Freud, Jung, Fry, Levi-Strauss, Lacan, etc., would all have different explanations— our psyches are so constituted that we thrive on the kinds of

entertainments folklorists call "wondertales": beguiling, grip-
ping, swiftly paced stories that trigger a very basic and power-
ful emotional response in the audience: astonishment or terror,
laughter or tears, suspense or erotic arousal. In preliterate times
and places, such stories were communicated orally. Now we get
them through computer-generated images. But if the technologi-
cal means of disseminating those stories has evolved, the narratives
themselves have remained essentially unchanged. Human beings
throughout the world, for example, have always been enchanted
by the adventures of "Thumbling" characters (as folklorists call
them): inch-high heroes who ride rodents as steeds and do battle
with monstrous garden spiders. Once upon a time, people would
sit raptly around the communal hearth, listening to the tribal tale-
teller spin such thrilling tales.[28] Then came illustrated children's
books about Tom Thumb. And movies like *The Incredible Shrinking
Man* (1957), comic books like *The Atom*, and TV shows like *Land
of the Giants*. Now there are video games where players can travel
to distant jungle planets and fight colossal insects. I'm sure that in
the not-so-distant future, there will be virtual-reality versions of
the same story, where the experience is totally immersive—where
we actually feel the giant tarantula's blood as it oozes onto our
faces when we impale it with a sewing-needle sword. I, for one,
can't wait.

JCT: Can you give some examples of popular films and stories that
display folkloric connections?

HS: The connections are so extensive that even a glimpse at Stith
Thompson's *Motif-Index of Folk-Literature* [1932–1936] makes it
abundantly clear that the vast bulk of sci-fi, horror, and fan-
tasy films are simply the modern, mass-produced versions of
age-old wondertales. I first became interested in this subject
when I noticed the parallels between the "chest-burster" scene
in Ridley Scott's *Alien* and very old folk tales about people who,
having accidentally ingested snake embryos, frog's eggs, or sala-
mander semen, eventually expel the full-grown creatures from
their bodies. Nathaniel Hawthorne, who was always on the
lookout for bizarre folk beliefs, could turn into moral allegories,
uses this motif in his story "Egotism, or, The Bosom Serpent"
(a title I appropriated for my 1988 book *The Bosom Serpent:
Folklore and Popular Art*). Another movie whose essentially folk-
loric nature has always fascinated me is the original *The Texas
Chainsaw Massacre* [1974]. Though very loosely inspired by the
atrocities of the 1950s necrophile and serial murderer Ed Gein,
the film is really a cinematic, Vietnam-era version of a folk-tale
type known as "The Bloody Chamber," in which a character—
generally female—is warned not to enter a particular room.
Disobeying the injunction, she ventures inside and discovers a

roomful of butchered victims whose ranks she promptly joins. The best-known example of the story is "Bluebeard," though variants have been collected from cultures around the world. Exactly why this fantasy exerts such profound and widespread fascination is a question no one has satisfactorily answered. What the power and popularity of Tobe Hooper's splatter masterpiece makes clear, however, is that much, if not most, of contemporary horror (whether the creators are consciously aware of this or not) is an updated reimagining of the timeless themes and story-patterns of folklore. And there's *The Incredible Shrinking Man*—a specifically 1950s retelling of the "Thumbling" tale. In general, low-budget horror and sci-fi movies— unpretentious entertainments that aspire to no higher purpose than providing the audience with thrills, chills, wonder, and titillation—are rich in folkloric elements, that is, in those narrative themes and motifs that have delighted ordinary human beings from time immemorial. Indeed, it's possible to go through the standard catalogue of folk-tale types compiled by Thompson and find cinematic equivalents of almost all of them.

JCT: Even extreme and tacky examples of horror movies, what we call *schlock*?

HS: You don't have to look for such schlocky fare as *The Brain that Wouldn't Die* [1959], *The Living Head* [1959], and *They Saved Hitler's Brain* [1963]. What you're really seeing are sci-fi analogues of the folk-tale motif known as "The Severed-Yet-Living Head." Similarly, movies like *Mesa of Lost Women* [1952], *Cat Women of the Moon* [1953], *Fire Maidens from Outer Space* [1956], and *Voyage to the Planet of Prehistoric Women* [1968] are really Grade Z versions of the tale type called "Voyage to the Land of Women." And any folklore scholar worth his salt would recognize movies like *I Married a Monster from Outer Space* [1958], *The Fly* [1958], and *Mr. Sardonicus* [1961] as variants of the folk-tale archetype known as "The Monster in the Bridal Chamber."

JCT: Ah, my misspent youth at the local movie theater!

HS: Me too!

JCT: Do you think these things are positive responses to the horrors of the surrounding real world...or are they escapes?

HS: I say in *The Bosom Serpent* that while sci-fi and horror movies might be built on mythic armatures, they are fleshed out by the fears and fantasies of the moment. (This is not, I hasten to say, an original insight but virtually axiomatic among critics who deal with these issues.) So while a movie like, say, the original *Invasion of the Body Snatchers* might embody the age-old narrative motifs identified by folklorists as "Transformation: Man to Vegetable Form" and "Plant Causes Magic Forgetfulness," it also reflects the sociopolitical anxieties of the Cold War era

that produced it. The same is true of *The Incredible Shrinking Man*, which uses the archetypal pattern of the "Thumbling" story to express pervasive, post–World War II male anxieties about domesticated, diminished masculinity. In fact, I'd go so far as to suggest that the primary function of popular story-telling in whatever form—oral folk tales, movies, etc.—is to give manageable shape to the inchoate anxieties that threaten our psychic equilibrium, to turn them into tidy, comprehensible narratives with satisfying resolutions. Sometimes, those anxieties stem from the scary stuff going on in the outer world. It's a critical commonplace to discuss, say, the cycle of classic 1930s universal horror films like *Dracula*, *The Wolf Man*, and *Frankenstein*, with their nightmarish European settings, in relation to the dark forces building up in that part of the world in the 1930s. Just as often, however—maybe even more so—the anxieties underlying horror and science fiction arise from the inner world: from our primitive dreads, archaic superstitions, inadmissible desires. I suppose the greatest, most enduring works are those that reflect both outer and inner realities at once. *Psycho*, for example, is clearly a product of the sexually duplicitous culture of 1950s America but resonates deeply with the most taboo primal fantasies.

JCT: Fair enough, I suppose. But how about the extremes of gore and violence...? Do you think that "anything goes"?

HA: It's always struck me as significant that the very first special effect ever created for the movies was an image of hardcore violence: the graphic beheading that makes up the entirety of Thomas Edison's 1895 Kinetoscope short, "The Execution of Mary, Queen of Scots." Employing a primitive stop-motion technique—and presenting itself under the sanctimonious guise of edifying historical recreation—this 30-second peepshow loop consists of nothing more than a scene of the title character being led to the scaffold and having her head whacked off. Among the lessons to be learned from this pioneering piece of cinema is that, from the moment of its invention, the cinema has been used to satisfy the innate human hunger for violent spectacle, to feed that primitive part of ourselves that William James called "the carnivore within."[29] Of course, there are moralists who will object that the beheading depicted Edison's short—which strikes the modern eye as almost comedically quaint—can't begin to compare with the hyper-realistic violence effects in today's movies and video games. But it's important to remember that, for viewers in 1895, Edison's trick-film decapitation was a state-of-the-art special effect, producing exactly the same degree of shock and sadistic titillation that today's audiences derive from, say, *Saw 3D*. When Hitchcock's *Psycho* was first released in 1960, for example, *Time* magazine

denounced the shower scene as "one of the messiest, most nauseating murders ever filmed. At close range, the camera watches every twitch, gurgle, convulsion, and hemorrhage in the process by which a living human being becomes a corpse." Nowadays, it's regarded as one of the greatest sequences in cinematic history precisely because it works almost entirely by suggestion. The point being that there seems to be a certain level of violent excitement people want from movies and that, to supply it, filmmakers have to keep finding new and improved ways to simulate graphic murder and bloodshed. Now I happen to be a glass-is-half-full type of person, and to my mind, the fact that our pop entertainments are so packed with gratuitous violence is an *encouraging* sign of how civilized we've become in a very short time, evolutionarily speaking. Consider the recent Coen brothers' version of Charles Portis's *True Grit*, which begins with a very graphic triple hanging. As that scene shows, there was a time not so very long ago in the United States when public executions were festive forms of weekend entertainment, drawing large audiences of men, women, and children, along with vendors selling lemonade and peanuts. Nowadays, we have reached the point where we are content to watch people die horribly in purely simulated form. I call that real progress! To be sure, it would be nice if we belonged to a species that didn't possess an appetite for violence at all. But we don't.

JCT: You've seen the list of the writers, painters, and film people interviewed here in my book...Any comments on them? Any of them your favorites? Have you met or interviewed any of them?

HS: I'm a fan of a lot of them. Stephen King has provided me with endless hours of reading pleasure, and I esteem his book *Danse Macabre* as the smartest piece of horror-criticism ever penned. I regard Peter Straub's *Ghost Story* as a modern Gothic masterpiece. I've always loved Bradbury, especially the early horror stuff, which I first encountered in a paperback called *The Autumn People*. And like all horror geeks, I went through an obsession with Lovecraft (one of my prized possessions, recently bestowed on me by a dear friend, is a nineteenth-century Compendium of Knowledge from Lovecraft's personal library, complete with his marginal notations and handwritten inscription on the front page).[30] I've had contact with a number of others in the book. I knew Forry Ackerman slightly and spent a pleasant day at the Ackermansion in Los Angeles while researching a book on movie special effects back in the early 1980s. I also met Ray Harryhausen while working on that book. I contributed a couple of entries to Jack Sullivan's *Penguin Encyclopedia of Horror and the Supernatural*. Back in the day, I was introduced to Julius Schwartz through a friend of mine who worked at DC Comics.

I've had pretty extensive correspondence with Robert Bloch while writing my book *Deviant*, about Eddie Gein, the real-life Norman

Bates. In fact, Bloch was instrumental in helping me come up with the subject of my follow-up book. When I asked him why people were so fascinated with Gein, he replied, "Because they've forgotten about Albert Fish." As a result of that exchange, I began researching the Fish case and the result was my second true crime history, *Deranged*. Unfortunately, he later took umbrage at something I said in *Deviant* (1998), my book about Ed Gein, where I characterized his novel *Psycho* as a "clever but minor pulp chiller." I suppose that was ungracious of me, given how generous he was with his time. In any case, he got his revenge. A few years later, in the introduction to an anthology he edited called *Monsters in Our Midst* (1993), he described my book *Deviant* as—you guessed it—"a clever but minor pulp chiller"!

Rick Geary

Rick Geary (1946–) grew up in Kansas City, MO, and attended the University of Kansas. His work writing and illustrating graphic novels and comic books has won him the National Cartoonist Society's Magazine and Book Illustration Award in 1994. Like his friend Harold Schechter, he specializes in Gothic horror and true crime stories. He is best known for his *Treasury of Victorian Murder*. He has also contributed to *Heavy Metal* and *National Lampoon* magazines.

The interview transpired on 28 February 2011 from his home in New Mexico.

Rick Geary: My interest in True Crime dates from the early 1970s, and is essentially visual in origin. A friend in Wichita, Kansas, a former policeman, gave me a collection of mug shots he had amassed over the years. Looking literally into the face of crime was an inspirational thunderbolt. Add to this the first atrocities, at the time, by the BTK killer, and I was on my way. As an artist, I love the "look" of the Victorian era, the clothing: the high collars, the tight corsets; the men's outrageous facial hair; the interiors packed with bric-à-brac; the carriages with their impossibly complicated harnesses. The style of the time was to conceal one's deepest urges beneath a cloak of propriety; but concealed beneath this cover, the Victorians were a lusty and passionate people. The crimes of the period also seemed more colorful than those today; or was it just because new mass-printing processes gave rise to a lively and sensationalist press that kept the stories in the public consciousness?

My series of thoroughly researched graphic novels, which comprise *The Treasury of Victorian Murder*, covers the most famous cases of the day in both Britain and the United States—Jack the Ripper, Lizzie Borden, Mary Rogers (with its Edgar Allan Poe connection), Madeleine Smith, and more political subjects like the

Garfield and Lincoln assassinations. Accuracy and clarity are my highest goals, and to this end, I employ many maps and overhead views as aids to understanding. Although I've now moved into accounts of twentieth-century cases, all of my volumes reflect my passion for the Gothic outlook, with its mysterious characters and its shadowy visual style.

I guess you could say my books are history lessons in terror. I am constantly surprised at the variety of people who appreciate them, especially those who are not necessarily big comic book fans. The largest audience seems to be young people, of high school age and earlier. Presumably, the graphic story format is an easier way for them to digest historical events.

"Different Engines": Alternate Worlds and Anachronistic Technologies: Cynthia Miller and T. L. Reid

It has come to me that some dire violence has been done to the true and natural course of historical development.... there is no history—there is only contingency.

> The Marquess in Gibson/Sterling's *The Difference Engine* (1992)

You know, the writings of Jules Verne had a profound effect on my life...I wanted to spend my future in the past!

> "Doc" Brown in *Back to the Future 3* (1990)

Of all Possible Worlds

The presumption that the Gothic tradition has perished under the glare of the postmodern spotlight is resoundingly refuted by the burgeoning variety of today's steampunk worlds of alternate realities and anachronistic technologies. The very concept of Gothic alternate realities is deeply rooted in "the stately pleasure domes" of Samuel Taylor Coleridge's "Kubla Khan," the literary fairy tales of E. T. A. Hoffmann, the Cthulhu Mythos of H. P. Lovecraft, the heroic historical fantasies of twentieth-century masters Poul Anderson and L. Sprague de Camp, and, most recently, the new galaxy-hopping, time-twisting space operas of Iain Banks, Kim Stanley Robinson, Greg Bear, and Gregory Benford. It has found recent mathematical confirmation in quantum theory and the many-branched universe of Stephen Hawking and the multiverse theories of Brian Greene.[31] Even in the academy, literary historians are leaving their ivory tower and toying with what historian Niall Ferguson has dubbed the *counterfactual* as a valuable tool in the understanding of the seemingly, random, even chaotic

THE GOLDEN COMPASS (Photofest) and WILD, WILD WEST (Photofest)

course of human events.[32] Filmmakers, meanwhile, have been envisioning their own virtual worlds, including Terry Gilliam's *Brazil* (1985), Robert Zemeckis's *Back to the Future* trilogy (1985–1990), Alex Proyas's *Dark City* (1998), Stephen Norrington's *League of Extraordinary Gentlemen* (2003), the Wachowski Brothers's *Matrix Trilogy* (2004), Christopher Nolan's *The Prestige* (2006), and Chris Weitz's *The Golden Compass* (2007).[33]

Most recently, a new kind of time-tampering history is recruiting into its virtual worlds the fictional and historical characters we know from the entire spectrum of the Gothic imagination. Dracula, Tarzan of the Apes, Sherlock Holmes, Bram Stoker, H. P. Lovecraft, and many other fictional characters and historical personages are newly incarnated into Brian Aldiss's Gothic trilogy (already discussed), the comics and novels of Philip Jose Farmer (the *Riverworld* and *Wold Newton* series, 1971–1983), and Alan Moore (*League of Extraordinary Gentlemen*, 1991–). Here they participate in each other's adventures and find identity in their shared bloodlines. Similarly, Batman, Superman, and the rest of the comic superhero canon flex their collective muscles in increasingly bizarre congregations and combinations. (Particularly pertinent to our purposes is the fact that the DC Comics universe now incarcerates the colorful villains in the Batman saga in the "Arkham Asylum for the Criminally Insane," a not-so-subtle tribute to H. P. Lovecraft's mythical Massachusetts village.[34])

Leading the way was Philip José Farmer, who created groundbreaking reimaginings of the Victorian and early twentieth-century periods in his *Riverworld* and *Wold Newton* series. The *Riverworld* canon began with the Hugo Award-winning *To Your Scattered Bodies Go*, followed by *The Fabulous Riverboat, The Dark Design, The Gods of Riverworld*, and *The Magic Labyrinth*. Collectively, they envision the adventures of Sir Richard Burton (translator of the *Arabian Nights*), who after his death in 1890 finds himself adrift on a river stretching 25 million miles, along whose banks wander the reincarnations of every human being who has ever lived—and will live—including Cyrano de Bergerac, Mark Twain, Hermann Göring, and a host of fictive characters and alien creatures. Here there's an afterlife, or never-when, set on a giant Earth-like planet, where people exist in a peculiar kind of immortal state wherein they can die and live, again and again. "Burton] had died. Now he was alive," writes Farmer, "[but] it was like no hell or heaven of which he had ever heard or read .…"[35] Not coincidently the words recall John Carter's astonishment at his death and transfiguration on Mars: "My first thought was, is this then death! Have I indeed passed over forever into that other life!"[36] Regarding *To Your Scattered Bodies Go*, Brian Aldiss writes, "It is a staggering notion, and, in a single, fast-paced book, Farmer's exploration of this marvelous metaphor—which reflects our own *real* enigmatic existence here on earth—is successful. Like Burton, we want to know what's happening, why, and what exists at the end of the river."[37]

Not to be outdone by this extravagant mixture of historical characters, Farmer's *Wold Newton* series intermingles the bloodlines of historical characters with the "real-lives" of great characters in fiction. He "researched"

mock biographies and wrote further adventures of Jules Verne's Phileas Fogg, Conan Doyle's Sherlock Holmes, and Burroughs' Tarzan of the Apes (whose genealogy includes—of course!—John Carter of Mars.).[38]

Alan Moore inherited Farmer's time-bending literary mantle in his graphic-novel series, beginning in the 1980s—*Watchmen, From Hell, V for Vendetta,* and *The League of Extraordinary Gentlemen*—all of whom have been adapted to film by, respectively, Zack Snyder (2008), the Hughes Brothers, James McTeague (2006), and Stephen Norrington (2003). "Time is *simultaneous*," he writes in *Watchmen,* in words that perfectly describe his world orientation, "an intricately structured *jewel* that humans insist on viewing one edge at a time, when the whole design is visible in every *facet.*"[39] Moore has freely acknowledged his debt to Farmer: "Philip Jose Farmer was a seminal influence upon the League," he writes in a blog posted in http://www.newsarama.com/comics/040929-Moore4.html, "I mean, I had read his *Tarzan Alive* and *Doc Savage: His Apocalyptic Life,* which had that whole 'World [sic] Newton' family tree that connected up all the pulp adventure heroes.... Whether we would have ever thought of that without the primary example of Philip José Farmer, I don't know." James Parker, recently writing in *The* Atlantic, cites William Blake as another important inspiration for Moore's "postmodern rituals," deploying collage, pastiche, and intertextuality in reclaiming and reinterpreting "an earlier, apparently exhausted symbolic [Victorian] world."[40]

The clans are busily gathering, as it were, in the first series of the League's adventures, set in the alternative world of 1898. In the opening pages, we meet Stoker's Mina Harker, Verne's Captain Nemo, Poe's Auguste Dupin, Haggard's Allan Quatermain, Stevenson's Edward Hyde, and Wells' Invisible Man. England "has need" of them, you see. Quatermain speaks for them about his death and new life: "The world would never tolerate the thought of Allan Quatermain, now grey and doddering, pruning his roses in some leaden suburb. No, I gave them what they wanted: a heroic death...Having provided my admirers with a suitable conclusion, I am free to live my afterlife, whatever span I have remaining, as my own."[41] And on it goes, new series after another...more and more adventurers real and fictional. Especially welcome are the appearances of psychic detective Carnacki, John Carter of Mars, and Captain Carter's great-nephew Randolph Carter (formerly of Lovecraft's Providence), who battle creatures whose projectiles are rocketing toward Earth, where H. G. Wells' *War of the Worlds* is about to begin...[42]

Different Engines

[Note: The anachronistic technologies of steampunk play an important part in the aforementioned virtual worlds. Just as Shelley's Victor Frankenstein, Jules Verne's Captain Nemo, and H. G. Wells' Dr. Moreau

William Gibson (left) and Alan Moore (drawing by the author)

had prophesied visionary sciences and technologies in their nineteenth-century world, today's writers, filmmakers, graphic novelists, and musicians are time-traveling back to new versions of a never-when Victorian era teeming with super scientists and fantastic gadgetry. A case in point is William Gibson and Bruce Sterling's landmark novel, *The Difference Engine* (1991). It depicts an alternate 1855 England, whose existence is threatened by political revolution and ecological disaster. Charles Babbage has successfully perfected his Analytical Engine, enabling the computer age to arrive a century ahead of its time. Across the ocean America is not a world power but has been fragmented into the Confederate States of America, the Republics of Texas and California, and the Communist Manhattan. Meanwhile, Lord Byron has not died in the Greek War of Independence but has become England's Prime Minister, head of the Industrial Radical Party. Byron's daughter, Ada, a brilliant mathematician who has been working with Babbage, predicts a union of machine and human that will precipitate a dystopian disaster in a future 1991, where rampant technology has virtually eliminated human agency.[43] Social satire, dystopian vision, and technological fantasy go hand in hand.

 This key example of Gothic retrovision is known as steampunk. It's a vision that has captured the imagination of a new generation of artists and enthusiasts who are not only creating their own Victorian fantasies but are also projecting the steampunk culture into their own lifestyles. In the

following two essays, Professor Cynthia Miller and T. L. Reid measure
this newest chapter in the Gothic imagination.]

Jules Verne, the author (KUCSSF)

Cynthia Miller

Cynthia Miller is a visual anthropologist and scholar-in-residence at
Emerson College. Her writings on the fantastic can be found in numer-
ous anthologies and scholarly journals, including the recent "In the Blink
of a Martian Eye: 'Lights Out!' from Page to Airwaves to Screen," in
Adapting America/America Adapted (2009); "It's Hip to Be Square: Rock
and Roll and the Future" in *Sounds of the Future: Essays on Music in Science
Fiction (2010)*; "The Rise and Fall—and Rise—of the Nazi Zombie in
Race, Oppression, and the Zombie" (2011); and "Domesticating Space:

Science Fiction Serials Come Home" in *Science Fiction Across the Screens* (2011). Her research on steampunk Westerns may be found in the *Journal of Popular Film and Television.*

Interview

This conversation, rendered here as an uncut essay, transpired at Emerson College on 20 February 2011.

Imagine a Victorian world where colorful flying contraptions crawl across the skies, rockets propel wrought-iron velocipedes, and clockwork men clamber about in mechanical bodies. Jules Verne and H. G. Wells brought these "different engines" into their contemporary world, calling forth both gods and monsters in the Machine and, in the process, creating the building blocks for countless alternative universes. These are the worlds of steampunk, where the fantastic intrudes into ordinary nineteenth-century settings, carrying with it timeless fears and fantasies.[44]

Originally coined in the late-1980s, the term "steampunk" was "retro-fitted," if you will, to describe a group of Victorian technofantasies[45]—darkly atmospheric novels of a time that never was—like K. W. Jeter's *Morlock Night* (1979) and *Infernal Devices* (1987), James P. Blaylock's *Homonculus* (1986), and Tim Powers' *The Anubis Gates* (1983), which were becoming increasingly popular with readers of science fiction and fantasy. A curious term, to be sure, describing even more curious tales of historical science fiction infused with Victorian visions of wildly anachronistic technologies. Here, in visions of London that are darker and wilder than anything imagined by Dickens, scientists and magicians, philosophers and poets, time travelers and clockwork humans animate worlds inspired by the Gothic scientific romances of H. G. Wells, Jules Verne, and Mary Shelley, where fantastic inventions are seamlessly integrated into everyday life.[46]

Victorian London is the favorite setting of steampunk works like this because it represents the epicenter of the real nineteenth-century's technological upheaval. The products of the Industrial Revolution were escaping the solitary inventor's laboratory and becoming mass-produced commodities.[47] The effects of rapid industrial change did not remain confined to London—or to New York, Paris, or Berlin—but rippled outward, knowing few boundaries. And so it was with steampunk, as well. In the decades since steampunk's formal inclusion in the literary and cinematic imagination, novels, short stories, and films have brought the genre's whirring gears and gleaming gadgetry to the far corners of the world.

Although some well-known steampunk works such as Brian Aldiss's trio of writings that began with *Frankenstein Unbound* (1973), William Gibson and Bruce Sterling's novel *The Difference Engine* (1990), and Alan Moore's graphic-novel series *The League of Extraordinary Gentlemen* (1993–) stay close to their Victorian roots,[48] others range farther afield: Phillip

Pullman's young adult trilogy, *His Dark Materials* (2005), begins in an otherworldly version of Oxford that is a blend of nineteenth-century settings and otherworldly technologies (including a truth-telling alethiometer). Cherie Priest's *Boneshaker* (2009) and its sequels, *Dreadnought* (2010) and *Clementine* (2010), inject zeppelin pirates, deadly gasses, and the titular "Incredible Bone-Shaking Drill Engine" into a Civil War–era United States. Joe R. Lansdale's *Zeppelin's West* (2001) transports the performers of Buffalo Bill's Wild West show to Japan via zeppelin. Led by Cody, whose head is kept alive in a Mason jar, mounted atop a steam-powered man, the tale borrows (and sometimes, liberates) characters and narrative devices from Shelley's *Frankenstein* (1818), Stoker's *Dracula* (1897), Verne's *20,000 Leagues Under the Sea* (1870), and even Baum's *The Wonderful Wizard of Oz* (1900) along the way.

As steampunk made its way from the page to the screen, it made itself at home on the American frontier, in the television series *Wild, Wild West* (CBS, 1965–1969). The series and its feature film remake (1999) followed the James Bond–style adventures of two gadget-laden Secret Service agents who battled an assortment of diabolical inventors and their superweapons in the late 1860s and early 1870s. Later, the unconventional Western heroes of the short-lived series *Legend* (UPN, 1995) and *The Adventures of Brisco County, Jr.* (Fox, 1993–1994)—a dime-novelist-turned-adventurer, and a lawyer-turned-bounty-hunter—met similar opponents in the 1890s, defeating them with the help of eccentric inventor-partners who equipped them with advanced technology of their own. In motion pictures, the film *Van Helsing* (2004), with its Gothic roots in both *Frankenstein* and *Dracula*, played out its action in central Europe, where good does battle with evil using a "sunlight bomb," buzz saw projectiles, and an automatic crossbow, all invented by scientist-sidekick Carl the Friar; and most recently, the film *Jonah Hex* (2010) deepened the fantastic tone of its source material— a long-running comic book series about a physically and psychologically scarred bounty hunter—by adding steampunk elements to its prominent supernatural themes. So, although the diversity of steampunk's characters and fantastic technologies is breathtaking, taken together, all of them work to place steampunk technology—with its collision of past and future and its dissonance of form and function—squarely in the visual foreground as a commentary on technology and progress. Robots, airships, and computers are—like the sewer-dwelling troglodytes of *Morlock Night*, the sapient armored bears of *The Golden Compass*, and the reanimated dead of *Homunculus*—spectacular alien presences in a seemingly familiar nineteenth-century world.

But it's not just the *world* of the narrative that's familiar—it's the character of the technology, as well. Seamlessly interwoven with the day-to-day life of the narrative, steampunk technology uses Victorian components and a deliberately Victorian aesthetic: exposed gears and soot-streaked smokestacks, painted iron, and polished brass.[49] Zeppelin-like airships fill the skies, robot servants belch steam, and the

giant computer in *The Difference Engine* is not electronic, but mechanical—Victorian technology as created by the hands and minds of the Victorians themselves.

It's been said that the true power of most steampunk lies in that moment when technology transcends understanding and becomes magic.[50] In the hands of the inventor-magician, we see technology create or destroy the destinies of individuals, communities, and entire worlds. That's a power we, as audiences and readers, seldom invest in our machines; but literary and cinematic steampunk undermines our easy certainties about technological progress and historical inevitability by immersing them in alien surroundings. As modern readers and viewers, we are familiar with these technologies in twentieth-century form—we are fully aware of their capabilities and conscious of their displacement from their "proper" eras—and we perceive them immediately as intrusive technologies-out-of-time. The machines' status as quasi-magical objects is reinforced by their near-uniqueness and their mysterious origins: We never see them being built or bought; they simply *are*. These fantastic machines highlight, by their very existence, the character archetypes, narrative tropes, and often, layers of meaning inherent in the storyline of steampunk texts. Readers and viewers are instantly alert to the machines' potential to remake the social order, and to the damage those devices can do in the hands of the reckless or the ruthless.

Time and again, steampunk grabs hold of our notions of the Victorian era and knocks them off-balance, turning London, Transylvania, Tokyo, or the American West into an alien world filled with exotic machines and monstrous creatures.[51] The discomfort this creates—on an intellectual level, and on a deeper, more existential level, as well—grows with chronological gulf between the steampunk technologies and their modern counterparts. Fantastic airships—zeppelins, motorized wings, propeller-driven bicycles, and the like (the visual hallmark of countless steampunk works)—are mild intrusions compared to the spaceships of Stephen Baxter's *Anti-Ice* (1993) and the atomic-powered locomotive of Paul di Filippo's *Steampunk Trilogy* (1995). It's wrong...exquisitely, horribly, wrong...and this conceptual dissonance created by the juxtaposition of modern capabilities and Victorian appearance reinforces that sense of disorientation that steampunk seeks to create in readers and viewers, raising questions about what other elements of the fantastic might lie in wait, just beneath the seemingly normal surface of its nineteenth-century world.

The disconnect between readers' and characters' understanding of these fantastic new technologies points out that steampunk, even when it does not formally claim the designation, is allohistory—an alternate past—the history that might have been, but wasn't.[52] Its versions of the nineteenth century diverge from ours, because in them certain critical events happened differently. Gibson and Sterling's *The Difference Engine*, for example, offers a version of reality where British scientist and mathematician Charles Babbage actually built a pair of mechanical computers

that remained drawing-board speculations in our world.[53] Steampunk technologies, intrusive as they may be, are indigenous to their (fictional) settings. They look like Victorian technologies because they, like the technologies that defined the real Victorian era, are the products of the individual scientists and inventors, and the nascent research-and-development laboratories of the era.

And in this similarity, steampunk's magic has become highly scientific, maintaining a kind of self-contained order within the universe of the narrative.[54] To the characters in steampunk tales, the new technology is a comprehensible, if not entirely seamless, extension of their rapidly changing nineteenth-century technological landscape.[55] If we think of the history of the industrial revolution as part of steampunk's narrative background, then the changes brought about by the introduction of factories and mass production are taken-for-granted parts of its characters' history, and their "present" is acted out in the aftermath of a "second industrial revolution" created by electricity, petroleum, and mass-produced steel. These products brought a flood of new machines that transformed the world of the middle class—from the home to the office to the city street. Incandescent lights blazed in streets and parlors; electric elevators and electric streetcars allowed cities to thrust upward and outward; refrigerated railway cars remade the diet of the middle class, while synthetic dyes remade their wardrobes; telegraph cables spanned the oceans, and the telephone, the typewriter, the mimeograph, and the motion picture became part of the technological furniture of everyday life.[56] Set against such a rapidly changing backdrop, airships, computers, and submarines seem—to residents of the steampunk nineteenth century—like the latest in a seemingly endless string of fresh technological wonders. Only their vast, almost magical power, revealed as the story unfolds, suggests their true alienness and their potential for disruption, even in an era accustomed to change.

Nineteenth-century science and technology are often characterized by this conflict of magical thinking versus pragmatism—the Gothic balance between the irrational and the rational, fantasy and realism—the two existing side-by-side in continual tension as the world around them grappled with notions of progress.[57] Chaotic, unregulated, and visionary, they formed a melting pot of imagination, ability, and possibility, with the machine reigning supreme as an icon of science-given-form. And while the continued advancement of technology pushed back the boundaries of the magical, the era's highly advanced technology often seemed—as science fiction writer Arthur C. Clarke famously observed—indistinguishable from magic. The fantastic machines it created stood for our ability to tame the most fearsome creations, with the Victorian inventor playing a role that was half-scientist, half-magus.[58]

And it's that magic, breathtaking and terrifying at the same time, that steampunk confers on the genres with which it is paired, whether we're talking about science fiction, melodrama, or even the Western. The

introduction of fantastic Victorian technologies inflects even the most traditional of narratives with glimmers of magic, horror, and futuristic realism—the powers exhibited by its extraordinary machines are beyond comprehension. They defy gravity, annihilate distance, reshape the landscape with the pull of a lever, and obliterate entire cities with the push of a button. The disjuncture of their appearance focuses audiences' attention on *meaning*—not only of historical time, space, and capacity, but of the stability of the present as its ongoing extension. It releases our unspoken fears about the inherent moral qualities of technology, and the politics of progress; at the same time, reminding us of the fragility of our historically grounded cultural identities.[59] We, like the characters on screen, and the Victorians on which they were modeled, struggle to find the balance between the fantastic and the possible, humanity and progress, gods and monsters—and ultimately, engaging in the dynamic social and cultural debates about the relationship between science and society. "Steampunk is fantasy made real," proclaimed an editorial in a recent issue of *SteamPunk Magazine*, "filtered through the brass sieve of nostalgia, vehemence, curiosity, wonderment, and apprehension. It is inherently political . . . it is antiestablishment. It is dangerous to pluck our dreams from muddy scribblings and coax them into existence. . . ."[60]

T. L. Reid

Tina-Louise Reid is a graduate teaching assistant for the Film and Media Studies program and an Osher Institute instructor at the University of Kansas in Lawrence, Kansas. She has taught at universities and at career and community colleges in the United Kingdom and the United States. Her current research interests include the permutations of fairy tales, the literary and visual depictions of carnivals, circuses, and sideshows as well as the multimedia persistence of steampunk in the science fiction genre. She has published articles on video artist Van McElwee in *Afterimage*, outside artist Prophet Blackmon for *Raw Vision*, and surrealist animator Jan Svankmajer in Peter Hames's collection *The Cinema of Central Europe*. Recently, *World Literature Today* featured her review of the film *Moon* in a science fiction–themed issue.

Interview

This conversation, rendered here as an uncut essay, transpired at the University of Kansas on 22 February 2011.

The growing cultural interest in steampunk as a lifestyle is reflected in *SteamPunk Magazine*, www.steampunkmagazine.com, a fine Internet presence that also exists as a blog, a downloadable PDF, and an actual hardcopy magazine. Its features range from fiction, interviews with authors,

and how-to articles indicating the processes necessary to make your own neo-Victorian wares. An excellent source posted by Cory Gross following the trajectory of speculative works from proto-steampunk tales to contemporary steampunk fare may be located on the Web at http://voyagesextraordinaires.blogspot.com/. Purportedly one of the oldest blogs, *The Steampunk Tribune* [http://www.steampunktribune.com/], provides an excellent array of events related to steampunk-themed work, such as by posting a trailer to a documentary concerning steampunk art enthusiasts—*I am Steampunk* by Joey Marsocci—or by linking to other blogs dedicated to steampunk literature, local conventions, events and balls, and radio plays; and it even furthers the steampunk embrace of multiculturalism by highlighting worthy international blogs to deliver an electronic impression of steampunk from around the world.

Since anachronistic sensibilities permeate steampunk, the musical trappings such as personae, lyrics, and instrumentation have proved malleable. As literary steampunk draws from the Gothic, musical permutations share much in common with the goth music scene as goths have accepted darkly inspired music of all forms, especially if Poe or Lovecraft is invoked. The influences have come full circle. As the progeny of the UK punk scene, Gothic bands gained notoriety in the United States. With its love of Victoriana and London as a locale, steampunk as an American musical phenomenon has taken Great Britain by storm. Although some artists dabble with modernized Victorian dress or occasionally foray into a cabaret characterization, recalling a bygone time, other musicians proclaim their groups as steampunk bands (not to be confused with bands that adopt the finery as a momentary tongue-in-cheek statement, as recently exhibited by the hilarious yet talented band Primus).[61] Although many steampunk bands inspire cult followings with their science fiction storylines, dry humor, and wicked sense of fun, the group Abney Park has risen to a more widespread prominence, through self-promotion and production via the Internet. (The lead singer Captain Robert even has his own blog.) A Seattle-based band named after the London cemetery, Abney Park has embraced the aviator-inspired, goggle-laden steampunk fashion (http://www.myspace.com/abneypark). Lyrically, Abney Park appeals to the listener's inner airship pirate with adventurous tales scored with highly danceable instrumentation both analogue and electronic. As many steampunk bands do, Abney Park often enters E. T. A. Hoffmann territory, as in "Dr. Drosselmeyer's Doll," which features a female dancer performing with wind-up machinations during Abney Park's live shows (recalling Olimpia from "The Sandman").

Unextraordinary Gentlemen (UXG) is a Los Angeles–based band replete with Victorian dress and steampunk manifesto to explain their musical approach. Their name is an obvious play on the title of Alan Moore's comic *The League of Extraordinary Gentlemen*, and in an overt reference to William Gibson, they refer to their drum machine as The Indifference Engine (http://www.myspace.com/unextraordinarygentlemen). Their

original songs contain an intricate cast of rebellious female and male characters, steam-driven apparatus, and atmospheric terrain true to the steampunk literary approach. This trio sometimes opens for The Vernian Process, a San Francisco ensemble that clearly pays homage to Jules Verne and Romantic science fiction literature. In the spirit of steampunk inclusion, lead singer Joshua A. Pfeiffer established a collective to publicize his band along with other musical acts (http://www.myspace.com/vernian-process). Their latest album, *Behold the Machine*, a prototype of which they allowed their fans to download for free before the official release, showcases their flair for the epic concept album decorated with traces of Pink Floyd and other progressive rock masters. As evidence of the supportive attitude of this subculture, The Vernian Process donated part of their album sale profits to save *Sepiachord* (www.sepiachord.com), an online blog and community dedicated to promoting steampunk bands and other tangentially related retrofuturistic musical artists.

To gain further understanding of the popular uses of "steampunk," see especially *The Steampunk Workshop* (http://steampunkworkshop.com/). Although this site enchants with proprietor Jake von Slatt's step-by-step accounts, images, and sometimes videos of baroque modifications, such as a Steampunk Stratocaster resplendent with clockwork components, he uses this blog space to promote the work of other artisans, inspiring others to create. The artist Datamancer, otherwise known as Richard Nagy, www.datamancer.net, has received recent acclaim for his objects, especially his customized computer keyboards and other ornamental contraptions that have sprung up on television's science fiction series. By nostalgically harkening back to a more optimistic time of technological evolution, artists construct contemporary myths, making sense of our current culture in a world gone strange. As an ironic, ornate, postmodern response to the streamlined, disposable modernity of consumer culture, this steampunk aesthetic, as it pertains to other artistic disciplines, values individuality, recycling, customization, and DIY (Do-It-Yourself) inventiveness, the "punk" part of the term.

"The Heresy of Humanism"

GREG BEAR AND GREGORY BENFORD

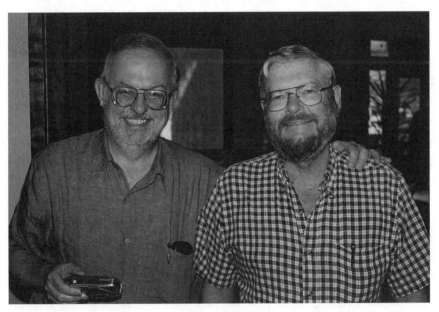

Greg Bear (left) and Gregory Benford (photo by the author)

Of all our fictions, there is none so utterly baseless and empty as this idea that humanity progresses. The savage's natural impression is that the world he sees about him was made for him, and that the rest of the universe is subordinated to him and his world, and that all the spirits and demons and gods occupy themselves exclusively with him and his affairs. That idea was the basis of every pagan religion, and it is the basis of the Christian religion, simply because it is the foundation of human nature.

Harold Frederic, *The Damnation of Theron Ware* (1896)

Well, don't forget that the whole thing about the conflict between
science and faith makes for great stories!

> Greg Bear (interview, 2005)

This colloquy of voices about the Gothic imagination, past and pres-
ent, concludes with a conversation between two of the brightest and
most respected writers in the current field of speculative fiction, Gregory
Benford (1941–) and Greg Bear (1952–). They offer an extension and a
personal meditation on the issues raised in the preceding chapter, particu-
larly a theme frequently found in today's science fiction writers, including
Frederick Pohl's *Man-Plus* and the novels of Philip K. Dick—*What does it
mean to be human?* Unique among the contributors to this book, they are
professional scientists, and they bring to their stories what Walpole had
insisted more than 150 years ago: a blend of "the imagination of Romance
with the realism of common life."

Gregory Benford is a physicist, educator, and author and is currently a
professor of physics at the University of California, Irvine. His more than
20 novels, in addition to the classic *Timescape* (1980) and the "Galactic
Center Saga" series (including *Great Sky River,* 1987) and *Beyond Infinity*
(2004) and *Sunborn* (2005). He has won two Nebula Awards, the John W.
Campbell Award, and the Australian Ditmar Award. In 1995 he received
the Lord Foundation Award for contributions to science and to the public
comprehension of it.

Greg Bear is the author of more than 30 books of science fiction and
fantasy, including *The Forge of God* (1987), *Songs of Earth & Power* (1994),
Darwin's Radio (1999), *Darwin's Children* (2003), and, most recently,
Quantico (2005) and *Mariposa* (2009). He has won two Hugo Awards
and five Nebulas for his fiction, and he is one of two authors to win a
Nebula in every category. He has been called the "best working writer
of hard science fiction" by *The Ultimate Encyclopedia of Science Fiction*. His
major themes include ghost stories *Dead Lines,* 2004) galactic conflict (the
Forge of God series), artificial universes (*The Way* series), and accelerated
evolution (*Blood Music,* 1985, and *Darwin's Radio,* 1999). Bear has served
on political and scientific action committees and has advised Microsoft
Corporation, the U.S. Army, the CIA, Sandia National Laboratories,
Callison Architecture, Inc., Homeland Security, and other groups and
agencies.

Both men are among many scientist-writers, such as Arthur C. Clark,
Poul Anderson, and Carl Sagan, who have inherited a century of rapidly
mounting tensions in the troubled relationships among art, science, and
religion. As both poets and scientists, Bear and Benford are willing and
able to address in their researches and in their stories not only many of
the themes and styles we have identified as the traditional Gothic/sci-
ence fiction mode—ghost stories, space opera, Faustian pacts, forbidden
knowledge, paranoia, parallel worlds, and so on—but also those specters

of scientific inquiry long ago raised by Victor Frankenstein: the blurring
of the lines between art and science, the emerging studies of nanotech-
nology, cellular intelligence, artificial universes, new mythologies, the
vectors of human genetic and cosmic evolution, and, finally, what Bear
and Benford call the "heresy of humanism." To quote the words of the
eponymous Faust in Goethe's Gothic masterpiece, they confront the ever-
growing suspicion that Man is only a

—[f]ool—who squints beyond with blinking eyes
Imagining his like above the skies.[1]

Undaunted, however, they would echo Richard Holmes's query at the
beginning of this book: Can there be *"a new kind of wonder born out of radi-
cal doubt"*?[2] Indeed, I suspect that beneath the armor of their hard science,
they still believe that John Carter arose from his dead body and astrally
traveled to Mars, where he awaits our own arrival.[3]

They (and we) have inherited the remarkably prophetic pronounce-
ments at the turn of the twentieth century in *The Education of Henry Adams*
(1906). Social historian Adams famously expressed doubts about what he
had been taught was the unity of a God-centered universe. Recoiling
from the shock of Darwinian theory, Adams confronted a "multiverse"
of new forces, the steam engine, electricity, the telephone, the watt,
ampere, and erg—forces that couldn't be measured by the yardsticks of
his predecessors. "Man had translated himself into a new universe," he
wrote, "which had no common scale of measurement with the old. He
had entered a supersensual world, in which he could measure nothing
except by chance collisions of movements imperceptible to his sense, per-
haps even imperceptible to his instruments, but perceptible to each other."
As a result, Adams predicted, in this new world of science, society, and
philosophy that Man must turn away from the Virgin and bow down
to the Dynamo. How quickly Freudian psychoanalysis, Jungian analyti-
cal psychology, Einsteinian relativity, Niels Bohr's Quantum Physics, the
sequencing of the genomes of microbes, linkages between living human
brains and mechanical appendages has followed! There's even been specu-
lations about the development of a giant Google search engine that reaches
out to the furthest limits of human knowledge![4]

And with this new Age of Wonder come new art forms. Here is another
complex, inexhaustible topic. Suffice to venture just one speculation
before turning to Greg Bear and Gregory Benford: Freeman Dyson sug-
gests that new art forms will be centered on biology and computers. "If
the dominant science in the new Age of Wonder is biology," continues
Dyson, "then the dominant art form should be the design of genomes to
create new varieties of animals and plants. This art form, using the bio-
technology creatively to enhance the ancient skills of plant and animal
breeders, is still struggling to be born."[5]

Now, let us see what Greg Bear and Gregory Benford have to say about these and many other topics.

The Conversation with Greg Bear and
Gregory Benford

This conversation between Greg Bear and Gregory Benford transpired at the University of Kansas on 10 July 2004. The occasion was the 2004 John W. Campbell Conference, at which both men received the John W. Campbell Memorial Award. I wish to thank James Gunn and Chris McKitterick of the University of Kansas Center for the Study of Science Fiction for facilitating our meeting.

Gothic Ghosts

JOHN C. TIBBETTS: Greg Bear, let's start with your most recent book, *Dead Lines* [2004]. Your Dedication certainly proclaims your love for those great "ghosters" like M. R. James, Le Fanu, H. P. Lovecraft, and Peter Straub. And I'm particularly glad to see you mention Shirley Jackson.[6]

GREG BEAR: They all write ghost stories. But Jackson has this female's perspective on ghosts. There's some pretty horrific stuff in *The Haunting of Hill House* [1959]. The ghosts are obviously there to scare the piss out of you, but the writers are taking pleasure in it! There are other writers I admire. You mentioned M. R. James, who wrote about things that may or may not be ghosts, but they're definitely not of *our* universe! And Lovecraft takes that same idea. They borrow those ideas from people like Arthur Machen and from William Hope Hodgson. Now, I love all of those writers. I just think they're very interesting spiritual writers. But it's a skewed spirituality, sort of a *dire* spirituality. What I want to do is use a scientific theory to give you experiences you've never had before, but in a familiar way, and what is that but the ghost story? But it's ghosts like you've never seen before, in contexts that you've never really experienced, but there's enough of an underpinning and a mythos to what you're seeing that it almost makes sense, and that's what provides the scare. You can tie this into experiences you or someone in your family may actually have had. You can say, Oh, I see that. 'Cause I borrowed it not just from ghost stories but from people who have actually seen ghosts. Which you gotta do when you're refreshing the medium. And the main point of the book is to scare the pants off you, because that's a lovely experience. And then you can turn the last page, and you can close it, and you can go to sleep. That's a very cozy feeling—

JT: —and *eventually* go to sleep. So, you're saying that *Dead Lines* is essentially a ghost story?

BEAR: Well, the reviews called it a ghost story, a fantasy. I think it's more of a science fiction novel. It's just that science is not usually thought to cross over into fantasy because it's constrained from it by cultural prejudices. But I do admit that *Dead Lines* is also the kind of ghost story I love. In the story, the world is running out of bandwidth, and there's a new source of forbidden information channels that reach into the regions of the Dead and release all kinds of dreadful things.[7] It's a Gothic story, in the sense that it blurs the lines between life and death, isn't it? For me, the ghost stories aren't scary so much as they are almost a spiritual experience. You're getting access to what could be a view of reality beyond what you could possibly know now. And science fiction in its extreme metaphysical forms does that to you. It exalts you. And a good ghost story can do that, too.

BENFORD: We all know that science can't replicate ghosts. But remember, it used to be very, very tough to replicate lightning. Now we can do it. What if there's a technological change such that you *could* start to study these phenomena, like ghosts?

JCT: These "technological changes" seem to turn out to be Pandora's boxes.

BEAR: They really could be, yeah.

JCT: Which brings up that cautionary element you see in the Gothic tradition. It keeps popping up. Even in the most modern kind of science fiction we still go back to the old days when Scientists Should Not Venture into the Forbidden Zones. That is such a deeply rooted fear that we have, still.

BENFORD: Well, particularly, I think it's an expression of a deeply puritanical impulse in Western society, particularly in the United States. And it has huge costs and policy implications. Here, let me give you an example. We're all worried about the "greenhouse" problem. But we think only in terms of using state power to stop people from burning fossil fuels. We don't think about all the other terms in the equation, the terms of the temperature of the earth. For example, could we build buildings with white roofs or generate more cloud cover to reflect more sunlight? Or, how about pulling carbon out of the air, which agriculture does every year, and then keeping it out of the air? Because, after all, the bulk of everything in a farm is waste product, and you let it lie in the fields and it rots and returns to the air. It's a big fraction of the carbon that cycles in and out every year. We don't think about grabbing that and, say, sequestering it somewhere. I've written a couple of papers for *Climate Change*, an academic journal, about this. The puritan impulse is to focus on our own evil. "Bad people! Don't burn fuels!" Instead of saying, hey, there are other things here that

we could be doing and we don't have to stop guys from burning coal in China. So there's a cost to these preconceptions.

JCT: It also—it's so healthy, too—God knows I'm going to quote Derrida—but to decenter our convictions, our monomanias, about these things—consider their oppositions, consider the gradations, consider how there are *other* options that can happen, that can work.

BENFORD: Well, it's natural to the species to divide problems into twos. I mean, our way of suggesting alternatives is to say "on the other hand." We have two hands so we think there are two points on an issue. Not so. Nature does not know this, right, and, therefore, in the greenhouse problem, there's three, four different things that we could do. But we don't even suggest or study them being done, because everybody's fixated on essentially a moral issue. "Bad species!—shouldn't burn all that coal!"

BEAR: Oh, it's biblical. It's very biblical. The whole notion of good and evil and the dichotomy between being the stewards of the earth and, you know, being the exploiters of the earth. It's a dichotomy. But as Gregory says, not a real dichotomy. There are many solutions, all of which cause great controversy in a society that doesn't understand how science works to start with. They're afraid of science. We just have people who are not numeric thinkers. They don't get along with numbers very easily. Like people who can't read very well. They have a hard time getting into books. Okay, so our society is through the way we teach and the way we discuss these issues, and the way science relies almost entirely on mathematics. Probably well over half don't get that kind of thinking. And it scares them. So that breaks down. It's a biological, epistemological breakdown into—what would you call the biology of education? That's not epistemology. What would biology of education be?

BENFORD: I don't know if there's a term for the biology—

BEAR: But to that extent we need to improve the way we teach people, and perhaps change the way we use language to get ideas across. And that's a long-term prospect.

BENFORD: The great thing about reading is, it's the best way to get into somebody else's mind. And it's unfortunate—

BEAR: It's better and more intimate than making love.

BENFORD: But it's still verbal. And the news of a couple of days ago, the study done by the U.S. census, shows that reading is declining in all age groups just about the same amount in the United States, and has fallen about 10 percent in the last 15 years, is very bad news for the long-term stewardship of this society.

BEAR: Well, again, I think it's part of that long-term problem that text has been difficult for many people to access. And movies and other things are starting to eat our lunch. But they're eating our lunch at a much more diverse table.

BENFORD: We're entering an age in which all of our information is digital, but our pleasures are analog. And you're never going to get away from that analog.

JCT: I'm not sure if I understood that.

BENFORD: Well, all the things that you do with your body are analog, not digital.

JCT: I guess I hadn't thought of it quite that way.

BENFORD: But everybody's in love with the digital because it's new. And the way we transmit our genetic info is obviously digital in the sense that DNA has got a coded information system. But the way we think is furiously analogic. Synapses run, and the chemical involvement—Anyone who's had five martinis knows that your thinking changes for analog reasons, not digital.

BEAR: Is it pure anal—It's not a sine wave. It's not analog in the sense of a sine wave. It really is some sort of...

BENFORD: But thinking is not digital.

BEAR: No. No, not at all.

BENFORD: And, therefore, the whole analogy of our thinking to computers is fundamentally false. I mean, we're actually—even if you wanted to use the analogy, we are self-programming computers. Because we can do things that change the memory. I mean, it's often said that a memory is never the same the next time, because by accessing it, you alter it. That's not true of computer files.

BEAR: Although, actually, in hard drives apparently it's getting more and more true that there's a mathematical algorithm that reconstructs from a very faulty record a perfect replica of what was put in there on your computer hard drive. Because you have to do that, because you're in such small spaces now that quantum effects are causing corruption to the data. So you have these mathematical algorithms that quite literally save your butt when you're storing information.

JCT: Wow! We began with ghost stories and somehow ended up with mathematical algorithms!

BENFORD: What's wrong with that?

JCT: It's just that we always think about ghost stories as a purely *Gothic*, not a scientific story form.

BENFORD: Just wait!

Storytellers All

JCT: You're on! But aside from all those things, your work is really about storytelling, isn't it? What lies behind all the scientific

and fantastic extrapolation, all the philosophical and religious riddles—is pure storytelling.

GREG BEAR: Well, don't forget that the whole thing about the conflict between science and faith makes for great stories!

JCT: And you've got characters we get to know, we care about.

GREG BEAR: That's what stories are. Stories are people, people who are doing things, doing interesting things. That's what it's all about. And you might have a literature of ideas—but *who* has ideas? People have ideas. They don't come out of the void. People have to act on them and to respond to the consequences. Ursula Le Guin has this great line, something like "The stars are very pretty. But it would be nice if there were someone to talk to!"[8]

JCT: Still, the scientific background, though, that you guys bring to your stories—even your ghost stories!—do you see this as representative of some new voices in science fiction?

BEAR: We're still young Turks!

JCT: Young Turks, I like that. Maybe, it's hard for us to read pure "space opera" anymore, since we know now that a solid scientific basis can be enough to provide a good rattling story.

BEAR: I still write space opera. *Anvil of Stars* is space opera, it's just very sophisticated space opera.

JCT: Was so-called space opera a big influence on you both?

BENFORD: Oh, sure, it has been for me. The novel I'm just finishing I hope this week, called *The Sunborn* [published 2005] is about interplanetary exploration, a thing that's almost entirely neglected now because we think we understand the solar system. But the bulk of the action occurs out at the orbit of Pluto, which, of course, we actually don't know much about. And it's an attempt to envision a different life-form that could inhabit the cold and the dark. I think the new resurrection of space opera over the last 10 years is in part an unconscious reflex, given that so much earth-bound science fiction concerns a future in which everyone seems to believe things are going to get worse. And it's hard to be optimistic for many people because of an old human habit—it's always easier to see the problems than the solutions.

JCT: It's easier to dramatize them, too.

BENFORD: Right, yeah. It's always easier to be downbeat in the same way that it's harder to be funny than it is to be solemn. The future, I think, doesn't have to be dark and depressing. I mean, we've obviously got problems. But I think a lot of them can be met. And people who are now looking out at the beginning of this century and saying, "Gosh, things are going to get a lot worse"—the relevant question is, "Yeah, *for whom*?" Because, for many people on this planet, things have always been bad.

Apocalypse and the Family of Man

JCT: Let's follow up on this. Greg, repeatedly you seem to be saying the twentieth century has been a disaster, that the twentieth century was breeding a kind of contagion.

BEAR: I'm afraid I once said that if you study the twentieth century long enough, you want to pack a gun! It's not a disaster, it's a challenge. And this is an interesting difference, depending on your perspective. I never regard my books as disaster novels—although sometimes they seem to be.[9]

JCT: But in *The Forge of God* you destroy the Earth! It's one of the more sustained and compelling passages of your prose I've ever read! I mean, what were you *thinking* when you were writing all of this?[10]

BEAR: Well, writers are bloody-minded individuals and we have the most fun doing the most horrible things. I immensely enjoyed *Star Wars*, the first one, but I realized that you can't just blow up Alderaan and Princess Leia's record collection in eight seconds. It's going to take a while. So as a hard science fiction writer I say, well, what's that *like*? And then, as a cinematographer, in my brain I'm asking, well, if you're on the surface of the planet watching this destruction, you can actually survive long enough to see amazing things. Absolutely astonishing things. It would be almost worthwhile to watch these things happen. And for me that moment comes when our main character, I think it's Edward, looks up to the east and sees the North Atlantic plate rising up. Or the North American plate rising up. And at that point you know you're dead. Why? Because as a physicist if it falls back, the release of energy will heat up the landscape around you and you're just a fragile ball of water, right? But at that point you've seen something no one has ever seen in the history of life on earth. And that's the combined horror and the exaltation. It's like a deer standing before a forest fire.

JCT: But is there an exaltation in *you* as you're writing it?

BEAR: Yes, in the sense of, I'm gonna make people feel extraordinary emotions. I think every artist does that.

JCT: By contrast, the apocalypse at the end of *Dead Lines* is so, well, *gentle*..

BEAR: Yeah, well. It's just about people.

JCT: Apocalypses come in all shapes and sizes.

BEAR: As I get older I'm less interested in blowing up the earth and, you know, just kinda figuring out what being around people means to me. I mean, I write something like that and they call you a cannibal for the rest of your life! Think of apocalypse as more of a metaphor for evolutionary progression, or change. In *Darwin's*

Radio I write about sudden bursts in human speciation, the sort of thing Stephen Jay Gould has called "punctuated equilibrium."[11] And we have the stress that results from trying to be the best we can be in spite of all our problems—and that allows us to naturally produce better children, capable of handling those stresses. That's not a disaster story. It's a story that maybe we have gone past the point of our competence. But is that sad? That's what happens with every set of parents and children. If parents don't want their children to do better and be better, are they very good parents? So my whole approach in something like *Darwin's Radio* is, yes, these kids in the story *are* slightly more competent than us at living in a world that we made, perhaps; but we don't know, they're an experiment. They're a very young experiment.

JCT: And an interesting subtlety is that the parents, in the process, are transformed themselves. They now undergo an evolutionary change.

BEAR: Isn't that what happens when you have kids? It's all a metaphor for the simple act of having kids. Having kids is optimism about the future. They're different from you, they think somewhat different from you, they are better adapted, we hope, to the world you created.

JCT: And you end the book with the parents seemingly estranged, now, from each other.

BEAR: You see more of that in the sequel, *Darwin's Children*. Again, this is because it's difficult to have children. It's painful and difficult and involves deep surveillance of emotions and conflicting ideas about how to raise kids. But always there's the love throughout. Even when the parents are separated in *Darwin's Children*, there's that continuing sense that this is the only partner you're ever going to have that makes any sense for you. And later, in *Darwin's Children*, they're working separately. But having kids is hard. It causes arguments, it causes debates, it causes reassessments, changes the marriage. And that's just part of the natural truth of what it means to have kids.

JCT: I hadn't realized that you're using a theory like "punctuated equilibrium" as a metaphor for child rearing...! Gregory Benford, you also talk about having children in *Great Sky River*. The relationship between the protagonist and his son is so critical to that book. Now, I've not read the two sequels, if sequel is the word.

BENFORD: Well, there's actually three—

BEAR: There's three. Three, altogether. .

JCT: But again the father-son thing emerges as the real theme, seemingly.

BENFORD: You're referring to Killeen and his son, Toby. They and their clan are on the run. Their planet is threatened with destruction by the cyborg forces. Well, fathers and sons is one of the great

themes of literature, isn't it? Agamemnon had some things to say about that! Actually, *Great Sky River* is part of a whole six-book sequence called the "Galactic Center" series that started back in 1977 with *In the Ocean of Night*. And it's really about the skills of us hominids holding things together in the face of imminent annihilation. They must enter into the scale of understanding that we're part of an entire galactic order, and that things have been going on a long time before we came on stage—that we're coming in not in Act One but maybe Act Seventeen of a *really* long drama. You have to go back to your basics, and that means that you have to have cultural continuity. Fathers have to tell sons what it really means to be a man, and how you act in the face of huge difficulties, difficulties that you may not, in fact, be able to surmount. In *Great Sky River* human beings are not this "winner" society that we're used to, they are rats in the wall of a system in which they face intelligences that are not human—in fact they're machines—that are far, far superior in many ways, and utterly malign. That's straight out of Lovecraft, you know? I wanted to turn on its head the assumption of the centrality of being human, which is so pervasive in human society—you know, "the measure of all things is man." Well, I call it in my most recent novel *Beyond Infinity*, the "heresy of humanism." It is a heresy to think that humans are central to the larger grand scale of creation, and it will cost you to believe that.

BEAR: Arrogance always costs you. In *Blood Music* I make it pretty clear that our need to see humanity as the center of the biological universe is as egotistical as the notion we once held that the Earth is the center of the galaxy![12] Astronomers from Galileo to Herschel and Hubble and beyond were always telling us that!

Evolution and Galactic Ecology

JCT: Something called "galactic ecology" is a concern for both of you. In particular, Greg, this seems to be one of the messages coming out of *The Forge of God*.

BEAR: Well, I read Benford in my youth!

BENFORD: Ha!

BEAR: And it seems like this is a perfectly reasonable attitude. What Greg is espousing has to be the attitude of the twenty-first century. And in *Forge of God*, you really are looking at that large-scale ecology of the galaxy.

JCT: I had not run into the term "galactic ecology" before. Could you give me a quick explanation?

BEAR: There's always been this question, Why aren't the Aliens here yet? You know, here we are sending out signals, but we don't hear any signals coming back. And my one answer that came back to me loud and clear was, well, you're birds chirping in the forest from the nest, and there are snakes out there, and they're going to crawl up the tree and eat you if you keep chirping your little heart out! And that seemed like a good story idea, a traditional science fiction story idea of disastrous encounters. That's the old Gothic theme, and you see it a lot in writers from Mary Shelley to Lovecraft—man's hubris, you know, risking disaster by courting unknown monsters. I mean, why are you announcing your presence when you're weak? And if you think there's no life out there, then, okay, we're safe. But if there is life out there, then you have to run with what you know about life, which is that life has both predators and partners.[13] The real metaphor of life is how things change and how they communicate with each other. And that's evolution. And we've had many fits and starts in trying to reach this understanding. We've tried to isolate ourselves as angelic intelligences, apart from biology, except for those damned *urges*, which just can't be overcome. And then we get all this persiflage about good and evil and cruelty and all that stuff. It's all part of a natural system. There may indeed be teleological and intelligently directed evolution, but we don't need to blame it on God. In its own way, DNA itself may be goal-seeking and problem-solving. The fact is, we're in pain, so we object to it. That's perfectly natural. But if you're going to talk about the large-scale stuff, you have to overcome your sense of pain long enough to realize. *Why?* What's the process here? If there is no process, there's certainly a development, and if there's development going on, where is it headed? If it's not headed any place you would particularly like to call progressive, then why is it not fitting your particular desires and needs? Why is the universe not catering to us? This is the scientific principle: the universe does not cater to you.

JCT: But you just said it might be in the DNA itself.

BEAR: In *Darwin's Children* I have it both ways. I say, look, we don't understand jack about what's going on here, but it's obvious that there can be intelligent design from within your own genome, spread around a neural network of different species, different animals, different ecosystems. That is the first time this has ever been, I believe, cogently expressed in that form—that this is internal creativity, it's obviously operating within the genome. Now the genome is a self-directing system reacting to changes, responding to the outside environment in very significant ways. So given that, yeah, we're looking at a universe that has both internal design; and then the big question from outside: is that all there is? Is that all there is?

And science at that point kind of stops off and says, well, it's all we can measure.

JCT: I hear a song by Peggy Lee in my head!

BEAR: Yeah. "Is that all there is, my friend?" But seriously, it's really a huge question, because that's a question of where science and faith collide. And what is faith? What is imagination? What is poetry and music? I tried to talk about their importance to our sense of humanity in my *Songs of Earth & Power*. They get so many people who are in pain through a hard day or a hard month or a hard year. Why? Because they just *know* there's something better out there. And as a biological thing, that makes things like faith essential to survival. Is it an illusion? That's a big question. If it's an illusion, it's still essential to survival, so you can't just pierce the illusion willy-nilly. But what if there *is* something going on? What if you're receiving these messages from a thing outside of process? And you're a scientist, and your whole upbringing is that *this is impossible*.[14]

Writing and Teaching

JCT: I'm getting the impression it must be great to be a student in one of your classes. Are both you guys still teaching?

BEAR: He is.

BENFORD: Well, I am. I'm a professor at U. C. Irvine.

JCT: So you haven't gone to full-time writing?

BENFORD: No, I never will. I mean, I've always thought it was too dangerous to be a full-time writer. Based on the experience of many of my friends, at least, who fall to alcoholism, bad work habits, drugs, a rather more interesting sex life.

 ...But, then, I'll defer to Greg Bear for that!

BEAR: Perversions he doesn't approve of, so!

JCT: Hmmm. Now, Greg, how about you—are you teaching at all?

BEAR: No, just lecturing off and on. No, teaching is hard work. And also I find that, with teaching, you have to remember how you use your own hundred set of caterpillar legs. And then you think about it, and then you stumble and fall in the ditch the next time you try to dance. So this is a metaphor for saying that, if you teach writing, which is probably what I'd only be qualified to teach, you'll get in trouble with your own writing. 'Cause you're going back over basics all the time. You can glide into that space where, you know, you don't even think about it.

JCT: So there's too much self-consciousness—?

BEAR: Imagine a sports figure teaching how to play baseball, or do ping-pong. Or imagine a great ballerina teaching ballet. They

usually don't until after they've retired. There's a reason for that. You're going over the basics again and again and again. And basics are what you want to forget about when you're at the top of your form.

BENFORD: I would never teach writing precisely because I enjoy the fact that I can do it without thinking about it. That I do it intuitively, and that's why it's recreation, and it's always been easy for me to, say, write novels because it was relaxing. If it became a full-time job I think it would be horrific.

BEAR: But how about in science? Does teaching science impede your ability to do theoretical science?

BENFORD: You know, I don't find that it does. I teach plasma physics, astrophysics, cosmology, and it's pleasant to reexamine the basics. Every once in a while in teaching a course, I've gotten an idea for something I could do just because I was forced to revisit the basics and think about them again. Trying to explain something to someone can clarify it to yourself.

BEAR: Why isn't that true about doing writing, then?

BENFORD: It's not true for me because writing is very intuitive for me. It's like— suppose someone wanted to say, Tell me how to make love. Well, I might be able to show you, but *tell*?

JCT: Well, then you how do you keep close to the scientific community? Do you still maintain a contact there?

BEAR: All the time. It's fun to talk about science. The thing about scientists is they don't have a lot of people who are willing to talk to them on a serious and listening level. You know, where you listen to what they're saying and come back with interesting questions. So science fiction writers kind of often do that. And that makes them great conversation victims for scientists. But we're willing victims, because we get our story ideas from a lot of those discourses. The other thing about talking to scientists is, science has a personality and a culture, and just as you would have to interview police detectives to understand about, you know, writing mysteries, and so on, talking to scientists, you get the feeling of the rhythm of their speech, how they use words, and how they interact with each other that's essential to creating the characters of the story.

The Scientist as Hero

JCT: Gregory Benford, so many of these topics and ideas can be found in your novel, *Timescape*. In the first place, it seems to me as a layperson you are saying something we don't encounter much in fiction—what the life of a scientist, particularly the physicist, is

like; and the pressures under which scientists operate—all about getting along and getting the grants and the tenure, and all of that kind of thing.

BENFORD: Right. I realized somewhere in the late 1970s that this enormously influential culture had no one writing novels about science and scientists.

BEAR: Well, C. P. Snow, in something like *The New Men* [1954].[15]

BENFORD: Right, but who had by the time he started writing novels actually stopped being a scientist. But yes. There are *fewer*, fewer examples. And I thought, wow, what a rich ground. And the most exciting thing to me in science is discovery. And discovery of the new is the cutting edge of science fiction, in my opinion. You cannot do that that you cannot first imagine. And that's true of scientists, too. So scientists have to have imagination. They are not just bookkeepers.

JCT: Icarus flew long before we had airplanes.

BENFORD: Right.

BEAR: The difference between Snow and Benford is that, in Snow's books, nothing significant is discovered. It's all about the process of the characters involved. It's a social priority. There's not really a deep novel about *discovery*. *Timescape* is all about something really cool being discovered. And that's kind of difference between the literary attitude that man is the measure of all things—and, therefore, we shall write about man—and the science fiction novel that says that while man's interesting, the universe is terrific! So what is man going to measure and discover?

BENFORD: Right. The interesting thing is that interface between us and the *strange*. The universe is fundamentally alien and we just keep trying to domesticate it. But there's always an alien boundary.

JCT: There's time-travel paradoxes aplenty here. It's like Chris Marker's *La Jetee*, where someone from the future reaches back into the past to alert people to take steps to prevent the disaster threatening the future. So, in *Timescape* we have two time periods, the world of 1963 and of 1998, interacting. But then, we shift to 1974 and to yet another future time period![16] Wow! I gather that the scientist, Markham, is your kinda guy?

BENFORD: Oh yeah. Well, Markham, by no accident, has exactly my biography. And he has my first name. I appear in the novel actually, under two different guises; the other is the California scientist, Gordon Bernstein. Markham is in 1998 and Gordon is in 1963. You see, it's all a form of disguised autobiography. What happens in the last chapter, or I intended to happen, is that Bernstein, in a sense, is in a quantum-mechanical state. Time is a *loop*, where cause-and-effect mean nothing. He sort of is stuck *in between*, and he becomes aware of how contingent his present is.

And so he goes in and out of states.[17] I attempted to convey what it would be like if you were subject to a quantum-mechanical state and you flipped between one and the other—

JCT:But here, the switch is *between* ON and OFF?

BENFORD: Yeah, it's in between. But I wanted to evoke just the sensation of feeling that time, or the timescape, was variable, that it rippled and moved, instead of time as this solid object that we think of. So that's the aesthetic intention in the last five, six pages of the novel. It's the attempt to see time as pliable and to see what it would feel like if it were pliable.

JCT:And there's this wonderful sort of elegiac quality to those final scenes in the dying world of England, when we see the selfish industrialist Peterson going back to his home, which is now a fortress. But it—and I mean this as an absolute compliment— kind of reminded me of R. C. Sherriff's *The Hopkins Manuscript*.[18] That's one of the great end-of-the-world scenes I've ever seen, not because it's a graphic description of cataclysm, but the quiet despair of how the characters are approaching their end BENFORD: *The Hopkins Manuscript*? I'll have to read it.

JCT: Yes, Sheriff has impeccable Gothic credentials, you know. He wrote the screenplay for *The Invisible Man* [1933].

BENFORD: My intention in *Timescape* was to say that Peterson is a guy who is an alpha-male, who treats people like objects, and he's, you know, upper class and all this; and he's planning for the collapse all along, and he gets into his redoubt and then realizes that he's still contingent—dependent upon the people in the community and they don't *owe* him. And then there's this feeling of dread that he's in a corner, and he can't get out, and he thought he was so smart, but he'd forgotten that you have to not treat people like objects.

JT: Greg Bear, where are *you* in your books?

BEAR: I'm God. So I'm in all of my books! Master of life and death! No, I just borrow stuff from my various, you know, subconscious processes and they become different characters, [modeled] somewhat after people in the real world. Mostly I model on their realities, their biographies, but their internal processes I have to think of in my own terms.

Death, Where Is Thy Sting?

JT: Obviously, living and dying are complicated elements in your stories. The divisions between them seem to, well, get blurred, as you say. In *Darwin's Radio*, a new generation, in effect, is born twice. And in *Dead Lines* people *die* twice.

BEAR: Right.

JT: What's going on?

BEAR: I've long believed that coming into this world and going out of this world are the two hardest things you'll ever do. You get your ticket stamped going in, you get your ticket stamped going out. It's just miserable. It's traumatic, it's miserable. And the question is at that point, why is there faith, why is there a need for faith? Because of these two truths. So the people say there must have been something before and there must be something after. Interestingly enough, we don't talk about what comes before. I think it's perfectly legitimate, even in a science fiction story to say, "What if there is something beyond our ken?" But the interesting thing about the reaction to *Dead Lines* is, I think, that it's got great reviews and it's been called a fantasy novel. Like I said before, I don't regard it as exactly a fantasy novel. It's a *discovery* of a new realm in a way that's very frightening. And structurally that's no different for me than what happens in *Blood Music,* which describes microscopic medical machines, where DNA is treated as a computational system. Which also, I think, would be very frightening. People hate two things. They hate biological transformation that is equated with disease. Okay, something changes, then it must go wrong. Or ageing. And then they hate the notion of other kinds of change that lead to death, which is the ultimate change. But what if that's not the end of the changes? And in *Dead Lines* I want to give you the impression that death is a process that has rules and is very, very moving and confusing and also strips away from you the things that you no longer need. I borrowed this from Bruce Joel Rubin's screenplay for a movie called *Jacob's Ladder* [1990]. (There'll be some spoilers if you print this!) *Jacob's Ladder* is a marvelous story about the supernatural, kind of a version of Ambrose Bierce's *An Occurrence at Owl Creek Bridge* [1890], where a man who was in Vietnam is going through the process of having all of his earthly persiflage stripped away from him. For him, the perspective is that he's seeing demons. But in the end of the story it's not that they're demons. It's that they're there to strip away what you don't need in the process of dying. There's a little bit of this sort of thing in Stephen King's *The Langoliers,* which is one of the more interesting time-travel stories, 'cause it's an organic vision of time.

JT: Which is gobbling up the universe.

BEAR: Gobbling up and changing, and it's unpredictable. It's not mathematically linear and predictable. I kinda like that. It's also a very scary story. And so what I'm saying is, *What if ghosts are dead skin left behind?* Then are there spiritual mites that chew that up and

get it out of the way? And that's a very natural process, and, again, most of my stories involve the ecology of natural processes.

Art and Science

JT: Let's think about winding this up. Don't we all wonder where the Artists of the future will be in all this?

BEAR: Well, we've already talked about *Songs of Earth & Power*. There's lots of music and poetry there. Mahler and Mozart both show up at the end!

JT: You're not kidding! There they are—rubbing shoulders with your fictional characters! The sheer audacity of it took my breath away! They're not dead, exactly, and not—

BEAR:—They've been, well, *delayed*, you could say. Consider: Mahler never finished his Tenth Symphony. I asked myself... *Why???* Because when you reach the Tenth Symphony, like Mahler, you've acquired a level of wisdom that creates a song of power. But in my book the elves—I call them the Sidhe—don't want humans to achieve that kind of power. There's forces that will come in to thwart that. I mean, it's a very paranoid vision, the whole Gothic thing, like Lovecraft's monsters out to get us. Think what happened with Mozart's unfinished Requiem: The "Man in Gray" shows up. Who was the man in gray? Salieri? A mysterious patron? A "Person from Porlock.?" Well, I *do* have a Person from Porlock in my book! Literally. Remember him?—he's the person who "interrupted" Coleridge's poem "Kubla Khan,"...and I say that maybe he's the person who also blocked the finish of Mozart's Requiem. There are so many instances in poetry and music and literature like this that are *really* interesting, because man is blocked from achieving a higher being. And you could take six or seven of those instances and string them into a story; and I did. I'm not sure if Borges actually wrote an essay on the mystery of *interruption*, but he could have.

JT: Seems like he did on everything else!

BEAR: Yeah. And that's why I think that these two novels [*The Infinity Concerto* and *The Serpent Mage*] are kind of extended combinations of George MacDonald and Jorge Luis Borges and, you know, half a dozen other fantasy writers.

JT: George MacDonald. Yes. *Lilith* absolutely blew my mind.

BEAR: It's great, isn't it? Christian surrealism!

JT: I mean, it's a leap of imagination that just left me—

BEAR: Yeah.

JT: —stunned.[19]

BEAR: I mean, *where* do all of our imaginations begin? Is it that reality is menacing, supportive, or a combination of the two? And our deepest fears come from trying to be a kid and get along in a world you don't understand. And when you're a baby there are lots of things you see that you don't know whether they're real or not. You have no context—

JT: So where does Art with a capital "A" come in? And the Artist? Gregory Benford, you talk about an awful creature called the "Mantis" in *Great Sky River*. It is an "artist"... sort of, but a very perverse one. It does bridge the gap between mechanical apparatus and organic life. Is *that* the height of the artistic frontier, like the Mantis claims?

BENFORD: Yes, well, we don't think of ourselves as malleable material?—as suitable material for the artworks of higher and more powerful beings. But, of course, the deer whose antlers are on the wall don't think that either! I thought a way to show the true position of humans on this scale was to show that "cosmic artists" would treat them as mere *material*, and that these others would regard the complexities of human society and our way of perceiving the world as just grist for their mill. Toward the end of *Great Sky River*, a human stumbles upon this gallery that the Mantis—

JT: —horrific stuff.

BENFORD: —has made up. And he's taken human beings, their bodies, and made them into festooned works, without any consideration of the point of view of the humans at all. And so all these grotesque things are created by another intelligence for aesthetic purposes that appear to us to be horrific.[20]

JT: While reading that, I kept thinking of the hideous reconstructions from human bones into chairs and tables you see in *Texas Chainsaw Massacre*.

BENFORD: Yes. Well—

JT: —Which is another kind of corrupt or perverted art.

BEAR: Hannibal Lecter's cuisine applied to furniture!

BENFORD: And you think of the Nazis who made lamp shades out of human flesh. Anything that reduces humans to the status of object is inherently insulting and horrific. And yet that attitude we have is part of the defensive posture of a species that has been winning for so long in the evolutionary lottery that maybe we've forgotten that we may *not* be the lords of creation.

JT: Well, what about maybe some more benign examples of art-making?

BENFORD: Yes. Artists in the future would regard our preconceptions or our perceptions of the world as suitable material. They would create effects that appear to be illusions, exploiting our habits of breaking down information to produce things that are

not real, but which we perceive as being real because they, in a sense, have subverted our visual processing power. You perceive it two ways, like an ambigram.

BEAR: Like the two faces in the vase.

BENFORD: Right. That shows that there's an ambiguity in the way we interpret visual information. You can make up images that you can see two ways. Well, what about three-dimensional objects you can see two ways? And that are moving, so it makes you see things that don't exist. But your own processing power is doing the work of creating the illusion. That's an art form that I think will come about.

JCT: Science is an art form?

BEAR: Yeah. It's a way of artificially putting things into context that you didn't understand before.

BENFORD: Well, that's true.

JT: What about aesthetics?

BEAR: Aesthetics is a class-based judgment system. For most of the people on this planet, art is amusement, which is something they don't want to strongly define. It diverts them from their everyday lives. Aesthetics comes in when you have a higher class or educated class that then wants to isolate their attitudes from those of the lower classes. Then you use more high-falutin' words with Greek contexts, or Roman contexts. Everything else is just—as far as I'm concerned—playing to the groundlings. We just don't know it.

BENFORD: Hmm. The idea that science is an art work. . . . But art never answers to the necessity of empirical verification.

BEAR: Until now. It's a constraint upon your behavior. Every art form is an assumption of a philosophy or an attitude that constrains your freedom of motion to do art. So we're all very amused that chimpanzees can paint, but we don't know what their context is, so they don't sell for a lot of money. Okay? But a scientist has a constraint that it has to be outside of just his or her personal relationship with the universe. Other people have to be able to see it and do it over again.

BENFORD: And check it.

BEAR: And check it. And that's an art form of the highest caliber. Because it's a *participative* art form. It doesn't just say that only one person can do it, the great genius is the only person who can do this experiment. That might be true of Michelangelo's David, but it's not true of Einstein's relativity or general relativity. We can do that experiment over and over and over again and get similar results. So that's a real work of art.

BENFORD: Yes. But, the trick, of course, is that art—science as art—is always provisional. It's always a partial vision.

BEAR: Well, now, that's an interesting distinction. We're used to thinking that art can be a completed vision within the culture. But we still read about great scientific things of the past as *incompleted* visions that we have now gone beyond. And I think artists do the same thing.

BENFORD: Sure. The Sistine Chapel is probably the ultimate of what you can do in that direction, and the evidence is that nobody has even attempted anything like that in a very long time. You can say that of Baroque music. How come people aren't writing Baroque music now? I think it's simply because they feel that in some sense it's exhausted, or it's complete. I've always wondered about that. Marx said that history repeats itself first as tragedy and second as comedy. But art can do the same thing. You start to make fun, or make fun *with*, the modes and mannerisms of the past.

BEAR: Which I think scientists do in a subtle way, too. It's less "ha ha" funny than, "You really goofed up your experiment, here's how you do it better!" And it's a constant sense of criticism of improvement far more disciplined than any art form I know of.

JT: But mistakes in art can be very important. Mistakes in a scientific procedure can be disastrous.

BEAR: But you learn from them.

BENFORD: Yes.

JT: But we don't treasure the mistakes. I mean, John Marin's watercolors are precious because when globs of water dripped down across the surface, he *kept* them there. He didn't correct them, you know.

BENFORD: But it's true that you learn from "mistakes." The classic example I would venture is that, when Einstein added a constant to his general field equations to make the solution for the universe to be static, he didn't realize that it was static but if you tipped it a little bit it was unstable, it would either contract or expand. He regarded that as a huge error. However, we now know the expansion of the universe is accelerating, and one way of looking at that is to say that that constant is real and is now driving the expansion. So it's a mistake. It starts to fix a problem, then it looks like it's wrong, and now it's back again in a different guise.

BEAR: And in 20 years it might be wrong again. 'Cause the whole Big Bang thing is starting to look a little gnarly, you know, we're starting to get some ideas that maybe this isn't what we should be looking at, because it's getting really complicated. So it's a wonderful back-and-forth of people who are educating their children, basically, to carry on with the mission, and to criticize them down the road. Very few artists do this. But scientists do.

BENFORD: That's true. It's the quality of self-criticism that makes science become the standard for believability in our society. After all, now since everybody has Adobe Photoshop, you can't even believe what you see.

BEAR: And with your illusions we couldn't even believe what we see in real life, so.

BENFORD: Seeing is no longer believing and it's going to take a long time for our culture to quite realize that.

BEAR: What I found interesting was that, for many scientists, sometimes seeing was still not believing, even under a scientific context. You know, because it doesn't fit in to the past experience. So, you have spiritual experiences, they are explained in nonspiritual ways by the hardcore scientists. Rather than saying, I do not know, a spiritual experience is relegated to being pure psychology. That is, of meaningless value because it refers to something outside of the context of science that we know today.

JT: I'm thinking, too, of Robert Bresson, the French filmmaker, who will bring about a spiritual condition, but under the most bland, inane, uninflected kind of camera work, viewing angle, and performance.[21]

BEAR: Right. Isn't that how it happens in real life? You know, ecstasy, inspiration, epiphany doesn't come with glorious Max Steiner music in the background and you're on the cliffs of France staring down at the water and suddenly God touches you. It usually happens when you're in the bathtub, or driving a car, or, you know, doing something else. So, epiphany is as rude as any other thing in reality.

JT: You take music into other directions, Greg. You mentioned earlier *Songs of Earth & Power*, where you write about composers whose music has profound effects, both in this world and in other worlds.

BEAR: Yes, I talk about music as a kind of magical incantation, like Arno Waltiri's "Infinity Concerto." Performing it can risk apocalypse. Music as a bridge that melds worlds. I'm afraid that combination of music and magic has confused some readers, though.[22]

JT: But didn't the German Romantics, from Wackenroder to Schumann, say the same thing?[23] But you don't stop there. There's your story, "Tangents," which is rather like a cross between Henry Kuttner and Albert Einstein!

BEAR: There was this keyboard hookup whose music called forth fourth-dimensional creatures—

JT: I thought immediately of Lovecraft's "The Music of Erich Zann"—

BEAR:—And it was fun to think what the hypersphere of the fourth dimension would look like if it intruded into our three-dimensional

space![24] But there's also *Blood Music*. My character can hear a kind of "internal music," of the operations inside his blood. Which is rhythm. It's coordinated rhythm. It's a communication that is everywhere; it completely absorbs us, consumes us. We can't arise out of it. So when we're talking to each other, we don't perceive the language we're using. And when, you know, genes are talking to each other, what's the context there? How many layers of translation did they go through? When particles are talking to each other, in my crackpot theory of physics, which I borrow from four or five other physicists, what are particles talking to each other *about*? And on what level is it constrained? So I'm just very interested in all the connectedness and the talking going on in the universe.

EPILOGUE

"Night Vision"

In Nature's infinite book of secrecy
A little I can read.
 The soothsayer in *Antony and Cleopatra*

The conversation with Bear and Benford bring us to the end—or is it a new beginning? We recall the adventures of Cyrano de Bergerac that began this book. He had journeyed to the Moon and beyond, ultimately to the sun. Mere mortality failed to slow him down. There's much more. Witness his epitaph:

All weary with the earth too soon
I took my flight into the skies,
Beholding there the sun and moon
Where now the Gods confront my eyes.

In 1846 the German philosopher and biographer Felix Eberty anonymously published his *The Stars and the Earth; Or, Thoughts upon Space, Time and Eternity*.[1] He imagined that the universe was a vast and indestructible visual archive, with pictures of every single event in Earth's history carried on the wings of rays of light. If a celestial observer began his viewing of our planet from the vantage point of a distant star and moved with great speed toward Earth, he could move forward in time to the present, in successive stages, from Abraham to Einstein. He might even choose to slow down occasionally to enjoy particular moments and events. Thus, I imagine *The Gothic Imagination* as such a time-and-space devouring trip, collapsing space and time in the journey forward from the wellsprings of the Gothic tale to successive moments, pictures, and sounds of the storytellers, painters, composers, and filmmakers of our present day.

Occasionally they come back to gather 'round the cosmic campfire to tell their tales, sing their songs, unveil their pictures, and pose new questions. How do they find our world and worlds beyond it, real and imaginary?[2]

In the decentering of our universe, our philosophies and our religions, do we risk losing *faith* and *wonder*? We are reminded that Lovecraft, the storyteller who stands at the center of this book, was undaunted. He wrote: "[I extol] the quality of mystic adventurous expectancy itself—the indefiniteness which permits me to foster the momentary illusion that almost any vista of wonder and beauty might open up, or almost any law of time or space or matter or energy be marvelously defeated or reversed or modified or transcended."[3]

And so, as historian Richard Holmes has told me in a recent interview, "The very notion of *wonder* becomes more and more complicated, because it evolves with knowledge and age as it takes you into more and more difficult areas—into the beautiful and beneficial...and into the terrifying and the menacing. We are continually tasked with *reimagining* what we're going through, which is very crucial now. And that's what storytelling can do."[4]

Let's now step away from the glare of the cosmic campfire. We gaze upward. Suddenly, starkly, we recover our night vision. A starry sky blazes above us. "In a dark time, the eye begins to see," wrote Theodore Roethke. Undiminished by the "glare of certainty and human pride," our imaginations are nourished afresh.[5] "We switch on the night," said Ray Bradbury.[6] His spiritual brother, John Carter of Mars, saw the stars and raised his arms, yearning, toward the heavens.

And we follow, our new eyes wide open.

NOTES

Introduction: Voices Heard 'Round the Cosmic Campfire

1. "Sailor of aerial seas" was the term used by Edmond Rostand in his fictionalized play about de Bergerac. Sam Moskowitz, in his profile of the famed swordsman-poet, notes that neither *Voyage to the Moon* nor *A Voyage to the Sun* were the first "interplanetaries" ever written nor the first in which a machine is constructed to carry its passengers to another world. See Moskowitz, *Explorers of the Infinite: Shapers of Science Fiction*, 17–32.

2. For example, recently, Kim Stanley Robinson imagines the astronomer Galileo taking a similar astral trip to the moons of Jupiter in *Galileo's Dream* (New York: Ballantine, 2009). When Galileo looks into a telescope, in words recalling John Carter's passage to Mars, "a wave of dizziness passed through [Galileo's] whole body; it felt like he was falling up toward the white moon. He lost his balance. He felt himself pitch forward, headfirst into the device....He was standing on the surface of the moon he had been looking at" (44–45). In a letter to the author, 5 February 2011, Robinson acknowledged, "It's true that Galileo's first trip to Jupiter is very like John Carter's great leap to Mars!"

3. Lin Carter, *Imaginary Worlds*, 50.

4. Sam Moskowitz, *Explorers of the Infinite*, 174.

5. Percy Shelley, *Hymn to Intellectual Beauty*, Stanza 5.

6. Writing in the *Wall Street Journal*, 15 March 2005, on the occasion of the publication of many of his stories by the Library of America, edited by Peter Straub, John J. Miller reports, "For a man who didn't believe in the afterlife, H. P. Lovecraft sure is having a remarkable run. Few people had heard of him when he died at the age of 46...in 1937, and fewer still had read the stories he sold to tacky pulp magazines. Nowadays, however, Stephen King and just about everybody else in the know recognizes him as the twentieth century's most influential practitioner of the horror story—a claim he arguably clinched last month with the publication of his best works in a definitive volume" (D8).

7. In words echoing the Brothers Grimm that children and adults had equal claims on the folkloristic legacy of their ancestors, Lovecraft discusses the importance of folkloric storytelling traditions at length in his letter to Emil Petaja, 31 May 1935. See August Derleth and James Turner, *H. P. Lovecraft: Selected Letters, 1934–1937*, 170–173.

8. Can fear and trembling be a source of pleasure, even joy? It's an important consideration in what is popularly known as *the sublime*. "There is a joy in fear," wrote Joanna Baillie in an 1812 play called *Orra: A Tragedy*, in a work Percy and Mary Shelley knew well. While vestiges of the sentimental romance cling to the Gothic narrative, they are largely supplanted by what Edmund Burke called the *terror sublime*. He first formulated this in his *Philosophical Enquiry into the Origin of Our Ideas of the Sublime and Beautiful* (1757). Imaginative transport is not only desirable, it is a mental and physical *necessity*. The sublime is an apprehension of danger in nature or art without the immediate risk of destruction: "When danger or pain press too nearly, they are incapable of giving any delight, and are simply terrible; but at certain distances, and with certain modifications, they may be, and they are, delightful, as we every day experience" (See Jerrold E. Hogle, ed., *The Cambridge Companion to Gothic Fiction*, 14–15, 28). In his estimable *A History of Terror*,

Paul Newman pursues the differences between the terror sublime and the real horror of pain and imminent death. One is essentially a *recreation*, the other all too real. The Gothic tradition, Newman writes, "teaches us that to enjoy fear, it is important to only *half* believe in it. More than that would make it a threat to sanity" (xi). This in turn stimulates the creative act.

9. Brian Aldiss and David Wingrove, "On the Origins of Species: Mary Shelley," in James Gunn and Matthew Candelaria, eds., *Speculations on Speculation*, 176.

10. The English Gothic craze can be traced to a June night in 1764 when Horace Walpole, the fourth Earl of Orford, Member of Parliament, awoke from a dream that led to the publication a few months later on Christmas Eve of his spectacularly successful *The Castle of Otranto: A Gothic Story*. The short novel contains many of the themes, incidents, and transgressions so influential thereafter: a medieval setting, haunted castle, villainous dark lord, usurped heir, pursued maidens, inherited sins, incest, and other elements. In the Preface to the Second Edition, Walpole famously remarked: "It was an attempt to blend the two kinds of Romance, the ancient and the modern. In the former, all was imagination and improbability: in the latter, nature is always intended to be, and sometimes has been, copied with success. Invention has not been wanting; but the great resources of fancy have been dammed up. . . . The author of the following pages thought it possible to reconcile the two kinds" (9–10). See Horace Walpole, *The Castle of Otranto* (New York: Holt, Rinehart & Winston, 1963).

11. Bruno Bettelheim, *The Uses of Enchantment*, 25.

12. Carl Sagan, *The Varieties of Scientific Experience*, 35.

13. Casual attempts to link science fiction with aspects of the Gothic imagination can bring howls of protest. James Gunn, for example, in "The Readers of Hard Science Fiction," objects to the partnering of the Gothic and science fiction in Mary Shelley's *Frankenstein*: "[The book] seems more like a gothic novel than science fiction because the experienced science fiction reader keeps wanting the tormented scientist to behave rationally, and he doesn't even behave like a scientist when he shrinks from his creation" (82). In his essay, "SF and the Geneological Jungle," Darko Suvin, former professor of English and Comparative Literature at McGill University and editor of *Science Fiction Studies*, refers to the impact of Gothic horror on science fiction as "pernicious" and a "parasitism." He strenuously objects to the "irruption of an anti-cognitive world into the world of empirical cognition." Surely, he says, "SF, built upon the premise that nature is neither a childishly wicked stepmother . . . nor inscrutably alien to man—surely SF cannot allow its contract with the reader to be contaminated by the Great Pumpkin antics of fantasy. Even more perniciously than is the case with the bland fairy tale structure, the black ectoplasms of fantasy stifle SF completely. Its time shrinks to the point-consciousness of horror, gloom, and doom, its daydreams turn into an inchoate nightmare, and under the guise of cognition the ancient obscurantist enemy infiltrates its citadel. . . . The social energy of readers is expended on Witches' Sabbaths instead of focusing it on the causes for our alienating, murderous, and stultifying existences: the power structures holding back the hominization of the sapiens, the true demonology of war and market breeding pride and prejudice" (67). Both essays are found in James Gunn and Matthew Candelaria, eds., *Speculations on Speculation: Theories of Science Fiction*.

14. Brian Aldiss and David Wingrove, "On the Origin of Species: Mary Shelley," in James Gunn and Matthew Candelaria, eds., *Speculations on Speculation*, 198.

15. There are four particularly fine examinations of Mary Shelley's *Frankenstein* and the circumstances under which it was inspired and its subsequent impact on the Gothic sensibility: Radu Florescu, *In Search of Frankenstein*; Donald F. Glut, *The Frankenstein Legend*; David J. Skal, *Screams of Reason: Mad Science and Modern Culture*, 31–87; and George Levine and U. C. Knoepflimacher, eds., *The Endurance of Frankenstein: Essays on Mary Shelley's Novel*.

16. Brian W. Aldiss, *Trillion Year Spree*, 16–20.

17. Jerrold E. Hogle, Introduction to *The Cambridge Companion to Gothic Fiction*, 2.

18. William Gibson and Bruce Sterling, *The Difference Engine* (New York: Bantam Books, 1992), 301.

19. Letter to Farnsworth Wright, 5 July 1927, in August Derleth, ed., *H. P. Lovecraft: Selected Letters, 1925–1929*, 150. In her study of Lovecraft, Vivian Ralickas states it this way: "Contrary to the humanist view which posits human life as intrinsically meaningful in relation not only to itself but to the cosmos, there is [in Lovecraft] neither anything distinctive nor significant about being human." See Vivian Ralickas, "Art, Cosmic Horror, and the Fetishizing Gaze in the Fiction of H. P. Lovecraft," 298.

20. Joseph Campbell, *The Hero with a Thousand Faces*, 30 (italics in the original).

Chapter 1: The Lovecraft Circle

1. Joyce Carol Oates' "The King of Weird" (46–53) is one of the best and most penetrating introductions to Lovecraft's work.
2. Stephen King, *Danse Macabre*, 72.
3. The Faust story, in its many incarnations, from Christopher Marlowe's *The Tragical History of the Life and Death of Doctor Faustus* (1604), Johann Wolfgang von Goethe's *Faust* (1806–1832), to the overreaching scientists and artists in Robert Louis Stevenson (*Dr. Jekyll and Mr. Hyde*, 1888), H. G. Wells (*The Island of Dr. Moreau*, 1898), H. P. Lovecraft (*Herbert West: Reanimator*, 1922), Thomas Mann (*Doctor Faustus*, 1943–1947), Brian Aldiss (*Moreau's Other Island*, 1980), and Greg Bear (*Blood Music*, 1985)—not to mention the numerous incarnations in paintings and music by painters and composers Eugéne Delacroix, Hector Berlioz, Robert Schumann, Arrigo Boito, Ferrucio Busoni, John Adams, and many others—continues to provoke and stimulate the Gothic imagination.
4. H. P. Lovecraft, "The Call of Cthulhu," in August Derleth and Donald Wandrei, eds., *The Outsider and Others* (Sauk City: WI, 1939), 255. Lovecraft's oft-stated "indeterminacy" is reflected in radical and often counterintuitive principles of the quantum mechanics embedded in the Heisenberg uncertainty principle, which declares that we do not know—and we *cannot* know—the details of our universe with absolute and limitless precision. This uncertainty principle was first published in 1927 in W. Heisenberg, Über den anschaulichen inhalt der quantentheoretischen Kinematik und Mechanik," *Zeitschrift für Physik* 43, 3–4: 172–198.
5. Robert Bloch, "Out of the Ivory Tower," in Peter Cannon, ed., *Lovecraft Remembered*, 323.
6. For a detailed account of August Derleth and Arkham House's remarkable connection with the Lovecraft legacy, see L. Sprague de Camp, *Lovecraft: A Biography*, 430–438.
7. The quote is from H. P. Lovecraft's own definition of "the true function of fantasy," as quoted in Jim Turner, ed., *Cthulhu 2000; A Lovecraftian Anthology*, xiv.
8. In "The King of Weird" Joyce Carol Oates applauds Joshi's Lovecraft biography as "virtually a day-by-day account of Lovecraft's life" and "contains a history of gothic literature, excerpts from Lovecraft's unpublished letters, essays, and travel pieces, and among other inspired passages, a description of New York in 1924 and how it must have looked to Lovecraft's wondering eyes" (52).
9. "The Outsider" may be interpreted as an autobiographical statement of Lovecraft's own sense of "otherness." The unnamed narrator escapes from the castle in which he has been imprisoned since childhood. Free at last, he encounters a grotesque creature from which people flee in revulsion. He reaches out to touch the beast—only to find he is touching his own reflection in the "cold" surface of a mirror.
10. In its depiction of the destructive effects of a powerful nuclear-toxic force emanating from a fallen meteor, "The Colour out of Space" was prophetic in its depiction of today's ecological disasters. The neurological and bodily afflictions described are eerily similar to the sufferings of victims of Agent Orange and radioactivity.
11. Another illuminating, albeit informal biographical treatment is Willis Conover's *Lovecraft at Last*. It lovingly documents in text and illustrations the epistolary relationship between the 15-year-old Conover and the elder Lovecraft. What emerges here is a warm and humorous portrait of Lovecraft usually missing in other volumes.
12. The famous quote is as follows: "I am Providence, and Providence is myself—together, indissolubly as one, we stand thro' the ages; a fixt [sic] monument set aeternally in the shadow of Durfee's ice-clad peak!" From a letter to James F. Morton, 16 May 1926 (See Volume 2 of August Derleth, ed., *H. P. Lovecraft: Selected Letters, 1925–1929*, 51).
13. "The Case of Charles Dexter Ward" is indeed one of the most closely observed tributes to Providence, particularly in its loving evocations of local history and colonial architecture. Ward is a young antiquarian whose obsession with his distant ancestor, Joseph Curwen, leads to the discovery that Curwen had discovered the secret of resurrecting the dead. Ward subsequently loots the grave and raises Curwen from the dead. Curwen promptly kills Ward and assumes his identity. In 1960 it was *very* loosely adapted for a film, *The Haunted Palace*, starring Vincent Price.
14. The archive at www.hplovecraft.com includes an endless list of popular songs that quote or allude to his stories. Also, it is now possible, reports *The Wall Street Journal*, to go on the Internet and take a virtual tour of Lovecraft sites in Providence, or to shop for a Cthulhu plush toy. You

can even buy a bumper sticker: "Cthulhu for President!" See John J. Miller, "H. P. Lovecraft: 68 Years Dead and More Influential than Ever," D8.

15. "Letter to *Weird Tales*," in Peter Cannon, ed., *Lovecraft Remembered*, 283. *Weird Tales* was in its almost 30 years of publication indisputably America's premiere fantasy fiction magazine. Its 279 issues, under the editorships of Farnsworth Wright, Edwin Baird, and Dorothy McIlwraith boasted a formidable lineup of authors, many of whom are represented in the pages of this book. In 1988 Robert Bloch fondly looked back upon *Weird Tales*: "No other contemporary magazine, pulp or slick paper, offered its writers such freedom to exercise imagination or gave its readers such a variety of fantastic fare....Male or female, teenager or septuagenarian, self-taught or formally educated their varied backgrounds and outlooks brought a dazzling diversity of style and content reflecting imaginative individuality" (xv). See Bloch's Introduction to Stefan R. Dziemianowicz in Robert Weinberg, and Martin H. Greenberg, eds., *Weird Tales*. For a detailed history of *Weird Tales*, see Robert Weinberg, *The Weird Tales Story*.

16. Stephen King, *Danse Macabre*, 84.

17. Appearing frequently in Lovecraft's stories is the "forbidden" *Necronomicon*, an ancient book invented by him in 1922. It supposedly was authored by "Abdul Alhazred" (a name Lovecraft had devised for himself as a boy). The fabled sage's career ended when he was gobbled up by an invisible demon! The book can be found under lock and key in the library of Miskatonic University in Arkham.

18. William Castle's shock exhibitionist tactics for the films *The Tingler, House on Haunted Hill, Strait-Jacket*, and others had its late nineteenth-century precedents in the *Theatre du Grand Guignol* in Paris. Max Maurey, who took over the management of the Theatre in 1897, advertised the Theatre as "The House of Horrors" and took out newspaper ads showing patrons getting heart checkups before entering the theatre. He also hired a house physician to revive any customers who collapsed from shock. "What drew the crowds," writes Harold Schechter in *Savage Pastimes*, "[was] the insanely violent melodramas—harrowing spectacles of torture, murder, and horrendous mutilation. For the next half century, the tiny one-time chapel attracted untold numbers of respectable Parisians and well-heeled tourists seeking the ultimate in morbid titillation— graphic hardcore sadism of a kind that is impossible to witness nowadays outside the realm of the most repellent 'video nasties' (as the British call such low-grade gore movies" (85).

19. Bloch's insights into characters like this recall lines by Thomas Hood (1799–1845) from *The Dream of Eugene Aram*.

20. In his book, *The Moment of Psycho*, David Thomson recounts the circumstances that led up to Hitchcock's adaptation of the Bloch novel: "In late 1958, to follow *North by Northwest*, Hitchcock was contemplating an English novel, *No Bail for a Judge*, by Henry Cecil. It turned on a judge's daughter, to be played by Audrey Hepburn, who sets out to prove her father's innocence in a murder case. Next to *Psycho*, it seems nearly archaic, but there was an attempted rape scene in the treatment that made Hitchcock flinch. So that project lapsed, and in June 1959 Hitchcock began to talk about *Psycho*. Robert Bloch's novel of the same name had been around in proof for a few months. It was based on the activity of a serial killer from Wisconsin, Ed Gein, who had been captured in 1957....Bloch also dreamed up the killing in a shower stall. He reckoned that was the epitome of invaded privacy. But his novel had the killer's knife, in one stroke, slashing through the shower curtain and beheading the woman. For Hitchcock the killing was too rapid. From the onset he saw the shower murder as a set piece, an extended frenzy of blows that might take a week to film" (13–14). For a more detailed look at the genesis of the film, see Stephen Rebello, *Alfred Hitchcock and the Making of "Psycho."*

21. The story, slated to air in 1961 concluded with a deranged magician's assistant (Brandon De Wilde) mistakenly—but literally—sawing a woman (Diana Dors) in half. It was the only *Hitchcock* program whose telecast was prohibited during the initial presentation. It was seen only in subsequent syndication. Bloch's story originally appeared in 1949 in *Weird Tales*. For an account of this and other Bloch adaptations for *Alfred Hitchcock Presents*, see Martin Grams, Jr., and Patrick Wikstrom, *The Alfred Hitchcock Presents Companion*.

22. Bloch is referring to what then was an underground movement in horror fiction that exploits the scariness of the *seen*, as opposed to the merely *suggested*. Now more mainstream in fiction and film, splatterpunk is a latter-day incarnation of the *grand guignol* style of theater of the late nineteenth century and the Futurist movement in Italy in the early 'teens with its celebrations of violence and explicit depictions of horrific acts and bodily mutilations. See the paintings of Francis Bacon. Current literary specialists include David Schow and Clive Barker and

filmmakers Hershel Gordon Lewis, John Carpenter, and David Cronenberg. "The horror film, like pornography," writes Isabel Cristina in *Recreational Terror*, "dares not only to violate taboos but to expose the secrets of the flesh, to spill the contents of the body.... Porn and horror are obsessed with the transgression of bodily boundaries" (61).

23. See also the interview with Campbell in *Mystery Scene* 47 (May–June 1997): 22–23, 65.

24. Curiously, it was this very same edition of Lovecraft's book that also first spurred the imagination of the young Stephen King. See his account in his *Danse Macabre*, 101.

25. Historically, the French *grand guignol* brand of extremely gory theater dates roughly from the late nineteenth century to the 1960s. In particular, the Parisian *Théâtre du Grand Guignol* was the darling of Paris' *épater les bourgeois* intelligentsia. Unlike the Gothic tale, this form of entertainment based its stories on real-life bloody and murderous criminal stories from newspapers and laboratory reports. In his *The Grand Guignol: Theatre of Fear and Terror*, Mel Gordon reports: "The shocking stage display was a more truthful unveiling of the savage human soul than anything available elsewhere on stage or in the cinema. Only life matched the horror of the *Grand Guignol*" (2).

26. Matthew Gregory Lewis (1775–1817) had close and significant ties with the English Romantics. He was a friend of Walter Scott, published a collection of ballads called *Tales of Wonder*, wrote a highly successful Gothic stage work, *The Castle Spectre*, translated parts of Goethe's *Faust* to his friend Lord Byron, and told ghost stories to the Shelleys at the Villa Diodati. For a detailed summary of Matthew G. ("Monk") Lewis' life and work, see Louis F. Peck, *A Life of Matthew G. Lewis*. Lewis was only 19 when he wrote his scandalous *The Monk*, a tale of the corrupt Abbot Ambrosio's wicked debauchery. Ambrosio's first virginal victim, Matilda, not only succumbs to his sexual sadism, but also proceeds to instruct him further in the practice! His second victim, Antonia, sells herself to the Devil. Ambrosio himself is finally tortured by the Inquisition and the Devil himself. *The Monk's* blend of visceral horror and erotic *frisson* anticipated the outrageous sexual perversities and mutilations of French *guignol* theater of the late nineteenth century. In his Introduction to *The Monk* (New York: Grove Press, 1952), John Berryman dubs *The Monk* "one of the authentic prodigies of English fiction, a book in spite of various crudenesses so good that even after a century and a half it is possible to consider it unhistorically" (11).

27. See Don Presnell and Marty McGee, *A Critical History of Television's* The Twilight Zone, *1959–1964*.

Chapter 2: The Heroic Age of Fantasy and Science Fiction

1. For a discussion of such "learned" speculations by these and other notable scientists of the day, including Herschel and Sir Humphrey Davy, see Richard Holmes, *The Age of Wonder*, 60–124.

2. Brian Aldiss, *Space Opera*, xi.

3. David G. Hartwell and Kathryn Cramer, "Space Opera Redefined," in James Gunn and Matthew Candelaria, eds., *Speculations on Speculation*, 260–261.

4. Henry Jenkins, *The Wow Climax*, 67–71.

5. For a full account of the Batman saga and, in particular, Kane and Jerry Robinson's work on the comics, see my "Living with Batman," 398–405.

6. For an account of the premiere of *Batman—The Movie* see my "High-Pressure Hype Surrounds 'Batman,'" 10–11.

7. The standard reference work on the subject is Robert C. S. Adey's *Locked Room Murders*. In addition to a valuable introductory essay on the historical development of the genre, there is also an extensive checklist of authors and stories, including a brief description of each puzzle, and a section containing solutions to all of the crimes cited. Notable anthologies of stories include *Death Locked In*, coed. Douglas G. Greene and Adey (New York: International Polygonics, 1987); *The Locked Room Reader*, ed. Hans S. Santesson (New York: Random House, 1968); *Whodunit? Houdini?*, ed. Otto Penzler (New York: Harper & Row, 1976); *All But Impossible!*, ed. Edward D. Hoch (New Haven: Ticknor & Fields, 1981); and *Tantalizing Locked Room Mysteries*, ed. Isaac Asimov, Charles G. Waugh, and Martin Harry Greenberg (New York: Walker, 1982). Asimov also edited an anthology of science fiction "locked-room" mysteries, *The 13 Crimes of Science Fiction* (New York: Doubleday, 1979).

8. See, for example, Randall Garrett's "Lord Darcy" adventure, *Too Many Magicians* (1966), Isaac Asimov's anthology, *The 13 Crimes of Science Fiction* (1979), Philip K. Dick's *Do Androids Dream of Electric Sheep?* (1968), and China Miéville's *The City & the City* (2009)

9. Charles Brockden Brown's *Wieland, or, The Transformation*, followed *The Mysteries of Udolpho* by only four years. The narrator, Clara, might have been speaking directly to Radcliffe's anti-supernatural strategies: "The dreams of superstition are worthy of contempt. Witchcraft, its instruments and miracles, the compact ratified by a bloody signature, the apparatus of sulpherous smells and thundering explosions, are monstrous and chimerical. These have no part in the scene...." See Fred Lewis Pattee, ed., *Wieland, or the Transformation*, 204.

10. Donna Heiland, *Gothic & Gender*, 68–76.

11. E. T. A. Hoffmann, *Kater Murr*, ed. and trans. Leonard J. Kent and Elizabeth C. Knight, 141.

12. See my "Phantom Fighters: 150 Years of Occult Detection," 340–345.

13. "The whole point of a sensational story," wrote Chesterton, "is that the secret should be simple. The whole story exists for the moment of surprise.... It should not be something that it takes twenty minutes to explain, and twenty-four hours to learn by heart, for fear of forgetting it. The best way of testing it is to make an imaginative picture in the mind of some such dramatic moment.... But too many otherwise ingenious romancers seem to think it their duty to discover what is the most complicated and improbable series of events that could be combined to produce a certain result. The result may be logical, but it is not sensational." See G. K. Chesterton, "On Detective Novels," in *Generally Speaking*, 4–6.

14. John Dickson Carr, "The Grandest Game in the World," in Francis M. Nevins, Jr., ed., *The Mystery Writer's Art*, 227–247, 229.

15. In 1967 John Dickson Carr wrote to Greene: "You seem to enjoy my efforts at the 'miracle' problem; try Chesterton and see how the thing is done by a master.... Though my youth was much influenced by Conan Doyle and Sherlock Holmes, a still greater influence came from Chesterton's short detective stories about Father Brown. Since so many of those concern impossible situations—locked rooms, incredible disappearance logically explained, and so on—it's not surprising that my own first efforts were along that line." Greene confirms that Carr's detective, Dr. Fell, was based on Chesterton himself: "Chesterton knew that he was the original of Carr's detective, but he did not mind, perhaps because Carr resolved never to allow Fell to do or say anything which might have embarrassed Chesterton or his acquaintances." Their appearances were similar; In *Hag's Nook* Fell is described thus: "He was very stout, and walked, as a rule, with two canes... His face was large and round and ruddy, and had a twitching smile somewhere above several chins... He wore eyeglasses on a broad black ribbon, and the small eyes twinkled over them as he bent his big head forward; he could be fiercely combative or slyly chuckling, and somehow he contrived to be both at the same time." Later, Dorothy Sayers acknowledge the similarity: "Chestertonian... are the touches of extravagance in character and plot, and the sensitiveness to symbolism, to historical association, to the shapes and colours of material things, to the crazy terror of the incongruous" (313). See Douglas G. Greene, "A Mastery of Miracles: G. K. Chesterton and John Dickson Carr," 307–315. See also my comparison of Chesterton and Carr in "Miracles of Rare Device: Chesterton's Miracle Crimes," in Ahlquist, Dale, ed., *The Gift of Wonder: The Many Sides of G. K. Chesterton*, 101–109.

16. In 1990 S. T. Joshi published *John Dickson Carr: A Critical Study*. In the Preface Joshi cites Douglas G. Greene as "the leading Carr authority" (i).

17. In his Introduction to *The Delights of Detection* (1961), Jacques Barzun speaks of this perfect structure: "It is an art of symmetry, it seeks the appearance of logical necessity, like classical tragedy, and like tragedy it cherishes the unity of place—the locked room, the ship or train in motion. Its successes thus partake always of the tour de force. As Yeats rightly remarked, 'The technique is *supairb* [*sic*]'" (15).

18. See Dennis Dooley and Gary Engle, eds., *Superman at Fifty! The Persistence of a Legend*.

Chapter 3: The Bradbury Chronicles

1. Isaac Asimov, *Asimov on Science Fiction*, 225.

2. To date the most authoritative and comprehensive examination of Bradbury's life and works is Jonathan Eller and William F. Toupence, *Ray Bradbury: The Life of Fiction*. For a detailed look

at Bradbury's screen plays, see my "The Illustrating Man: The Screenplays of Ray Bradbury," 61–78.

3. Forrest J Ackerman has left us an affectionate memoir, *Famous Monster of Filmland*. He dedicated it to "every fan who ever wrote me a nice letter or made me a pleasant phone call or called on me and left enthusiastic or gave me an unexpected gift or contributed cash for the upkeep of my Museum" (4). And now, it seems, his *Famous Monsters* lives on! A December 2010 publication bearing a similar masthead announces that the late "Uncle Forry" is the "Honorary Editor-in-Chief of a new bi-monthly incarnation. While the puns and the whimsy and the veneration for monsters past will remain, it is reaching out for today's readers and their current horror interests."

4. Vincent Price, "Homage to Ackerman," in Forrest J Ackerman, *Famous Monsters of Filmland*, 7.

Chapter 4: Destination: Mars!

1. This reference to Burroughs' mythic sources is important. Harold Schechter in his *The Bosom Serpent* notes that the profound implications of Burroughs' popular fiction "is distinguished by a special kind of immortality: what remains alive is not the language of the original text or even the name of the creator but simply the story itself" (9). Thus, the name Tarzan is known around the world, even to those who have never heard the name Burroughs. Similarly, Leslie Fiedler asserts in *What Was Literature?*: "The majority of American pop artists have always seemed (or been) as anonymous as the nameless storytellers of folk tradition." This requires creators possessing "easy access to their own unconscious where it impinges on the collective unconscious of their time" (85–86).

2. For an overview of George McWhorter's work at the Burroughs Archives, see my "Back to Barsoom: Remembering Edgar Rice Burroughs," 160–169 (written under the pseudonym "John T. Carter").

3. At this writing, *John Carter of Mars* is a Disney/Pixar release slated for release in August 2012. The script is by director Andrew Stanton (*Finding Nemo* and *Wall-E*) in collaboration with storyboard supervisor Mark Andres (*The Incredibles*) and Pulitzer Prize–winning author Michael Chabon (*The Amazing Adventures of Kavalier & Clay*). Taylor Kitsch is cast as Carter and Lynn Collins as Dejah Thoris. There are rumors that it will be the first of a trilogy.

Chapter 5: The Extravagant Gaze

1. For example, Percy Shelley's poem, "Ghasta, of The Avenging Demon," has the following lines:

> At last came night, ah! Horrid hour,
> Ah! Chilling time that wakes the dead,
> When demons ride the clouds that lower,
> —*The phantom sat upon my bed.*

2. For a richly illustrated examination of the impact of nineteenth-and-twentieth century painters and illustrators such as Caspar David Friedrich, Arnold Böcklin, Arthur Rackham, Gustav Tenggren, Heinrich Kley, and Kay Nielsen on the artists and animators of the 1930s films of Walt Disney, see Robin Allan, *Walt Disney and Europe*.

3. Russell's *Gothic* dramatized the haunted summer of the Villa Diodati in June of 1816, when Byron, the Shelleys, and Dr. Polidori gathered to tell their ghost stories. The film evoked—and enhanced, with advantages—every Gothic device in the book, as it were, including pederasty, abortion, adultery, blasphemy, incest, self-mutilation, vampirism, and attempted murder. Even Shelley's dream, as recalled to Mary, of a woman with eyes in the nipples of her breasts, is here. Natasha Richardson portrayed Mary, Julian Sands Percy Shelley, and Gabriel Byrne Lord Byron. For a full account of the hysterical doings, see Joseph Lanza, *Phallic Frenzy: Ken Russell and His Films*, 260–269. Another film that dramatized the same event, albeit in a more moderate manner, was Ivan Passer's *Haunted Summer* (1988).

4. Like Géricault and Goya, Hoffmann was a frequent visitor to insane asylums, in his case the asylum at St. Getreu, outside Bamberg. He was permitted to watch, unobserved, his friend Dr. Adalbert Marcus' treatment of his patients. Consequently, many of his stories, particularly "The Sandman" and the "Johannes Kreisler" stories, dealt with irrational and psychotic states. Indeed, as Hoffman specialist Ronald Taylor has declared, "No other German writer

has absorbed so fully, and re-lived so intensely, the psychological facts of schizophrenia, of hypnotism, of telepathy, and of other irregular and irrational conditions of the mind. Above all, no other German author has pursued so relentlessly the conviction that in such conditions of the mind, when the forces of the unconscious hold sway, certain truths are made evident whose significance is denied to 'normal men'" (71). See Taylor, *Hoffmann*.

5. On 2 July 1816 the government frigate *Medusa* foundered off the coast of Senegal. Since there were not enough lifeboats, a raft was built to support 150 people. But the raft was cast adrif,t and after 13 days of horrors with sharks and cannibalism, 15 survivors were finally rescued. The enormous canvas was exhibited at the Salon of 1819, and reactions to its dynamic composition and gruesome detail were mixed, to say the least. "The *Medusa* surprises the viewer with its relentless, concentrated energy," writes Lorenz E. A. Eitner, "to which even the harsh light-dark contrasts make a contribution. Its composition seems to consist entirely of nerve and muscle…a gigantic *écorché*, forever in tension" (193). For a detailed history and consequence of the painting, see Eitner, *Géricault: His Life and Work*, 158–201.

6. Regarding the portraits of the insane, Henry Zerner writes, "These pictures are the culmination of Géricault's work with portraits. They have most of the trappings of portraits in that the lunatics are distinct persons and look like real people. But they are not portraits in the conventional sense; they are not made to commemorate those represented but to investigate their symptoms and make sense of their intense feelings. The cumulative effect of these meditations on mental pain and anxiety is overwhelming, more moving for us today" (29). See Henri Zerner, "Mysteries of a Modern Painter," 25–29.

7. Goya specialist Robert Hughes reports these works arose from Goya' shock at the reactionary and repressive government, which seemed to exist in a gridlock between liberals and conservatives. His sardonic protest surfaced in the *Caprichos*, sent to press when he was 53 years old. These images depict, says Hughes, "the crossroads of the demonic and the sexual" (30). Goya himself spoke of his *Caprichos*: "The author is convinced that censoring human errors and vices—though it seems the preserve of poetry and oratory—may also be a worthy object of painting. As subjects appropriate to his work, he has selected from the multitude of errors and stupidities common to every civil society, and from the ordinary obfuscations and lies condoned by custom, ignorance or self-interest, those he has deemed most fit to furnish material for ridicule" (28). The subsequent *Disasters of War* were even wilder. Hughes writes, "These dark sexual images, so intensely vivid in their presentation and yet so elusive in their literal meaning, are among the most mysterious components of European Romanticism and they invert the rationalist pretensions of the Enlightenment" (31). In sum, concludes Hughes, Goya's worldview reminds one of the nihilistic attitudes of Gothic writers from Matthew Lewis to Lovecraft: "Goya found himself less and less able to sustain an optimistic belief in the power of reason to organize a just world.…Hysteria, evil, cruelty, and irrationality are not merely the absence of wisdom any more than black in Goya's paintings is merely the absence of color. Education will not stop these fates from spinning and snipping the thread of life. Culture will not exorcise them…They are pervasive, as demons were to the medieval mind" (31). See Robert Hughes, "The Liberal Goya," 26–31.

8. See Goya, *The Sleep of Reason: Reality and Fantasy in the Print Series of Goya*.

9. In the words of the esteemed British novelist, Penelope Fitzgerald, "[Blake] spoke with his visions on equal terms, sat down with them and answered them back. They came as welcome visitors: Jesus Christ, the angel Gabriel, Socrates, Michelangelo, his own younger brother Robert, dead at the age of 19. What seemed external reality he called a cloud interposed between human beings and the spiritual world, which would otherwise be too bright to bear.…It was his mission to recall us from materialism to the freedom and joy of the imagination, and it was humanity's duty to listen to his prophecies." See Penelope Fitzgerald, "Innocence and Experience," 5.

10. Washington Allston (1779–1843) was an American painter who was a close friend of Coleridge. Like Coleridge, his most famous work remained unfinished at his death. "Belshazzar's Feast" was a vast canvas at which Allston labored for more than 25 years.

11. This is a very important point, and one intrinsic to all the arts of the period. Whether Coleridge's "Kubla Khan" (begun 1797), with its evocation of a sublime landscape, is indeed an *unfinished* fragment or designed to be complete *in itself* is explored at length in Richard Holmes, *Coleridge: Early Visions*, 162–168. The great philosopher of Jena, Friedrich Schlegel (1772–1829), contends John Daverio, saw in the idea of the fragment a "given of modern experience, a manner of shaping and perceiving that affected literary prose" and philosophy and politics. Similarly, as Daverio points out, the seemingly "incomplete" fragments in the music of composers like

Robert Schumann reveal the *fragment* "as a constructive mode and artistic phenomenon [which] was fundamental to the whole Romantic world view." See John Daverio, *Nineteenth Century Music and the German Romantic Ideology*, 53–54. The painterly sketch, or *ébauche*, was promoted to greater legitimacy in the eyes of the academy by painters like Eugéne Delacroix and Thomas Couture (1815–1879). See Albert Boime, *Thomas Couture and the Eclectic Vision*, 452–454.

12. Schubert's *Die Wintereisse* (1828) and Schumann's *Liederkreis* (1840) song cycles, based on texts by Mueller and Eichendorff, respectively, reflect in songs and words the mysteries and symbolic implications of the German forests. Friedrich's paintings may be considered as visual correlatives of these works. See an extended examination of these connections in my *Schumann: A Chorus of Voices*, 226–257.

13. For a lavishly illustrated volume, see Joseph Leo Koerner, *Caspar David Friedrich and the Subject of Landscape*.

14. An early example of the German literary fairy tale, *Henry von Ofterdingen* (published posthumously in 1802) by Novalis (1772–1801), is a novel of travel and experience as young Henry struggles to release his poetic soul from the constricting world cold, calculating reason: "The fairy night mirrored itself in Henry's soul. He felt as though the world lay unlocked within him and was revealing to him as to an intimate friend all its treasures and hidden charms" (77). Novalis, *Henry von Ofterdingen*, trans. Palmer Hilty (New York: Frederick Ungar, 1982).

15. Goethe's novel, a *Bildungsroman* (a novel of education), included among the many people figuring in Wilhelm Meister' life, the tragic figure of the 13-year-old Mignon, a mysterious and abandoned child, the product of an incestuous relationship, who exhibits a preternatural maturity despite her age. She inspired several piano pieces and songs by Schumann; and her funeral scene his *Requiem for Mignon* (1852). See my *Schumann: A Chorus of Voices*, 328–332.

16. In her invaluable *The Hard Facts of the Grimm's Fairy Tales*, Maria Tatar charts the history of the various editions of the Tales (3–38). Jacob was 27 and Wilhelm 26 when the first edition was published in 1812. Very much aware of their readers, young and old, notes Tatar, "[the Brothers] played a role in shaping the plots of the tales they heard. Every storyteller has a unique repertory of tales, one developed in collaboration with an audience. Much as the tellers of the tales may appear to exercise unilateral control over their material, their powers of invention are to some extent held in check by their audiences" (25).

17. See Gordon Birrell's Introduction to Frank G. Ryder and Robert M. Browning, eds., *German Literary Fairy Tales*. "It was not until the end of the eighteenth and the beginning of the nineteenth century... that the folk fairy tale was first acknowledged as oral literature of the highest order. Significantly, the endorsement of the folk tale went hand in hand with the creation of a new and far more ambitious variety of literary fairy tale, a narrative invention of such extraordinary appeal that it became, for a brief period, the very centerpiece of Romantic literary theory" (xiv). In particular, see the fairy tales of E. T. A. Hoffmann. They are remarkable for their shifts between the waking, "realistic" world and the fantastic dream worlds that interpenetrate it. In "The Golden Pot," for example, his authorial voice advises us: "While you are in this region that is revealed to us in dreams at least, try, gentle reader, to recognize the familiar shapes that hover around you in the ordinary world. Then you will discover that this glorious kingdom is much closer to you than you ever imagined" (20). Hoffmann, "The Golden Pot," in Leonard J. Kent and Elizabeth C. Knight, *Selected Writings of E. T. A. Hoffmann*, vol. 1.

18. In *Danse Macabre* Stephen King claims, "Kids are the perfect audience for horror. The paradox is this: children, who are physically quite weak, lift the weight of unbelief with ease. They are the jugglers of the invisible world—a perfectly understandable phenomenon when you consider the perspective they must view things from.... The irony of all this is that children are better able to deal with fantasy and terror *on its own terms*.... A certain amount of fantasy and horror in a child's life seems to me a perfectly okay, useful sort of thing. Because of the size of their imaginative capacity, children are able to handle it, and because of their unique position in life, they are able to put such feelings to work" (105–107).

19. For some background on how Sendak came to publish *The Juniper Tree*, see Selma G. Lanes, *The Art of Maurice Sendak*, 191–207. The quote is from page 205.

20. Carl Sagan, *The Demon-Haunted World*, 12–13. Sagan echoes the words of several historians who defend the horrors and atrocities occasionally found in fairy tales. For example, Harold Schechter, in *The Bosom Serpent: Folklore and Popular Art*, notes, "Folk stories are not quaint little artifacts but vital products of the human imagination which serve to articulate (and thereby, to some degree, moderate) the communal anxieties of the day by assimilating them into deeply narrative patterns" (65).

21. According to Maria Tatar in *The Hard Facts of the Grimms' Fairy Tales*, as early as 1811 the Brothers were claiming that their efforts as collectors were scholarly intent and that they were writing largely for academic colleagues to capture German folk traditions in print before they died out and to make a modest contribution to the history of German poetry. However, realizing that children were appropriating the Tales for themselves, the Preface to the Second Edition in 1818 (the same year as the publication of *Frankenstein*) "emphasized the value of the tales for children, noting—almost as an afterthought—that adults could also enjoy them and even learn something from them" (19).

22. Mahler worked throughout his composing life on various settings to *Wunderhorn* texts by Achim von Arnim and Clemens Brentano that had been collected from 1805 to 1808. Schumann and Mendelssohn earlier had also set some of the texts in their *Lieder*. Mahler's most popular of several versions is for voice and orchestra, dating from 1892. They do not properly constitute a cycle, although they have much in common in their evocations of naivete and innocence, tinged occasionally by a deeper sense of irony. "They should be called nature and life rather than art," Mahler said. See Henry-Louis de la Grange, *Mahler*, 768–769.

23. Lynda Nead, *The Haunted Gallery: Painting, Photography, Film c. 1900*, 40. See Chapter Two ("The Haunted Gallery") for a fascinating examination of the many tricks and transformations of the pioneering period in film at the turn of the twentieth century. "Although film continued the themes and drew on the trap-door special effects of magic theatre," argues Nead, "the world of the haunted studio that it created was altogether more unruly and dangerous than its live counterpart" (90).

24. Quoted in Higham, Charles, *The Adventures of Conan Doyle*, 164–166.

25. To date the definitive treatment of the tragic story of Barrie and his "lost boys" is Andrew Birkin, *J. M. Barrie & the Lost Boys* (New York: Clarkson N. Potter, 1979); and concerning the inception of the various incarnations on stage, screen, and in literature, see Roger Lancelyn Green, *Fifty Years of Peter Pan*.

26. From November 1997 to February 1998 the Royal Academy in London displayed an exhibition entitled "Victorian Fairy Paintings," featuring the work of Charles Doyle, Richard Dadd, Arthur Rackham, and others. "Fairies and fairyland occupied a unique position in the workings of the collective Victorian imagination," noted the Foreword to the exhibition book, "and this exhibition and its catalogue attempt to give some explanation for the phenomenon." See *Victorian Fairy Painting*.

27. See Morton N. Cohen's *Lewis Carroll: A Biography* (1995) for the definitive discussion of the troubled relationship between Charles Lutwidge Dodgson and the Liddell family, particularly Alice. Despite the magic moments they shared in 1862, which blossomed into the first "Alice" book, she and Dodgson quickly grew disillusioned with each other and rarely spoke. She was a lonely, sad woman of 80 when she came to New York as a guest of Columbia University on the occasion of Dodgson's centenary celebration. It marked the first time in decades that she publicly spoke of him (519–523). This incident was dramatized in Gavin Millar's film, *Dream Child* (1995), starring Coral Browne as Alice Liddell Hargreaves.

28. I had the privilege of interviewing Dame Jean Bromet in her apartment in Cadogan Square. Although she talked about her father's interests in spiritualism—"He talked to me about spiritualism when I was about six. 'You mustn't worry about death,' he would say, 'and what death is; there is not the end of everything; there is another life afterwards'"(36)—she made no direct reference to the Cottingley Fairy episode. See my "Holmes in London, 1988," *Baker Street Miscellanea*, 32–43.

29. Mary Norton's five-volume series, *The Borrowers*, began in 1952 and have won numerous prizes. The "Clock" family are tiny people who "borrow" things to survive in the homes of "big" people. The books are indebted to the "thumbling" motif of folklore and fairy tales.

Chapter 6: "Where No Man Has Gone Before..."

1. For a useful overview, see J. P. Telotte, ed., *The Essential Science Fiction Television Reader*.

2. Wheeler Winston Dixon, "The Space Opera and Early Science Fiction Television," in J. P. Telotte, ed., *The Essential Science Fiction Television Reader*, 93–110. While detecting the contemporary social-political relevance of these stories is all very fine, Harold Schechter argues that

we should not overlook their vital connections to fairy-tale traditions. "In my view," he writes in *The Bosom Serpent*, they are "healing symbols in the midst of bloodshed and horror...The reverence for child's fantasy that has gripped America in recent years can be seen as a positive force: the sign, not of the complete absence of a functioning myth, but, on the contrary, of the appearance of a genuine and vital mythic archetype, carrying a weight of symbolic meaning into the cultural mainstream" (127). Thus, Tom Corbett and Captain Kirk display the qualities of Peter Pan: Clad in spacesuits instead of leaves of forest green, they exist outside of time and fly away from the mundane adult world toward their own cosmic Never-Land.

3. M. Keith Booker, "The Politics of *Star Trek*," in J. P. Telotte, ed., *The Essential Science Fiction Television Reader*, 195.
4. Quoted in Michael Shermer, *Science Friction*, 240.
5. Frankie Thomas, "Westward the Stars!" *American Classic Screen*, 47–52.
6. For colorful descriptions of life on the "live" television set of the 1950s, see Ira Skutch, ed., *The Days of* Live. See also my "The Watchers: *Tales of Tomorrow* on Television," *Journal of the Fantastic in the Arts*, 379–398.

Chapter 7: The Music of Terror

1. For an extensive survey of music in the fantastic cinema, see Randall D. Larson, *Musique Fantastique*.
2. Maurice Sendak, *Caldecott & Company: Notes on Books and Pictures*, 4.
3. For a witty, incisive, thought-provoking and eloquent approach to the whole subject, see Lawrence Kramer, *Musical Meaning: Towards a Critical History*, 1–3.
4. See my *Schumann: A Chorus of Voices*, 53–54.
5. John Daverio, *Nineteenth-Century Music and the German Romantic Ideology*, 2.
6. Jean Paul and Hoffmann appeared at a time when the composer was just beginning to emerge as a unique "voice" in society and art. Previously, there had been simply musicians, some of whom composed. Beethoven, whom Hoffmann prized most, marked a change and demanded from society an acknowledgment of his distinction from others. Thus, the stories, critiques, and essays of Jean Paul, Hoffmann, and others confirmed and celebrated the emergence of the new musicians and composers and their new musical expressions. Schumann, as the most literary of composers, duly acknowledged their works in his own writings and, particularly, in his music. See R. Murray Schafer, *E. T. A. Hoffmann and Music*; and Erika Reiman, *Schumann's Piano Cycles and the Novels of Jean Paul.*
7. Perhaps more to the point, the major studios all employed European-trained composers such as Max Steiner, Dimitri Tiomkin, Franz Waxman, and Erich Wolfgang Korngold, who were fully credentialed to deploy the music and styles of the classical masters to compose their soundtracks. Heinz Roemheld, for example, who worked at Universal, contributed an elaborate classical pastiche score to *The Black Cat* (1934). For an overview of the subject, see my *Composers in the Movies: Studies in Musical Biography*, 18–80.

Chapter 8: Postmodern Gothic

1. For an overview of occult studies and phenomena, see Ruth Brandon, *The Spiritualists: The Passion for the Occult in the Nineteenth and Twentieth Centuries*. For spiritualism's impact on Gothic literatures, see Howard Kerr, *Mediums and Spirit-Rappers and Roaring Radicals: Spiritualism in American Literature, 1850–1900*.
2. Sigmund Freud has been a frequent subject for Professor Peter Gay, Emeritus Professor at Yale, including *Freud, Jews, and Other Germans: Masters and Victims in Modernist Culture* (1978) and *Freud: A Life for Our Time* (1988). "Freud never claimed to have discovered the unconscious," says Gay. "He said it was the [Romantic] poets who discovered this first. He was very clear about this. He said, 'What I did was to make a *scientific* study of it.' And he thought there was a difference; and I think he was quite right. He thinks that the greatest of them all, Shakespeare (whom the Romantics loved), certainly knew something about the unconscious, even if he doesn't

express it in any systematic way" (441). See my "An Interview with Peter Gay," *The World and I*, 435–446.

3. Misha Kavka, "The Gothic on Screen," in Jerrold E. Hogle, ed., *The Cambridge Companion to Gothic Fiction*, 213.

4. Lisa Hopkins, *Screening the Gothic*, 115.

5. Defining "postmodern" is, admittedly, fully as troublesome as defining "Gothic" and "Romantic" and "science fiction." Certainly, there are a number of writers—Heidegger, Derrida, Lyotard, Jameson, and Baudrillard who have proposed their own formulations. But I recommend Richard Rorty (*Philosophy and the Mirror of Nature*, 1980; and *Objectivity, Relativism, and Truth*, 1991), whose clear thinking and accessible prose are especially useful for the non-specialist. I am indebted to him. For a synthesis of his thinking, see Ray Linn, *A Teacher's Introduction to Postmodernism*, 28–48.

6. For further discussion of the postmodern aspects of these films, see Lisa Hopkins, *Screening the Gothic*, 68–73, 105–115; and Levine and Knoepflmacher, 278–285.

7. Gardner Dozois and Jonathan Strahn, eds., *The New Space Opera 2*, 2.

8. Quoted in Kevin M. Moist, "Visualizing Postmodernity," 1242–1265.

9. Before the collaborations with Beaumont and Richard Matheson, Corman's films of the late 1950s had been superbly tacky, including *The Wild Angels, Rock All Night*, and *War of the Satellites*. After *The Intruder*, the adaptations by Beaumont and Matheson of Poe and Lovecraft marked a new direction into more mainstream films with bigger budgets. The Poe films that appeared between 1960 and 1965, most of which starred Vincent Price, are *The House of Usher, The Pit and the Pendulum, The Premature Burial, Tales of Terror, The Raven, The Masque of the Red Death*, and *The Tomb of Ligeia*. About the Poe cycle, Geoffrey O'Brian remarks in "Horror for Pleasure" in the *New York Review of Books*, "Corman's Poe cycle was to some extent about the contrast between Vincent Price's mannered delivery—a faint echo of the grand theatrical tradition of Edwin Booth and John Barrymore—and the Gidget-Goes-Hawaiian inflections of the supporting players. Everything about Price's acting was pitched to a level of full-blooded melodrama…and in his isolation, as a grotesque remnant of the past, he assumed a nearly tragic dignity. Notwithstanding the deliberate campiness of Corman's approach, his Poe films have proved sturdier than most would have predicted; amid all the swirling fog and tumbling rafters, they stir up real discomfort" (67). See also David Chute, "The New World of Roger Corman," 27–32.

10. Charles Beaumont, "Black Country," in *The Hunger and Other Stories* (New York: Bantam Books, 1959), 181–182.

11. "Foreword" to *The Magic Man* (Greenwich, CT: Fawcett, 1975), xi.

12. Charles Beaumont, *Remember? Remember?* 3.

13. This entertaining and insightful examination of the horror genre discusses the work of horror as a dance—a moving, rhythmic search. "And what it's looking for is the place where you, the viewer or the reader, live at your most primitive level….It is looking for what I would call phobic pressure points." See Stephen King, *Danse Macabre*, 18.

14. We find a remarkably prophetic and relevant passage in these words from the Calvinist James Hervey (1714–1758) in 1745 from his *Meditations Among the Tombs, in a Letter to a Lady:* "Legions, of disasters, such as no prudence can foresee and no care prevent, lie in wait to accomplish our doom. A starting horse may throw his rider, may at once dash his body against the stones and fling his soul into the invisible world. A stack of chimneys may tumble into the street and crush the unwary passenger under the ruins.…. So frail, so very attenuated is the thread of life that it not only bursts before the storm but breaks even at a breeze. The most common occurrences, those from which we suspect not the least harm, may prove the weapons of our destruction." Hervey would have a profound influence on William Blake, whose "Epitome of James Hervey's Meditations among the Tombs" was painted in 1820–1825.

15. Haldane's quote has been attributed to *Possible Worlds and Other Papers* (1927). Similar remarks have also been attributed to Arthur Stanley Eddington: "The universe is not only stranger than we imagine, it is stranger than we *can* possibly imagine."

16. One of the most famous of the Grimm's *Tales*, "The Juniper Tree," tells of a woman who abuses her stepson, decapitates him, chops his corpses into pieces, and serves them up to the family in a stew. Later, the victim's stepsister buries the bones under the juniper tree. The bones are absorbed into the tree and ultimately a beautiful bird appears and flies away, singing.

17. A particularly detailed account of the activities by Lord Byron, the Shelleys, and Dr. Polidori at the Villa Diodati in the summer of 1816 is found in Richard Holmes' *The Age of Wonder*.

The exact date of the memorable evening when Byron first proposed a competition of ghost stories is open to speculation, but Holmes bases his date of 17 June 1816, on Byron's fragment of "Augustus Darvell" bearing that date. From that time also came Percy Shelley's "Mont Blanc," Polidori's *The Vampyre* (suggested by Byron), and, of course, the genesis of Mary Shelley's *Frankenstein*, published anonymously two years later. See 325–330.

18. The standard history of all things "Dracula" is Raymond T. McNally and Radu Florescu, *In Search of Dracula: A True History of Dracula and Vampire Legends*.

19. Tropp, *Images of Fear*, 138. Tropp points out that Stoker's *Dracula* breaks down the distinctions between gender and sexuality. Its treatment of erotic love is full of reversals—"of a potential wife and mother at Dracula's breast, of a vampire as a willing victim, of an obscene parody of childhood innocence used to illustrate adult violation" (139). One important ramification of all this, Tropp continues, is that "either sex can be dominant, wielding the teeth the way sadists wield the whip—men on women or women on men" (142). Indeed, the figure of the predatory woman/vampire had been prominent from the very beginning of the Gothic tale—witness the characters of Matilda and Antonia in Matthew Lewis' *The Monk* (1896), and continuing through Lucy Audley in Mary Elizabeth Braddon's *Lady Audley's Secret* (1862), Jean Muir in Louisa May Alcott's *Behind a Mask, or, A Woman's Power* (1866, published under the pseudonym of "A. M. Barnard"), and Le Fanu's eponymous *Carmilla* (1862)—not to mention the paintings of Edvard Munch. The classic treatment of this subject is Sandra M. Gilbert and Susan Gubar, *The Madwoman in the Attic: The Woman Writer and the Nineteenth-Century Literary Imagination*.

20. This underrated vampire story from 1846 was dismissed as a "penny dreadful" in its day (it is sometimes attributed to Thomas Preskett Prest). It portrays in Varney a figure suffering his "undead" existence as a punishment for past crimes. Told in part in his own words, Varney is weary of the trials and tribulations of his immortal life. He suffers from knowing that his victims must die in order for him to live. His own death from suicide is not punishment for him so much as relief. "You will say," Varney tells a companion as he prepares to fling himself into a volcano, "that you accompanied Varney the Vampyre to the crater of Mount Vesuvius, and that, tired and disgusted with a life of horror, he flung himself in to prevent the possibility of a reanimation of his remains" (868). The book has been published in three volumes by Arno Press in 1970 with commentary by Devendra P. Varma.

21. See my "Robots Redux: *A. I. Artificial Intelligence*," 256–261.

22. See Aldiss' essay on the Gothic tradition in "Science Fiction's Mother Figure," in Brian Aldiss, *The Detached Retina*, 52–86.

23. Mary Shelley's early years were fraught with difficulties. The daughter of the feminist Mary Wollstonecraft Godwin, she had run away with a married man (Percy Shelley), been pregnant at 16, and was almost constantly pregnant throughout the following 5 years. Yet, she lost most of her babies soon after they were born. Moreover she had not yet married when she began to write *Frankenstein*, which she referred to as "my hideous progeny." In her classic 1974 essay, "Female Gothic," Ellen Moers claims that "no other Gothic work by a woman writer, perhaps no other literary work of any kind by a woman, better repays examination in the light of the sex of its author." In her story of the creation of the monster, "Shelley brought birth to fiction not as realism but as Gothic fantasy.... Here, I think, is where [*Frankenstein*] is most interesting, most powerful, and most feminine: in the motif of revulsion against newborn life, and the drama of guilt, dread, and flight surrounding birth and its consequences For *Frankenstein* is a birth myth, and one that was lodged in the novelist's imagination.... So are monsters born" (80–82). In sum, Mary's example serves today's female writers: "The young women novelists and poets of today who are finding in the trauma of inexperienced and unassisted motherhood a mine of troubled fantasy and black humor are on the lookout for Gothic predecessors" (85).

24. Charles Brockden Brown (1771–1810) was, in the opinion of historian Fred Lewis Pattee, "the father of American literature": "He was an innovator in a revolutionary age, a literary genius in a land barren of literary men" who produced "the most noteworthy piece of fiction in America during the first generation of the republic" (ix–xxviii). True to Horace Walpole's dictum of combining dream and reality, Brown wrote, "To excite and baffle curiosity, without shocking belief, is the end to be contemplated" (quoted in Pattee, xxvii). Brown produced in *Wieland, or the Transformation* (1798) a classic example of the Ann Radcliffe school of rationally explained horrors—in this case the villainous Carwin's preternatural ability to "throw" his voice, thereby inducing Theodore Wieland to slaughter "in the name of God" his family. At his trial, Wieland justifies his crimes to the jury as divinely inspired: "I will not accept

evil at [your] hand, when I am entitled to good; I will suffer only when I cannot elude suffer-ing" (199). See Fred Lewis Pattee, ed., *Wieland, or the Transformation* (New York and London: Harcourt Brace Jovanovich, 1926).

25. *Edgar Huntly* is set in rural Pennsylvania and concerns young Huntly's search for the murderer of his fiancee's brother. The pursuit becomes obsessive and leads to terrifying encounters in the wilderness with panthers, precipices, and demonic Indians. Particularly noteworthy are the hallucinatory scenes of violence in the wilderness that anticipate Edgar Allan Poe. *Edgar Huntly* has not enjoyed the enduring popularity of *Wieland*. However, in the words of editor David Stineback, it is "at least his most challenging novel, the work in which he takes the greatest risks with his imagination...[It displays] the horror of a rational mind and active conscience encountering its own radical limitations [and] has been a predominantly American counter-part of the classic Gothic novel" (7–8). See David Stineback, ed., *Edgar Huntly; or Memoirs of a Sleepwalker* (New Haven: College and University Press, 1973).

26. See Richard Slotkin, *Regeneration through Violence: The Mythology of the American Frontier, 1600–1860.*

27. Gore Verbinski's *The Ring* (2002) is a remake of a Japanese 1998 horror film. Both are based on the novel by Koji Suzuki.

28. A particularly enchanting visualization of the land of Faerie, as described here, is in Charles Sturridge's *Fairy Tale* (1997), a dramatization of the "Cottingley Fairies" incident in the early 1920s that convinced Sir Arthur Conan Doyle of the existence of fairy folk. See his interview in these pages.

29. William James, "A Strong Note of Warning Regarding the Lynching Epidemic," in *The Works of William James: Essays, Comments, and Reviews,* 173.

30. Professor Schechter refers to a publication in 1764 entitled *A New and Complete Dictionary of Arts and Sciences*, by "A Society of Gentlemen."

31. See Stephen Hawking, *The Grand Design* (New York: Random House, 2010). Writing in *The Hidden Reality* (New York: Alfred A. Knopf, 2011), Brian Greene notes, "With its hegemony diminished, 'universe' has given way to other terms that capture the wider canvas on which the totality of reality may be painted. *Parallel worlds* or *parallel universes* or *multiple universes* or *alternate universes* or the *metaverse, megaverse,* or *multiverse*—they're all synonymous and they're all among the words used to embrace not just our universe but a spectrum of others that may be out there" (4, italics in the original).

32. In his invaluable *Virtual History: Alternatives and Counterfactuals*, historian Niall Ferguson dem-onstrates how the practices of "virtual history" and the "counterfactual"—those that ask the question, *"what if...?"*—are important tools in the arsenal of the professional historian. Citing postmodernism's proposal that studying history is an *interpretive practice* rather than an objective, neutral science, he further reminds us that history evolves primarily from a "periphery of minor causes" and unfolds "in a fundamentally chaotic way." It is not predetermined, "and there are no rails leading predictably into the future" (70). Inevitability lies only in retrospect. Ferguson quotes the wise advice of British historian Hugh Trevor-Roper: "How can we explain what happened and why if we only look at what happened and never consider the alternatives....It is only if we place ourselves before the alternatives of the past..., only if we live for a moment, as the men of the time lived, in its still fluid context and among its still unresolved prob-lems...that we can draw useful lessons from history" (85). I would suggest that the imagined alternative worlds of the steampunk practitioners, no less than for the extrapolations of the professional historians, demand *plausibility* as the key to their legitimacy as an alternative his-tory and/or universe.

33. A fascinating early example of "steampunk cinema" (although the term was not yet in use) is a film produced in Czechoslovakia, Karel Zeman's *The Fabulous World of Jules Verne*, which was released in 1958 and only now is available on DVD. The visual sense of steel-engraved images is conveyed through a wide variety of techniques, including live-action black-and-white film, stop-motion photography, animation, paper cutouts, double exposures, still images, and min-iatures and models. Fantasy writer Howard Waldrop, writing in *Locus* magazine, reports that all the futuristic inventions depicted are 1890s projections of what planes, machine-pistols, and giant cannon *would* look like, not what actually came to pass in the real world. "The script itself could have been written by Verne himself in 1899—it's full of incidents on which to hang the gigantic work of art which is the entire film....It *is* a great piece of filmmaking." (See the DVD review in *Locus Online:* http://locusmag.com/2004/reviews/10_WaldropPerson_Verne.html.)

34. Arkham Asylum is located on the outskirts of Gotham City and houses the Joker, the Riddler, Poison Ivy, and Two-Face, among others. The Asylum (originally named "Arkham Hospital") was created by Dennis O'Neil and first appeared in *Batman Comics* #258 in 1974. It has subsequently surfaced in a series of graphic novels, led by Frank Miller's *The Dark Knight Returns*; on television in *Batman: The Animated Series*; video games; and on film in *Batman Forever* and the sequels.

35. Philip José Farmer, *To Your Scattered Bodies Go* (New York: G. P. Putnam's Sons, 1971), 10.

36. Edgar Rice Burroughs, *A Princess of Mars* (New York: Grosset & Dunlap, 1917), 18.

37. Brian Aldiss, *The Trillion Year Spree*, 312–313.

38. In *Tarzan Alive* and *Doc Savage: His Apocalyptic Life*, Philip José Farmer created the alternate world of "Wold Newton," which introduced the concept that Tarzan and numerous other "fictional" characters from the Victorian and early twentieth century periods of fantasy, detective stories, and pulp novels—including Sherlock Holmes, the Scarlet Pimpernel, and the Shadow—not only really existed but share bloodlines. Their possession of superhuman intellect and physical powers stems from their peculiar geneology. Farmer reports that a meteor strike upon a group of people traveling by coach in Wold Newton, Yorkshire, England in 1795 (a historical fact, by the way) resulted in radiation exposure that accounts for the benevolent mutations and intermarriage of their offspring.

39. James Parker, "The Sorcerer," 33.

40. James Parker, "The Sorcerer," 34.

41. Alan Moore, "Alan and the Sundered Veil," *The League of Extraordinary Gentlemen*, Vol. 1, 1898 (La Jolla, CA: America's Best Comics, 2000), n.p. (Originally published in single magazine form as *The League of Extraordinary Gentlemen*, Vol. 1 #1–6, 1999.)

42. An exhaustive examination of Alan Moore's *League of Extraordinary Gentlemen* universe has been produced by Jess Nevins in a series of books for Moore's own America's Best Comics imprint.

43. Ada Byron is a shadowy figure hovering over the strife-ridden and ecologically disastrous London of 1855. Dubbed by an adoring populace, the Queen of Engines and the Enchantress of Numbers, she also leads a hidden life of compulsive gambling addiction. Many of her mathematical calculations are designed—and fail—to predict gambling outcomes. Her calculations predict and bring about, however, something far more dangerous—a dystopian world of 1991 that reduces human agency to a minimum: "New fabrics of conjecture are knitted in the City's shining cores, swift tireless spindles flinging off invisible loops in their millions, while in the hot unhuman dark, data melts and mingles, churned by gear-work to a skeletal bubbling pumice, dipped in a dreaming wax that forms a simulated flesh, perfect as thought…In this City's center, a *thing* grows, an auto-catalytic tree, in almost-life, feeding through the roots of thought on the rich decay of its own shed images" (428–429). See William Gibson and Bruce Sterling, *The Difference Engine* (New York: Bantam Books, 1992). *The Difference Engine* was nominated for the British Science Fiction Award in 1990, the Nebula Award for Best Novel in 1991, and both the John W. Campbell Memorial Award and the Prix Aurora Award in 1992.

44. Peter Nicholls, "Steampunk." *The Encyclopedia of Science Fiction*, in John Clute and Peter Nicholls, eds., 1161.

45. Author James P. Blaylock has referred to steampunk as "Technofantasy in a neo-Victorian Retrofuture." For more, see Blaylock's blog, "Steampunk Scholar": www.steampunkscholar. blogspot.com.

46. See also works by nineteenth-century writer Albert Robida, such as *Le Vingtième Siècle* (1883), *La Guerre au vingtième siècle* (1887), and *Le Vingtième Siècle: la vie électrique* (1890), for earlier examples of what is now known as steampunk.

47. Lavie Tidhar, "Steampunk," *Internet Review of Science Fiction*, March 2005: www.irosf.com/q/zine/article/10114 n.p.

48. Nader Elhefnawy, "Of Alternate Nineteenth Centuries." *Internet Review of Science Fiction*, July 2009 (26 October 2010): www.irosf.com/q/zine/article/10562, np.

49. Peter Bebergal, "The Age of Steampunk," *Boston Globe*, 26 August 2007.

50. Tidhar, "Steampunk," n.p..

51. Steffen Hankte, "Difference Engines and Other Infernal Devices: History According to Steampunk," 250–251.

52. Karen Helleksen, "Toward a Taxonomy of the Alternate History Genre,"

53. Herbert Sussman, Herbert, "Cyberpunk Meets Charles Babbage: The Difference Engine as Alternative Victorian History," 1–23.
54. Tidhar, "Steampunk."
55. Margaret Rose, "Extraordinary Pasts: Steampunk as a Mode of Historical Representation," 319–333.
56. Ruth Cowan Schwartz, *A Social History of American Technology*, 149–171.
57. Martin Willis, *Mesmerists, Monsters, & Machines: Science Fiction & the Cultures of Science in the Nineteenth Century*, 4–11.
58. Willis, *Mesmerists, Monsters, & Machines*, 5.
59. Shawn James Rosenheim, *The Cryptographic Imagination: Secret Writing from Edgar Poe to the Internet*, 206.
60. Libby Bulloff, "Our Lives as Fantastic as Any Fiction!", *Steampunk* no. 4 (http://www.steampunkmagazine.com).
61. All of the steampunk bands mentioned mix acoustic instruments—guitars, mandolin, violin, and so forth—with electronic keyboards for a mix of old-fashioned cabaret and/or classical touches punctuated by industrial-sounding bleeps and bloops. The smaller bands do not seem to have retrofitted instruments yet Abney Park has antiquated the lead singers' microphone, guitar, and their keyboard in a cog-laden Victorian style. (The synthesizer/laptop could be the console on a steamship—Tesla-powered, of course!). See their website: http://www.abneypark.com/abney_park_images/instruments.html.

Chapter 9: "The Heresy of Humanism"

1. Johann Wolfgang von Goethe, *Faust*, Part II, Act V, lines 396–397.
2. Richard Holmes, *The Age of Wonder*, 459.
3. In a more than whimsical way, the development of photography, in conjunction with the telescope, assists us in following the, er, footsteps of John Carter. By the late nineteenth century the eye and hand of the astronomer were replaced by what historian Lynda Nead in *The Haunted Gallery* describes as the "unwavering and penetrating gaze of the photographic exposure." These images were reproduced in scientific journals and periodicals and brought to the wide public celestial objects that had been previously invisible to the naked eye. Nead refers to this as "a new order of sublimity that liberated the visual imagination and enabled it to roam through the immensity of the universe." Indeed, continues Nead, the very act of gazing into the telescope and at the photographic image became a kind of "interplanetary journey" for the viewer. Quoting the nineteenth-century French astronomer, Camille Flammarion, this kind of astronomical observation established nothing less than an "empathic identification," enabling viewers, not unlike Edgar Rice Burroughs' John Carter, to leave their bodies and travel through the heavens. "In Flammarion's case, to look at a photographic image of the moon was to detach oneself from the everyday things of the Earth and to embark on the first stage of an endless celestial voyage" (207–214).
4. Henry Adams, *The Education of Henry Adams*, 381–382.
5. Freeman Dyson, "When Science & Poetry Were Friends," 8.
6. Known today primarily for her classic short story, "The Lottery" (1946), and her macabre novels, Shirley Jackson (1916–1965) led a troubled life afflicted with chronic illness and occasional mental instability. The only full-length biography to date is Judy Oppenheimer, *Private Demons: The Life of Shirley Jackson*.
7. In *Dead Lines* the proliferation of a new line of wireless phones opens the gateway not only to ghostly apparitions of the dearly departed, but the more threatening shadows of hungrily devouring fiends. The commercial boast of the product acquires an ominous tone: "So easy to talk anymore, wherever you were, whatever you might be" (202). A warning is sounded: a warning of the "side effects" of this new technology. An engineer Arpad Kreisler claims also to have solved the problem of diminishing available bandwidth: "I discovered a new source of bandwidth, forbidden information channels, not truly radiation at all, unknown until now.... Trans is like the way photons and electrons and atoms, everything tiny, sing to each other all day, every day, tell each other where and who they are, to balance the books and obey the laws and keep everything real. We send our messages along similar channels... Trans

reaches below our world, lower than networks used by atoms or subatomic particles, to where it is very quiet. Down there is a deeper silence than we can know, a great emptiness. Huge bandwidth, perhaps infinite capacity. It can handle all our noise, all our talk, anything we have to say, throughout all eternity" (85–86). Greg Bear, *Dead Lines* (New York: Ballantine Books, 2004).

8. In her classic essay, "Science Fiction and Mrs. Brown" (1976), Ursula LeGuin quotes Virginia Woolf about the central importance of *character* in any kind of story: "I believe that all novels, that is to say, deal with character, and that it is to express character—not to preach doctrines, sing songs, or celebrate the glories of the British Empire.... The great novelists have brought us to see whatever they wish us to see through some character." Even in the science fiction story, elaborates Le Guin, a character, say, the apocryphal "Mrs. Brown," proves too *large* for the story: "so that when she steps into the [spaceship], somehow it all shrinks to a shiny tin gadget, and the heroic captains turn to cardboard, and the sinister and beautiful aliens suddenly appear to be, most strangely, not alien at all, but mere elements of Mrs. Brown herself...." See Ursula Le Guin, *The Language of the Night*, 103.

9. The expression was voiced in Bear's novel, *Vitals* (2002), a latter-day Faustian fable about a young scientist in search of organisms that will block the bacterial deterioration of the human body. He rejects prevailing notions like uploading the mind into cyberspace or into a robotic brain or the nanotechnology that would send nano-machines to clean up an ageing body. He instead argues for mitochondrial chromosome adjustment. "The mind *is* the body," he argues. "Everything you know and think is embedded in your neurons, but your consciousness is in the cells of your entire body. Your mind is really a complex of brains, with major contributions from the nervous and immune systems. The flesh is intelligent, all flesh... Take the body away, and you become near-beer, bitter without the kick" (26). In the "acknowledgments" in the book, Bear notes: "The concept of bacterial cooperation is firmly established in scientific papers and books.... The notion of a distributed bacterial network—a bacterial mind, if you will—is far from fantasy" (355). Greg Bear, *Vitals* (New York: Ballantine Books, 2002).

10. After the Earth is completely destroyed by a mysterious force of "Planet Eaters," the survivors are whisked away in a space ship provided by a beneficent race called The Benefactors. After witnessing from space Earth's final death-throes, they are suspended in deep sleep. Three centuries later they awake and begin to populate a newly restored Mars, now called New Mars. Humanity will thus move forward to interstellar space, where they will embark on a vengeful search for the Planet-Eaters.

11. Can evolutionary change occur within just a few generations? Bear's *Darwin's Children* proposes that just as millions of years ago there must have been an evolutionary "jump," or punctuation from the Neandertal to *homo sapiens*, now in the present transpires another "jump" to a new subspecies. Bear's speculations have been increasingly voiced ever more loudly during the recent "evolution wars." For example, Stephen Jay Gould and his colleague, Niles Eldredge, famously critiqued the Darwinian theory of gradual selection by emphasizing the contingent nature of history, the nonadaptive qualities of organisms—"the directionless arrow in a purposeless cosmos." While they do not deny that natural selection creates well-adapted organisms, they do object that it works gradually on preexisting structures. Rather, it moves in "jumps," punctuated by brief periods of rapid change ("punctuated equilibrium"). In other words, not everything in nature can be explained through the adaptationist paradigm. "If we have lost a degree of grandeur for each step of knowledge gained," writes Gould, "then we must fear Faust's bargain: 'For what shall it profit a man, if he shall gain the whole world, and lose his own soul?'" Gould's response was succinctly formulated in his famous essay, "Modified Grandeur." He took as his starting point the final lines from Darwin's *On the Origin of Species*: "There is a grandeur in this view of life... whilst this planet has gone cycling on according to the fixed law of gravity, from so simple a beginning endless forms most wonderful and most beautiful have been, and are being evolved." Darwin had never implied *progress* as the necessary feature of organic history, pursued Gould; rather Darwin had alleged that *Homo sapiens* are a "tiny and unpredictable twig on a richly ramifying tree of life—a happy accident of the last geological moment, unlikely ever to appear again if we could regrow the tree from seed" (20). But here, argues Gould, in words echoing those of astronomer Herschel and poet Percy Shelley more than a century before, lies *grandeur* (or, I would say, *wonder*): "We can now step off and back—and see nature as something so vast, so strange (yet comprehensive), and so majestic in pursuing its own ways without human interference, that grandeur becomes the best word of

all for expressing our interest, and our respect." In a similar pronouncement, Carl Sagan has declared in *The Demon-Haunted World*: "No contemporary religion and no New Age belief seems to me to take sufficient account of the grandeur, magnificence, subtlety and intricacy of the Universe revealed by science" (35).

12. Greg Bear's *Blood Music*, first published in 1983 as a short story and expanded into a novel two years later, may be credited as the first account of nanotechnology in science fiction to describe microscopic medical machines and to treat DNA as a computational system, capable of being reprogrammed. In the original short story Vergil Ulam, one of those latter-day Gothic scientists who Ventures Too Far, develops complicated biochips that have their own intelligence. Interacting with his blood, "they" transform him from within. Not only his spine, his musculature and skin are changing, but he's afraid that "they" will jump the blood-brain barrier and penetrate and *understand* his brain. As the "infection" develops, Vergil claims he can "hear" all the operations inside his blood, a kind of internal "music." He says, "I'm more than just good old Vergil Ulam now. I'm a goddamned galaxy, a super-mother" (26). Upon Vergil's death, the story's narrator discovers he too has become infected. "every square inch of the planet will teem with thought," he predicts. "Years from now, perhaps much sooner, they will subdue their own individuality—what there is of it. New creatures will come, then. The immensity of their capacity for thought will be inconceivable." Bear says he came up with the idea after reading an article about biochips, "theoretical organic computers that might be as small as a single cell." The short story is included in Greg Bear, *Tangents* (New York: Warner Books, 1989).

13. On a recent Discovery Channel program, Stephen Hawking has pronounced similar, albeit controversial claims that trying to make contact with alien races "is a little too risky. If aliens ever visit us, I think the outcome would be much as when Christopher Columbus first landed in America, which didn't turn out very well for the Native Americans." In his novel, *The Forge of God*, Bear elaborates on "galactic ecology": "The ecosystem of Earth must evolve an 'organ' or arm equipped with perception and logic, just as life had once adapted to the land by developing certain kinds of eyes and limbs and neurological structures.... Suddenly, it is becoming self-aware, and looks outward. She's developing eyes that can look far into space and begin to understand the environment she has to conquer. She's reaching puberty. Soon she's going to reproduce" (311–313). Greg Bear, *The Forge of God* (New York: Tor, 1987).

14. Where, then, might we find a Creator? And what about immortality? Ever since the late nineteenth century, many esteemed philosophers, biologists, and physicists have boldly tackled the problem. A few relatively recent examples will suffice. In his *Varieties of Religious Experience* (1902) Williams James had objected to the Positivist contention that unverifiable belief is unscientific, illusory, and antiquated nonsense, by famously pronouncing his extrapolation of "The Science of Religion": "Facts, I think, are yet lacking to prove 'spirit return'.... I consequently leave the matter open." But, James continued, "For practical life, at any rate, the *chance* of salvation is enough. No fact in human nature is more characteristic than its willingness to live on a chance. The existence of the chance makes the difference...between a life of which the keynote is resignation and a life of which the keynote is hope" (449–450). Recently, Professor Kenneth R. Miller, for his part, argues that evolution, genetics, and molecular science do indeed support the existence of a Creator. "A biologically static world," writes Miller, "would leave a Creator's creatures with neither freedom nor the independence required to exercise that freedom. In biological terms, evolution is the only way a Creator could have made us the creatures we are—free beings in a world of authentic and meaningful moral and spiritual choices" (291). Again turning to Carl Sagan, he suggests that scientific inquiry in itself is "informed worship." If a "god" or anything like the traditional sort exists, he continues, "then our curiosity and intelligence are provided by such a god. We would be unappreciative of those gifts if we suppressed our passion to explore the universe and ourselves." However, if such a god does *not* exist, "then our curiosity and our intelligence are the essential tools for managing our survival in an extremely dangerous time" (31).

15. C. P. Snow's *The New Men* is part of a sequence of novels entitled *Strangers and Brothers*, depicting intellectuals in academic and government settings in the modern era. The best known in the series is *The Corridors of Power* (1963).

16. In Benford's *Timescape* a team of scientists, headed by the American Gregory Markham and Britisher John Renfrew, has hit on a scheme to contact the past. An ecological disaster has befallen the world, a "diotom bloom" is steadily poisoning the ocean and killing plant and

animal life. Power shortages, food rationing, rioting are everywhere. The two men theorize that by beaming "tachyons" into the past, they can alert scientists in 1963 to preventative measures and warn them against the effects of chlorinated hydrocarbons and phytoplankton. However, if past events are altered, how will the world of 1998 be changed? Tachyons are particles that travel faster than light, that are shot across light years. The year 1963 still exists, as it were, but light years away in another part of the universe. *It's in the sky, quite literally.* However, the scientists in 1998 cannot transmit *too much* information, lest the scientists in the past would solve the problem, which would mean that there would be no reason to have sent the message in the first place—or an alternate timeline would be set up. To avoid the paradox, the 1998 scientists would send just a *piece* of the vital information, just enough to get research started, but not enough to solve the problem entirely. Meanwhile, in 1963 a California scientist, Gordon Bernstein, struggles to decode the transmissions from 1998 before the future world is destroyed utterly.

17. One of the all-time classic time-loop paradoxes is Robert Heinlein's "By His Bootstraps" (1941). A much more recent take is novelist Charles Wu's playful *How to Live Safely in a Science Fictional Universe*: "The path of a man's life is straight, straight, straight, until the moment when it isn't anymore, and after that it begins to meander around aimlessly, and then get tangled, and then at some point the path gets so confusing that the man's ability to move around in time, his device for conveyance, his memory of what he loves, the engine that moves him forward, it can break, and he can get permanently stuck in his own history" (232).

18. When the noted English novelist and playwright (*Journey's End*) R. C. Sheriff (1896–) turned to science fiction, he produced in *The Hopkins Manuscript* (1939), one of the classics of the genre. Told from the point of view of a retired schoolmaster, the earth faces the imminent collision with the moon. The story's power derives from its sensitively observed characters and the theme that man's greed, not accidents of nature, will spell the doom or our world. The 1963 edition from Macmillan is beautifully illustrated by Joseph Mugnaini.

19. Regrettably, George MacDonald and his two remarkable adult fantasies, *Phantastes* (1858) and *Lilith* (1895), are known today only to specialists. MacDonald (1824–1905) was born in Aberdeenshire, where he became a Congregationalist minister. Retiring at just 26, he devoted the rest of his life to writing fairy tales and adult novels. *Lilith* is about a young student home from Oxford who finds a hidden door at the back of a closet and enters a world of waking dream (a plot device openly borrowed years later by C. S. Lewis for his *Narnia* novels). "[Lilith] is profound and moving," observes Lin Carter in his introduction to the Ballantine Adult Fantasy Series 1969 edition, "haunted with shadowy figures, filled with bright, mocking faces, illuminated with flashes of stark and terrible and thrilling imaginative force. Its psychological perception and use of dream symbols is amazing, and bears close comparison with the best of Kafka" (viii). For more about this extraordinary writer, see U. C. Knoepflmacher, *Ventures into Childhood: Victorians, Fairy Tales, and Feminity*, 229–267.

20. In a sequence reminiscent of Victor Frankenstein's creation of a mate for the monster, Benford envisions a cruel Mantis, which thinks it can bridge the gap between mechanical forms and humans. But the hybrid creation, like Frankenstein's bride, is a horrible parody of a woman that must be destroyed. "Combining it with other life forms is the very height of the artistic frontier," says the Mantis. "Admittedly, I may have made errors, unaccountable errors, in some details." At which point the Mantis bids the hero of the novel, Killeen, to copulate with the hideous thing (265). Horrified, Killeen kills the creature dead. "Had humans ever done that to lesser forms," Killeen wonders to himself, "used them for part of manufacture or casual amusement?" (322). Gregory Benford, *Great Sky River* (London: Victor Gollancz, 1988).

21. Bresson's films, particularly *Diary of a Country Priest* (1955), *A Condemned Man Escaped* (1958), and *Pickpocket* have been lauded for their deeply felt spirituality achieved through the most minimalist of stylistic approaches. See Paul Shrader, *The Transcendental Style in Film* (1972).

22. In a remarkable passage, Bear describes a concert of music that combines Mahler's Tenth Symphony and the *Infinity Concerto* by Waltiri. The music is a bridge, a translation toward man's creative future: "Humans had found their place in the world to come. They had lived in this universe long enough to master it not with magic, but on its own terms. Not with outside skill, but with skills taught by the hard, unyielding nature of reality. And they had turned those skills into devices for creating wonderful, impossible music.... The audience was being made aware of the world they would ultimately have to face." Greg Bear, *Songs of Earth & Power* (New York: Tor, 1994), 391.

23. In his short life, Wilhelm Wackenroder (1773–1798), with Ludwig Tieck and Friedrich Schlegel, forged the foundations of German Romanticism (although the term "Romanticism" was not yet in use) and profoundly influenced composers such as Robert Schumann. In my opinion, no one has ever written about music in a more ecstatic, impassioned way. The following passage, from *Confessions from the Heart of an Art-Loving Friar* (1797), is typical: "I consider music to be the most marvelous of these inventions, because it portrays human feelings in a superhuman way, because it shows us all the emotions of our soul above our heads in incorporeal form, clothed in golden clouds of airy harmonies—because it speaks a language which we do not know in our ordinary life...which one would consider to be solely the language of angels." Alas, English translations of his work are difficult to find. See Mary Hurst Schubert, trans. and annotated, *Wilhelm Heinrich Wackenroder's "Confessions and Fantasies"* (Pennsylvania State University Press, 1971), 180.
24. "Tangents" envisions a new kind of keyboard, a "tronclavier," whose music—squeaks and squawks to the human ear—calls forth creatures from the fourth dimension. Chinks of three-dimensional space are torn away as portions of vari-colored, weirdly shaped creatures come and go. Soon, the player himself is pulled into the fourth dimension, literally *peeled away* like a stick-on label from a flat surface.

Epilogue: "Night Vision"

1. It was later revised and enlarged by Richard Proctor in 1882. See Lynda Nead's *The Haunted Gallery* for a detailed account, 233–234.
2. At this writing, it has been announced that NASA's Kepler planet-hunting satellite is identifying thousands more possible planets orbiting other stars. The goal of the project is to assess the frequency of Earth-like planets around the Sun-like stars. Summarizing the news from the cosmos, Geoffrey W. Marcy of the University of California, Berkeley—a veteran exoplanet hunter and a mainstay of the Kepler work—refers to the announcement as "an extraordinary planet windfall, a moment that will be written in textbooks. It will be thought of as a watershed." See Dennis Overbye, "Kepler Planet Hunter Finds 1,200 Possibilities."
3. Letter to James Morton, 12 March 1930, in August Derleth and Donald Wandrei, eds., *H. P. Lovecraft: Selected Letters III, 1929–1931*, 123–129.
4. Author's interview with Richard Holmes, Washington, D. C., 25 September 2010. James Gunn reports that science fiction master Theodore Sturgeon always employed a similar phrase in the form of a question: "*Ask the Next Question.*" He used it often in talks he delivered for the Center for the Study of Science Fiction at the University of Kansas. "In fact," remembers Gunn, "Ted signed his autograph in his latter days with a 'Q' with an arrow through it (pointing right). You see that symbol on the Sturgeon Award we present for the best SF short story of the year."
5. See Kathleen Dean Moore's essay, "The Gifts of Darkness," in Paul Bogard, ed., *Let There Be Night*, 11–13.
6. In his wonderful little book, Ray Bradbury reminds us to "switch on the night," and thereby switch *on* the wonders of the universe. (*Switch on the Night* [New York: Pantheon Books, 1955]). See also another little book related to "night vision" that has changed my life, and to which my book is indebted, *Let There Be Night*, edited by Paul Bogard.

INDEX

Page numbers in *italics* denote illustrations.

Each entry that contains subcategories lists the "bio" (or biography) entry first. Titles of films are listed in a group alphabetically at the end of each relevant subcategory.

Ackerman, Forrest J, 165, *173*, 344
 Bio, 172–173, 391n3
 Associations with Ray Bradbury, 143,
 173–175
 Founder of *Famous Monsters of Filmland*,
 172, 292
Action Comics, 71, 163
Adams, Henry, 6, 361
Addams, Charles, 230
Adey, Robert C.S., 389n7
Age of Wonder (book), *see* Holmes,
 Richard
A.I. (film), 332–333
Albright, Donn, 175, *175*–176
Aldiss, Brian, 284, *325*, 348
 Bio, 325–326, 327–330
 Collaborations with Stanley Kubrick,
 332–335
 "Gothic" trilogy, the, 326, 348, 352
 On Gothic as SF, 4–5
 On New Wave SF, 121, 330
 On Mary Shelley's *Frankenstein*, 5
 Billion Year Spree, The, 326, 330, 332
 Dracula Unbound, 326, 331
 Frankenstein Unbound, 326, 330–331
 "Helliconia Trilogy," 325
 Island Called Moreau, 326, 331
 Oedipus on Mars, 335
 "Super Toys," 332–333
 Trillion Year Spree, The, 326
Alfred Hitchcock Presents (television series),
 25, 32–33, 388n2
All-Story Magazine, 178, 181
Alternate Worlds (book), *see* Gunn, James

alternate worlds/ virtual worlds/
 counterfactuals in SF, *see* Science
 fiction
Amazing Stories (magazine), 56, 92, 93,
 101, 116, 162–163
American Classic Screen (magazine), 248,
 257
Anderson, Poul, 1, 4, *101*, 285, 346, 368
 Bio, 101–102
 Collaborations with Gordon Dickson,
 102–103, 108–109
 "Flandry of Terra" stories, 108
 "Time Patrol" stories, 107, 245
 Boat of a Million Years, 101, 106,
 110–113
 Brain Wave, 105–106, 110–111
 Broken Sword, The, 101, 104
 Tau Zero, 101, 112
 Vault of the Ages, 104–105
Androcentric presumptions, 6
 see also "Heresy of Humanism"
Anvil of Stars, *see* Bear, Greg
"Arkham," Massachusetts, 20
Arkham Asylum, 348, 399n34
Arkham House, *see* Derleth, August
Ashbery, John, 309
Astounding Science Fiction (magazine), 97,
 116, 132, 336
At the Mountains of Madness (novel), *see*
 Lovecraft, H. P.

Babbage, Charles, 350
"Back to the Future" Trilogy, 349–351
Bailey, Robin, 126

Banks, Ian, 346
Barrie, Sir James M., 218, 394n25
"Barsoom" (Mars), 1
Bartok, Bela, 275, 278
Barzun, Jacques, 275, 390n17
Batman, *59*
 Batman movies, 71, 74–76, 389n6
 Batman television, 76–77
 Creation of comic book character,
 71–77, 389n6
Bear, Greg, 1, 110, 142, 346, *359*
 Bio, 360–361
 On art and science, 376–381
 On evolution, 401n11
 On "galactic ecology," 369–370,
 402n13
 On ghost stories, 362–363, 375–376
 On Gothic SF, 361
 On human computers, 365
 On music, 403n22
 On space opera, 366
 On teaching, 371
 On tensions between science and
 faith, 366
 Anvil of Stars, 366
 Blood Music, 360, 369, 375, 402n12
 Darwin's Children, 360, 368, 370, 401n11
 Darwin's Radio, 368
 Dead Lines, 360, 362–363, 367,
 374–375, 400n7
 Forge of God, 360, 369, 375, 402n12
 Songs of Earth and Power, 360, 371, 376,
 380, 403n22
 Sunborn, The, 366
 Tangents, 380, 404n24
 Vitals, 401n9
Beaumont, Charles, 169, 284, *287*
 Bio, 286–287
 Death of, 294–295
 Jason V Brock on, 288–296
 Roger Corman movies, 287, 290–291
 Subjects and style, 287–288
 Writing for *The Twilight Zone*, 287, 289,
 290–291
 Charles Beaumont: The Magic Man,
 292–296
 Hunger, The, 286
 Intruder, The, 290–291
Beckwith, Henry
 Bio, 19–20
 Lovecraft research, 19–24

 Tour of Providence, 19–24
Benford, Gregory, 2, 346, *359*
 Bio, 360–361
 On Gothic SF, 361
 On space opera, 366
 On teaching, 371–372
 On tensions between art and science,
 377–381
 On time travel, 373–374
 Great Sky River, The, 360, 368–369,
 377, 403n20
 Timescape 360, 372–374, 402n16
Ben's Dream (story), *see* Van Allsburg,
 Chris
Berlioz, Hector, 273
 Damnation of Faust, The, 276
 Symphonie fantastique, 275–276
Bettelheim, Bruno, 5
Bierce, Ambrose, 375
Billion Year Spree, The (book), *see* Aldiss,
 Brian
Blake, William, 392n9
Bloch, Robert, 2, 4, 42, 345
 Bio, 25–26
 On Gothic mode, 4
 Protégé of Lovecraft, 11, 25–35
 On *Psycho* as novel and film, 29–32,
 343–344
 Relationship with Hitchcock, 29–32
 On writing for television, 25, 32–33,
 388n21
 Opener of the Way (stories), 25, 28–29
Blood Music (story and novel), *see* Bear,
 Greg
Boat of a Million Years (novel),
 see Anderson, Poul
Boime, Albert, 3
 Bio, 202
 On Gothic mode, 5, 202–208
 On madness of Goya and
 Gericault, 204
Borges, Jorge Luis, 376
Bosom of the Serpent, The (book), *see*
 Schechter, Harold
Bradbury, Ray, 2, 4, *142*, *148*, 288, 289,
 292, 384
 Bio, 141–142
 Friendship and collaborations with
 Joseph Mugnaini, 146–162
 Friendship and collaborations with Ray
 Harryhausen, 142–147

Relationship with Forrest J Ackerman, 173–175
On *King Kong*, 143–145
On special effects, 146–147
Dark Carnival, 141, 158–159, 167
Icarus Montgolfier Wright, 148, 152, 160–161
Martian Chronicles, The, 141, 166, 167, 178, 197
Something Wicked This Way Comes, 141, 149, 150, 151–153
Switch on the Night, 404n6
Bradbury Chronicles, The (stories), *see* Nolan, William F.
Brain Wave, see Anderson, Poul
Brock, Jason V, 288–296, 292–296
 see also Beaumont, Charles
Brockden Brown, Charles, 35, 283
 Prophet of American Gothic, 397n24
 Edgar Huntly, 337, 339, 398n25
 Wieland, 337–338, 390n9, 397n24
Broken Sword, The (novel), *see* Anderson, Poul
Burke, Edmund, 385n8
Burroughs, Edgar Rice, 1, 95, 177
 Bio, 179
 As mythmaker, 391n1
 Attitudes toward "civilization," 186
 Attitudes toward race, 185
 Attitudes toward religion, 184
 Attitudes toward women, 183–186
 Fandom, 179, 188–189, 190–191
 "John Carter of Mars" books, The, 1, 3, 137, 177, 178, 179, *180*–184, 189–190, 348, 349, 380, 385n2
 John Carter (film), 191, 391n3
 "Tarzan" books, The, 179
Burton, Tim, 75–77
Byron, Ada, 399n43
Byron, Lord, 316
 At the Villa Diodati, 396n17

Campbell, John W., 113, 132, 336
Campbell, Joseph, 7
Campbell, Ramsey, 2, *36*
 Bio, 35
 Influence of Lovecraft, 15, 36–37
 On Liverpool upbringing, 38–40
 Demons by Daylight, 40
 Face that Must Die, The, 39–40, 41
 Hungry Moon, 44–45

Incarnate, 43
Inhabitants of the Lake, 36–37
Obsession, 48–49
Cannon, Peter, 388n15
Caprichos (etchings), *see* Goya, Francisco
Captain Video (television show), 245–248
"Carmilla" (story), *see* Vampire
Carr, John Dickson, 2, 11, 77
 Bio, 79–80
 On "locked room" mysteries, 78–86, 389n7
 On the Gothic mode, 78, 82
 On G.K. Chesterton, 81, 390n15
 On "Dr. Gideon Fell," 81
 Three Coffins, The, 81
Carroll, Lewis, 394n27
Case of Charles Dexter Ward, The (novel), *see* Lovecraft, H. P.
Castle, William, 388n18
Castle of Otranto (novel), *see* Walpole, Horace
Center for the Study of Science Fiction at the University of Kansas, *see* Gunn, James
Ceremonies, The (novel), *see* Klein, T. E. D.
Charles Beaumont: The Magic Man (documentary), *see* Brock, Jason V
Charnas, Suzy McKee, 2, 284, *313*
 Bio, 313
 On vampires on stage and in literature, 315
 Comparing traditional and postmodern vampire themes, 316–325
 The Vampire Tapestry, 314–325
Chesterton, G. K., 1, 79, 81, 212, 216, 310, 390n13
 And John Dickson Carr, 81, 390n15
Clarke, Arthur C., 330, 333, 355, 360
Coleridge, Samuel Taylor, 207, 346, 376, 392n11
"Colour out of Space, The" (story), *see* Lovecraft, H. P.
Comic books, 58, 71
"Conan the Barbarian" stories, *see* Howard, Robert E.
Confessions from the Heart of an Art-Loving Friar (novel), *see* Wackenroder, Wilhelm
Conover, Willis, 387n11
Corman, Roger, 287, 290–291, 331, 396n9

Cottlingley Fairies, *see* Doyle, Arthur
 Conan
 see also *Fairy Tale*
Craven, Wes, 48
Crippen & Landru, *see* Greene, Douglas G.
Crumb, George, 280
Cthulhu Mythos, *see* Lovecraft, H. P.

D'Onofrio, Vincent, 61, 67
Danse Macabre (book), *see* King, Stephen
Danse Macabre (symphonic poem),
 see Saint-Saens, Camille
Dark Carnival (novel), *see* Bradbury, Ray
Dark Matter, see Straub, Peter
Dark Valley Destiny (biography),
 see De Camp, L. Sprague
Darwin, Charles, 183, *283*, 284, 401n11
Darwin's Children (novel), *see* Bear, Greg
Darwin's Radio (novel), *see* Bear, Greg
Das Knaben Wunderhorn (song cycle), *see*
 Mahler, Gustav
De Bergerac, Cyrano, 1, 348, 383, 385n1
De Camp, Catherine Crook, *see* De
 Camp, L. Sprague
De Camp, L. Sprague, 1, 66, *130*, 285
 Bio, 130–131
 On H. P. Lovecraft, 13, 14
 On the "Harold Shea" stories,
 131–132, 133
 Collaborations with Fletcher Pratt,
 131, 133–134
 Collaborations with Catherine Crook
 de Camp, 135–136
 Lovecraft: A Biography, 13
 Time and Chance, 139
Dead Lines (novel), *see* Bear, Greg
Debussy, Claude, 279
Demons by Daylight (stories), *see* Campbell,
 Ramsey
Derleth, August, *17*, 27
 And Arkham House, 11, 387n6
 On the "Cthulhu" mythos, 15–18
 Critique by S. T. Joshi, 15–18
Detective Comics, 71
Dick, Philip K., 360
Dickson, Gordon, *see* Anderson, Poul
Difference Engine, The (novel), *see* Gibson,
 William
Disasters of War (etchings), *see* Goya,
 Francisco

Disney, Walt, 391n2
Doyle, Arthur Conan, 217, 221, 394n28
Dr. Jekyll and Mr. Hyde (novel), 387n3
Dracula (novel), *see* Stoker, Bram
Dracula films, 285
Dracula Unbound (novel), *see* Aldiss, Brian
Dreams by Daylight (short stories), *see*
 Campbell, Ramsey
Dunwich Horror, The (novel),
 see Lovecraft, H. P.

Eberty, Felix, 383
Edgar Huntly (novel), *see* Brockden
 Brown, Charles
Edison, Thomas, 343
Education of Henry Adams, The (book),
 see Adams, Henry
Ellison, Harlan, 295
Erwartung (music), *see* Schoenberg, Arnold

Fabulous World of Jules Verne (film), *see*
 Verne, Jules
Face that Must Die, The, see Campbell,
 Ramsey
Fairbanks, Douglas, Sr., 72
Fairy Tale (film), *216*, 217–222
 see also Sturridge, Charles
Fall of the House of Usher (opera), *see*
 Debussy, Claude
Famous Monsters of Filmland (magazine),
 see Ackerman, Forrest J
Fantastes (novel), *see* MacDonald, George
Farmer, Philip José, 348
 "Riverworld" series, 348
 To Your Scattered Bodies Go, 348
 "Wold Newton" series, 348, 349,
 399n38
Faust (novel), *see* Goethe, Johann
 Wolfgang von
Faust Symphony, see Liszt, Franz
Faust tradition of, 387n3, 401n10
Fell, Dr. Gideon, 81
Ferguson, Niall, 398n32
Fevre Dream (novel), *see* Martin, George
 R. R.
Fiedler, Leslie, 116, 391n1
Finney, Jack, 128
First Fandom, *see* Science fiction
Forge of God (novel), *see* Bear, Greg
Frankenstein (novel), *see* Shelley, Mary

"Frankenstein" films, 285
Frankenstein Unbound (novel), *see* Aldiss,
Brian
Freud, Sigmund, 284, 395n2
Friedrich, Caspar David, 201, 202, 208,
209, 231
German patriotism, 210–211
Symbolic landscapes, 210–212
Gipfelerlebnis, 124
Fuseli, Henry, 202–203

Gahan Wilson's Diner (film), *see* Wilson,
Gahan
"galactic ecology," 369–370
Galilei, Galileo, 6, 56
Galileo's Dream (novel), *see* Robinson,
Kim Stanley
Gaspard de la nuit (music), *see* Ravel,
Maurice
"Gateway" books, *see* Pohl, Frederik
Gay, Peter, 395n2
Geary, Rick, 285–338
Bio, 345
On graphic novels, 345–346
Illustrations by, *338*
Gein, Ed, 31, 341, 388n20
Géricault, Théodore, 201, 202
On madness, 205–208, 392n6
"Raft of the Medusa," 201, *206*, 392n5
Gernsback, Hugo, *56*, 93
Ghost stories, *see* Gothic
Ghost Story (novel), *see* Straub, Peter
Gibson, William, 6, *350*, 352, 354
Gilliam, Terry, 348
Goethe, Johann Wolfgang von
Faust, 274, 387n3
Wilhelm Meister's Apprenticeship, 212, 274
"Mignon," 212
Golden Compass, The, *see* Steampunk
"Golden Pot, The," see Hoffmann, E. T. A.
Gothic
General definition, 4–7
Historical aspects of, 339
Influence of, 6
literary tradition, 49, 278, 339,
386n10
fairy tale tradition, 212–216, 340–342,
393n14, 393n17, 394n26
painting, 208–212, 391n2
and Romanticism, 4–6, 404n23

and science fiction, 4–5, 18, 346, 361,
386n13
and postmodernism, 284–285, 339,
346–349, 396n5
and the "terror sublime," 385n8
and "locked room" mysteries,
see Carr, John Dickson; *see also*
Radcliff, Ann
and the "Faustian bargain," 401n11
and ghost stories, 362–363, 375–376
and graphic novels, *338*, 345–346,
348–352
and the tension between art and
science, 376
and the tension between science and
faith, 355, 366
and the tension between realism and
fantasy, 386n10
vampires, *see* Vampire
Gothic (film), *see* Russell, Ken
Gould, Stephen Jay, 401n11
Goya, Francisco, 201, 202, 205
Illness and madness, 205–208, 392n7
Caprichos, 205
Disasters of War, 205
"The Sleep of Reason Breeds
Monsters," *201*, 204
Grand Guignol, 42, 388n18, 388n22,
389n25
Great Sky River, The (novel), *see* Benford,
Gregory
Greene, Douglas
Bio, 80
Research on John Dickson Carr,
80–86
On Ann Radcliffe, 81
On Crippen & Landru, 80, 86
Grimm, Brothers, 393n16
As folklorists, 212–213, 216, 385n7,
394n21
Influences on Gothic writers and
illustrators, 212–213, 305
"The Juniper Tree," 396n16
Grimm, Ludwig, 214
Gunn, James, xii, 98, 126, 326, 386n13,
404n4
Bio, *xiii*, xiv
Alternate Worlds, xiv
Center for the Study of Science
Fiction, 117, 326

Harryhausen, Ray, 301, 344
 Bio, 141–147
 On special effects, 146–147
 On friendship with Ray Bradbury,
 142–147
 On *King Kong*, 143
Haunted Gallery, The, see Nead, Lynda
Haunted Gallery, The (history), see Nead,
 Lynda
Haunting of Hill House (novel), see Jackson,
 Shirley
Hawking, Stephen, xii, 402n13
Hawthorne, Nathaniel, 306, 341
Heinlein, Robert A., 111, 146, 251
 Juvenile SF, 248
 Space Cadet, 248, 251
Henry von Ofterdingen, see Novalis
"Heresy of Humanism," 6, 359, 369
Herrmann, Bernard, 279
Herschel, Sir William, xi, 6, 57
His Dark Materials (novel), see Pullman,
 Philip
Hitchcock, Alfred, 29
Hodgson, William Hope, 362
Hoffmann, E. T. A., 9, 11, 35, 78, 96,
 204, 274, 346, 395n6
 "Golden Pot, The," 133, 223,
 393n17
 Kater Murr, 78–79
 "The Sandman," 215, 391n4
Holmes, Richard, 384
 Bio, *iv*, xii
 Age of Wonder, x, xii
 On science and fiction, x
 On wonder, x
Hopkins Manuscript, The (novel), see
 Sheriff, R. C.
Houdini, Harry, 221–222
Howard, Robert E., 3, 11, *58*
 Bio, 59–61, 138
 Creator of "Conan," *59*, 62, 68,
 136–137
 Relationship with Novalyn Pricej,
 60–70
 As subject of *The Whole Wide World*,
 59–70
 As subject of *Dark Valley Destiny*, see De
 Camp, L. Sprague
Howard Phillips Lovecraft (biography), see
 Long, Frank Belknap

Humanoids, The, see Williamson, Jack
Hunger, The (stories), see Beaumont,
 Charles
Hungry Moon, The (novel), see Campbell,
 Ramsey

Icarus Montgolfier Wright (story and film),
 see Bradbury, Ray; Mugnaini, Joseph
Ice and Iron (novel), see Tucker, Wilson
Incarnate, see Campbell, Ramsey
Incredible Shrinking Man, The (novel), see
 Matheson, Richard
Inhabitants of the Lake, The, see Campbell,
 Ramsey
Intruder, The, see Beaumont, Charles
Invasion of the Body Snatchers (1955 film), 342
Ireland, Dan, 61, 66
 Bio, 59
 On Robert E. Howard, 62–70
 On *The Whole Wide World*, 59–70
Island of Dr. Moreau (novel), see Wells, H. G.
Isle of the Dead (music), see Rachmaninoff,
 Sergei

J. M. Barrie and the Lost Boys (book), see
 Barrie, Sir James M.
Jackson, Shirley, 41, 362, 400n6
James, Henry, 47–48
James, M. R., 37, 362
James, William, 284, 343, 402n14
Jenkins, Henry, 58
John Carter (film), see Burroughs, Edgar
 Rice
"John Carter of Mars" stories, see
 Burroughs, Edgar Rice
Joshi, S. T.
 Bio, 11
 On Lovecraft research, 11–19, 387n8
 On *Lovecraft: A Life*, 12–13
 On *Lovecraft: A Biography* (de Camp), 13
Jumanji (book), see Van Allsburg, Chris
Jumanji (film), see Van Allsburg, Chris
"The Juniper Tree" (story), see Sendak,
 Maurice
 see also Grimm, Brothers

Kane, Bob, 3
 Bio, 71
 on creating Batman, 71–77
Karloff, Boris, 34

Kater Murr (novel), *see* Hoffmann, E. T. A.
Kelly, DeForest, see *Star Trek*
Kindertotenlieder (song cycle), *see* Mahler, Gustav
King, Stephen, 2, 284, *296*, 385n6
 Bio, 296–297
 On horror fiction, 42–43, 302–302
 On H. P. Lovecraft, 10, 301
 On celebrity culture, 297–298
 On childhood fears, 301–302
 Collaborations with Peter Straub, 297;
 see also Straub, Peter
 Cujo, 301
 Danse Macabre, 297, 344, 393n18, 396n13
 Dark Tower, 298
 Different Seasons, 298
 Maximum Overdrive, 299–300
 Shining, The (film), 299
King Kong (film), 143
 see also Bradbury, Ray; Harryhausen, Ray
Klee, Pau, 243
Klein, T. E. D., 2, 35, 45, *50*
 Bio, 51
 Editor of *Twilight Zone*, 40, 52
 Ceremonies, The, 52–54
 Dark Gods, 54
Kornbluth, Cyril
 Collaborations with Frederik Pohl, 117–118
 Space Merchants, The, 115, 118, 119–120
Kramer, Larry, 274
Kubla Khan (poem), *see* Coleridge, Samuel Taylor
Kubrick, Stanley, 122
 Music in *The Shining*, 275
 Association with Brian Aldiss, 332–336
Kunstmaerchen, *see* Gothic, fairy tale
Kuttner, Henry ("Lewis Padgett"), 109, 121, 134, 146

La Jetée, *see* Marker, Chris
Lang, Fritz, 34
Le Fanu, J. Sheridan, 362
League of Extraordinary Gentlemen (film), 348
League of Extraordinary Gentlemen (graphic novels), *see* Moore, Alan
Legion of Space (novel), *see* Williamson, Jack

LeGuin, Ursula, 336, 401n8
Leiber, Fritz, 54
Lewis, C. S., 403n19
Lewis, Matthew G., 49, 389n26
Liederkreis (song cycle), *see* Schumann, Robert
Ligeti, György, 273, 281
Lilith (novel), *see* MacDonald, George
Lincoln Hunters, The (novel), *see* Tucker, Wilson
Liszt, Franz, 273, 274, 276
Locked-Room Murders (book), *see* Adey, Robert C. S.
"Locked-Room Mysteries," *see* Carr, John Dickson
Long, Frank Belknap, 12–13
Long Loud Silence, The (novel), *see* Tucker, Wilson
Love and Death in the American Novel (book), *see* Fiedler, Leslie
Lovecraft, Howard Phillips, 4, *9*, 60, 301, 362, 380, 384, 386n19, 357n4
 Bio, 10–11
 Biographies of, *see* Cannon, Peter, ed.; Conover, Willis; De Camp, L. Sprague; Joshi, S. T.; Long, Frank Belknap
 On afterlife, 385n6
 As atheist, 16
 On folklore, 387n7
 On native Providence, 19–24, 37, 386n12
 Influence of Poe, 12
 "Lovecraft Circle," *see* Bloch, Robert; Campbell, Ramsey; Long, Frank Belknap
 On the mythical town of "Arkham," 20
 Influence on popular culture, 385n6, 387n14
 "Cthulhu" writings, 10, 15, 21, 346
 At the Mountains of Madness, 12, 18
 The Case of Charles Dexter Ward, 24, 38, 387n13
 "The Colour out of Space," 12, 387n10
 The Dunwich Horror, 14
 Necronomicon, The, 27, 36, 51, 388n17
 "The Outsider," 12, 387n9
 "Shunned House, The," 22
 Lovecraft: A Biography, *see* De Camp, L. Sprague

Lovecraft: A Life (biography),
 see Joshi, S. T.
Lovecraft at Last (biography), *see* Conover,
 Willis
Lovecraft Remembered (biography), *see*
 Cannon, Peter, ed.

MacDonald, George
 Fantastes, 403n19
 Lilith, 376, 403n19
Machen, Arthur, 53, 362
Mahler, Gustav, 215, 376
 Kindertotenlieder, 215
 Das Knaben Wunderhorn, 215, 394n22
Man-Plus (novel), *see* Pohl, Frederik
Mark of Zorro, The (novel), *see* Fairbanks,
 Douglas, Sr.
Marker, Chris, 373
Markim, Al, 249
"Mars Trilogy" (books), *see* Robinson,
 Kim Stanley
Martian Chronicles, The (book), *see*
 Bradbury, Ray
Martin, George R. R., 312, 324
Matheson, Richard, 169
Maturin, Charles, 53–54
Maximum Overdrive (film), *see* King,
 Stephen
McWhorter, George, 190, 391n2
Melmoth the Wanderer (novel), *see* Maturin,
 Charles
Merlin, Jan, 249
Merritt, A., 95
Meyer, Stephanie, 312
"Mignon," 393n15
Miller, Cynthia, 285
 Bio, 375
 On steampunk novels and films, 352–356
Milton, John
 Paradise Lost, vi
Miraculous Mandarin (music), *see* Bartok,
 Bela
Mitchell, Tim
 Bio, 202
 On the Romantic landscape, 208–210
 On Caspar David Friedrich, 210–212
Moers, Ellen, 397n23
The Monk (novel), *see* Lewis, Matthew G.
Moore, Alan, 285, *350*
 League of Extraordinary Gentlemen,
 348–349, 352

Moreau's Other Island (novel), *see* Aldiss,
 Brian
Moskowitz, Sam, 385n1
Mozart, Wolfgang Amadeus, 273, 376
Mugnaini, Joseph, *154*
 Bio, 155–156
 Collaborations with Ray Bradbury,
 146–162
 Methods of working, 156–160
 Dark Carnival, 158–159
 Golden Apples of the Sun, 151
 Icarus Montgolfier Wright, 148, 151–152,
 160–161
 Something Wicked This Way Comes, 151
 Illustrations by, 149, 157, 158, 159
 see also Bradbury, Ray
Music of terror, *see* Sullivan, Jack
Mussorgsky, Modest, 276
Mysteries of Harris Burdick (stories), *see*
 Van Allsburg, Chris
Mysteries of Udolpho, The (novel), *see*
 Radcliffe, Ann

NASA, x–xi
Nead, Lynda, 217, 394n23, 400n3
Necronomicon (book), *see* Lovecraft, H. P.
New Worlds Magazine, *see* Science
 fiction
Night on Bald Mountain (symphonic
 poem), *see* Mussorgsky, Modest
Nightmare, The (painting), *see* Fuseli,
 Henry
Nimoy, Leonard, *see* Star Trek
Nolan, William F., 176, 293–294
 Bio, 166
 On *The Bradbury Chronicles*, 166,
 168–169
 As bibliographer of Ray Bradbury,
 166–171
Novalis, 212, 393n14

O'Brien, Willis, 143
Obsession, *see* Campbell, Ramsey
Occurrence at Owl Creek Bridge (story), 375
Opener of the Way (short stories), *see* Bloch,
 Robert
"Outsider, The" (story), *see* Lovecraft, H. P.

Pal, George, 213, 286
Paradise Lost, *see* Milton, John
Penderecki, Krzysztof, 275

Peter Pan films, *see* Barrie, Sir James M.
Peter Pan (novel), *see* Barrie, Sir James M.
Peter Pan (play), *see* Barrie, Sir James M.
Philosophical Enquiry into the Origin of Our Ideas of the Sublime and Beautiful, see Burke, Edmund
Poe, Edgar Allan Poe, 279, 337
 Influence on music, 281–282
Pohl, Frederik, *92*, 125, 178
 Bio, 115
 Collaborations with Jack Williamson, 98, 120–121
 Collaborations with Cyril Kornbluth, 115, 117–119
 Gateway books, 121–122
 Man Plus, 115, 178, 360
 Space Merchants, The, 115, 118, 119–120, 123
 Way the Future Was, The, 120
Polar Express, The (book), *see* Van Allsburg, Chris
Polar Express, The (film), *see* Van Allsburg, Chris
Polidori, John, 312
Pratt, Fletcher, 133–134
Preisner, Zbigniew, 219
Prest, Thomas Preskett, 397n20
Price, Novalyn, *see* Howard, Robert E.
Price, Vincent, 396n9
Princess of Mars, A (novel), *see* Burroughs, Edgar Rice
Prokofiev, Sergei, 281
Psycho (film), *see* Bloch, Robert
Psycho (novel), *see* Bloch, Robert
Puccini, Giacomo, 321
Pullman, Philip, 352–353
Pulp magazines, *see* Science fiction
"punctuated equilibrium," 368, 401n11

Rachmaninoff, Sergei, 273
Radcliffe, Ann, 81, 275
 Mysteries of Udolpho, 49, 78
Raft of the Medusa (painting), *see* Géricault, Théodore
Ravel, Maurice, 279
Reeve, Christopher, *87*
 Bio, 87–88
 On role of "Superman," 87–92
 With Margot Kidder, 88–89
 Superman IV, as author of, 91
Reid, T. L., 285

Bio, 356
 On steampunk culture, 356–358
Rice, Anne, 323
"Riverworld" series, *see* Farmer, Philip José
Robinson, Kim Stanley, *192*
 Bio, 192–193
 Influence of Burroughs, 195, 197
 Interests in Mars, 196–200
 Galileo's Dream, 6
 The "Mars" trilogy, 178, 193–195, 198–200
Roddenberry, Gene, 263
Romero, George, 299
Russell, Ken, 66
 Gothic, 391n3

Sacre le du printemps (ballet music), *see* Stravinsky, Igor
Sagan, Carl, 5, 216, 360, 393n20, 402n14
Saint-Saens, Camille, 281
"Sandman, The," *see* Hoffmann, E. T. A.
Schechter, Harold, 285
 Bio, 337
 On folklore, 395n2
 On true crime stories, 340, 345
 Bosom Serpent, 340, 341, 391n1, 393n20
Schoenberg, Arnold, 280–281
Schumann, Robert, 108, 212, 215, 273, 274, 380, 393n11
 And E. T. A. Hoffmann, 395n6
 Liederkreis, Opus 39 (song cycle), 392n11
 "Mignon" music, 393n15
Schwartz, Julius
 Bio, 162
 Associations with Ray Bradbury, 162–166
 As editor, 163–166
Science fiction (SF)
 Alternate/ virtual/ counterfactual worlds, 131, 346–347, 398n32
 Fandom, 102
 First Fandom, 123, 173
 "Golden Age," 55–58, 103, 113
 New Wave (*New Wave Magazine*), 121, 330
 Pulp magazines, *55*–58, 94, *114*
 Relation to Gothic, *see* Gothic
 Space opera, 57, 97–98, 137, 285, 366
 And steampunk, *see* Steampunk

Scriabin, Alexander, 277
Sendak, Maurice, 213, *214*
 Bio, 213–214
 As illustrator of the Brothers Grimm, 213, 214–216
 Where the Wild Things Are, 213, 216
 On children's literature, 215, 216
Shatner, William, see *Star Trek*
Shelley, Mary (nee Godwin), xi, 331, 352
 As progenitor of Female Gothic, 397n23
 As prophet of science fiction, 5
 At the Villa Diodati, 396n17
 Frankenstein, 5, 326, 330, 349, 353, 386n13, 386n15, 397n23
Shelley, Percy, 3
 As Gothic poet, 5, 391n1
Sheriff, R. C., 374, 403n18
Shining, The (film), *see* Kubrick, Stanley
Shining, The (novel), *see* King, Stephen
"Shunned House, The," (story), *see* Lovecraft, H. P.
"Skylark" and "Lensman" stories, *see* Smith, E. E. "Doc" Smith
"Sleep of Reason Breeds Monsters, The" (etching), *see* Goya, Francisco
Smith, E. E. "Doc" Smith
 "Skylark" and "Lensman" stories, 163, 245
Something Wicked This Way Comes (novel), *see* Bradbury, Ray
Songs of Earth and Power (novel), *see* Bear, Greg
Space Cadet (novel), *see* Heinlein, Robert
Space Merchants, *see* Pohl, Frederik
space opera, *see* Science fiction
Space Patrol (television series), see *Tom Corbett*
Stapledon, Olaf, 6, 328
Star Trek, 245, 247, 258
 Comments by De Forest Kelley, *270*, 271
 Comments by Leonard Nimoy, *258*, 268–270
 Comments by William Shatner, *258*, 267–268
 Comments by George Takei, 259–266, *260*
Steampunk
 Definitions of, 349–351, 352–356
 As consumer culture, 356–358
 Alan Moore, as practiced by, 350

William Gibson, as practiced by, 350
The Golden Compass, *347*, 348, 353
Steampunk Magazine, 356
Wild, Wild West (television series), 353
Steampunk Magazine, see Steampunk
Stoker, Bram, 322, 324, 353, 397n19
Straub, Peter, 284, *303*, 385
 Bio, 302–303
 Attitudes toward horror fiction, 303
 Collaborations with Stephen King, 303, 306–308, 312
 On creativity, 308–311
 "Blue Rose Trilogy," 311
 Dark Matter, 312
 Ghost Story, 306, 311, 344
 Houses without Doors, 304–311
 "Juniper Tree, The," 305, 310–311
Stravinsky, Igor, 277
Sturgeon, Ted, 404n4
Sturridge, Charles, 216
 Bio, 217
 Fairy Tale, *216*, 217–222
Sullivan, Jack, 344
 Bio, 274
Sunborn
 On "Music of Terror," 275–282, 395n7
 see also Bear, Greg
"Super Toys" (story), *see* Aldiss, Brian
Superman
 Creation of, 71, 163
 Christopher Reeve on, *see* Reeve, Christopher
Superman IV (film), *see* Reeve, Christopher
Switch on the Night, see Bradbury, Ray
Symphonie fantastique (symphony), *see* Berlioz, Hector

Takei, George, see *Star Trek*
Tangents (stories), *see* Bear, Greg
Tarzan of the Apes (novel), *see* Burroughs, Edgar Rice
Tau Zero (novel), *see* Anderson, Poul
Tennis Court Oath, The (poems), *see* Ashbery, John
Texas Chainsaw Massacre (film), 377
Third Level, The (stories), *see* Finney, Jack
Thomas, Frankie, see *Tom Corbett*
Thomson, David, 388n20

Three Coffins, The, see Carr, John Dickson
Tibbetts, James C., *123*
 Bio, 3
 As member of First Fandom, 3–4, 123
 Association with James Gunn, xiii
Time and Chance (autobiography), *see* De
 Camp, L. Sprague
Time Machine (novel), *see* Wells, H. G.
Time Patrol, see Anderson, Poul
Time travel
 Gregory Benford on, 373–374
 Wilson Tucker on, 127–128
 Poul Anderson on, 107, 245
 Jack Finny on, 128
Timescape (novel), *see* Benford, Gregory
Tingler, The (film), 388n18
To Your Scattered Bodies Go (novel), *see*
 Farmer, Philip José
Tom Corbett, Space Cadet, 245, *246, 247,*
 252, 255
 Frankie Thomas bio, 248
 Production history, 245–257
 Fandom, 254
 Special effects, 253–254
Tosca (opera), *see* Puccini, Giacomo
Totentanz, see Liszt, Franz
Trillion Year Spree (book), *see* Aldiss, Brian
Tucker, Wilson, *123*
 Bio, 123–124
 On time travel, 127–128
 On First Fandom, 123, 124, 125–126
 On SF conventions, 124–125
 Ice and Iron, 129
 Lincoln Hunters, The, 127–128
 Long Loud Silence, The, 128–129
 Wild Talent, 127
 Year of the Quiet Sun, 126–127
Turn of the Screw, see James, Henry
Turn of the Screw, The (novel), 280
Twilight series, *see* Meyer, Stephanie
Twilight Zone (magazine), *see* Klein, T. E. D.
Twilight Zone (television series), *see*
 Beaumont, Charles

Vampire
 As Gothic tradition, 312
 Dracula, see Stoker, Bram
 Dracula (film), 343
 Dracula (stage), 315
 Varney the Vampire, 312, 313, 397n20

"Carmilla," 312
Vampire Tapestry, The (novel), *see* Charnas,
 Suzy McKee
Vampyre (novel), *see* Polidori, John
Van Allsburg, Chris, 213, *223*
 Bio, 223–224
 On methods of working, 231, 233–237
 Illustration by, *227*
 Ben's Dream, 226, 231
 Jumanji, 224, 225, 230
 Mysteries of Harris Burdick, The, 226–229
 Polar Express, The (book), 229, 234–237
 Polar Express, The (film), 235–237
 Wreck of the Zephyr, The, 223–231
 Wretched Stone, The, 233
 Z Was Zapped, 233
Varese, Edgar, 282
Varieties of Religious Experience (book), *see*
 James, William
Varney the Vampire (novel), *see* Vampire
Vault of the Ages, see Anderson, Poul
Verne, Jules, 126, 197, 285, 349, *351,*
 352, 398n33
Villa Diodati, see Shelley, Mary
*Virtual History: Alternatives and
 Counterfactuals* (book), *see* Ferguson,
 Niall
Vitals (novel), *see* Bear, Greg

Wackenroder, Wilhelm, 380, 404n23
Walpole, Horace, 4–5, 275
 Castle of Otranto, 386n10
War of the Worlds (novel), *see* Wells, H. G.
Way the Future Was (autobiography), *see*
 Pohl, Frederik
Weird Tales (magazine), 26–27, 28, 56,
 60, 388n15
Wells, H. G., 7, 94, 95, 126, *286*
 Island of Dr. Moreau, 100
 Time Machine, 100
 War of the Worlds, The, 178, 312, 349
What Was Literature?, see Fiedler, Leslie
Where the Wild Things Are (book), *see*
 Sendak, Maurice
Whole Wide World, The (film), *see*
 Howard, Robert E.
Wieland (novel), *see* Brockden Brown,
 Charles
Wild, Wild West (television series), *see*
 Steampunk

Wild Talent, *see* Tucker, Wilson
Wilhelm Meister's Apprenticeship,
 see Schumann, Robert
Williams, Wade, 257
Williamson, Jack, *92*, 196, 285
 Bio, 92
 On space opera, 93
 Legion of Space, 93, 98, 245
 Collaborations with Frederik Pohl, 98
 Humanoids, The, 96
 Wonder's Child, 100
Wilson, F. Paul
 Bio, 170–171
 On *The Bradbury Chronicles*, 171–172
Wilson, Gahan, 213, *238*
 Bio, 238
 On children's literature, 241–244
 On macabre humor, 239–240
 Gahan Wilson Diner, 213
"Wold Newton" series (books), *see*
 Farmer, Philip José

Wollstonecraft, Mary, *see* Shelley, Mary
Wreck of the Zephyr (book), *see* Van
 Allsburg, Chris
Wretched Stone, The (book), *see* Van
 Allsburg, Chris
Wright, Elsie and Francis, 218
Wright, Farnsworth, 60

Year of the Quiet Sun, *see* Tucker, Wilson

Z Was Zapped (book), *see* Van Allsburg,
 Chris
Zellweger, Renee, 61, 64
Zemeckis, Robert, 224, 348
Zeuschner, Robert
 Bio, 179–180, 186–187
 Research on Edgar Rice Burroughs,
 180–192
 On the "John Carter of Mars" books,
 181–192